Studies in British Art

Hogarth: His Life, Art, and Times

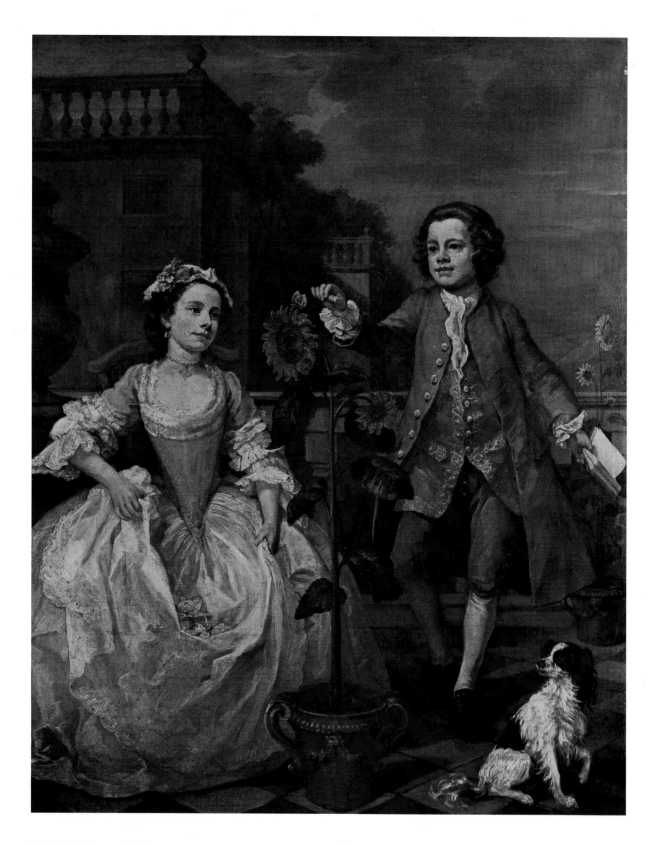

The MacKinnon Children; ca. 1742; 71 x 56½ in. (National Gallery of Ireland, Dublin)

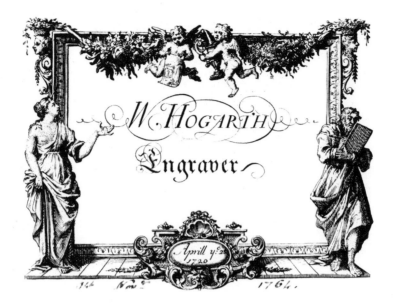

Hogarth: *His Life, Art, and Times*

by RONALD PAULSON

VOLUME I

Published for the Paul Mellon Centre for Studies in British Art
(London), Ltd.

by the

Yale University Press, New Haven and London

1971

Library of Congress catalog card number: 74–151586
International standard book number: 0–300–01388–4

Designed by John O. C. McCrillis
and set in Baskerville type
by Connecticut Printers, Inc., Hartford, Connecticut
and printed in the United States of America by
Meriden Gravure Co., Meriden, Connecticut

Distributed in Great Britain, Europe, and Africa by
Yale University Press, Ltd., London; in Canada by
McGill-Queen's University Press, Montreal; in Mexico
by Centro Interamericano de Libros Académicos,
Mexico City; in Central and South America by Kaiman
& Polon, Inc., New York City; in Australasia by
Australia and New Zealand Book Co., Pty., Ltd.,
Artarmon, New South Wales; in India by UBS Publishers'
Distributors Pvt., Ltd., Delhi; in Japan by John
Weatherhill, Inc., Tokyo.

Contents

VOLUME I

VOLUME II

List of Plates, Volume I

Photographs have been supplied by the following: National Portrait Gallery, 25, 26, 65b, 107a, 121, 261, 271a, 297; Royal Academy, 27, 108, 114, 139; Ministry of Public Works, 32, 33, 34, 41; Royal Library, 50a, 53, 231a, 313a; Miller & Co., Hartford, 61; Paul Mellon Center, 62, 63, 64, 74, 85, 91, 92, 107b, 158, 160, 162, 200, 201, 202, 203, 204, 205, 206, 224, 263, 267, 269, 270, 283, 299b; Stearn & Sons, 65a, 87, 88, 132, 133, 159, 168, 169, 174, 282; Courtauld Institute of Art, 66, 67, 177; Keith Gibson, 68; A. C. Cooper, 73, 76, 148, 149, 260; National Maritime Museum, 75, 193; Dulwich Gallery, 77, 173; Philadelphia Museum of Art, 78, 80; Leicester Art Gallery, 79; R. B. Fleming, 83, 121–28, 152a, 153a, 170, 248–51; Metropolitan Museum of Art, 84; National Gallery of Ireland, 86, 115, 165, 176, 179; Newbery, 109, 198; Annan, 112; Ashmolean Museum, 120; Blinkhorn, 128; Frick Collection, 129; Columbus Art Gallery, 137, 138; Manchester City Art Galleries, 140; St. Bartholomew's Hospital, 141–43; Todd-White, 151b; Birmingham Art Gallery, 154a; Huntington Library and Art Gallery, 163, 167; Tate Gallery, 164b, 175, 178, 191, 196, 197, 220; H. Edelstein, 166; National Gallery, London, 182–87, 266; Bristol Art Gallery, 256–59; Aberdeen City Art Gallery, 262; John R. Freeman & Co. photographed all the British Museum and Royal Collection prints and drawings. The remainder were supplied by the Meriden Gravure Company, who photographed the great majority of Hogarth's engravings directly from George Steevens' collection (now part of the W. S. Lewis Collection; see *HGW*, I, 74).

Preface

The sole researched biographies of Hogarth are John Nichols' *Biographical Anecdotes of William Hogarth* (1781, with revised editions running to 1817) and Austin Dobson's *William Hogarth* (1879, last edition 1907). Nichols based his on contemporary memories, manuscripts, and collections, and Dobson, though seldom venturing beyond him, corrected a number of the errors that resulted from hearsay testimony and guesswork. The many other "lives" of Hogarth have been based almost exclusively on Nichols and Dobson, and their contributions have been mainly interpretive; the "Hogarth" who has emerged is approximately the caricature Nichols (or perhaps, to give him his due, his collaborator George Steevens) perpetuated, toned down somewhat by Dobson. The only scholars since Dobson who have appreciably augmented our knowledge of Hogarth's life, as opposed to his works, are Charles Mitchell, who went to primary sources to produce some new facts about Hogarth's "Peregrination" through Kent in May 1732 (*Hogarth's Peregrination*, 1952), and the late Col. William Le Hardy, a professional archivist who began a careful search of the London parish registers and records: a task, inexplicably, never before undertaken. This research, hardly begun at Colonel Le Hardy's death, was brought to my attention, and subsequently published, only after I had independently covered the same ground (see chap. 1, n. 13). The present biography is the first attempt to establish the facts of Hogarth's life from a large range of primary sources: public records (rate books, baptismal and burial registers), records of banks and insurance companies, memoirs and letters of contemporaries, and notices in contemporary newspapers and magazines (including his own advertisements).

Hogarth's manuscripts, the fullest source of information about his character and thought, also disclose a great deal about his life. Except for separate pages scattered in libraries all over the world, the vast majority of these writings are in the British Museum, to whose trustees I am grateful for permission to publish long passages. John Ireland, who owned most of them (more, apparently, than the collection now in the British Museum), rewrote Hogarth's notes, constructing whole sentences and sometimes paragraphs of his own in order to make a narrative out of them. The result, published in the third volume of Ireland's *Hogarth Illustrated* (1798), loses a good deal of the sense of a mind in action expressed in the scribblings; but Ireland, to a remarkable extent, does make the correct intuitive leaps. He writes what he thinks Hogarth meant to say, filling out hints and incoherencies: the phrase "water arising," crossed out by Hogarth,

becomes the saying "water rises to its own level," toward which Hogarth was probably groping. If Hogarth had lived to polish his notes, they might have sounded something like Ireland's version. But most of his thoughts in the notes are only half-formulated; for all his sensitivity, Ireland sometimes distorts Hogarth's meaning, and exact transcription of the manuscripts tends to distort it even more. Hogarth was jotting down notes in what is virtually a shorthand, and his mind often raced ahead of his hand.

When only the facts are at stake, I have slightly regularized the manuscripts to facilitate reading, deducing what I think he *intended* to say from the abbreviations, ellipses, and erratic spelling that served as his shorthand. But I have retained his words and syntax, and so also the allusiveness lost in Ireland's expansions. I feel free to do this now that the great majority of the manuscripts, accurately transcribed as they stand and published by Joseph Burke and Michael Kitson, are readily available to anyone who would like to check my readings. However, when the actual arrangement of words affects Hogarth's tone and meaning, and when it is useful to illustrate his thought processes, I have transcribed them exactly, with all the false starts, omissions, repetitions, and confusions. I have uncovered a number of Hogarth's letters, and quotations from these, with his public utterances, have been transcribed exactly.

In the case of George Vertue's manuscripts, another extensive source of information about Hogarth, I have not found the same regularizing necessary. Vertue almost always makes good, if somewhat crabbed, sense, and the crabbedness is part of his charm. I am grateful to the Walpole Society for permitting me to quote from its invaluable edition of Vertue's notebooks (also in the British Museum).

There is relatively little information which might inspire speculation on Hogarth the man. To see him as clearly as possible, it is necessary to examine the caricatures and unflattering literary portraits and trace his reflection in the mirrors of his friends and contemporaries. Vertue, Thornhill, Fielding, and Garrick in their different ways illuminate certain aspects of Hogarth no other source could reveal, as do the institutions to which he dedicated himself—St. Bartholomew's Hospital, the Foundling Hospital, and the St. Martin's Lane Academy. A life of Hogarth is also to some extent an account of his friends, of the politics of London art in the eighteenth century, and of various social and political developments. I hope that the flow and ampleness of this biography will convey, as I intended, the feeling of the entire era.

Finally, there are the paintings and prints themselves. The scholarly works that make a biography like this possible are the catalogues of the artist's *oeuvre*. Without Beckett's compilation of the paintings, Oppé's of the drawings, and my own of the engravings a biography would have been impossible. I have not tried to work in all of Hogarth's paintings, let alone all of his prints and drawings; and have generally avoided discussing works not certainly by Hogarth.

However, I did locate a number of paintings not known at the time Beckett made his catalogue, and some are included. This biography is intended to complement my catalogue and study of the engravings, *Hogarth's Graphic Works,* and whenever possible I have avoided repeating myself. Engravings that are problematical, requiring more discussion to establish a date than is merited in a biography, can be examined there. I have not, however, inserted all the cross-references to *HGW* unless the context demanded: it is thoroughly indexed and anyone interested in more complete information on a given print can easily find it.

The need to establish biographical fact would not in itself have inspired me to write this book; I also wanted to show how Hogarth's background, milieu, personal life, and aesthetic ideas contributed to produce and define his unique kind of art. Of critical works on Hogarth, the only serious and sustained one is Frederick Antal's *Hogarth and His Place in European Art* (1962). Antal's book, despite its rigid Marxist framework, its unrestrained adulation of Hogarth, and its carelessness with regard to fact, is a valuable critical work and a mine of insights. (For documentation, see my remarks, *Journal of English and Germanic Philology,* LXVI [1967], 594–95.) Many times a casual remark of Antal's has divulged an aspect of Hogarth's character or work that had never occurred to me. Had he lived to complete and edit his manuscript, I am sure it would have been a much more compact and compelling work.

Most historians of English art place Hogarth in the transition period between the reign of foreign (Lely and Kneller) and clumsy native artists and the rise of the great Reynolds and Gainsborough. But this is to see him strictly in terms of portraiture, and then to oversimplify. He is a much more significant figure than such a generalization allows; and, I think, far more interesting than Reynolds and (though never so exquisite a painter) than Gainsborough. My tendency has been to see the so-called "comic history paintings" as the central fact of his career, with portraits and other works a secondary concern. While upon occasion he took portraiture very seriously, it was a matter of intense interludes—1728–32, with a few scattered portraits over the next few years, and 1738–42, with a few reaching to 1745, and finally a scattering from 1757 on. At any rate, I would like to correct the emphasis of Beckett's catalogue of Hogarth's paintings in which the divisions are "Single Portraits," "Portrait Groups," and finally "Miscellaneous," under which fall the "comic histories" and Hogarth's most original and important work.

The research for this book was begun in 1965 during a sabbatical year spent in England. I wish to thank the John Simon Guggenheim Foundation for its aid during 1965–66, the American Council of Learned Societies for a grant-in-aid for the summer of 1965, and the Penrose Fund of the American Philosophical Society for a grant-in-aid for the summer of 1967. For trips to various spots where Hogarth paintings may be seen I am grateful to the Paul Mellon Founda-

tion for British Art, which encouraged and subsidized the manuscript and also supplied many of the photographs. The manuscript was completed in the spring of 1969, but with the absorption of the Mellon Foundation by the Paul Mellon Center of British Art and British Studies at New Haven in the winter of 1969–70, it became the property of that foundation. The Yale University Press then undertook its publication, renewing a happy relationship that began with my first book.

For permission to reprint manuscript materials in their possession or copyright, I am grateful to the following: the American Philosophical Society, Philadelphia; the Henry M. and Albert A. Berg Collection of the New York Public Library, Astor, Lenox and Tilden Foundations; Geoffrey Bles, Ltd.; the Bodleian Library; the Bridewell Royal Hospital, now King Edward's School, Whitley, Surrey; the British Museum; Dr. James Browne; the Columbia University Press; Mrs. Copland-Griffith; Sir Christopher Courtney and the East Riding Archive Office; the Fitzwilliam Museum; the Thomas Coram Foundation for Children; the Guildhall Library; the Harvard College Library; the Harvard University Press; Mrs. Donald F. Hyde; R. W. Ketton-Cremer; the Hon. Society of Lincoln's Inn; the Linnaean Society of London; the Merchant Taylors' Company; Methuen & Co., Ltd.; the Pierpont Morgan Library; John Murray; the National Library of Scotland; the Public Record Office, London (Crown Copyright); the Royal Academy of Art; St. Bartholomew's Hospital; the vestry of St. Mary Redcliffe, Bristol; the Royal Society of Arts, London; the Sun Life Assurance Company, London; the Westminster Public Library, London; the Yale University Library; and the Yale University Press.

For permission to reproduce pictures from their collections I wish to thank Her Majesty the Queen; the Aberdeen City Art Galley and Regional Museum; the Albright-Knox Gallery, Buffalo; the Earl of Ancaster; the Hon Brigadier Sir Richard H. Anstruther-Gough-Calthorpe; Art Properties, Inc., J. Paul Getty Collection; Ashmolean Museum, Oxford; the Viscount Bearsted; the Beaverbrook Art Gallery, Fredericton; the City of Birmingham Art Gallery; Viscount Boyne; the City of Bristol Art Gallery; the Trustees of the British Museum; Nigel Capel-Cure Esq.; the Baron Chesham; the Marquess of Cholmondeley; the Columbus Gallery of Fine Arts, Columbus, Ohio; the Thomas Coram Foundation for Children; the County Museum and Art Gallery, Royal Institution of Cornwall, Truro; Alleyn's College of God's Gift, Dulwich College Art Gallery; the Marquess of Exeter; the Syndics of the Fitzwilliam Museum; the Frick Collection; the Viscountess Galway; the Horne Collection, Florence; Mrs. E. A. S. Houfe; George Howard Esq.; the Henry E. Huntington Library and Art Gallery; the Hyde Collection; the Greater London Council as Trustee of the Iveagh Bequest, Kenwood House; W. S. Lewis; the Hon. Society of Lincoln's Inn; the Musée du Louvre, Paris; the Manchester City Art Galleries; Mr. and Mrs. Paul Mellon; the Metropolitan Museum of Art, New York; the

Minneapolis Institute of Arts; the Pierpont Morgan Library; the National Gallery, London; the National Gallery of Ireland, Dublin; the National Gallery of Scotland, Edinburgh; the National Portrait Gallery, London; the National Trust, Clandon Park, Ickworth, and Upton House; the Trustees of the seventh Duke of Newcastle, deceased; the New York Public Library, Berg Collection; the Philadelphia Museum of Art; the Earl of Rosebery; the Viscount Rothermere; the Royal Academy of Arts, London; the Royal College of Surgeons of England; the Royal Naval Hospital and National Maritime Museum, Greenwich; the Governors of the Royal Hospital of St. Bartholomew; Lord St. Oswald (Nostell Priory Collection); the Dean and Chapter of St. Paul's Cathedral; Smith College Museum of Art; Sir John Soane's Museum; the Southwark Borough Council: the South London Art Gallery; the Tate Gallery; the Hon. Colin Tennant; John Todhunter; the Walker Art Gallery, Liverpool; and various private collections.

I wish I could name all of the people who have personally assisted me in all the libraries and museums I have visited. But for the help and encouragement of the following I would still be floundering: Jean Adhémar, Hugh Amory, Geoffrey Beard, G. E. Bentley, Jr., Mrs. Mavis Bulmer, Mrs. Genevieve Butterfield, Harry Carr and Lt. Col. Eric Ward of the Quatuor Coronati Lodge of London, Eric Chamberlain of the Fitzwilliam Museum, J. L. Clifford, H. S. Cobb, the Rev. James R. Copeland, Sir Francis Dashwood, Lt. Col. Alan Faith of Bridewell Royal Hospital, W. Fox of St. Bees School, W. E. H. Fuller of the Sun Life Assurance Company, Gerald O'Grady, the late H. A. Hammelmann, C. M. Hancher, John C. Harvey, M.D., Dr. Albert Hollaender of the Guildhall Library, Martin Holmes of the London Museum, Sidney Hutchison of the Royal Academy, Mrs. Donald F. Hyde, B. C. Jones of the Cumberland-Westmorland Record Office, George M. Kahrl, Dr. D. J. M. Kerling of St. Bartholomew's Hospital, John Kerslake of the National Portrait Gallery, the late R. W. Ketton-Cremer, Kenneth W. Labaree, the Rev. G. A. Lewis Lloyd, Hugh Macandrew of the Ashmolean Museum, Richard Macksey, Sheila G. MacPherson of the Kendal Record Office, Oliver Millar, W. M. F. Oliver of the London Hospital, David Piper of the Fitzwilliam Museum, H. Prevett of the Haberdashers' Company, Robert Raines, M.D., George Rousseau, Henry Rowell, Charles Ryskamp, Sidney Sabin, Col. Sir Douglas Scott of the Coram Foundation, Miss A. H. Scott-Elliot, J. B. Shipley, John Todhunter, John Velz, Robert W. Wark of the Huntington Library and Art Gallery, Ellis Waterhouse, John White, Calhoun Winton, and J. W. Woolley of the Merchant Taylors Company.

I am particularly happy to mention my friends Lawrence Gowing, Michael Kitson, Roy Strong, and J. B. Trapp, who were kind enough to introduce me, a novice, to the art world of London, opening doors and cutting red tape, thereby facilitating my work and increasing my enjoyment in the task. Basil Taylor deserves a category of his own: from the beginning he extended en-

couragement, advice, hospitality, and friendship on my many trips to London. It was he who shepherded me into my happy relationship with the Paul Mellon Foundation. I want also to thank Paul Sharp, Angus Stirling, and Colin Sorenson of the Foundation, who assisted in many ways while the manuscript was in their hands, and Mrs. Patricia Barnden, who personally gathered most of the photographs and permissions. My old friends at Yale, Maynard Mack and Louis Martz, who read the manuscript and offered valuable suggestions, Jules Prown of the Mellon Center, and Chester Kerr and Anne Wilde of the Press, understand, I am sure, the particular debt of gratitude I owe each of them. Jennifer Alkire was the best of all copyeditors.

Finally, Earl R. Wasserman, who generously took time to read crucial parts of the manuscript: long before I knew him personally his critical essays on the poetry of Dryden and Pope taught me how Hogarth's works should be approached. In the later stages of writing this book I was fortunate enough to spend many hours sharing with him what Hogarth called the "love of pursuit" in the prints, recreating, I believe, the pleasure Hogarth intended and that his contemporaries enjoyed when they "read" him.

<div align="right">R.P.</div>

London
May 1970

I. The Range of Possibilities
1697–1720

Richard Hogarth in London

There is a Beauty in these Things at a distance, taking them *en Passant,* and in *Perspective,* which few People value, and fewer understand. . . . behold, to crown all, a fair Prospect of the whole City of *London* it self; the most glorious Sight without exception that the Whole World at present can show, or perhaps ever cou'd show since the Sacking of *Rome* in the *European,* and the burning of the Temple of *Jerusalem* in the *Asian* part of the World.

Defoe is describing London as it must have looked to an ambitious youth arriving from the country. Up close, "this great and monstrous Thing, called London" was another matter.[1] It was a very different thing from Westmorland, whence Richard Hogarth is supposed to have traveled: "a Country eminent only for being the wildest, most barren and frightful of any that I have passed over in *England,* or in *Wales* it self."[2]

Richard Hogarth, the painter's father, was born on 24 January 1663 or 1664 somewhere in the north country, quite possibly in the Vale of Bampton in central Westmorland.[3] In one way or another, apparently without attending more than a good local grammar school, he acquired a solid grounding in Latin and Greek and set up a school of his own. Rising out of a family of farmers or shepherds to be a schoolmaster, he must have seen himself as a self-made man with a future. Westmorland was the kind of place an ambitious and scholarly young man would inevitably have left behind. Freeholds were easily lost in those days, and anyone who did not have a freehold was paid abysmally low wages. The statistics of modern historians support Gregory King's analysis of 1696 that showed over half the population living near the subsistence or starvation level.[4] Richard Hogarth could not have earned much as a Latin master in his native district, even if he served as a submaster at St. Bees or the Bampton Free School. He may already have begun writing his first textbook by his early twenties; in any case, at that age he decided to set off for the metropolis.

About 1686 he made the trip south, attended in all probability by his friend (and presumably student) Thomas Noble and by Edmund Gibson, both of the

Bampton area.[5] Noble and Gibson traveled south to become students at Oxford, and in the latter case to begin a brilliant scholarly and ecclesiastical career ending as Bishop of London. Gibson is alluded to in Plates 1 and 3 of *A Harlot's Progress* (1732): first as the source of preferment which interests the clergyman more than the defenseless girl who is being corrupted under his nose; and second as the author of pompous "Pastoral Letters." Richard Hogarth went south to earn a living, make a name for himself, and begin the long downward course to failure, debtor's prison, obscurity, and death.

The earliest trace of his presence in London is a little textbook published in May 1689, *Thesaurarium Trilingue Publicum: Being an Introduction to English, Latin and Greek.*[6] Though unsigned, its author is identified in a laudatory poetic epistle by one J. H. as "Victrix *Hogarthica* Penna" (the victorious Hogarthian quill). An introductory letter, complimenting the author on his guide to spelling and hoping women will find it useful, as they are especially in need of it, is signed T. N.; most probably Thomas Noble, who was still at Oxford.[7] From the introductory testimonials, the book appears to be aimed at young ladies and gentlemen who might "wish to make the acquaintance of correct writing" ("Scripturam si forte velis cognoscere rectam") or wish to compose verses or little songs. It is equally clear that it would serve for a "petty" or elementary school of five- and six-year-olds, where English spelling, pronunciation, and grammar were taught and children were made to memorize moral aphorisms. The first part (as Richard explains in his preface) treats "the true Spelling and Division of Words, which is the first step an English Scholar makes after he has learn'd his A, B, C." In the second part, devoted to Greek, he appears to be more concerned with his peers, the scholars. Here, after explaining that he has written in English only because the first part was in English, he adds that "Notwithstanding, if that be the only Fault, I shall enlarge it, and make it Latin, and bind it up alone, if God prosper it to the end intended, which is the Promotion of good Learning."

All in all, the *Thesaurarium* strikes a number of characteristic Hogarthian notes (the "Hogarthica Penna" of the commendatory verses). He writes as forcefully and polemically, as opinionatedly, as his son. Explaining his own peculiar method of dividing words into syllables to facilitate the teaching of spelling, he asserts that the credit of good education "would soon grow into Contempt, if (after the Opinion of some careless Men) we should spell every word according to the Pronunciation that time by Corruption has given them." (Strong words, and more so if his son's spelling is considered.) Defending his use of the vernacular in his preface, he asks that the reader

> not quarrel at me, because I have done it in English; for that upon serious deliberation I judged would be the best, as supposing it to be of more general use; my purpose being chiefly the Education of the English Scholar.

. . . Neither would I have thee disgusted at the unevenness or unpleasant-
ness of the Style, for that the Subject would not admit of better. . . .

The commonsense approach of the book, and the strong sense of decorum
(rough style for rough subject), together with the cheerful outspokenness, even
crankiness, may recall Richard's north country origins; certainly these are con-
sistent with the characteristics one would expect in Hogarth's father. Richard
was a conventional pedagogue of his time in his emphasis, and overemphasis, on
rules and memorization; but after a long list of such rules, he ends "I cannot
think of any further Rule [that] can be given; so that the Writers Fancy must
only guide him in the rest."[8]

Richard was also conventional in his relish for sententiae. In the middle of
the book he inserts a series of little "Lessons for Children," each written out first
and then divided into his system of syllables. They demonstrate the Augustan
assumption about literature, "for wheresoever the Speech is corrupted, the
Mind is so too," but they also reflect the typical Roman values instilled in Eng-
lish education (and indeed, they may have been cribbed from ancient authors).[9]

If the *Thesaurarium*'s author was a sententious stoic Romanist—in that sense
an "Augustan"—and a believer in rules, he also displays a marked tendency to
theorize and to build systems. When he turns to the subject of orthography,
Richard explains that he would do away with the letters H, K, Q, Y, X, Z, W, F,
and G—though, he adds in his preface, he offers such theories only "to the consid-
eration of the nicer sort, not being so Ambitious as to desire their passing into
Practice." He emerges as a mixture of teacher and pedant, perhaps something of
an autodidact, but with an ability to write simple, clear, and occasionally vigor-
ous prose, behind which one senses kindliness and some humor. The inclination
to treat grammar, Latin, and learning in general as a game is often evident: he
includes a list of homonyms, he says, so that children can make a game of their
study by quizzing each other—which "will be the greatest spur to their profi-
ciency in learning." Such a technique, besides using *dulce* to promote *utile,*
depends upon a love of puns that may have been characteristic of the father and
certainly was of the son.

The *Thesaurarium* was an ambitious undertaking. Richard's attempt to com-
bine textbook and self-help manual, incorporating a somewhat irrelevant theory
of an improved, phonetic alphabet, and other private concerns, may explain
why the book does not appear to have flourished. In his second book Richard
has already been reduced to working for the booksellers as a scholarly popular-
izer. The *Gazophylacium Anglicanum,* an abridgement of Stephen Skinner's
Etymologicon Linguae Anglicanae (1671), was published in November 1689,
eight or nine months after the *Thesaurarium*—enough time for the hack work
required to eliminate Skinner's elaborate introduction and shorten the diction-
ary.[10]

Reminiscences jotted by William over half a century later indicate that he thought of his father as an author, not a schoolmaster. "His Fathers Pen," he writes, "like that of many other authors was incapable of more than putting him [i.e. William] in a way to shift for himself"; and in another draft he writes that his father's "dependence was cheifly on his Pen."[11] Though Richard designated himself as a schoolmaster in the ratebooks, in his letters, and as late as 1711 on the title page of his *Disputationes Grammaticales,* he does not appear to have been licensed with the Bishop of London; and I have found no advertisement or notice of his school in any contemporary newspaper, although many schoolmasters did so advertise, and Richard and Anne Hogarth advertised other enterprises.[12] He probably began as a sub-master and later established one of the innumerable private grammar schools that appeared and usually soon disappeared. He may have had several of these in the 1680s and 90s, and he may have continued to call himself *Ludimagister* at times when a school was only a project in his head.

In 1690 he was a lodger in a house in Bartholomew Close, just off Smithfield Market, occupied by John Gibbons and his wife Anne, who had themselves moved in only within the last year.[13] The house was located in the close to the right of the passage to Middlesex Court, one of a row of dark and shadowy timber, lath, and plaster houses, probably in no very good condition, having escaped the fire of 1666 and therefore the opportunity of rebuilding.[14] It was in this house, some seven years later, that William Hogarth the painter would be born.

John Gibbons had a large family of at least nine children, but by the time he settled in the house in Bartholomew Close only three still remained at home: there were two daughters, Anne, then a spinsterish twenty-nine; Mary, sixteen; and a son, John, who was fourteen and soon to be apprenticed. Besides these, the tax assessor listed "M^r Hogath [sic] Lodger" and a maid.[15] Nothing is known of the elder Gibbons' profession (although based on John's apprenticeship, grocer is a good guess) or his prosperity. As a matter of course he would have kept his shop in the front room, lived in one or two rooms, and let the rest of the house. Richard may have given private lessons or he may have taught at someone else's school; but he did not then have a separate location for his school or it would have appeared in this or one of the subsequent assessments being made in support of William III's wars.

All that now remains of the Gibbons family is their Bible, which survives because it passed through Anne Gibbons' hands to her son, William Hogarth, and bears his marks as well as his grandparents'.[16] It is a worn, squat little volume, a King James version with Book of Common Prayer and Sternhold-Hopkins Psalms, and is manifestly a family Bible, much-handled. Here it is recorded that Anne Gibbons was baptized 10 November 1661, and that "november 4

1690 richard hogarth took to wife anne dagtur of John Gibbons and of Anne his wife."

Although the act is noteworthy in view of William's parallel situation forty years later, it is not surprising that a lone stranger in the bosom of a household-ing family should fall in love with one of the daughters and create a place for himself in the family. Richard chose the elder daughter, Anne, three years his senior, and probably (to judge by her age) either her father's chief assistant in his business or the family housekeeper. Love aside, it is easy to imagine them drawn together by mutual need. She was a strong-willed woman, and at a later time she supported the whole family by her own efforts; she possessed family and security but, at age 29, no husband. He was a learned man, perhaps witty, cer-tainly talkative and full of opinions, with at least one book to his credit. Though the marriage was inscribed in the family Bible, there is no record of it in the calendars of marriage allegations or the St. Bartholomew the Great marriage register, so it was presumably performed in a dissenting church.

In the fall of 1692 John Gibbons died suddenly, without time to write a will, and was buried on 13 November in St. Bartholomew's churchyard.[17] The house continued in the Widow Gibbons' name. The maid, evidently a luxury that could no longer be afforded, was discharged, and in the tax assessment of 1692–93 a line drawn across the page, separating the Widow Gibbons and her children from "Rich⁴ Hogerath" (the various misspellings may say something about his north country pronunciation) and "Ann his wife," suggests that they had a floor to themselves.[18] By 1695, daughter Mary was still there, son John had gone into apprenticeship, and two or three boarders had been taken on; and when the boarders John and Elizabeth Brooke produced a child, it was said in the bap-tismal registry to have been born "att Mʳ Hogards house yᵉ schoolmasters." Since he was not a ratepayer, Richard must, at this time, have been using one floor of the house as his school and must have appeared the dominant member of the household.[19]

Four children had been born to the Hogarths so far. The first, John, was re-corded in the Bible: "John Hogarth Son to Richard Hogarth and Anne his Wife was born Aug. 13. 1691 a little before one of the Clock in the Afternoon." He was baptized 23 August and died 3 September (the spelling, Hoggard); Elizabeth Hoggard was baptized 3 September 1692, not long before John Gib-bons' seizure, and died 20 January of the following year; Anne (the first of that name) was baptized 3 February 1693/4 and died on the 20th of the same month. This sad list is all the record that remains of those early years of the Hogarths' married life. The first child to survive infancy was Richard, baptized 11 April 1695; the next two, William and Mary, survived into adulthood.[20]

Bartholomew Close at this time was teeming with middle-class activity. Be-sides Richard, the schoolmaster, and presumably his school, there was a tavern called the Flying Horse, and around the close lived (and in most cases worked)

a joiner, a tobacconist, a physician, a chandler, a baker, an upholsterer, a tailor, a plasterer, a draper, a victualler, a stonecutter, and even a painter (one John Dalton). These were all nonconformists, but the Bishop of London also owned a house in the close, though probably let to a nonconformist.[21] And immediately adjacent was the ancient church of St. Bartholomew the Great, displaying a "new payr of stocks with a wiping [whipping] post" in the churchyard. In 1697 men like Mr. Pindar, who kept the sweating house in Westmorland Court, and James Hatten, an alehouse keeper at the Cock, on the corner of Duck Lane, were convicted of profane swearing and condemned to pay 2s each or "to be set (publickly) in the stocks for the space of one whole hour."[22]

The 1690s had been a time of relaxation of the nonconformist laws by a sympathetic king. At the same time, Englishmen felt the burdens of war as a Dutch king fought off his continental enemy, Louis XIV, in a long series of depressing and indecisive campaigns. 1697 dawned with hopes for peace, and in April they materialized in the peace conference assembled at Ryswick. Autumn saw the announcement of the Peace of Ryswick in September, the birthday of William III on 4 November, his return from the Continent on the sixteenth, and the opening of the new cathedral, St. Paul's, in early December: three long months of bonfires, the ringing of bells, and the firing of cannon. The fireworks in St. James' Park were "the finest that ever was seen in *England,* the Charge of which, as it is said, will amount to 10000 *l.*" St. Paul's, though not completed for another twenty years, was opened for a service of Thanksgiving on 2 December.[23]

Six days after the king's birthday, on Wednesday 10 November, a fifth child was born to the Hogarths, and on Sunday the twenty-eighth he was baptized William. Many of the boys baptized that week must have been given that name, and though "William" was a family name among the north country Hogarths, it probably seemed a lucky choice at just the moment when the victorious Protestant king's birthday and successfully negotiated peace were so grandly celebrated.[24] So lucky that the next child, born two years later, was named Mary after his queen.

The baptismal font in which the Hogarth children were baptized, one of the two pre-Reformation fonts remaining in London, can still be seen in the south transept of St. Bartholomew the Great. The circumstances of the baptisms, especially William's, are just ambiguous enough to shed light on his father's religious identity problems. St. Bartholomew the Great, founded in 1123, was one of the oldest churches in London; by the last half of the seventeenth century, however, it was an outpost of the established church in a center of nonconformists. On the afternoon of Sunday, 30 October, for example, just a fortnight before William Hogarth's birth, the *Post Boy* (2–5 November) noted that

vast multitudes of People came to the Philadelphia-Meeting, in *Bartholomew* Close; but those Religionists, for Reasons best known to themselves,

have shifted their Quarters, and left a Bill over the door signifying that they meet there no more. The Mobb incensed at this disappointment, vented their fury upon some of the Neighbouring Windows.

While no doubt deriving from the restless atmosphere of festivity that fall, this riot points to the nonconformism of the neighborhood into which William was born, and to the mob that he saw so often in this or that corner of London. The question—one which arises often with Hogarth—is whether his family was of this mob or outsiders looking in.

In May 1695 St. Bartholomew's, apparently under pressure from higher authorities, had instituted a separate parish register for nonconformists, which remained in effect until 1710, drawing most of its sustenance from Bartholomew Close.[25] Before 1695 the Hogarth children had been listed in the regular baptismal register of St. Bartholomew's. Richard the younger, born just before the new register was instituted, was entered as an afterthought in the margin of the regular register, but William's birth and baptism were both entered in the nonconformist register: "William Hogarth was borne in Bartholomew Closte next doore to Mr Downinges the printers November ye 10th 1697 & was baptized ye 28th November 1697." The next child, Mary, was registered as "borne in Bartholomew Closte ye November 23th [sic] 1699" in the nonconformist register, but notice of her baptism was entered in the regular register, on 10 December.[26] The next Hogarth child was born in a different parish. The baptism in St. Bartholomew's of a child whose birth was registered in the nonconformist ledger, it should be emphasized, was an exceptional occurrence.

The listing of the earlier Hogarth children in the regular parish register, as well as the baptism of William and Mary, suggests that Richard was a moderate Presbyterian. The Scottish source of the Westmorland Hogarths supports the possibility. There is no telling how rigorous or separatist Richard's forebears were, but southern Presbyterians were not opposed to the established church to the extent that other nonconformist sects were, and they often attended Church of England services and took communion.[27] But Richard lived among nonconformists who refused to allow their children inside the established church to be baptized. He and Anne appear to have been married in a meeting house, and he taught without a license (dependent on swearing to the 39 Articles, which most nonconformists could not do). In both cases, records may not have survived—and enforcement of the teaching license was lax; but these lacunae could be explained by Richard's conscience. On the other hand, it is evident that he permitted himself latitude in the taking of the church sacraments, and some years later (although he had named two of his children William and Mary) he was willing to compile a monarchist, high church catalogue of the great men from sacred and Roman history. Hoping this list might be adopted by one of the church schools like St. Paul's, he included Charles I, who "Suffer'd Martyrdom

for Religion and the Laws," Charles II, and James II, while omitting Cromwell and William III.[28]

The Family Bible shows that the Gibbons were either Anglican or at least communicants, and this inference leaves two possibilities for Richard: either he was converted by his in-laws or conformed to their practice, or he independently conformed to the pedagogical community and his ambitions for a successful career as scholar and teacher. In any case, a Presbyterian of Scottish descent, with all that implies of uncompromising anti-establishment faith, went to London and adjusted to the beliefs of the world he wished to emulate. One must not lose sight of the context: the period between 1660 and the accession of William III in 1688 had been a time of almost unrelieved persecution of nonconformists. This persecution, and men's behavior in the face of it, was in the background of all Puritan thought; and while in the 1690s the question of conformity to the establishment was primarily a social matter, the grimmer context remained a living memory.[29]

There was a Presbyterian meetinghouse actually adjoining St. Bartholomew the Great, in an old building called Middlesex House in Middlesex Court, just around the corner from the Hogarths' house.[30] Built smack against St. Bartholomew's south side, the meetinghouse had a window, used at least during times of secrecy and persecution, "which opened from the meeting-house into the adjoining church. It was situated directly opposite to the pulpit, in the latter building; so that a person in the gallery of the meeting-house could clearly discern the congregation in the church and watch the different parts of divine worship. . . . The meeting-house is a small inconvenient building and accessible by a flight of several steps. There are three galleries of tolerable depth, and the roof is supported by large beams, after the old manner." In one corner was a statue of a popish priest holding a child in his arms. The congregation was never large, "nor indeed would the size of the meeting-house admit of it." If this was the Hogarths' church, they probably continued to attend it long after leaving Bartholomew Close.[31] Whatever one may conclude about Richard Hogarth's religious position, clearly his was a family of nonconformist persuasion in a nonconformist neighborhood, taking the sacraments of the established church. The window through which nonconformists could watch the Anglican services in St. Bartholomew's is emblematic of the situation.

It is a telling fact that, among all the Hogarth traditions, there is none about William's religion. Jane Hogarth is portrayed in late life going to, and dominating, the Chiswick church; but I have found no record of William's actively participating in any church (although he supported many charities). One may take this lack to indicate the unimportance of religion—or at least organized religion—in his life; religion is, however, present in his works, serving sometimes an aesthetic, sometimes a conventional moral purpose. The traces of a Puritan heritage are evident in the moral framework of his prints, in his concern with

the spiritual biography of the individual *sub specie aeternitatis,* and in his deep sense of the individual's responsibility for his choices and the consequences of free action. The almost obsessive concern with these matters may have its origin in his Presbyterian family background.

To begin with, he cannot have escaped the Puritan mythology which, surviving in nursery tales in even the most secularized families, told of the man who conducted business instead of worshiping on Sunday, stayed too long in an alehouse, and, riding home, fell off his horse and drowned in a river. The visible world was, to the Puritan, full of symbolic significance: every object, every act, could be spiritualized. When someone fell on an icy patch of road it reminded the thoughtful Puritan that the unwary man sets his feet in slippery places. The house struck by lightning was a sign of God's judgment, and even the burning of a house might lead to a meditation on the power of temptation to kindle the flames of sin in one's heart.

Puritan hermeneutics analyzed texts—Scripture and Nature—in terms of example or precept, promise and threat, the reward of virtue and the punishment of error. This sequence, embodied in Interpreter's House in *Pilgrim's Progress,* is reiterated in book after book of Puritan meditation. There is much talk about the importance of example over precept, and example was often most effective when made visual and sensuously present. The pictorialism of the Puritans is evident in John Robinson's wish that he could "present this lively to your eyes, which I am fain to do now only to your minds and understandings."[32] These visible examples take the form of *"Promises* whereby we are encouraged to our Duty, or *Threatenings* whereby we are awed so as to keep within the bounds of it." Interpreter, after showing Christian the reprobate who has dreamed of the Last Judgment, counsels: "Let this mans misery be remembered by thee, and be an everlasting caution to thee."[33]

Bunyan's works, especially *Pilgrim's Progress,* appeared on the bookshelf beside the Bible in the most meager library. Here was the ordinary man's spiritual biography, which Hogarth was to echo in his earliest print cycles. There are four types of character-as-example in Bunyan's allegory: the sincere wayfarer like Christian, the insincere wayfarers who are his foils (Hypocrisie and Formalist), the threats and temptations along the way (Flatterer, Worldly Wiseman, and the people of Vanity Fair), and the wayside memorials, those erstwhile wayfarers who are preserved as admonitions in the symbolic poses of their failure. Hogarth's emphasis—with the Puritan authority of works like *The Life and Death of Mr. Badman,* but also with important satiric influences—falls on the insincere wayfarer, though he replaces insincerity with delusion (and avoids a Mr. Badman), and the sincere wayfarer becomes a foil, often a minor figure; the denizens of Vanity Fair fill the rest of the canvas, and frozen above in pictures on the walls of the rooms are the wayside memorials.

There is, of course, a significant difference between the worlds of Hogarth

and Bunyan: Bunyan at the outset of his narrative leaves the "wilderness of this world," the waking life, and enters the world of dream, an ordered spiritual realm of clearly demarcated good and evil. Hogarth begins his career in this allegorical realm; but very soon, trained by an already partly secularized source, his father, and drawing upon other non-Puritan traditions, he enters the waking world of "wilderness" with its ambiguities and paradoxes and confusions. He does not, however, forget that Scripture as well as Nature is the source of precepts, and his exploration of Nature for its exemplary meaning frequently includes the scriptural analogue (albeit often with secular irony), which is in one sense a half-conscious reminder of the close relationship between these areas of exegesis.

In 1697 Richard wrote a letter in Latin to Thomas Gale, the headmaster of St. Paul's School, wryly signing himself "Keeper of the Press" ("Preli Curator"); perhaps with a pun intended, since *prelum* was literally a wine press. In this curious letter he says he has been correcting the Latin of Marcello Malpighi's *Opera Posthuma* and commends the work to Gale's "friendly criticism and that of the Royal Society." "I have never before," he writes,

> that I can remember disentangled an author writing so childishly and barbarously; therefore let the reader do what sailors do, who when the water stinks hold their noses, for he should scorn the words and attend the sense.
>
> I have amended many (I could almost say an infinity) of the author's errors; nevertheless I fear some have gone unnoticed; for only Hercules cleaned the Augean Stables.[34]

However grandiose his claims, the most obvious trace of Richard's hand on the *Opera Posthuma* is the Latinizing of the publication line as "Londini, Impensis A. & J. Churchill, at [?] Insigne Negri Cygni in Vico dicto Pater-noster Row."[35] The letter shows that he was no stranger to Gale and wished to keep his name before him. Bad luck for Richard, a few months later, in September of 1697, Gale was appointed Dean of York and was succeeded at St. Paul's School by one John Postlethwaite.[36]

A second letter of the same year, this time in English, went to his old friend Thomas Noble, now chaplain to the Countess of Carlisle (Gale was a Yorkshireman by extraction, and Noble may have acted as an intermediary). This letter also concerns, though no less indirectly, the promotion of Richard's scholarly ambitions:

> I am extremely obliged to you for the Honours of yours to Mʳ Heplinstall in behalf of my particular friend: 'Twas concise and full and very satisfactory as indeed all that he receives are: Yesterday he receiv'd a Letter from Mʳ Peters of Truro in Cornwall in which there was a concurrence of the Schoolmasters of the whole County highly approving and encouraging of it,

So that I hope you will not doubt but it will answer the Character you have given of it.[37]

Despite the wobbly pronoun, changing from "he" to "it," the "particular friend" is plainly one of Richard's textbooks or a new one in manuscript; he is evidently collecting letters of approbation on this work from noted scholars and teachers who might adopt it in their schools.

The letter also indicates, however, that Richard is now augmenting his earnings, or at any rate his prospects, by running errands and acting as a London factotum for the Countess of Carlisle, or for her through her chaplain Noble. And he is probably doing a poor job of it, to judge by the superscription on the letter: he has written ". . . Chaplain to the Right Honourable Anne Countess Dowager of Carlisle . . . ," whereas Elizabeth, the Countess Dowager, had died 30 December 1696 and the present Lady Carlisle (since 1692) was named Anne. Since Richard must have received word of Lady Elizabeth's death by February, he may have meant Anne but forgot and retained "Dowager." Not the mistake of a wary courtier.

By April 1701 the Hogarths had moved from Bartholomew Close to a smaller house at the bottom of St. John's Street, just above Smithfield and only a short way from their former residence.[38] The last of the Widow Gibbons' daughters, Mary, had married one Timothy Helmesley around 1700 and begun raising a family in her mother's house; this may have induced the Hogarths, with their three children and a fourth expected, to move out.[39]

In the St. John's Street house in October 1701 was born another daughter, Anne, who would remain with William, selling his prints and keeping shop for him, till his death. She was baptized in St. Sepulchre's Church on 6 November.[40] By 12 November 1703 the Hogarths had moved again and were settled somewhere in St. James' ward, a little farther north than their last move. On that day another son, Thomas, was baptized at St. James' Church. It is quite possible that the family was already settled into St. John's Gate, but it can definitely be placed there at the beginning of the next year.[41]

In the *Post Man* for 8–11 January 1703/4 Richard ran the following advertisement for a new line of business, presumably hoping to better support his growing family:

At *Hogarth's* Coffee House in St. Johns Gate, the mid-way between Smithfield Bars and Clerkenwel, there will meet daily some Learned Gentlemen, who speak Latin readily, where any Gentleman that is either skilled in that Language, or desirous to perfect himself in speaking thereof, will be welcome. The Master of the House, in the absence of others, being always ready to entertain Gentlemen in the Latin Tongue. There is likewise design'd a Society of Trades to meet every Monday night in the Great Room over the Gateway, for the promoting their respective Trades.

In the issue for 15–18 January "daily" is elaborated to "Every day at 4 a Clock."[42]

It is impossible to say whether the family itself lived in one of the rooms in the Gate, but it does seem fairly certain that Richard had given up schoolmastering: he claims to be always on hand in the coffeehouse, by genteel implication to teach adults Latin. This would leave no time for a regular school of his own; and if he had a school in conjunction with, or even nearby, his coffeehouse, he would surely have alluded to it in his advertisement.[43]

St. John's Gate, much remodeled and purged of all its eighteenth-century associations, is now occupied by the Order of St. John; it was originally the south gate of the Priory of St. John of Jerusalem, built about 1504. One entered the priory through what is now St. John's Lane, and the priory extended north into St. John's Square and beyond. The gate, flanked by projecting towers, is built in the perpendicular style with obtusely pointed windows, arched door-ways, and battlements along the top, composed of brick and freestone; the inner walls, of hard red bricks, are three feet thick, and on the outside cased in nine-inch stone. Before the remodeling, there were three stories and an attic in each tower, each story apparently a single rectangular room, connected by a circular staircase of elm. The "great room," the one room over the arch, was not much larger than the tower rooms, though high-ceilinged. Entrances to both towers were on the north (the priory) side of the gate, and the spandrils of the doorcase were ornamented with devices in relief representing a cock, a hawk, a hen, and a lion, supporting the shields of the priory and its builder, Sir Thomas Docwra. The building's greatest claim to fame is that part of it served from 1731 on-wards as the printing office of Edward Cave's *Gentleman's Magazine* and ap-peared on every issue in a small woodcut. The "great room" was the room where Cave had his presses and where Garrick supposedly made his debut as an actor, where Samuel Johnson worked, and doubtless where William Hogarth visited.[44]

The description of Hogarth's coffeehouse in the advertisements makes it sound as if it were inside St. John's Gate. I have found no record of a coffeehouse there prior to Richard's, and the interesting conception may have been his. A Harvey's Coffee House existed there in 1735, and in 1771 another occupied "the Room that has been constructed in modern Time over the Arch," which in that year was removed.[45] This room—very likely the same used by Richard—was over the arch but under the "great room," part of the temporary wooden struc-ture that appears in Wenceslaus Hollar's sketch of 1661, filling the whole gate-way except for two small passages, one for vehicles, the other for pedestrians. (From the *Gentleman's Magazine* woodcut, however [see pl. 1], this structure appears to be brick supported by a crossbeam.) There would have been ample space for a coffeehouse here, presumably with its own entrance stairs.

Richard Hogarth's coffeehouse was no doubt economically-motivated, but,

like some of his son's enterprises, it also had an idealistic aim, one consistent with his main interest. Eilhardus Lubinus in 1614 had proposed setting up Latin-speaking colonies or colleges, and was only waiting for some "Emperor, or King, yea, even some Prince or Magistrate in any Commonwealth" to "vouchsafe to light a taper or torch" to materialize the plan—one manifestation of the "great experiment" toward making Latin the standard language of communication. The primary object of English schools was to make Latin live again, and spoken Latin distinguished the learned from the unlearned man. But it was as practical as it was humanistic: Latin offered a literary style and a storehouse of proper and eloquent expressions, essential to the man of law or medicine, as well as the clerk and the Englishman traveling abroad. Telling Latin phrases were always useful, and the habituées of a Latin coffeehouse would have collected them in commonplace books.[46] In this sense, Richard's coffeehouse expresses exactly the aim of his *Thesaurarium,* the list of great men in his later *Disputationes Grammaticales,* and his adaptation of Robertson's *Latin Phrases;* and, of course, it also casts some light on his son William's use of Latin tags in his prints.

There was nothing remarkably new about Richard Hogarth's conception. One of the early pamphlets on coffeehouses relates that patrons liked to quote the classics and show off their pedantry; even the apprentice "doth call for his coffee in Latin," and learned quotations were so numerous as to "make a poor Vicar to tremble." John Houghton, another writer on coffeehouses, quotes a former member of the Royal Society as saying "that coffee-houses had improved useful knowledge, as much as they [the universities] have, and I speake in no way of sleight to them neither."[47]

They were orderly meeting places, Puritan in origin and background, begun during the Commonwealth, that offered coffee as opposed to stronger drinks. For this reason, they were often attacked in their early years by vintners, brew-

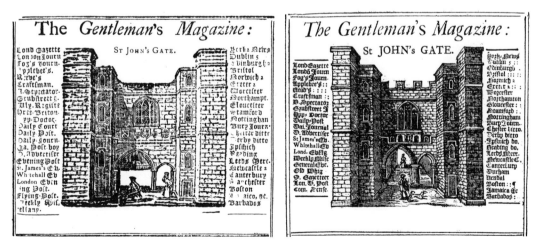

1. Artist unknown, St. John's Gate (*Gentleman's Magazine*); two versions

ers, and tavern-keepers. They attracted the better sort of people, serving in many cases as a home away from home, where businessmen conducted business, read the newspapers, and ate their meals. Signs on the wall listed the rules and orders, sometimes even fines for swearing or starting a quarrel, making excessive noise or disputing too loudly or on sacred matters. By the end of the century they were everywhere in London.

Ned Ward in *The London Spy* describes one such coffeehouse as it must have looked at the time Richard Hogarth's was flourishing in St. John's Gate:

> Accordingly, in we went, where a parcel of muddling muck-worms were as busy as so many rats in an old cheese-loft; some going, some coming, some scribbling, some talking, some drinking, others jangling, and the whole room stinking of tobacco like a Dutch barge or a boatswain's cabin. The walls were hung with gilt frames, containing an abundance of rarities, viz., Nectar and Ambrosia, May Dew, Golden Elixirs, Popular Pills, Liquid Snuff, Beautifying Waters, Dentifrices, Drops, Lozenges, all as infallible as the Pope. . . . Indeed, had not my friend told me 'twas a coffee-house I should have took it for Quack's Hall, or the parlour of some eminent mountebank.[48]

Even acknowledging that Richard Hogarth may have kept an especially learned coffeehouse, and thought of himself as a proselytizer of the true doctrine and an agent for the good, he must at times have viewed this as something of a come-down for the scholar and schoolmaster he had envisioned less than fifteen years earlier when he arrived in London.

A London Childhood

> Here at a Table sits (perplext)
> A griping Usurer, and next
> To him a gallant Furioso,
> Then nigh to him a Virtuoso;
> A Player then (full fine) sits down
> And close to him a Country Clown.
> O' th' other side sits some pragmatick,
> And next to him some sly Phanatick.[1]

The coffeehouse, with its conversation (Latin and otherwise) and piles of newspapers, its placards and great variety of Londoners, was a stimulating place for William Hogarth to spend his youth. However, the whole area of London in which he lived, bounded by Newgate Street on the south and open country on the north, left its unmistakable marks on him.

The center, the heart, of this area was Smithfield; not only was Hogarth born here but his grandmother remained, relatives were constantly visited, and the market and fair enjoyed here. It was one particular paradigm of London—there were many others—that would be stamped on his consciousness, and it consisted of a church, a marketplace that for a few weeks each year became a fairground, a hospital, and not far away two grim prisons, Newgate and the Fleet (pl. 2).

I have already described the church—St. Bartholomew the Great, with its nonconformist annex. Across the open square of Smithfield Market was St. Bartholomew's Hospital, as ancient as the church, a ruinous old rambling structure which in the 1730s would be reconstructed into a beautiful Palladian quadrangle by James Gibbs, with huge paintings from the New Testament by William Hogarth decorating the grand staircase. The third element of this complex was the great marketplace, crowded with cattle and livestock brought down from the north, thronged with people buying and selling. Smithfield, though important as a market, was anciently famous for its executions by burning and its fairs. The last fire went out in 1611 over the ashes of one Bartholomew Leg-

gatt, a Unitarian who would not accept the Athanasian and Nicene creeds. On this ground was spread each year, during the first days of August, a fantastic world that was both an escape from the London of the rest of the year and a London in microcosm.[2] Trading was overwhelmed by entertainment, and the shows overlapped into the grounds of the other two institutions that bore the name of St. Bartholomew. As time passed, the duration of the fair also stretched from days into weeks. Hogarth, in later life, remembered that "shews of all sort gave me uncommon pleasure when an Infant."[3] He was referring to Bartholomew Fair.

One may construct a vivid picture of Bartholomew Fair at the turn of the century by following Ned Ward as he strolls through Long Lane and the Cloisters, past the waiting prostitutes, and through the St. Bartholomew's Hospital gates into the fair.[4] First he stops at a quack's or mountebank's booth around which the crowd is waiting "ankle deep in filth and crowded as close as a barrel of figs, or candles in a tallow-chandler's basket, sweating and meeting with the heat of their own bodies." He comments on "the unwholesome fumes of such a crowd mixed with the odoriferous effluvia that arose from the singeing of pigs." Above on his platform, the Merry Andrew begins his spiel by scorning his audience; he blows his nose on them and then "begins a tale of a tub which he illustrates with abundance of ugly faces, and mimical actions, for in that lay the chief of the comedy, with which the gazers seemed most to be affected."

This Merry Andrew had created a sensation a year or so before by singeing his pig with Exchequer notes and roasting him with tallies, thus satirizing the shaky financial state of King William's revolutionary government at a time when it was attempting to obtain loans. The governmental crisis was serious—the two-year-old Bank of England had for a time to suspend payment on its notes—and the Merry Andrew's satire was considered subversive enough to earn him a whipping. Clearly, politics would be a poor choice of subject for prospective satirists; but these clowns also demonstrated numerous ways of satirizing other topics, such as London and things in general, including their own audience. Ward's Merry Andrew, ending his sales talk, sounds like the one pictured in Hogarth's *Masquerades and Operas:* "Then screwing his Body into an ill-favored Posture, agreeable to his Intellects, he struts along before the glittering train of Imaginary Heroes, leading them to play the Fool inside."

Next, Ward visits the booths of the rope-dancers and tumblers who danced on the low rope, vaulted on the high rope, and walked on the slack and sloping ropes. Then, attending a droll called *The Devil of a Wife,* he comments on the evident discrepancy between the roles played and the uncouth actors (a situation explored by Hogarth in more than one print), with "everyone looking, notwithstanding his dress, like what he really was, and not like what he represented." Beneath the costumes he detects the bodies, and beneath the feigned accents the voices, of scissorsgrinders, chimneysweeps, and other vendors.

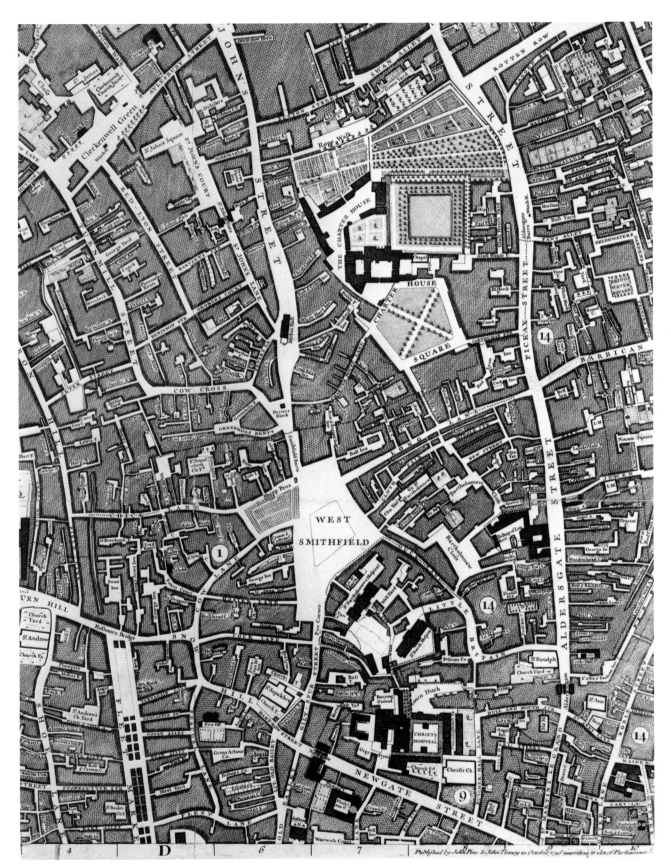

2. The Smithfield area, detail of John Rocque's map of London, 1746 (BM). At the very bottom (at D) is the Fleet Prison, which is continued on pl. 4.

Another droll opens with a scene showing "a trunk-breeches king in a fool's cap, and a feather in it, attended by his cringing nobility, some Court jilts, and two or three flattering priests," intended to represent an old English court. This scene rapidly gives way to the study of Friar Bacon with his brazen head (a great favorite); then to a scene of rustic bumpkins, the miller and his son Ralph—in this instance, the actor "seemed to be the same thing he imitated"; and finally to the court of a country justice, "whose weakness and indiscretion . . . were designed to let the people know what ignorant magistrates have sometimes the administration of justice, and how common a thing it is for a wise man to bow a learned head to an empty noddle in authority." Around these travesty characters, anarchistically conceived and so regarded by the audience, gambol Friar Bacon's conjured spirits, flying shoulders of mutton, and dancing and singing devils, "with whose magical pranks the mob were wonderfully pleased, as well as greatly astonished." Here, long before they migrated to the West End of London, are the motley elements that would make John Rich's entertainments such a success in the 1720s; and also a clear indication that the mob liked satire on authority.

For a few weeks every year, the great actors from the West End theaters played at the fair. As a child, William could have seen John Mills, who played serious gentlemen, or the low comedians William Bullock, Henry Norris, and William Penkethman. Bullock (tall) and Norris (short) often appeared together, "*Bullock* in a *short* Coat, and *Norris* in a *long* one," seldom failing to elicit laughter.[5] Thomas Doggett too, one of the best comic actors of the day and joint manager of Drury Lane, kept a booth at the Hosier Lane end of Smithfield, where he presented new drolls and "Also Variety of Comick Dances and Songs, with Scenes and Machines never seen before."

In the early years of the century William could have seen *The Old Creation of the World* at Heatley's Booth, always being supplied with additional programs of current interest: "the glorious Battle obtain'd over the French and Spaniards, by the Duke of Marlborough," as well as "several *Figures* dancing *Jiggs, Sarabands,* and *Country-Dances,* to the Admiration of all Spectators; with the merry conceits of Squire *Punch,* and Sir John *Spendall.*" In 1704 he could have seen *Jephtha's Rash Vow* at Doggett's Booth, with Penkethman and Bullock playing the farcical characters of Toby and Ezekiel. In 1707 Mrs. Mynn's booth played Elkanah Settle's adaptation of *The Seige of Troy,* in which heroic scenes involving Menelaus, Ulysses, and Sinon were followed by scenes between Bristle the cobbler and his wife; she wants to go out to Troy "to see the great Horse the *Grecians* have left behind 'em," and he will not let her. In all of these entertainments William Hogarth must have noted with pleasure and instruction the contiguity of the spectacular Biblical scenes and the squabbles of Noah and his wife, scenes with Jephtha and his daughter and with Toby and Ezekiel, with Paris and Helen and with Bristle and his wife. When he

painted his "Humours of a Fair," *Southwark Fair,* twenty-five years later he included all of these (*The Seige of Troy* had in fact not been played for some years).

Although there were all sorts of marvels to be seen at the fair, from the "Little Farey Woman" (26 inches high) to the Great Hog (10 feet long and 13 hands high), Hogarth seems to have been interested solely in the people he saw—the pickpockets, quacks, whores, and charlatans—and in the play-acting he observed both onstage and off. Associated by many writers with Babel and Babylon, the fair was attractive precisely because there people of whatever age or class could lose themselves in a world where their imaginary projections coincided with the reality, and their most anarchic and aimless desires could be explored. The fair was a last place, short of the gin shop, where man could escape civilization and return to his instincts and primal chaos. On the other hand, it was also a living moral exemplum. As Sir Robert Southwell wrote in 1685 to his son Edward, in London with his tutor, one "cou'd convert that tumult into a profitable book." He advises the boy to climb up into a high window "in order to survey the whole pit at once": "The main importance of this fair is not so much for merchandize, and the supplying what people really want; but as a sort of Baccanalia, to gratifie the multitude in their wandring and irregular thoughts."[6]

This Vanity Fair became practically, when not literally, Hogarth's subject matter. It is easy to imagine him caught between his father's good Roman morality, as expressed in the sententiae of his *Thesaurarium,* and the lure of the booths, plays, and sordid mankind itself. This dualism is reflected in all of his works: strong moral intent not masking his sympathy for the joys of the fair, usually presented as a means of escape from the externally imposed order that distinguished the rest of the year.

The moral issues raised by the fair came to a head in 1708—an important year for Hogarth, with disaster closing in on his family. At that time the twenty-one-year lease of the fair to the Sword Bearer expired, and great efforts were made to pare its duration from fourteen days to the original three. In June the Court of Common Council, claiming that the fair was "not occupied in Dealers in Goods, Merchandizes, &c., proper for a Fair; but used chiefly for Stage-plays, Musick and Tipling," ordered that it be limited to three days "and no longer."[7] On 3 July the Common Council rejected petitions for the revocation of their order; and the announcement was printed in the *Gazette* for 2 August. This curtailment, like all the previous ones, was only temporary.

If the fair was the most important place of Hogarth's childhood, it becomes visible and understandable only in the context of its neighbors, St. Bartholomew's church and hospital. One can only guess at what these meant to Hogarth: his father would have said the church was an alternative to the fair, the hospital a sign that the life of the fair had consequences. His own return to St. Bartholomew's Hospital to paint murals and to serve as a governor points to

his roots in the place (his mother and sisters continued to live within its precincts, operating a milliner's shop in the Cloisters, until the 1730s). And one cannot ignore the fact that the restless people he was to create in his paintings and prints are always turning to hospital, church, or fair.

Perhaps, given Hogarth's particular vision, his graphic world would have been structured as it was no matter where he lived. But one may be excused for speculating on the degree to which his proximity to this complex of institutions, unique in London—church, market-turned-fair, and hospital—influenced both his life and art. As they appear in his paintings and prints, the church, the fair, and the hospital serve as outlets (sometimes true and sometimes false) for a radical dissatisfaction with everyday life. The transformation of market into fairground is virtually a paradigm for most of his print cycles. The fair—or the theaters, masquerades, executions, gin shops, and so on—offers a way out of oneself into new and exciting identities and situations. The church ought to provide spiritual peace, instead of generating boredom through dull sermons or superficial enthusiasm through fanatical displays. The hospital ought to heal bodies as the church heals souls, instead of offering panaceas and a final resting place, or prison, for the hopelessly ill or insane.

Although Hogarth never really left Smithfield, when he was seven his horizons were expanded to include Clerkenwell, a few streets north, a thriving suburb into which many people had moved to build new homes after the Great Fire. In 1675 it reached to what is now Bowling Green and Corporation Lanes; on St. John's Street it went as far north on the east side as the corner of Compton Street. The area included many pleasant gardens and members of the nobility and gentry lived there. By 1708, when the Hogarths were residents, Clerkenwell contained 1146 houses, and from official returns of the year 1710, there were 1500 families, comprising 9000 persons, residing in the parish of St. James.[8]

St. John's Street, where the Hogarths first lived, was the main thoroughfare between Smithfield Market and the north. The Gatehouse was in a somewhat better neighborhood. St. John's Square, into which the Gatehouse opened to the north, was a spacious, pleasant place.[9] On the north side of the Square, in 1727, was born John Wilkes, later Hogarth's friend and enemy; at the time of the Hogarths' residence, Wilkes' father, a distiller, was living two blocks away in Turnmill Street, Clerkenwell Green. On the west side of the square was the town house of Gilbert Burnet, Bishop of Salisbury, who lived here in retirement from 1708, visited by the great Whig Lords. Early in 1710 a mob rioted in the square—the Tory partisans of Dr. Henry Sacheverell, whose incendiary sermon attacking the Godolphin Ministry had led to his impeachment. Burnet, in his *History of his Own Times,* says the mob shouted

'The Church and Sacheverell!' and such as joined not in the shout were insulted and knocked down. Before my own door one with a spade, cleft

the skull of another, who would not shout as he did. There happened to be a meeting-house near me, out of which they drew every thing that was in it, and burned it before the door of the house. They threatened to do the like execution on my house; but the noise of the riot coming to court, orders were sent to the guards, to go about and disperse the multitudes and secure the public peace. As the guards advanced the people ran away.[10]

Although the Hogarths had by this time moved again, the riot (repeated in other parts of London) would have had special meaning for them, implanting in William's mind the images of Sacheverell and the restless London mob, both of which would serve him in later years.

While to the north of the Gatehouse stretched an elegant square, to the south the Hogarths' windows looked down on the narrow gutter of St. John's Lane, which centuries earlier had led to the entrance of the priory. The contrast between the romantic past of the Gatehouse with its ancient escutcheons and the reality of the muddy, shabby, crowded street beneath encouraged the sort of homily the Latinist might have passed on to his son. From what is known of Richard, the reading matter available in his house would probably have included romances—the fare of the aristocracy—and sophisticated anti-romantic satires like those of Samuel Butler, John Dryden, and Sir Samuel Garth, abounding in such contrasts. Looking down from the coffeehouse windows, William would have seen the Old Baptist's Head with a sign of John the Baptist's head on a charger, like the one he later painted in *Noon*. On the other hand, if he looked up he would have been able to watch St. Paul's dome rising amid scaffolding in the distance over the jagged rooftops.

North through St. John's Court and Jerusalem Passage (where Thomas Britton, the "musical small-coal man" lived)[11] led to the old parish church of St. James, where the most recent Hogarth children were baptized. Beneath a squat square tower eighty feet high, the main entrance was reached by a passage under houses very like the approach to St. Bartholomew the Great, which the church in general resembled. "The walls are lined with oak of different height," Edward Hatton recorded about this time, "that round the communion table is about 9 feet high. The pews and pulpit are also of oak, tho' pretty old; as is also the altar-piece, where the painting of the commandments is somewhat decayed. They are placed between the Lord's Prayer and Creed, and over are the Queen's arms painted."[12] This is more or less the interior Hogarth painted thirty years later in the fifth plate of *A Rake's Progress*. Anglican churches, as he portrayed them, are either running to seed or filled with sleeping parishioners. It was in this church on 10 August 1705 that another short-lived Hogarth child, Edmund, born on 28 July, was baptized. And on 17 December of the same year, Richard, William's only surviving elder brother and childhood playmate, was buried here; he had lived just ten years.[13] William was then eight; these deaths

must have weighed heavily on a sensitive child, demonstrating better than Puritan homily that man's suffering was not necessarily commensurate with his guilt.

Young Richard survives only in the pages of the family Bible. One note in the hand of his friend Richard Helmesley, son of Mary Gibbons and Timothy Helmesley, says "Richard Hogarth ditto Helmesley." The two of them seem to have written notes back and forth in the Bible margins. "I like my cosen Ann Hogarth," young Helmesley wrote on another occasion, followed by, presumably in Anne's hand, "Poor dear Dick." William, however, makes no appearance on these pages. Only later, when he had inherited the Bible, do his notations begin to appear, marking passages for use in his prints.

North of the churchyard was Clerkenwell Close, where "at the Surgeon's sign," with "the figures of Mad people" over the gate, lived a chemist and a surgeon who, according to their advertisements, "by the blessing of God cureth all Lunetick, Distracted and Mad people; they seldom exceed three Months in the Cure, several has been Cured in a fortnight, and some in less time; they have cured several from Bethlem, and other Mad-houses in, and about this City; there is conveniency in their House for all People, of what Quality soever," and —they add—"No Cure, No Money." More conventional diseases were cured too, such as the dropsy; they claim to "have taken 10, 12, 15, 20, and sometimes 24 Gallons of Water by Stool and Urine, with a genteel Chimical preparation, without Tapping."[14]

Londoners did not take much advantage of the countryside which lay a brief walk to the north. Even if they had been interested in the beauties of nature, the highways of 1706 were to be avoided: these "and the ditches hard by are commonly so full of nastiness and stinking dirt, that oftentimes many persons who have occasion to go in or come out of town, are forced to stop their noses to avoid the ill-smell occasioned by it. . . ."[15] All around the edges of the city were smoking brick kilns, vagabonds and highwaymen, cow- and hog-keepers, and market gardeners. If William went to the open fields, it was not to observe nature but to watch one of the less savory public sports, such as animal baiting or pugilists fighting with bare fists and broadswords. The animals to be baited were led in procession through the streets and handbills were passed out announcing "a match to be fought by two dogs, one from Newgate Market against one of Hony Lane market at a bull . . . likewise a *green bull* to be baited which was never baited before, and a bull to be turned loose with fireworks all over him; also a mad ass to be baited . . . and a dog to be drawn up with fireworks."[16] Hockley-in-the-Hole, the most famous bear-garden, is portrayed in Hogarth's various versions of the scene in which Hudibras attacks the bear-baiters. He may also have retained the memory of Mr. Preston, master of the bear-garden, who was nearly devoured by one of his bears. The Reverend Mr. Pead of St. James' preached a sermon "On Mr. Preston being torn to pieces by his own

bears," which sounds as if it focused on poetic justice, God's judgment, and the like.[17] Such images returned in Hogarth's prints, most memorably perhaps in the *Four Stages of Cruelty*.

In later years he portrayed at least two famous pugilists, John Broughton and George Taylor (James Figg appears once or twice in crowded compositions). Exhibitions of pugilism might begin with "two masters of the noble science of self-defence," and go on to four men who would "fight at sword for a hat of half-a-guinea price, and six to wrestle for three pair of gloves at half-a-crown price each pair."[18] Although these bouts, like the bear-baitings and the fair, were viewed as a public nuisance and occasionally suppressed by the Middlesex Grand Jury, they continued to take place and attract large crowds, which by the time Hogarth was grown included royalty.

Another source of disreputable entertainment (one that would rise in public esteem during Hogarth's lifetime, largely due to his own efforts) lay to the south of Smithfield. St. Paul's Churchyard had for centuries been the center of London's printing and publishing trade, and the houses around the yard were shops for the sale of printed material of all kinds and quality. Here lived and operated the Bowles family of printsellers, soon to pirate works by Hogarth; others could be found in Paternoster Row and in Ave-Maria Lane and Warwick Lane, the little streets leading north to Newgate, Old Bailey (where Henry Overton, another famous printseller, vended at the White Horse), and beyond the City gates to Long Walk, Duck Lane, Little Britain, and into Bartholomew Close itself. In these printshops Hogarth would have obtained his first glimpse of the gaudy world of London and St. Bartholomew's Fair translated into the comic or moralizing black-and-white of engravings and block prints, which lent it a significance perhaps not immediately apparent to the boy as he experienced it.

One other area, yet further south, must have been sometimes visited by the Hogarths—Edmund Hogarth's shop at the foot of London Bridge. Richard's brother had followed him to London. Just when he arrived is uncertain, but in 1705 he settled in the City as a victualler at the Red Cross at the Bridgefoot of London Bridge near the Waterhouse, in the parish of St. Magnus Martyr. (William's newest brother, Edmund, was named for his uncle in August.) He purchased his freedom of the Haberdashers' Company on 8 February 1705/6 by redemption (no information appears in the records about his parentage), and so must have been apprenticed around 1698. On 12 August 1707 he secured a license to marry Sarah Gambell, thirty, a spinster of St. Swithin's parish.[19] His own age is given as thirty-five (which would put his birth in 1672). His age suggests that either he was apprenticed later than the usual age or could not afford to purchase his freedom of the company for some time after his apprenticeship. Once settled, however, he seems to have succeeded in business and, when he died a year after Richard in 1719, he was comfortably well off.

The ancient gothic bridge with its overhanging houses supported on brackets

made a street across the water. Much larger than the Ponte Vecchio in Florence, it had two or three places from which one could view the river through iron railings. The houses themselves enjoyed the best view in London, but were also plagued by disadvantages: to reduce the load on the bridge, the houses had to be very flimsy, and in the winters cold. The noise must have been intolerable: Ned Ward refers to the "frightful roaring of the bridge waterfalls," so loud that "like the inhabitants near the Cataract of the Nile, I could hear no voice softer than a speaking trumpet, or the audible organ of a scolding fish-woman."[20] Considering that the bridge was the only route to the Surrey side of the Thames, a path twenty feet wide, the traffic noises must have been jarring as well.

Edmund's house was at the south or Surrey end of the bridge or just off it, "near the Waterhouse," the waterworks or water-pumping station, which conveyed water to various parts of the City by wooden mains formed of tree trunks. Uncle Edmund, a practical soul, insured both house and shop. The bridge was constantly catching fire, and one house or a few would be swept away, and soon replaced; the result was a wonderful hodgepodge of architecture.[21] Going to visit his uncle, William would also have noticed on the great stone gate at the southern end of the bridge the exhibited heads of traitors and other malefactors—much replenished after the rebellion of 1715. When he wanted to depict a prototypical merchant in *Marriage à la Mode*, he returned to Uncle Edmund's neighborhood and showed London Bridge, with displayed heads, through the merchant's window.

This then was the scope of the London of William Hogarth's childhood. The strange territory he was to explore would be to the west: first Covent Garden, then Leicester Fields, and finally a country villa in Chiswick. The City, however, remained the primary locale in his prints.

Whatever his financial status, Richard Hogarth's social position as a school-master was relatively high; and even as a coffeehouse proprietor (a tradesman) he emphasized the intellectual advantages of his establishment. His daughters, when they were old enough, went into a trade that supplied luxury items (in a class with makers of chocolate, perukes, and the like), and, at least when they moved to St. Anne's Parish, catered to an upper-class clientele. From William's remarks, there is every reason to think that his father may have wanted him to pursue a learned career, and inculcated in him an ambivalent attitude toward trade long before he encountered the Thornhill family.

Richard certainly sent him to school. In his autobiographical notes he recalls that he "drew the alphabet with great ease" but had a "natural turn" for drawing rather than for "learning a language": "When at school my exercises were more remarkable for the ornaments which adorn'd them than for the Exercise itself." And he adds, speaking of his lessons and his drawings: "I found Block-heads with better memories beat me in the former but I was particularly distin-

guishd for the latter." More important, he would have us think, he liked "shews of all sort" and "mimickry common to all children was remarkable in me."[22] Drawing and acting are closely related in his autobiographical writings, as are his "pleasures" and his "studies."

He would have received some kind of schooling when he was about five years old (1702). If Richard's own school was by then a thing of the past, he might have sent William to a neighborhood school; but unless in serious financial straits, he would probably have considered his family above a charity school.[23] In any case, it would be surprising if he did not take a major part himself in the teaching of his son.

Whatever the exact arrangements for young William, schooling to him implied (as he remarked) "language," and, particularly, Latin. Not even the reformers of education like Comenius and Locke questioned the hegemony of Latin. All schools operated on the same principles: "Intelligent understanding of rules, constant 'apposing' or questioning, and the practical recognition of *repetitio,* as *mater studiorum.*"[24] The procedure was to teach the child to read and write English at five or six years (ordinarily in a petty school), and at seven enter him in a grammar school. For the first half-year he studied Latin vocabulary from Comenius' *Orbis Pictus* or a similar book and learned the accidence as he read. The second half-year he finished accidence and added *sententiae pueriles,* Latin paragraphs like the English ones Richard printed in his *Thesaurarium.* This training could continue until the student was ready for the university, between the ages of fifteen and seventeen. Obviously he learned a great deal of Latin, and there are signs throughout the prints and writings that Hogarth did not forget the vocabulary, the *sententiae,* and the *topoi* that were pounded into him in these early years.

Being brought up by a schoolmaster would only have intensified the striking contrast between the preposterous regimentation of the grammar school and the freedom of the practical education available around the London streets. At the outset, William encountered the paradox of life in a coffeehouse, full of lively characters, where Latin was spoken: the curious mixture of a visual and auditory chaos and a verbal structure quite alien to contemporary experience. More generally, Hogarth's youth must have been dominated by a confusion of emphases: from his own instincts (or the influence of some unidentified relative) the visual, the people and places of London, their colors and shapes; from his father the verbal pattern, the printed page, reading, and moralizing. These two modes of perceiving, understanding, and recording would shape much of his particular art.

Who first turned Hogarth toward art? He testifies himself that "an early access to a neighbouring Painter drew my attention from play" and thereafter "every opportunity was employed in attempts at drawing."[25] It is probably futile to speculate on the identity of this painter, who presumably lived near the

Hogarths sometime before 1713. Any painter would have served; and if none
had materialized, someone else would have triggered the artist in Hogarth.
Judging by his later admiration for the work of good sign painters, it could
have been someone of that profession, or a coach painter. A painter named John
Dalton is listed in the baptismal registers as living nearby in Bartholomew Close,
and a Mr. Rogers, painter, appears in the St. Bartholomew's churchwardens'
reports. In the autobiographical notes, a few pages away from the reference to
the "neighbouring Painter," Hogarth refers to a "Mr. Woolaston" who "had a
relation who used to miscall colours all his life time yet otherwise his sight was
clear and his Judgment good." A John Wollaston (born ca. 1672) is mentioned
by George Vertue and did live near St. John's Gate. He played violin and flute

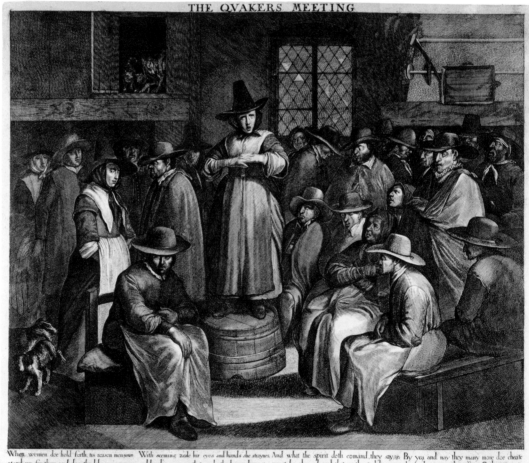

3. Egbert van Heemskirk, The Quaker Meeting (engraved by Carel Allardt); date unknown (BM)

and performed with Thomas Britton, the "musical small-coal man," in Jerusa-
lem Passage, and painted his portrait.[26]

The only painter of any note who might have lived near Hogarth in his child-
hood, and whose style would have had a significant effect on his, was Egbert van
Heemskirk. The only information available about him is, unfortunately, hear-
say: he died in London around 1704, when Hogarth was only seven, and his
son (also Egbert) was apprenticed to Sadler's Wells as a singer but also made
drolls like his father's. In the nineteenth century a painting attributed to
Heemskirk hung in the Old Baptist's Head Tavern, just down the street from
St. John's Gate;[27] it is all that connects him with the Clerkenwell area, but for
want of other evidence, it is not totally inconclusive. Heemskirk was the one
painter in England at the time who could have served as a contact with the
tradition of Brouwer and Teniers, and set Hogarth on the path toward the style
he finally developed. Hogarth appears to have been aware of Heemskirk's
Quaker Meeting paintings, at least in their engraved versions (which anticipate
his own style of engraving in some respects [pl. 3]), and he was certainly aware
of the satiric designs of the younger Heemskirk in the late 1720s.[28]

The years of Hogarth's childhood up to 1708 can only be imaginatively re-
constructed, but there is no reason to think they were not pleasant, carefree
ones. One can speak with more certainty about the years following.

The Fleet Prison

In the summer of 1707 Richard Hogarth was still operating his coffeehouse, advertised now as headquarters for one George Daggastaff and his poetic miscellany called *The Diverting Muse*. Anyone with contributions of poetry, epigrams, or satire might "direct them for Mr. George Daggastaff, to be left at Mr. Hogarth's Coffee-house in St. John's Gate-way near Clerkenwell."[1] The literary tone of the Hogarth establishment was still being asserted in these last notices of its existence. Sometime between the summer of 1707 and the end of 1708 the coffeehouse failed and Richard was confined for debt in the Fleet Prison (pl. 4). In January 1708/9 Mrs. Hogarth was advertising her home remedies "next Door to the Ship in Black and White Court, Old Bailey":

> In pity to Infants that cannot tell their Ails, there is now publish'd (having been many Years in private Practice) a most Noble and very safe Medicine, call'd, the GRIPE OINTMENT, which by outward Use only, and in the very moment of Application, Cures the GRIPES in Young Children, and prevents FITS, one half Crown Pot whereof will bring up a Child past all danger from either. Sold only By Mrs. Anne Hogarth next Door to the Ship in Black and White Court, Old Bailey.[2]

In March, an auction of a library of Latin and Greek books was held at the Black-Boy Coffee-House, a few blocks away in Ave Maria Lane.[3] No mention is made of the owner, but the disposal of Richard's library certainly took place around this time. The money to keep the family afloat and Richard out of the "common side" of the Fleet must have come from the sale of everything that had any value.

Two years later, on 23 September 1710, Richard was writing a letter from "Black and White Court in the region called the Old Bailey within the bounds of the Fleet" to Robert Harley, then the Queen's first minister, pouring forth the woes of his imprisonment and seeking assistance.[4] Exactly how he got there is not known. It cannot have been the booksellers who put him in debtors' prison, though the profits from his books might have kept him out; his difficul-

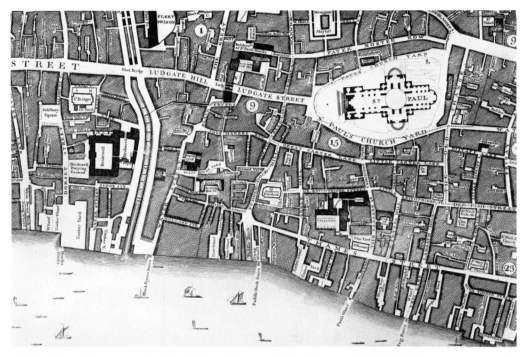

4. The Fleet Prison area, detail of Rocque's map of London; 1746 (BM). This map connects directly at the top with the bottom of pl. 2. Black and White Court is marked by a 1.

ties with that group, on which William commented with such bitterness, came later and involved sins of omission rather than commission. Richard must simply have overextended himself, bought the stock for his coffeehouse and perhaps books and household supplies on credit, and when the coffeehouse did not flourish, unable to pay his debts, was faced with ruin.

The situation of a debtor was appalling and his courses of action fraught with dilemmas.[5] He could simply go into hiding, in which case he was considered a felon and was liable to capital punishment. He could surrender himself to his creditors, who could declare him bankrupt, if he did not do so himself, and take his all (he had to swear to the sum) or a composition of so much per pound. Or they could put the debtor in prison until he paid his debt in full or promised a satisfactory composition. The latter course was dangerous: the creditors might never let the debtor out again since, once in prison, he would be unable to earn any money. Bankruptcy was equally dangerous because the debtor had no assurance that the creditor would not take his all *and* leave him to languish in debtor's prison. Once inside the Fleet, a debtor could only hope that his creditors would relent or accept terms such as his promise to work off the money, or that someone would settle the debt for him. None of these possibilities applied to Richard Hogarth.

The best insight into the plight of the debtor at this time is provided by Daniel Defoe, who for personal reasons kept up a running commentary on the

subject in his *Review,* with particular fervency during the years of Richard's incarceration. When Richard was first heard of in London, Defoe was fighting a losing battle with his own creditors, and in 1692 his unfortunate speculation in civet cats ended in his failure to the extent of £17,000. In 1706 he was still trying to come to terms with various creditors and obtain a discharge by reviving the old Commission of Bankruptcy of 1692. Although he had escaped prison himself, he was very much aware of the nightmare situation facing debtors in the Fleet and other debtors' prisons. The law, according to the *Review* for 21 February 1705/6, was in a position to

> confine Men to Perpetual Imprisonment for Debt, and that Men who cannot pay too, as well as they that can, Men Ruin'd by known Disaster, as well as Men of Fraud; to put Men to Torture and Famine, and neither let them Work to Pay, nor to Live; to smother Men in Noysome Dungeons, and Croud them with Murtherers and Thieves; to Condemn them to the Temporal Hell of a Gaol, and barr them up from all the helps of Art, Industry, and Time to Restore their Families, and pay

In a later *Review* (11 May 1706) Defoe turns to the debtor's "innocent Family": "for the Children of a Bankrupt are here punish'd for the Father's Transgression, and no Man ought to be starv'd, much less the innocent Offspring of the unfortunate."

On 1 March 1708/9 he estimated that there were 5000 bankrupts and insolvent debtors in the prisons of the kingdom. On 10 March he divided these into classes: first, the "meaner Tradesmen, poor Handicrafts, and labouring People, whose Debts are from one Hundred Pounds downward" (he calculates about 2000 of these). "These live most of them in the common Sides, and are there fed by the Basket, as 'tis call'd, or live by begging at the Grates of the Prisons; and tho' many of them suffer Hardship enough, yet generally speaking, these live better than many in the Master-Sides of Prisons, whose Wants are inexpressible." The second class consisted of "more Capital Tradesmen, Gentlemen, and some Clergymen, Whose Characters and Education, rather than Substance, have prevented going among the other, that cannot beg or feed on the Basket, but endure a Thousand more Miseries and Extremities than those that do, whose Hardships and Sufferings are born with Silence and Mourning of Soul, rather than Noise and loud Complainings" (2000 of these).

Although Richard may have begun in this second class, he managed to end in the third class (around 800): "There are a higher Sort yet, and these consist of such Tradesmen and Gentlemen, who tho' not able to pay their Debt, and free themselves, have yet something left to bear them up under Prison-Charges, tho' it is wasting every Day, as well by the chargeable subsisting in Prison, as by their Families abroad; all their Affairs suffering a general Shipwreck, and the industrious Hands lock'd from looking after their own Affairs. These are wasting

and consuming, and being without Prospect of Deliverance, tho' for the present they LIVE, yet are hastening a-pace to the Miseries of the first two Classes."

Describing the Fleet in 1708 Hatton commented that "for the pleasantness of the Prison and Gardens, and the . . . large extent of its Rules, it is preferred before most other Prisons, many giving Money to turn themselves over to this from others."[6] That no petitions for redress of abuses have survived from the period of Richard's confinement (though they survive in abundance from later times) does not prove that there was no abuse, but it may be evidence that only with the advent of John Huggins and his grasping deputies in 1713 did the situation become intolerable.

The Fleet itself was surrounded with walls twenty-five feet high with palisades on top. The horror of the common side is hardly imaginable. There were sometimes thirty of forty prisoners in a room not sixteen feet square, locked in at 8 P.M. in winter, 9 in summer, and the door not opened until morning. There were no sanitary facilities and there were times when the rooms were so crowded that half had to sleep in hammocks slung from the walls. Prisoners paid 2s 6d a week for a room of their own, and the fee "for liberty of the house irons at first coming in" was £1 6s 8d, augmented by extra fees to the chaplain, porter, chamberlain, and turnkey, amounting altogether to £1 6s 4d (by Huggins' time this had risen to £3 5s 4d). These conditions are depicted in Plate 7 of A Rake's Progress: the Rake is shown with his pathetic plan for paying his debts, the warden stands by waiting for more garnish, and the other desperate or demented inmates with whom he shares the cell are apparently obsessed with their own impossible plans of escape. To gain the freedom of the Rules—to move outside the prison walls—one paid around 5 guineas and gave security. The Rules extended south from the prison on the east side of Fleet Canal to Ludgate Hill, east to Cock Alley, north on Old Bailey as far as Fleet Lane, west on Fleet Lane to the Canal, and from thence south to the prison again: an area that included Black and White Court, where the Hogarths lived in 1709.[7] Further, for 5s 6d a prisoner could be granted Day-Rule, or a pass to go abroad beyond the Rules, for a day during term time.[8]

One may infer then that sometime before the end of 1708 Richard took refuge or was imprisoned in the Fleet. By the beginning of the new year he had secured enough money, through selling household items or borrowing from brother Edmund, to secure the freedom of the Rules and had settled in Black and White Court, in the Old Bailey Precinct of St. Sepulchre's Parish, from whence he wrote his petition to Harley. There is naturally no sign of the Hogarth name among the ratepayers of the precinct, but a Benjamin (or Benoni) Gibbons, who lived in Black and White Court till 1712, rented the house next to Deputy Collins' to an unnamed tenant. If, as seems likely, he was sheltering the Hogarths, the next house, John Bindon's, must have been the Ship Tavern.[9]

Although an insolvent debtor could not legally earn a living while under

arrest, his wife could, and his children also. William, being between eleven and fifteen at the time, probably worked. As to his mother, to judge by the portrait Hogarth painted of her in old age, she was a solid, sturdy, and reliable woman, who must have carried a large part of the burden in these years. Richard himself may have kept some sort of a school while living within the Rules.[10] At any rate, many complaints of debtors working are found in the records of the prisons.

One way out of debtors' prison was supplied by an act of Queen Anne's first and second years, which contained a clause to the effect that "Every Prisoner, that could swear himself not to have 5 *l.* left in the world to pay his Debts, and actually entred or listed himself a Soldier in the Queen's Army, or furnish'd a Man in his Room, was to be discharg'd." Richard, of course, would have found no advantage in enlistment and could not have afforded a surrogate. But this was the option exploited by the rogue Colonel Francis Charteris (or Chartres), who first entered William Hogarth's sphere of consciousness while his father was fighting to free himself from the Fleet. Charteris, later notorious as a rapist and represented in Plate 1 of *A Harlot's Progress,* was taking up insolvents, listing them in his company, and discharging them for up to 40 guineas a man. On 28 February 1710/11, precisely when the debtors' petitions were pending, Charteris was "brought to the Bar [of the House of Commons]; where, upon his Knees, he received a Reprimand from Mr. Speaker; and was discharged out of Custody, paying his fees."[11]

Debtors might also benefit from the influence of the Queen's first minister, Robert Harley, known to have acted in Defoe's behalf when he was languishing in prison for having written *The Shortest Way with the Dissenters.* Harley was, as it chanced, a great bibliophile and collector of manuscripts, and his religious background (stressed in many party pamphlets) of dissenter turned moderate Tory may have suggested to Richard another parallel. In January 1708 his fall from Godolphin's ministry, almost coincident with Richard's fall, had been followed by Whig calumnies and accusations of treason with a consequent threat of the tower, which continued into 1709. He may have seemed to Richard a man who, though hounded like himself by implacable enemies, managed to emerge victorious: becoming Chancellor of the Exchequer in August 1710, when the Godolphin Ministry fell. His first and most pressing duty was to cope with the national debt, which had grown to such alarming proportions that the civil list was nearly £700,000 in arrears and the Bank, the stockbrokers, and many City men were attempting to strangle the new ministry by refusing to advance money. Various plans were offered Harley at this time, including several by the indefatigable Defoe (in August he wrote his *Essay upon Credit*) and one by Richard Hogarth from the Fleet.

Richard's remarkable letter of 23 September is a reminder of his proposals to save the economy, an address to a man of learning written in Latin of a most

flowery kind, and a plea for patronage (presumably of the sort Defoe enjoyed) or at least for assistance in extricating himself from his troubles:

> To the best of Maecenases [*Optimo Mecaenas*]:
>
> In accordance with your most perceptive character and from my name which I have inscribed below, you will easily recall that not long ago I sent you by post two proposals, harmful to no one, by which the royal revenue can be raised for the following year. I beg you, seeing that I am ever most respectful of you, not to forget me. I would willingly run to you if I could do so through this window. But I cannot, wherefore I beg you to have pity on my condition. Others (I mean Charles H—— and his brothers, with others) have fished these proposals out of me, and, as I hear, are showing them to some who are close to the Queen. I would be astonished, however, if credence were given to these nobodies [*terrae filiis*], ignorant butchers and cobblers, since whatever they have, they have taken from me. Moreover, they are the most insensible enemies to all monarchy and its friends and to you in particular; for which reason I avoid contact with them.
>
> I have no few friends in this city, clergymen of the first class, unprejudiced people who, if asked, will be guarantors of my trustworthiness, diligence, talent, and soundness of thought, if you deign at length to remember me.
>
> My particular talent lies in investigating most abstruse matters [*rebus difficilioribus*], inasmuch as I have spent thirty years in correcting papers and I have not yet passed my forty-sixth year, and I was virtually born for every kind of difficult business, but now I am jailed by perverse misfortune, and my soul wastes away under the weight of twenty-two children, those born to me, those entrusted to me, and still living, without any forthcoming prospect of assistance from my friends, but entirely abandoned. Alas! pity me!
>
> I am now completing a most splendid dictionary compiled from all those previously edited, much fuller than any of them, together with Roman antiquities, a general phraseology after Smetius, and other necessary things, in the manner of Elisha Cole. While I struggle to produce it, I perish [*pario pereo*]. I therefore supplicatingly implore your aid
>
> <div style="text-align:right">I who am the least of your
servants and yet most faithful
Richardus Hogarth</div>
>
> Posted from Black and White Court
> in the region called the Old Bailey
> within the bounds of the Fleet,
> 7–23. 1710.[12]

The "twenty-two children" (*viginti duorum liberorum*) must have included

the family of his brother-in-law William Gibbons, who was confined in Ludgate for debt, or pupils entrusted to his care.

In fact, by the end of August Harley had solved the immediate crisis and provided for the army pay, and no more is heard of Richard Hogarth's proposals. His letter was dated 23 September. Harley put together his ministry during that month, and on the twentieth he had the Queen dissolve Parliament; he left London in October, and the new Parliament sat at Westminster in December. On 3 January of the new year,

> A Petition of the poor insolvent Debtors belonging to the *Fleet* Prison, in behalf of themselves, and great Numbers of distressed Persons, now under Confinement in the respective Gaols of the Kingdom of *England*, was presented to the House, and read; setting forth, that by their long Confinement, and Necessities, they are reduced to the last Extremity, and must inevitably perish, unless relieved by the House: And praying, that a Bill may be permitted to be brought in, to oblige their Creditors to accept the utmost Satisfaction they can make, and to restore them to their Liberty.[13]

If not a coincidence, the sequence might suggest that the enterprising Richard was involved with this petition. That it reached the House and was acted upon might further suggest that Harley had in some way encouraged Richard, or others like him, to draw up the petition at this time.

As soon as word got around that a bill was pending, petitions poured in from gaols all over England.[14] In the *Review* for 24 February 1710/11 Defoe mentions the bill approvingly as one that would relieve insolvent debtors "by obliging their creditors to accept of all the Satisfaction they are able to make," but adds that it is limited to debts of only £20.[15] The bill was, however, held up in Lords and did not finally clear both houses until May 1712, over a year later, by which time the debt limit had been raised to £50. On 14 May the bill was back in Commons, and on 22 May it received the royal assent.[16] The "Act for the Relief of Insolvent Debtors, by Obliging their Creditors to Accept the most Satisfaction they are capable to make, and Restoring them to their Liberty" (10 Anne cap. 29) emphasizes the fact of the war and the need to free ablebodied citizens in such dangerous times.[17] By the terms of the act all debtors in prison since 7 December 1711 were given the opportunity to appear in court and present a schedule of their whole estate, with the names of creditors and amounts owed, and swear that their statement was true and that they were not withholding anything to defraud their creditors. Notice was to be inserted in the *London Gazette* thirty days before the meeting of the Quarter Sessions for debtor and creditor; and if the justices of the sessions were satisfied, the debtor would be released.

Before the end of May the names and lists of names began to appear in the *London Gazette* for the Session of 15 July. Richard Hogarth is listed in the

issue for 31 July–2 August with a number of other debtors as "having petitioned one of her Majesty's Justices of the Peace for the City of London, and his Warrant Signed thereupon, directed to the Warden of the said Prison, to bring them to the General Sessions of the Peace held at the Guildhall of the said City, on the 8th of September next, to be discharged persuant to an Act lately passed for Relief of Insolvent Debtors. . . ." The Sessions Books, in a special ledger for Insolvent Debtors in 1712, record under 9 September:

> Discharged Richard Hogarth in the ffleet
> James Langdon proves him prisoner and
> summoned Creditors, due Notice
> in Gazette
> Debts & Effects Delivered in Court

The second person named was to swear that the debtor was a prisoner on 7 December 1711 as per the Act. On 14 September Richard himself was serving as a witness for William Gibbons, who had been a prisoner in Ludgate, to prove him prisoner on the above date; and their brother-in-law Timothy Helmesley was witness to prove that notice had been given to his creditors to appear in court. This William Gibbons was a younger brother of Anne Hogarth, a freeman of the Cutlers' Company, and possibly involved in the coffeehouse venture with Richard.[18]

Defoe, in the *Review* for 29 January 1712/13, notes that 20,000 "Prisoners, or rather, Poor Debtors, have been discharged or certified for Discharge, by Vertue of the late Act; none of whose Debts are above 50.l to any one Man." He admits that "innumerable Frauds have been cover'd by that Act, discharging perjur'd Villains, who have gotten in without any Right . . ." Nevertheless, he adds, "Thousands of Honest, Distress'd, Industrious Trading-Men, and their Families, are set free by it, restored to their Liberty, in order to struggle again with the World, and keep their Families and Children from Beggary and Starving . . ."—and this group presumably included the Hogarths.

After nearly four years of virtual imprisonment, Richard Hogarth was again free to come and go as he liked, and, with his family, could try to return to his old neighborhood and pick up the threads of his former life. There is no way to gauge the effect of the experience on Richard and his wife. The hardships must have been intense. The winter of 1709, for example, was one of the coldest in memory, with post boys found dead, frozen to their horses; fuel grew outrageously expensive, and the cold lasted till the end of April. During this time two more children, William's surviving brothers Thomas and Edmund, died.[19] When he emerged, Richard was a man of fifty, his hopes behind him, though still working on his dictionary.

Remembering Dickens' reaction to his experience as a youth in the blacking factory, one can hardly overemphasize the importance of Richard's collapse and

confinement on William. He never mentions, in any surviving writing, that his father went to prison, although his account of those early years does suggest something of the hardships his family suffered. The record, however, may be deduced from his works, and it is a detailed one. In the seventh plate of the *Rake's Progress* (pl. 5) Tom Rakewell has been confined in the Fleet Prison for debt. One of his fellow prisoners is a bearded, unkempt man, wearing a wig that is too small for him and a dressing gown rather like the Distressed Poet's. A paper is falling from his pocket labeled "Being a New Scheme for paying ye Debts of ye Nation by T: L: now a prisoner in the Fleet," and another paper, sticking out of his pocket, is marked simply "Debts."

One day William was free in the wide expanse of London's fairs and markets, its games and illusions; the next, he was plunged into the restrictive world of prisons, sponging houses, courts, and Rules. His father was a prisoner, without employment or resources, his mother was trying to support the family by selling home remedies. At home he found himself in crowded, uncomfortable quarters,

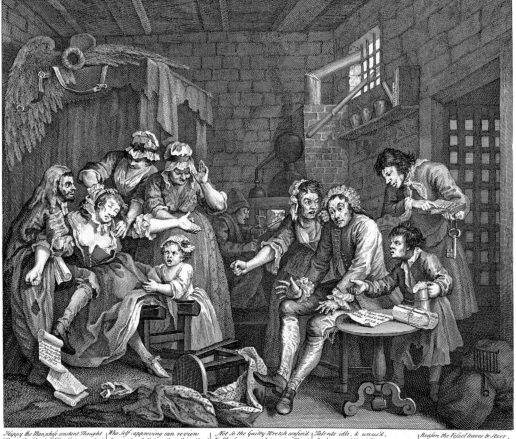

5. A Rake's Progress, pl. 7; 1735 (third state); 12½ x 15¾₆ in. (W. S. Lewis Coll.). Note: Measurements throughout refer to the design only.

probably shared with the family of William Gibbons, and outside he found himself among some of the shadiest of London characters, including not only the shabby-genteel debtors just managing to avoid the utter squalor of the inner prison—sometimes innocent victims, often rogues, and almost always men who by trying to live up to some hypothetical standard had exceeded their means— but also the habituated denizens of this demimonde who exploited them, supplying them with food and comforts at exorbitant rates and criminal interest. This was the world that Hogarth captured in his prints as no one else did. It is easy in the light of these years to understand why the 1729 House of Commons enquiry into the Fleet was important to him, not to mention his own paintings of the Committee meeting in the prison, which first brought him to the attention of the London picture buyers. The emphasis throughout his work is on prisons, real and metaphorical, on the relationship between the individual and institutions, on punishment hardly warranted by the crime, and on the image of the deluded and isolated individual. Even when he is not dealing with people who are in a prison of one sort or another he portrays rooms that are more like prison cells than boudoirs or parlors.

The years in the Fleet may also have been the factor that delayed Hogarth's apprenticeship from 1712, his fifteenth year when it would ordinarily have begun, until January 1713/14; he probably had to work to help pay off the creditors. Years later he recalled the relatively advanced age at which he took up engraving. While delaying his apprenticeship, Richard's financial disaster may have determined it as well: if his father had intended him for something better, perhaps a learned profession, these hopes collapsed when he went to the Fleet. It seems likely that William stopped attending school entirely, unless he was intermittently tutored by his father. His irregular education—involving much reading but little disciplined learning—explains much in his autodidactic posture of later years. He knew Latin tags but could not spell them; he had a strong sense of rhetorical effect but his sentences tended to collapse in disorganized syntax.

William emerged with a deep and abiding fear of entropy, and the determination never to repeat such a breakup. Both his ambivalent attitude toward chaos in his works and his careful, canny business sense—his concern to have enough money, to secure his property (all the profits of his engravings) to himself legally—may stem from this time; or at least such an inclination was strengthened by the experience. The means by which Richard Hogarth eventually gained his freedom must also have impressed itself on his son. He could not rely on the generosity of his creditors, his patrons, or even his merchant brother; the only hope left him was an Act of Parliament, and Parliament, remarkably enough, cooperated.

Although they did not extricate him, the booksellers had not altogether aban-

doned Richard, and he had continued to write. While within the Rules of the Fleet he completed and saw published another Latin textbook, *Disputationes Grammaticales or Grammar Disputations* (December 1711).[20] This little book is made up of a dialogue in English and Latin, with an index of men and objects appended. It was in this list that Richard demonstrated his orthodoxy by celebrating the Stuarts and omitting regicides and usurpers.

The book is a grammar, probably intended for the first form (Lily's was still used in the second), apparently based on Richard's classroom experience ("By Richard Hogarth, *Schoolmaster*"). The Latin dedication "To the Scholars, Schoolmasters, and Under-teachers of Great Britain," however, remains a characteristic utterance with its argument that games are the best instruction, its implication that here is a new and revolutionary system which will supersede the old, and its promise that something even better ("quiddam majus et magis vobis accommodum") will follow.[21] The success of the book can only be conjectured—Richard does not appear among the 186 writers of Latin grammars enumerated in Solomon Lowe's *Grammar of the Latin Tongue,* published in 1726.[22]

However, in April 1713 appeared *New School Dialogues, English and Latin; partly collected from Walker's Idioms and Adages, Terence, Coderius, Erasmus, and other Writers of Colloquies: Partly Composed and digested by R. H. and now the first time Made publick, for the use of the Lower Forms in Schools.*[23] If this is our R. H., and the book perhaps the "something even more to your liking" he had promised, his efforts were rewarded: it was adopted by St. Paul's School.[24] Thus, the Hogarth family may have lived in somewhat greater security during the last years of Richard's life. They are listed as householders in Long Lane during these years, and the Widow Hogarth continued to hold the house after Richard's death in 1718.[25] But booksellers, to judge by William's later statements on the subject, were not to be trusted; they made the profits and let their authors starve. Moreover, they apparently prevented Richard's masterpiece from being published.

While imprisoned in the Fleet, Richard wrote Harley that he was working on a dictionary like Elisha Cole's. This was an English-Latin, Latin-English dictionary "containing all things necessary for the translating of either language into the other," first published in 1677. The manuscript itself survived, kept by William as a bitter remembrance; it passed after Jane Hogarth's death to Mary Lewis, who sold it to John Ireland. According to John Nichols, who had seen it, it was "a thick quarto," containing an early edition of Adam Littleton's *Linguae Latinae liber dictionarius quadripartitus* (originally published in 1673) and William Robertson's *Phraseologia Generalis, or A Full, Large, and General Phrase Book* (1681).[26] Cole's dictionary had been superseded by Littleton's Latin-English and Robertson's English-Latin dictionaries, so it was reasonable for Richard to use these as his working copy. There were many corrections writ-

ten into the text and in addition 400 pages of closely-written manuscript. In the first volume, in William's hand, was inscribed "The manuscript part of this dictionary was the work of Mr. Richard Hogarth."[27]

This was the work William referred to in his autobiographical notes many years later as the source of his distrust of booksellers. Explaining why he turned to drawing (implying that a learned profession was an alternative), he writes that besides his natural talent,

> I had before my Eyes the precarious State of authors and men of learning[.] I saw not only the difficulties my father went through whos dependance was cheifly on his Pen, the cruel treatment he met with from Bookseller[s] and Printers [but] particularly in the affairs of a lattin Dictionary the compiling had been [the] work of some years. which being deposited in confidence [in] the hands of a certain printer, during the time approbation letters on the specimen were obtained from all the great schools in England Scotland and Ireland, who were in short pleased but several of those also of his acquaintance who were by the correspondance he held as appears by letters I have still by me were of the first class.

And finally, he believed that his father died "of Illness occationd by partly the useage he met with from this set of people"—"and partly," he adds enigmatically, "by disappointments from great mens Promises."[28] The last must refer to subscriptions, without which many booksellers would not have begun so large a project. Certain "great men"—those patrons whom Hogarth was ever to distrust—apparently encouraged his father's hopes with promises of support and subscriptions from their friends, which were unfulfilled. Certain booksellers probably held back because Richard's dictionary would have detracted from sales of a dictionary whose copyright they already owned (Littleton or Robertson); others probably thought the project unprofitable. It must have seemed to his son that London was one great set of rogues preying on the individual who struggled to survive and maintain his own standard of excellence. The decent, hard-working scholar went to prison, while the roguish booksellers picked his brains and scavenged his writings without adequate recompense, and, when they could, cheated him outright. This image, together with that of the unhelpful patron, remained with Hogarth all his life, affecting at crucial moments his own actions as well as his works.

It is always difficult to assess the influence of a father, especially when he is as shadowy a figure as Richard Hogarth: but enough evidence remains to allow for some generalizations, without labeling the son's characteristics as emulation or reaction. The problem is further complicated in Hogarth's case, of course, by the unknown quantity, Puritanism, as it relates to Richard's life and his classical concerns. He drew on two areas of authority and experience. He was a north country Presbyterian but also a teacher of classical languages, and in his pub-

lished works the classical rubs shoulders with the biblical, the virtues of Roman heroes with those of Christian martyrs. His son's obsession with the social pretender, the Presbyterian who would pass as an Anglican, the outsider as an insider, and so on, may have derived from the situation of the Hogarth family in Bartholomew Close and elsewhere.

The *Disputationes Grammaticales* was published when William was fourteen, and it is likely that at some point his father, the dedicated pedagogue, at least attempted to try out his methods on his son. William must have rebelled against his father's world of dead language and rules. His spelling was blatantly unstandardized, in direct contradiction to Richard's *Thesaurarium*, though his handwriting itself (when meant to be read) was not bad, and he had a decided flair, reminiscent of his father's, for pithy phrasing. It is difficult not to connect his strong stand against rules and regimentation in later life with his father in one way or another; and since there is evidence that his father continued to use the old, rote methods of teaching, however good his intentions, one may assume that Hogarth reacted against rather than emulated. And yet Richard and his various "academies" come to mind in considering William and his artists' academy; as does Richard the self-made man, not of a university, making his way unaided in the great city. William's itch to systematize and place before the world a written text, let alone his leading motive to teach, may be traced to his father. And while his Line of Beauty, and his aesthetic precepts, are anti-rules, they are presented in a manner and a spirit not unlike Richard's.

Finally, and most important, William's mind, like his father's, worked verbally rather than visually. Peter Quennell has astutely observed how this may have contributed to the visual mnemonics he developed in art school to replace sketching from nature; he would record his impressions by a visual shorthand, return to his studio, and translate them into images. "Accustomed [by his father] to thinking in linguistic terms," Quennell writes, "Hogarth divined that art might itself be a form of language—with this difference, that, whereas the vocabularies that Richard Hogarth taught were rigid and comparatively lifeless, the idiom that his son was hoping to perfect would be newly modelled on his experience of the world." Quennell refers suggestively to the "later stages of adolescence when an unconscious impulse to rival one's father is counterbalanced by a determination to avoid resembling him."[29] This dichotomy is most evident in the literary quality of Hogarth's art.

One part of his father—the failure—William had to push out of his consciousness. His obsession with success, his attachment to Sir James Thornhill, and his lifelong emulation of Thornhill can only be adequately explained as an attempt to satisfy a need never fulfilled by his father.

4

Apprenticeship

On 2 February 1713/4 the Registry of Apprentices of the Merchant Taylors' Company records the binding of William Hogarth to Ellis Gamble, engraver, for seven years.

At his own apprenticing, twelve years before, Gamble was described as the son of Robert Gamble, a "gentleman" of Plymouth.[1] He had been apprenticed to Richard Hopthrow of Orange Court, also an engraver, in 1702. According to the age given on his marriage allegation and the usual age of apprenticeship, Gamble must have been born around 1685, and thus Hogarth's senior by only a dozen years. Though his apprenticeship to Hopthrow was concluded by 1707 at the latest, he did not purchase his freedom of the company for another five years. He may not have had sufficient money before that; and on 15 September 1710 he took a wife, one Margaret Smalbone, at St. Martin in the Fields. Both he and Margaret are said to be of St. Martin's parish at this time. Gamble's signature and handwriting are clear and literate.[2] Finally on 3 March 1712/3 he purchased his freedom of the Merchant Taylors' Company, when he was described as an "engraver" of Blue Cross Street, Leicester Fields.

Hogarth's apprenticeship should have begun in 1712 when he was fifteen. Gamble, of course, could not have taken him before March of the following year, but the delay until February 1713/4, when Hogarth was sixteen years and three months, is probably explained by the movement of the Hogarths from debtors' prison to Long Lane. Before 1714 William may not have been expendable. Though there is no indication in the Registry of Apprentices that any money exchanged hands, as was usual at an apprenticing, perhaps at this point Edmund Hogarth came to the rescue; through his wife Sarah he was in some way related to Ellis Gamble, and he may have arranged for the apprenticeship and either persuaded Gamble to take William gratis or paid him to do so. All that Hogarth himself had to say about the matter in later years was that his father was too poor to do more than put him "in a way to shift for himself," and so "accordingly he serv'd a prentiship to a silver plate engraver." In another version he noted that he was "taken early from school" to serve his apprenticeship.[3]

Since the thirteenth century, apprenticeship had been supervised by the guilds in order to ensure fair play among workers, to prevent one master from luring away another's apprentice, and to make sure that ignorant workmen were not allowed into the guild. The Company enrolled the names of all apprentices in a guild book, and the apprentice was bound by indentures, which were inspected by the officers of the guild, and his name and the date of binding were recorded.[4] The terms of the indentures changed little between the sixteenth and eighteenth centuries. The apprentice swore to serve his master truly and to keep his conduct morally above reproach, while the master promised to instruct the apprentice in his craft, provide him with room and board, and uphold a moral standard as his guide. This document, usually drawn up by the clerk of the company to which the master belonged, was written twice across a sheet of parchment or paper; the two copies were then cut apart so as to leave on each a jagged or indented edge, from which the document took its name.

At a public ceremony with the apprentice, his master, and the Company officers present, the register was entered in the guild book, to cancel the possibility of fraud by the master or apprentice. If, for example, the boy had been bound to an unqualified master, or if the boy were in some way unqualified, it would come out at this point. The Merchant Taylors required that the master present his apprentice "before the Master and Wardens for the tyme being at their Comon Hall to th'intent that they by theire examynation may understand that he be free of Birth and not challenged for a Bondman and borne under the Kinges obeysance. . . ."[5] The Merchant Taylors' Hall in Threadneedle Street was entered by "a handsome large Door-case adorn'd with two demy columns, their Entablature and Pediment of the Composite Order," and here in the great hall, hung with tapestries telling the history of their patron John the Baptist, Hogarth's indenture was read and approved by the court, and he was enrolled in the book.[6]

Apprenticeship ended with a public act too: seven years later the apprentice appeared again before the assembly court, this time to ask for his freedom.[7] According to the Statute of Artificers, he had to be no less than 24 years of age, but this rule was not often observed, 21 seeming to have been the lower limit. He went with his master to the guildhall, and the master publicly testified to the apprentice's true service. He had to pay fees for admittance: the legal sum was 3s 4d, but the beadles, clerk, and other guild officers also received small fees, raising the total considerably. In Hogarth's day, these fees often amounted to £10, £20, or £30 and it was common for the new freeman to give a breakfast or dinner for the Company. It was customary for the master to help fit out the apprentice for his start in life. In the seventeenth century he often gave him a double suit of apparel at the end of his term, or the tools he would need; in the eighteenth, when the relationship was collapsing, the master more often simply paid a sum of money to clear himself of all further obligations. By that time also

the capital necessary to set up in business was much greater than in previous centuries, which might explain Gamble's waiting five years to take his freedom.

The master to whom William was apprenticed was evidently a clever engraver. During the apprenticeship Gamble was living in a house on the south side of Blue Cross Street (now part of Orange Street) between Whitcomb and St. Martin's Street (not far from his master Hopthrow, who lived in Orange Court). The Merchant Taylors' records give that address for Gamble in March 1712/3; he first appears in the rate books on 30 September 1714 when the second rate was paid, and so may have sublet a shop before becoming a householder.[8] Hogarth's apprenticeship may have coincided with Gamble's taking over a whole house, for as an apprentice he moved into his master's house as a member of the family. At least one other apprentice was in the Gamble house when Hogarth arrived: a Stephen Fowler, listed in the Registry of Apprentices as son of Benedict Fowler, a waterman of St. Margaret's Parish, Westminster, who paid Gamble £15 for the apprenticeship in 1713. Another apprentice, a Flemish lad named Felix Pellett, joined them in 1717, by which time Gamble's increasing importance had raised the fee to £30.[9]

Indeed Gamble prospered during these years, no doubt with the assistance of his talented apprentice. On 23 May 1718, toward the end of Hogarth's term, Gamble (then listed as "ingraver by the Mews," which was nearby) was elected a liveryman of the Company on payment of a fine of £15. After giving a note for his fine payable in one month, he was sworn in. As a liveryman he could hold office in the Company and purchase larger shares of its stock than were available to the Company's yeomen; he was privileged to wear the Company's robes at public ceremonies; and a year after the payment of the fine, he could vote in the City elections for both higher officials and M.P.'s. In 1724, a few years after Hogarth had left his house, Gamble moved to the north side of Cranbourn Street, apparently renting from (or sharing a house with) Thomas Rayner, a goldsmith.[10] It is hard to say whether this move took him up or down: he may have worked with Rayner, chasing the bowls and plate he made. He is mentioned in the *London Journal*, 27 April 1723, when one Esther Smith was committed to Newgate for stealing £15 in gold and silver from his shop. In 1728 he was engraving plate for Paul de Lamerie, the great Huguenot goldsmith (and probably had done so for some years before), but difficulties arose between them, and in January 1732/3 he was declared bankrupt at Lamerie's petition. Bankruptcy did not put him out of business, nor did it involve resignation as a liveryman; in 1737 he took another apprentice, one William Granville, though his fee had been lowered to £10 by this time.[11]

The implication is that Gamble was a man of some talent and industry, but improvident and perhaps unlucky. A further implication, from Hogarth's later comments on his apprenticeship, is that he was no easy taskmaster. The master replaced the apprentice's father; he was responsible for the apprentice's physical

and moral development, and one of the qualifications guilds looked for in a
master was a wife and family of his own. But it was not an easy life for the
apprentice. The work hours were long, defined by statute for artificers who
worked by the day as from 5 A.M. to 7 or 8 P.M. from the middle of March to the
middle of September, leaving not more than two and a half hours for all meals.
From mid-September to mid-March the hours were those of daylight. He re-
ceived no wages, and the master was entitled to all the apprentice's products
and earnings. His pay was restricted to instruction and maintenance. As the in-
dentures state, the master supplied teaching, meat, drink, and lodging, the ap-
prentice obedient service.

Sports and pastimes were universally frowned upon: no dice or cards, no foot-
ball, in some places no plays; no mumming and dancing, use of music, or enter-
taining of one's friends. Extravagance in dress and personal adornment were
suppressed: clothes had to be plain but decent—sober garments, hair neatly
trimmed, not in curls or hanging about the ears. During these years the papers
were full of accounts of unruly apprentices, and advertisements for runaways.
One master told his guild court that his apprentice "did threaten him in an un-
usuall manner, and often swore he would be his death, and would crush his head
against the table, with many such like provoking expressions." Most annoying
of all, apprentices were constantly running away before their term was up, "just
when their work was beginning to repay their masters," as Defoe put it.[12]

It is certain that Hogarth felt the life constricting: "he soon found that busi-
ness too limited in every respect," he recalled. And whenever he wrote about
the problem of learning his craft—whether engraving or drawing at the academy
—he emphasized how he wanted to balance his "studies" and his "pleasures."[13]
It is easy to imagine him chafing under the long hours, straining his eyes over
tiny heraldic engravings, and eagerly looking forward to the little time he was
given away from the shop.

During these formative years, from sixteen to twenty, he must have soaked up
more than the technique of engraving coats of arms. There can have been few
more alert observers of London life; and he embarked on his apprenticeship in
the year Queen Anne died and the Hanoverians arrived from Germany, the
Tories went into exile, retirement, or prison, and the Whigs emerged trium-
phant. There was constant talk of the Stuart Pretender returning—as indeed he
attempted to do in 1715, with the consequent treason trials and executions. In
addition to politics, the ordinary routine of London deserved contemplation.
A month before Hogarth started his apprenticeship he might have read in the
Post Boy:

London, Dec. 19. The Sessions at the Old Baily did not end till Monday
last; and it has not been known for many Years, that so many Persons re-
ceiv'd Sentence of Death at one time, there being then Condemn'd 23

Persons, being 6 Women, and 17 Men, . . . 7 for Burglary, 5 for Shop-lifting, 4 upon the late Statute for Entring of Homes, and Stealing Goods above the Value of 40s. and the rest for several Capital Offences.[14]

From the evidence of later years, it seems almost certain that Hogarth, despite apprentice rules, spent a great deal of time at the theater; and at print shops, book stalls, and generally around London, surveying and mentally and physically recording the sights. He may have already begun his practice of memorizing the forms of what he saw or catching them in outline upon his finger nail. The well-known story, from a few years later, concerns a friend who saw him "draw something with a pencil on his nail. Enquiring what had been his employment, he was shewn the countenance (a whimsical one) of a person who was then at a small distance."[15]

Nichols cites an anecdote of his apprenticeship told by a fellow apprentice, a "person of indisputable character, and who continued his intimacy with Hogarth long after they both grew up into manhood." He was with Hogarth at the time of the events he related:

> During his apprenticeship, he set out one Sunday, with two or three companions, on an excursion to Highgate. The weather being hot, they went into a public-house, where they had not been long, before a quarrel arose between some persons in the same room. One of the disputants struck the other on the head with a quart pot, and cut him very much. The blood running down the man's face, together with the agony of the wound, which had distorted his features into a most hideous grin, presented Hogarth, who shewed himself thus early 'apprised of the mode Nature had intended he should pursue,' with too laughable a subject to be overlooked. He drew out his pencil, and produced on the spot one of the most ludicrous figures that ever was seen. What rendered this piece the more valuable was, that it exhibited an exact likeness of the man, with the portrait of his antagonist, and the figures in caricature of the principal persons gathered round him.[16]

Whether one accepts this particular set of facts or not, it is evident that Hogarth was remembered as sketching actions he witnessed in a comic vein and as having a talent for catching likenesses (he himself noted his childhood talent for mimicry).[17] All evidence points to his original impetus in art being toward the grotesque and comic, in the tradition of Brouwer, Ostade, and Heemskirk.

While the life of an apprentice would have seemed tedious to one of Hogarth's temperament under any circumstances, he was further hampered by a master who was fundamentally an artisan (a goldsmith), and in no sense an artist. Hogarth's dilemma was not a unique one; artists had been fighting since the Renaissance to clarify the distinction between craft and liberal art. It is not cer-

tain whether Hogarth yet thought of himself as an artist, or whether his comic drawings were merely an escape from the long hours of careful silver engraving; but coming from his father's house he cannot have been too happy thinking of himself as an artisan.

During the Restoration goldsmiths had combined the functions of craftsman and banker.[18] By the time Hogarth was apprenticed, however, the two professions were separated, and even if his financial status remained secure, the goldsmith's prestige and social status had suffered; the banker, like Sir Richard Hoare, became one of the de facto rulers of England, while the goldsmith, however fine an artist, remained a craftsman and tradesman. This decline in status was accompanied by a decline in the importance of the Goldsmiths' Company; many goldsmiths, or goldsmiths' engravers, chose to be members of other companies. The infiltration of Huguenot goldsmiths from France also contributed to this movement. The well-known Huguenot goldsmith Peter Archambo was a freeman of the Butchers' Company, and the engraver Simon Gribelin became a freeman of the Clockmakers' Company—perhaps because he could not get into the Goldsmiths' at that time, or perhaps because much of his work was initially on watch-cases. Legally, the assay and touch of the Goldsmiths' Company was allowed to freemen of other companies; in the mark registration books are marks registered by members of Drapers, Merchant Taylors, and Clockmakers companies.

As so often seemed to happen, Hogarth found himself in a borderline situation, apprenticed to a goldsmith's engraver, whose status fell somewhere between a merchant and an artist. The goldsmith himself cast the plate; the ornament could also be cast, cast separately and applied, or embossed (hammered out of the body of the metal), and all of this was done by the gold- or silversmith. Engravers like Gamble were called upon to do any decorative engraving required. Only the simplest engraved borders were done at the goldsmith's shop; any work requiring a higher degree of skill was sent to a specialist, and this work might extend from a cypher or a coat of arms to an elaborate allegorical design.

Mostly, however, the engraving was limited to heraldic motifs. Engravers upon silver fell into two general classes. Many, like Gamble, devoted themselves entirely to engraving plate, watch-cases, and sometimes bookplates, limiting themselves to heraldic designs. From Hogarth's own comments, this must have been the extent of Gamble's ambition. George Vertue notes that Hogarth was "bred up to small gravings of plate work & watch workes";[19] Hogarth himself complains that all he made was "Monsters of Heraldry," and the shop card he later executed for Gamble (pl. 8) shows that his master also sold jewelry and such objects. If tradesman is writ large on Gamble's career, the other class of engraver included those like Gribelin, and later Hogarth himself when he set up in business, who, while basically illustrators, also decorated silver for a fee. They had

made the essential rise from silver to copper—at which Hogarth must have been working in his spare time long before 1720.

Historically, the important phenomenon during these years was the presence of the Huguenot refugees, who introduced changes in the style of smithing and engraving and stole business from English workmen, forcing them to lower their prices. They were much in evidence, living in the Parish of St. Anne, Soho, east to west from Hog Lane to Wardour Street and north to south from Oxford Street to Leicester Fields, and especially around Old Compton Street and Berwick Street. Since England was at war with France most of the time, they tended to keep to themselves. One wonders how Gamble, or Hogarth, felt about the incursions of the foreigners, who offered a higher standard of workmanship at the same or lower prices. English goldsmiths found themselves forced to accept these new standards (including the new style) and prices or lose their trade.[20] Gamble himself engraved plates for Lamerie, the greatest and most influential of the Huguenot goldsmiths, who was living in Windmill Street, Soho, and was a member of the Goldsmiths' Company. Hogarth's experience as an apprentice doubtless acquainted him with a number of Huguenot refugees and exposed him to their style of silver engraving and other products of their art as well.

The Huguenot influence was in fact to the advantage of the engraver. In the first half of the eighteenth century the main influence on English silver changed from Dutch to French, from elaborate embossed decoration to simple forms with a minimum of decorative details—the "Queen Anne" style. In seventeenth-century England ornament was almost entirely embossed, and engraving, except for coats of arms, was out of fashion. The new style, with its plain, unembossed surfaces, allowed for a return to engraving; as a result engraved decoration reached a higher standard of excellence than ever before. Another result, of course, was an influx of French pattern books.[21]

Thus when Hogarth began his apprenticeship the "Carolean baroque" style, with richly-embossed ornament, was being replaced by the purer French forms, sometimes stripped of all ornament. English-born goldsmiths continued to use the William and Mary ornament, embossed parallel or spiral fluting and gadrooning. But the engraver of plate like Gamble was naturally drawn to the Huguenots or native goldsmiths who followed the Huguenot style. Within the years of Hogarth's apprenticeship the amount and complexity of the engraving increased as the Queen Anne style developed into early Georgian. More specifically, this change involved the replacement of the square shield (in which the coat of arms was enclosed) by the circular or oval cartouche, surrounded by acanthus foliage and strap- and scroll-work, and later by swags of flowers, grotesque masks, and palmettes; all of which gave the engraver an opportunity, previously denied him, to display his virtuosity. English engravers and their apprentices learned this new style of ornament from the endless pattern sheets

issued by the great French masters of late Baroque design, Jean Berain and Paul Ducerceau.[22] With these pattern books, it should be added, almost every other conceivable sort of design reached England. While, for example, the general forms and motifs used by Berain appear in the early engravings of Hogarth, his style—his use of line—owes more to J. Barbet's (fl. ca. 1635) as it appears in his *Livre d'architecture d'autels, et de cheminées* (1641).[23] In general, of course, these models led Hogarth toward mythological subjects and the conventional forms of putti, herms, satyrs, savage men, and so on.

It is unfortunately impossible to identify Gamble's engraving. The work of the goldsmith himself is difficult enough to pin down. Although bearing the master's mark, it might have been made by anyone in his workshop, and the engraving, done by another craftsman in his own workshop, is utterly unidentifiable except by style. And nothing is known of Gamble's style except as Hogarth may reflect devices learned from his master—which, however, are utterly conventional. Hogarth's style, insofar as it tends to humanize the heraldic forms, is

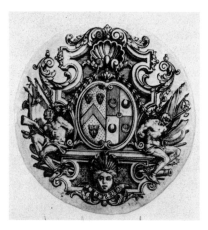

6. Tatton Arms; date unknown; 2⅜ in. diam. (BM)

easier to recognize, but only in supporters and allegorical figures, which were by no means always part of the commission. Several pieces have been attributed to him and one or two are very likely his (pls. 6, 7); but none can be attributed with certainty to the period of his apprenticeship. Besides the relative anonymity (for the most part) of such work, the family plate, regarded largely as a reserve of capital easily realizable in time of emergency, often ended in the melting pot.[24] Plate was not regarded as an art form so much as a malleable commodity, as Prior suggests in *Alma:*

> My Copper-Lamps at any Rate,
> For being True Antique, I bought;
> Yet wisely melted down my Plate,
> On Modern Models to be wrought.
>
> (III. 458–61)

7. Four Elements; date unknown. Juno: 2$\frac{3}{16}$ x 1$\frac{15}{16}$ in.; Neptune: 2$\frac{1}{16}$ x 1$\frac{7}{8}$ in.; Tellus 3$\frac{3}{4}$ x 6$\frac{7}{8}$ in.; Vulcan: 4$\frac{1}{4}$ x 4$\frac{3}{4}$ in. (W. S. Lewis)

It would conform to the latest fashion of decoration much more readily than paintings or statuary, or even architecture. This phase of Hogarth's career is therefore empty of attribution.

He made no effort himself to foster the memory of this time, preserving no impressions of his engravings and referring to it only as a waste period that kept him from copper engraving and prevented him from ever mastering its refinements. As an apprentice to a silver engraver he was taught the handling of the tools of his trade, not the principles of art; he was made to copy or to adapt at best allegorical figures and emblems, at worst purely decorative patterns, and this imitation of art to the exclusion of nature prejudiced his attitude toward "art" and copying for the rest of his life. He discusses in his autobiographical notes the nature he would have liked to copy rather than "the monsters of Heraldry," which he would later associate with design for its own sake in certain kinds of history painting. He insists that "he soon found that business too limited in every respect. Engraving on copper . . . at twenty was his utmost ambition." Because he turned to copper so late, the bad habits of engraving contracted during his "former business," which all had to be "unlearn'd," "prevented together with his impatience his attaining that beautiful stroke on copper which has often been [accomplished] by early habits and great care." He goes on to explain that "For want of beginning early with the Burin on copper Plates, as well as that care and patience I dispaired of at so late as twenty of having the full command [of] the graver for on these two virtues the Beauty and delicacy of the stroke of graving cheifly depends." Finally, he concludes, "the

chief part of my time was lost till I was three and Twenty in a business that was rather detrimentall to the arts of Painting and Engraving I have since pursued."[25]

These references all place his break with Gamble around 1720, and 23 April 1720 is the date engraved on his shop card (title page), the first datable engraving that has survived. It is evident from the records of the Merchant Taylors' Company that he did not complete his apprenticeship, and from his shop card that he left Gamble nearly a year before its end. Indeed perhaps the most important fact about his apprenticeship is that he did not complete it. The ordinary reason for a forfeit of indentures was that the apprentice got into trouble and his master expelled him; another, which Hogarth himself suggests retrospectively, was that he became so fed up with the life that he broke off—out of pride, ambition, or disgust with the business of silver engraving. Although he does not say so, a third possibility must be considered: that other problems made it necessary for him to get out and support his family.

By 1714, when William was apprenticed, Richard Hogarth was described in the Apprentices' Register as "of St. Bartholomews," so had presumably by then moved to the south side of Long Lane, where he remained till his death in 1718. He first appears in the rate books for St. Bartholomew the Great Parish in 1716, rated at 13s. He must have died suddenly, on 11 May 1718, without time to write a will. There was no mention of his death in the papers, no advertisements for debts outstanding or for an auction of his library (if any remained). He simply vanished from the London scene as quietly as he had come, to be replaced in the rate book by "widow Hoggarth," who continued to live in the house until 1728.[26]

William may have been compelled to leave off his apprenticeship at this point to help his mother, but more likely she continued to hang on by herself, perhaps deciding to begin the millinery business that she was operating later with her daughters. She may have been aided by Richard's brother Edmund, the prosperous merchant. At the beginning of 1719, however, Edmund too died, and his will specifically cut off the Widow Hogarth with "one Shilling if lawfully demanded & nothing else of mine." The will, written on 14 February 1718/19, just before his death, made clear that he wanted no such liabilities as the family of his unfortunate brother to burden his own widow.[27] It may have been at least partly as a result of the double catastrophe that William forfeited his indentures; or perhaps he simply used it as his excuse.

Thus by April 1720 he was back living with his mother "near the Black Bull" in Long Lane and setting himself up, outside the context of any guild, as an independent engraver. On the twenty-third of that month he dated his own shop card, with his name and the above address prominently displayed, flanked by figures of Art and History, with some of the cherubs he had grown accustomed to making for Gamble filling in the top.

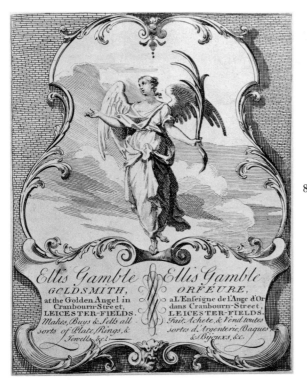

8. Ellis Gamble's Shop Card; ca. 1724; 7⅜ x 5⅞ in. (BM)

The break with Gamble was not necessarily a violent one. In a few years Hogarth made a shop card and perhaps a bookplate for his ex-master.[28] The shop card (pl. 8) is a competent piece of work as such things go: an angel in a cartouche, with some signs of Hogarth's hand not only in the angel herself (with too many fingers) but in the haphazard execution of the brickwork ornament. Hogarth compensates for his unprofessional lack of precision, however, with a lively representation of the angel. The card cannot have been made until 1723 or '24 when Gamble had moved to the sign of the Golden Angel in Cranbourn Street, where he announced that he "Makes, Buys & Sells all sorts of Plate, Rings, & Jewells &c." He evidently expanded his operation, calling himself "goldsmith," and overexpansion may have led to the bankruptcy of a few years later.

Gamble's final influence on Hogarth is hard to assess. Of course, Hogarth reacted against all that he stood for: mechanical copying from art rather than nature, and by extension "art" in general, especially as manifested in the decorative tradition of history painting and the general use of remote mythological subjects. His constrictingly precise work on these subjects for Gamble taught him a great deal about baroque forms, which he would repeatedly parody in his own work. At the same time, it started him toward refining these forms in the direction of the delicate rococo curves—the effect that he ultimately called his Line of Beauty—which became almost obsessive in some of his later works; it

also lured him into an elaboration of detail which is the glory and confusion of his art. The dull copying itself gave him an opportunity to store up images and motifs for later use, instilling in him a sense of signs and symbols and the mnemonic power of emblems that complemented his extra-curricular interest in the Dutch and German graphic satires.

Although he did not realize it at the time, and preferred to overlook it in later recollections, his having been trained as an engraver rather than a painter was a great piece of luck for a man of Hogarth's particular talents and temperament. This training put him in a unique position, when the time came, to appeal beyond the verdict of the connoisseurs, who he felt kept a stranglehold on taste and patronage in England, to the general public for judgment.

5

Early Career as an Engraver

Our prime witness to Hogarth's career, and to the general plight of the arts and the artist in his lifetime, is the engraver and antiquarian George Vertue. Born in 1684, Vertue reached apprenticeship age about 1699, and coming, like Hogarth, "from parents rather honest than Opulent" (as he recalled in his autobiography), "after propper School learning. he was put apprentice to a Master who chiefly practiced Engraving of Silver plate &c. Ornaments, Coats of Armes in which profession he at this time had the top reputation of any in Town." Reputation notwithstanding, Vertue's master went bankrupt in a few years. The boy took up drawing briefly, but soon turned to copper engraving, which he studied "for about 7 years till about 1708/9 when he made some two or three Specimens of work, which giving much hopes to those his Friends who were skilld in the Art, encouraged him to begin for himself. . . ."[1] After leaving Michiel Vandergucht, his master in copper engraving, Vertue spent his first year on his own engraving book illustrations, until he was recommended to Sir Godfrey Kneller and introduced to the business of reproducing portraits.

Vertue's career was typical of the ordinary, successful engraver—and, up to a point, was parallel to Hogarth's. Both were apprenticed to silver engravers, craftsmen rather than artists, and both then went on to study copper engraving. Both started with book illustration. From this point on, however, their careers diverged. Vertue remained all his life dependent on printsellers or patrons, and since printsellers got rich at the expense of their engravers, his hopes rested largely on patrons. As a copyist-engraver, whose specialties ran from portraits to antiquarian objects, his best bet was the wealthy collector who wanted his family portraits or collections perpetuated in good engravings. The patron might offer a munificent reward based on the difficulty and value of the workmanship itself, but the print dealer was interested only in what he could sell, and the less he paid for the plate the more he would profit. Vertue secured noble patrons, but (as his expressions of dismay at the deaths of the second Earl of Oxford and Frederick Prince of Wales show) he was not very lucky in keeping them; they seemed to die just as his future appeared to be assured.

Vertue represents the prototypical engraver of the time. Of better than average competence, he also possessed an eloquence with words that forcibly conveys the engraver's problems at the time Hogarth was entering the profession. He outlines the path Hogarth could have followed but chose to reject for one more suited to his particular genius. At one point in a general survey of the arts, apparently written around 1749, Vertue lapses into an elegy on engraving. He enumerates all the more profitable arts first:

> as the history painter. when his works are done. he receives all the luster and honour and reward of his merit, that is due to him. from every prince Nobleman or Gentleman.
> so does every Statuary for every such monument or works done he has the full reward—honour. and reputation his work deserves.
> so every portrait painter. for each picture, being finisht varnisht framed. &c in its intire glory, has his reward & honour.— . . .

He goes on to list the rewards of enamelers, limners, gold chasers, wood carvers, frame makers, even coach painters:

> all these are fully paid honourd and rewarded for their skill & their works.—but the only unregarded—and unpittyed is the poor copper Engraver. <Burinators> who must generally expect his reward for his labours. to be collected, from sharp avaricious persons. whose fortune is rais'd by trading—and gripeing and impositions in every way possible. Such works done for himself. <But if he is the labourer for other mens vending or proffit. he must be contented with low prices and small reward—> therefore it is, and has been the misfortunes of Laborious assiduous works Engravd to be underpaid—and less regarded. not unlike (of Poets) born under a three-penny planet. and never worth a groat—[2]

Vertue's elegy, however, is accompanied by a careful analysis of the reasons why engraving "is the least profitable—most evidently & certainly"—of the arts. They all derive from one chief cause: engraving is a reproductive rather than an original art form. Gerard de Lairesse's *Art of Painting* (1707) expresses the generally accepted view that engraving "respects Painting, as Painting does Nature: For as the latter has Nature for it's Model or Object, which it faithfully imitates with the pencil; so Engraving likewise copies Painting. . . ." Its aim was to spread the fame of paintings by the sight as word-of-mouth description does by the ear. Jonathan Richardson, a critic whom Hogarth read and later knew, in 1715 pointed out the inferiority of prints compared with originals: "a sort of works done in such a manner as is not so proper as that whereby Paintings or drawings are performed, it not being possible by it to make any thing so excellent as in the others"; the only advantage being that "thereby great numbers are produced

instead of one, so that the thing comes into many hands; and that at an easy
price."[3]

From these limited aims follow the natural slowness of the engraving process
and the lack of intrinsic value in the product. Accuracy of form, tone, and tex-
ture, not expressiveness, were prime requisites, and these were only slowly and
laboriously achieved with tiny networks of lines. For the reproductive plate,
indeed for any large plate, the convention was a virtually continuous series of
lines, very like the halftone of present-day newspapers. The importance of
Marcantonio Raimondi, and to some extent of Lucas van Leyden, in the history
of printmaking lies in their method of shading, which could be reduced to an
easy representational convention: what William M. Ivins has called "a sort of
rudimentary grammatical or syntactical system" for engravers. A wonderfully
adaptive technique, this "tidy organized linear web" was suited to the ability of
the average engraver and was learned as a routine.[4] Of course, it also strictly
limited any possibility of conveying the engraver's personality. Of the final
product, neither the copperplate nor the impression on paper ("a sheet being
a small value") carried any value. The sheet carried even less than the copper-
plate since it was "subject to be multiplyd. and consequently more in number
so each of less value." Engraving, Vertue argues, is different from all other works
of art in that it is never *"exhibited* to view in fullest perfection" but rather
filed away in a cabinet for purposes of reference.

It follows that unlike a painting "where the work done is rewarded or paid
for—at once the value of it," engravings are only valuable in proportion to the
quantity sold. They are thus "also subject by workmen the printers. (common
Ignorance) to be marr'd or ill printed," and "to be sure the more in number
printed. is worse and worse." With insult added to injury, "the painters allwayes
gives every body to understand. their reputation is rather sulled than illus-
trated—thro' perhaps their great Vanitys of their own self productions." Finally,
the printsellers "squeeze & screw. trick and abuse the reputations of such En-
gravers—to raise their own fortune by devouring that of the Sculpture-Engrav-
ers. who cannot dispose of the necessary numbers of prints from the graved
plates" without the printsellers' help.

The print publisher was an entrepreneur who paid men to engrave prints for
him, and published and stocked them as if they were pots and pans; he had his
own shop where he retailed the prints, and he sold them wholesale to other
printshops. The printseller was inevitably interested in what Ivins has called
"exactly repeatable" images—hence burs and other irregularities that distin-
guished one impression from another were polished off; engravings were pre-
ferred to etchings because they could better approximate paintings, they were
more easily standardized, and they allowed many more impressions. The print
publisher had to have a plate that would continue to produce dividends over
a long period of time. These plates represented the most important part of his

invested capital; witness the advertisements of print dealers boasting of a new stock of plates purchased from a bankrupt or defunct rival. From the print publisher's point of view there was no room for a contemporary Rembrandt who made original etchings. The artist himself was subdivided into the painter who made the painting, the draughtsman who copied the painting in black and white for the engraver, and the engraver who rendered the drawing on the copperplate. "The engravings in consequence were not only copies of copies but translations of translations."[5]

The vicissitudes of the engraver's lot and the printseller's trade in these years can be pieced together from Vertue's notes and the newspaper advertisements. The basic changes that took place around the beginning of Hogarth's apprenticeship involved a market for London-based engravers as opposed to total reliance on imported engravings, and a shift from the Netherlands to France as the source for prints, engravers, and engraving style—the same developments already noticed in silver engraving.

When Vertue embarked on his career at the beginning of the century the great Wenceslaus Hollar had been dead for twenty-five years and William Faithorne for ten. Vertue accurately describes the situation as "at a low ebb": Robert White, a portrait engraver, was within a few years of his death, and Vertue's master, Michiel Vandergucht, was never sought after by Englishmen. Simon Gribelin, who came to England in the 1680s, was the only French engraver of any ability working in England at the time. An engraver of copper as well as silver, with some of the French delicacy of style, Gribelin's most famous works were the *Tent of Darius* after Le Brun (which Hogarth years later used as the basis for his composition of *Garrick as Richard III*) and seven prints after the Raphael Cartoons—the first of a long series of such copies. The reason for the "low ebb," Vertue explains, was the continuing wars between France and England, "so violently carry'd on that little or no Correspondence of y Art of graving, from France hither, [was] brought over, nor no Artist from that part in Several years came over." As a proof he notes that none of the history painters, such as Verrio and Laguerre, could find an engraver fit to reproduce their designs. The Dutch influence, which would not have served Verrio and Laguerre, nevertheless was felt in an immense influx of engravings emphasizing portraiture and domestic scenes. The most important Dutch commission of Queen Anne's reign was the engraving of the Van Dyck portraits in English collections: Houbraken came over from Holland to make the drawings, from which Van Gunst, remaining in Holland, made the engravings—one of which Hogarth later described in the *Analysis of Beauty* as "thoroughly divested of every elegance."[6] Though commissioned long before, they were not finished until after the Peace of Utrecht.

The "low ebb" and the "sterility of Artists" offered an opportunity for Vertue, who began to publish around 1709, as he points out. By 1710, after his head

of Archbishop Tillotson, he considered his own reputation a good one: "as This was then the Unanimous opinion of people of Skill & judgement at the time that Edelinck was lately dead in France—and Mr. Robt. White in England. Van Gunst in Holland, it seems as if the ball of Fortune was tossed up to be a prize only for Vertue." Vertue's prices for octavo plates of a single head were 10 guineas, 8 guineas, and 6 guineas the lowest. He charged the Society of Antiquaries £21, including the copperplate, for his portrait of Richard II in Westminster Abbey (1718), and 15 guineas for his engraving of the shrine of Edward the Confessor, when the Society provided the copperplate (1721).[7]

The great subject to be encountered in printshops was Italy—its palaces, gardens, statues, paintings. Travelers who wanted pictures of what they had seen bought them nostalgically in London printshops, and those who had never been out of England wished to know what they had missed. The influence of the Italian Renaissance artists, then of the Dutch, and finally of the French was disseminated through these reproductive prints. During these years, therefore, the print industry was largely an import business. An individual would buy a lot (often including paintings, which were also usually copies) from one of the great international print centers, Amsterdam or Paris. He might be simply an impresario, or, as time passed, more often a wholesale printseller who lacked space in his shop for display. He would exhibit his prints in a coffeehouse, or sometimes in a private house, and after a week or so conduct an auction. These prints were invariably advertised as "lately brought from France and Italy" or simply as "by several foreign masters." To take one example: on 26 January 1711/12, at Nixon's Coffee House at the corner of Fetter Lane in Fleetstreet, original paintings "fit," as all of these advertisements say, "for Hall, Stair-Cases, and Closets" could be seen, together with "Prints of the best Italian, French, and other Masters, as well framed as unframed." Printed catalogues were available.[8]

There were relatively few retail print dealers, and they most often advertised maps and the like, securing what art prints they carried from the auctions. Those dealers who did advertise illustrative prints seldom mentioned native English works, prior to the South Sea Bubble of 1720–21. The most prominent dealer in art prints was J. Smith "at the Picture-Shop in Exeter-Exchange in the Strand, at the West-end, within; with Allowance to them that sell again," i.e., both retail and wholesale.

> All Gentlemen that are curious in Prints, may now be supply'd from great Varieties just arriv'd from Italy and France, by those celebrated Engravers Bloemart, Tardieu, &c. with all the famous Dorigny's Works; and a large Choice of others from the Paintings of Raphael, Titian, Michael Angelo, Rubens, Josippi Cary, &c. and the Statues of Rome complete, &c. at reasonable Prices; by Jo. Smith in Exeter Exchange in the Strand.

He adds in another notice that he also sells "all sorts of Prints and Maps, cheap and Ornamental for furnishing Rooms, Stair-Cases and Closets."[9] The other great printsellers of the time were the Overton brothers and the Bowles brothers, about whom I shall have more to say later.

While the engravings of High Renaissance paintings and sculpture were the most sought-after, there was also a ready market for the original prints of foreign engravers—Callot, Ostade, Teniers, Rembrandt, and others. One shop that specialized in northern prints was the Anchor, perhaps significantly a bookseller's shop, under the south portico of the Royal Exchange. These shops, in which the young engraver could find examples of all the current styles of printmaking as well as reproductions of most of the great works in the continental tradition, were the real school of aspiring young artists like Hogarth.

A word should be said about the paintings that were to be seen in London at the same time. Every week or so an auction was advertised with original works said to be by Titian, the Carracci, Pietro da Cortona, Bassano, Viviano, Claude, both Poussins, Van Dyck, Rubens, Luca Giordana, Carlo Maratti, Salvator Rosa, Gerard Dou. This particular group was to be seen at the Three Chairs, corner house of the Little Piazza, Covent Garden, on 24 February 1712/13.[10] Less plausible but as frequently named are Raphael, Michelangelo, Correggio, and of course the great favorite of eighteenth-century English connoisseurs, Guido Reni. Such paintings were sold at the same coffeehouses as the engravings, and came from the same sources: a dealer bought a lot from overseas or a collector died and his pieces were auctioned. The number of such auctions and shows in the early eighteenth century was staggering.

Hogarth thus had an opportunity to see an enormous body of paintings and engravings of the European Renaissance, north and south, and, as his works indicate, he took advantage of the opportunity. But most of the paintings were obviously copies, at best "school of" or studio works. While introducing him to many forms, motifs, and themes in the great tradition of European art, these pictures must also have been a source of irritation to Hogarth: the copies—indifferently good or bad, painted or engraved—were valued highly, an index of the public's subservience to foreign fashion and its complete lack of interest in native English art.

Because the great majority of engravers depended for their living on this demand for copies, they were often no more than employees of the print publishers. A few engravers (Vertue was one) advertised, and presumably sold, their own work at their own shops, but their profits were shared with the printsellers, who offered the main outlet for their wares. John Simon advertised his mezzotint of Lord Chief Justice Parker after Kneller's portrait, which was to be sold by him in Long Acre (over against Cross Lane), and by the printseller E. Cooper at the Three Pigeons in Bedford Street.[11] He may have retailed the print at his

shop and wholesaled it to Cooper; but when only one printseller's name is given, it can mean either that he and the engraver are in business together, sharing profit or loss, or that the printseller has bought the plate. With mezzotint portraits like Simon's there was not usually enough demand to warrant sharp practice. However, if Lord Chief Justice Parker had suddenly become a hero and his portrait was in great demand, Cooper (if he conformed to the practice of most printsellers) might well have had one of his employees copy Simon's mezzotint: thus underselling the original and gathering the whole profit to himself.

The state of engraving described by Vertue changed for the better as English relations with the Continent improved. With the Peace of Utrecht in the air, the Frenchman Nicholas Dorigny, who according to Vertue had "justly the reputation of the first graver. in Europe," was lured from Italy, where he had copied the major works of the Renaissance, to England where he could engrave the Raphael Cartoons: the one great monument to High Renaissance history painting that could not be found in Italy. He was brought over by some English gentlemen, "partly with the hopes of having extraordinary encouragement from the crown," partly because "he had already found a good encouragement in the Sale of his other plates to England." "From his comeing to England," writes Vertue, "I may justly date the rise of the reputation of sculpture graving."[12]

At the same time, Dorigny's case was symptomatic of the problems engravers faced during this period. He arrived in 1711, sure of this "encouragement from the Crown," and spent his first year being feted and waiting for the nobility to act. His original intention was to engrave the Cartoons (pls. 9a and b) for the Queen, "to be done at her expense only with intent to make presents of the Prints to ye Nobility, & foreign Ministers &c." But the Queen lost interest when he set the price at £5000, and his chief supporter, Robert Harley (Earl of Oxford), the Lord Treasurer, apparently had enough to do sustaining his restless ministry. The alternative was to sell the prints by subscription at 4 guineas a set. (For her part, "the Queen gave him an appartment at Hampton Court during the time he should be doing them. and fireing & a bottle of Wine daily.") The *Daily Courant*, 18 February 1713/14, announced that the engravings were in progress and would be sold by subscription: "he hath left the Proofs of two of them to be seen in the Hands of Mr. Penkethman against Garraway's Coffeehouse in Exchange-Alley; where Subscriptions are continued to be taken; Also Setts of Dorigny's Works, after the most celebrated Masters at Rome, are sold there." It is impossible to be sure, but it sounds as though the printseller were still middleman, if not Dorigny's employer.

As time passed and the work became more onerous, Dorigny sent to Paris for two engravers, Claude Dubosc and Charles Dupuis, who "agreed upon small termes" to assist him. After two or three years, with the plates only half done, they broke with Dorigny and prepared to return to Paris. In London, however, Dubosc "feigned some excuse to stay some time longer here & promis'd to follow

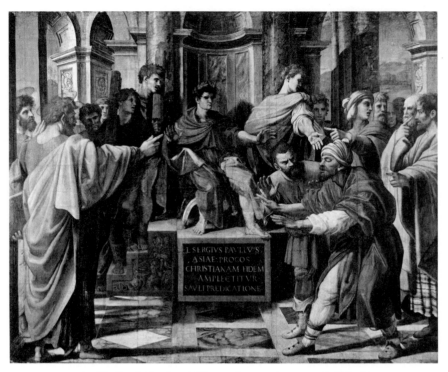

9a. Raphael, Paul and Elymas (cartoon); 1515–16 (V & A)

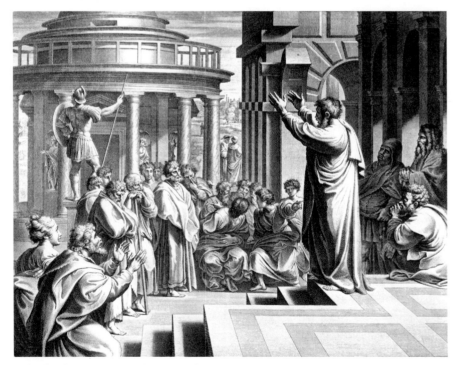

9b. Raphael, Paul preaching at Athens (engraving by Nicholas Dorigny); 1719 (BM)

in a few months after" Dupuis. In fact, as Vertue explains, he never intended to follow because, knowing Dupuis was a better workman, he wanted him out of the way; and further, he had concluded "an underhand agreement" with the Bowles brothers to make cheap copies of the Cartoons to undersell Dorigny's. The story was the same with all the subsequent emigrants from Paris: in London "there was much more probability to live comfortably, than at Paris where of that Art [engraving], there is so many excellent Masters."

If the first great engraving enterprise of the period was Dorigny's undertaking —a foreigner's copy of an Italian masterpiece that Charles I happened to secure for the English—the second was Dubosc's engraving of Laguerre's paintings of Marlborough's Battles: a foreigner's engraving of another foreigner's decorations made for an Englishman's house to celebrate great English victories. The concatenation is interesting, and reflects a gradual shift toward the English side of the equation. According to Vertue, Dubosc undertook these engravings for printsellers at £80 for each plate, to be completed in two years. Whether this arrangement paralleled Dorigny's is not certain, but it was the usual one until Hogarth published his *Harlot's Progress*. To meet the printseller's deadline, Dubosc was forced to follow Dorigny's lead and bring in other engravers to assist him: Du Guernier, who had been in England for several years already working as a book illustrator; and, from Paris, Nicholas Dauphin de Beauvais and Bernard Baron. Beauvais soon returned to France (where he engraved Coypel's *Don Quixote* illustrations, which were to have a marked influence on Hogarth); Baron spent the rest of his life in England, becoming one of the most distinguished engravers of the new generation, and executing commissions for Hogarth.

The third great project was the engraving of Thornhill's paintings in St. Paul's cupola: an Englishman's paintings in a great English public building (though still largely based on designs of Raphael and Rubens). The engraving was done by Dubosc and Baron, with the aid of a young engraver of Hogarth's age, Gerard Vandergucht (son of Vertue's master, he had come as a youth from Antwerp). Vandergucht's early recognition is explained by Vertue's comment that he "became equally forward in Etching and graving after the French manner, as those who were bred there."[13] He was no longer guilty of that stiff approach, so common among the English as well as the Dutch, which Hogarth noticed in Van Gunst's copies of Van Dyck.[14]

Between 1714 and 1720, then, the whole direction of engraving in England changed: the French style replaced the Dutch, and French engravers came to London to practice their trade with less competition and greater rewards. The engravings that brought recognition were those that accurately reproduced the great paintings in English buildings or collections, again by foreigners—with the one notable exception of Sir James Thornhill.

Vertue stresses the fact that engraving "requires much Labour study juvinile strenght & sight, to arrive at any excellence,"[15] and Hogarth later admitted that he had not had this careful training early enough to acquire "the Beauty and delicacy of the stroke" upon which engraving depends. Etching, on the other hand, could be mastered with less experience, greater speed, and far less expense. All that was needed, one source notes, was *"Imprimis,* a bottle of aquafortis, being the only kind of spiritous liquor not drunk and sold at Abridge. 2dly, a burnisher, 3dly, some soft varnish for stopping up. 4thly, and lastly, a hand-vice, to melt off the varnish. . . . All these materials ought honestly not to cost you more than 10s."[16] But it was also to avoid the stigma of being a mere copyist, and because his natural talent lay this way, that Hogarth focused from the beginning on etching. The first noticeable influence on his work is Jacques Callot, a professional etcher, not a painter who also etched or a copyist of paintings by others. Callot not only produced the small, lively genre works that appealed to Hogarth, but also offered a solution to the etcher who must pass as an engraver. Callot achieved the effect of engraving by using a specially designed etching point, the *échope* (which he may have invented), and by occasionally applying an engraving tool to the etched line while the etching ground was still on the plate.

It was probably from Abraham Bosse, who wrote the first technical treatise on engraving and etching, that Hogarth learned the secret of Callot's swelling and diminishing line. William Faithorne, whose translation Hogarth would have read, explains that to make an etching look like an engraving the artist must employ deep biting on the important lines ("wherein the *Aqua fortis* eats in full and deep") and in some cases add pressure on the needle so as to cut through the varnish into the plate itself. He reproduces a plate showing heavy scoring in the foreground which, though etched, could pass for engraved lines.[17] Hogarth attempted this method in his small illustrations for *Hudibras* with unsatisfactory, or at any rate different, results (pl. 10). The heavy lines were too deeply bitten, the contrast too great between the "engraved" and the etched lines. However, by the time he made the illustrations for Beaver's *Roman Military Punishments* (published in 1725), he was able to produce a respectable imitation of Callot's *Misères de la guerre* (pls. 11–13). Something of the mannerist forms that were peculiar to Callot—long thin bodies tapering up to minute heads—appears here, but Hogarth could not, or did not wish to, duplicate the graceful, over-stylized swell that Callot achieved with his *échope;* his lines and his forms are blunter and flatter. The small bookplates made a few years later for his friend George Lambert and for the Paulet family reflect a more mature, personal use of the Callot style, and these are pure etchings with no attempt at an illusion of engraving (pls. 14, 15).

For his larger works, beginning with *The South Sea Scheme* of 1721 (pl. 20), he began to experiment with the finishing and engraving of the whole plate. In

10. Hudibras' First Adventure (small plate); publ. 1726; 4½ x 4¹⁵⁄₁₆ in. (BM)

the works where sustained reproduction and the appearance of an engraving were required, he again followed Bosse, who explains in his treatise on engraving how etching can be used for the preliminary work on a plate, which can then be finished with an engraving tool—a time- and labor-saving device which by Hogarth's day was in common use among engravers; Vertue notes that Vandergucht, Dubosc, and Baron employed it. Hogarth first utilized this method with success on a large plate with his *Lottery* (1724) and the large *Hudibras* plates (1726). He continued, however, to leave sizeable areas of white exposed. Not until the end of the decade and *Henry VIII and Anne Boleyn* (ca. 1728) did he completely fill the plate with the engraved system of lines, imitating the complicated tonalities of a painting. Before the *Harlot's Progress* (1732), at any rate, he was consciously attempting to produce independent prints, and not to reproduce a work in another medium.

When Hogarth set up for himself as an engraver, around 1720, he doubtless

11. Fustigatio, illustration for Beaver's *Roman Military Punishments;* 1725; 1½ x 2¹³⁄₁₆ in. (W. S. Lewis)

12. Beheading, illustration for Beaver's *Roman Military Punishments;* 1725; 1½ x 2¹³⁄₁₆ in. (W. S. Lewis)

13a. Jacques Callot, Le Pendaison, from *Misères de la guerre;* 1633 (BM)

13b. Jacques Callot, La Roue, from *Misères de la guerre* (BM)

14. Bookplate for George Lambert; ca. 1725; 2¹³⁄₁₆ x 2¾ in. (BM)

15. Paulet Bookplate; date unknown; 2⅛ x 2⅜ in. (BM)

carried out any commission that would earn enough to support him. While continuing to do the same silver engraving he had done for Gamble, he also turned out ephemeral announcements and business cards, such as those for the actor Spiller and the undertaker Humphrey Drew (pls. 16, 17). His sights were set, one supposes, on the illustration of books, the highest reach to which an apprentice like himself could legitimately aspire. Book illustration at this time, however, was hardly an improvement on armorial engraving, as most engravers were simply paid by London booksellers to pirate continental illustrations.

Hogarth's first effort at illustration, datable before 1721 or 1722 when he received the important commission to contribute illustrations to La Motraye's *Travels*, must have been the seventeen small illustrations for *Hudibras*, or at least the majority of them. These plates, with the illustrations for Gildon's *New Metamorphosis* and Horneck's *Happy Ascetic* (both published in 1724), are the only works he made that were largely copied from earlier illustrations; and the *Hudibras* plates are much cruder than those for *New Metamorphosis*. His clumsy use of the etching-engraving combination in these plates, in contrast with his mastery of the technique in works published in 1724, makes it safe to infer that they were among his first efforts. He presumably had difficulty selling them: though an improvement on the stiff 1709 illustrations he copied, they were coarse compared to Vandergucht's fluent engravings of the same period. They were finally bought and published in 1726, only after he had successfully published a larger, much more elaborate series of *Hudibras* plates. It is significant that he begins, however tentatively, with this homage to Samuel Butler, one of the great English satirists in the tradition that led to Dryden, Pope, and Swift.

The direction he will take is even clearer in his shop card (title page), dated

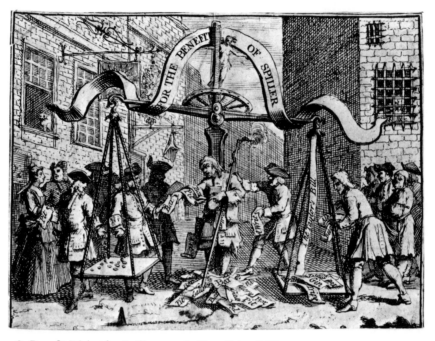

16. Benefit Ticket for Spiller; 1720? 3⅜ x 4⅜ in. (BM)

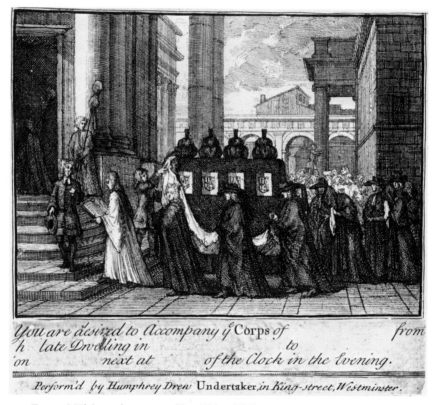

17. Funeral Ticket; after 1720; 4⅝ x 6½ in. (BM)

April 1720; it is a surprising performance, intellectually and prophetically, if not artistically. The decorative work is what one would expect of a silver engraver and the etching of the figures is competent, revealing some individuality in the line, especially in the old man's robes. More interesting, however, is the balancing of this old man, History, against the female figure of Art. Even if his presence does not suggest that Hogarth has already conceived a modified history painting as his aim, it demonstrates that here is no ordinary engraver of plate or shop cards.

The artist's ambition is also plain in his ticket for the comedian Spiller (pl. 16), apparently executed in March 1720, a month before the shop card.[18] In this, perhaps his earliest print as an independent engraver, Hogarth introduces a debtors' prison and the instruments of punishment for debt, here transferred to the spendthrift actor James Spiller. He uses the same sort of popular symbols as the Bubble prints, dealing with the mania for speculation in the Low Countries, that had begun to reach English printsellers in 1720. These were completely emblematic works, in which realistic figures were displayed with allegorical and idealized ones, amid contemporary buildings and explanatory inscriptions. Hogarth must have studied these prints closely (he was shortly to produce a Bubble print himself), thinking seriously about the relationship between the reportorial and the emblematic. In the ticket for Spiller, Hogarth represents "History" by depicting a world of commonplace reality—a spendthrift and duns, a tavern and a debtors' prison, tailors and tavern bills—in an emblematic context: the non-realistic scales (topped by Fortune and her wheel) and the auto-da-fé being built around Spiller's feet. The print unites the real and the symbolic; the raw materials of experience are distanced, judged, and understood.

Another early commission, a funeral ticket for Humphrey Drew the undertaker (pl. 17), is more directly reportorial. Here history is the portrayal of a public ceremony or occasion, with some psychological interest, as the mercer tries to wave away the gaping crowd. A third approach—injecting an aspect of the droll—is reflected in two tiny prints that are probably, though not certainly, by Hogarth: *Search Night* and *The Rape of the Lock* (pls. 18, 19). The first is simply a chaotic night encounter in the Dutch manner, with many glowing lanterns and a disheveled man and woman apprehended at love play. The second, an illustration for Pope's poem, is a picture of a tea party (perhaps, as has been claimed, a design engraved on a snuffbox)[19] involving a psychological relationship different only in degree from that of *Search Night*. In fact, one might deduce that it was conceived as a pendant of *Search Night* were it not a quarter of an inch smaller.

These three forms—the emblematic, the reportorial, and the droll—are established at the very outset of Hogarth's career, not far from the time of his shop card, with a remarkable prescience and self-consciousness. Hogarth, it would

appear, knew where he was going to such an extent that even his hack work was conceived both as the working out of a problem and the search for a formula that would satisfy his buyer and lead to more commissions. Of course, conversely, he may simply have been inspired by the aesthetic and material rewards gained from his first spontaneous efforts to continue his work along the same lines.

The ambitious young man might have risen gradually through competent book illustration and other engraving-to-order, but he preferred to gamble on attracting the attention of the general public. His natural talent for the comic and satiric must have led him to look around for a subject, and in 1720 he did not have far to look. The spring and summer unfolded before his eyes the boom and accompanying madness of the South Sea Bubble. As stock values rose, so did the number of buyers who thronged Exchange Alley and the number of schemes floated in the wake of the South Sea Company, which had shouldered aside the Bank of England, assumed the national debt, and become a powerful political force. This was the period of such light satires as William Chetwood's *The Stock Jobber*—jibes at the abettors and exploiters of the craze for investing. A simple enumeration of the projects in which people were investing was sufficient for most of the satires: insurance companies, finance companies, and fisheries were soon augmented by companies for launching everything from chains of pawnbrokers to funeral furnishings and companies for exploiting every part of the Americas, including uncharted territory.[20] Broker and buyer alike ignored all the rules of sound investment in their eagerness to speculate, lured by the hope of immense capital gains. And the speculation was accompanied by a sudden greed for luxury items—new houses, coaches, jewelry, clothes—with the inevitable rise in prices. The jeering at this point was on the whole "popular," manifested in the rabble who shouted "South Sea" and "stock-jobber" at fashionable coaches, and pelted them as they passed.[21]

The rage had begun in Paris, with the Scotsman John Law's Mississippi Company (Bubble), and had spread to Amsterdam, which enjoyed a greater freedom of the press than Paris. From Amsterdam came the great flow of Bubble satires that began to reach London in the spring of 1720. They were rapidly copied and in June English adaptations began to appear. Of the satires on the London craze for speculation, virtually every one at this stage was a copy or adaptation of a foreign print. Most often the designs were merely copied, the verses translated into English, and the allusions anglicized.

Wild speculation offered a perfect situation for satirists, naturally conservative and skeptical of innovation, to exploit. Corruption of course appeared to be at the bottom of the Bubble affair. But floating above there were frustrated aspirations, delusions corrected by reality, the endlessly printed banknotes as opposed to the dwindling volume of trade, the appearance of great fortunes con-

18. Search Night; date unknown; 2⅝ x 3⅞ in. oval (W. S. 19. The Rape of the Lock; date unknown; 2¼ x 3⅛ in.
Lewis) oval (W. S. Lewis)

cealing a void. The cartoons followed a characteristic pattern: they employed
images of bubbles, clouds, and wings; inevitably the wheel of fortune appeared
prominently, sometimes as a merry-go-round; actors were shown miming their
parts on stages; and so on. The setting was a street (the rue Quincampoix or its
London equivalent, Exchange Alley) with closely observed contemporaries be-
ing led about by allegorical figures of Fortune and Folly. These prints served
a function not wholly unlike that of the Dutch and French silver and reproduc-
tive engravers who migrated to England: they set English engravers to copying
them and then inventing their own versions, and they left their stamp on Eng-
lish political caricature more powerfully than before because they treated a situ-
ation exactly parallel to the one prevailing in London.

Fortunes were being made in the summer of 1720. Sir James Thornhill,
whom Hogarth was soon to meet, was decorating a luxurious house for Robert
Knight, the cashier of the South Sea Company, and on 27 June he sold £2000
of South Sea stock on the Exchange; if he did not reinvest, he was one of the few
who emerged with a profit.[22] Everyone was buying and selling and buying again.
The nobility were the most deeply embroiled, and especially the Scottish Whig
nobility, who had supported John Law and devoted themselves to South Sea
stock; Hogarth singled them out for attack in his print (pl. 20), along with Eng-
lish noblemen wearing orders.[23]

In August the market began to fall. Ominously, summer came to a close with
the plague ravaging southern France (supposedly unleashed by dockers unload-
ing wool from a merchant vessel in Marseilles harbor) and the superstitious in-
terpreted it as a judgment on their materialism sent by God. In early September
English investors first began to fear that the price might continue its descent,
though on the eighth the South Sea Company was still putting on a great show
of confidence. Stocks continued to fall, however, and a couple of days later it was

evident to everyone that fortunes were being swallowed: people who had bought stock at £1000 for October delivery were watching prices fall below £600. During September and October the King remained in Hanover, and this too shook public faith; there were rumors of a Jacobite coup d'état and Harley's return to power. The plague continued to move northward in France and talk of God's judgment grew.

October, November, and December saw an unparalleled economic confusion in England. "The gentleman in Exchange Alley who said he had bilked his cabman 'on account of having been bilked himself' stands for a universal picture of default. In some cases the default was genuine; in others it was a panic-stricken clinging to cash. Each aggravated the other."[24] New mansions and ships stood half-built, and the luxury trades of tailoring, watchmaking, and not least silverplate making and engraving suffered as orders were canceled or forfeited. In November George I returned, but the Bank of England refused to help the South Sea Company out of its difficulty, and the opening of Parliament was deferred a fortnight.

In December Parliament met. By the end of the month a coalition of Whigs and Tories had pressed for a Committee of Inquiry, and the really shady side of the South Sea venture became apparent to the public. The committee met in January and interrogated the cashier Knight, who fled to France on the night of the twenty-first. At that point real panic broke out, first in the House of Commons and then throughout England. If it had all seemed a horrible accident before, now the suspicions of design and skullduggery were confirmed. Death—natural or by suicide—and disgrace followed within the next few months for several of the principals, including the King's First Minister, with rumors extending the blame to a royal mistress, possibly the Prince of Wales, or even the King himself.

The first of the original English satiric prints appeared early in 1721. *The Bubblers Mirrour or England's Folly* was a pair of prints portraying a fortunate and a ruined speculator, each with a symbolic coat of arms and supporters. Both are surrounded by margins filled with lists of the Bubbles: projects for "Coal Trade from Newcastle," "Furnishing of Funerals," "Manuring of Land," "Bleaching of Hair," "Insurance on Horses," "Radish Oil," and "Drying Malt by the Air." The other original English contribution—if it deserves that adjective—was *The Bubblers Medley*, another pair of prints, these showing a scattering of copies of other Bubble prints in the manner of a composite photograph.[25]

Of the Bubble prints listed in the *British Museum Catalogue of Satiric Prints* (roughly from nos. 1610 to 1722), no more than two or three are in any sense unique, and these too may derive from lost continental originals. The one noteworthy exception is Hogarth's print on the subject (pl. 20), presumably made sometime in 1721. Like many of the other prints it refers in particular to the

monumental folly of the year 1720. It was strangely unadvertised, and the only clue to its dating is the fact that the figures of Villainy whipping Honesty stripped to the waist may have been the basis for similar figures in a crude emblematic woodcut called *Lucifer's New Row-Barge for First-Rate Passengers,* published around 13 May 1721.[26] But the influence may, of course, have gone the other way.

Hogarth's bears no resemblance to the other English contributions; it follows from the Dutch prints with its elaborate architectural setting and mixture of real and allegorical figures. In an incredible study of perspective (even for him), he has placed the Guildhall at one side, the London Monument at the other, and St. Paul's and other London buildings between, each with its own vanishing point. In these surroundings he has set a remarkably coherent group of figures; the best passage in the print is the scuffling crowd under the Devil's shop window. They are small, like the figures that appear against large architectural shapes in many Dutch prints, but they are drawn with a firmer line than their Dutch prototypes (the influence of Callot is apparent here), and with a much greater sense of grotesque individuality.[27]

A possible model for Hogarth's work is one of the many Bubble prints, Bernard Picart's *A Monument Dedicated to Posterity in Commemoration of ye Incredible Folly Transacted in the Year 1720* (pl. 21). Hogarth's Monument and its revised inscription ("This Monument was erected in memory of the destruction of this city by the South Sea in 1720") may have originated here, perhaps also the general composition, including the gambling group at the left and even the wheel motif. Further inspiration may have derived from Allan Ramsay's bubble satires, especially "The Rise and Fall of Stocks in 1720: An Epistle to Lord Ramsay," in which his cast of characters is presented:

> Clergy, and lawyers, and physicians,
> Mechanics, merchants, and musicians,
> Baith sexes, of a' sorts and sizes,
> Drap ilk design, and jibb'd for prizes;
> Frae noblemen to livery varlets,
> Frae topping toasts to hackney harlots. . . .

Both Hogarth and Ramsay single out the clergy: "Some reverend brethren left their flocks, / And sank their stipends in the stocks." Ramsay's hopeful prophecy includes an allegorical cast similar to Hogarth's:

> The honest man shall be regarded,
> And villains as they ought rewarded.
> .
> Trade then shall flourish, and ilk Art
> A lively vigour shall impart

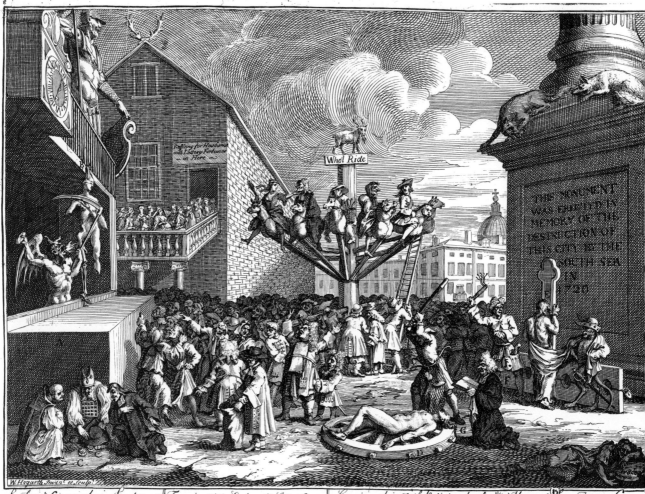

See here ÿ Causes why in London,~ Tripping their Souls with Lotts & Chances Leaving their Strife Religious bustle, (E) Honour, & honesty, are Crimes
So many Men are made & undone, Shareing oft from Blue Garters down Kneel down to play a pitch & Hussle, (C) That publickly are punish'd b
That Arts, & honest Trading drop~ To all Blue Aprons in the Town~ Thus when the Sheepherds are at play (G) Self Interest and (F) Vilani
To "Swarm about ÿ Devils Shop (A) Here all Religions flock together,~ Their flocks must surely go Astray; So much for Monys, magick po
who cuts out (B) Fortunes ÿ olden Haunches Like Tame & Wild Fowl of a Feather, The woeful Cause ÿ in these Times, Guess at the Rest you find out n

20. The South Sea Scheme; 1721 (first state); 8¾ x 12½ in. (W. S. Lewis)

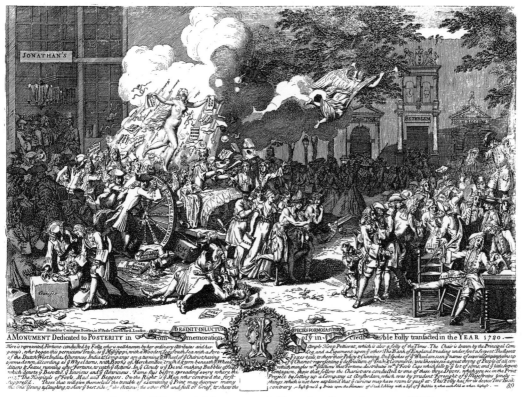

21. Bernard Picart, A Monument dedicated to Posterity; 1720 (BM)

> To credit languishing and famisht,
> And Lombard-street shall be replenisht.

Hogarth's own limping couplets, explaining the roles of Honesty, Villainy, Trade, and even the Arts, sound much the same.

When the wheel of fortune depicted by Picart and other Bubble artists appears in Hogarth's print, it is transformed: first into a merry-go-round, then into the torture instrument. The first recalls Callot's *La Pendaison* in his *Misères de la guerre* (pl. 13a), and the second his *Roue* (pl. 13b). These, unlike the ideas that go back to Picart, are allusions, and technically the most interesting part of the print. It is not certain how many people Hogarth expected to recognize Callot, and to see this contemporary English scene as in some sense another *misère de la guerre;* or for that matter to notice the religious allusions, which extend beyond the bad shepherds ignoring their flocks to the scourging of Christ and the casting of dice for His robe. But already, in his first serious satiric print, Hogarth has broached a technique he will develop with great subtlety in his mature works, which he owes to the contemporary literary tradition.

The allusions in this case work to impart an importance to the scene—the

impact of a war or a crucifixion—that is perhaps simplistic. The print, as satire, attacks the gambling crowd, presumably related to the crowd at the crucifixion, and portrays its disorder based on individual self-interest. Significantly, Hogarth does not blame trade or suggest that there is anything sinister about it in itself, but rather implies that this catastrophe has incapacitated Trade (his allegorical figure). The attitude is characteristic for Hogarth, who felt that these people, instead of investing or actually stimulating trade, were only out for quick profits. In the light of many of the other Bubble prints, this was a relatively sophisticated view for a political caricaturist at the time. However, he ignores the most obvious villain, attacked by many of the other satires: the stock-jobber, the middleman who manipulated the traders and the ordinary speculators. This mediating figure, who later became important in Hogarth's satires, is curiously absent here. *The South Sea Scheme* is aimed at the speculators, simply a mob of all kinds of people trying to make easy money. The presence of priests of all faiths, prominently engaged in the gambling rage, illustrates the emphasis on misdirected activity: they should be watching after their flocks, as the rest of the people should be working at their normal occupations. Beyond this infatuation with money, there is only a general air of villainy at work—in the foxes around the Monument's plinth, and in the figure of Villainy labelled "F". But it is not clear that these villains or exploiters are stock-jobbers or any specific agents; rather they seem to be personified aspects of the speculators themselves: Self-Interest and Villainy overcoming Honor and Honesty. The explanatory verses state as much. Presumably Hogarth, who saw himself as a "historian," wrote his own verses—they are crude enough. Certainly he engraved them (there are mistakes corrected and uncorrected); he had not yet reached a point where he could afford a writing engraver, and probably did not want a collaborator to share his profits. At this stage of his career, he thought of himself as artist-writer, a satirist in the tradition of the great Augustans.

Whether the origin of a particular artistic device is visual or verbal is a difficult question, but at any given historical moment one can arrive at generalized answers. Although usually considered verbal, devices such as parallelism and contrast, analogy, puns, even irony could have been learned from the Bubble prints (often appearing in pairs) as well as the poems of Butler and Dryden and Pope. The vocabularies of art and literature were in many ways similar. The only technique which I take to be purely literary at this moment in time, and characteristically Augustan, is the playing off of a simple, often popular, form against new, complex, sometimes contradictory meanings. Irony is part of the effect, but the operative element in this mode is allusion: the reader recognizes the echoes of a travel book or an epic or of a particular scene in a particular epic. Beyond this, the general satiric metaphor, in which the folly or evil is shown crowded and overwhelming in a narrow space with a single, trampled representative of virtue, was equally likely to appear in the poetry of

Dryden and the prints after Brueghel (another analogue to *The South Sea Scheme* might be his *Justitia* with its racked victim in the foreground).

It seems likely that Hogarth began *The South Sea Scheme* early in 1721, when the smoke was beginning to clear. But this was a carefully worked and elaborate print, and it may have taken him some months to finish it. The absence of advertisements or any contemporary comment on the print—certainly a surprising performance in light of the other Bubble satires—is puzzling, and may mean that he did not offer it to a printseller. The earliest publication line is matched on *The Lottery* (pl. 30), which though perhaps intended originally as a companion piece to *The South Sea Scheme,* was not finished and published until 1724. It is possible that Hogarth held them both until sometime in 1724 before selling them to Mrs. Chilcott and the other printsellers. One might even speculate that he did not finish *The South Sea Scheme* until the interest in Bubble prints had begun to wane—an explanation that would account for the absence of a printseller's name, and of advertising, until after the success of *Masquerades and Operas* in 1724. This possibility is supported by Hogarth's later remarks to the effect that *Masquerades and Operas* was his first attempt to publish a print on his own.

Hogarth's first important illustrating commission came early in 1721, presumably around the time Aubrey de la Motraye's *Travels through Europe, Asia, and into Parts of Africa* was advertised for subscription on 2 April (*Daily Courant*); it was announced as "adorn'd with Maps, Cuts, and other Representations proper to the Eastern and Northern Nations," and subscriptions were begun at this time. The enterprise was also important because it was executed entirely by Englishmen: Hogarth, David Lockley, Robert Smith, and George Vertue himself (who mentions the project).[28]

The engravings done by Hogarth may have been started as early as the date of the proposals for subscription, but on the other hand at least one of the illustrations—and in general his whole conception—was influenced by Bernard Picart's great *Cérémonies et coutumes religieuses de tous les peuples,* which did not appear (at least in its entirety) until the beginning of 1723, the date on the Amsterdam edition. The engravings may well have come some time after the proposals, since they were based almost entirely on designs, tapestries, maps, coins, and other artifacts supplied the engravers. This book represents Hogarth's only excursion into purely reproductive engraving, and accounts for the uncharacteristic compositions, with their widely spaced people and eastern style (pl. 22). Only the drawing, attached to one of the maps, of Charles XII at Bender reflects Hogarth's skill with the etching needle at this time (pl. 23). It is an outdoors composition, showing soldiers and potentates on horseback, in the general manner of the Laguerre *Battles of Marlborough,* engravings which had been published in 1717. This small area on a large page, carefully signed "W. Ho-

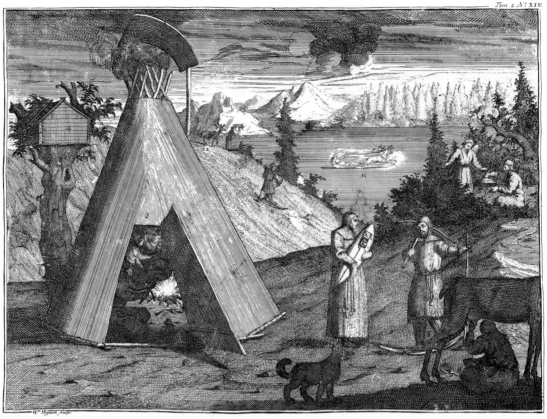

22. A Lapland Hut, illustration for La Motraye's *Travels;* 1723/4; 9⅞ x 13½ in. (W. S. Lewis)

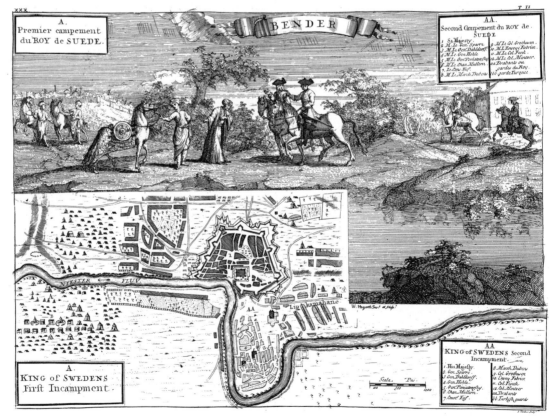

23. Charles XII at Bender, illustration for La Motraye's *Travels;* 1723/4; 9¾ x 13⁹⁄₁₆ in. (W. S. Lewis)

garth Inv^t et Sculp^t," represents his one and only attempt at serious history in the style he was soon to parody in his large *Hudibras* plates.

The La Motraye plates, with the influence of Picart, are important in Hogarth's development because they gave him a chance to deal with contemporary (though foreign and strange) customs in compositions involving large groups of people in architectural settings or closely reported interiors. Some of Picart's own plates in *Cérémonies et coutumes* are comparable to the product Hogarth was now approaching. There was also a satiric element present in Picart's scenes, especially in his delineation of Jewish customs (pl. 24), and the effect would have struck Hogarth as quite different from the emblematic satire of Picart's Bubble print.[29]

Uninteresting as many of its plates are, La Motraye's *Travels* must have drawn Hogarth away from the emblematic representation of *The South Sea Scheme* toward the more natural and congenial depiction of detailed contemporary scenes. The two fat volumes, for which he executed at least a dozen plates, were delivered in February 1723/4—"next Door to the new Church, Bloomsbury, at Mr. Crochly's on producing his Receipts for the first Payment, and

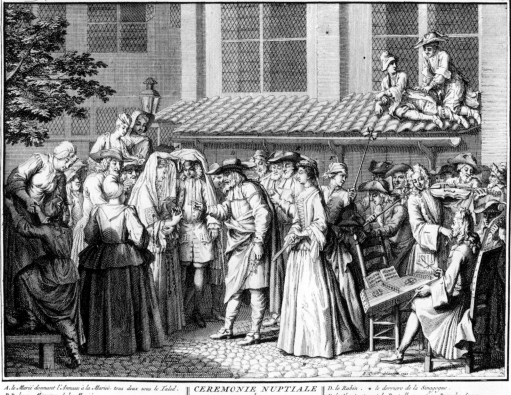

A. le Marié donnant l'Anneau à la Mariée, tous deux sous le Talod .
B.B. les 2 . Maraines de la Mariée .
C.C. les 2 . Parrains du Marié .

CÉRÉMONIE NUPTIALE
des
JUIFS ALLEMANDS .

D. le Rabin . * le derriere de la Sinagogue .
E. le Chantre tenant la Bouteille pour faire Boire les Époux .
F. deux garçons avec des Batons croez qui marchent devant les Mariez .

24. Bernard Picart, Cérémonie nuptiale des Juifs Allemands, from *Cérémonies et coutumes religieuses de tous les peuples . . . ; 1724*

acquitting the second.''[30] Most of the plates were used again for the French edition, being subscribed for at the same time, but the plates were doubtless paid for outright and Hogarth can have received no more than his original payment. Although this was a large engraving venture, he probably received no very great amount, as he did no more than engrave designs presented to him.

These were busy years for Hogarth, when he was trying to do many things at once, not the least of which was merely to survive. If there is any truth in them, the stories of his struggle to make ends meet must refer to this time. The earliest published anecdote of his life, in the *Public Advertiser*'s obituary of 8 December 1764, is one of these:

> I have heard it from an intimate friend of his, that being one day arrested for so trifling a sum as twenty shillings, and being bailed by one of his friends, in order to be revenged of the woman who arrested him (for it was his landlady,) he drew her picture as ugly as possible, or, as Painters express it, in *caricatura;* and in that single figure gave marks of the dawn of superior genius.

The conclusion is fairly typical. Nichols, who passes the story on two decades later, thinks it may not be true because a friend of Hogarth's once told him that ''had such an accident ever happened to him, he would not have failed to talk of it afterwards, as he was always fond of contrasting the necessities of his youth with the affluence of his maturer age.''[31] However, if he had been ''arrested'' (in Nichol's version he was only ''distressed to raise so trifling a sum''), Hogarth, who never mentioned his father's arrest and incarceration, may not have wished to mention his own.

> On the other hand, he would have stressed his hardships, and another friend remembered hearing him say of himself: ''I remember the time when I have gone moping into the City, with scarce a shilling in my pocket; but as soon as I had received ten guineas there for a plate, I have returned home, put on my sword, and sallied out again with all the confidence of a man who had ten thousand pounds in his pocket.''[32]

The detail of the sword too is significant if one recalls the sword affected by the Distressed Poet, the hack who wished to pass for a gentleman.

Beyond survival, however, he was determined to rise above the circumstances not only of a goldsmith but of an engraver too; having turned from silver engraving to copper, it now became necessary to study art—to draw ''object[s] something like nature instead of the monsters of Heraldry.'' To achieve this end, he turned (even before executing *The South Sea Scheme*) to the new art academy opened by John Vanderbank and Louis Cheron in St. Martin's Lane, where a young artist could find instruction in the formal aspects of art that would elevate him from the level of a mere mechanic, and could draw from the

life. This was no casual undertaking: he had to be able to afford a two guinea fee and spend a part of his time at the academy and at home working out academic problems that had nothing to do with the day-to-day problems of survival. But in October 1720, in the initial list of subscribers for the new academy, Hogarth's name appears.[33] At this point two aspects of his life open up that will require chapters to themselves: his relationship with Sir James Thornhill and his training as a painter.

His first twenty years offered Hogarth a range of possibilities he might choose to exploit; and while developing them to the utmost, he never transcended them. Hogarth was destined to remain not simply within the geographical confines of London (with only a few trips away, largely unrecorded), but within the limits staked out by the accidents of his life, from coffeehouse to prison, and within the narrow liberties of an apprenticeship to a silver engraver, the assumptions promulgated by the art treatises and portrayed in the wares of printsellers' shops, and the economic supply and demand of the London art market. He tried often to extend these limits, but managed only to push to the furthest boundaries, apparently not wishing or daring to break through. The next phase of his life, leading to *A Harlot's Progress,* is essentially the dual story of his rise to prominence and the evolution of his own characteristic genre out of the talents he possessed and the limitations he faced.

II. The Evolution of a Genre
1720–32

6

The Presence of Sir James Thornhill

It was, Hogarth remembered, "the Painting of St Pauls and greenwich hospital which were during this time"—the years of his apprenticeship—"running in my head."[1] Even if one takes into account his perspective of over forty years later, by which time he wanted to establish clearly a line of succession from Thornhill to himself and needed to defend Thornhill's diminishing reputation, it is not difficult to see why this artist was his ideal. Thornhill was a decorative painter in the grand manner, a history painter, and an Englishman—the living reply to William Aglionby's complaint that "we never had, as yet, any of Note,

25. Sir James Thornhill, Self-portrait (detail of pl. 33)

26. Jonathan Richardson, Portrait of Sir James Thornhill; ca. 1733 (National Portrait Gallery, London)

that was an *English Man*, that pretended to *History-Painting*," a circumstance he attributed to "the little Incouragement" which the art "meets with in this Nation; whose *Genius* more particularly leads them to *Face-Painting*."[2] It took a particular kind of man, as well as a particular kind of talent, to win this victory for the English artist; and this man was one of the chief influences of Hogarth's life—on his style of painting as well as of living; a figure against whom he measured himself, and whose image he protected until the very end almost as an alter ego. In the family Bible he proudly put himself down as marrying the "daughter of Sir James Thornhill"; years later when he wrote his notes on the English academies he identified Thornhill as his father-in-law; and he probably accepted the Serjeant Paintership, or at least gave himself the title in his final self-portrait, largely because Thornhill had been Serjeant Painter before him. Most important of all, Thornhill's career dramatized for him the success of an industrious artist in the England of Queen Anne and the failure (from one point of view at least) of personal patronage in the England of the Hanovers and Sir Robert Walpole—the England Hogarth inherited.

This man, in so many ways like Hogarth, was different in one basic respect: he was a successful courtier, for whom patrons were the steppingstones to greatness, and was on terms of intimacy with the "great" as well as the talented. To begin with, he came of country gentry who had supported Parliament during the Civil War but had subsequently fallen in the world; the money and the family seat were gone but the manners and the connections remained. He was born in Woollands, Dorset, 25 July 1675 or '76, a decade after Richard Hogarth.[3] Thornhill too made the trip to London, forced into business by his father's gentlemanly poverty, but was rewarded with all the success that eluded the elder Hogarth. On 9 May 1689 he was apprenticed to Thomas Highmore of the Painter-Stainers' Company, a man of Dorset stock distantly related to the Thornhills. Highmore's official connections, and Thornhill's own assiduity, brought the young artist into contact with Antonio Verrio and Louis Laguerre, the two most prominent decorative painters of the day; one Italian, the other French. He appears to have assisted Verrio with the Hampton Court decorations in 1702-04.[4] By 1 March 1703/4 he had saved enough money to purchase his freedom of the Painter-Stainers' Company, and in the same year he received the commission to decorate Stoke Edith, Herefordshire, followed in 1706 by his decoration of the Sabine Room at Chatsworth, and his paintings of *The Fall of Phaeton* on the dome over the adjacent stone staircase.

These were important commissions for a young man of thirty-one, but in 1707 he obtained the greatest history painting commission in England—the allegory of the Protestant Succession in the great hall at Greenwich Hospital.[5] Although the reason for his being chosen is not certain, probably nationality and timing were the important factors. He was the only qualified Englishman available for such an undertaking; Verrio, the obvious choice, had just died, and it may

have seemed a good time to let an Englishman—who had the endorsement of the Duke of Devonshire for his work at Chatsworth—decorate this building commemorating England's seamen and built by her great architect, Sir Christopher Wren. It is also likely, considering their later parsimony, that the governers thought Thornhill would come less dear than Laguerre or another foreign artist.

The time was ripe for the sort of nationalism that called for an English painter to decorate the great English public buildings; Thornhill seems to have grasped this bit of *realpolitik* and exploited it. When the commission for decorating the Prince and Princess of Wales' bedchamber at Hampton Court came up in 1713 or '14 it went to the brilliant Venetian painter, Sebastiano Ricci, who had just been lured to England by his nephew Marco and the promise of fat English commissions. He acquired it through the patronage of the Duke of Shrewsbury, Lord Chamberlain, in whose charge lay such works. Nevertheless, Charles Montagu, Lord Halifax, who became First Lord of the Treasury on 11 October 1714, "told my Ld. Duke. that if Richi was imploy'd he wou'd not pay him for it." Vertue, who tells the story, explains that "his reason was this, that Mr. Thornhill our Country man has strove against all oppositions & dificultys & now had got near the very Top of the Mountain & his grace woud thro' him down & crush all his endeavours. wich woud prevent & discourage all our country men ever after to attempt the like again."[6] And the commission went to Thornhill. The competition between Thornhill and the foreign artists is best documented, however, by the second great commission of his career, the Cupola of St. Paul's Cathedral.

St. Paul's, unlike the distant Greenwich Hospital, was a part of Hogarth's life from the beginning, easily visible to him from the room over St. John's Gate as it rose above Little Britain. At that time the cathedral had already been under construction for nearly thirty years, and during Hogarth's years in St. John's Gate the great dome and the west towers went up: first a mass of scaffolding, which was then gradually peeled away to reveal the bright ocher stone. By the fall of 1708 the dome and both towers were completed. In October the ball and the cross were in place on the lantern and the coppersmith paid, and by early 1709 the governors were seeking an artist to decorate the cupola. The contending artists were, besides Thornhill, the Italians Pellegrini and Cattenaro and the Frenchmen Pierre Berchet, Louis Cheron, and Louis Laguerre. Laguerre is not mentioned in the governors' minutes, but Vertue, writing in 1721, claims that Laguerre had been "chosen unanimously" and had begun "to draw & dispose the work in the Cupola," when "an Order (a month afterwards) came from the Commissioners to forbid his proceeding any further (by some political contrivance) prevented his doing of that great work." After Laguerre was stopped, he continues, "many other Painters gave in their designs & sketches. & mighty contests & parties were made about it, but, at length. it was resolved in

favour & Interest of Mr Thornhill, who has since done it. (who its plain over-turn'd the meritt & Interest of this modest engenious man [Laguerre])."[7] According to a tradition recorded in the *Gentleman's Magazine* in 1790, Archbishop Tennison, one of the trustees of the building, was supposed to have said, "I am no judge of painting, but on two articles I think I may insist; first that the painter employed be a Protestant; and secondly that he be an Englishman."[8]

On 28 June 1715—by which time Thornhill had completed the Lower Hall at Greenwich—and with no explanation for the five-year lapse, the Commissioners chose Thornhill (he was to receive £4000). Thus Thornhill, the only English candidate, was given the commission; like the episode at Hampton Court, this was a victory Hogarth would recall in later years as he romanticized Thornhill, the Englishman who had carried off the greatest of contemporary commissions, both royal and ecclesiastical. Ricci, Vertue writes, "left England . . . when he found it was resolvd Mr. Thornhill shou'd paint the Cupolo of St. Pauls." On 1 May 1716, Thornhill gave an "entertainment" in the cupola to celebrate the beginning of his work, although he had drawn in "the principal grand lines before."[9]

On Tuesday 28 August, Dudley Ryder, a young student of the Middle Temple, decided around ten in the morning (having nothing better to do) to visit St. Paul's "to view the City from the top of it."[10] He enjoyed the sight, but "had a great curiosity to see the inside of the scaffolding of the Dome upon which Mr. Thornhill is painting." The result is the single glimpse that has survived of Thornhill the man:

[T]he man that keeps the keys for the whispering gallery told me that nobody ever went up there. Mr. Thornhill would not admit it. However, I desired him to show me the door into it, which he did, and told me if I would ring the bell and ask for Mr. Thornhill they would admit me up and I must then make my excuse to Mr. Thornhill. This shocked me a little at first. However, I thought it could be no such great crime to beg the favour of seeing his painting and design. Accordingly I ventured and was admitted up by his servant. When I came I made my bow to Mr. Thornhill and told him I had a great curiosity to see so extraordinary a piece of painting as that of the Dome of St. Paul's and begged the favour of being allowed the liberty to view what was done of it. He told me this was a liberty which he did not usually allow to anybody, because if it was people would come in so great crowds that they would interrupt him in his study and painting. However, since I was come, I might go about it and view any part of it. I thanked him for the liberty and began to look about me, and then told him we should now be able to vie at last with Paris for history painting which we have been so deficient in before. He told me he had been about this a year already and expected to finish it in a year more.

Then Ryder looked about, observing to himself that the architectural painting
was by this time finished, only "the gilding and enriching the great part of it"
remaining to be done; "but then the history part is not begun yet." After a
while,

> Mr. Thornhill came up to me again and talked with me about painting and
> told me he supposed I was a virtuoso. I told him I took a pleasure in seeing
> fine painting. He asked me if I did not paint myself. I told him no. He took
> me, I believe, for one that understood it pretty well, but I was afraid of talk-
> ing to him lest I should discover my ignorance. He at length seemed
> mighty complaisant and glad that anybody that was a judge would come to
> take notice of his performance. He said there were but few that took a pleas-
> ure in viewing these things, and would give themselves the trouble to come
> and see him [cf. his earlier remark about crowds], and therefore he was not
> much troubled upon that account with many people. I went up to the top
> of the scaffolds where the very top of the Dome is painted chiefly with roses
> gilded within squares. It will be exceeding rich. There are two or three
> more persons who are under-workers that are working at these figures but
> Mr. Thornhill himself comes and overlooks them and directs them. When
> I came away I gave his man a shilling that opened the door for me.

Then Ryder repaired to a tavern with a cousin, and "could not help" telling
him "of my great exploit in venturing to address Mr. Thornhill and going
through with the difficulty of seeing his painting. I cannot but fancy cousin
would take notice of the little vanity in me to tell that and the pride I took in
doing it."

It is not possible to say whether Ryder reveals Thornhill's susceptibility to,
or his employment of, flattery. But the incident can be taken as some indication
of the relationship established between Thornhill and the young William Ho-
garth a few years later. The only other anecdote that survives of Thornhill's
work at St. Paul's tells how he took a few steps backward, the better to see the
painting he was engaged on—"till he arrived at the very edge of the scaffold,
where he must inevitably have fallen to the pavement three hundred feet below,
had not Bentley French, his attentive footman, arrested his forgetful steps and
saved him from destruction." Another version has the quickwitted servant dash-
ing paint on "the just-finished face of an Apostle, compelling [Thornhill] to
rush forward to save his work."[11]

The other stories have to do with Thornhill's sharp eye for payment, the
steep rise in the prices he charged, and the elaborate stratagems he sometimes
employed to get his money out of the governors (in the case of the Duchess of
Marlborough at Blenheim, his prices led to a complete break and suspension of
work).[12] He could walk backward to get a better view of his painting unmindful
of the drop behind him; but he could also haggle over prices, and it is never

quite clear whether he was standing up for the rights of the English artist or for himself. These qualities were later to appear in Hogarth, who may also have learned from Thornhill's experience that connections are necessary for obtaining any large commission. By Hogarth's time, however, all that remained without a Halifax or a Sunderland was the behind-the-scenes manipulation Vertue loved to record.

By the end of the decade Thornhill was a public figure of some prominence. The *Freethinker* of 21 July 1718, for example, discussing the increasing elegance of shop signs or "Female-cupolas," suggests that soon even Kneller or Thornhill may be employed to paint them[13]—the names were becoming synonymous with artistic merit. Several honors were bestowed on this first recognized painter of English stock. In June 1718 he was appointed History-Painter in ordinary to the King (a post, considering George I's position on art, more honorary than active), and in March 1720 he was appointed Serjeant Painter, replacing his late master, Thomas Highmore.[14] This was an honorable and lucrative but unproductive position: it carried with it the prerogative of painting and gilding all His Majesty's residences, coaches, banners, and whatnot, which grossed over £1000 in a good year; but the work itself, for which assistants were employed, involved little more than house painting. Finally, in May 1720, Thornhill was knighted—the first English-born painter to be so honored.

Vertue, who liked to point out the seamy side of both Thornhill's and his son-in-law's careers, explains the knighthood, if not the other offices, as the result of what he considers a typical contretemps. John Huggins, "a noted Soliciter," once successfully extracted the powerful Lord Sunderland from "an affair of no great reputation to himself." Thereafter Sunderland "was ready to obtain any favour" for the lawyer; and

> Thornhill being intimate with Huggins and aspireing to Honour & Ambition—greatly got Huggins to propose to Lord Sunderland to get Thornhill Knighted by the King and made his History painter. which this nobleman did procure for Thornhill, who was Knighted by this means and Huggins Solicitation . . . besides his merrit distinguishd him as an ingenious history painter & Serjeant Painter to his Majesty—[15]

Huggins had a reputation for cunning, and his administration of the Fleet Prison (one of his perquisites) finally involved him in hearings at the House of Commons. It is not known exactly what Thornhill had done for Huggins (beyond decorating a ceiling of his country house, Headley Park[16]), though a friendship there certainly was, extending later to Hogarth, who became an intimate of Huggins' son William. More interesting, however, either Vertue had forgotten that the History Paintership came two years before the knighthood, or he was suggesting that Huggins was responsible from the start for Sunderland's patronage of Thornhill, which begins to look like a three-cornered arrangement.

As Vertue points out, merit mixed with intrigue brought about Thornhill's advancement. Unlike Addison and Steele's Captain Sentry, he was willing to add the bit of political oil that made such honors possible. Honors, of course, beget honors. In October 1720 he was installed as Master of the Painter-Stainers' Company—which was more an honor to the Painter-Stainers than to Thornhill, who might have preferred to ignore his origins in apprenticeship to a City company.[17] The Painter-Stainers' Company was composed of house and decorative painters, mere artisans; but membership was probably a convenience if not a necessity for someone like Thornhill, who was constantly employing wall painters in his capacity as Serjeant Painter. He presided over one meeting, but in the year of his office he attended only seven more times.

In March 1722, having bought back his ancestral estate and become a Dorset landowner, Thornhill was returned to the last parliament of George I.[18] On his estate he erected a tall obelisk in honor of George I, visible from all the surrounding country, and painted on the ceiling of the drawing room an allegorical representation with his own head in the center.[19] In May 1723 he was elected a Fellow of the Royal Society.

The effect of Thornhill's reputation and his works on the young Hogarth, toiling over silverplate, filling in escutcheons, and then trying to make a living as an engraver, may be conjectured. Until he joined the St. Martin's Lane Academy, and (later) met Thornhill personally, the painter was presumably only a great name and a vague ideal. Nevertheless, the works were there for Hogarth to see and absorb. Greenwich's Painted Hall was available when he began his apprenticeship in 1715, and in October 1717 the cupola of St. Paul's could be examined. While he continued work on other parts of the dome, Thornhill had his major designs—the history paintings of St. Paul's life—engraved and sold by subscription; a common proceeding, which not only enabled Hogarth to obtain manageable copies of the paintings, but also offered him a model for the engraving and distributing to a wide public of one's own history paintings. On 2 May 1720, when he was knighted, Thornhill presented a set of the prints to the King, and they were delivered to subscribers on the ninth.[20] It is doubtful whether Hogarth could have afforded a set at this time; but the prints were among the few pictures he kept on the walls of his house long after Thornhill's death.

At this time all Hogarth could say about the St. Paul's and Greenwich designs was that one was biblical and the other mythological-allegorical. The Greenwich forms were the first to be reflected in his engraving, perhaps because they were allied in a way to the popular Dutch emblematic prints that were a part of his professional experience. Just a touch of this world appears in his *South Sea Scheme,* in the figures of Honesty and Honor, isolated among all the grotesque figures that swarm over the plate—Hogarth's observation of his own contemporaries filtered through the conventions of Callot, Heemskirk, and the Dutch

painters of the grotesque. It may have been a wish to improve his rendering of the human figure and to understand the allegories of history painting that led him to turn toward academic training; and this offered itself with the opening of the St. Martin's Lane Academy in October 1720.

When Hogarth joined the academy he not only came into contact with the world of "serious" art in London, but also found himself in the middle of its broils and confusions—a battleground from which he occasionally withdrew in the decades following, but to which he always returned at moments of crisis (some of them of his own making). Thornhill was momentarily out of the picture in the fall of 1720, which may explain why Hogarth's first contact with the art academies was (according to the available evidence) in St. Martin's Lane. But even a contact with this anti-Thornhill academy was indirectly a contact with the great man.

When the first academy of painting in England was founded in 1711, Thornhill had just returned from his first trip to the Continent. On St. Luke's Day (18 October)—which the English considered an auspicious moment for the start of painterly projects—a large group of artists met in a house in Great Queen Street where, as Vertue (a member of the academy) wrote, "formerly many great noblemen had livd. (& once the Land-bank was kept there) but gone to decay and uninhabited."[21] Artists and connoisseurs subscribed at a guinea each and elected Sir Godfrey Kneller governor. Thornhill was elected one of the twelve directors, who included Michael Dahl, Jonathan Richardson, Louis Laguerre, and Antonio Pellegrini. The academy was evidently no more than a place where artists could assemble at night to draw or paint from casts or from the life. Following the precedent of continental academies, connoisseurs were also admitted, and there must have been a large quotient of socializing.

Vertue hints that within two or three years some dissidence arose in the academy, centered in Thornhill and Louis Cheron. Stories have survived of personal difficulties between Thornhill and Kneller—both proud, self-important, and domineering men. One evening, for example, Kneller discovered the model in an unusual pose and when he questioned Thomas Gibson, who supervised the life class, he learned that Thornhill was using the model and Gibson's drawings for figures he was painting on the ceiling of the Painted Hall. "I see, I see!" Kneller is supposed to have cried. "Mr. Dornhill is a wise man. But if I was Mr. Dornhill I should let Mr. Gibson draw *all* my figures for me."[22] Another story relates that Kneller had decided to employ Thornhill to paint the staircase of his house at Whitton near Twickenham, but when he heard that Thornhill was painting portraits in his spare time he withdrew the commission and gave it to Laguerre, saying "no portrait painter would decorate his house."[23] The first story sounds characteristic of Thornhill, the second of Kneller; the aging portrait painter and the rising history painter, the last of the great foreign

portraitists descended from Van Dyck and the first of the native English paint-
ers, were bound to jockey for position.

There are hints of trouble in a letter Kneller wrote in 1713 shortly before the
annual election held on the Monday before St. Luke's Day. From this letter to
Gibson, in Kneller's almost impenetrably obscure English, it appears that a
faction ("some few are out of humour") had attempted to frame new bylaws;
and Kneller, having just been informed, was planning how to quell the rebel-
lion. From a second letter it is clear that he secured a majority and retained
control of the academy.[24] Thornhill's general plan for reform centered around
the hope of securing royal or governmental backing for the academy. He ap-
proached Lord Halifax, who had secured him the Hampton Court commission.[25]

Worn down by factionalism or by age (he was now 67) Kneller resigned as
governor in 1715, and at the meeting the Monday before St. Luke's Day the new
governor was elected: according to Vertue, Laguerre was the logical choice, but
Thornhill's assiduity, and Laguerre's apathy, secured Thornhill the election.
In his letter of acceptance (29 October) he refers to the artists as "a Society, who,
if they were as publicly encouraged as in Nations round us, would not fail to do
service and credit to our King and Country"—words very like those of the men
who forty years later sought a state academy.[26] It is not certain what changes
Thornhill brought about, but before long he too came under attack; "Partyes
rose against him," as Vertue put it. Hogarth himself recalled this period, doubt-
less secondhand from Thornhill:

> Jealousys arose, parties were found and president [i.e. Thornhill] with all
> adherents found themselves comically represented in procession all around
> the walls of the room, the first proprietors soon put a padlock upon the
> door, the rest as subscribers did the same and thus ended this academy.[27]

Thornhill, "at the head of one party," then set up a new academy in a "place he
built at the back of his own house in the piazza" of Covent Garden; both Ho-
garth and Vertue affirm that this academy was "furnish'd gratis to all that re-
quir'd admition." But, Hogarth adds, so few artists were attracted, or remained,
that it soon closed. Vertue suggests more specifically that Cheron (Thornhill's
old ally against Kneller) and John Vanderbank, "growing tired with" Thorn-
hill's management of the academy, withdrew. Hogarth writes: "Mr. Vanderbank
headed the rebelious party and converted an old <presbyterian> meeting house
into an academy upon a footing with the addition of a woman figure to make it
the more inviting to subscribers." This was opened in October 1720.

Vanderbank, only three years Hogarth's senior, at seventeen had been a mem-
ber of Kneller's original academy, and by 1720 was a joint proprietor of the new
academy. At the death of his father, John Vanderbank the wealthy tapestry
weaver, he inherited £500 in cash; and his leadership in the academy was at least
partly due to his financial contribution, several times the ordinary subscription

of two guineas. He was, however, already known as an artist. In 1719 he had painted the portrait of Nicholas Sanderson, Professor of Mathematics at Cambridge, which was followed by a long succession of stiff, Kneller-like portraits. He tried decorative history painting in 1720, on the staircase of No. 11 Bedford Row, which still survives, and was working on a huge (22 by 8 feet) copy of Raphael's *Marriage of Cupid and Psyche*. At the same time he collaborated with Cheron, Parocell, Tillemans, Angelis, and others on the ten paintings of "The Life of Charles I," at least one of which (*The Apotheosis of Charles I*, now in a private collection) was his work. So little is yet known about Vanderbank that it is hard to assess his impact on Hogarth, but (as is evident from his *Don Quixote* designs) it may have been almost as important in its way as Thornhill's. Vertue comments in 1723 on Vanderbank's combination of natural talent ("having never travell'd abroad") and free living, which must have made him an interesting teacher for Hogarth, who also claimed to like his pleasures as well as his studies.[28]

Cheron, the other partner in the academy, was at this time a man of seventy, chiefly noted for his designs for engravers, especially book illustrators—that is, for his talent as a draughtsman rather than as a colorist. Vertue especially commends his academy figures and his drawings after Raphael's works in Rome. These drawings were "done with great exactness & skill [and] will be always much Valued & esteemd amongst the Curious." In his youth, however, he had been much employed in history painting on the Continent, and in 1694 the first Duke of Montagu, Verrio's patron, persuaded him to come to England, where he worked for the Duke on decorations at Boughton and Ditton Park. He was one of the five artists asked to submit designs for the decoration of St. Paul's dome in 1709. His coloring on surviving oil sketches is Venetian and not unlike Thornhill's; his handling too is light and bravura. Vertue adds that "he was of an affable good natur'd temper. very communicative of his Art with a plain open sincerity that made him agreeable & belov'd." And, unlike Vanderbank, he lived "regular & sober. was healthful to his end." He died in May 1725, and his will lists a number of his works to which Hogarth would have had access: a "Galatea of Raphael, a Bacchanalia after Poussin, and Jupiter after Carachio," and his own versions of a *Brazen Serpent, Ecce Homo,* and *Charity*.[29]

The academy was located, as Hogarth noted, in an old Presbyterian meeting-house; presumably the building in Peter's Court, just off St. Martin's Lane, that appears in the rate books as "Russell's Meeting House" and was rented by the sculptor Roubiliac in the 1740s.[30] It was this academy, a splinter of a splinter, that William Hogarth joined in October 1720, appearing on Vertue's list of original subscribers next to one Alexander Gamble, "enameller," apparently a relative of Ellis Gamble. Hogarth was now 23 years old, only recently out of his apprenticeship, and the subscription fee of two guineas must have worked a hardship on him. Although he apparently came upon the scene too late to have

benefited by Thornhill's academy (he would surely have mentioned it), he must have been aware of the advantages to a poor struggling artist of the free room for drawing.

In December, as Vertue put it, they were "at a stand to make & settle orders. for yᵉ propper government of this Accademy of Painting." From Hogarth's later comments on academies, it appears that a group of directors controlled the academy and made all the decisions; and if Vertue's proposals had any effect, or reflected the usual procedure, the directors arranged the drawing sessions, set and disposed the model, and instructed the "young persons." The usual instruction for young persons who wished an academic training was to work backward from standard idealized shapes to shapes in nature, which could then be seen in terms of these idealized shapes—a method distressingly similar to that of the engraver of heraldic arms. The academy separated its young persons from the more experienced artists, and the student began by copying pages from books of eyes, noses, mouths, faces, hands, and feet; then progressed to books that contained outlines of whole bodies of men, women, and children. Vertue is very precise: "after each student has drawn or copied *each* <without omission> of these figures or examples. then to proceed to another degree of Learning."[31] Next he copied drawings after statues, and finally casts of actual statues. Only then could he turn to life study.

The model for English academies was of course the French Academy's school, in which the young artist was set to copying the works of the old masters, first in drawing, then in painting; then casts from the antique; and finally from the life. To grasp how ridiculous it must have seemed to Hogarth, one need only look at a handbook of 1720, Thomas Page's *The Art of Painting,* which demands in its preface that beginners

> proceed . . . exactly and in the same Order as the Rules are set down in the Book . . . [i.e.] being perfect in drawing Hands, Feet, and other parts of the Body (making your draught ever more exactly like your Copy before you leave it, and so as you may scarce know one from the other) before you undertake the drawing of Heads; and Heads before you meddle with an whole Figure. . . .

And even when the student reaches the whole figure, proportions are similarly defined: figures are divided into 10 faces, some into 9, 8, or 7. Prophets, prophetesses, and sibyls, for example, are 7 heads high. Such catalogues must have been the source of much mirth and irritation to Hogarth:

> The sole of the Foot is the sixth Part of the Figure.
> The Hand is the length of the Face.
> The Thumb contains a Nose.
> The inside of the Arm, from the Place where the Muscle disappears,

which makes the Breast to the middle of the Arm, four Noses.
 From the Middle of the Arm, to the beginning of the Hand, five Noses.
The longest Toe is a Nose long.
 The two utmost Parts of the Teats, and the Throat-Pit of a Woman,
make an Equilateral Triangle.[32]

In all of this, it must be remembered, the student saw neither cast nor living
body: he imitated copies of Greek and Italian works, "for they . . . are the perfect
Rule of Beauty, and give us a good Gusto, carrying an Air of Divinity in them
beyond the rest of the Operations of Mankind"; and "gusto" is repeated over
and over as the quality that elevated the old masters above mortal painters. Most
important perhaps for Hogarth, the face was approached through Le Brun's
"Characters of the Passions," copies of copies, reduced to stereotypes;[33] as Page
insists, mastery of the face will be achieved "by little and little" "by good Prints
and diligent Practice."[34]
 It is easy to reconstruct the list of the casts used; they were standard in every
academy, and taught the young artist to view the world through the eye of the
Franco-classical academician. They appeared in Vertue's suggested list and Ho-
garth's compilation in his *Analysis of Beauty,* which also probably directly re-
flects the models in the St. Martin's Lane Academy. These were the Farnese
Hercules, the *Apollo Belvedere,* the *Laocoön,* the *Venus de Medici,* and prob-
ably the *Gladiator, Antinous,* and some of Fiammingo's putti.
 The assumption behind this procedure, reasonable enough as a basis for aca-
demicism, was that by the time the student had made all these copies "his taste
would have been sufficiently formed by his study of the masters for him to be
able to select from the model before him according to taste and reason."[35] But,
as Quennell has observed, considering Hogarth's upbringing, "Any system of
aesthetic training that suggested the early stages of a classical education was, of
course, anathema. Both at school and during his apprenticeship he had had
enough of copying."[36] It is evident that Hogarth came to associate the old mas-
ters with the "classics" of Latin and Greek literature; the rote copying of the
one may have fixed in his mind the traditional myths of the other. Copying other
men's works, he argued, was like pouring wine out of one vessel into another:
there is no increase of quantity and the flavor of the vintage is liable to evapo-
rate. He wished to gather the fruit, press the grapes, and pour out the wine for
himself. But he also felt his studies had nothing to do with "nature": "what is
copied for example at an academy is not the truth, perhaps far from it, yet the
performer is apt to retain his perform'd idea instead of the original." The Me-
dici *Venus* may be a referent against which truth can be judged, but for Ho-
garth, the eighteenth-century Londoner, it would never be truth itself.[37]
 He remembered that at the academy he had begun "copying in the usual way
and had learnt by practice to do it with tolerable exactness." Even when he

reached the point of drawing from life, with that female nude who was supposed to attract subscribers, he was still taught to copy "a bit at a time"—the eye moving back and forth from sitter to paper, losing the sense of the whole. "I was naturally," he wrote in his autobiographical notes,

> (as I could not help prizing the time best suited to the common enjoyments of life) thrown upon an enquiry after a shorter way of attaining what I intended to aim at than that usually taught among artists. and having first consider'd what various ways and to what different purposes the Memory might be managed and adapted I fell upon one I thought most suitable to my situation and Idle disposition.

Instead of copying he "took the short way of getting objects by heart so that wherever he was [he] caut some thing and thus united his studies with his pleasure by this means he was apt [to] catch momentary actions and expressions"[38]—as opposed to the eternalized ones of the casts and the classically-observed and posed models. These he captured, not by what is ordinarily defined as sketches from life, but rather by a shorthand of a few lines from which memory would later supply the rest. The stories of his interest in how to draw St. George and the Dragon in three lines, or of his sketching faces on his fingernail, give some indication of the system of "visual mnemonics" he developed. Another sign of his method is the paucity of surviving sketches: he tended to rely on mental notations which he developed, perhaps much later, directly in compositions in oil or pen and ink. The great majority of the drawings that have survived are studio compositions, sketched preparatory to an engraving. The exceptions are a few life class drawings that appear to serve no purpose beyond demonstrating that he could do as well as the other conventional copiers if he desired, and the occasional candid sketches of friends like Gabriel Hunt or Ben Read—sketches that were posted on tavern walls for the amusement of their friends.[39]

If he was in some sense rebelling against the methods used by teachers like his father in promulgating the classical education, he nevertheless formulated his solution in verbal terms. His aim, he said, was not to copy objects "but rather read the Language of them <and if possible find a grammar to it> and collect and retain a remembrance of what I saw by repeated observations only trying every now and then upon my canvas how far I was advanc'd by that means." The artist must be adept at recording these memories, in order to be prepared when the time comes to use them; otherwise he will be like the man who might "know the words and their meaning and yet never be able to write, lacking the hand to perform."[40]

If one theme Hogarth reiterates in his notes is the verbal quality of his method, the other is the need to have both his "studies" and his "pleasures": ". . . if I have acquired anything in my way it has been wholly obtain'd by Observation by which method be where I would with my Eyes open I could have

been at my studys so that even my Pleasures became a part of them, and sweetned the pursuit." When he wrote this sentence he was, of course, looking back over his life and seeing his youth as he wanted to see it. And so his application of the theory to history painting may be an afterthought. But "this way of painting," he remembers thinking,

> might one time or other become in better hands more usefull and enter-taining in this Nation than by the Eternal proposition of beaten subjects either from the Scriptures or from the old ridiculous stories of the Heathen gods as neither the Religion of the one or the other require promoting among protestants as they formerly did in greece and more lately in Rome.[41]

The memory had at least this foundation in fact: the academy no doubt estab-lished in his consciousness the hierarchy in which history painting takes the crown (his story of the apprentice thinking of the paintings at Greenwich and St. Paul's suggests that he already knew it). As one critic put it, "History-Painting is that Concert, comprising all the other Parts of Painting, and the principal end of it is to move the Passions"—"a Complication of all other sorts of Painting," story, figure painting, portraiture, landscape, and therefore obviously greater in the aggregate.[42] It also stood higher on the absolute scale of value: history paint-ing showed man behaving at his most heroic. Every manual on painting worked up, chapter by chapter, to history. Descending on this humanistically oriented scale, next came portraits, concerned with human character; then lower down, landscape, sea pieces, animal pictures, fruit and flower pieces, still lifes, and in-animate objects; and at the bottom "drolls" and grotesques, which showed man as less than he was.

A treatise Hogarth must have looked into was the English translation of Gerard de Lairesse's *Art of Painting:* its emblematic frontispiece shows a pile of books (Horace, Ovid, Homer, and Vergil) mingled with palettes, brushes, and rules, an idea he was to explore in one of his self-portraits; an allegorized figure of "Painting," being crowned by the three Graces, holds a panel with a portrait she has just finished of the many-breasted goddess Nature. Lairesse, like some of the copyists Hogarth was to show in *Boys Peeping at Nature,* omits much of nature from his "Painting"—certainly those parts Hogarth thought the artist cognizant of his pleasures as well as his studies should be aware of. Lairesse, him-self painted frankly in all his grotesque ugliness by Rembrandt, sums up the sort of theories that opposed the inclinations of a man like Hogarth (and, a hundred years earlier, a man like Rembrandt):

> The *modern painting* can therefore not be accounted *art, when nature is simply followed;* which is a meer imperfect imitation or defective aping her. Even, were a thing represented ever so natural, well-designed and prop-erly ordered; the condition, manners and custom well observed, and the

colouring most exact, yet the knowing will not think it artful: but when nature is *corrected and improved* by a judicious master, and the aforesaid qualities joined to it, the painting must then be noble and perfect.

Within this unsatisfactory category of "modern painting," he distinguishes between the domestic interiors and daily occurrences of De Hooch and Vermeer and the far less satisfactory cottages, brandy shops, alehouses, and bawdy houses of Ostade and Brouwer.[43] Such works, Jonathan Richardson noted in Hogarth's own time, "may please, and in proportion as they do they are estimable . . . but they cannot improve the mind, they excite no noble sentiments; at least not as [history painting] naturally does."[44] History painters continued to be the most highly ranked artists in any academy. And Hogarth never forgot this crucial fact, even as he recognized the diminishing possibility of finding a subject commensurate to the style or (as Thornhill's story unfolded) a patron who would commission such a picture.

It is also clear that Hogarth learned the fundamentals of academic drawing and theory and, whatever he may have said later to the contrary, began to apply them soon after matriculating in St. Martin's Lane. The change is immediately apparent if *The South Sea Scheme* (pl. 20) is placed alongside its ostensible pendant, *The Lottery* (pl. 30), which could have been constructed out of his academy sketchbook. Nevertheless, it is probable that he was something of a rebel within the academy, especially verbally, telling his colleagues about his mnemonic system and perhaps about "nature." It is also probable that the conventional pedagogic methods of Vanderbank's academy helped to foster in him the impression that Thornhill's new academy, where one simply went and painted from a model or did as one pleased, offered more scope to the students—as the authoritarian structure established by Vanderbank confirmed his growing distrust of intolerance. At either academy, the classical preoccupation with the nude body, reflected in the emphasis on the life class, had the simultaneous effects on Hogarth of strengthening his already precocious grasp of the human body and of scanting another subject very necessary for the history painter: perspective. The simple stage setting of *The Lottery* is a great improvement over earlier works, but if he ever fully grasped the problems concerned with the architectural components of a composition—which is doubtful—it was only through his own study and experience.

The subscribers' list to the St. Martin's Lane Academy in 1720 reads like a roll call of the artists between Kneller and Reynolds. Besides the old Louis Laguerre and Louis Cheron, and the young John Vanderbank, there were, of the older generation, the Swede Hans Hysing, an established portrait painter who lived with and painted like Michael Dahl; and Louis Goupy, a less successful portraitist, noted for the "neatness & care" of his drawings.[45] George Knapton,

a year younger than Hogarth and related to the Knapton booksellers, was study-
ing at this time with Jonathan Richardson; he went on to Italy in 1725, return-
ing to England seven years later to set up a fashionable portrait practice.[46] Bar-
tholomew Dandridge, born in London in 1691, son of a house painter, had at 20
attended Kneller's academy; he was beginning to produce portraits that resem-
bled Vanderbank's, though they were less free, and in the late 1720s he painted
conversation pictures similar to Hogarth's.[47] Another subscriber, Arthur Pond,
though never much of an artist, became what Vertue called "the greatest or top
virtuoso in London." His father was a merchant of some kind—Vertue says "a
wealthy citizen"—who lived "on the Middle of London Bridge," and on the
strength of this wealth Pond traveled on the Continent until 1727, when he set-
tled in Covent Garden and set up as a portrait painter and art expert, copyist of
old master drawings, print and picture dealer, purveyor of painters' materials
and picture frames.[48] Rich amateurs were his best customers; he procured colors,
brushes, varnishes, and canvases for them, as well as old masters and Rembrandt
etchings. Others, about whom I shall have more to say later, were the Sympsons,
father and son, and Hogarth's special friend John Ellys.

Dr. William Cheselden, later considered the best surgeon (and carver at a
dinner table) in London, was also a member of the academy. Cheselden was al-
ready the greatest anatomist in London and was giving lectures that were so
popular as to draw people away from the dissections at the Barber-Surgeons'
Hall in Monkwell Street and to elicit a fine and censure from the Barber-Sur-
geons' Company. Hogarth doubtless visited the dissections, both as education
and as theater, and it is quite possible that he attended Cheselden's lectures,
which were prominently advertised at the same time he was attending the acad-
emy. It would have been characteristic of Hogarth to combine an aesthetic with
a more broadly practical and experiential activity.[49]

Another member of the academy was a Yorkshireman named William Kent,
a man of 36 just returned from Italy and patronized by the powerful Earl of
Burlington. The man who was later to topple Thornhill was appropriately an
Englishman, but an Italianized one (called "Signior"), who thus embodied the
best of both worlds: English chauvinism and English reverence for Italy. This
formidable young man, to whom Hogarth must have taken an instant dislike,
came from a poor Yorkshire family which could not support his artistic inclina-
tion and so apprenticed him at eighteen to a coach and house painter; at twenty
he ran away to London—"without leave. or finishing his apprenticeship." Vertue
adds, however, that already he had made friends among the Yorkshire gentry
and went to London with a contribution from them and letters to the proper
people. If he arrived in London around 1704, the following years are undocu-
mented until 1709, when he sailed for Italy, and his path diverged forever from
Hogarth's. One wonders what course Hogarth would have followed had he made

the trip to Italy when he broke off his apprenticeship. It is certain that he never echoed poor Jonathan Richardson's cry, "would to God however I had seen, or could yet see Italy,"[50] and an Italianate Hogarth is hard to visualize. On the other hand, the experience proved a highly rewarding one for Kent.

In Italy he attracted patrons among the young English gentlemen on their grand tours, and when in 1713 he won the Pope's prize for painting (actually, as Vertue notes, "the second prize in the second class"), his friends made sure it was publicized back in England.[51] The first great patron to whom he attached himself was the rich young orphan, Thomas Coke of Norfolk, not yet seventeen and on his grand tour. They appear to have met in the spring of 1714 in Naples, and by June Coke's account books begin to record payments to Kent, who thereafter accompanied Coke's train as an adviser and friend. They parted temporarily in Padua, and Kent returned in October to Rome, there making the most important contact of his career: Richard Boyle, third Earl of Burlington.[52]

Burlington, who set out on his grand tour in May 1714, at twenty, was "a good natured pretty gentleman, but in Whig hands," who struck up a friendship with Prince George Lewis as he passed through Hanover which would stand him in good stead when later in the same year that prince succeeded to the English throne.[53] He was a great Yorkshire landowner whose seat, Londesborough, was not far from Kent's birthplace, and he may have been drawn to him accordingly. Kent, however, was ingratiating and ambitious, and Burlington was an aspiring Maecenas in need of tutoring. By November Kent had secured Burlington his first "old master," a *Temptation of St. Anthony* after Annibale Carracci, which was followed in December by a Viviano. In February, Burlington left Rome with a large number of pictures, which probably reflected Kent's taste as well as his own, and included a Domenichino, two Marattis, another Viviano, and a Pietro da Cortona—or whatever passed for these. This was a short tour, and Burlington was back on English soil on 30 April (1715).

Kent's reputation as a painter had continued to grow, and as early as July 1714 his friend and patron Burrell Massingberd was writing him, "I have nothing to add but to beg you'll study and not think of comeing over [back to England] *donec Raphael Secundus eris*," and Kent himself wrote that John Talman (another friend-patron) was "continually preaching to me ye may be a great painter."[54] In their pleasant and knowledgeable countryman these emergent young gentlemen saw the makings of a great artist.

In May 1716 Kent was in Naples with Coke again, receiving payments for his lodging and support. He remained with Coke, buying and copying paintings, until the latter's departure in mid-1717. He presumably carried on in the same happy way for two more years, until the fall of 1719 when Lord Burlington, now an ardent Palladian, returned for his second tour. Again they met, toured, and this time returned to England together, with Kent settling in Burlington House, the Earl's new Palladian townhouse in Piccadilly. His patron began immediately

to employ him at painting decorations for the house and, as Vertue recalled, "promotted him on all ocasions to every thing in his power. to the King, to the Court works, & Courtiers declared him the best History painter—& the first that was a native of this Kingdom...."[55]

By June 1720, three months before the opening of the St. Martin's Lane Academy, Kent was already "upon ye greatest works in England," as he wrote to Massingberd, painting historical works for "Lord Burlington, Lord Duck Shandoes [Chandos] and Lord Castlemaine untill I have fix'd these work a little I am afraid shall not be at liberty to [go] into ye North." By this time he had met his literary champions Alexander Pope and John Gay, doubtless through Burlington. In 1720 Gay's *Poems on Several Occasions* was published with illustrations by Kent in the Italianate manner; in this instance his shaky draughtsmanship was combined, in the frontispiece, with his own engraving—a mistake he was wise enough not to repeat. Gay responded with a fulsome tribute in an "Epistle to Paul Methuen," another patron of artists, attributing to Kent's painting "Titian's strong fire and Guido's softer grace" and recommending that Kent return to Rome and decorate its palaces with his history paintings:

> There on the walls let thy labours shine,
> And Raphael live again in thy design.

Burlington subscribed for fifty copies, partly at least for the sake of Kent. Hogarth was almost certainly a reader of Gay, and must have remembered these lines when he drew *Masquerades and Operas* ("The Bad Taste of the Town," pl. 28).

At the St. Martin's Lane Academy Kent stood out among his peers in his Italianness, his familiarity with the great, his important projects, and his incredible reputation; he was further distinguished, no doubt, by his positive opinions and air of self-importance. The exaggeration of his merit as an artist would have been apparent to one aware of his surprisingly feeble draughtsmanship and feebler painting technique. It seems probable that Hogarth took an instant dislike to Kent, long before his career began to threaten Thornhill's.

The parallels between Kent and Hogarth are no less instructive than the contrasts: both were poor boys from the north country and apprentices who failed to complete their apprenticeships. Both were in appearance patently plebeian (Kent fat and florid, Hogarth short and stocky), and in temperament ambitious, self-seeking, and finally unscrupulous in achieving their ends. Kent's smoothness, I suspect, riled Hogarth most of all; Hogarth, as a result of his background (and perhaps by conscious design as well), was anything but smooth. Kent's easy sophistication—his ability to get along with and manipulate the great—was a talent Hogarth never developed, and one he must have regarded with mixed envy and contempt. His dislike of Kent probably explains the irritation with

foreigners, smoothness, and patronage that remained with him throughout his career, long after his skirmishes with the Yorkshireman.

The first Thornhill–Kent confrontation took place in early 1722 when Thornhill asked £800 to decorate the Cube Room in Kensington Palace (part of his prerogative as Serjeant Painter), and, without warning, Kent was given the job for £300. As Vertue wrote, "a mighty mortification fell on S^r James Thornhill." As at Blenheim, his prices had proved too high; but, Vertue added (probably on further information), "besides the Lord Burlington forwarded Mr Kents Interest as much as layd in his power at Court. & strenuously oppos'd S^r James." Years later, at the time of Kent's death, Vertue elaborated: Burlington "oppos'd. S^r James Thornhill K^t painter to the King, removd him from the Court works favour &c."[56]

As to the quality of Kent's work, Vertue describes in some detail the five rooms at Kensington that he eventually decorated and concludes: "all these paintings are so farr short of the like works. done here in England before by Verrio. Cook. Streeter Laguerre. Thornhill. Richi. Pellegrini. &c. in Noblemens houses. in Town & Country." The contrast between the history painting of the novice Kent and the great Thornhill, indeed obvious, was no doubt discussed in the St. Martin's Lane Academy.

The story of Thornhill's fall from prominence goes back to 1718 when Wren was suddenly and unceremoniously ejected as Surveyor General to H. M. Works, and the amateur Palladian William Benson was installed in his place. With Wren's departure, Nicholas Hawksmoor was also removed from his position as Clerk of the Works, along with all the other clerks. The downfall of the old Board of Works, responsible for much of the greatest architecture in England, resulted in part from Wren's age and George I's conviction that the Board was being mismanaged; but the primary force was Burlington, newly converted to the ideals of Shaftesbury and Colen Campbell, who wanted to purge the Board of the old school of architecture.

In 1711 appeared the Earl of Shaftesbury's *Characteristics*, which defined the aesthetic that would guide the Burlingtonians. Beauty and morality were equated, and the common characteristics were order, harmony, and proportion. The ideal set forth—which through its popularizer Jonathan Richardson would have a great influence on the English nobility as a whole—was the "man of breeding," the connoisseur who knew the "right models" for art, the literature and art of classical antiquity. Then in 1712 Shaftesbury prefixed to his *Notion of the Historical Draught of the Judgment of Hercules* a polemical "Letter concerning Design" addressed to Lord Somers, which attacked the "models" of Wren's Board of Works. Although it did not get beyond manuscript at the time, it must have been known to the Whig circle of virtuosi by 1713 when an English translation of the *Judgment of Hercules* appeared.[57] Shaftesbury fore-

sees a time in the near future when the war will be over and Britain will be "the principal seat of arts," and she must be ready. The time has come for connoisseurs to gird up their loins, and he offers a clarion call to action which Burlington was to heed. He recalls how the great English public buildings have "miscarried": "through several reigns we have patiently seen the noblest public buildings perish (if I may say so) under the hand of one single court-architect." And he questions "whether our patience is like to hold much longer."[58] He lumps Vanbrugh with Wren and his school, and as to those graceful church steeples which Hogarth so admired: "it is like we shall see from afar the many spires arising in our great city, with such hasty and sudden growth, as may be the occasion perhaps that our immediate relish shall be hereafter censured, as retaining much of what artists call the Gothic kind." Shaftesbury—a great Whig name—was laying the foundations for a Whig aesthetic to replace what he considered the Tory and baroque aesthetic of Queen Anne's Board of Works; this aesthetic, curiously at odds with Whiggish ideas of personal freedom, went into effect soon after the Whigs took power in 1714.

It is not certain when Burlington fell under the spell of Shaftesbury's creed. Richard Graham's flattering dedication in the 1716 edition of Dryden's translation of Du Fresnoy's *Art of Painting*, after describing Burlington's unsurpassed knowledge of all arts, makes these provocative statements: "It is not for common purposes that *Heaven* has entrusted these rich *Talents* in your Hands. You stand accountable for them to Your *Prince*, Your *Countrey*, and Your noble *Relations*." Burlington must have been aware of Shaftesbury's doctrine by 1717 when the first volume of Colen Campbell's *Vitruvius Britannicus* appeared, arguing that the old baroque style with its "capricious ornaments" was obsolete; and Burlington promptly commissioned Campbell to begin work on Burlington House, ousting the Tory James Gibbs.

The interior decoration had been started by the Italians Marco and Sebastiano Ricci, the former working between 1708 and 1713 on the entrance hall, the latter between 1712 and 1716 on the staircase. Presumably, as soon as Kent returned from Italy Burlington set him to work on the ceiling pieces for the apartments to which the staircase led. Thornhill, and later Hogarth, were undoubtedly aware of the large histories Kent painted in Burlington House, on which he based the reputation which secured for him the Kensington Palace decorations, though whether either of them ever penetrated the fastness to see the pictures is questionable. Besides a *Glorification of Inigo Jones*, Kent painted a large *Banquet of the Gods* (pl. 27) and an *Assembly of the Gods*, scattered with awkward figures, some of them with large Pellegrini features and others with the long puppet-like bodies of Ricci figures. The *Banquet* looks as if Kent may have drawn upon some antique paintings or reliefs; otherwise his style is lush Venetian with Sebastiano Ricci's flair reduced to carelessness. The Kent–Bur-

27. William Kent, Feast of the Gods; 1719–20 (Royal Academy)

lington kind of history painting must have contributed significantly to Hogarth's rejection of the mythological mode during the crucial years at the academy.[59]

The external architectural, like the internal decorative, style projected by Shaftesbury, Burlington, and Kent was sentimental in origin, based on ideas of *virtu* as well as geometric rule. Burlingtonian palladianism sought the associations of ancient Rome, as other facets of the art movement in the eighteenth century sought associations with Chinese and Gothic. "It was the sentiments and virtues associated with classical architecture," as Christopher Hussey has written, "more than its objective, formal qualities that aroused their enthusiasm, just as it was the departures of Wren and Vanbrugh from the strict canon, and not necessarily the intrinsic qualities of St. Paul's or Blenheim, that aroused their indignation."[60] Burlington's prose, perhaps quite sincere, was summed up in 1732 in Pope's *Epistle* to him, in which he is depicted as a restorer of Roman values, the responsible aristocrat who builds and plants for socially useful ends, the Roman who is a public benefactor and himself a designer and builder.

If Burlington was to live up to this description, it was essential that he control H.M. Board of Works. There was no room for the Gothic extravagance of the old Queen Anne architects or their decorative painters who assisted in transforming chapels into theaters or drawing rooms, "Where sprawl the Saints of Verrio or Laguerre." Verrio was dead and Laguerre retired from decorative painting around 1720 "& wholly imployd himself in finishing many paintings he had unfinished by him." Always indolent, he became increasingly dropsical, "his leggs swelling much," and died of an apoplexy—appropriately, the Bur-

lingtonians must have thought—at the theater on 20 April 1721.[61] That left only Thornhill.

The politics involved in the affair of the Kensington apartments were not, however, quite so simple. "The Original Cause of this difference," Vertue explains, went back to Thornhill himself. As he rose from commission to commission, he was supported by the "great favour of the Quality & Interest of the Surveyors & Officers of the Kings works." Later, he continues,

> on all hands [Thornhill] declared himself opposite to all their interest. & by drawing & designing. & demonstrating their ignorance in y[e] art of building. he woud Sett himself up against them for the Place of Surveyor. or Architect. & in short for all in all. Therefore they have play'd him this trick.[62]

Benson, the new Surveyor General, was evidently not scorned by Thornhill, who with Vanbrugh survived the purge. (Vanbrugh apparently kept his comptrollership only because of his powerful friends, especially the Earl of Carlisle.) Thornhill may even have assisted with the dismissals. At any rate, when in 1719 Benson was suspended for flagrant misrepresentation concerning the condition of the House of Lords, he suggested Thornhill as his successor.

Thornhill must have encouraged Benson; he did have architectural ambitions, though limited (like Benson's) to the experience and execution of an amateur,[63] and wanted to set up "for all in all." Vanbrugh, who had once before (out of respect for Wren) declined the office and had every right to expect it now, was upset.[64] "What a clamour!" recalled Vertue a few years later, "what outcries of Invasion! what blending of Parties together—against him [Thornhill] in all his affairs. of painting also, that to this Time he sensibly feels it and has long been unimployed even in his own way of history Painting." And perhaps remembering Kneller's complaint, Vertue adds a word about the time when Thornhill "only attempted to face painting, which gave uneasiness to some who do not forget him on that score when it layes in their way."[65] It is always dangerous to aspire to be an "all in all." The pattern would be painfully repeated in the years of Hogarth's greatest success.

In fact, a combination of the Earl of Sunderland—Thornhill's patron—and the Duchess of Marlborough, a persistent enemy of Vanbrugh, appears to have supported Benson in advancing Thornhill as a rival candidate. To oppose this party, Vanbrugh renounced his claim to the office in favor of Thomas Hewett, perhaps hoping to secure the comptrollership for life, some money, and the return of Hawksmoor, none of which materialized. But in August 1719 Hewett, late Surveyor of the Woods and Forests, an even less competent architect than Benson but an old friend of Kent's from the days in Italy, became Surveyor General.

After the affair of the Kensington Palace decorations was over, Thornhill—

by then a supporter of the Prime Minister in the House of Commons—secured Sir Robert Walpole's order to have Hewett put the circumstances in writing. In a letter to the Lords Commissioners of the Treasury, dated 14 February 1722/3, Hewett explains that "before Michaelmas last" the King ordered the decoration of some rooms in Kensington Palace; Hewett showed him some sketches, from which the King chose one. "And after I ordered a model to be made and Sir James Thornhill painted it, which His Majestie saw and approved of, and commanded me to tell the Vice Chamberlain he should treat with Sir James for the price, and that it should be done out of hand, which is all I know of the matter."[66] Hewett's date must refer to Michaelmas 1721; Kent had already done £350 worth of work by August 1722, though he did not complete the Cube Room until 1725.[67]

Clearly, the Kent faction had cut off Thornhill at the very last minute. When the time came to decide, the judging body was an Office of Works hostile to Thornhill's art—not the same board that had given him his great commissions. Those who had not been purged were in no mood to support Thornhill, and the rest were in Burlington's pocket. Sunderland and his "Marlborough faction" were probably of little help to Thornhill after the Earl's resignation from the Treasury following the South Sea scandal in the spring of 1721. Sunderland did remain Groom of the Stole, a member of the Privy Council, and the King's favorite, though fighting for his political life; but his death in April 1722 negated any chance of his further assistance.

The conflict of personalities had not helped Thornhill, but his fall must have been essentially doctrinal. With his removal, "the school of fashionable purists led by Lord Burlington captured the citadel of architecture, the Office of Works, and sealed the doom of the Baroque school of Wren."[68]

The St. Martin's Lane Academy flourished for a short while. The annual advertisement appeared in the *London Journal* for 12 October 1722 for the academy to commence on the first Monday in October:

> This Week the Academy for the Improvement of Painters and Sculptors, by Drawing after the Naked, open'd in St. Martin's Lane, and will continue during the season, as usual.
> N.B. The Company have agreed not to draw on Mondays and Saturdays.

The group presumably met the other nights of the week. Vertue relates that in November the Prince of Wales, Lord Herbert, and the great art patron Sir Andrew Fountaine visited the academy and "staid there an hour a Woman being then the Moddel to draw after. to whom was given five Guineas. by order of the Prince."[69] Again on 12 October 1723 the notice appeared in the *London Journal*, that "The Academy of Painting and Sculpture in St. Martin's Lane, was opened on Monday last, as usual," i.e. on Monday 7 October.

The academy cannot have endured much beyond the 1723–24 season, how-
ever. Vertue writes that it survived "a few years," and Hogarth recalled that
"this lasted a few years but the treasurer sinking the subscription money the
lamp stove etc were seized for rent and the whole affair put a stop to."[70] This
sounds like the work of the pleasure-loving Vanderbank, who was certainly no
longer keeping the academy by May 1724; as Vertue tells it:

> haveing livd very extravagantly. keeping. a chariot horses a mistress drink-
> ing & country house a purpose for her. besides at his Mothers house his
> painting room. & much encouragement from Nobility & Gentry run so far
> into debt that he was forc'd to go out of England to France. & took with him
> his *lemon* or wife which he coud not be prevaild with to part from.

The family's wealth had probably encouraged him to lead the life of a young
gentleman rather than an artist, and the collapse of the South Sea Bubble may
have contributed to his difficulties. In October he was back in London, married
to the "lemon," but living within the liberties of the Fleet.[71]

With this collapse in mind, Thornhill in November 1724 made another at-
tempt to get up an academy, again at his house in Covent Garden and gratis—
again perhaps with a national academy, headed by himself, as his object.
Whether Hogarth remained with the St. Martin's Lane Academy until the end
is uncertain, but he must at this point have joined Thornhill's free academy.
He writes ironically of both of Thornhill's attempts: "so few would [lay them-
selves] under that obligation," i.e. to come and draw gratis, that it failed; and
again he explains that Thornhill had "at his sole expense given the liberty on
application for any one to draw every evening gratis."[72]

It is not certain when Thornhill first moved to Covent Garden. He can be
placed "under the Great Piazza" in March 1715/16 when six paintings by Luca
Giordano were to be seen and sold at his house.[73] In October 1718 he etched an
invitation to celebrate the Feast of St. Luke at his house in Covent Garden.[74]
But he may have been only a tenant all this time, since his name appears in none
of the Overseer of the Poor account books until February 1722/3, when he
lived in the last private house on the north side of the Piazza, in the northeast
corner adjoining the building that would be the Covent Garden Theatre. By
the time he opened his academy he had added a large room to his house, where
the students painted.[75]

A few years later Vertue wrote of the Covent Garden Piazza: "inhabited by
Painters. A Credit to live there," and listed Ellys, Russel, Murray, Thornhill,
Swarts, Wright, Smibert, Angellis, Vander Vaart, and Zincke.[76] At this time
Covent Garden, center of the theater district, and with many artists living in or
near it, became the center of Hogarth's London even before he actually lived
there, and remained so until his move to Leicester Fields in 1733.

Thornhill at this time, when Hogarth probably first met him, was in his late

forties, apparently not as sober and staid as he appears in all the surviving portraits and self-portraits (pls. 25, 26). One of his drinking companions of not many years before, the poet Matthew Prior, described him:

> The one they call'd MONTE SPINOSA I think
> A Brownish Complection, a lover of drink
> A drawer of Devils they say was his Trade
> My Landlard drew worse in his House, I'm afraid.

To this one may add the look of cool detachment in his eyes and the long nose, and assume that his ambition and hard work were tempered by conviviality as well as charm.[77] Besides admiring him as an artist, Hogarth must have liked him as a man. Hogarth himself, though no portrait survives from this period, can be visualized by working back from the Roubiliac bust of 1740: a short, brisk young man with sharp features, more like a terrier than (as later) a pug. His acquaintances, if they had written about him, would have noted his great energy and, probably, his cocky self-assurance. Moving unhesitatingly up the ladder of acceptable artistic types, he was a person who found it necessary to prove his merit—and the Thornhills were his first important and knowledgeable audience.

In the Thornhill house he found a collection of paintings that included works by Caravaggio, Veronese, Annibale Carracci, Guido, Domenichino, Albani, Poussin, Rubens, Giordano, Sebastiano Ricci, Luti, and Pannini. Before long he became acquainted with a son named John and a daughter Jane, aged about 15 then. In this household the great world of history painting and artistic polemic, of Burlington and Kent, was the center of discussion; and it was to become Hogarth's own world. Here it would be very evident that Thornhill, the Englishman, had for a few years enjoyed the greatest patronage (church and state) and produced subjects worthy of the grand style in which he rendered them (the growth of English national power and the life of St. Paul). Now the great patrons were turning to such as Kent, who lacked the style; and even the subject of a growing England, if Thornhill had only known it, was becoming ludicrous in the age of Sir Robert Walpole. The phenomenon one may observe in Thornhill's career is of the utmost importance to Hogarth's. For, as Lawrence Gowing has said, "The collapse of 'great' painting—the kind of painting in which there was a natural, traditional accord between a great theme, a grand manner and splendid patronage—was the ultimate basis of modern painting."[78] This will be the story, or one story, of Hogarth's career. His first response was to satirize the perversion of "splendid patronage."

Could new dumb Fauſtus, to reform the Age,
Conjure up Shakeſpear's or Ben Johnſon's Ghost,
They'd bluſh for shame, to see the Engliſh Stage
Debauch'd by fool'ries, at so great a coſt.

What would their Manes say? should they behold
Monſters and Maſquerades, where uſefull Plays
Adorn'd the fruitfull Theatre of old,
And Rival Wits contended for the Bays.

Price 1 Shilling. 1724

28. Masquerades and Operas; Feb. 1723/4 (first state); 5 x 6¹¹⁄₁₆ in. (W. S. Lewis)

"The Bad Taste of the Town"

In February 1723/4 a small print, referred to in the papers as "The Bad Taste of the Town" (pl. 28, now generally called *Masquerades and Operas*), became a cause célèbre and was eagerly bought up, pirated, and reissued.[1] This one satire ridiculed not only masquerades, operas, and pantomimes, but ignorant "connoisseurs" as well: at the center—clearly equated with these false tastes —was the gate of Burlington House, that Italian palace transplanted to the middle of eighteenth-century London; and Burlington Gate was surmounted by a statue of William Kent, with Gay's allusion to him as a Raphael dramatized in the figures of Michelangelo and Raphael as slaves at his feet. The implication was that Burlington House was the very citadel of bad taste in London. The use of Kent must have been partly personal, but Hogarth was also indirectly retaliating for Sir James Thornhill.

To understand the genesis of Hogarth's first important print, however, two contexts must be considered, one general and the other particular. The first is his background in literary satire; stimulated at an early age by his father's interest in books, he extended his reading to suit his own inclinations. He must have been saturated with and conditioned by the writings of Butler, Swift, and the English school of satirists; but his assumptions, satiric and aesthetic, can be summed up by the *Spectator,* that great storehouse of socially shared Augustan attitudes. It was the source, or at least the shaping influence, of many of Hogarth's ideas; the art treatises came later and were read through Mr. Spectator's eyes. Not that he agreed with everything in it—he took issue with Addison's statements about the ancients excelling the moderns in painting as in poetry, and he singled out No. 83 for criticism in *The Analysis of Beauty* and in *Time Smoking a Picture*.[2] However, he accepted the general attitude toward art that Addison expresses in No. 5:

> An Opera may be allowed to be extravagantly lavish in its Decorations, as its only Design is to gratify the Senses, and keep up an indolent Attention in the Audience. Common Sense however requires, that there should be nothing in the Scenes and Machines which may appear Childish and Absurd.[3]

"Common Sense" and "requires" are the key words and represent the *Spectator's* aesthetic standard. How laughable, for example, to see the opera's hero "exposed to a tempest in Robes of Ermin, and sailing in a open Boat upon a Sea of Paste-Board"; or, in No. 18, to listen to music sung in a language no one understands; or, in No. 29, to hear a lover *singing* his billet-doux, including the superscription, alone in a desert accompanied by musical instruments and a chorus. Addison's conclusion in this essay, linking the opera with the other arts, including painting, is that

> Musick, Architecture and Painting, as well as Poetry and Oratory, are to deduce their Laws and Rules from the general Sense and Taste of Mankind, and not from the Principles of those Arts themselves; or in other Words, the Taste is not to conform in the Art, but the Art to the Taste. Musick is not design'd to please only Chromatick Ears, but all that are capable of distinguishing harsh from disagreeable Notes. A Man of an ordinary Ear is a Judge whether a Passion is express'd in proper Sounds, and whether the Melody of those Sounds be more or less pleasing.

For better or worse, the *Spectator's* simple aesthetic of the primacy of nature over art served Hogarth throughout his career: he consciously tried to ignore convention or rule when it did not stand the test of common sense, and he never trusted the taste of connoisseurs against that of the average man. Like the good Englishman he was, he wanted drama, with plot, speeches, and motives that could be understood; opera libretti, as Paul Henry Lang points out, "were not bona fide dramas but literary texts that provided the composer with the opportunity for a lyric effusion."

> Opera cannot express the fullness and richness of life in the manner of the spoken theatre; its expressive possibilities are not on the same plane with reality but are stylized abbreviations of it. Therefore, completeness of content is replaced by formal completeness, the empirical by the symbolical, the expansive by the intensive.[4]

Such formal, disturbingly unreal conventions as the da capo aria were diametrically opposed to Hogarth's artistic aims; and at the outset of his career the contrast between his desire for "nature" or "life" and the opera's rendition of form is a telling one, prefiguring the split between form and content that played a crucial role in his development. In a sense the story of his life was an attempt to apply the empiricism of *Spectator* criticism to painting, as his innate sense of color, form, and texture continually tried to reassert itself.

But in the year 1723 he was delving into satire, and like the *Spectator,* he could measure the operas, puppet shows, pantomimes, masquerades, and other popular amusements against a norm of common sense. Looking around for a timely subject for a satiric print, he could also refer to his memory of Kent's

appalling presumption and to the shoddy paintings that were replacing Thorn-
hill's. The death of Wren at the end of February 1722/3 may have reminded
him, as one paper put it, that Wren "was near five Years ago removed from the
Surveyorship General of the King's Works, which Post he had enjoy'd for above
50 Years."[5] His graceful steeples were everywhere visible to be contrasted with
the cold regularity of Burlington House.

Masquerades were topical throughout the 1720s; in 1723, while they were not
getting any worse, they were attracting more unfavorable attention. The usual
advertisements for costumes in the papers were augmented by notices of new
anti-masquerade pamphlets (*The Conduct of the Stage Considered, with Re-
marks on the pernicious Consequences of Masquerades* and *An Essay on Plays
and Masquerades*); by personal attacks on the masquerade impresario, the
Swiss adventurer John Jacob Heidegger (*A Seasonable Apology for Mr. H—g—r,
The Masqueraders, or Fatal Curiosity,* and *Heydegger's Letters to the Bishop of
L—n*); and especially by notices of royal attendance, even patronage. The accu-
sations against masquerades remained much the same as those made by the
Spectator a decade earlier: "In short, the whole Design of this libidinous As-
sembly seems to terminate in Assignations and Intrigues . . ."—by wearing inap-
propriate costumes and masks, coquettes disguised themselves as Quakers,
whores as fine ladies, rakes as Roman senators, and grave politicians as rakes.
"The Misfortune of the thing is, that People dress themselves in what they have
a mind to be, and not what they are fit for."[6]

Heidegger himself served as the link between masquerades and operas. He
took over the management of the Haymarket Opera House in 1713 when Owen
MacSwiney absconded, leaving the actors unpaid. Realizing that the Italian
opera was enjoyed in England only by the cultivated few, he alternated dramatic
and operatic productions with subscription balls and masquerades.[7] Notices like
the following—"The Opera House in the Hay-Market is now painting and
adorning, not at the Charge of Mr. Heydegger, but of the Royal Academy of
Musick"[8]—reiterated the point that Heidegger, the man who was synonymous
with masquerades, was also thought of as running the opera; in fact, they shared
the same building. When the Royal Academy of Music, Handel's opera com-
pany, was established in 1719, none other than Lord Burlington was the prin-
cipal sponsor, guaranteeing £1000 toward the £10,000 required. He was an
early and continuing supporter of Handel, who was housed at Burlington
House, where he performed private concerts on the harpsichord. Also suggestive
of the centralization of foreign and delusionary entertainment in England was
the notice that "At the New Theatre, over-against the Opera-House in the Hay-
market," the "New Company of Comedians" from France were performing
"with Entertainments of Singing and Dancing." Apparently even lotteries were
drawn on the stage of the Opera House at this time—"at which," it is added,
"were present a great Appearance of Nobility and Gentry."[9] The Italian opera

stars continued to be feted by the English, much as foreign artists were, or (perhaps to Hogarth's mind) English artists who went to foreign countries and came back Italians. Madame Cuzzoni, a paper noted, is "visited and entertained by our Nobility and Gentry [and] is duly receiving valuable presents from them."[10]

If masquerades and operas constituted one popular source of entertainment, another was the pantomimes performed at Lincoln's Inn Fields Theatre by John Rich, a consummate pantomimist who called himself "Lun." Even before he became a friend of Hogarth's, his performances, like those of many actors, were closely observed by the artist. His acting is described by Thomas Davies: "his gesticulation was so perfectly expressive of his meaning, that every motion of his hand or head, or of any part of his body, was a kind of dumb eloquence that was readily understood by the audience." The popularity of his pantomime entertainments was not hard to explain:

> By the help of gay scenes, fine habits, grand dances, appropriate music, and other decorations, he exhibited a story from Ovid's *Metamorphoses,* or some other fabulous writer. Between the pauses or acts of this serious representation, he interwove a comic fable, consisting chiefly of the courtship of Harlequin and Columbine, with a variety of surprising adventures and tricks, which were produced by the magic wand of Harlequin; such as the sudden transformation of palaces and temples to huts and cottages; of men and women into wheel-barrows and joint-stools; of trees . . . to houses; colonades to beds of tulips; and mechanics' shops into serpents and ostriches.[11]

Watching these performances, Hogarth—on his way to becoming a serious-minded moralist in the *Spectator* vein—must have felt that the drolls and spectacles of Bartholomew Fair were invading the classic English theater of the West End.

This situation became ironic in the fall of 1723 when Drury Lane, the rival company which specialized in Shakespeare, Jonson, and the classic English dramatists, tried (or was forced by financial pressures) to exploit the popularity of the Lincoln's Inn Fields productions. On 26 November Drury Lane produced *Harlequin Dr. Faustus* (by John Thurmond), and on 20 December Rich replied with *The Necromancer or Harlequin Dr. Faustus,* one of his most successful productions, which proceeded to draw people away from Drury Lane to such an extent that Cibber, Wilks, and Booth—the patentees—were in a very bad way before the end of the year.[12] Thus in November and December pantomimes were topics of discussion, and the subject for a satiric print began to emerge in the new popularity of *The Necromancer* and its victory over the serious theater: a subject easily dramatized by showing the plays of Shakespeare, Jonson, and Congreve being carted away from the Lincoln's Inn Fields Theatre, where *The Necromancer* is playing.[13]

Another name familiar to Londoners of the 1720s was Isaac Fawkes (or Fawks, or Faux), the sleight-of-hand artist:

> On Thursday Night last [7 March 1722/3] his Royal Highness the Prince, and several Noblemen and Gentlemen, went to see the famous Mr. Fawks in the Haymarket, who were extremly well pleas'd with his extraordinary Performance; as also with the two Boys.

Advertising his "Dexterity of Hand," Fawks describes his act as follows:

> [He] performs his most surprising Tricks by Dexterity of Hand, who far exceeds all that ever show'd in Europe before, with the Cards, &c Corn, Mice, curious India Birds, and Money; and also several curious Fancies different from what has been perform'd before, being entirely new, which has given Satisfaction to all Persons that have seen him perform. Likewise the surprising Activity of Body perform'd by his Little Boy, of 12 Years of Age; returning his Body into many various Shapes, that surpasses humane Faith to believe without seeing; for which he has received considerable Rewards from the Nobility of this Kingdom who have seen him perform. Also vaulting and showing Postures on the Slack Rope, the like never perform'd by any Person in the Kingdom before. His Performances are from 10 in the Morning till 9 at Night.[14]

Thus Fawkes, on a very low level, would have reminded Hogarth of the opera, pantomime, and masquerade and their disguising or distorting of nature. His advertisements, like the one above, often mention his "Rewards from the Nobility"; a notice in a paper for October 1723 reads "The famous Mr. Fawks, as he modestly stiles himself, has since Bartholomew and Southwark-Fairs, put seven hundred Pounds into the Bank; He may certainly challenge any Conjuror of the Age to do the like."[15] Fawkes emerges from the papers as a symbol of distorted values, another illustration of misdirected patronage and degenerating standards of aristocratic taste.

He also exemplifies the movement of sleight-of-hand entertainments from the fairs to the patrician West End. His summers were spent at the fairs, and his winters consisted of a progress in the direction of the West End. In 1723 he spent the winter and spring in "the Fore-Room at the French Theatre, over against the Opera-House in the Hay-Market"; in May he removed to a "Great Booth in Upper Moorfields" and he divided the summer between the Fairs; in the fall he had a booth on Tower Hill. Then on 18 December he was performing in the same building with Heidegger, Handel, and his Italian operas, in the same room as the masquerades; indeed his advertisement announced his times of performance as "beginning every Evening precisely at Five, excepting Tuesday and Saturday, being the Opera Nights, when there will be no Performance at all."[16]

Hogarth at this point might have been reminded of the *Spectator* in which a projector explains that "he had observed the great Trouble and Inconvenience" entailed in going from one show to another in different parts of the town: the puppet shows were in one place, the dancing monkeys in another, and the opera in a third, not to mention the lions, far off in the Tower.[17] His solution was to bring them all together in one place in a single opera.

Hogarth may have begun his print in December, but the final incentive—or the final assurance of its topicality—came on 6 January of the new year, when Bishop Gibson preached the annual sermon before the Societies for the Reformation of Manners, and used the occasion to attack masquerades.[18] He called them the chief of "the various engines contrived by a corrupt generation" to undermine public morality, "being neither better nor worse than an opportunity to say or do there, what virtue, decency and good manners will not permit to be said or done in any other place." They gave both sexes "the freedom of profane discourse, wanton behaviour, and lascivious practices without the least fear of being discovered," and so destroyed the sense of shame in youth, "the great guard to the virtue of mankind and the chief preservative against vice." But his objections were patriotic as well as religious: they "were brought among us by the ambassador of a neighbouring nation in the last reign, whilst his master was in measures to enslave us; and indeed there is not a more effectual way to enslave a people, than first to dispirit and enfeeble them by licentiousness and effeminacy." The court, in lending itself to such designs, acts, he argues, as a model for the rest of the nation. He can envisage masquerades "spreading and growing into a fashionable diversion, which was usually the case of such diversions as were favoured and countenanced by persons of figure and standing, by whom they were generally carried from thence into all parts of the kingdom." Here, as in the *Spectator* attacks, are the implications explored in Hogarth's print and persisting in his later satires.

Finally, on 11 January the *Daily Post* announced that this might be Fawkes' last season, he "being already so much encouraged, as to be enabled to live privately in a handsome Manner." And on 21 January a correspondent wrote in Nicholas Amhurst's *Pasquin:* "Dear Pasquin, if affairs go on at this rate, the poet and the player will become useless things, while the joiner, the dragon-maker, and posture master run away with all the credit and profit."

Hogarth's print was published by 18 February, when *Pasquin* described it approvingly. Its major virtue was to unite in one image all the aesthetic follies of the time that had previously been attacked separately. The print uses the same composition as *The South Sea Scheme,* replacing the Guildhall with the Opera House, the Monument with the Lincoln's Inn Fields Theatre, the merry-go-round in the background with Burlington Gate, and the chaotic mob of speculators with groups crowding to enter the respective buildings. The perspective is somewhat less erratic in the later print, but more important, Hogarth has used

his composition to create parallels and contrasts: operas, pantomimes, palladianism, and Fawkes, all sharing the effect of distorting nature, attracting the nobility, replacing native talent with foreign fads, and putting out of business the representatives of true taste, whether Shakespeare and Congreve at Drury Lane or (by implication) Thornhill at Kensington Palace. The result is a design which makes its point with much greater clarity than *The South Sea Scheme*.

As the newspapers indicate, every aspect of Hogarth's satire was in a sense justifiable except his attack on Burlington, the most personal and controversial part of the print. But Burlington House had already been presented by Gay as the Citadel of Taste in the midst of a muddy and treacherous London in *Trivia* (1716): "Beauty within, without proportion reigns." As *Pasquin* pointed out in its description of the print, the door of the "Academy of Arts" is shut. The basic contrast offered by the print is that between the open doors of the two theaters, into which people are being lured, and the closed door of the exclusive Burlingtonians. The verses accompanying the earlier state of the print do not mention Burlington Gate; only *Pasquin* No. xcv, being carted away on the wheelbarrow, draws attention to Burlingtonian architecture (this issue attacked the new palladianism, contrasting mechanical and commonsense approaches to the "orders"). Evidently Hogarth did not want to emphasize the attack on Burlington and Kent; rather, he meant it to speak for itself. In the second state he removed *Pasquin* No. xcv and placed an indirect allusion in the concluding line of a new set of verses: "Good Gods! how great's the gusto of the Age." Only with the word "gusto" does art enter the picture. Any reader of art manuals or the *Spectator* would recognize this as an art term designating the fine excess that distinguished great art—a term sometimes defended, sometimes attacked.[19]

There are other muted, subversive notes. Great men with ribbons designating the Order of the Garter or the Bath, with their ladies, are shoving to get into the pantomime, and royal approval is even more directly implied by the grenadiers who guard the doors of the theaters. The "£1000" waved by the devil who leads the crowd into the masquerades may refer either to the king's annual grant of that amount to the Royal Academy of Music, or to the Prince of Wales' donation of that amount in support of Heidegger's masquerades.[20]

Hogarth's print is not aimed at the delusive quality of these entertainments that the *Spectator* emphasized—though this was part of the context for a contemporary, who would have interpreted the fool drawing the infatuated crowd as the immersion in a fantasy life. The concern of Hogarth's print is, rather, with the relationship between the nobility as patrons and the crowd. The mediators who were missing in *The South Sea Scheme* appear here in the figure of Heidegger, in the satyr and fool who literally draw the deluded people into the opera house, in the signboard showing noblemen paying homage to Italian opera singers, and in the images on Burlington Gate and the signboard for *Dr. Faustus*. Three groups can be distinguished: the nobility; the rest of the people,

lured by their patronage; and the impresarios like Heidegger who exploit the satyr and the fool in both of these classes.

In less than a week the print had achieved enough popularity to earn the dubious compliment of a piracy. On Monday 24 February Hogarth ran an advertisement in the *Daily Courant:*

> N.B. The Original Prints representing the Bad Taste of the Town, are sold at the principal Print-Shops, viz. Mr. Hennekin's, the Corner of Hemming's Row; Mr. Regnier's, in Great Newport-street; Mr. Bolle's [Bowles'], in St. Paul's church-yard; Mr. Gautier, in the Piazza in Covent-Garden; Mr. Overton's, at the Market; at the Corner of Pall-Mall; at Wm. Hogarth's, the Engraver thereof, at the Golden Ball in Little Newport-street, and no where else. Price 1s. Copies as well done as the present Copies sold at other petty Print-Shops, will be sold for a penny a piece in three Day's Time.

"Original" and the ironic last sentence are Hogarth's reply to the cheap copies already in circulation. Evidently one passing for an original was advertised the very next day, and on Thursday the twenty-seventh he replied in the *Daily Courant:*

> On Monday last it was advertised that the Original Prints, called the Bad Taste of the Town, to be sold at a Shilling a Piece; this is to confirm it, and to certify it will never be sold for less; and to prevent the Publick's having the Copy impos'd on them at certain Print Shops, by means of a sham Advertisment on Tuesday last. Note, Wm. Hogarth, Inv. et Sculp. is engraved at the Bottom of the Original.

Hogarth's earliest known advertisements, with their barely repressed indignation, already have that directness and vigor which was to characterize all his subsequent notices to his public.

The immediate culprit would appear to have been Thomas Bowles, who was advertising a pirated copy on 6 March for 6*d,* and was one of those to whom Hogarth had consigned his print for sale. Bowles, famous as "the great print-seller," had begun his business around 1709 selling maps in his shop next to the Chapter House in St. Paul's churchyard; by the 1720s he was selling the widest assortment of prints and illustrated books in London. In 1720 his younger brother John had started a business of his own, but closely connected with his brother's, in a shop opposite Stocks Market. Although they appear to have been utterly unscrupulous, it should be remembered that prints were merely a commodity to them, that there were no laws protecting the artist, and that their contemporaries included such legendary scoundrels as the bookseller Edmund Curll.

To Hogarth, looking back on his youth, this betrayal by the printsellers was to constitute one of the important parallels between his life and his father's:

> I found this Tribe as my father left them when he died <which was> about four or five years before this time of Illness occationd by partly the useage he met with from this set of people <and partly by> disapointments from great mens Promises. So that I doubly feelt their usage which put me upon publishing on my own account but here again I [met] a monopoly of Print-sellers equally distructive to the Ingenious for the first plate I Published called the Tast of the Town in which the then reigning follies were lashd, had no sooner begun to take run but I found coppies of it in the print [shops] selling for half the price whilst the originals return'd [to] me again in which I [was] obliged to sell my plate [for what] these pyrates pleasd to give me, as there was no place of sale but at their Shops.[21]

This passage was written by Hogarth in his autobiographical notes in the early 1760s. But only a decade after this experience, in 1734, he or one of his close associates, petitioning Parliament for redress, put it more systematically: the engravers' expenses, labor, and invention could only be rewarded "By the Profits arising to them from the Sale of their Prints; and the Reputation they acquire by them in their Profession; which gradually enhances the Value of what they shall afterwards produce."[22] The situation described in 1734 is actually much closer, as regards Hogarth, to that of 1724 when he published *Masquerades and Operas*. The artist lacks a house where he can conveniently exhibit or sell his prints, and so he is at the mercy of the printsellers, who form a monopoly, there being perhaps a dozen of note in the whole of London. "Hence it is easy to conceive, how it comes about that they are all agree and stand firmly by one another, in oppressing and keeping in their Power the very Men, without whom their Shops wou'd soon become unfurnish'd." First, the petitioner explains, the engraver takes his print to the printseller, who insists "upon a most unreasonable Share of the Profits for selling the Prints, near double what a Bookseller ever demands for publishing a Book. It is in vain for the Artist to remonstrate, or try any other Shop. They are all agreed, and no less is ever to be taken. So of Consequence he must submit."

The next step follows when the printseller discovers that there is a demand for the print. Then he procures cheap copies, which he sells to the ordinary buyer as originals, or sends them to the provinces, where there is less chance to compare them with the originals.

> When the Artist returns to make Enquiry into the Number of his Prints, that are sold, and expects a Return to his Labour and Expence; He is told, with an insolent and careless Air, 'His Prints have been copied—The Copies sell as well as the Originals—Very few of his have gone off' and is presented with a large Remainder, which he is forced to take home with him.

Nor is this the end of the artist's misery: "though at first he may complain of [the printseller] wherever he comes, and stand out in Opposition against him, [he] must of necessity at last fall into his unmerciful Hands."

> His Share of the Profits falling so short of the Expence of Time and Money which he was at in the Execution of his Design; he is first driven by his Necessity, and for a present Supply, to part with the Original Prints returned upon his Hands, his Plates, and all to these very Men at their own Price; which, you may be sure, will be very low, as they know he has no other Chance of disposing of them.

At this point in the pamphlet Hogarth's own story ends, but the possible fate of the engraver, which he studiously avoided himself, is projected:

> And soon after, seeing how vain it is to attempt any thing New and Improving, he bids farewel to Accuracy, Expression, Invention, and every thing that sets one Artist above another, and for bare Subsistence enters himself into the Lists of Drugery under these Monopolists; where if he has Strength of Constitution to Work Night and Day, (no matter whether well, or ill,) he may perhaps be able to bring the Week about, but never is suffered to Thrive, or grow Rich, lest he should grow out of their Power.

He thus joins those hacks who engrave the cheap copies for the printseller who originally cheated him.

It appears from these passages that *Masquerades and Operas* was the first print Hogarth had sold on consignment, keeping the plate to himself. (The obscurity of *The South Sea Scheme,* the "first Plate" he published, makes it at least possible that he attempted the same there, with even less success.) In general, he sold his plates outright. Having attempted this independent arrangement for *Masquerades and Operas,* he discovered first that his print was pirated, then that his own retail printshops were having cheap copies made. When he demanded his money he was told that no one had bought his originals—they had bought instead the cheap copies, on which the full printsellers' profit could be realized. In order to make any profit at all, Hogarth was at length forced to sell his plate, presumably to Bowles. The addition of Hogarth's address, "the Golden Ball in Little Newport Street," to a later state of the print may mean that he first took back his stock and tried to sell it himself, from his own shop, before giving up and selling the plate. Bowles continued to collect Hogarth's early plates and pirate his later ones, but Hogarth never again had anything professionally to do with the Bowles brothers; he turned to the other major printselling family of the time, the Overtons.

By 1724 he had left his mother's house and moved to a room or a floor in a

house in Little Newport Street, evidently used as a shop, with the sign of a golden ball.[23] He cannot have been very well off. The money, as well as the reputation, from a plate like *Masquerades and Operas* would have been of the utmost importance to the young artist; the experience undoubtedly contributed to his continued outrage over piracies in the 1730s, and it remained fresh in his mind nearly forty years later when he wrote his autobiographical notes.

But if he did not make the profits he anticipated from his print, he at least brought himself to the attention of the public. Nicholas Amhurst, for one, praised the print in *Pasquin* and employed him to make a frontispiece for his collected *Terrae Filius* papers; subsequently, as editor of the *Craftsman,* he may have brought Hogarth's work to the attention of Bolingbroke, Swift, and (if the attack on Burlington had not already done so) Pope. On 20 February a prologue spoken at the new theater next to the Opera House in the Haymarket alluded to Hogarth's print and "the Taste of this fantastick Town," and on 4 March when Charles Gildon's *New Metamorphosis* was published, Hogarth's name was in the headline of the advertisement (*Daily Courant*): "Just published, printed in two Pocket Volumes, and adorned with Cutts engraved by Mr. Hogarth."

Gildon's work strikes a new note for Hogarth: it is an updating of Apuleius' *Metamorphoses* in which the ass is replaced by *"a fine* Bologna *Lap-Dog,"* which is more readily "admitted to the Closets, Cabinets, and Bedchambers of the Fair and the Great" than an ass. Gildon's satire had been published in 1708, and Hogarth was apparently employed to copy the plates for that edition and add a few of his own, none of which is very distinguished; only the fame of *Masquerades and Operas* could have led the publisher to produce his name in the advertisements. Hogarth's frontispiece (pl. 29), however, is of great interest, especially since it was copied from the anonymous frontispiece of 1708. It presents in one plate the interplay of story and frame, present and past, real and fictional which (very crudely) informs Gildon's fable; this kind of interplay will reappear in Hogarth's *Hudibras* frontispiece and, somewhat modified, in much of the work that follows. The frontispiece shows a contemporary scene framed by a window-like structure; on the viewer's side, two satyrs are pointing to it and indicating its satiric nature (they reflect the popular derivation of satire from satyr). Above the window are the figures of Lucian and Apuleius (authors of the classic stories of Lucius transformed into an ass), each with his ass, and between them is Gildon, who had modernized them. Thus the contemporary story is presented as seen through a window (the draped curtains barely suggest a theatrical effect), with clear reference to its sources and analogues, its satiric intent, its ancient authors, and its modern adaptor. All are presented as part of the historical context for the contemporary action with its lapdogs and loose women; the operation of Hogarth's mature compositions, though enormously elaborated, will not be very different.

This print, appearing at the same time as *Masquerades and Operas,* an-

29. Frontispiece, *The New Metamorphosis;* March 1723/4 (second state); 5⅜ x 3 in. (W. S. Lewis)

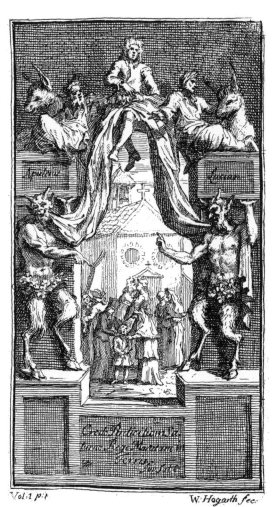

30. The Lottery; publ. 1724 (second state); 8¹³⁄₁₆ x 12⅝ in. (W. S. Lewis)

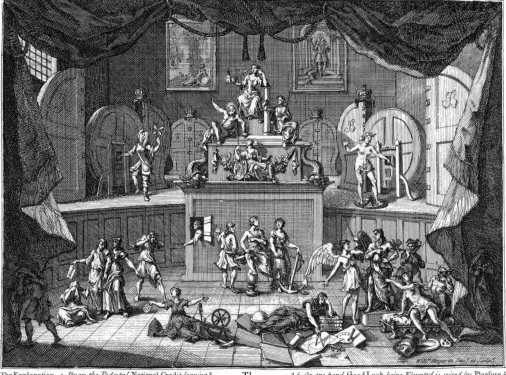

The Explanation. *1. Upon the Pedestal* National Credit *leaning on a Pillar supported by* Justice. *2.* Apollo *shewing* Britannia *a Picture representing the Earth receiving enriching Showers drawn from her self (an Emblem of* State Lottery's*). 3* Fortune *Drawing the Blanks and Prizes. 4.* Wantonness *Drawing ye Numbrs. 5. Before the Pedestal* Suspence *turnd to & fro by* Hope *&* Fear.

The
LOTTERY

6. On one hand, Good Luck *being Elevated is seized by* Pleasure *&* Folly; Fame *persuading him to raise sinking* Virtue, Arts *&c. 7. On ye other hand* Misfortune *opprest by* Grief, Minerva *supporting him, points to the Sweets of* Industry, *8.* Sloth *hiding his head in ye Curtain: 9. On ye other side,* Avarice *hugging his* Mony, *10.* Fraud *tempting* Despair *wth Mony at a Trapdoor in the Pedestal.*

nounces in its own way Hogarth's aims as a satirist and as a modern. As a satirist he was now a known force on the London scene. He had not only launched his career and experienced pirating, but had also produced a print that was to influence Pope's conception of *The Dunciad* (1728) and thereafter a whole stream of satires, culminating in Fielding's farces. Satire was a form that was much appreciated in the 1720s; Hogarth came upon the scene at just the right moment, when the tradition of Butler, Dryden, Swift, Pope, and Gay had reached its ultimate fruition and prepared the public for a graphic satirist of comparable stature. Hogarth filled that need. As this timing explains something of Hogarth's very rapid rise, so the waning of interest in satire in the 1750s explains something of his difficulties in that decade.

Masquerades and Operas either introduced Hogarth to, or ingratiated him with, Sir James Thornhill. Between its appearance in February and the opening of Thornhill's academy in November, Hogarth showed in various ways the presence of Thornhill in his thoughts. He might have seen the paintings in St. Paul's and Greenwich Hospital many times before, but only at this point did he begin to reveal what he was learning from them. They were, however, quite different experiences, and the effect of Greenwich emerged first. The ceiling of the Lower Hall was Venetian baroque, only slightly played down to suit the sensibilities of sober Englishmen. It was full of figures in classic attire, flowing in masses sometimes indistinguishable from the clouds on which they reclined, but each with a distinct allegorical significance, which Thornhill often carefully inscribed on his drawings. With his help, Sir Richard Steele wrote an elaborate account of the Painted Hall when it was finished in 1714, which later served as the basis for the pamphlet called *An Explanation of the Painting in the Royal Hospital at Greenwich*.[24] It is a little difficult to imagine Hogarth grasping the significance of these coruscating figures without some such key or Thornhill's own guiding hand. But at about this time such figures began to appear in his ambitious plate, *The Lottery* (pl. 30).

The South Sea Scheme, with its wonderful clumps of figures but awkward architecture and perspective, followed the tradition of Dutch drolls; the figures were all grotesques, with only a stab at portraying ideal figures in Honor and Honesty. *The Lottery,* on the other hand, reflects signs of academic training, knowledge of Raphael's *School of Athens,* and firsthand study of Thornhill's Greenwich ceiling. Like these it is wide and crowded with idealized, academy figures. Every figure and object is a personification of some sort. It reminds one of those dream visions the *Spectator* liked to employ, such as the one in No. 3 (3 March 1710/11) which allegorized England's financial situation and from which Hogarth may have taken his image of National Credit as a young virgin enthroned. Most significantly as regards Hogarth's development, however, he portrays his personifications on a stage (in 1723 lotteries were in

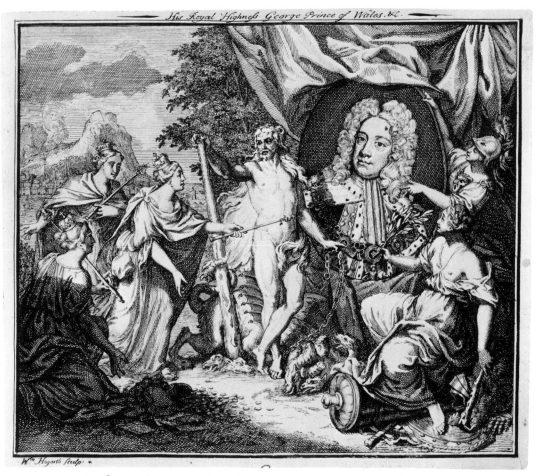

31. George Augustus, Prince of Wales; date unknown; 5¾ x 7 in. (BM)

fact being drawn on the stage of the Opera House): suggesting that they are as delusive as a Rich pantomime. A gradual transition from emblem to allegory to symbolism may be traced through Thornhill's decorative histories and at the same time through the intermediate imitation of real people dressed as allegorical figures on a stage. Hogarth characteristically seems to have required both.

Another print, *The Prince of Wales* (pl. 31), apparently originated at about the same time from Hogarth's contact with Thornhill's ceiling of the Upper Hall, which had been finished in October 1722. The Hercules figure, which Thornhill calls in his *Explanation* "Heroic Virtue," appears, as does Wisdom— Pallas Athena—shown on the ceiling of the Painted Hall together banishing Calumny, Detraction, Envy, and others (pl. 32). It is appropriate that Hercules should figure centrally in Thornhill's allegory of the Protestant Succession; as Heroic Vertue, Hercules was iconographically connected with William III, fighting the Hydra of France. Hercules appears again on the ceiling of the Upper Hall supporting a portrait of Queen Anne and Prince George, assisted

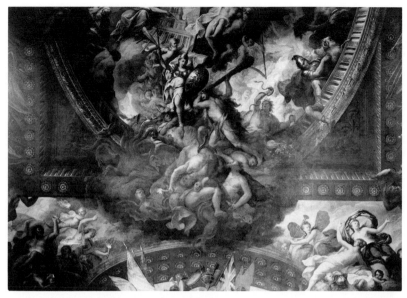

32. Sir James Thornhill, Hercules defeating Calumny, Detraction, and Envy: detail of the Painted Ceiling, Lower Hall, Royal Naval Hospital, Greenwich; 1707–17 (British Crown Copyright)

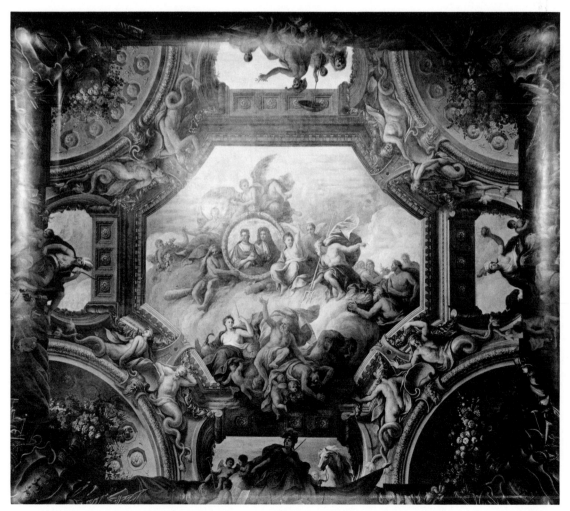

34. Sir James Thornhill, Detail of Queen Anne and Prince George, ceiling of Upper Hall, Royal Naval Hospital, Greenwich; 1721–22 (British Crown Copyright)

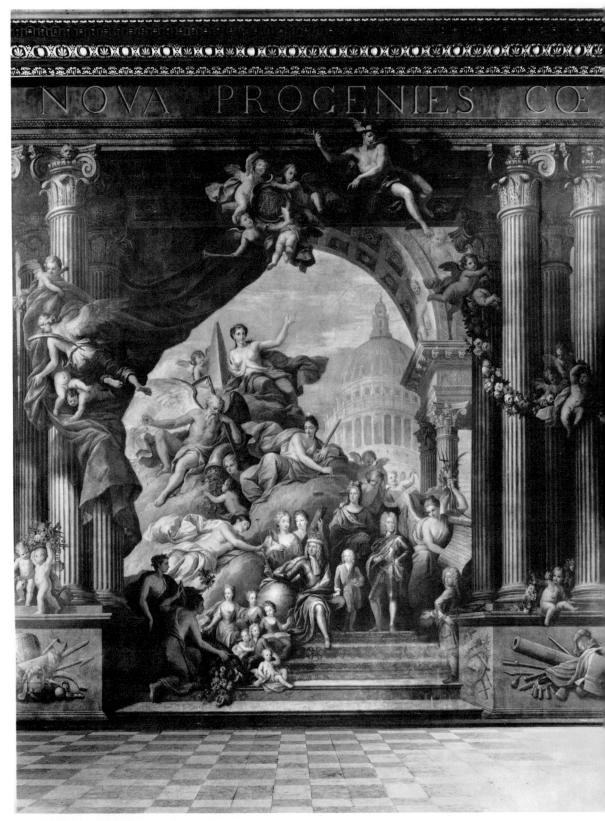

33. Sir James Thornhill, George I and his Family, Upper Hall, Royal Naval Hospital, Greenwich; 1722–24 (Brit. Crown Copyright)

35. Royalty, Episcopacy, and Law; May
 1724; 7¼ x 7 in. (W. S. Lewis)

by Conjugal Concord, Liberality, Piety, Victory, and Neptune (pl. 34). And
this is the way Hogarth uses Hercules in his print, supporting the portrait of
the Prince of Wales with various goddesses and muses offering homage and the
riches of England. He was to refer directly or obliquely to this figure, with his
associations of Heroic Virtue, the Protestant Succession, England, Greenwich,
and Thornhill, throughout his career.[25]

At about the same time, Hogarth was also etching a satire based on the Wil-
liam and Mary on the ceiling of the Lower Hall—or on George I and his family,
which Thornhill was then preparing for the wall of the Upper Hall (pl. 33). In
the same baroque robes and accouterments, the same cloudy surroundings as
Thornhill's Greenwich paintings, he posed a king, a bishop, and a judge. The
occasion for this etching, usually called *Royalty, Episcopacy, and Law* (pl. 35),
had arisen in the spring of 1724 when a flurry of articles and pamphlets appeared
anticipating a solar eclipse on 11 May. By the first of May specially-prepared
glasses were being advertised by William Rodwell, and, predictably, the Bowles
brothers were touting rival glasses "judiciously prepar'd to preserve the Eye in
looking at the Eclipse." Amid all this excitement, Hogarth imagines what one
might see through a telescope when the moon intervened between earth and
sun: "Some of the Principal Inhabitants of yᵉ Moon, as they were Perfectly
Discover'd by a Telescope brought to yᵉ Greatest Perfection since yᵉ last

Eclipse.''[26] The telescope, a device related to Gildon's lapdog, reveals what was not visible at the great distance that stretches between these regal figures and the public (whether on a Greenwich ceiling or in fact): that they are only robes hung over frames, the king's head turning out to be merely a guinea, the bishop's a Jew's harp, and the judge's a gavel.

The print uses the forms and scale of the Thornhill royal families, while the details are drawn from the oldest, most primitive emblematic tradition of graphic satire, reaching back to the Reformation portrait of the pope's head: on close scrutiny, it proves to be constructed entirely of symbolic popish objects like wafers and chalices. Thus the tongue of the Jew's-harp which is the bishop's head is operated by the handle of a pump that resembles a church tower. Pumping the handle (around which is wrapped a Bible) rings a bell in the steeple and pours coins into a chest stamped with the bishop's armorial bearings: knife, fork, and spoon below a miter. His left foot, peeping out from under his robe, is a cloven hoof. With the increased size of the figures relative to the picture space Hogarth has advanced a long way from the tiny, crowded figures of his earlier "drolls." If in *The Lottery*—no longer a cartoon but a kind of history engraving —he stepped from purely emblematic satire into allegorical representation, in *Royalty, Episcopacy, and Law* he used these baroque shapes that appear to be king, bishop, and judge to betray the trumpery reality beneath the garb of power. Thereafter he continued to emphasize the baroque finery, while playing down the crudely emblematic ridicule.

Royalty, Episcopacy, and Law must have been published in May or June; *The Lottery* was finished and announced for sale on 19 September in the *Daily Post.* The advertisement itself suggests that it may have been started earlier, perhaps shortly after its pendant *The South Sea Scheme,* but was only completed and published in the wake of the popular *Masquerades and Operas:* "On Monday next [i.e. 21 September] will be publish'd, a curious Print, call'd, the Humours of the LOTTERY, by the Author of the little Satyrical Print, call'd the Taste of the Town. To be sold the Corner of Hemmings Row [;] in Little Newport-street, and most other Print Shops, Price 1 s."

Not long after, Hogarth began to conceive another print which bears a devious, problematic relationship to Thornhill: *The Mystery of Masonry brought to Light by the Gormogons* (pl. 36). This clumsy though carefully finished print, usually taken as an attack on Freemasonry, was completed during the first month of Thornhill's new free academy, which Hogarth almost certainly attended. Thornhill, about to become master of his lodge, was one of the most prominent Freemasons in London.[27] The question of the print and its relation to Thornhill is complicated by its obscurity, which is largely due to false perspective and scale. Most of these problems are resolved, however, by an examination of the occasion and the print itself.

The first formal Grand Lodge of Freemasons was organized in London in

1717. By 1721 the Grand Master was the Duke of Montagu, the first of a long line of noblemen to hold the position, and through him the Freemasons rose to social prominence—along with masquerades, operas, and pantomimes.[28] Thornhill may have been a Freemason from the start; he appears in the earliest surviving records of his lodge and in 1725 became master. In 1723, however, when the unstable young Duke of Wharton was Grand Master, fissures began to appear, evidently enlarged by the publication of James Anderson's *Constitutions* in February of that year; the Jacobite Wharton withdrew and apparently helped found a rival, and possibly Jacobite, society called the Gormogons.[29] The Gormogons themselves appeared in the early fall with a notification in the *Daily Post* of 3 September.

> Whereas the truly ANCIENT NOBLE ORDER of the Gormogons, instituted by Chin-Quaw Ky-po, the first Emperor of China (according to their account), many thousand years before Adam, and of which the great philosopher Confucius was Oecumenical Volgee, has lately been brought into England by a Mandarin, and he having admitted several Gentlemen of Honour into the Mystery of that most illustrious order, they have determined to hold a Chapter at the Castle Tavern in Fleet Street, at the particular Request of several persons of Quality. This is to inform the public, that there will be no drawn Sword at the Door, nor Ladder in a dark Room, nor will any Mason be receiv'd as a Member till he has renounced his Novel Order and been properly degraded. N.B.—The Grand Mogul, the Czar of Muscovy, and Prince Tochmas are enter'd into this Hon. Society; but it has been refused to the Rebel Meriweys, to his great Mortification. The Mandarin will shortly set out for Rome, having a particular Commission to make a Present of the Ancient Order to his Holiness, and it is believ'd the whole Sacred College of Cardinals will commence Gormogons. Notice will be given in the Gazette the Day the Chapter will be held.

Mireweys, the Czar of Muscovy, and Prince Tochmas were figures much in the news that summer. Mireweys (or Meer-Vais) was the son of an Afghan Chief who had deposed the "Sophy" or head of the "Sufawi" dynasty in Persia, and Prince Tachmas (or Thaumas) was the rightful heir, the "Young Sophy," now in exile but supported by the Czar of Russia.[30] The allegorical relationship to George I, the Pretender, and the King of France was obvious and was exploited by Wharton and the Gormogons. It was through such allegories that Jacobite opposition expressed itself in the 1720s.

Aaron Hill, a Freemason himself, published an essay on the subject in his *Plain Dealer* of 14 September, arguing that the Freemasons had better heed these symptoms of decay and reform themselves. He is appalled at the leniency of admissions—vintners, drawers, wigmakers, and tailors have been admitted, and before long, he fears, women will be; all of which has brought contempt

upon the order. Stories have been spread, as in books like *The Grand Mystery of Freemasonry Discover'd*[31] and in the Gormogon notice, about some lodges: "Alarming Reports, and Stories of Ladders, Halters, Drawn Swords, and Dark Rooms. . . . Unless the Grand Master puts a Stop to these Proceedings, by a peremptory Charge to the Brotherhood, I wish I cou'd honourably enter into Another." Hill then alludes to the Gormogons, although he concludes that rather than meet their stipulation of being degraded as a mason, he will decline their offer of membership tendered by the mandarin Hang-Chi.

This essay, in a periodical that had joined Hogarth in attacking pantomime, I take to be his starting point, and I suspect that—as with the pantomime—his aim here was to reprove, not destroy. Indeed, to take the approach of the Gormogons would have entailed sidling too close to Jacobitism. The last couplet of the inscription under his print, based as it is on Pope's description of Atticus (Addison), catches the right tone:

> Who would not Laugh when such Occasion's had?
> Who should not Weep, to think yᵉ World so Mad.[32]

The print appears to be an attempt to correct abuses among the Freemasons themselves; Hogarth is saying, as Pope does of Addison, how sad if this *were* so—exactly echoing Hill's tone.

Hogarth was himself demonstrably a Freemason by 27 November 1725, in the lodge that met at the Hand and Appletree in Little Queen Street, which joined High Holborn and Great Queen Street.[33] This lodge had been constituted 10 May of the same year, but may have met earlier; and Hogarth may well have been a member when he made his print in November of 1724.

Moreover, the print is carefully finished and signed as "Grav'd by Ho–ge," and so advertised. Hogarth was certainly not trying to conceal his identity; in fact, this print is distinguishable from other unsigned and relatively slapdash prints he was producing at the same time (though, significantly, they are superior). An explanation might begin with Hogarth's attempt to impress Thornhill, the Freemason, who like Hill was probably interested in masonic reform. It seems possible that the print was undertaken with Thornhill's encouragement, if not at his suggestion; therefore Hogarth labored to produce a highly finished work, and did not have it ready for publication until the first of December.[34]

The print criticizes the emphasis on mystery and symbolism in the masonic ritual. With Freemasonry still in its infancy, such an admonition was reasonable. Beginning as an imitation, even a kind of parody, of the guild of masons, the Freemasons drew their symbolism from the building of Solomon's Temple; and by 1724 the system's complexity and flamboyancy—judged by *The Grand Mystery of the Freemasons Discover'd*—might have reminded Hogarth of, say,

Italian operas. His feelings about masonic symbolism must have been mixed: on the one hand he would have observed (perhaps as an insider) their posturing and mystery for its own sake as folly and delusion, while at the same time as an artist he saw that they offered ways of "delineating a system of morality veiled in allegory and illustrated by symbols"[35]—and a further sanction for his own inclination and practice.

Meanwhile, the Gormogons' parody of the Freemasons was still newsworthy. On 17 October *The Weekly Journal, or Saturday's Post* reported that "we are informed a great many eminent Free-Masons have degraded themselves, and come over to this Society [of Gormogons], and several others rejected, for want of Qualification." And on the twenty-eighth the second edition of *The Grand Mystery of the Freemasons Discover'd* was published, with "Two Letters to a Friend—the first, concerning the Society of Free Masons; the second, giving an Account of the most Ancient Order of Gormogons."[36] Each letter is signed Verus Commodus, and the second is based on Hill's *Plain Dealer* essay, most of which is reproduced. Here the Society of Gormogons is used as an ideal against which to judge the Freemasons: the Gormogons admit members for merit, while the Freemasons admit "without any other Regards than the Entrance-Fine, and consequential Gluttony, and Ebriety, promiscuously, and without Distinction"; and as to secrets, the Gormogons "put on no affected Grimaces, in order to palm upon the Publick, the most insignificant Trifles for the profoundest Mysteries; nor do they treat real and venerable Mysteries as Trifles." This, of course, is the opposite of Hogarth's usage: he employs the Gormogons as a caricature of the Freemasons, not an ideal alternative.

Commodus indicates something of the reasons for the schism, and in doing so gives Hogarth another of the images—the most outrageous—for his print:

I cannot guess why so excellent and laudable a Society as this of the GORMOGONS, should think it worth their while to make it an Article to exclude the *Free-Masons* . . . Except there be any Truth in what I have heard reported. · . The Report is this, That the *Mandarin* [Hang Chi] has declared, that many years since, Two unhappy busy persons who were *Masons* [Anderson and Desaguliers], having obtruded their idle Notions [*Book of Constitutions*] among the *Vulgar Chineze*, of *Adam*, and *Solomon*, and *Hiram*. · . Being Crafts-men of their Order; and having besides, deflower'd a venerable OLD Gentlewoman, [taken unwarrantable liberties with the Operative Charges and Regulations], under the Notion of making her an *European* HIRAMITE (as they call'd it). · they were hang'd Back to Back, on a Gibbet. · And ever since, it has been an Article among the *Gormogons*, to exclude the Members of that Society, without they first undergo a solemn *Degradation*. · . Tho' methinks, The Business

of the OLD Gentlewoman affords, as our Weekly Politicians say, Matter of Speculation; and at the worst, I hope the inraged Matron went too far in her Evidence, and was rather *saluted* than *violated*.

Hinting that Hill's fears and the Gormogons' accusations may not be unfounded, Hogarth places among the true Freemasons a costumed, sword-bearing man and a woman Freemason holding a candle. These Freemasons stand in front of one of their lodges, the Grapes Tavern (an accusation being that they only met to drink). Across the foreground, in front of them, parade the Gormogons, led by A. the Emperor Chin-Quaw-Kypo, B. Confucius, S. In-Chin the present Oecumenical Volgi, and D. the Mandarin Hang-Chi. The old lady on the ass being "saluted" refers to the "venerable old gentlewoman" in Verus Commodus' letter, and the ladder and other props are taken from the various accounts of the Gormogons.[37] The lady on the ass, however, may point to another source for the print's conception: earlier in the year Hogarth had published illustrations for Gilden's *New Metamorphosis,* an adaptation of Apuleius' *Metamorphoses,* and his frontispiece (pl. 29) shows both Lucian and Apuleius and their asses. At the end of Apuleius' work, and in any of a number of emblem books, Hogarth would have come across "Asinus portans mysteriam," which was at the center of the Eleusinian mysteries and, in Apuleius, carried the image of Isis.[38]

Presumably the drawer and Sancho Panza are intended as part of the procession, laughing only at the sight of the "old gentlewoman," not as a third group amused by the whole Gormogon procession (like the two men in *Masquerades and Operas*). The feeble sense of scale and perspective confuses the composition. Hogarth tries to indicate depth by the repoussoir cellist at the left and by lightly indicating the Freemasons at the back, but the foremost Freemason's feet are just behind Quixote's; and the procession itself, because of the positions of the ass and Quixote, seems to be coming from the Grapes Tavern instead of parading in front of it. Nevertheless, the print is interesting because it reflects both Hogarth's developing relationship with Thornhill and his awareness of images from emblem books and Coypel's *Don Quixote* illustrations.

From the latter he takes most of his characters with hardly a change; but far from merely pilfering, he uses them as a context of allusion. The illustration from which these figures were taken (one, the Chinese Sage, "D," came from another Coypel plate) was *Don Quixote's Adventure at the Puppet Show* (pl. 37)—the amazed Sancho Panza and the laughing drawer are reacting to Don Quixote's confusion of illusion with reality as he attacks the puppets. Quixote, as deluded by the Gormogons as by the puppet show, wears a Freemason's apron and pays homage to the "mysteria" on the ass. Most of Hogarth's audience would have recognized the figures of Quixote and Sancho (though the point would have been clear enough if they had not), and a choice few could have been

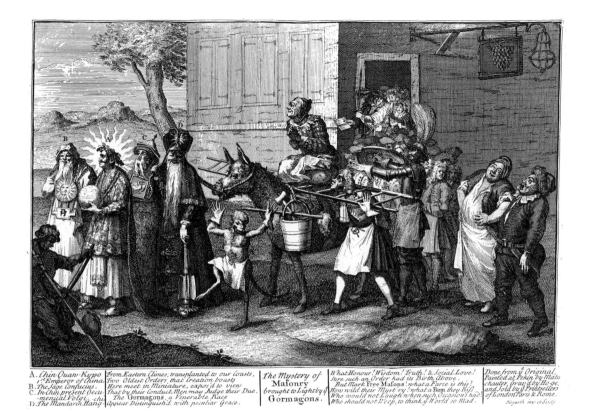

A. Chin Quaw-Kypo	From Eastern Climes, transplanted to our Coasts.		What Honour! Wisdom! Truth! & Social Love!	Done from ye Original
1.st Emperor of China.	Two Oldest Orders, that Creation boasts	The Mystery of	Sure such an Order had its Birth, Above.	Painted at Pekin by Matu
B. The Sage Confucius.	Here meet in Miniature, expos'd to view	Masonry	But Mark Free Masons! what a Farce is this!	chaiter, grav'd by Ho-pe,
C. In Chin present Oecu-	That by their Conduct, Men may Judge their Due.		How wild their Myst'ry! what a Bum they Kiss!	and Sold by ye Printsellers
-menical Volgi ... chi	The Gormagons, a Venerable Race	brought to Light by ye	Who would not Laugh when such Occasion's had!	of London Paris & Rome.
D. The Mandarin Hang	Appear Distinguish'd with peculiar Grace.	Gormagons.	Who should not Weep, to think ye World so Mad.	Hogarth inv: et Sculp

36. The Mystery of Masonry brought to Light by the Gormagons [sic]; Dec. 1724 (second state);
8½ x 13½ in. (W. S. Lewis)

37. Charles-Antoine Coypel, Don Quixote demolishing the Puppet
Show (engraving by Gerard Vandergucht); 1725 (BM)

expected to recall the particularly rich context of the puppet show, and for that matter of the "Asinus portans mysteriam" emblem. It was therefore a plate that reached the lowest, most unrefined citizen, though only such sophisticated and discerning gentlemen as Sir James Thornhill would recognize and appreciate the subtler allusions.

Hogarth also assumes the same general relationship as Coypel between figures and picture space, as opposed to the small, Callot-like figures and great empty spaces, or crowded *horror vacui*, of his Dutch models. And, as I have noted, he shows Londoners dressed in the fantastic Freemason and Gormogon regalia, rather as in one of Picart's *Cérémonies et coutumes*, thus preserving both the allegorical and realistic levels and approaching a theme concerned with disguise and playacting which, in his next print, he would depict on a real Drury Lane stage.

When the mock-masonry print was finished, presumably late in November, Hogarth sold it to a Mr. Holland, a printseller in Earl Street, near Seven Dials, who subsequently added to the enigmatic "Grav'd by Ho–ge," "Hogarth inv: et Scul:". He sold the prints wholesale to the other printsellers of London, according to the first advertisement, dated 2 December.[39]

By the end of 1724 Hogarth must have been dividing his time between his quarters in Newport Street, his mother's and sisters' flats in the vicinity of St. Bartholomew's Hospital, and the Thornhill residence in Covent Garden. His thoughts and his work were revolving around Thornhill, and when he came to visit Thornhill's house it was probably more as a friend, or possibly a son, than as a student.

Hudibras

The next event which brought Hogarth and Thornhill together was the death of the robber and escape artist Jack Sheppard. Sheppard's last and most spectacular escape had been from Newgate Prison on the night of 15 October—"to the great Admiration of all People," as the *Weekly Journal* said, "he being chain'd down to the Floor in the Castle of the Jail, with Fetters on his Legs of a prodigious Weight." He was quickly recaptured, however, and did not escape again. *The History of the Remarkable Life of John Sheppard* was advertised on the nineteenth, and on the twenty-fourth a portrait "drawn by a Painter who went to see him" was advertised by Thomas Bowles. On 10 November the *Daily Journal* noted that "Sir James Thornhill, the King's History Painter, hath taken a Draught of Sheppard's Face in Newgate."[1]

It is interesting to surmise why Thornhill decided to draw a convicted criminal at this particular time, and what Hogarth had to do with it. The Sheppard portrait was a unique phenomenon in Thornhill's career, but not completely inexplicable. In his huge sketchbook (now in the British Museum) allegorical designs in the grand style are jostled, sometimes on the same page, by sketches of intimate, realistic, sometimes grotesque characters in the manner of Dutch "drolleries" (pls. 38a and b).[2] This was not an unusual predilection, or sideline, for a history painter like Thornhill. Karel van Mander, who in *Het Schilderboek* agreed that the noblest subjects for a painter were a religious or historical theme and the idealized nude figure, himself painted genre pictures like Brueghel's as well as history paintings; Annibale Carracci of course mingled caricature and genre studies with history paintings. But Thornhill never allowed this predilection to get the upper hand. He painted a number of portraits, but except for the one of Sheppard they were all conventional.[3]

Thornhill's hobby, as it might be called, explains the origin of his regard for Hogarth and perhaps the pleasure with which he received *Masquerades and Operas*. Whenever he and Hogarth first met, they would have recognized a mutual taste for "drolleries" and a reaction against the idealized world of history painting. By 1724, with the rise of Kent and the Burlingtonians, and the paint-

38a. Sir James Thornhill, Sketchbook, f. 29 (BM)

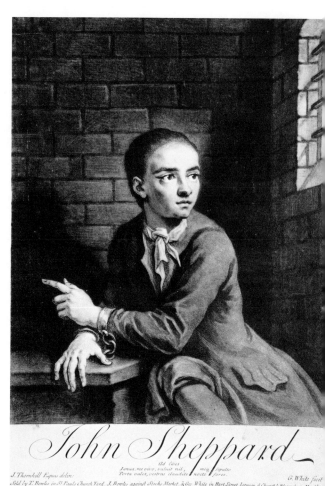

John Sheppard

39. Sir James Thornhill, Jack Sheppard (engraving by
George White); Dec. 1724 (BM)

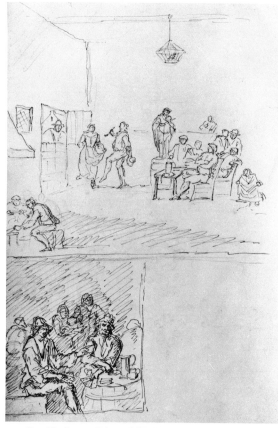

38b. Sir James Thornhill, Sketchbook, f. 52 (BM)

ings by Ricci and Kent at Burlington House, Thornhill may well have been looking for diversion. A germ of interest in the Sheppard portrait, then, was apparently nourished by recent events and a recent contact, and it seems within the realm of possibility that Hogarth accompanied Thornhill to Newgate, as Thornhill later accompanied him to the same prison to paint Sarah Malcolm. The place, of course, was hardly new to Hogarth. During the years of his father's insolvency he must have become all too familiar with landmarks like Newgate's tower straddling Newgate Street and its emblematic statues: Justice, Fortitude, and Prudence on the east side; Liberty, Peace, Security, and Plenty on the west side. He evidently read as a boy *The Memoirs of the Right Villainous John Hall* (1708), to which he alluded in *A Just View of the British Stage*—a pamphlet containing a long and horrendous description of Newgate, pointing out, among other things, that one could amuse oneself by pausing under the gate near the grate of the Women Felons' Apartment and listening to them swear extempore.

Around the first week in November Thornhill went to Newgate and drew the powerful picture of the thin, almost childlike criminal, alone in his cell (pl. 39).[4] Sheppard himself, whether Hogarth saw him in person or only in Thornhill's likeness, may have interested him as a distorted mirror image of his own career: born miserably poor but taught to read and write, he was apprenticed to a cane chair maker, ran away from him, was aided by the kindness of a Mr. Kneebone, a woolen draper in the Strand, and apprenticed to Owen Wood, a carpenter in Wych Street, Strand. After four tedious years with Wood, he neglected his work, fell into bad female company, committed several robberies, quarreled with his master, and once free of his apprenticeship joined a gang of thieves and squandered the two years of life remaining in thievery, imprisonment, escapes, and recaptures. He was hanged on 16 November, aged 22.

On the twenty-eighth the *British Journal* published a poem celebrating Thornhill's immortalizing of Sheppard:

> *Thornhill,* 'tis thine to gild with Fame
> Th' obscure, and raise the humble Name;
> To make the Form elude the Grave,
> And *Sheppard* from Oblivion save.
>
> Tho' Life in vain the Wretch implores,
> An Exile to the farthest Shores,
> Thy Pencil brings a kind Reprieve,
> And bids the dying Robber live.
>
> This Piece to latest Time shall stand,
> And shew the Wonders of thy Hand.
> Thus, former Master's grac'd their Name,
> And gave egregious Robbers Fame.

> *Appelles Alexander* drew,
> *Caesar* is to *Aurellius* due,
> *Cromwell* in *Lely's* Works doth shine,
> And *Sheppard, Thornhill,* lives in thine.

The last stanza indicates the unique appeal of Thornhill's portrait: he has portrayed an actual criminal, poor, alone, and about to be hanged, and not the metaphorical criminal Alexander, Caesar, or Cromwell. But such lines, reminiscent of the gist of many popular rogues' biographies, imply an ironic relationship between high and low criminals that would remain with Hogarth.

On the day the *British Journal's* encomium appeared, the patentees of Drury Lane—Cibber, Wilks, and Booth—produced their own exploitation of Sheppard, a pantomime called *Harlequin Sheppard,* intended to out-pantomime Rich. On the same night Dryden's "dramatick Opera of Dioclesian" was staged at Rich's theater: "the Decorations were magnificent and new, and the Musick new set, which was received with extraordinary Applause." *Harlequin Sheppard,* however, "was dismiss'd with a universal Hiss.—And, indeed, if Shepherd had been as wretched, and silly a Rogue in the World, as the ingenious and witty Managers have made him upon the Stage, the lower Gentry, who attended him to Tyburn, wou'd never have pittied him when he was hang'd."[5]

On 5 December the Bowles brothers and George White published White's mezzotint of Thornhill's portrait at a shilling.[6] On the tenth Hogarth's own response to Sheppard, to Drury Lane's pantomime, and in some sense to Thornhill's portrait too was published: "A Print representing the Rehearsal of a new Farce, call'd three Heads are better than one, including the famous Entertainments of the Harlequin Doctor Faustus, and Harlequin Shepherd . . . Sold at the Print Shops in and about London and Westminster. Price 6d."[7] It is reasonable to assume that Hogarth returned to a proven subject when the occasion offered itself, and in *A Just View of The British Stage* (pl. 40) produced an adjunct to *Masquerades and Operas.* Why, however, did he and so many of his contemporaries pick on the patentees of Drury Lane, when Rich was the more blatant offender—the Father of the Evil, so to speak? These attacks began in 1718 and continued more or less up to 1724.[8] The answer is that Hogarth attacked not the obviously reprobate but the hypocritical, the disappointing, or the pretentious. Steele had been made governor of Drury Lane with great hopes that he would implement the strictures against bad theater he had published in the *Tatler* and the *Spectator;* theatergoers hoped for a Jeremy Collier to purge the stage of indecency and the prevalent pandering to the lower instincts of the rabble. Alas, in order to survive Drury Lane was forced from the outset to imitate Lincoln's Inn Fields and even the opera: introducing a pair of pantomimists from France for harlequinades, singers for operas (albeit in English), dancers, jugglers, and tumblers to follow the play, and other examples of what Addison and Steele re-

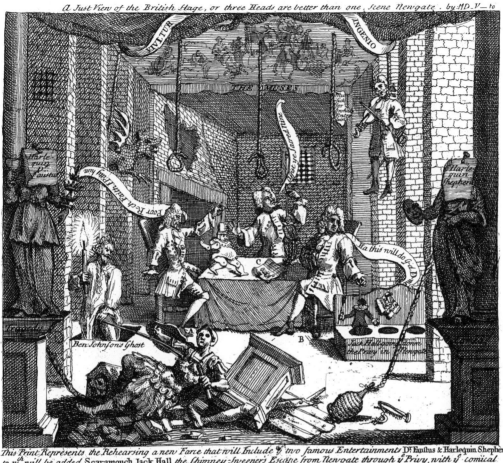

40. A Just View of the British Stage; Dec. 1724 (second state); 7⅛ x 8⅜ in. (W. S. Lewis)

garded as irrational entertainment. The same plays that Steele had attacked also continued to be performed, and in the early days at least, Drury Lane was successful in its rivalry with Lincoln's Inn Fields.⁹ In 1724 Drury Lane was still professing the high ideals of art and morality, while trying to outdo Lincoln's Inn Fields in the sensationalism of its harlequin pantomimes. It was accordingly an obvious target, and the irony of the motto displayed above its stage, "Vivitur Ingenio," is obvious:¹⁰ to the patentees their plays alone are art, the rest is consigned to oblivion. So also the words put in the patentees' mouths: "Poor R–ch Faith I Pitty him," and "Assist ye Sacred Nine"—all underline Hogarth's comic contrast between their high-flown pretensions and their real pandering.

After this one glimpse of a common area of experience, and Thornhill's and Hogarth's reactions to it, all is in darkness until publication of the large *Hudi-*

bras plates—far removed from the small, grotesque *Hudibras* illustrations—but it is not impossible to fill in the few years between. While Thornhill knew all there was to know about decorative and history painting, he was also intrigued by the present, which he could only express from time to time in portraits, sketches, or a jeu d'esprit like the portrait of Sheppard. By the same token, Hogarth had a great natural talent for the immediate observation of contemporary life, but wanted to learn about the higher reaches of art.

An indication of Thornhill's ideas and their possible influence on Hogarth can be found in a preliminary sketch for one wall of the Upper Hall at Greenwich Hospital. The subjects for opposite walls were, as a continuation of his general subject of the Protestant Succession, the landings of George I and William III. The problem was how to portray George I landing in 1714. Thornhill was thinking seriously of representing the event as it occurred, but within the conventions of history painting. Along the top and down the side of the drawing, which shows the participants in contemporary dress, he has written:[11]

> Objections yᵗ will arise from yᵉ plain representation of yᵉ K. Landing <Sᵇʳ 18th 1714> as it was in fact, & in yᵉ modern way & dress.
>
> ¹ First of all it was night, wᶜʰ to represent would be hard & ungraceful in Picture.
>
> No Ships appearing, & boats make a small figure.
>
> ² Then who shall be there to accompany him[?] If the real nobles that were there, then, some of them are in disgrace now. & so will be so much Party in Picture.
>
> ³ To have their faces & dresses as they really were, difficult.
>
> ⁴ The King's own dress then not graceful, nor enough worthy of him to be transmitted to Posterity.
>
> ⁵ There was a vast Crowd wᶜʰ to represent would be ugly, & not to represent would be false.

Here, neatly arrayed, are the conflicts involved in eighteenth-century history painting: ugly facts versus the ideal, the timeless, and the general. A part of Thornhill may have wished for an entirely realistic portrayal, but Thornhill the professional history painter has written his compromise solution down the right side of the sheet:

> ¹ Take Liberty of an evening sky, & torches.
>
> ² Make only 5 or 6 of yᵉ Chief Nobles; yᵉ rest in yᵉ Crowd.
>
> ³ Inquire their dress yᵉ best you can & get their faces from yᵉ life.
>
> ⁴ Make yᵉ Kings dress as it now is, & as it should have been then, rather than what it was.
>
> ⁵ Take yᵉ Liberty to lessen yᵉ Crowd as they ought to have been then.

He adds at the bottom, "Take yᵉ Liberty to bring in yᵉ yacht that brought over

yᵉ King & yᵉ Barge & Guns firing &c." The sketch and notes are impossible to date; they may have been done as early as December 1717 when Thornhill first submitted sketches for the Upper Hall, or as late as October 1722, when he had finished the ceiling and began work on the walls.[12] But the sketch shows that before he had met Hogarth Thornhill was thinking seriously about the problem that Hogarth was to see as the central one of his career: how to treat a modern subject in history painting, or, conversely, how to make history painting relevant to the contemporary world. For Thornhill the problem was theoretical only: the final version (pl. 41) of the landing of George I was fully allegorical, with even a scalloped chariot to replace the ship, executed in grisaille in imitation relief, and matched by the allegorical entry of William III on the opposite wall.

The problem still existed for Thornhill, however, as he began planning and blocking out the remaining wall of the Upper Hall. By May 1725 he was ready to begin the painting, and had probably by then reached a solution, again a compromise: he decided to portray George I and his family in contemporary dress but surrounded by allegorical figures, some on a larger scale than the human figures (pl. 33). It is also some indication of Thornhill's feelings about his-

41. Sir James Thornhill, The Landing of George I, Upper Hall, Greenwich; ca. 1722 (British Crown Copyright)

tory painting that he included himself—standing on the steps leading to the
royal family, dressed as a contemporary gentleman, pointing to the conclusion
of his masterpiece (with St. Paul's dome looming in the background, as a further
reminder of his works). This self-portrait (pl. 25) should be contrasted with
Verrio's self-portrait on the wall of the Heaven Room in Burghley House, where
he shows himself in classic undress, sketching the scene, with Iris above, sending
him his colors in a rainbow shaft of light.

When Hogarth met him, Thornhill was no longer anchored in his baroque,
Greenwich phase. The Greenwich ceiling reflects the influence of Pietro da
Cortona, modified in favor of Venetian baroque by the colors. With their rigor-
ously conceived and executed allegories, these paintings exerted considerable
influence on Hogarth's engraved work of 1724—in one instance as a direct imi-
tation, in the others as parodic forms. The panels at St. Paul's, however, and the
side panels of the Upper Hall at Greenwich, all grisaille, are quite different.
They are modeled in general on the Raphael Cartoons—at St. Paul's they use the
same subject—and are clearly defined, sculpturally composed, and largely classi-
cal, though not without Rubensian overtones.[13] The designs at St. Paul's (pl. 42)
are taken from Raphael and his French imitators and, in one instance, from
Rubens. *The Conversion of Paul* is freely based on Rubens' versions of the story
at Berlin and Munich: the figure of Paul is closest to the Munich Rubens, but
using Raphael's Paul (*Paul Preaching at Athens*) for the upper torso, Thornhill
has raised the arm (receding from the spectator in Rubens) so that it is over
Paul's head in the same plane with his body. In general the Rubensian figures
are planimetrically presented, flattened into a relief, their movement slowed.
On the other hand, in the designs based on the Cartoons Thornhill is more dra-
matic than Raphael. For example, in his version of *The Blinding of Elymas*
(clearly based on Raphael's), he emphasizes the contrast between the quiet Paul
and the groping Elymas; and Sergius Paulus, impassive in Raphael's Cartoon, is
gape-mouthed and gesturing in Thornhill's. Thornhill has also increased the
agitation of the draperies and broken up the forms, in general enlivening the
elements. Again, in *The Sacrifice at Lystra,* where Raphael's altar has a rectan-
gular plinth, Thornhill gives his a baroque form (and Hogarth, when he intro-
duced the motif into *Strolling Actresses,* followed Thornhill). In every case,
however, Thornhill has contained this agitation within a relatively planimetric
composition, and the effect—one that Hogarth was to explore and extend to
great lengths in his own works—is of a baroque content controlled by classical
order.

Neither the Greenwich ceiling nor the St. Paul's cupola was an extreme to be
confused with certain examples of continental baroque on the one hand or
Poussinesque classicism on the other. Rather, each represented an attempt to
adopt the best of both worlds as the context—mythological fancy and political
glorification in one case, religious worship in the other—demanded. Hogarth

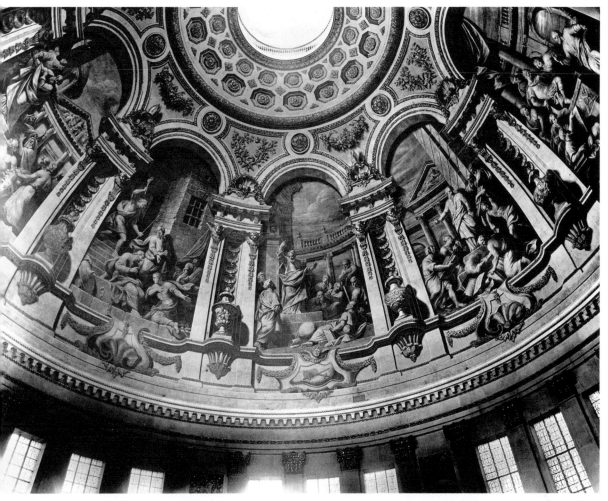

42. Sir James Thornhill, Life of St. Paul, Cupola of St. Paul's Cathedral; 1715–20 (reproduced by permission of the Dean and chapter of St. Paul's Cathedral)

was initially influenced by the Greenwich ceiling, but as he got a grip on his engraving and worked up to *Hudibras,* he seems to have preferred the grisaille Raphaelesque biblical subjects, whose monochrome may have contributed to the needs of an engraver, over the classical mythology and the swirling, Venetian forms. Thornhill himself seems to have been moving in this direction at the time. The more serious, Raphaelesque Thornhill, while adopting the Venetians' color and, in his sketches, their freedom of brushwork, must have objected to their essentially decorative conceptions, and played down their influence in his own didactic histories. Indeed, in these years of his contact with Hogarth Thornhill can be seen moving from the elaborate allegories of the Painted Hall to St. Paul's and the Upper Hall, Wimpole Chapel, the easel paintings of religious subjects, and ultimately to the copies of the Raphael Cartoons, the final testament with which he occupied his last years.

This conception of history painting was, I think it safe to surmise, presented to Hogarth as normative, free of the baroque excesses of certain old masters. Thornhill must have urged Raphael's Cartoons on Hogarth and stressed a view of history painting that is best summed up in Steele's *Spectator* essays on art. The Cartoons cannot be overestimated as an influence on Englishmen's attitudes toward history painting. To begin, Raphael was preeminent among painters in the main tradition of art treatises and art criticism. Then, as a history painter Raphael was best represented in the Stanze of the Vatican and in the Cartoons in Hampton Court Palace. Jonathan Richardson, who returned to them repeatedly for his examples in his treatises, and referred to "that Awful Gallery at Hampton-Court," summed up the general feeling: "God be prais'd that we have so near us such an invaluable Blessing. May the Cartoons continue in that place, and always to be seen; Unhurt, and Undecay'd, so long as the Nature of the Materials of which they are compos'd will possibly allow."[14]

It is no coincidence that the essays on art that most influenced Hogarth were by Thornhill's friend, and perhaps student in things artistic, Richard Steele, who sat for his portrait to Thornhill, was a member of the Queen's Street Academy, reported an elaborate exegesis (no doubt Thornhill's own) of the completed Painted Hall in one of his periodicals, and expressed views in the *Spectator* similar to Thornhill's. Perhaps because of his connection with artists like Kneller and Thornhill, Steele took art as his own province in the *Spectator*. He had two preoccupations, which exactly coincided with Hogarth's as they developed, and at least one of which was supported vigorously by Thornhill: the moral purpose of art and the importance (especially in moral terms) of the Raphael Cartoons as a model for English artists.

If, as the *Spectator* constantly reiterates, opera, pantomime, puppet shows, and similar entertainments invariably replace reality with monsters and magicians, the same is certainly true, Steele shows, of most of the history painting praised and bought by English connoisseurs to decorate their houses and public

buildings. Instead of "charming Portraitures, filled with Images of innate Truth, generous Zeal, courageous Faith, and Tender Humanity," artists paint and connoisseurs recommend "Satyrs, Furies, and Monsters." Such works as the Raphael Cartoons, he writes in another essay, "with the great and venerable Simplicity of the Scripture Stories, had better Effects than now the Loves of *Venus* and *Adonis,* or *Bacchus* and *Ariadne.*"[15] And finally, in No. 226, wholly devoted to the subject, he begins by referring to his earlier complaint "that the Art of Painting is made so little Use of to the Improvement of our Manners" and argues that "Images of Virtue and Humanity" should be instilled in painting:

> Who is the better Man for beholding the most beautiful *Venus,* the best wrought *Bacchanal,* the Images of sleeping Cupids, Languishing Nymphs, or any of the Representations of Gods, Goddesses, Demy-gods, Satyrs, *Polyphemes,* Sphinxes or Fauns? But if the Virtues and Vices which are sometimes pretended to be represented under such Draughts, were given us by the Painter in the Characters of real Life, and the Persons of Men and Women whose Actions have rendered them laudable or infamous; we should not see a good History-Piece without receiving an instructive Lecture.[16]

The single most important dictum, as Steele says, was that moral pictures express themselves "in a Manner much more forcible than can possibly be performed by the most moving Eloquence." On these grounds an engraver (as opposed to a painter) might think of himself as an inheritor and clarifier of (and ultimately capstone to) the tradition of the great Augustan moralists, without losing touch with the tradition of history painting. Hogarth frequently echoes the sentiment, insisting that his prints embody "what cannot be conveyed to the mind with such precision and truth by any words whatsoever," and that "occular demonstration will convince and improve man sooner than ten thousand Vols."[17] A case is also implied for the readily duplicated reproduction over the single original.

Moreover, history painting is now merely decorative and operatic, concerned with satyrs and nymphs, out of touch with real people and real problems; to be proper history painting the mythological subjects should be replaced by meaningful ones—"the characters of real Life, and the Persons of Men and Women whose Actions have rendered them laudable or infamous." Steele here seems to prefigure Hogarth's "modern moral Subjects"; although his theory (like his theory of stage comedy) seems to seek the representation of good examples rather than bad, in his analysis of the Raphael Cartoons he singles out for praise the portrayal of the "mercenary Man" who falls down dead in *The Death of Ananias* and the "graceless Indignation of the Sorcerer, when he is struck blind" in *The Blinding of Elymas.*[18]

These precepts, combined with the conventions of history painting, were first practiced by Hogarth in the twelve large engraved plates for Samuel Butler's *Hudibras,* which he executed during 1725. Significantly, Hogarth made his initial statement about history painting as an engraver—before he could possibly have considered himself a painter, perhaps before he had even touched brush to canvas. *Hudibras* fitted into the tradition of history painting understood in Hogarth's England largely through the engraved reproductions by Dorigny, Dubosc, and Baron, rather than through the paintings themselves (which, except for the Raphael Cartoons, were far off in Italy); it implied a large painted original that did not exist. In a real sense the print, not the painting, was Hogarth's history.

Sometime between the success of *Masquerades and Operas* in February 1724 and the autumn of 1725, Hogarth came to an understanding with the print-seller Philip Overton about producing a set of large illustrations to *Hudibras.* Overton may have been impressed with the success of *Masquerades and Operas,* or Hogarth may have approached Overton with samples; it is impossible to know who conceived the idea, though Overton's reluctance to attach Hogarth's name to the advertisements suggests that he considered the subject more important than the artist. The scheme played on the popularity of the Coypel *Don Quixote* plates. Hogarth had seen the French edition, engraved by Beauvais, before he copied some of the figures in his *Mystery of Masonry;* Overton published large copies, engraved by Bickham and Mynde, in 1725, and their success must have suggested to either Hogarth or Overton that "the don Quixot of this Nation," as they called Hudibras in the ads, could profitably be treated in the same way.[19]

Hudibras was the satire Hogarth had turned to earlier, perhaps as his first engraved subject, and it is easy to imagine him experimenting, copying, elaborating, gradually inventing his own style and designs with this book which may from childhood have stimulated his impulse toward satiric art.[20] The small etchings, based on designs in the wooden style of English book illustrations of the early eighteenth century, were rough but forceful versions of Dutch low-life pictures—an experiment in the grotesque. The best example is the lively proof etching of *Hudibras and Ralpho made Prisoners,* which becomes clumsy and dull, however, in the finished illustration (pls. 43a,b).

By 1725 Hogarth was no longer interested only in the grotesque. Early in that year he made two illustrations for Milton's *Paradise Lost* (pls. 44, 45); though quite small, they are patently in the grand manner which he had no doubt been practicing at the academy. Five plates for La Calprenède's *Cassandra,* published in September, were further efforts in the same direction. Thornhill's illustrations, designs engraved by Dubosc, Dupuis, and others, were in this style; the designs for Baskett's Bible (1717) may well have been in Hogarth's mind as he

43a. Hudibras and Ralpho made Prisoners (first, proof state); publ. April 1726; 4⅛ x 5 in. (Royal Library, copyright reserved)

43b. Hudibras and Ralpho made Prisoners (second, published state); publ. April 1726; 4⅛ x 5 in. (W. S. Lewis)

made his Milton illustrations.[21] And Hogarth was always very conscious of the fact that Thornhill never reproduced his own designs, seldom even touching needle to copperplate himself.[22]

The illustrations for *Paradise Lost,* though evidently intended for an edition Jacob Tonson was bringing out, found no buyer.[23] Thornhill had furnished designs for Tonson and may have been Hogarth's sponsor. But the illustrations must not have satisfied Tonson, or perhaps he already had an illustrator more to his liking. Hogarth's reputation, what there was of it at the end of 1724, was for facetious drawings in the Dutch manner, and foreign artists were as much the staple of book publishers as of picture dealers. Hogarth was thus drawn back to his forte, the *grotesque.*

But in the large *Hudibras* plates he successfully juxtaposed the grotesque and the heroic styles. He was able to work to a congenial size now, as had not been the case with the tiny book illustrations. The Coypel *Don Quixote* plates provided a general sanction for the subject as well as the size and shape, and for the idea of vending a series of large plates from a well-known book *extra libris,* presumably for framing. What Coypel did not supply was a model for his contrast of the grotesque and heroic; Coypel's *Quixote* is simply delicate French rococo. Hogarth makes his program clear in the frontispiece (pl. 46), which includes in one design the satyrs, fauns, putti, and goddesses of baroque book illustration—and, for that matter, of the history painting attacked by Steele—with the grotesque shapes of Butler's poem. A satyr lashes Hudibras and Ralpho, yoked to the scales of Justice and drawing his chariot around the foot of Mt. Parnassus, and leading, as in a triumphal procession, Hypocrisy, Ignorance, and Rebellion. The putto who sculpts this scene has for his model not ideal Nature (portrayed as Britannia) but Butler's satiric poem, held before him by another satyr. This

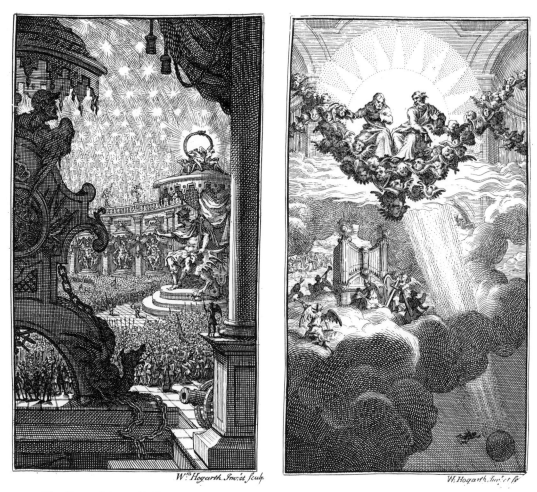

W.ᵐ Hogarth. Inv.ᵗ et Sculp *W. Hogarth. Inv.ᵗ et fe*

44. The Council in Hell, illustration for *Paradise Lost;* 1725 (first state); 5⁹⁄₁₆ x 3⅛ in. (W. S. Lewis)

45. The Council in Heaven, illustration for *Paradise Lost;* 1725 (first state); 5⁹⁄₁₆ x 3¹⁄₁₆ in (W. S. Lewis)

 These are hitherto undescribed proofs of the prints. Apparently finding his illustrations too large for the specified page size, Hogarth cut them down by ⅛ inch (second state, Royal Library, Fitzwilliam; *HGW*, pls. 58, 59): reducing the cord above the tassel at the top, some of the pillar at the right, and the step and part of the plinth at the bottom of the *Council in Hell;* and part of the architectural structure at the top, part of an angel head and some columns at the right, and space at the bottom of the *Council in Heaven*. In the latter he also added angel heads across the arc. (Cf. *HGW,* cat. nos. 55, 56.)

group is balanced on the other side of the frieze by a faun holding up to Britannia's face a mirror which reflects an undistorted image, implying no doubt that England under the Hanovers no longer resembles Butler's picture (the caption refers to the "Vices of those Times"), and also that Hogarth has deliberately turned from ideal Nature to satire for his subject—yet still within the convention of history painting, exemplified by the putti and satyrs.

Significantly (the same paradox is evident in his *Beggar's Opera* paintings), these conventional putti and satyrs are the fully realized figures, moving about in the picture space, while Hudibras and Ralpho are artifacts carved in bas-relief. In the subsequent plates Hudibras and Ralpho take over and the conventional figures disappear, although references remain in the size and relative monumentality of the contemporary figures and the heroic compositions in which they perform. The result is what might be called a grotesque history painting, one step on the path to what Steele seems to be defining as the modern history painting.

The influence of academy drawing classes is apparent, but Hogarth's principal source was the Raphael Cartoons; he would have known these from the Dorigny engravings, and through Thornhill he may already have seen the originals at Hampton Court. The rectangular plates recall the histories of Raphael, as does the horizontal band of figures, relatively large in relation to the picture space, with space above and one or more repoussoir figures below. All are more separate and clearly defined, more expressive and articulated, than in his earlier prints. The monumentality and the planimetric, almost classical composition set off the *Hudibras* plates from the rollicking low-life scenes of the Dutch baroque as well as the delicate rococo of Coypel's *Don Quixote*.

The formula is still, like Thornhill's, a somewhat baroquized Raphael, as is clear in the most baroque of the plates, *Hudibras and the Skimmington* (pl. 48). Here Hogarth has based his composition quite consciously on the baroque processional paintings that Steele must have had in mind when he referred to fauns and satyrs, "the Loves of *Venus* and *Adonis,* or *Bacchus* and *Ariadne,*" which his audience would certainly have recognized; specifically he alludes (with the hornblower) to the most famous of these, Annibale Carracci's *Procession of Bacchus and Ariadne* in the Farnese Palace (widely disseminated in engravings, as in pl. 49). The contrast illustrates Hogarth's achievement in endowing history painting with a moral significance lacking in Carracci's operatic composition.[24]

The baroque shapes in *The South Sea Scheme* and *The Lottery* were ideal forms against which to judge satirically the grotesque shapes of the fools and knaves. But in *Hudibras* the baroque has become more equivocal: the curving, twisting shapes are used to portray the antics of the grotesquely deformed Hudibras, of rustics and buffoons. As a reader of Butler, however, and a follower of Dryden and Swift, Hogarth does not stop here. The contrast between the composition and the rustics and buffoons is mock-heroic. Hudibras (Butler's gross,

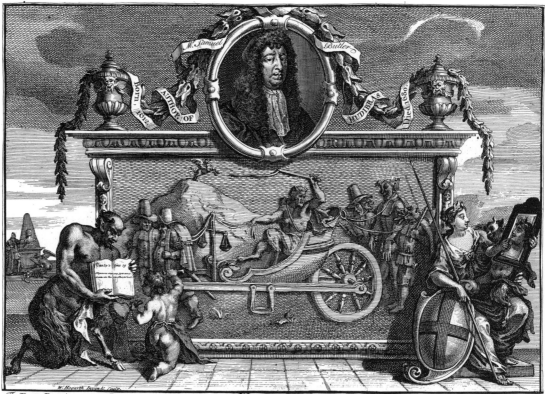

The Basso Releivo, on the Pedestal, Represents the | *Frontispiece* and its | Lashing around mount Parnassus, in the Persons
general Design, of M.BUTLER, in his Incomparable | EXPLANATION. | of Hudibras, & Ralpho, Rebellion, Hypocrify, and
Poem, of Hudibras, Viz.BUTLER,S Genious in a Car. | | Ignorance, the Reigning Vices of his time
Printed & sold P. Overton, near S.^t Dunstans Church in Fleetstreet & I Cooper in James street Covent Garden.

46. Frontispiece, *Hudibras* (large plates); Feb. 1725/6; 9⅜ x 13⁹⁄₁₆ in. (W. S. Lewis)

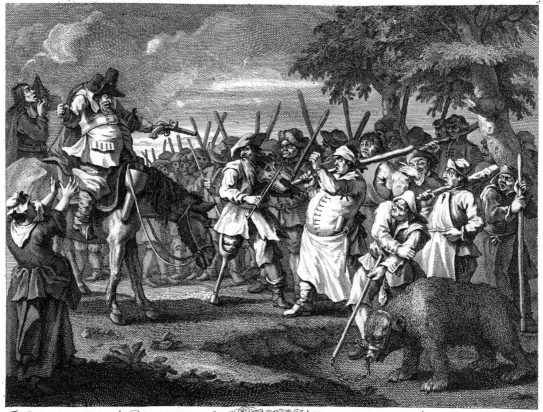

The Catalogue and Character | Whom in a bold Harangue, ⸸ Knight | *Hudibras's* First | H'encounters Talgol, routs the Bear, Conveys him to Enchanted Castle,
Of th'Enemies left. Men of War: | Defies, and Challenges to fight. | ADVENTURE. | And takes the Fidler, Prisoner; There shuts him fast in Wood. a Bastile.
P.^t Hogarth, delin et sculp. | Sold by Phil: Overton, near S.^t Dunstans Church Fleetstreet and In.^o Cooper in James street Covent Garden.

47. Hudibras' First Adventure; 9⁹⁄₁₆ x 13 in. (W. S. Lewis)

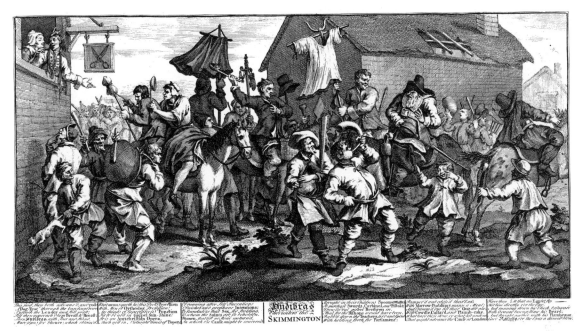

48. Hudibras and the Skimmington; 9¹¹⁄₁₆ x 19½ in. (W. S. Lewis)

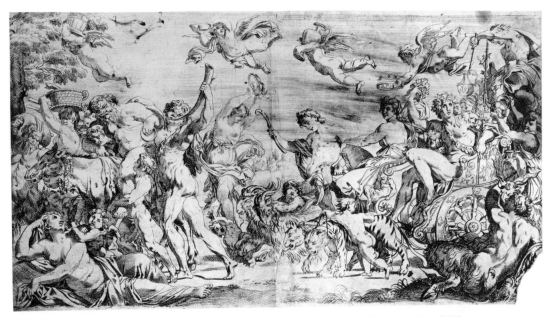

49. Annibale Carracci, Bacchus and Ariadne (engraving); 1597–1600 (BM)

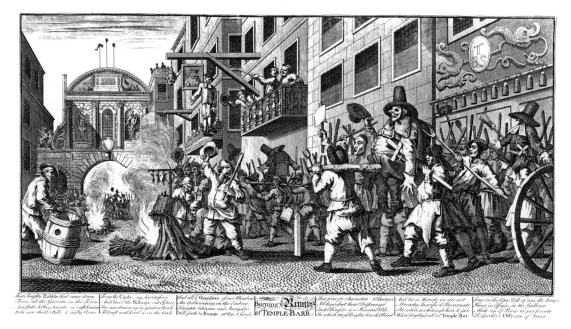

50. Burning the Rumps at Temple Bar; 9⁹⁄₁₆ x 19⁷⁄₁₆ in. (W. S. Lewis)

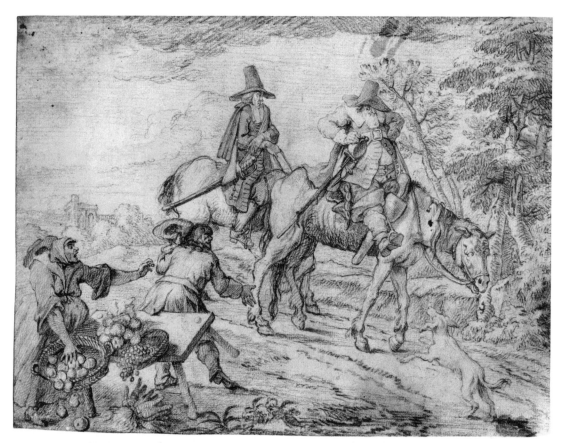

51a. Hudibras sallying Forth (drawing); 9½ x 13 in. (Royal Library, copyright reserved)

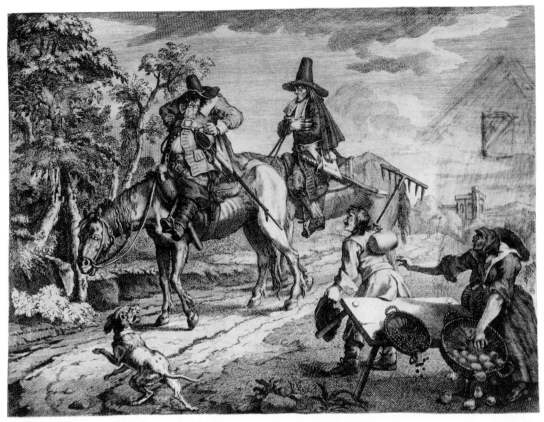

51b. Hudibras sallying Forth (engraving, first state); 9¹¹⁄₁₆ x 13¼ in. (Royal Library, copyright reserved)

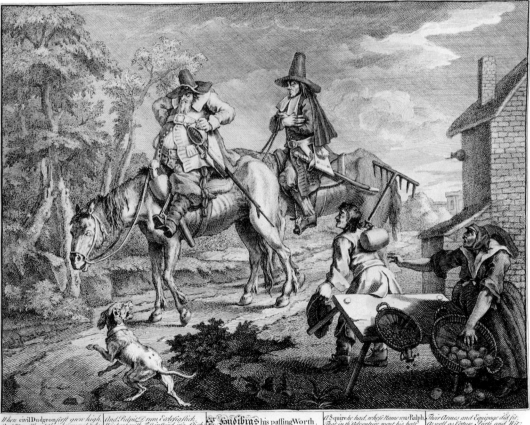

When civil Dudgeon first grew high, And Pulpit Drum Ecclesiastick, Sᵣ Hudibras his passing Worth, A Squire he had, whose Name was Ralph, Their Armes and Equipage did fit;
And Men fell out they knew not why, Was beat with Fist instead of a Stick; The manner how he sally'd forth; That in th'Adventure went his half. As well as Vertue, Parts, and Wit:
When Gospel-Trumpeter surrounded Then did Sir Knight abandon Dwelling, An equal Stock of Wit and Valour Their Valours too were of a Rate,
With long ear'd Rout, to Battel sounded, And out he rode a Colonelling. He had laid in, by Birth a Taylor._ And out they sally d at the Gate;

51c. Hudibras sallying Forth (engraving, second state); 9¹¹⁄₁₆ x 13¼ in. (Royal Library, copyright reserved)

hypocritical version of Don Quixote) is the Puritan who sallies out in search of imaginary evils and claims to see in the innocent Charles I the antichrist, and in a bear-baiting a manifestation of the devil. Here he is trying to interfere with a Skimmington, a procession celebrating a henpecked or cuckolded husband, regarding it as much more sinister than the traditional rural sport it was. The contrast between the grotesque shapes of the rustic bumpkins, including Hudibras himself, and the swirling heroic forms of such baroque processionals as Carracci painted would have implied for Dryden and Pope the sad degeneration of the present revealed by a contrast with the heroic past: a Shadwell, Theobald, or Cibber against an Aeneas or Vergil. The theme of divine love—the god who finds the beautiful mortal, Ariadne, abandoned by her lover—is reduced to the cuckolded husband with his shrewish wife. But Hogarth, like Butler, also uses these forms to objectify Hudibras' crazy image of himself and his surroundings. Hogarth, ultimately, is attempting to create a modern history, not to denigrate moderns in terms of classical history painting. He uses the heroic level not to degrade the rustics but to suggest a level of misinterpretation and aspiration on the part of Hudibras, who sees in these peasants the gaudy show of an ornate processional; just as, in another scene (pl. 47), he takes a harmless bear-baiting as a great battle. The history painting composition serves as a psychological referent, while at the same time helping to define the kind of picture Hogarth has produced. He is criticizing the baroque profusion and operatic quality by associating them with Hudibras' distorting imagination, as they psychologically define Hudibras. Far from a norm, the baroque shapes represent delusion, pretension, perhaps hypocrisy. But the norm against which this excess is presumably to be judged is found in the Raphaelesque shapes of true history painting.

The use of, and attitude toward, history painting may seem somewhat equivocal in the *Hudibras* plates. The history is, of course, religious and not mythological; Hudibras is a religious hypocrite. Interestingly, it is through the religious hypocrite that Hogarth broaches the character of those rigid, one-track pretenders who are the subject of his various progresses. Hudibras' progress is a series of confrontations with the sane, if disorderly, secular world of bearbaiting, tippling, and cuckolding. The two oversized plates emphasize the conflict: the first (pl. 48) shows Hudibras in futile combat with the Skimmington mob, and the second—the climactic plate (pl. 50)—depicts the populace rejoicing at the overthrow of Puritanism and the restoration of Charles II, launching a saturnalia that includes the burning of Hudibras and his followers in effigy. The confrontation of Carnival and Lent is a motif that runs, in one form or another, through Hogarth's work and reappears in almost precisely the same guise ten years later in *Night,* the climax of *The Four Times of the Day,* which also takes place on Restoration Day.

Drawings and unfinished proofs survive from this series. The drawings are very competent and finished exercises in academic discipline, probably reflecting both Hogarth's recent training and his need for finished drawings to show Overton. The drawings for the early plates are equally polished, but executed in different styles: one is executed in a pale yellow wash and finished with a delicate pen line (pl. 51a); another is done more boldly in red chalk. It may be significant that the drawings become sketchier and less complete as they near the end of the series: they have served their purpose with Overton, and now Hogarth can work for himself. His own sketches are almost invariably private notations; only the ones made for submission to a publisher or for an engraver are relatively finished. (The careful drawing for *The Lottery* therefore may have been for purposes of sale or an advance toward the engraved plate.)

Comparing the proof of Plate 1 (pl. 51a) with the finished print (pl. 51c), one can see Hogarth at work. He was evidently unhappy with the proof (pl. 51b), which appeared too heavily weighted on the left side: the foliage behind Hudibras and Ralpho was too dark, too carefully defined. This was not the first proof taken—a little bush at the left has already been burnished out and sketched in anew. To redress the balance Hogarth toned down the foliage, leaving it a more uniform gray, and lightened some of the shading on Hudibras. Evidently feeling that this was not enough, he also added a rather haphazard building at the other side of the plate to balance the foliage. Though this was in itself a mistake (as Hogarth's second thoughts often are), the result is remarkably classical considering the subject and action depicted. Hogarth's intention is underlined by his desire for regularity and symmetry. It is possible that his representations of the stage may have led him to make symmetrical and planimetric compositions. But the ideal of the Raphael Cartoons was a more compelling, if auxiliary, influence. *Hudibras' First Adventure* (pl. 47), the most Raphaelesque, is the triumph of the series. Here Hogarth accomplishes a real solidity of characters and setting. In *Hudibras Vanquished by Trulla,* to take a plate that fails, the Raphaelesque discipline is absent and he has trouble relating separate groups scattered across the plate. The scattering also brings out his inability to render the architectural elements as decisively as he does the figures.

Something more of Hogarth's intention in these plates can be seen in his title page dedication to the Scottish poet Allan Ramsay. Unfortunately one cannot be certain whether the surviving title sheets were used with the first (subscribed) impression or later. Ramsay, both a poet and an Edinburgh bookseller, subscribed for thirty sets, and evidently sold them in his shop.[25] It is thus difficult to say whether Hogarth dedicated the plates to him because he bought thirty sets or because he wrote congenial poetry. There may have been some Scottish family connection, but Ramsay's north country background, certain aspects of

his career, and the kind of poetry he wrote would suffice to explain the dedication. In fact, considering the profession that Ramsay's son Allan, then twelve years old, was to follow, there was some prescience in the dedication.

Ramsay was born in 1684 or 1685, twelve years Hogarth's senior. After his apprenticeship he set up in Edinburgh in 1710 as a periwigmaker.[26] His first poems began to appear in 1713, and by 1718 he had established himself as his own publisher, an idea that might have had some influence on Hogarth. In 1719 —another interesting parallel—he began a campaign against literary pirates, successfully appealing to the town council. In 1720 he published the octavo edition of his collected works and issued proposals for a subscribers' edition, which was published in Edinburgh 27 July 1721, calf-bound, on fine paper, with a frontispiece portrait of Ramsay and a list of subscribers that included such English literary figures as Steele and Pope. At a guinea a copy, this subscription brought Ramsay 400 guineas (he claimed that the South Sea crash prevented him from making more). The book must have been much talked of in London, and Hogarth would have seen it. More poems came rapidly from Ramsay's press: the first collection of *Fables and Tales* in 1722, the first volume of the *Tea-Table Miscellany* and *The Ever Green* (collections edited by Ramsay), and *The Gentle Shepherd* in 1725. Between 1723 and 1725 he gave up wigmaking for bookselling.

To Hogarth, he would have appeared a Scottish Samuel Butler, with overtones of William Hogarth in his generally heroic treatment of objects both commonplace and symbolic (as in "Tartana, or the Plaid"). Works like "Lucky Spence's Last Advice," the deathbed speech of an old bawd, might seem Hogarthian, but the main exhibit would be *Christ's Kirk o' the Green*. There is a valuable truth in the remark by one of Ramsay's editors that Butler's forte was wit, Ramsay's humor: Hogarth's *Hudibras* resembles the spirit of Ramsay more closely than Butler in that it lies closer to ordinary reality. Butler is still a metaphysical poet at heart, though turning metaphysical fancy to his own satiric ends; Ramsay is closer to nature.[27] Hogarth would have been especially interested in Ramsay's tailnote to *Christ's Kirk,* in which he offers a critical self-justification: "The main Design of Comedy [is] to represent the Follies and Mistakes of low Life in a just Light, making them appear as ridiculous as they really are, that each who is a Spectator, may evite his being the Object of Laughter." Already Hogarth was picking and choosing, singling out those contemporaries with whom he felt a close link and in relation to whom he could define himself.

The co-dedicatee of the *Hudibras* plates is a more puzzling case. William Ward of Great Houghton was a London barrister, a man of about 44. He reputedly commissioned Hogarth to produce a set of *Hudibras* paintings for his country house, East Haddon Hall; there is no other recorded connection between them.[28] Although it may be placing the cart before the horse to see this

commission as the reason for the dedication, such a theory would conform to Hogarth's later practice; he was likely to dedicate a series to the first subscriber, or to someone who subscribed and was so taken by the seven or eight plates he saw that he commissioned the series painted.

Proposals for the subscription to the *Hudibras* plates were published 6 October 1725, and the set was promised for Christmas; at this time "seven Plates" were "already done, and Specimens of them to be seen" at Overton's and Cooper's printshops.[29] It is evident from the dimensions given that two of the seven plates finished were the *Skimmington* and *Burning the Rumps at Temple Bar*. There was no mention of the artist's name, and the set was subscribed for only 15*s*, with 5*s* paid down. By 30 November, when a new advertisement appeared, the price had gone up to 18*s*. The increase was not explained, and only two more plates were finished. Some sort of disagreement or crisis must have arisen. It is difficult to imagine Hogarth being dilatory or turning to some other work (except briefly) when this important project was underway; an argument with Overton over the business aspect of the subscription, or illness, would be the most reasonable explanation. The Christmas publication date was not met, and there were no advertisements between 7 December and 3 February, when the plates were finally announced as ready for subscribers on the twenty-fourth (the subscription for the first impression was closed on the twelfth). At this point the information that they were "Designed and Engraved by Mr. Hogarth" was added, and the price was mysteriously raised to 15*s*. The inclusion of the name at this late date can only mean that Hogarth insisted on it, or that the fame of the plates, seen in Overton's and Cooper's shops, had spread. (The unsigned *Kent's Altarpiece,* his only achievement in the interim, would hardly have drawn attention to him.) But his name was again missing from the ads once the plates were finished and announced ready for the subscribers.

On 3 May the seventeen small plates appeared too, illustrating an octavo edition of *Hudibras.* Their belated publication was certainly elicited by the success of the large plates; in the advertisements and on the title page Hogarth's name appears prominently.

The question of what constitutes true history painting arose in a somewhat different form in 1725, when Thornhill and Hogarth clashed a second time with William Kent. It was a year of minor irritations for Thornhill. In May he demanded more money for the painting of the Upper Hall, stating that "the three sides of the Upper Hall are nearly finished and the painting of the front wall far advanced." In June, after unsuccessfully trying to bring down his price, the Board agreed to pay £500 for the whole work, which was finished by July 1726. Judging by Hogarth's story, told in *The Analysis of Beauty,* Thornhill was not happy with the settlement—£500 does seem little for the Upper Hall—and so

retaliated by turning over the unfinished "front Wall" with the portraits of the royal family to his assistant.[30]

Then on 26 June, Kent, who had been making handsome profits from the Kensington apartments since 1722, was notified by his friend the Duke of Grafton that he had been commissioned to paint the ceiling and wainscots of the Gallery and the Great and Little Closet. A Mr. Howard, evidently one of Kent's assistants, was commissioned at the same time to do the gilding and provide scaffolds for the painters. Folded together with this paper in the archives of the Board of Works is a second letter, dated "Great Piazza Cov. Garden, Sept. 29th 1725" and addressed to the Commissioners of the Board of Works:[31]

> Gentlemen
>
> Being informed that you have received instructions, I presume thrô mistake, to employ some improper Person to do the Gilding on ye wainscot in the Gallery at Kensington &c. is the occasion of giving you this trouble;
>
> And as the gilding has ever been performed by my Predecessors as well as myself down to this present Time so I can not help thinking it a great incroachment on your Office as well as my patent & those who shall succeed me.
>
> The Lords Comssrs of the Treasury are our imediate Directors & by their Authority I am always willing to be concluded;
>
> I must therefore desire that before you come to any hasty conclusion their Lordships may be truly apprizd of the Affair
>
> I am Gentlemen
>
> > Your very Humble Svt;
> >
> > > J. Thornhill

Thornhill's letter was passed on to the Lords of the Treasury, and in an entry of 5 October from the Treasury Minute Book, item "r," the Board of Works Report of 20 September, reads: "Write to the Vice Chamberlain to let My Lordship know if any agreement has been made with Mr. Kent about the painting and write to the Board of Works to let them know that the Gilding on the Wainscot is to be performed by Sir James Thornhill the King's Serjeant Painter—whose office it is to perform works of that nature." It was a small victory; the war was going to Kent, who succeeded Ripley as Master Carpenter in 1726 and became Surveyor of the King's pictures.[32]

Meanwhile, however, Burlington and his other enthusiastic friends had been pushing Kent toward the chimera that was history painting. On 23 July 1724 he had written to Massingberd that he was engaged to paint an altarpiece for the new church in George Street near Hanover Square. In 1725 a commission was secured for him to paint an altarpiece for St. Clement Danes Church in the Strand, which was finished and in place by August—around the time Thornhill

52. A Burlesque on Kent's Altarpiece at St. Clement Danes; Oct.
1725; 11⅛ x 7 in. (W. S. Lewis)

was trying to wrest the gilding away from Kent at Kensington Palace. On the twenty-fifth the *Daily Post* noted:

> The Altar Piece at the Church of St. Clements' Dane, being a musical Representation, variously explain'd, some finding in it St. Celicia and her Harp, and some, Princess Sobieski [the Pretender's wife] and her Son, but the Generality agreeing it was not a Thing proper to be placed there; upon Complaint to the Bishop of London at his last Visitation of the said Church, we hear his Lordship, in order to secure the Solemnity of the Place and Worship, and to preserve Peace and Unity among the Parishioners, hath lately very prudently order'd the Church Wardens to take it down.

A Letter from a Parishioner of St. Clement's Danes to the Right Reverend Father in God Edmund Lord Bishop of London[33] reveals that the painting cost £80 and that the church was "thronged with spectators" when the word about its peculiarities got around, some of them Jacobites who "came not to join in prayer with the rest of the congregation, but to worship their Popish saint and hug themselves with the conceit of being alone in the secret" (a secret reminiscent of the Jacobite allegory behind the Gormogons). The only allusion to the painter appears in the sentence "When your Lordship shall examine, who is the Painter, and of what principle? how long he had been from the Court of Rome, before he painted that Picture? and whether he brought no Picture or resemblance of the Princess Sobieski over with him?" The reference is clearly to Kent, who, though no Jacobite, was influenced by Italian art, known to have been awarded the Pope's prize while in Italy, and apparently so influenced by Italian art that he unthinkingly produced a subject at odds with Protestant tradition— a saint and a musical party—and through sheer clumsiness stumbled into a likeness of the Pretender's wife.

One clergyman and several of the St. Clement parishioners tried to stop the Bishop's order, but on 4 September the picture was taken down and hung in the vestry room.[34]

Hogarth was so intrigued by this event, nicely timed with Thornhill's small victory over the gilding, that he took time off from the *Hudibras* plates (of which six or seven must have been finished), to get in another dig at Kent and to express himself on the matter of religious art. His reaction must be gauged from his version of the altarpiece (pl. 52), a scathing commentary with its great, lumpy, totally bungled bodies (no doubt a final memory of drawing sessions at the academy), its conventional cherubs and clouds, and its total lack of spiritual significance.

The feelings of Kent and the Burlington circle about Thornhill were also recorded, not long after the altarpiece fiasco. On 28 August 1726 John Gay wrote the Countess of Burlington, then on the Continent, to describe how he

and Kent, having exhausted all the delights of London, sought entertainment one night at Bartholomew Fair. There they attended *The Siege of Troy*, in which, Gay noted, Settle undertook to correct Vergil in favor of poetic justice:

> for Paris was kill'd upon the spot by Menelaus, and Helen burnt in the flames of the town before the Audience. The Trojan Horse was large [as] life and extreamly well painted; the sight of which struck Kent with such astonishment, that he prevaild with me to go with him the next day to compare it with the celebrated paintings at Greenwich. Kent did not care to reflect upon a Brother of the Pencil; but if I can make any judgment from hums, & hahs, and little hints, he seem'd to give the preference to Bartholomew Fair.

He reports the explanation of the guide, who confuses cardinal virtues with Roman Cardinals, the Princess Sophia with the Princess of Savoy, and the Queen of Prussia with the Queen of Persia—the results being analogous to the misunderstandings over Kent's altarpiece. "This is a proof that a fine puppet-show may be spoild and depreciated by an ignorant interpreter."[35] It is well to remember that Hogarth's opponents included satirists as sophisticated as he—and some who were his masters. It must have particularly delighted Kent and Gay to observe the ignorant detecting the same absurdities in Thornhill's paintings that Hogarth had recently pointed out in Kent's altarpiece. The parallel with puppet shows makes the attack all the more biting. Gay's letter also suggests that he knew the Burlingtons liked to hear such stories at Thornhill's expense, without any reflection being made on Kent as the storyteller; Gay's role was that of jester.[36]

In the wake of the *Hudibras* plates, another major engraving project was undertaken and abandoned; perhaps it was inevitable that the "English Don Quixote" would be followed by the Spanish. Jacob Tonson, who had seen but not used Hogarth's two illustrations for *Paradise Lost,* was publishing a series of ambitious works in the mid-1720s. An elaborate edition of Racine in 1723 was followed by Tasso's *Gerusalemme Liberata* in 1724, both in the vernacular, both illustrated luxury editions. Sometime in 1726 Tonson and Lord Carteret, the Whig politician, then Lord-Lieutenant of Ireland, projected a similar Spanish-language edition of *Don Quixote*. If the story that Queen Caroline complained to Lord Carteret that she could find no edition of *Don Quixote* worthy of her library is true, she must still have been Princess of Wales at the time;[37] Vanderbank's set of preliminary designs are dated as early as 1726. She was to be disappointed, for the book did not finally appear until 1738, the year after she died.

Carteret, known as an accomplished Spanish scholar and admirer of Cervantes, apparently assumed responsibility for all aspects of the edition. The

53a. The Freeing of the Galley Slaves, illustration for *Don Quixote* (drawing); ca. 1727; 9⅜ x 7⅜ in. (Royal Library, copyright reserved)

53b. The Freeing of the Galley Slaves, illustration for *Don Quixote* (engraving, caption omitted); 8¹¹⁄₁₆ x 7⅛ in. (W. S. Lewis)

54. John Vanderbank, Freeing the Galley Slaves (drawing), illustration
 for *Don Quixote;* ca. 1727 (BM)

Tonson edition of Tasso had simply used re-engravings of the Bernardo Castello designs (first printed in 1590), but Carteret wanted original designs, and furthermore disapproved of Coypel's rococo illustrations. One can only conjecture on what happened at this point. Six finished engravings by Hogarth survive, and innumerable drawings by John Vanderbank eventually engraved by Gerard Vandergucht, who had also engraved small copies of the Coypel illustrations for another edition.[38]

It is easy enough to reconstruct Vanderbank's progress. Although there are sometimes six or eight versions of a single scene leading up to the engraved design, two main sets show how he worked. A set of sixty-two preliminary designs in the British Museum is dated between 1726 and 1729 (five, however, are marked 1730) and signed with his full name and "invenit." A set of sixty-five in the Pierpont Morgan Library replace "invenit" with "fecit" to distinguish them from the preliminary designs; these are the finished drawings from which the engravings were made. They are all dated 1729 in Vanderbank's hand, some with the exact day of August and September. The tailpiece of two fighting horsemen, the last to be completed, is signed "December 22, 1729." This must have

been the cutoff date; after that, Hogarth can have had no more contact with the project.

In fact, he was probably out of the picture by the end of 1727 when he began to devote himself to oil painting. His six illustrations are for the beginning of the book and deal, with one exception, with the same episodes as Vanderbank; but the precise moment and the interpretation are different. There is no way of knowing now whether they were asked to collaborate or to compete for the commission; whether Carteret invited one and Tonson the other; or whether Hogarth began the project (perhaps shortly after he finished *Hudibras*) and lost interest or was found wanting, at which point Vanderbank was employed. Hogarth could be rather slow with a project that proved uncongenial, such as the tapestry cartoon commissioned by Joshua Morris and some of his conversation pictures.

The commission was obviously impossible for Hogarth from the start, less because of the subject than the sponsorship. To begin with Carteret himself, it is difficult to say how much of a Burlingtonian he was politically, but aesthetically his taste had been conditioned by Shaftesbury and the Burlington circle. Although he was a friend and admirer of Swift, he makes clear in his "Dedication" published with *Don Quixote* that he admires Cervantes as "one of those inestimable figures who, by the fertility of their immortal genius, have produced (albeit through burlesque) the most serious, valuable and salutary effects which one can imagine." The operative words are "albeit through burlesque": his doubts are further exposed in the eight-page "Advertisement concerning the Prints" written by Dr. John Oldfield, a friend of Carteret's who evidently served as his intermediary with the artists, especially since he had to spend part of his time in Ireland. This attached essay stated the policy of the editor as to the illustrations, indicating how important this aspect of the project was to Carteret. Coypel's illustrations were rejected, Oldfield says, because of their "injudicious" choice of subject, i.e., "gross and unlikely" incidents like the attacks on the windmill and the flock of sheep. It is difficult to imagine Carteret or Oldfield, with this philosophy, turning to the illustrator of *Hudibras* for designs. According to Oldfield, the illustrator should concentrate instead on the scenes which give "occasion for some curious and entertaining expression," which are "the most desireable and amusing." Indeed, he sees book illustration as a kind of history painting and would raise it from a supplementary status to the level of an art form.

The Carteret–Oldfield ideas would have interested Hogarth with their overtones of Jonathan Richardson's *Theory of Painting;* to judge by the engravings he produced, he was trying hard to avoid burlesque, to illustrate the proper scenes, and to follow instructions. As to the designs, Oldfield, according to Carteret, "invented most of them" himself, and gave the illustrators detailed descriptions.[39] Vanderbank's designs, surviving as they do in various versions,

show him falling into line with Oldfield's strictures until they have reached the ideal expressed in the "Advertisement." It is not difficult to imagine Hogarth chafing at such an arrangement, and as he proceeded, at the prospect of so many dozens more. They were, after all, mere illustrations of a text.[40]

If Hogarth did not withdraw, he was rejected; but some sort of a contract had been made, and he was paid, for the finished drawings remained the property of Tonson, passing to Dodsley when the publishers merged and eventually published long after Hogarth's death. Two drawings have survived, one on the blue paper used for *Falstaff and His Recruits* and *The Beggar's Opera* paintings early in 1728, the other in the style of some of the *Hudibras* drawings (and the Vanderbank drawings [cf. pls. 53a, 54]). The decision to discontinue, however, must have been made on the basis of the prints. The etching style itself isolates the figures, making them stand out much more than Hogarth's subsequent works of the 1730s (pl. 53b). They were perhaps too Coypelish in design and not delicate enough in execution for Carteret, suffering the disadvantages of a rococo design without the saving grace of Vandergucht's smooth style.[41]

Around the time of the Tonson project, either just before or just after the *Hudibras* illustrations, Hogarth planned a large *Don Quixote* series like the *Hudibras* plates. The choice of *Sancho's Feast* (pl. 55) is typical of Hogarth in that he takes the plebeian Sancho as his subject rather than the aristocratic Don Quixote and shows him deluded into thinking he is the King of Baratraria, with his folly being exploited by his "subjects," who are starving him. Here he is, as the caption tells us, "Starved in the midst of Plenty": because he sees himself, and thinks he is seen by the others, as king. This, rather than Hudibras and the bearbaiters or Don Quixote tilting against windmills, is the situation par excellence of Hogarth's later works. It is also significant that Mrs. Hogarth (probably in the 1780s) told the etcher Livesay that "Hogarth's portrait" appears in the print "in the person of Sancho."[42]

The conception may go back as far as 1724, when Hogarth first saw Beauvais' engravings of Coypel's designs; *Sancho's Feast* appears in this set in a somewhat different form, but it is plainly the model for his composition. He may have submitted it as early as 1724 to Henry Overton, who at that time was planning a set. It was then rejected or possibly included in some sets: Overton's consisted of nine engravings, five dated 1725, by Bickham and Mynde; Sancho's feast was not illustrated. At that point Hogarth may have gone to, or come to the attention of, Henry Overton's brother Philip, who reached an understanding with him for the series of plates of his own invention based on Butler's *Hudibras*. The plate of *Sancho's Feast* remained with Henry, who indeed published it: its size made it a feasible addition to the 1725 set, though it looks like a separate publication. Henry Overton and J. Hoole, who published it, remained in partnership until 1734; it is possible that, stimulated by the success of the *Hudibras* plates, they issued it after 1726 with Hogarth's name prominently displayed. It was re-

SANCHO *at the Magnificent Feast Prepar'd for him at his government of* Barataria *, is Starved in the midst of Plenty,* Pedro Rezzio *his Phisician; out of great Care for his health ordering every Dish from the Table before the Governour Tasts it.* Printed for H.Overton & J.Hoole *at the White Horse without Newgate*

W.Hogarth Inv.t et Sculpsit

55. Sancho's Feast; date unknown (third state); 10⅞ x 11⁹⁄₁₆ in. (W. S. Lewis)

issued at some later time with Hogarth's name displayed even more prominently above the design: "This Original Print was invented and engraved by Will^m Hogarth." It is also possible that Henry Overton, on the strength of the success of *Hudibras*, started Hogarth on a new series which never fully materialized, or that Hogarth engraved *Sancho's Feast* to compensate for his failure with the series of small illustrations for Tonson.

The *Don Quixote* illustrations are more important than Hogarth's own small part in the Carteret edition might imply. In art as in literature Cervantes' classic served in the eighteenth century as a bridge from classical concepts of decorum and rules to the genuine interest in the ordinary experience of everyday. Clearly, this influence was felt by Vanderbank as well as Hogarth. Even Vanderbank's designs, with all their revisions, did not wholly satisfy Carteret. In his letter to the British ambassador in Spain, Sir Benjamin Keene, he stresses the difficulties of illustrating *Don Quixote* and apologizes for the prints he has secured (impressions of which he is sending Keene).[43] Although certain details had been imposed upon him, Vanderbank did his best to translate his Quixote into English, elaborating detail which was essentially native, and not to Carteret's liking.

Vanderbank is an interesting case, parallel in his way to Thornhill, and representative of the serious English artist of the time. Thornhill, the successful history painter, had yearnings for the particularity and disorder of everyday contemporary life. Vanderbank, the successful portraitist who also tried his hand at conventional decorative painting, was occupied for most of his short career with drawings and paintings of *Don Quixote*, starting at just the time Hogarth made his *Hudibras* and *Quixote* plates.[44] Toward the end of his life he was using these paintings to satisfy his creditors.[45] Thus he is another case of the schizoid English artist of Hogarth's time, making a living by portraits but yearning for a more personal expression, relevant to his own time and surroundings, which could only be achieved through interpreting Cervantes' story.

It was Hogarth's aim, expressed in the abortive *Quixote* plates, to find this outlet and make it available for all English artists. If one may judge by his example, English book illustration of the first half of the eighteenth century (probably from around 1720 on) contributed strongly to the trend away from portraiture, even from idealized history painting, toward treatment of everyday subjects. Picaresque tales and other forerunners of the English novel, above all *Don Quixote*, served as important transitional agencies, providing artists like Hogarth and Vanderbank with a subject and (in book illustrations) an outlet for concerns that were suppressed by orthodox critical standards.[46] Vanderbank, in turning to oils as a medium for his *Quixote* illustrations, parallels Hogarth's direction. He had gone as far as he could with engraving; oils were necessary before he could take the next step up and far beyond Vanderbank.

After *Hudibras* and *Don Quixote* Hogarth made no further major effort at engraving until the *Harlot's Progress,* which would solve for him the problem he shared with Vanderbank. Considering the very small number of engravings he issued between 1726 and 1732, it seems certain that during these years his energies were channeled into painting—the subject of the next chapter. A few additional prints, however, deserve mention.

A tradition has it that Hogarth was approached by some London doctors to present the figures involved in the Toft case. It is doubtful whether, at the time, Hogarth's fame was quite that extensive. More likely he once again found a timely subject and exploited its topicality. On 2 December 1726 Lord Hervey wrote to his friend Henry Fox:

> There is one thing that employs everybody's tongue at present, which is a woman brought out of Surrey who had brought forth seventeen rabbits, and has been these three days in labour of the eighteenth. I know you laugh now, and think I joke; but the fact as reported and attested by St. André, the surgeon (who swears he delivered her of five), is something that really staggers one. I was last night to see her with Dr. Arbuthnot, who is convinced of the truth of what St. André relates. Every creature in town, both men and women, have been to see and feel her; the perpetual motions, noises and rumblings in her belly are something prodigious. All the eminent physicians, surgeons and men-midwives in London are there day and night to watch her next production. St. André's printed account of the whole progress of this affair is to come out to-day, and if I can get it in time enough to send with the other things, you shall have it. Mr. Molineux (who married Lord Essex's sister) swore to me that he himself, when she was in labour, took one part of one of the rabbits out of her body. In short the whole philosophical world is divided into two parties; between the downright affirmations on the one hand for the reality of the fact, and the philosophical proofs of the impossibility of it on the other; nobody knows which they are to believe, their eyes or their ears.[47]

It should be obvious which side Hogarth was on, especially considering the fools the nobility and the royal physicians were making of themselves. His satires of the 1720s show that he relished most the delusions of the great.

The story of Mrs. Toft goes back to a note in the *British Journal* for 22 October:

> They write from Guildford, that three Women working in a Field, saw a Rabit, which they endeavoured to catch, but they could not, they all being with Child at that Time. One of the Women has since, by the help of a Man Midwife, been delivered of something in the Form of a dissected

Rabit, with this Difference, that one of the Legs was like unto a Tabby
Cat's, and is now kept by the said Man Midwife at Guildford.

It took more than a single rabbit, however, to bring Mrs. Toft to the public
attention. Not until 19 November did the story break: "From Guildford comes
a strange, but well attested piece of News." A woman of Godalming, who had
a husband and two children, had been delivered a month before by the man-
midwife John Howard of a rabbit "whose Heart and Lungs grew without its
Belly." Fourteen days later she was delivered of a perfect rabbit, and later four
more; one came each day until they totaled nine, all dead at birth and pickled by
Mr. Howard to show to the Royal Society. The total delivery as of 19 November
was fourteen, and "Mr. Molineux, the Prince's Secretary, is, we hear, gone
thither by his Royal Highness's Order, to bring a faithful Narration of the
Affair."[48]

By 3 December the woman, one Mary Toft, had been ordered to come to
London by the King and was lodged at a bagnio in Long Acre, where many
people came to see her and physicians were constantly examining her, as another
birth was expected momentarily. The *British Journal* adds to its account: "A
fine Story! *Credat Judaeus Apella.*"[49]

It was all over by the tenth, and Mrs. Toft had been exposed. "The Woman"
was at the bagnio in custody of the High Constable of Westminster; on the sev-
enth she had confessed but would not name her confederates till assured of the
King's pardon. The porter of the bagnio, whom she had sent to buy rabbits, told
all. "Several Noblemen have been very active therein, not willing that so vile an
Imposture, a Blemish on human Nature, should pass for Truth, and as such be
inserted in our Histories."[50] On the tenth the *London Journal* adds that Mr.
St. André, the surgeon who had published the gullible account referred to by
Lord Hervey, "has promised a particular Account of the Frauds she used, and
by what Means she impos'd upon him and the publick."

With this, a flood of pamphlets appeared: on 12 December was announced
*A LETTER from a Male-Physician in the Country, to the Author of the Female
Physician at London,* arguing that it is impossible for women to generate rabbits
or other animals; and on the fifteenth, *The Anatomist Dissected; or the Man-
Midwife finely brought to bed By LEMUEL GULLIVER* and *An exact
DIARY of what was observed during a close Attendance upon MARY TOFT
. . . By Sir RICHARD MANNINGHAM, Kt.,* who had exposed the fraud. "An
Anatomical Farce" called *The Surrey Wonder* was being staged by Rich, and
Jack Laguerre (son of Louis) published a mezzotint portrait he had made of
Mrs. Toft.[51] On the twenty-fourth Hogarth's print, entitled *Cunicularii, or The
Wise Men of Godliman* (pl. 56) was published, showing all the participants in
characteristic poses around the laboring Mrs. Toft.[52] Although a hasty etching

in the popular style, it is carefully constructed as if on a stage, and the general composition, with Mrs. Toft in her tester bed and the credulous Londoners approaching from the doorway (like blasphemous Wise Men), closely anticipates the third plate of *A Harlot's Progress*.

If *Cunicularii* was a purely topical print, hastily—though strikingly—executed, the other three prints published around this time are unequivocally political. Hogarth was either a naturally apolitical man or a very circumspect one. His satiric prints of the 1720s follow the Augustan satirists—in some cases precede them—and so tend to fall into the anti-Walpole camp. But they remain very general for those times. *Masquerades and Operas* had a political inspiration and alludes to the ruling faction and, indirectly, to the Crown; but its impact remains essentially social and moral. *Royalty, Episcopacy, and Law (The Inhabitants of the Moon)* was political, but so general that it might refer to any reign, any ministry; moreover it appeared before much concerted effort was made to attack the financial corruption of Walpole's ministry.

There really was no effective opposition to Walpole before 1726. William Pulteney made a few unsuccessful attempts, but the first important action came with the intervention of Bolingbroke and the meeting of Tories and disaffected Whigs—the two Pulteneys, Bathurst, Chesterfield, Pope, Swift, Arbuthnot, and Gay—in the summer of 1726 at Dawley, Bolingbroke's country estate.[53] Swift was in England to prepare for the publication of *Gulliver's Travels*, which appeared on 28 October. But the "symbol of the summer's achievement" was in fact the publication on 5 December of the first number of the *Craftsman*, the anti-Walpole organ put together by Bolingbroke and William Pulteney, with contributions by the Scriblerians and some of the best political polemicists of the time, to expose "how craft predominates in all professions" and particularly "the mystery of statecraft." As one pamphleteer described the frantic activity on the eve of battle: "All hands were employed and engines set to work, manuscripts were circulated, the press loaded, coffee house talkers, table wits, and bottle companions had their instructions given them."[54]

It was probably coincidence that the same week that ushered in the *Craftsman* saw the announcement ("speedily to be published") of Hogarth's *Punishment of Lemuel Gulliver* (pl. 57), itself an allusion to the anti-Walpole satire of Swift's work published a few weeks earlier.[55] Hogarth had remarkably little time to read the book and make his careful and painstaking etching. His print was out by 27 December, not long after the earliest responses to *Gulliver's Travels*: such pamphlets as *The Brobdingnagians. Being a Key to Gulliver's Second Voyage,* and *The Key to Gulliver's Voyage to Lilliput,* followed by keys to the other voyages and *Gulliver Decipher'd* (all advertised on 5 December), and *A Letter from a Clergyman to his Friend; with an Account of the Travels of Captain Lemuel Gulliver* (8 December).[56]

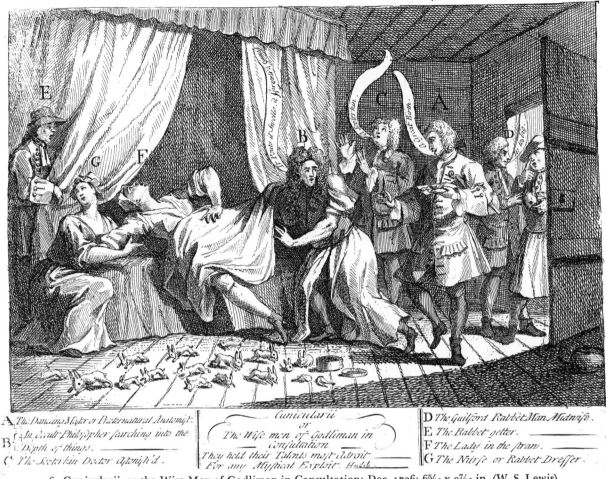

56. Cunicularii, or the Wise Men of Godliman in Consultation; Dec. 1726; 6⅝₁₆ x 9⁷₁₆ in. (W. S. Lewis)

57. The Punishment inflicted on Lemuel Gulliver; Dec. 1726 (first state); 7⁷₁₆ x 12⅛ in. (W. S. Lewis)

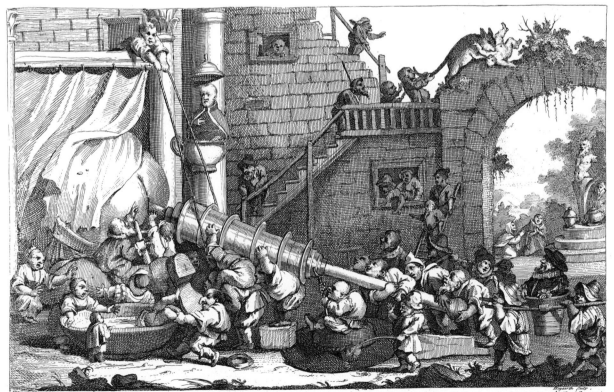

The Punishment inflicted on Lemuel Gulliver by applying a Lilyputian fire Engine to his Posteriors for his Urinal Profanation of the Royal Pallace at Mildendo which was intended as a Frontispiece to his first Volume but Omitted

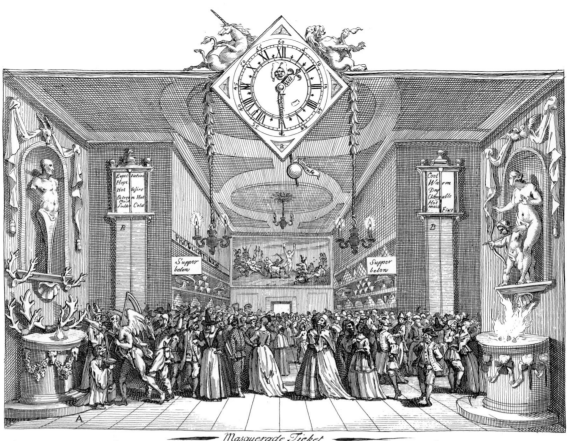

Masquerade Ticket

A. a ſacrifice to Priapus. B. a pair of Lecherometers ſhewing ỹ Companys Inclinations as they approach 'em. Invented for the uſe of Ladys & Gentlemen by ỹ Ingenious Mʳ H———r price one ſhilling

58. Masquerade Ticket (second state); 1727; 7³⁄₁₆ x 10 in. (W. S. Lewis)

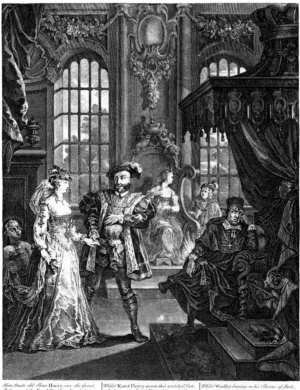

Here ſtruts old Bluff Harry, once the Great,
Reformer of the Engliſh Church and State:
Twas thus he ſtood, when Anna Bullen's Charms,
Allur'd th' Amorous Monarch to her Arms,
With his Right hand, he leads her as his own,
place this matchleſs Beauty on his Throne;

Whilst Kate & Piercy mourn their wretched Fate,
And view the Royal Pair with equal Hate,
Reflecting on the Pomp of glittering Crowns,
And, Arbitrary Power that knows no Bounds;

Whilst Woolſey leaning on his Pillow of State,
Through this unhappy Change forſees his Fate,
Contemplate merely upon worldly Things,
The Cheat of Grandeur & the Faith of Kings.

59. Henry the Eighth and Anne Boleyn; ca. 1728 (first state); 17³⁄₈ x 14⁵⁄₁₆ in. (W. S. Lewis)

On 16 November Pope had written Swift that he found "no considerable man very angry at the book," and with Gay he wrote on 17 November, "The politicians to a man agree, that it is free from particular reflections."[57] The "Voyage to Lilliput" was, of course, full of particular and general reflections on the government, and Hogarth's purpose in his print was apparently to point them out as clearly as possible. His own contribution was to define Gulliver's punishment as an enema, an appropriate invention, considering that Gulliver's crime was ejecting liquid. *The Punishment of Lemuel Gulliver,* plainly aimed at the Walpole Ministry, is about an England in decline. As in *Royalty, Episcopacy, and Law,* both church and state are represented. The purging is overseen by a First Minister carried in a thimble and a clergyman is officiating from his pulpit made of a chamber pot. The church and government are shown supervising this purging of a heroic and harmless Gulliver while ignoring the rats devouring their children and the term of Priapus being worshiped by their congregations. Gulliver's Lilliputian home was a ruined temple; if the pulpit's position is indicative, Gulliver's posteriors are where the altar should be, and the ceremony of purgation becomes another form of religious perversion. As in *Royalty, Episcopacy, and Law,* the satire is still general, but the implications are sobering. Significantly, like Swift's satire itself the print attacks the gullibility of Gulliver as much as the evil of the Lilliputians: Gulliver (or John Bull) is stupidly tolerating the enema. He is related to the protagonist of Hogarth's later progresses as the First Minister, the ecclesiastic, and the other Lilliputians are to the lesser figures in those works. As this may suggest, Hogarth was exploring his own subject, as well as expressing himself on the state of England. He no doubt wished to align himself with Swift (to whom he attributes the invention of the plate, spelling his name backward), as earlier with Ramsay, for practical or at least symbolic purposes.

The Punishment was followed sometime in 1727 by the *Large Masquerade Ticket* (pl. 58), which shows worshipers adoring a figure similar to that in the earlier print with a Venus added for balance; another anti-ministerial print, *Henry VIII and Anne Boleyn* (pl. 59), appeared sometime late in 1727 or early in 1728. The unanswered question is whether the Opposition solicited Hogarth or whether he was trying to get on the bandwagon. Nicholas Amhurst, editor of the *Craftsman* and already associated with Hogarth, would appear to be the most logical connection. Hogarth may even have received some money from the Opposition during these lean years of his apprenticeship to painting. Nevertheless, these were only tentative and rather veiled attacks; *The Masquerade Ticket* connects the political and the social, but again only in general terms, and *Henry VIII,* perhaps the most clearly and specifically anti-Walpole of his prints—playing upon the popular equation of Walpole and Cardinal Wolsey—is mysterious, like the *Masquerade Ticket* unsigned and unadvertised (though evidently sold in Edinburgh by Allan Ramsay).[58]

Both prints are relevant to the accession of the new king. The Prince of Wales had been associated with the masquerades because of his patronage of Heidegger (Hogarth may have alluded to this in *Masquerades and Operas* in 1724). On his accession in June 1727, therefore, masquerades seemed to receive the royal sanction.[59] The newspaper notices of that fall would have been sufficient to merit Hogarth's print with its prominently displayed "1727." *Mist's Weekly Journal* for 21 October, for example, notes that "His Majesty was at the Masquerade on Monday Night at the Haymarket, and, 'tis said, there will be 7 more this Winter." The print probably came out that fall; by 29 January of the new year, the young Henry Fielding had written and published his poem, *The Masquerade,* the first of a long series of parallels with Hogarth's work.[60]

Meanwhile, on 26 October Cibber's production of Shakespeare's *Henry VIII* received its first performance—enlivened by an alarm of fire, but well received anyway for its elaborate imitation of the recent royal coronation, suggesting the inevitable parallels between Henry VIII and George II, Cardinal Wolsey and Walpole. The *Craftsman,* reviewing the play on 18 November, draws attention to the resemblance between "The Character of this ambitious, wealthy, bad Minister," Wolsey, and Walpole, and poems very like the one under Hogarth's print appear in subsequent issues; all reflected the Opposition's hope that the new king would follow Henry VIII's example and dismiss his chief minister. Hogarth's print may have been in circulation by the end of the year or early in 1728. The further point he makes in his print is that Wolsey, like the clergyman in *The Punishment of Lemuel Gulliver* or *The South Sea Scheme,* instead of doing his duty as a clergyman is encouraging his king in the evil ways depicted in the *Masquerade Ticket.*

These prints are the last tangible evidence of Hogarth's reactions to politics until the mid-1750s. What happened in 1728 is something of a mystery. By then he had begun painting some of the Court party, and (like Thornhill in his notes on the entry of George I) he probably felt that he could not mix politics and painting. Yet during this time—at the end of 1727 or early in 1728—Hogarth carried out his most fashionable, and perhaps financially rewarding, engraving commission, the Walpole Salver (pl. 60). The goldsmith for whom he engraved was Paul de Lamerie (for whom Ellis Gamble did some work). Although a goldsmith ordinarily chose his own engraver,[61] it seems quite possible, considering what is known of Sir Robert Walpole, that he personally selected Hogarth to ensure his future silence. Walpole would have been less than his usual astute self if he had not recognized two facts: that graphic satire was far more dangerous than literary, and that Hogarth was potentially the most dangerous graphic satirist of the age. Hogarth, who wanted always to reach the largest possible audience, can have had no very strong attachment to one party or the other.

A word should be said about the Walpole Salver, Hogarth's swan song as a professional engraver (as opposed to an artist whose works were engraved).

60. The Great Seal of England (from the Walpole Salver); 1728/9; 9¼ in. diam. (BM). This is an impression taken from the silverplate, now in the V & A.

Custom, going back to the sixteenth century, required that the Officer of State responsible for the Great Seal, or other seals of office, retain the discarded silver matrix when a seal became obsolete on the death of the king and have the silver made into plate. In the earlier seventeenth century this usually took the form of a cup, but in the time of William III it took the form of a salver, the top engraved with a representation of the seal itself. The earliest which has survived, from the Lord Chancellor's seal of the Earl of Halifax, was made on the death of Queen Mary in 1694 and engraved by Simon Gribelin. Walpole's first had been engraved by Joseph Sympson, Sr., and the second represented Hogarth at his most elaborate and careful.[62] Hogarth returned to the allegory Thornhill had taught him at Greenwich; there the older artist depicted "*Wisdom* and *Virtue* represented by PALLAS and HERCULES destroying *Calumny, Detraction,* and *Envy,* with other Vices," and here Hogarth shows Hercules holding in subjugation Calumny and Envy, and supporting the sky to help Atlas.[63]

Hogarth had had some practice with the Hercules figure, the representative

of Heroic Virtue, who appeared in both *The Prince of Wales* and the various versions of the arms of the Duchess of Kendal.[64] A recurrent motif in the Greenwich paintings, he now served as the central figure in Hogarth's last "heathen gods" history. But Hogarth was not to discard him, rather disguising his presence in composition after composition; one wonders, looking back to the Walpole Salver, if Hogarth considered him a kind of heroic prototype, one of the "Monsters of heraldry" he could not believe in, and at the same time a symbol of the lost greatness of England, art, and Thornhill.

At this time George Vertue first mentions Hogarth as an engraver in his notebook. Though unfortunately undated, the reference summarizes his career from *Hudibras* to the first paintings:

> another work appeared which was well enough accepted. being undertook by printsellers the several Stories of Hudibrass being designd in a burlesque manner humoring very naturally the Ideas of that famous poem. these designes were the Invention of W^m. Hogarth a young Man of facil & ready Invention, who from a perfect natural genius improvd by some study in the Academy. under the direction of Cheron & Vand^rbank. has produced several charicatures in print, if not so well gravd, yet still the humours are well represented. whereby he gain'd reputation—from being bred up to small gravings of plate work & watch workes. has so far excelld; that by the strenght of his genius & drawing, & now applying himself to painting of small conversation peices, meets with good encouragement. according to his Meritt.[65]

9

The Beginnings of a Painter

Vertue says specifically that it was only after completing the large *Hudibras* plates that Hogarth started to paint:

> afterwards [he] got some little insight & instruction in Oyl Colours. without Coppying other Paintings or Masters immediatly by the force of Judgment a quick & ready Conception. & an exact immitation of Natural likeness became surprizingly forward to be the Master he now is <Jan. 1730>.[1]

Though Vertue's note does not rule out Hogarth's having experimented with paints before, it does strongly suggest that he did not devote himself to painting until 1726. For one thing, the years 1723–25 must have been largely devoted to engraving as he tried his utmost to rise above plate decoration and make a name for himself as a copper engraver. Only with his earnings from the large and demanding *Hudibras* project (still based entirely on drawings) could he afford to spend most of his time painting, turning out only an occasional print. William Ward's request for a painted version of *Hudibras* may have set him off,[2] but his principal motivations were a general desire to rise above engraving and a particular eagerness to emulate and prove himself to Sir James Thornhill (with by this time perhaps a further incentive in Thornhill's daughter Jane).

Various clumsy, thickly painted canvases have been attributed to Hogarth's "apprenticeship" to painting.[3] In fact, however, his career as a painter is a blank until 20 December 1727, when he was commissioned by Joshua Morris, the tapestry weaver of Great Queen Street, Soho, to paint a cartoon of "The Element of Earth." Morris was at this time preparing hangings for the Duke of Chandos' princely country house, Cannons, and Hogarth's cartoon may have been intended as part of that project (in which, perhaps significantly, Thornhill was involved).[4]

Someone—possibly Thornhill, possibly Vanderbank—recommended Hogarth to Morris "as a person skilful in painting patterns for that purpose."[5] Hogarth "accordingly," as related in Morris' deposition, went to see the tapestry-maker, who informed him "that he had occasion for a tapestry design of the Element of

Earth, to be painted on canvas;" Hogarth replied that "he was well skilled in painting that way, and promised to perform it in a workmanlike manner; which if he did, [Morris] undertook to pay him for it twenty guineas." Not long after, Morris discussed his commission with a knowledgeable friend (presumably an artist) and learned that Hogarth was not a painter but an engraver. Being therefore "very uneasy about the work" he had commissioned, he sent a servant to Hogarth's studio to tell him what he had heard; to which Hogarth offered the sanguine reply "that it was a bold undertaking, for that he never did any thing of that kind before; and that, if his master did not like it, he should not pay for it."

It would be interesting to know what this design, now lost, consisted of; it may have been related to one of the Dutch series representing "Four Elements" or to Le Brun's cycle *The Elements,* which were copied in the Soho tapestry factory—or to his own engraving of the goddess Tellus (pl. 7).[6] The discrepancy between his two statements to Morris sounds the cheeky, confident note that carried Hogarth through most of his enterprises; his comment that he had never done "anything of that kind before" presumably meant that he had never made a cartoon for tapestry. The challenge to produce something along the lines of the Raphael Cartoons must have been singularly stimulating to the novice painter, and he accepted. The testimony of Morris' informant that he knew only engravings by Hogarth strongly suggests that *The Element of Earth* may have been his first commissioned painting.

According to his deposition, Morris waited a long time for Hogarth to finish, sending several times to inquire after the work; which, when finally completed, Hogarth left at one of Morris' shops rather than his house, being ashamed to let him see it. More probably, Hogarth found the project less to his liking than he had thought, had trouble with the painting, put it off, and when he finished it took it to the first place he thought of, forgetting Morris' instructions (if there had been any). At any rate, Morris heard that it had been delivered and sent for it; he "consulted with his workmen whether the design was so painted as they could work tapestry by it; and they were all unanimous that it was not finished in a workmanlike manner, and that it was impossible for them to work tapestry by it." The absence of "finish" suggests that it lacked the firm outlines of a cartoon, and is not inconsistent with the appearance of some of Hogarth's early paintings. They would have looked strange indeed to a tapestry weaver accustomed to careful, essentially linear cartoons.

Morris sent a servant back to Hogarth with his painting and word that it would not do but that "if he would finish it in a proper manner," he would still take and pay for it. Hogarth now promised to finish the cartoon in a month, but again ran into difficulties and took three months. When he finally showed it to Morris, the latter, "when he saw it, told him that he could not make any use of it, and was so disappointed for want of it, that he was forced to put his workmen

upon working other tapestry that was not bespoke, to the value of 200 l. which now lies by him; and another painter is now painting another proper pattern for the said piece of tapestry."

Hogarth did not, however, let the matter rest. He promptly went to court, asking £30 for his fee plus the materials required ("which Defendant faithfully promised to pay when demanded"). The case was tried before Lord Chief Justice Eyre at Westminster Hall, 28 May 1728, with Morris producing weavers and fellow craftsmen to testify that it was impossible to make tapestry from the cartoon Hogarth had submitted; and Hogarth producing Thomas King, Vanderbank, Jack Laguerre, Thornhill, and one Collumpton to testify to the quality of his painting. Vanderbank was probably John Vanderbank of the academy, although it is just possible that Hogarth secured his brother Moses, who had succeeded their father in charge of the tapestry works in Great Queen Street in 1727 and would have been a more impressive witness in this particular case.[7] Hogarth's argument was presumably that the agreement had been made (Morris did not contest this) and that the painting was a competent piece of work. The point at issue was whether "competence" implied simply a painting or a work on which a tapestry could be based. Hogarth, arguing the former, won his case, and had his first taste of the law as a recourse in controlling unruly patrons.

Thornhill may have advocated this particular line of action, based on his own experiences in wringing money from his patrons; he had already gone to court to secure money promised for the work done for Knight, the South Sea treasurer, with only middling results.[8] Hogarth's success may have stimulated Thornhill to follow the same course a month later when he took Benjamin Heskin Styles to court. Thornhill, according to Vertue, had been working "for the last five or six years" on Moor Park, the house near Rickmansworth, Hertfordshire, that Styles, a successful South Sea speculator and M.P. for Devizes, bought from the Duchess of Monmouth and had rebuilt by Leoni. Thornhill had supervised the decoration and himself painted the Hall and Saloon. The work in the Saloon was in his baroque style, though not obtrusively, and the grisailles in the Hall of the eight heroic virtues, simulating statues in niches, were classical in effect. Because of the baroque tendencies, or perhaps only for harrassment, Lord Burlington or one of his group persuaded Styles of his error in employing so gothic an artist as Thornhill. One stipulation made by Thornhill when he undertook the project was that he be paid "at the same price each picture as Mr. Kent had for the Altar peice at St Georges Church, Hanover Square. church. proportionable to which price of Mr Kent. or any other work done by him Sr James is resolved to take no less." This telling detail offers another precedent for his future son-in-law, who demanded as much for his *Sigismunda* as the "old master" *Sigismunda* had brought at Sir Luke Schaub's sale; and provides some grounds for the Burlingtonians' effort to get the pictures rejected. "Mr Kents friends & interest, no doubt endeavourd to foment this difference & slurr the reputation of Sr

James," Vertue noted. Styles accordingly decided to reject Thornhill's work, saying that "he was inform'd that Sr James had not done his part with care nor finisht his workes as he was capable to do." Thornhill brought the matter to trial in July, and came equipped with artists to testify as they had successfully done in Hogarth's case: his witnesses included Michael Dahl and Thomas Murray. Styles saw the way things tended and made a settlement out of court, which, however, must not have proved satisfactory; Thornhill evidently brought a second suit against him, this one actually taken to court and decided in Thornhill's favor by the same Lord Chief Justice Eyre who had found in favor of Hogarth.[9]

Styles' response, after paying Thornhill, was simply to remove his eight heroic virtues and set into the wall four huge paintings by Amigoni—"no doubt intended as a mortification" to Thornhill. They depict Zeus' seduction of Io, Hera's changing Io into a heifer, Argus her guard being lulled to sleep by Hermes, and Hera receiving the head of Argus and endowing the peacock's tail with its hundred eyes.[10] Thornhill's classical restraint was replaced with a baroque depiction of the loves of the gods—a lesson not lost on Hogarth, who, already aware of Steele's admonitions, returns frequently to this particular aspect of fashionable history painting.

There is some question as to whether he assisted Thornhill with any of his decorative work in 1726 or 1727. According to Nichols, he was responsible for a satyr in the *Zephyrus and Flora* ceiling at the Huggins' house in Hampshire (of course a satyr would be attributed to Hogarth); and helped with the staircase pictures at No. 75 Dean Street, Soho.[11] It is evident from his own testimony that Hogarth did not work on the portrait of the royal family at Greenwich, which was in progress when he became acquainted with Thornhill. The Greenwich paintings were finished by November 1726, but Thornhill had to keep petitioning for payments for several more years. As he was completing the Upper Hall and the cupola, the ceiling of the Painted Hall, only ten years old, was given its first cleaning—to eradicate the effects of the sea air in an attempt to make the whole interior look fresh and new. Hogarth knew all the circumstances and recounts them in his "Britophil" article and *The Analysis of Beauty*.[12] On the one hand, his lack of training would have made him a liability on such a project; but on the other, he was a talented and eager learner.

One can assume that he began to experiment with small pictures of groups of people. Relying on his success in *Masquerades and Operas* and *Hudibras,* he probably tried to make pictures of people in conversation, similar to those Philippe Mercier was doing in 1726 and 1727, but with more and livelier people.

While the cartoon for Morris was in progress, however, Hogarth was discovering a subject that would in effect inaugurate his career as a painter. On 29 January 1727/8 John Gay's *Beggar's Opera* opened at Rich's Lincoln's Inn Fields Theatre; this strange new piece, a satire on operas, itself a drama inter-

spersed with ballads parodying opera arias, seems to have puzzled its audience through most of the first act. Then came Polly Peachum's plea to her mercenary parents:

> Oh, ponder well! be not severe;
> So save a wretched wife!
> For on the rope that hangs my Dear,
> Depends your Polly's life.

At this point Polly won over the wavering audience, and the rest was a resounding success.[13] The first notice emphasized that this "new English Opera" was "written in a Manner wholly new," adding that "There was present then, as well as last Night, a prodigious Concourse of Nobility and Gentry, and no Theatrical Performance for these many Years has met with so much Applause." This and Pope's remark that *The Beggar's Opera* was "a piece of satire which hit all tastes and degrees of men, from those of the highest quality to the very rabble," reminds one of Vertue's statement to the same effect about the reaction to *A Harlot's Progress* in 1732.[14] They were in fact very similar phenomena, depending on some of the same sources of interest in their audiences.

The play ran for 62 nights during the first season, and the remark that it had made Rich gay and Gay rich was already current by 3 February when it was published in the *Craftsman*. Added interest was provided by the well-publicized love affair between Lavinia Fenton, the Polly of the cast, and the Duke of Bolton—she 20, he 43 and married. He sat in a stage box at the first performance and was said to have been one of those enamored of Polly-Lavinia's rendition of "Oh, ponder well," returning again and again to watch and hear her. At the close of the first season, on 19 June, he took her off the stage to become his mistress.

The first months of 1728 marked in some ways the climax of the Augustan Age: in January *The Beggar's Opera,* in February Fielding's first play, *Love in Several Masques,* and in May Pope's *Dunciad. The Dunciad* and its world of emblem and allegory may have held little interest for Hogarth by this time, but *The Beggar's Opera* offered him a double incentive for thought: as the fashionable gathering place of the season, it was ripe for an artist experimenting with group portraits at card parties and other social occasions (one reads of people who had guests to their house "and afterwards entertain'd them at the Playhouse with the Beggar's Opera")[15]; and it contained the blend of realism and stylization, fact and symbol that appealed to him.

Hogarth was, as his earlier prints attest, an avid theatergoer. In his writings he constantly takes his examples from the theater, most often from Shakespeare but also from Ben Jonson and from contemporaries like Henry Fielding. He recalls with pleasure Master Stephen in *Everyman in his Humour* and Tom Thumb, and he refers to Bardolph's red nose and to Falstaff's saying *"stand*

before me boy I would not be seen to his little page when the lord Chancellor was passing by." He is known to have frequented the Clare Market Club of actors and engraved a ceremonial tankard for their use.[16] But besides enjoying the theater, he recognized the stage as a useful compositional unit for the sort of graphic scene that interested him and a source of expressive faces, their drama heightened by greasepaint and theatrical lighting. The very nature of the London stage was significant to Hogarth the painter as it was to Gay the dramatist, the one satirizing overblown history paintings, the other overblown operas.

Continental theaters, emphasizing spectacular and operatic style and elaborately painted scenery, were baroque par excellence in creating an illusion of unlimited space within the limited area of a stage with a proscenium arch. The English stage of the early eighteenth century adopted the proscenium arch and the painted scenery, but was different in essential ways. It was much smaller, accommodating relatively few spectators, some sitting on the stage itself, and so possessed an important feeling of intimacy. While continental drama was operatic and stylized, English drama, from the Elizabethan Age on, catered to "the native taste for quick action and close, vivid characterization [which] led to a more concentrated show with a great importance attached to spoken dialogue and the humanity of the characters."[17] Thus a small auditorium was needed, where the characters could be seen and heard; also, of course, frequent changes of scene were indicated, as opposed to the single set of classical French theater with the unities of time and place observed. The scenery of continental playhouses usually slid up and down, and so was stored above or below the stage; English sets, with the smaller stage and quicker changes, split in the middle and slid off to the wings on either side of the stage.[18] *The Beggar's Opera,* for example, shifted from Peachum's counting house to Lockit's prison to the thieves' den and so on, producing a rapid series of tableaux very like those represented by Hogarth a few years later in his "progresses."

It would also have been extremely suggestive to a theater-lover like Hogarth, and one who wished to combine his "pleasures" and "studies," that Jonathan Richardson in his influential *Theory of Painting* (1715) makes a comparison between painting and the theater. Contrasting words and pictures, he goes on to say: "The Theatre gives us representations of things different from both: there we see a sort of moving, speaking pictures, but these are transient; whereas Painting remains, and is always at hand." A painting, while no less vivid than a stage production, has the added advantage of permanence. A second problem with the stage, Richardson continues, is that it "never represents things truly;" one is always aware of the discrepancy between the actor and the Oedipus or Caesar he plays. While on the stage the viewer's "just notions of these things are all contradicted and disturbed," in a painting the ideal itself can be projected from the painter's imagination.[19]

The first of Richardson's points provided a kind of sanction for the theater as

a central inspiration of painting, and the second suggested a likely subject for a painter who took the first seriously: not the idealized Oedipus or Caesar, as traditionally painted, but the actor playing Oedipus or Caesar on a stage—whether a real one or one of the artist's imagining. This was Gay's subject.

At about the same time he turned to *The Beggar's Opera* Hogarth painted *Falstaff examining his Recruits* (Lord Iveagh), based on Shakespeare's *Henry IV, Part 2*, which evidently represents the scene as it was played on the stage. Sketches of this scene and of *The Beggar's Opera* survive (Royal Coll.) on the same bluish paper; presumably they were drawn not far apart. *Falstaff*, however, uses the stage as a compositional unit without giving any indication that it is a stage or is within a theater.[20] Even the first sketch for *The Beggar's Opera* surrounds the actors with the audience.

Hogarth must have seen the first, or at least an early, performance and produced the chalk sketch. He chose as his subject act III, scene 11, in which all the principals appear: Macheath in chains is begged "Hither, dear Husband, turn your Eyes" by each of his "wives," who then turn to their respective fathers, Lockit and Peachum (jailer and thieftaker), and beg them to "sink the material Evidence, and bring him off at his Tryal." Hogarth has chosen the scene and moment of greatest psychological tension: Macheath with his eyes on some distant point, completely noncommittal; the girls beseeching equally their lover and their fathers; their fathers expressing varying degrees of denial. The scene has, indeed, allowed him to repeat the composition of the Choice (or Judgment) of Hercules, which was to be a favorite with him.[21]

Judging by the Morris experience, it is quite likely that Hogarth quickly developed the sketch into the first painting (pl. 61) and offered it to John Rich for sale. Rich, later a close friend, may at this time have been a stranger or merely an acquaintance. But whether the picture established the contact or was a result of their acquaintance, their friendship grew and was maintained until Rich's death over thirty years later. Because of Pope's and Fielding's attacks, Rich has been much maligned; but Hogarth must have learned a great deal about expression and composition from watching this actor, conceded even by his enemies to be a masterful pantomimist. From him Hogarth may have learned that expression involved not only a flexible face but a pliable body. Rich's acceptance of Gay's play after Drury Lane had rejected it was a piece of luck: it was not, of course, a characteristic Lincoln's Inn Fields play, and Rich played no part in it himself. But it was the play that set him up for the next few years and earned him enough profits to build a new theater in Covent Garden, next door to the Thornhill house.

He bought Hogarth's small, rather awkward picture of *The Beggar's Opera*, and before the end of 1729 had commissioned a larger and more elaborate version, probably for hanging in the theater. This picture (pl. 64) is dated 1729, and by 5 November 1729 Sir Archibald Grant, an M.P. with whom Hogarth had

other connections I shall examine shortly, saw the picture, complete or nearly so, and ordered a copy for himself.[22]

As a picture destined for Rich, Hogarth's first version tried to recapture the first night; it is seen from the point of view of the actors, who are painted as portraits, while the audience is reduced to good-humored caricatures. Horace Walpole identified the fat man in profile on the right (with riding crop under his arm) as Sir Robert Fagg, the noted breeder and racer of horses, who is turning his back on the performance. The long-visaged man on the left he identified as Sir Thomas Robinson of Rokeby, famous for his lavish entertainments and amateur architecture. The thin, pointed-faced beau standing next to Fagg is Major Robert Paunceford.[23] In the final version commissioned by Rich these same figures are normalized into realistic portraits like the actors. This appears to be an idealized performance, with an audience selected by Rich, including the Duke of Bolton, whose eye meets Polly's across the stage. Only with this version does Polly's right arm, which made her psychological tie with Macheath, drop and point toward Bolton to indicate their relationship. Included are not only Rich's players but his most influential friends, and of course Rich himself and Gay (who may have been the face just above Fagg's in the earlier version).

The final version also shows a completely different, and much larger, more spacious and baroque stage, with a crouching satyr at each wing. One might imagine that this painting was commissioned for Rich's new theater in Covent Garden, to celebrate the play that probably financed it; but the subscription for the new theater was not begun until 1730, and the only picture I have seen of the stage (from later in the century) shows an erect female figure on either side instead of satyrs. It remains possible, of course, that Hogarth misdated the canvas; that Rich wanted a painting of how his theater *should* look (and the satyrs were either part of his vision or part of the Lincoln's Inn Fields stage at this time); or, perhaps the most obvious answer, that Hogarth simply idealized the composition.

Be that as it may, the six paintings Hogarth made of *The Beggar's Opera* are, for lack of other evidence, the best chart available of his development as a painter between 1728 and 1730. The first three must have been painted close together. Only with II (pl. 62) does he succeed in relating the central figures to each other, making them a single tight unit; and even then Peachum remains clumsy, with his hat wrong and his head not set correctly on his body. II and III come closest of any to the monumental simplicity he seems to have been seeking, which he finally achieved in the *Harlot's Progress* compositions. At this point he has created a kind of history painting composition of his own which does not require crowd scenes or echoes of battle scenes or processionals: the effect of his actors blocked on their stage, in their contemporary dress, is one of solidity and monumentality.

Here he presents, as Thornhill did Sheppard, a highwayman, two of his mis-

tresses, and their fathers (the highwayman's jailer and fence). But he makes it perfectly clear that these are not highwaymen, lovers, jailers, and fences, but actors on a stage: the stones of the prison set are not carried out in the floor, which is made of wooden boards; the stage curtains are in plain sight, as are members of the audience seated on both sides and (in II, III, and IV) behind the actors.

While Hogarth was searching for a monumentality of construction, he did not want to sacrifice the pure expressiveness that flowed from his brush. IV (pl. 63), sketchily executed, is unfinished, the curtain only indicated at the top; perhaps for this reason it is the most expressive of all the *Beggar's Opera* paintings—though not necessarily the best transcript of what actually appeared on the stage of the Lincoln's Inn Fields Theatre. There is no wrong note, no distortion for effect: he has solved the problem of Peachum's hat by canting it toward Polly (instead of down at his finicking hands), and raising his left hand in a negative gesture. Polly's face is turned from profile and is more expressive, less posed and statuesque, than in the earlier versions; even Lucy is for once expressive, her face (usually averted) partly in view; and the spectator at the far left, her face too turned toward us, is better than the averted face of the final two versions (where her pose is too like Lucy's). This version, with its mastery of paint, also demonstrates one of Hogarth's recurrent problems in his painting, already noted in his engraving: to maintain the freshness of his original idea in the finishing of the picture—or, for that matter, to know when he is finished.

IV is a transitional painting: the flagstones instead of floorboards make one wonder whether he was toying with the idea of turning the stage into a real prison. The scale is changing, the stage becoming larger, the audience seated on the stage more prominent and more intimately related to the actors. It was left unfinished, I suspect, because he decided in V and VI to enlarge upon the new idea that was beginning to emerge.

Actors in a play gave Hogarth exactly what he needed at this time: the freedom to improvise denied him in conventional portrait groups of the ladies and gentlemen whose business he now wished to attract. The *Beggar's Opera* figures are certainly better related to each other and less isolated than those of, say, the *Woodes Rogers Family* (pl. 75), painted around this time, or the *Beckingham Marriage* (pl. 84), painted a little later; and yet they were real people and not the inventions of traditional history painting or his own imagination. Moreover, the actors could be juxtaposed on the stage with their roles and with aristocratic members of the audience; thematic and psychological tensions could be suggested. A brilliant possibility for a conversation piece was offering itself; he could peddle his modello—one of the small versions perhaps—and suggest that around the standard group of actors from *The Beggar's Opera* he would introduce portraits of Lord X and his party. He evidently followed up this idea only in the last two paintings, however, and they repeat the same group of onlookers.

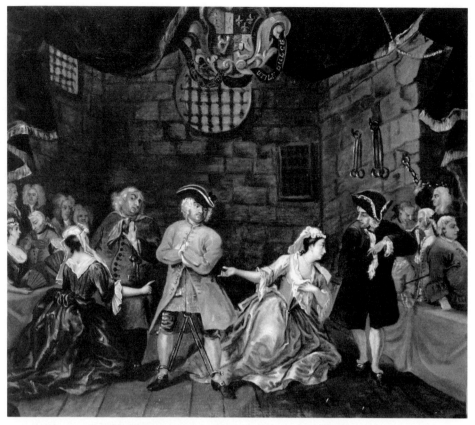

61. The Beggar's Opera (I); 1728; 18 x 21 in. (W. S. Lewis)

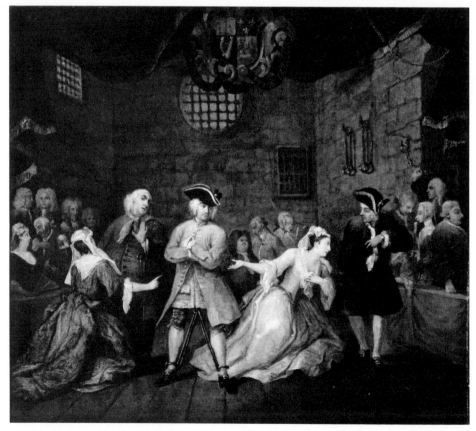

62. The Beggar's Opera (II); 1728; 20 x 20 in. (the Hon. Lady Anstruther-Gough-Calthorpe)

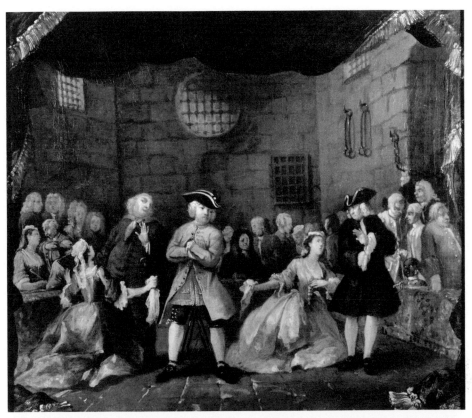

63. The Beggar's Opera (IV); 1728–29? 19 x 22½ in. (Nigel Capel Cure, Esq.)

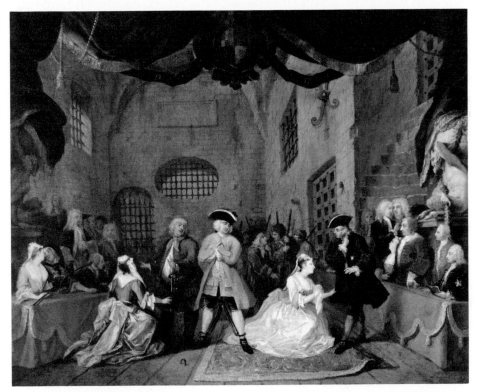

64. The Beggar's Opera (V); 1729; 23¾ x 28⅞ in. (Mr. and Mrs. Paul Mellon)

This final version (pl. 64), originally painted for Rich, is a remarkable synthesis of the virtues of the overly finished early paintings and the freely-painted, indeed unfinished expressiveness of IV. The style of IV dominates the canvas (much of this freedom was lost in VI, the mechanically executed copy made for Sir Archibald Grant [Tate]), but the faces and figures of the main characters approach a high finish. The secondary figures are more casually rendered, and the background figures are only indicated. In this version Hogarth has reached maturity as a painter. If the date 1729 inscribed on it is accurate, it shows that he developed in little more than a year's time from a groping, primitive painter to one unexcelled in pure technique by any other English painter of the eighteenth century. It is hard to believe that five paintings reflecting such improvement could have been made between the spring of 1728 and the end of 1729, even considering that all were repetitions of a single scene.

The final version is much wider; more panoramic, elaborate, and in every sense mature than any of the earlier paintings. Before, the actors filled the picture space and were themselves surrounded by spectators who were lightly indicated or mere caricatures. Now the actors are reduced to neat little figures on a gigantic stage (made more so by the recessions of the elaborate stage set); the crowd behind has become a group of actors (presumably getting ready to participate in the "Dance of Prisoners in chains" of scene 12); and the spectators appear in two neat rows on either side of the actors, developed here into careful and not unflattering portraits. If the third painting sacrificed the psychological involvement of the characters to monumentality, these last two paintings have sacrificed it to panoramic and decorative effect. The characters speak out as part of a thin, undulating chain reaching from one side of the stage to the other—unified by the salmon red of the spectators' boxes on either side and Macheath's coat in the middle—and in V this color link is further emphasized by Polly's light salmon sash, bodice, and arm ribbon.

The two conceptions reflect essentially different interpretations of Gay's accomplishment in *The Beggar's Opera*. The first group, with large figures dominating the picture space, explores Gay's play as an alternative to opera (or, in Hogarth's terms, to decorative history painting), with its small, intimate stage, subdued sets, and contemporary costumes. The last two paintings put a great deal more emphasis on the play as parody of opera. They reduce the size of the players in their contemporary dress and play up the theatrical quality of the trappings that surround them. The effect is more clearly mock-heroic, reflecting Gay's intention: to make thieves sound like opera singers playing gods and heroes. Here were two possibilities, quite different, for historical compositions. One would become the unit for a series of related scenes in the progresses, and the other would provide the scale for a large independent composition like *Southwark Fair* or *Strolling Actresses*.

The performance of *The Beggar's Opera* was, then, the decisive aesthetic event for Hogarth between his *Hudibras* plates of 1726—in which he had already begun to experiment with the idea of modernizing history painting—and the "comic history" of the *Harlot* in the 1730s. Besides the structure and conventions of the stage itself, which were already evident (sometimes physically present) in his engraved work, Hogarth made use of two crucial elements in *The Beggar's Opera*. First was the lowering of the Italian opera heroes and heroines—with the arias, highflown speeches, and other conventions—into the figures of contemporary robbers and prostitutes. This of course was obvious to Hogarth's contemporaries, and the only distinctive Hogarthian insight was that this transference could also apply to the equivalent of opera in art—to history paintings, those extravaganzas based on a biblical or literary text, which had become as decorative and overformalized as operas. This insight was already part of Hogarth's equipment (witness *Hudibras*), but Gay's ballad opera may have reinforced his interest and suggested the idea of an original subject instead of illustrations for an established text. However, there was one major difference: Hogarth was not out to satirize the tradition of history painting, only its excesses; he could not, like Gay, ridicule his own form.

The second element of importance in *The Beggar's Opera* was Gay's device of having his thief employ the jargon or diction of a gentleman. What Hogarth saw that his contemporaries apparently missed—or at least did not exploit—was the complex effect produced by the thief's adopting the style of the gentleman. In terms of the Augustan mock-heroic mode, Gay was adapting the heroic level to parallel rather than contrast with his low subject: as if Theobald's heroic view of himself in *The Dunciad* incriminated Vergil's Aeneas rather than polarizing him. In *The Beggar's Opera* the diction and the mock-heroic similes in the mouths of thieves do not, as in Dryden and Pope, allude to an ideal; they indicate a correspondence between the depredations of robbers and the heroic activities their own words evoke. The thieves constantly align themselves with their betters ("Sure there is not a finer gentleman upon the road than the captain!"); they employ similes (if Polly Peachum marries Macheath, she is told, she will be "used, and as much neglected, as if [thou] hadst married a lord"); and, more generally, they assume an inappropriate diction: Macheath talks like a gentleman, Peachum and Lockit like merchants, Polly like a romantic heroine, and the whores like ladies.

One implication is that opera heroes and politicians, under their rhetoric and respectability, share the cutthroat values of Macheath and Peachum, the highwayman and the fence. As the beggar tells the audience at the end, he wanted to show "that the lower Sort of People have their Vices in a degree as well as the Rich, and that they are punish'd for them." The punishment, of course, is the only distinction. By embodying the mock-heroic relationship in a character's

diction, Gay reveals the character's self-rationalization and upward aspiration—his desire to emulate the more respectable, and successful, citizen or aristocrat. The "Rich" are Gay's real game, not these poor rogues; the rich whose imitation of a false ideal is only dimly reflected in the whore and highwayman who hang for their crimes. In between are the middlemen, the fences, thieftakers, and jailers, who also use the jargon of their superiors but exploit the whores and highwaymen: perhaps because the ideal of the highwaymen is courtly, while that of the thieftakers is middle-class and mercantile.

There is a suggestion of psychology in Hogarth's use of the mock-heroic in his *Hudibras* prints, where the forms of history painting, artistic equivalent of the literary epic, serve to portray Hudibras' crazy image of himself and his surroundings. Hogarth employs the heroic level not to denigrate the rustics but to suggest a level of misinterpretation and aspiration on the part of Hudibras. The effect is strong enough to make one suspect that Gay's use of the high-low contrast was immediately recognized by Hogarth as resembling his own device, but opening up new possibilities. Thus the paintings of *The Beggar's Opera* show actors playing parts (of other actors—Macheath, etc.—playing parts) on a stage where they are juxtaposed with the very gentlemen and ladies they are imitating as characters. Hogarth exploits the fact that the nobility had seats on the stage to achieve one obvious effect: Lavinia Fenton, playing Polly Peachum, looks away from her supplicating stage lover, Macheath, toward her real lover, the Duke of Bolton. Surely Hogarth the ironist must have seen this situation (even if Bolton did not) as a realization of Gay's central proposition about the relationship between thieves and gentlemen; it very clearly conveys the play's theme, placing criminals next to the equally culpable aristocrats who are watching and urging them on. In the earlier versions of the painting the aristocrats are all over the stage, more or less surrounding the small group of actor-thieves; their faces are distorted into caricatures of exploiters and degenerates, some looking as though they were paper cutouts. In fact Hogarth has made the actors appear much more real and substantial than the aristocratic spectators, who come as close as any figures in his work to caricature. In the final version of the painting they are regularized to seem more like portraits, and segregated to either side of the stage; but there are still a great many of them.

In the final version Hogarth adds to "UTILE DULCE," which has appeared on the ribbon attached to the royal arms over the stage, the direct reference to the audience, "VELUTI IN SPECULUM" (even as in a mirror). The final version is, in fact, an extraordinarily complex study in the nature of reality based on the old metaphor of life as a stage. An enormously expanded version of the *New Metamorphosis* frontispiece, it contrasts the "rather clumsy, bourgeois stability of the actors"[24] with the theatrical quality of the baroque, billowy curtains, the royal arms, the set itself (which dwarfs them), and the sculpted satyrs. Here Polly-Lavinia turns toward the Duke of Bolton, who exists somewhere between audi-

ence and actor, partaking of both (is he acting according to stage conventions or is Polly acting according to his aristocratic conventions?), while Gay, the author, and Rich, the producer, watch both dramas unfold. The actors who have been added at the back of the stage talk among themselves, oblivious of the play, like some of the spectators; they represent an intermediate state between these aristocrats and the actors in their roles, for they are not yet "on stage," their scene has not yet begun. Even the satyrs on either side of the stage, *contrapposto* in different directions, seem alive in relation to the sculpted heads of deities, part of the stage structure, before which they crouch. The satyrs become observers somewhere between the audience and the architecture of the stage, analogous to the satyrs in the frontispieces of *The New Metamorphosis* and *Hudibras*. Here, of course, Hogarth has gone far beyond Gay's intention, producing in a single picture almost all the themes with which he will be concerned throughout his career.

Sensing something but by no means all of Gay's strategy, contemporary critics attacked his play for offering criminals as ideals for ordinary citizens to copy; Gay, of course, meant to illustrate how the respectable models of politicians, judges, and lawyers lured people into criminality. Hogarth must have noted these censures, in particular a book called *Thievery A-la-mode; or The Fatal Encouragement,* which came out toward the end of 1728. In it a young man vainly seeking his fortune in London attends a performance of *The Beggar's Opera* and afterward notices everywhere portraits of Macheath and Polly—which were indeed reproduced on fans, playing cards, screens, and snuffboxes.[25] Seeing that these characters are universally admired, he becomes a highwayman, comes to grief, and, dying, confesses his crimes, "concluding with a hearty Prayer, that he might be the only person seduced by the extravagant Applause the Town gave the Character of a Thief in the *Beggars Opera*."[26] It is a portrait of Macheath that the Harlot keeps on her wall near her bed, a pin-up, an ideal of conduct to follow. But, as if to demonstrate that he has grasped Gay's real meaning, Hogarth places next to it a portrait of Dr. Sacheverell, the respectable clergyman who had toppled a ministry with his incendiary sermons and then risen from one lucrative benefice to another.[27]

Only with the *Beggar's Opera* paintings do the central issues and contradictions of Hogarth's career clearly emerge. The problem is clarified by Hogarth's chronology. When he was born in 1697 Jonathan Swift was 30, Daniel Defoe 37 (of Richard Hogarth's generation), John Gay 12, Alexander Pope 9, Samuel Richardson 7. He was young for the Augustan generation, and old for the next (Fielding was born in 1707). But he was almost exactly contemporary with the great European painters Tiepolo (born 1696), Canaletto (1697), Chardin (1699), Longhi (1702), Boucher (1703), and Quentin de la Tour (1704). One should not try to draw too profound a conclusion from these dates, especially as

to the coincidence with the births of continental artists. But the literary world was very much his concern, and his ethos fell between that of Swift and that of Fielding (Gay tends to represent a similar transition); he did come to know the works of Chardin, La Tour, and Canaletto, if not the other artists, and he must have known Canaletto personally. While his engravings (what might be called the literary side of his oeuvre) were very much defined by the tradition of the Augustans, as well as the graphic tradition of the Low Countries (itself profoundly literary), it is a curious fact that his paintings as such—as paint applied to a surface—are of a piece with the works of the great Continental artists. To look at a Canaletto or a Chardin, even a Boucher or Tiepolo, and then a Hogarth, is to look at different aspects of experience executed by hands trained in the same studio. It becomes clear very quickly in Hogarth's career as a painter—certainly by the fourth version of *The Beggar's Opera*—that he was best at two things, sometimes quite extraordinarily hard to reconcile: a highly intellectualized satire and pure painting.

The *Beggar's Opera* paintings, as I have noted, employ two styles, sometimes in the same painting: one is a highly finished, finicky, and detailed surface; the other is unfinished, very sketchy and brilliant, with thin paint defining forms (volumes, not outlines) and giving a wonderfully fresh and expressive sense of process and discovery. The first is less satisfactory, and Hogarth's mature style is essentially a development and refinement of the unfinished style. In terms of contemporary fashion, these two extremes epitomized the polished, glossy, "licked" style of the Italian portraitists, and the broad "bold manner" of the Venetians (especially Tintoretto, but in Hogarth's time Ricci, Piazzetta, and Pellegrini) which showed off masterly technique of the brush. They often appear in the work of a single painter: the former was intended for the general public, for functional paintings, and the latter was more appreciated by connoisseurs. Both styles have a precedent in Hogarth's teachers—in Vanderbank (the unfinished, for example, in his *Don Quixote* paintings), in Cheron, and in Thornhill; but the color scheme is so much like Thornhill's that it seems pointless to carry the search further.

The most notable characteristic of Thornhill's paintings is their color, which sets them apart from other contemporary English decorative paintings. As opposed to Verrio's hot, often garish colors, and Laguerre's blue-gray tints carried over from his work with Le Brun, Thornhill's palette is essentially Venetian, a "happy palette" as Croft-Murray calls it, of "cool browns, deep pinks and crimsons contrasting with sea-greens, clear blues and frothy whites," which redeemed "many a carelessly modelled composition."[28] From this source Hogarth inherited his love of the lilac, indigo, lemon, strawberry, and above all salmon pink of the late baroque and the Venetians.

Though the distinction between sketch and finished painting is by no means unique, Hogarth's mingling of the two styles in "finished" paintings reminds

one of Thornhill's peculiar dualism. The work of both men reflects the academic distrust of "great and bold handling" expressed in Lairesse's rule:

1. Boldness of hand, in the dead-colouring.
2. More care, circumspection and labour in the second colouring, and,
3. Thorough patience and attention in the re-touching or finishing a picture; the nigher to perfection, the more care.[29]

Thornhill's sketches are thus executed with a bravura Venetian handling of paint; in fact, his sketches, whether in oil, chalk, pencil, or pen, are lovely and expressive artifacts. But as almost all writers on Thornhill have noticed, the finished paintings—especially the large-scale histories—lose all this charm and become quite dull if not clumsy (apart from the delicacy of his coloring). It is as though, like Hogarth, he could model figures instinctively but not finish them off. A further result of this disability is that the sketches emerge in a light, intensely rococo manner, while the finished work, in spite of itself, is in a hard, well-defined classical style. Although in the large works this may be to some extent the result of later repainting, it is sufficiently confirmed in the surviving relatively untouched paintings.[30] Within the realm of Thornhill's finished paintings one must also, of course, distinguish between the free baroque of the Greenwich ceiling and the restrained classicism (inevitably more finished) of St. Paul's and the Greenwich grisailles.

If, however, Thornhill in general moved from a baroque style and relatively free painting to a classical, more restrained manner, the procedure was reversed in Hogarth. When he turned from engraving to painting, he found himself captured by a completely different medium, one that proceeds not by linear means but by building volumes, indeed by building light upon dark—exactly the opposite of engraving; and he must have discovered very soon that this was where his real genius lay. In the developing oil sketches for *The Beggar's Opera* the classicism of the *Hudibras* plates goes out the window.

Hogarth's painting technique changed little during his career. His most important departure was to paint directly on the canvas without preliminary drawings, a departure from the academic assembling of drawings for each figure or object. Many oil sketches survive—discarded first thoughts; but the only two surviving drawings connected with subject pictures are, significantly, of stage scenes: tentative sketches for the *Beggar's Opera* paintings and for *Falstaff Examining his Recruits* (pages from the same sketchbook).[31] And even these, compared with the final paintings, show how little he changed his original composition: he seems to have had the sketch in mind and then, without preparatory studies, drawing on his memory, attacked the canvas directly. Within this basic composition he often added figures of contrasting character, accreting his design by means of parallel and opposing forms. His statement to Charles Grignion when, after many trials, he was finally satisfied with Garrick's face in the en-

graving of *Garrick as Richard III* probably sums up his method of painting as well: "I never was right save when I had been wrong." X-raying his paintings, or merely cleaning, therefore leads to fascinating discoveries. Moving from conception to canvas, he says, he sometimes returned to "the life for correcting the parts I had not perfectly enough remember'd when I came to put them in practice," but this was done only "too seldom."[32] His method, Oppé has commented, "may seem almost miraculous, but Hogarth had faith in himself to perform miracles, and his paintings only too often have the air of improvisation." One of the significant facts about Hogarth, which Oppé saw as a shortcoming, is that (as Antal put it) "his drawings were intended to capture action and movement rather than form and structure."[33] This he could do better with paint than by engraving, and in this too he was anti-academic; he was searching for something that was more important to him, at the moment at least, than human structure.

His method of applying paint was important for the preservation as well as the effect of his paintings. He never attempted the systematic laying on of glazes—as Reynolds, for example, did after his return from Italy—but began with a thin monochrome underpainting, usually in cool grays and greens (occasionally in sienna). Over this, once dry (and sometimes before), he applied a relatively transparent painting of the actual colors intended, with no apparent science relating them to the underpainted colors, and then finished with highlights in rich, creamy, and occasionally impasto color. One consequence was that his relatively direct painting on the canvas produced works that have aged well. A cleaned Hogarth—like those produced when the Tate Gallery cleaned most of theirs in 1965–66—looks virtually as it must have when it left his studio. The contrast with the paintings of the scholarly Reynolds is instructive. He experimented with glazes and colors; within his own lifetime the carmine had faded, and the sitters today are mere ghosts; the bitumen cracked and the shadows now resemble peeling blisters and running sores.

The difference between individual pictures is largely dependent on the stage at which Hogarth stopped painting each one. We may question why, at the outset of his painting career, he preserved so many pictures that hover between underpainting and finishing—some of his best, in fact. De Piles offers the critical rationale Hogarth may have observed, arguing that unfinished paintings "have more spirit, and please more than those that are perfected, provided their character be good. . . . The reason is, that the imagination supplies all the parts which are wanted, or are not finished, and each man sees it according to his own goût."[34] Connoisseurs sometimes collected oil sketches, but an English connoisseur was unlikely to collect English sketches. Horace Walpole was one of the few who collected Hogarth's, and these relatively unfinished works were the only Hogarth paintings he did gather; his concern was primarily with Hogarth's subject—murderesses, actors, and prison wardens—but he was undoubtedly not immune to the liveliness of expression. Hogarth himself obviously recognized

his talent for immediate expression in oils, and perhaps often felt disappointed with the final static result. He kept these sketches first as modelli, perhaps as reminders of works that may have passed out of his hands, but also certainly because he appreciated their beauty. They were for himself. The story of his development as a painter is the search for a style that will pass for finished without losing the fluency of the underpainting.

Conversation Pictures

One wonders to what extent Hogarth's childhood experiences of prisons, prisoners (sometimes more honest than their jailers), and criminals (real and putative) contributed to his almost obsessive treatment of *The Beggar's Opera* with its thieves, actors, and aristocratic audience. In 1729 he was drawn back to the scene of those childhood memories, the Fleet Prison itself, and given an opportunity to paint the debtor-as-prisoner confronting his warden, with a committee of members of Parliament as audience.

The Fleet at this time was much worse than when Richard Hogarth languished there. In 1713 John Huggins, the crafty friend of Thornhill and the Earl of Sunderland, had bought the patent for the wardenship, paying £5000 for his own and his son's lifetime.[1] Huggins was a close, grasping man, who in the same year, as High Bailiff of the City and Liberty of Westminster, advertised in the newspapers against infringements of his patent for apprehending or arresting persons or seizing goods;[2] and by 1723 prisoners' petitions were accumulating to show that self-interest was guiding his operation of the Fleet. These petitions mainly concerned Huggins' extortions: he was extracting fees (garnish) far in excess of those settled by law in 1693, charging the same fee more than once, even demanding Christmas gifts of the prisoners, and conserving on his own outlay by letting the prison run down, failing to replace furniture and bedding or to repair drains, gutters, and necessary houses.[3] Answering the allegation that he detained the bodies of dead prisoners from their relatives or friends until he was paid rent and fees due him—and that "rather than accept of what may be in their Power to give him, he often suffers the Dead-Body to lye above Ground seven or eight Days, and often Times eleven or twelve Days, to the great endangering the Health of the whole Prison, by the nauseous Stench, . . . and when he has refused what he thought not worth his Acceptance, he buries them in the common Burying-place for Prisoners. . . ."—Huggins' characteristic response was to refer the question to his deputy:

> For Answer thereto, My Lords, the Deputy-Warden saith, That scarcely a
> Prisoner hath died on the Master's-Side, that was not largely indebted to

him; and therefore possibly he may have used endeavours to get what part of the Money was due to him, as he could fairly from the Deceased's Relations.[4]

And later, in the more serious enquiry of 1729, Huggins pleaded no knowledge of what his subordinates did, stressing the unruliness of his prisoners and the difficulties of his job. So long as the keeper was allowed to extract a profit from the prisoners in his charge there were bound to be abuses.[5]

Another source of Huggins' income was the escape of prisoners; indeed he admitted to the 1729 Committee "that so many prisoners had escaped, during the time he was warden, that it was impossible to enumerate them, he having kept no list of the persons so escaped."[6] The escapes were accomplished through bribes, but it was never proved conclusively that Huggins himself took the bribes; there was always an intermediary.

Huggins' reliance on his deputies reached a head in August 1728, when, having secured as much money as he needed (or, more likely, discerning the storm clouds ahead) and feeling that he was "growing in years, and willing to retire from business, and his son not caring to take upon him so troublesome an office," he sold his patent to his most recent deputy, Thomas Bambridge (an attorney by profession), and one Dougal Cuthbert for £5000.[7]

The storm clouds were indeed gathering. In 1725 Edward Arne, uncle of the composer Thomas Arne and an upholsterer and undertaker, having failed to pay his fees to the warden, "was carried into a stable, which stood, where the strong room on the master's side now is, and was there confined (being a place of cold restraint) till he died"; and it was further alleged that "he was in good state of health, before he was confined to that room."[8] Then in 1728 Robert Castell, architect and author of *The Villas of the Ancients Illustrated* (1728), grew tired of paying the exorbitant fees demanded of him by Bambridge, and for punishment Bambridge confined him in a sponging house adjoining the Fleet; this place was at the time raging with smallpox, which Castell told Bambridge he had never had, "and that he dreaded it so much, that the putting him into a house, where it was, would occasion his death, which, if it happened, before he could settle his affairs, would be a great prejudice to his creditors, and would expose his family to destruction." Bambridge accordingly put him there, and he caught smallpox and died.[9] Known among the Palladians for his architectural work, he was more importantly a friend of the M.P. James Edward Oglethorpe, who began agitation in the House of Commons.

In January 1728/9 Bambridge overreached himself, picking on a baronet with connections:

On Saturday Morning Mr. Bambridge, Warden of the Fleet Prison, was stabbed in the Belly with a Knife, by Sir William Rich, Bart. We hear that Sir William had by a second Habeas Corpus been brought from the King's

Bench to the Fleet, and on Friday Night was carried into the Prison, and lodged on the Common Side, and the next Morning Mr. Bambridge, with several Assistants, came to see him, when a Quarrel ensued (said to have been occasioned by a Demand for 5 l. for a Baronet's Fee, and which Fee we hear Sir William had paid once before) and Mr. Bambridge was wounded, but it is thought not mortally.

Sir William was consequently "close confined in the strong Room, or Dungeon of that Prison, manacled and shackled, and a Centinel with a loaded Musquet at the Door."[10] The "strong Room" was a lightless underground vault, built over the common sewer, where the dead were placed before burial, and in which recalcitrant prisoners were lodged.[11] Sir William's friends hove into sight, and on 8 February Bambridge was called to court "to shew Cause . . . why he iron'd Sir Wm. Rich, Bart."; but on the eleventh the court decided that Bambridge could keep Rich "in Irons, confined in any Part of the Gaol, where it best consisted with his own Safety."[12]

On the twenty-fifth, however, a committee was appointed by the House of Commons on the motion of Oglethorpe to inquire into the state of the jails in England, and Oglethorpe was appointed chairman.[13] On the twenty-seventh the committee of both Lords and Commons went to the Fleet "to examine into the State of that Gaol, in order for Relief of the Insolvent Debtors, &c. when the Irons were taken off Sir William Rich, Bart." They questioned Rich and the other debtors about their treatment, but Bambridge was so little affected that the next morning when the committee returned it "found Sir Wil. Rich loaded again with Irons, considerably heavier than those he had on the Day before; for which Mr. Bambridge, the Warden of the prison, is taken into Custody."[14]

On 3 March the London Grand Jury, meeting at the Old Bailey, found a bill of indictment against Bambridge for his assault on Sir William Rich, and also a bill against Rich for his assault on Bambridge. On the fourth the Committee of the House of Commons went again to the Fleet to hear prisoners' complaints and the newspapers began to leak hints of corruption: the exorbitant fees and the bribes that permitted prisoners to escape to the Indies. On the fifth the committee went again to hear complaints—"as the Committee are indefatigable in finding out the scandalous Abuses; It's not doubted but the poor Prisoners for the future will be treated with some Humanity."[15]

Then on 8 March "several of the Committee of the Honourable House of Commons, came to the Fleet Prison, where Mr. Bambridge was brought before them, and examined upon several Articles of Complaint exhibited against him."[16] This confrontation, or a subsequent one in the next week or two, was the occasion of Hogarth's sketch of the committee meeting in the Fleet (pl. 65a). The tenor of such confrontations can be imagined from accounts like that of Jacob Mendes Solas, a Portuguese who had been kept manacled and shackled in

65a. A Committee of the House of Commons, or The Bambridge Committee (oil sketch on paper); 1728/9; 18½ x 23½ in. (Fitzwilliam Museum)

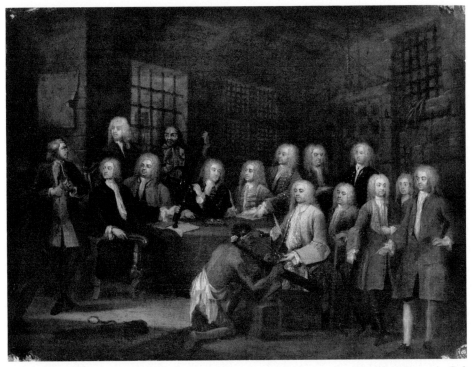

65b. A Committee of the House of Commons; 1728/9; 20 x 27 in. (National Portrait Gallery, London)

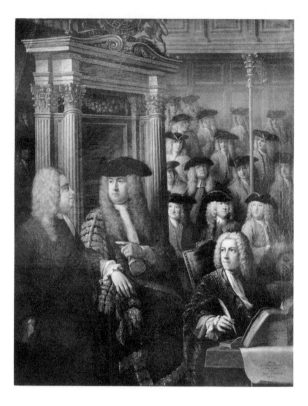

66. Sir James Thornhill and Hogarth, The House of Commons; 1730; 50 x 40 in. (The National Trust, Onslow Coll. Clandon Park). The two heads at the right of the bottom row (Col. Richard Onslow and Thornhill) are the work of Hogarth.

the "strong room" for nearly two months; when, during his testimony, a member of the committee hinted at a confrontation with Bambridge, "he fainted, and the blood started out of his mouth and nose."[17] The effect of Hogarth's oil sketch lies in the interplay between the expressions of the prisoner and the warden, and its reflection in the committee-as-audience.

If Hogarth was not in the Fleet on that day, he attended at least one of the official confrontations in the House of Parliament and transferred his setting back to the Fleet. In either case he needed some entrée to the committee, which at this time could have been through Thornhill.[18] Thornhill, contrary to common belief, was not on the original committee that went to the Fleet and made the investigation. (It is of course just possible that he got himself added after the first naming of the committee.) He only appears at the end of April on the committee that went to meet with Lords over the act to disable Bambridge. This committee, a much smaller one, was apparently composed of a selection of the Fleet Committee (including its chairman) plus a few Commoners who would not be biased by what the others had personally seen and heard of Bambridge at the Fleet. Thornhill was also on the list of the General Committee in *The London Journal* of 5 July, but by then the investigation had turned to other prisons.

Thornhill might have secured permission for Hogarth to sketch the proceedings even if he was not himself on the committee; or he may have secured the permission after April, when he became a member, and Hogarth replaced the

scene in the Fleet. The latter sounds unlikely, however, because Hogarth's repu-
tation at this time was based on his eyewitness reporting; re-creation was counter
to the pose he adopted and carried on through the succeeding decades. More-
over, Hogarth's friendship with Thornhill suffered a serious, if temporary, set-
back at the end of March; and if Thornhill secured a privilege for Hogarth, it
must have been at some earlier date.

One possibility should not be overlooked. Sir Arthur Onslow was elected
Speaker of the House of Commons at the opening of the new Parliament on 23
January 1728, and within the next year or so he asked his friend Thornhill to
commemorate his association with Walpole, some of his friends (including
Thornhill) and even his clerks. The finished painting is dated 1730, at least one
row of heads having been painted by Hogarth (pl. 66). It seems quite likely
that Thornhill may have secured Hogarth access to Commons to sketch mem-
bers, or that he established contact between Hogarth and Onslow himself. One
of the heads painted into the picture by Hogarth was Colonel Richard Onslow,
who was a member of the Fleet Committee.

If Onslow's *House of Commons* painting, in conception at least, came first, it
can have had little influence on Hogarth's new work. A Thornhill composition,
it has three-quarter-length portraits of Onslow and Walpole in their accustomed
positions in the House, and the heads of others; the result is much more a por-
trait with attendant friends than one of Hogarth's conversation pictures, and
bears no relation to the Dutch portrait groups in which each figure is more or
less equal to the others. Hogarth may have gotten the idea of a large public
group from the *House of Commons* picture, but he portrayed a specific occasion,
a dramatic one, sketched as it happened, with a criminal at its center.[19]

In the sketch Hogarth uses a "Choice of Hercules" composition, as with *The
Beggar's Opera,* but more limited in scope. The chairman, a recognizable por-
trait of Oglethorpe, acting as a mediator between Bambridge the warden and
the prisoner, provides the sort of role inversion explored in *The Beggar's Op-
era*. A criminal warden opposes an innocent, persecuted prisoner, the real crim-
inal against the reputed one, with a judge to choose between them and a polite
audience looking on.

Hogarth must have attended one or more of the meetings of the committee in
the Fleet Prison, sketching the room, the general scene, and probably some of
the participants. He must also have let the members see his likenesses of them,
and then in his studio produced the modello, which he later gave to Horace
Walpole. Within the blank faces of the modello he could insert the faces of
whichever committee members were interested in a picture, and, hopefully,
produce as many pictures as were called for.

Several versions of the finished picture have been recorded, but the only one
known to survive is in the National Portrait Gallery, London (pl. 65). The one
documented commission, by Sir Archibald Grant, does not necessarily refer to

this particular version; whoever commissioned it wanted a portrait-gallery effect instead of the dramatic scene that is portrayed in the modello. The finished painting was accordingly enfeebled—Hogarth dropped the prisoner to his knees and turned his back on Bambridge, turning the faces of several more committee members toward the viewer. The result is the loss of the central confrontation between jailer and prisoner, who have become props for the committee members. The figures make a stiff horizontal band across the canvas, which might as well have been painted by Gawen Hamilton or some other contemporary painter of conversation pictures.[20] The only figure that more or less resembles a surviving portrait is Oglethorpe himself, mainly through his tall, thin body, and in spite of the prominent chin given him. The truth is that the faces are largely undistinguished, and one need only compare them with those in a group like *Lord Hervey and his Friends* to see how poor a job Hogarth has done, if the National Portrait Gallery picture is indeed his work.[21]

Despite the failure of this surviving version of the finished picture, one can understand Hogarth's rationale for such a portrait group. It takes him beyond the stage of a theater to unfeigned actuality that is both historical and timeless. Beyond its status as a particular portrait group representing a particular moment in time, this picture offers memorials of the men presented and warnings —moral exempla—of the evil warden (as, in later groups, of the effects of intemperance or venality); and it draws critically upon the aesthetic of utility and emotional force transmitted by Steele's *Spectator* essays on art.[22] This immediate aim is always evident in Hogarth's later works; in the *Rake's Progress* the scene in the Fleet Prison also serves as a reminder of the garnish still required of the penniless debtor—an image which was copied in broadsides and pamphlets attacking the continuing abuses in the Fleet.

All this time, while Hogarth was practicing painting and making use of Thornhill's casts and pictures, and perhaps his influence in Parliament, he was, as he would have said, mixing pleasure with business. Thornhill's hospitality and academy provided an ideal excuse for being near his daughter Jane, a girl of about fifteen when Hogarth joined the academy in 1724, and by 1729 near the age of consent.

It is not known exactly when or where Jane Thornhill was born, where or how she spent her youth, or what kind of girl she was—whether she stayed in the Thornhill house and sewed, or tried to live up to her father's title and wealth. Certainly she had always been well off, and even without the signs of punctilio in her father one would suspect a tendency toward social self-consciousness in the daughter. (Her brother, John, although he evidently liked the company of Hogarth, artisans and artists, nevertheless ended as the typical eldest son, doing nothing.) After Hogarth's death, Jane was apparently well able to conduct his business and defend his reputation; thus it seems probable that she was a fairly

strong and competent woman. There is a story that "old Widow Hogarth" used to say to visitors at the Golden Head, showing the "Market Wench" (the *Shrimp Girl*), "They say he could not paint flesh. There's flesh and blood for you; —— them!"[23] This was also the woman who advertised against pirates in as strident a vein as Hogarth himself, secured a special addendum to the revision of his Engravers' Act in 1767 giving her an additional twenty years' copyright on his engravings, and fought Horace Walpole and John Nichols tooth and nail when they published passages on her husband that were less than glowing. The portrait of her as a young woman painted by Hogarth shows a handsome and statuesque, probably proud, woman, and this—taken with the portrait in old age by Zoffany—points to a woman who is tough and independent, even crusty (pls. 67, 68). But the most vivid impression is that of Sir Richard Phillips, who, as a boy, saw the old lady striding majestically up the aisle of the Chiswick church, with silk sacque, raised headdress, black calash, lace ruffles, and crutched cane, accompanied by her companion, Mary Lewis, and preceded by Samuel, her gray-haired servant, who had wheeled her to the church in a Bath chair; he carried her prayer books ahead of her, ushered her into her pew, and shut the door after her.[24]

From what is known of Hogarth's mother and Jane, they shared one char-

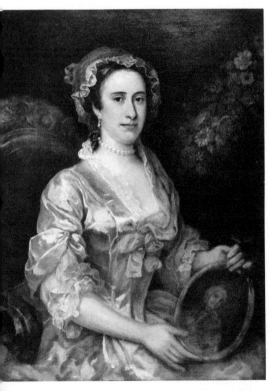

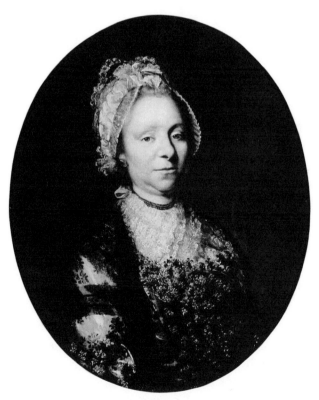

67. Jane Hogarth; ca. 1738; 35½ x 27½ (the Right Hon. the Earl of Rosebery)

68. Johann Zoffany, Jane Hogarth; ca. 1780–83 (George Howard, Esq.)

acteristic—both were solid, capable women, pillars of strength for their husbands, if not indeed the kind of bulwark that becomes at times a burden for the one being supported: something on the order of Sarah Young in *A Rake's Progress*. But of course they were also very different; Hogarth married above him when he took Jane. If he thought of himself as wedding the master's daughter, he may have recalled his father's marriage to the landlord's daughter. It is impossible to determine whether he was urged by love of Jane, desire to be son-in-law to a great and admirable man, or both.

It could not have been entirely coincidence that he eloped with Jane immediately following the Bambridge Committee's exposé of the Fleet Prison, either just before or just after his commemoration of it in a painting: in one coup he would acquire a new father and exorcise his memories of the Fleet and the darker days of his youth. Thus on 20 March 1729, the day the House heard the Commons Committee's report and moved to prosecute Bambridge and Huggins, Hogarth took out a marriage license from the Faculty Office of the Archbishop of Canterbury: "William Hogarth, of S[t] Paul's, Covent Garden, Middx. Bach[r], above 25, & Jane Thornhill, of same, Sp[r], above 21; at same."[25] The marriage took place on the twenty-third, but not, as stated in the license, at St. Paul's, Covent Garden. Instead, the couple traveled out to the village of Paddington and were married at Paddington Parish Church. It was the only marriage that day.[26]

Vertue noted that Hogarth had married Sir James Thornhill's daughter "without his consent," and Nichols, possibly from an independent account, envisaged an elopement.[27] It should be noted that Jane was listed on the license as "above 21." If a woman were under twenty-one, the consent of parents was necessary for marriage. No birth record of Jane has been found, but Hogarth's early biographers said that she was not eighteen. When she died, her age was given as eighty, i.e., born 1709 and therefore twenty when married. The idea of an elopement is perhaps further strengthened by Hogarth's attack on contracted marriage in *Marriage à la Mode*.

The marriage was noticed in the *Craftsman* for 5 April: "Mr. Hogarth, an ingenious Designer and Engraver, was lately married to the Daughter of Sir James Thornhill, Kt. Serjeant-Painter, and History Painter to his Majesty."[28] By 5 April, then, the secret was out; Nicholas Amhurst, editor of the *Craftsman*, was a friend and would have learned of the marriage. (Note, incidentally, that Hogarth is not yet referred to as a painter.)

Tradition has it that the Hogarths crossed the river to live in Lambeth, but since this was reportedly a summer residence, it is possible that after a honeymoon spent in Lambeth they returned to Hogarth's studio.[29] If he did not soon go back to work, he could not have had time to transact his business with the *Bambridge Committee* picture; in fact, selecting this time for a marriage, let alone an elopement, strongly suggests that he did not get any commission until

later. There can have been little real clash with Sir James or his new son-in-law would have found it very difficult to find a commission among the M.P.'s. There is a reconciliation story, of course, which sounds manufactured. Lady Thornhill is supposed to have restored good feeling by advising Hogarth to place some of his *Harlot's Progress* paintings in his father-in-law's way.

> Accordingly, one morning early, Mrs. Hogarth undertook to convey several of them into his dining-room. So beset, under the influence of such powerful attractions, had the father been possessed of less humanity than was imputed to him, the ingenious artist would most probably been induced to acquiesce. When he rose, he enquired whence they came; and being told by whom they were introduced, he cried out, 'Very well; the man who can furnish representations like these, can also maintain a wife without a portion!' He designed this remark as an excuse for keeping his purse strings close; but, soon after, became both reconciled and generous to the young couple; and lived with them in great harmony. . . .[30]

If true, nearly two years elapsed before the reconciliation—and neither the *Beggar's Opera* paintings nor the *Bambridge Committee* was sufficient to regain Thornhill's good graces.

This seems a long time before a reconciliation, unless the term is defined as including the invitation to move into the Thornhill's house. For the fact is that Hogarth and Jane evidently did not move in with the Thornhills in the Great Piazza until 1731, perhaps after the subscription for the *Harlot's Progress* had begun. Vertue locates them in Thornhill's house by that time,[31] and the next surviving reference before this appeared in the *Craftsman* for Saturday, 5 December 1730:

LOST,

> *From the Broad Cloth Warehouse, in the Little Piazza, Covent Garden,*
> A light-colour'd Dutch DOG, with a black Muzzle, and answers to the Name of Pugg. Whoever has found him, and will bring him to Mr. Hogarth, at the said place, shall have half a Guinea Reward.

This may be the pug who appears in *The House of Cards* (1730) or, challenging his opposite, struts in *The Strode Family* (ca. 1738). He is the first of a series of pugs Hogarth kept. There is no telling whether his 1745 portrait of himself with, and resembling, his pug was a result of long association or whether the long association with pugs was another of those symbolic gestures of Hogarth's which show that he knew exactly how he wanted to appear. The advertisement

itself almost certainly means the broadcloth warehouse was his own address at the time.

In his account of his life, reported by Dr. Ducarel, William Tothall remarked that "Hogarth lived some time in his house in the footing of a most intimate friend."[32] Tothall, who crops up again later in Hogarth's life, was another self-made man, of about the same age. Placed with a fishmonger uncle at an early age by his widowed mother, he could not stand fishmongering and ran away to sea, where he remained enduring a life of adventure until he was nearly 30. Around 1727 he gave it up, returned to London, and began working for a woolen draper at the corner of Tavistock Court and the Little Piazza, Covent Garden, which corresponds to the address of the broadcloth warehouse mentioned in Hogarth's advertisement. His master helped him in various ways and began to take a fatherly interest in his enterprising employee, lending him money to start a sideline in shalloons and trimmings for the tailors who bought his yard goods and encouraging him to sell rum and brandy from the cellar of the house. At this time, then, he was living above his master's warehouse and Hogarth probably sublet a part of the quarters for himself.

Hogarth must have been living here, not at his former address in Little Newport Street, when he married Jane, since the marriage register gives St. Paul's, Covent Garden, as his parish; and if he was still at the warehouse in December 1730 he must have brought Jane back with him after their marriage. Here they apparently remained until invited by the Thornhills to move across the square and join them in quarters better suited to the daughter of a knight.

It is unimaginable that Hogarth remained long away from his work in these busy months. He needed money and reputation, and also Thornhill's confidence —all of which required application. If Thornhill objected to the idea of Hogarth as a son-in-law, it was because of his probable future as shopkeeper, printseller and engraver; this would explain why Thornhill moved the couple into his house, where Hogarth could paint but hardly carry on a trade, and why Hogarth apparently made no engravings himself between his marriage in March 1729 and *Boys Peeping at Nature,* the subscription ticket for *A Harlot's Progress,* in 1731. In the meantime his only contact with engravers was the gentlemanly and profitable one of furnishing them with designs (a drawing brought a guinea or more), and he even tried to get someone else to engrave the *Harlot's Progress* for him. The use of Vandergucht, who engraved most of his designs, is significant. Although they were obviously acquainted, the association was not based on friendship alone. For the last ten years Vandergucht had been one of the most sought-after engraver-etchers of other men's designs, including Thornhill's and Vanderbank's (his *Don Quixote* etchings had beat out Hogarth's); so one can imagine Hogarth now, wishing to consider himself risen above the rank of engraver, and when asked to contribute frontispieces, paying Vandergucht to do the engraving (or at least pleased that the bookseller did so). The references to

Hogarth in the advertisements for these books—usually in the eye-catching head-line—show that he was well-known by this time.

The exceptions were two etchings he made early in 1730 to illustrate Lewis Theobald's *Perseus and Andromeda* (perhaps for his friend Rich, at whose theater the play appeared), and a shop card made for his sisters (pl. 69). They had opened a milliner's shop in 1725 in Long Walk near the Cloisters, part of St. Bartholomew's Hospital, about a block away from their old home, Bartholomew

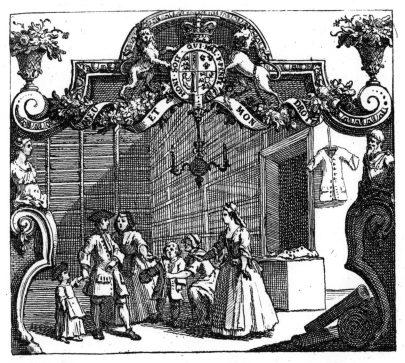

69. Shop Card for Mary and Anne Hogarth; 1730; 3⅝ x 4⅛ in. (W. S. Lewis)

Close. Anne, the younger sister, was in charge of the shop, or at least the shop was registered in her name. They were sub-tenants and do not appear in the Land Tax Books, but Anne Hogarth is mentioned in the books for collecting workhouse rates for the Parish of St. Bartholomew the Less. In 1726 Anne is listed with two shops or flats, and in 1727 Mrs. Hogarth is listed for one of them, suggesting that by this time she had moved from her house in Long Lane to live with her daughters.[33]

Long Lane was not a fashionable address. After the fire of 1666 Charles II had granted the governors of the hospital permission to recoup some of their losses by converting the rooms of the cloisters into seventeen shops, using the rents to maintain sick and wounded soldiers and seamen. By the time the Hogarth women were living there, the cloisters were taken up on both sides by seamstresses and millinery shops, and at fair time especially had a bad reputation. The narrow street was crowded with signs of the Anchor, Golden Ball, Seven Stars, Three Horseshoes, Three Pigeons, Porter and Dwarf, Three Welsh Harps, Three Golden Anchors, Black Boy, Indian Queen, Golden Key, and the Sun—all of which Hogarth would have studied with interest and admiration, for he enjoyed shop signs as other people did trees and gardens.[34]

In these years the hospital was undergoing a radical change. At a meeting in July 1723 the governors of the hospital had been of the opinion "that some part of this House be immediately rebuilt and that the whole in process of time will fall under the same necessity." A general plan was to be prepared and laid before the next meeting by a committee that included the architects James Gibbs and Nicholas Hawksmoor. This was the first step toward the erection of the buildings that still contain the hospital. By September 1728 a plan of one part of the square of intended new buildings was produced, "containing a large hall for the meeting of the Governors, at a General Court, a Compting house, for the Governors' meeting . . . a hall for taking & discharging of Patients, a house for the Clerk to reside in & other convenient Offices." The cost was not to exceed £8500. The committee was desired to prepare a plan of the whole square, the same to be engraved on a copperplate, one impression to be sent to every governor. On 1 May 1729 a plan of the new building, prepared by Gibbs, was approved by all the governors present and ordered to be engraved on copper and 400 impressions taken on the finest paper. By 24 July the plan had been sent to every governor and approved, and a subscription was begun to erect the new buildings.[35]

The hospital as it then stood was very irregular, and the whole, according to the preamble to the subscription, "had hardly so much as the outward appearance of an hospital."[36] This pile was to be replaced by a regular square of four elaborate blocks of buildings. But first the old buildings, and adjoining buildings, had to be destroyed. (Later the problem of decorating them would be reached, and Hogarth would again enter the picture.) Among other buildings,

the cloisters had to be torn down and the shops within the hospital removed. Tenants were given notice shortly after 25 September 1729 (when it was announced at a meeting of the hospital governors) that they must be out by Lady Day (25 March) next, 1730.[37] By that date the Hogarths must have moved out, and Hogarth, to celebrate the opening of their new shop, etched a shop card for them making the announcement. It showed, in a stylized baroque frame, with the royal arms overhead (as it had appeared over the *Beggar's Opera* stage), the actual interior of a shop with bolts of material, clerks, and customers. The sisters moved just outside the hospital gate, doubtless still in one of the many buildings in Little Britain owned by the hospital, but still sub-tenants and so not in the rate books.

The absence of engraved works in these years, then, can be attributed in part to Hogarth's preoccupation with painting; but as later events proved, he was also influenced by his ideas (and Thornhill's and/or Jane's) of an artist's status. At any rate, he and Jane moved into the Great Piazza (pls. 70, 71). He never refers to this as a shop—though he was eventually to engrave and vend the six plates of the *Harlot* and one or two others there. Essentially, it gave him a good address, the sort of studio appropriate to a portraitist, and a ringside seat for the center of London fashion, theater, gambling, and wenching—and therefore law enforcement. Gentlemen and highwaymen, ladies and women of pleasure strolled the arcades, moving from coffeehouse to theater to bagnio to auction rooms and china shops.

Since Thornhill's academy was long since defunct by the time the Hogarths moved in, it is probable that the son-in-law used the extra room as his studio. Thornhill spent his summers at his seat near Stallbridge, Dorset, but during these years he was also spending much of his time at Hampton Court Palace. For in March, just before the elopement, he had obtained permission from the King to copy the Raphael Cartoons, and from then until completion in 1731 references to Thornhill place him at Hampton Court.[38] As Serjeant Painter he was probably assigned quarters in the palace while he worked—and perhaps he returned for part of each week to Covent Garden. His departure in March 1729 may have provided the lovers their opportunity to elope, but before the project was finished Hogarth was evidently actively assisting him.

The seven Cartoons, which hung in the King's Gallery at Hampton Court, commonly called the Cartoon Gallery, had been engraved in Thornhill's time by Gribelin, Dorigny, and Dubosc; Le Blon had received permission, like Thornhill, to copy them, but he intended to use them as designs for tapestries. Thornhill's plan, a characteristic one, was to use them as teaching aids; he intended to treat them analytically, copying out details of hands, heads, and feet as well as the general composition. In August 1729 Vertue visited Hampton Court while both Thornhill and Le Blon were working there. Thornhill's cop-

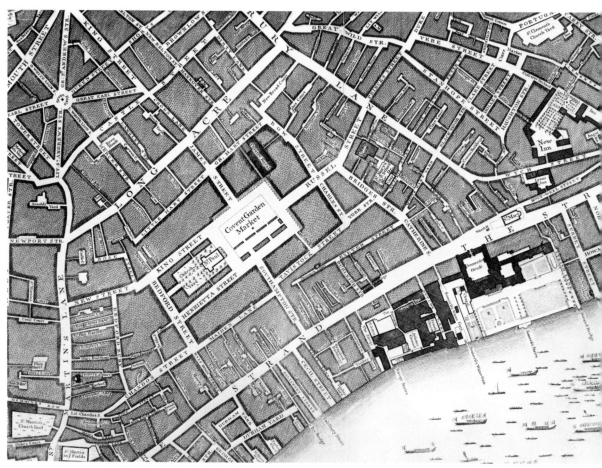

70. The Covent Garden area, detail of John Rocque's map of London; 1747; (BM)

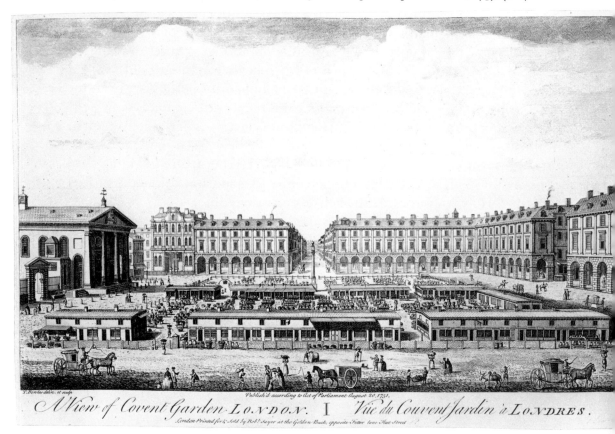

71. A View of Covent Garden; 1751 (BM), but unchanged from 1730 except for the configuration of wooden shed
As we look north, Thornhill's is the last private house at the northeast corner.

ies, he recorded, "are done with all the exactness possible the same size as the originals. he having now finisht two pictures & begun another." But he also noted "his several studies of the heads hands feet. separately &c. from these originals on paper drawn out lines some shaded. some not are surely the truest & justest demonstration of Raphaels merit."[39]

Thornhill's plan seems to have been to make one set of full-size copies of the cartoons as they were (the originals were deteriorating rapidly and were probably not expected to survive much longer, which was another reason for his project); a set of one-half size; and a set of one-quarter size, in which the missing parts would be reconstructed. Finally, he was to make a series of details, and these at least were to be engraved. The project is characteristic of both father- and son-in-law; certainly it was Thornhill who originally stimulated Hogarth's interest in the Cartoons, but the project to paint (i.e. restore, make available to contemporary Englishmen and artists) and engrave the Cartoons could have come equally from father- or son-in-law. The project continued, with frequent visits from interested artists and connoisseurs, until in August 1731 the full-size copies were finished. The details of hands, legs, heads, and feet were never finished, though at least one etching remains (perhaps by Hogarth) and a number of drawings and tracings.[40]

Thornhill also needed something to occupy his mind during these years. In the last years of his life he witnessed the Italians once again securing the patronage of the Burlingtons and the great Whig lords. Vertue, commenting on his copies of the Raphael Cartoons, noted:

72. Sir James Thornhill, Sketch of his Family; ca. 1730 (the Right Hon. the Marquess of Exeter)

its certain that after so much reputation. friends & meritt. as the most Excellent Native history painter, which is justly allowd at this present to be his character. he hath no great work, or imployment underhand—is suggested to be the reason he has undertook to copy these workes of Raphael —it is however, happy for him. that his fortune, is very easy.[41]

Not long after the reconciliation with Hogarth, and while he was at work on the large copies, Thornhill made a sketch in pen and violet wash (pl. 72), in preparation for a painting of his family and friends. He shows himself in the center pointing to one of his Raphael Cartoons on his easel, with his son John behind him and Lady Thornhill seated to his right, and beyond these a group labelled "Mr Hogarth &c.," the "&c." referring to Jane. The painting, probably intended for his country seat, with its ceiling self-portrait and column to George I, was never carried out.

In January 1730/1 Hogarth made a list of the commissions that he had not yet fulfilled.[42] Among these were three going back to 1728, and certainly among his very first; two of these were for personal friends, who had probably ordered more and had not pressed him too hard for delivery. John Rich had commissioned a family group on the strength of the first *Beggar's Opera* painting, and at least one other picture, the large *Beggar's Opera*, which was by this time finished. Christopher Cock, the auctioneer and a neighbor of Hogarth's in Covent

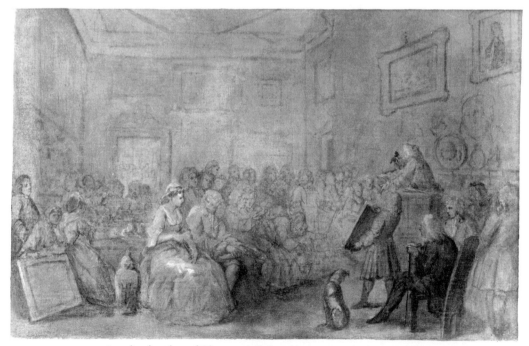

73. An Auction of Pictures (oil sketch); ca. 1730 (private coll.)

Garden, had commissioned two pictures in November 1728, companion pieces; it is likely that Hogarth had him in mind too when he made his modello of an auction, which probably shows Cock's auction room (pl. 73). The third person was one Thomas Wood, who had commissioned two other pictures from Hogarth, portraits of his daughter and his dog Vulcan.

The next commission that can be dated is the remarkable one of Lord Castlemaine for "an Assembly of 25 figures" on 28 August 1729. Sir Richard Child, who in 1718 had become Viscount Castlemaine in the Irish peerage, was heir to the great banking family and celebrated his status by building the first of the great Palladian palaces, Wanstead House, Essex, designed for him by Colen Campbell himself. Hogarth traveled east of London to this great house and sketched the ballroom at the south end, where the "Assembly" was to take place, and no doubt took likenesses of the host and hostess.[43] He then must have laboriously collected sittings from all the rest of the "25 figures" in his Covent Garden studio. It was the most impressive of the early commissions; perhaps the ultimate challenge, to get such a crowd into a canvas 29 by 24 inches and at the same time convey accurately the architectural splendor of the newly-decorated ballroom—decorated, ironically, by William Kent. As the list of January 1730/1 shows, it was not quickly finished (pl. 80).

On 5 March 1729 Sir Archibald Grant commissioned two pictures that were evidently to be copies of works Hogarth had already finished, *The Bambridge Committee* and *The Beggar's Opera*. While he probably took time with the paintings for friends in order to do a good job, knowing the recipients would not mind waiting, he must have delayed work on the copies of popular prototypes for Grant through sheer indifference: he cannot have been too eager to make further copies of works that had reached the final state of their evolution. And after completing *The Woollaston Family* (pl. 79), his masterpiece among the large assembly groups, he must have realized that 25 figures was an excessive number; after a certain point, adding extra people became a mechanical process. Besides, by January 1730/1 he was deep in the *Harlot's Progress,* and it was probably for this reason that he made his list—to force himself to get this work off his hands.

Most of the portrait groups, or conversation pictures as they are usually called, are undatable as to commission if not completion, but there were at least two dozen of them between 1728 and 1731, by which time Hogarth had also nearly finished the *Harlot's Progress.* He was hard at work supporting his wife in the style to which she was accustomed and building up his reputation as a serious painter. As early as late summer or early fall 1729 Vertue was commenting on "The daily success of Mr Hogarth in painting small family peices & Conversations with so much Air & agreeableness," which "Causes him to be much followd, & esteemed. whereby he has much imployment & like to be a master of great reputation in that way." Vertue then goes on to marvel at Hogarth's rise:

"'Tis much from no View at first of being a painter. but only bred to Grave small works *in Silver*...." In 1730 he writes:

> Mr Hogarths paintings gain every day so many admirers that happy are they that can get a picture of his painting. a small peice of several figures representing a Christning being lately sold at a publick sale for a good price. got him much reputation. also another peice the representation of the Gentlemen of the Committee of the House of Commons. to jayles. setting upon the examination of those malefactors. well painted & their likeness is observed truly. many other family peices, & conversations consisting of many figures. done with spirit a lively invention & an universal agreableness.[44]

Already Hogarth seems to have grasped the proper way to sell new kinds of paintings, through public exhibitions in his Covent Garden studio (as a little later with the first *Harlot* painting) and public auction. Such uncommissioned but timely paintings as *The Christening* (pl. 85), which included a portrait of John (Orator) Henley, could be seen by many prospective patrons, sold to the highest bidder, and serve as the basis for future commissions.

It is helpful to step back and categorize the different kinds of portrait groups Hogarth was painting and experimenting with in these busy years. In the background is the fact that European portraiture in the eighteenth century was still dominated by the aesthetic bias of Renaissance and French classicism toward idealized portraiture, which of course catered to the sitter's self-esteem; the sort of Roman bust Rysbrack produced is a suitable example. Naturalistic portraits, however much enjoyed, were felt to be a lower kind of art as well as somewhat unfair to the sitter.[45] Hogarth's own comments show that he regarded portraiture as a lower branch of art than history painting. But there was also a hierarchy among portraits: the greater the idealization, the more the portrait would be esteemed, even as comparable with a history painting. But as all aspired in that direction, there was a marked tendency toward the stereotyped and general, resulting in those interchangeable portraits of the Restoration and early eighteenth century. To catch a speaking likeness was, in fact, both to miss the point and to vulgarize, unless in offbeat pictures like drinking or clubbing scenes. The moral function of the portrait painter, analogous to that of the history painter, was to laud virtue, and his social function was to describe ideal types of kings, statesmen, soldiers, courtiers, and scholars. Pulling him asunder were the ambitious sitter on one side and his own artistic pretentions on the other.

The portrait stereotype was produced by Van Dyck and transmitted by Lely and Kneller and all the lesser painters, English and foreign-born, who imitated them. This model, designed for aristocrats, was by Kneller's time standardized as a long, vertical figure (Lely's had tended to be more horizontal and reclining) wearing a close-fitting coat, with a plump but equine face and an especially long

nose, further standardized by a typical wig (the Kit Cat portraits were said to be no more than "a lot of wigs with Whigs inside them").[46] The women all had narrow eyes, double chins, and identical lips. The face was as polite and urbane as the Augustan poets' personae or their use of parallel and antithesis. These were essentially social portraits. Their own standardization was further emphasized by the mass-production methods of the painters' studios and by the bland mezzotints, reproduced in a quantity that even the studio hacks could not match.

One inevitable result of this stereotyping was that even sea captains and merchants looked like aristocratic, sociable, but detached Augustan gentlemen. Walking through the National Maritime Museum at Greenwich, where Lely, Kneller, and Dahl can be seen at their best, one finds an occasional brilliantly painted Lely, and the Dahls have character and some force. Kneller, however, the early eighteenth-century norm, remains unrelievedly dull and repetitious, managing to make even admirals look alike in a stylish, unseamanlike way. Their heads alone could easily fit into his series of Kit Cat portraits, those writers, statesmen, and politicians who all have the same face, except that some are fatter than others. To a large extent, the sitter wished the painter to generalize or disguise him as an aristocrat. In the later seventeenth century it had been customary for the gentry to have themselves painted and hung in their houses and given to their friends; but religious scruples, modesty, and a sense of class had prevented very many others from doing so. The true Puritan naturally rejected the idea of a portrait of himself as vanity. When, near the end of the century, professional men began to have their portraits painted as a matter of course, it was not in the attire of their professions but in that of the gentry.

One thing that must have bothered Hogarth initially about portrait painting was this strong element of disguise in portraiture of the professional class. If royal mistresses in the Restoration were painted as goddesses, Mary Magdalen, even the Virgin Mary, "following them, more reputable ladies were disguised as royal mistresses, only slightly more buttoned-up, and so on down the social scale, the designs set by the most fashionable painters, especially Lely, being repeated verbatim except for the head."[47]

Later Hogarth would react to the foreignness of English portraiture by signing himself "W. Hogarth Anglus pinxit," but in his conversation pictures he simply sidestepped the issue and ignored a portrait tradition he deplored. Here he could convey character and social position very precisely by means of the relationships between people, the objects they kept around them, their furniture, and the drama of the resulting interplay. He could ignore portrait poses, or utterly expose them *as* poses. Conversation pictures were the first real break with the stereotyped portraiture of the time: their aim was not to produce an effigy, or to observe the Renaissance pattern of depicting an ideal image or one that conveys the sitter's whole spiritual and physical being, but rather to catch the sitter

in action in a particular moment in his proper social milieu, most often with his family.

A conversation, as Vertue, Hogarth, and others used it, was a very general term that included Dutch drolls as well as small parties in polite society, *The Bambridge Committee,* and *The Beggar's Opera.* Vertue said that Heemskirk was accustomed to refer to his "drunken drolls" as "Conversations," and he applied the term to the works of Brueghel, Brouwer, and Teniers.[48] Small-scale portrait groups and social genre seem to have been the criteria.

It is well, however, to subdivide according to some inherent differences. The contemporary definition of conversation picture in its most restricted sense was "a representation of two or more persons in a state of dramatic or psychological relation to each other"; to which another writer adds, rather proscriptively, that "the Figures should be considerably smaller than life, represent real people, and be associated in an informal portrait group; from which it follows (though this is not essential) that some incident or domestic occupation may be introduced." The setting is familiar, connected with the sitters, and lacking the studio prop-

74. Philippe Mercier, A Party on the Terrace of Shottover House; 1725 (the Right Hon. the Viscount Rothermere)

erties of columns and curtains. One must therefore rule out not only drolls but "ceremonies, state functions and court balls . . . , even though the participants may conduct themselves in a fairly informal way."[49] Such conversations had been attempted in England a few times, but never followed up; the first signs of the vogue appeared in pictures of a favorite horse, owner, and groom in a paddock setting—in the 1690s by Jan Wyck and in the early 1720s by his pupil John Wootton and by Peter Tillemans.[50] The particular brand reaching England was derived from the French *conversations galantes*, which softened and refined the Dutch groups; they were introduced by Philippe Mercier, a Watteau imitator who, born in Berlin and schooled in the Academy there under Pesne, traveled in France and Italy, and settled in England around 1719.[51] *A Party on the Terrace of Shotover House* (pl. 74) is signed and dated 1725, and *Viscount Tyrconnel with Members of his Family* can be dated 1725–26. Hogarth, meanwhile, would have come into contact with visiting and immigrant artists, both French and Italian, at Vanderbank's academy, and might have had access to Dr. Mead's and other private collections, where Watteaus as well as Merciers were to be seen.

The conversation he evolved was distinct from Mercier's, resembling the Dutch conversation of Metsu, Netscher, Slingeland, and Musscher—with its love of objects almost emblematized—painted in the style of the French small groups of Tournières, Watteau, and Mercier, with their freedom of brushstroke and more generous sense of space, an outdoors feeling even when the scene is indoors. It is a distinct form for Hogarth: compared with the *Beggar's Opera* compositions, his family groups are timid as compositions, with small, hard figures in a large picture space. Initially, at least, they were (to use Richardson's simile) more like "a great many single Grapes scatter'd on a Table"[52] than a bunch; and as paintings were too desperately finished, even finicky. One is immediately struck by the contrast between the solid bodies of the *Beggar's Opera* actors and the thin, doll-like ones of these gentlemen and ladies.

The earliest datable picture of this type is *The Woodes Rogers Family* (pl. 75), with three main figures, widely separated. It contains indications of the two basic compositions that Hogarth gradually developed for his conversations: there is a couloir between the two men, but if the figures were brought closer together a slight pyramid would be formed. As it is, the figures are very small and scattered in a straight line across the canvas; the servant girl is jammed into the overcrowded left corner. A slight psychological involvement is apparent between the men: an adjutant shows Rogers the letters patent for his governorship of the Bahamas, for which he set out on 19 May 1729, and his wife watches. Behind the wife is her maid, and at her feet a dog. Besides the psychological involvement, there are symbols: behind Rogers a ship, a monument with his motto, and a globe, referring to his circumnavigation of the world and to his impending voyage to the Bahamas. There is thus a slight suggestion of topical-

ity, of an occasion: the governorship and the impending departure, which allow one to date the painting closely. All these elements go into the Hogarthian conversation picture, separating it from the simple, relatively straightforward groups of Mercier, Dandridge, and their imitators.

The couloir, or inverted pyramid, structure is developed in another outdoor scene, *The Jeffreys Family* (National Gallery, Washington, D.C.), probably painted in 1730. A lake makes a great hole in the middle of the canvas, and one person holds a fishing rod. The house on the other side of the lake, perhaps theirs, separates the mother, father, and one child from the other three children. *The Ashley and Popple Families* (SD 1730, pl. 76) uses the same structure as *The Jeffreys Family* but with more adults, and the two main figures are drawn together until they almost touch over the couloir (although the fishing pole and lake are still in evidence). *The Fishing Party* (pl. 77) uses the same structure but with fewer figures—really only mother, child, and a maid. Here the relationship between humans and a natural setting has become important, the natural setting dominating; this is one of Hogarth's most French compositions—one which leads nowhere, however, in his subsequent work.

The conversations of the Rich and Fountaine families (Fielding Marshall Coll. and pl. 78), two versions of the same composition, are the most complex of the inverted pyramid structures. The lake is gone but the central couple create the same effect by facing away from each other, making two little conversation groups. She is devoting her attention to another woman (wife of one of the gentlemen), he to a picture being shown him. If he were a bachelor this would explain the break, the wives belonging to the other two men (one of whom, however, looks like a servant or the picture dealer). Both the *Rich* and *Fountaine* pictures point to the structure Hogarth used in his large assembly, *The Woollaston Family* (SD 1730, pl. 79), where two groups appear, linked by the host. No such solution offered itself with the other large assembly he was commissioned to paint for Lord Castlemaine, *The Wanstead Assembly* (pl. 80). There were too many figures to get in, and the result, when he at last finished it, was merely a crowded group. The absence of subsequent paintings of this scope may have been due to his lack of interest or his clients' impatience with the dilatoriness of his performance. Although his initial impulse seems to have been to put in more figures than any competitor, the best pictures are not the crowded ones but those in which a relatively few people are interestingly related.

The second general composition Hogarth used for his small private groups was pyramidal, and this seems to have been a somewhat later development. The two children groups (both 25 by 30 inches, dated 1730, pls. 81, 82) have the figures still widely spaced, but the couloir is gone. *The House of Cards* is an adaptation of the arrangement of the central figures in *The Beggar's Opera;* though the individual poses are different, the pattern is the same. But here both pictures are working toward a simpler, more stable pyramid structure. *A Children's*

75. The Woodes Rogers Family; 1729; 16½ x 22 in. (National Maritime Museum, Greenwich)

76. The Ashley and Popple Families; 1731; 24¾ x 29¼ in. (Royal Coll., copyright reserved)

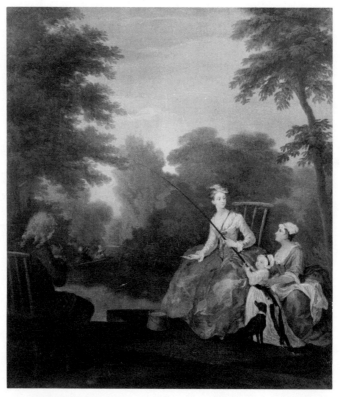

77. A Fishing Party; ca. 1730; 21⅜ x 18½ in. (Dulwich College)

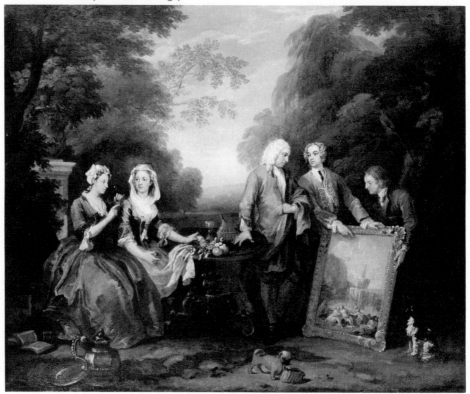

78. The Fountaine Family; ca. 1730; 18½ x 23½ in. (Philadelphia Museum of Art, John H. McFadden Coll.)

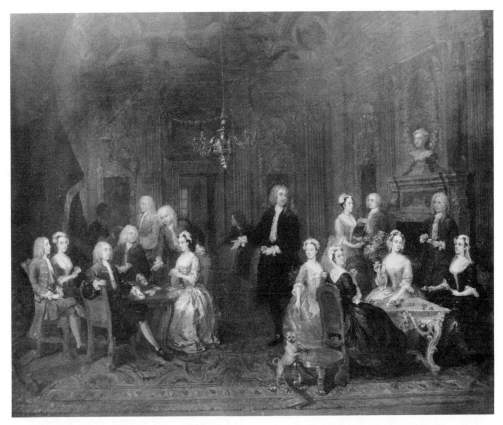

79. The Woolaston Family; 1730; 39 x 49 in. (on loan to the Museum and Art Gallery, Leicester)

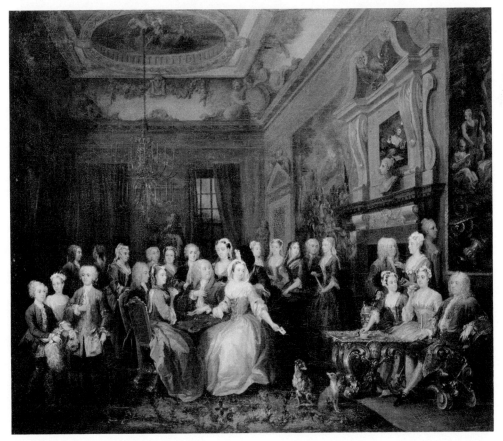

80. An Assembly at Wanstead House; 1730–31; 25 x 29¼ in. (Museum of Fine Arts, Philadelphia, John H. McFadden Coll.)

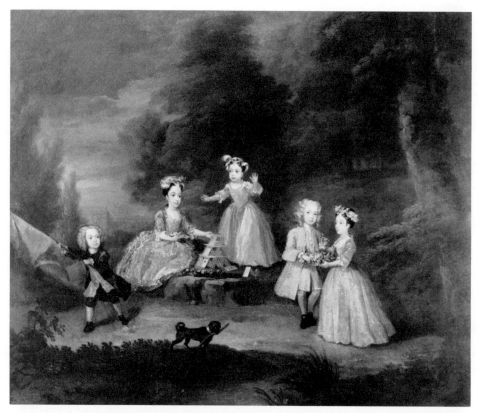

81. The House of Cards; 1730; 25 x 30 in. (private coll.)

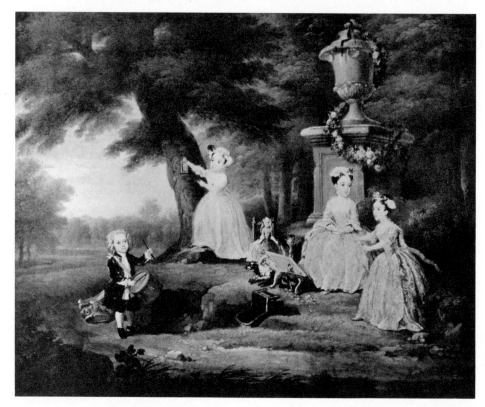

82. A Children's Party; 1730; 25 x 30 in. (private coll.)

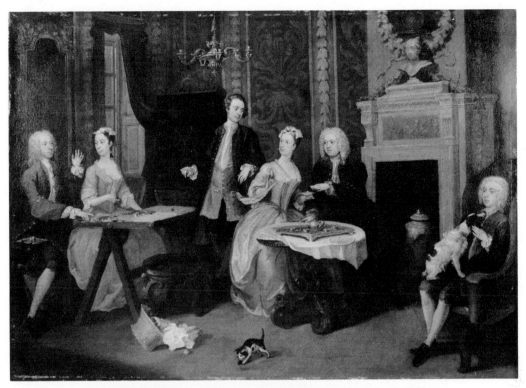

83. A Family Party; 1730–31; 21 x 29½ in. (Mr. and Mrs. Paul Mellon)

84. The Wedding of Stephen Beckingham and Mary Cox; 1729; 50½ x 40½ in. (Metropolitan Museum of Art, New York, Marquand Fund)

Party, though still rather like the split compositions—boy-girl, girl-girl, connected by the tea table—makes an off-center pyramid. In this picture the separateness, or unrelatedness, of the figures is a virtue, suggesting something true about childhood, especially about children who are playing at being grownups. The two pictures are charming precisely because they reflect Hogarth's literary sensibilities: they are concerned with problems of illusion and reality, as *The Beggar's Opera* was but the run-of-the-mill conversation was not. Children were always to be Hogarth's safest, freest ground for portraiture.

In the *Children's Party* in particular there is a curious interplay of irony and symbolism: the soldier boy with a toppled piece of masonry (*vanitas*), one girl looking at him and pointing to a mirror, and another girl at the opposite side of the canvas moving toward him with outstretched arms. The dog knocking over the tea table fits into the general *vanitas* theme (and looks ahead to the overturning of the tea table in *Harlot,* Plate 2). *The House of Cards* has an additional boy engaging in some sort of mock-marriage with the first girl, while the other boy, a mock-soldier with a battle standard, leaves his girl, who shows emotion at his departure (or at the precarious balance of the house of cards that separates the two couples), and a pug carries a dead branch in his mouth in imitation of the little boy imitating a charging general. (This is probably the familiar Pugg, Hogarth's surrogate, making an appearance.)

The pyramid structure, which pulled families together, proved more serviceable than the inverted pyramid, and it was the main pattern in Hogarth's second phase of family groups. In *The Vane Family* (ca. 1731?, Vane Coll.) the father and mother are the apex and two children and a nurse are the sides of a triangle, still slightly off center, as in *The House of Cards.* Vane is another Macheath figure, the center of all attention; the nurse, seen from behind, is the stock figure Hogarth used in the *Beggar's Opera* pictures for Lucy Lockit. Picture after picture repeats the pattern, from *The Ashley Cowper Family* (commissioned 1728, unfinished in 1730/1; Tate), with the urn at the apex, to *The Wesley Family* (SD 1731, Duke of Wellington), in which the five figures make a flattened pyramid.

These remain small, increasingly polished conversations, and only in 1731 or later do they begin to achieve the monumentality Hogarth was striving for in his other works. In *The Broken Fan* (Lord Northbrook) and *Woodbridge and Holland* (Marshall Field) the figures begin to grow larger in relation to the picture space, or at least appear less lonely, and this effect is still more noticeable in the elaborate *Family Party* (pl. 83). These pictures begin to anticipate the best of Hogarth's conversation pictures of the mid-1730s and his ultimate masterpieces of group portraiture, the *Graham* and *MacKinnon Children* of the 1740s.

The Beckingham Marriage (1729–30, pl. 84) may be considered as a slightly different form in that it represents a public ceremony with portraits of the fam-

ily and the officiant involved. But this painting, with its primitive string of people across the canvas, fails because it has no immediate sense of the married couple, no psychological interest relating to the ceremony, whereas *The Beggar's Opera* establishes a relationship, and a fairly complex one, among its main figures. The limitation of conversation pictures, large and small, is evident: the artist has to get in the people required by his purchaser, in a given setting. As Ralph Edwards says, "The 'literary' and representational elements bulk large in such pictures, restricting the artist's invention and even perhaps to some extent inhibiting his powers."[53] Although Edwards' view is based on a Clive Bell-Roger Fry formalism, it points to Hogarth's difficulty. His literary and representational powers were more developed than his formal technique, and these no doubt sold his pictures. His best efforts are those in which he approached the purchaser with a modello, or in which, exhibiting a modello, he attracted purchasers. Even so, a picture like the *Bambridge Committee* was marred by the deviations he was forced to make from the modello in order to get in all the people required. It goes without saying that the conversation picture did not allow scope for Hogarth's satiric talent, except perhaps in the groups of children, where general and harmless satire was permissible.

As to his success in the field, Vertue's various statements tend to be inconsistent—he speaks more fervently of Dandridge, and later calls Gawen Hamilton the best of all conversation painters; but one may accept his factual comments on Hogarth's success. Even if it was no greater than that of Dandridge or others, it was nevertheless marked and sufficed to make the public aware of Hogarth as a painter.

Hogarth's own comments are succinct. His hatred of drudgery, he says, his failure to be a first-rate copper engraver, "and other reasons made him turn his head to Painting Portrait figures from 10 to 15 inches high" of subjects in conversation. But this kind of painting, "tho it gave more scope to fancy than common portrait was still less but a kind of drudgery"—i.e., like the engraving he had escaped earlier.[54]

Nevertheless, he had many commissions for his small portrait groups in 1730, and in late 1731 Vertue was still classifying him as a painter of "small figures." In July 1731 he was characteristically mixing painting and instruction with Mrs. Pendarves, who on the thirteenth wrote to her sister Anne how she disliked Mrs. Lafountain's painting: "but I am grown passionately fond of Hogarth's painting, there is *more sense* in it than any I have seen." She refers to the *Wesley Family* group, which Hogarth had just done, and remarks that she "had the pleasure of seeing him paint the greatest part of it; he has altered his manner of painting since you saw his pictures; he finishes more a good deal." One of the characteristics of these early conversations, noticeable in *The Wanstead Assembly* and becoming more evident in *The Western Family*, is a beautiful, diaphanous quality in the faces, as of traces of *pentimenti*. He had, of course, come to

realize that finishing was desired, and the contrast between the lovely handling of the accessories and the overly finished faces is less painful here than it was in the *Ashley Cowper* group. The second fact Mrs. Pendarves records is Hogarth's fame for catching a likeness. She notes that she has released Lady Sunderland from a promise for a picture of herself by Zincke the enameler in order "to have it done by Hogarth." "I think," she goes on, "he takes a much better likeness, and that is what I shall value my friend's picture for, more than for the excellence of the painting." Finally, she has clearly seen a little of Hogarth himself, and she concludes: "Hogarth has promised to give me some instructions about drawing that will be of great use,—some rules of his own that he says will improve me more in a day than a year's learning in the common way." That last phrase sounds like the confident Hogarth of the 1730s and 40s. He evidently made a conquest of Mrs. Pendarves.[55]

But as Vertue noted, Hogarth had already turned from conversations to more congenial and independent subjects, which he sold at auction or to visitors to his studio. In 1729 he sold *The Christening* (or *Orator Henley Christening a Child*) and about the same time *The Denunciation* (or *A Woman Swearing a Child to a Grave Citizen*). Both (pls. 85, 86) have the same banded composition that came off rather well in the *Hudibras* engravings, but in the paintings Hogarth has not yet subdued the space above and below his figures; he has not moved in close enough to break up the straight horizontal line of their heads and the straight, stiff bodies he has learned to avoid in his prints. In *The Denunciation,* as in the final version of *The Beggar's Opera* (pl. 64), the main characters are painted in clear focus, the others are somewhat fuzzy. For example, the child teaching her dog a trick is sharply painted, suggesting a parallel with the central group of the lover teaching the pregnant girl her trick. These pictures generated commissions for more of the same; and for other works as well, which fall in the category of drolls.

It is only a short step from *The Beckingham Marriage* to *The Christening,* a work in which the portraits are satirically and topically intended. It depicts another ceremony, more publicly identifiable with the most notorious clergyman of the day, John (Orator) Henley, officiating, and with psychological interest directing the viewer away from the ceremony to the participants.[56] Anticipating the situation of the first plate of *Marriage à la Mode,* the husband and wife are both ignoring the ceremony, he admiring himself in a mirror, she slouched in a chair and being courted by another man. The composition is somewhat less stiff and packed than *The Denunciation,* the colors lighter with whites, bright blues and pinks.

Thomas De Veil is, according to tradition, the justice portrayed in *The Denunciation;* and he may also be the man who appeared five or ten years later in *Night,* the last plate of *The Four Times of the Day.* If Hogarth put Henley in

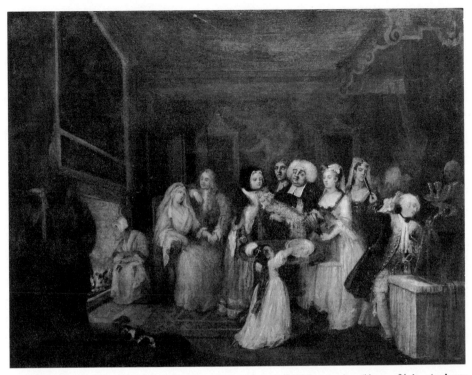

85. The Christening, or Orator Henley christening a Child; 1729? 19½ x 24¾ in. (private coll.)

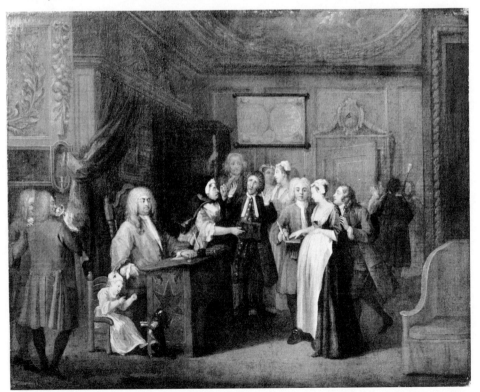

86. The Denunciation, or A Woman swearing a Child to a Grave Citizen; 1729? 19½ x 26 in. (National Gallery of Ireland, Dublin)

a christening, he would probably have put De Veil in a court hearing. De Veil and Sir John Gonson were the most famous magistrates at this time, but it was De Veil who would have held such a session as the painting shows in his house. He had become a justice in 1729 and soon after took a house in Leicester Fields; in spite of his reputation (Fielding liked to refer to him as a prototypical trading justice), his apologist insists that he was not corrupt, but confesses that "he had his profit in view; for though he was far enough from covetousness, if we restrain that vice to the mere gathering and keeping of money, yet he had a strong passion for acquiring it, that he might live in his own way, which was magnificent enough, and gratify his propensity to pleasures, which were very expensive."[57] This same apologist notes his "propensity for the fair sex" (though married four times, with twenty-five children) and his reputation for helping out shady women (e.g., someone else's kept mistress) and taking his reward in trade.[58] He is cited for his proficiency at the sort of task performed by the justice in *The Denunciation:* he could handle these cases and keep them quiet.

Hogarth, as Vertue and Mrs. Pendarves attest, was famous for his skill at catching likenesses—more so, perhaps, than for the general excellence of his execution; he was also famous for his comic scenes. So it was natural for the more discerning to approach him with commissions, not for formal portraits (which Vanderbank could do better), but for combinations of good likenesses and comic scenes. These early "comic history paintings," then, are direct sequels to *The Beggar's Opera* and *The Bambridge Committee,* with at least one recognizable portrait in each: the most notorious preacher in London, and the most notorious magistrate.

In early 1730/1 Vertue notes that Hogarth was commissioned to produce another work along these lines.[59] The Lord Mayor, Humphry Parsons, had been sworn in in October 1730; Sir Isaac Shard, a famously "prodigious penurious Kt," had also become Sheriff that fall.[60] Parsons employed Hogarth to ridicule Shard's miserliness, and the result was a picture of Shard

> in his habit and manner, being remarkably singular seated in a great chair in judgment as it were upon a Malefactor. that was brought before him. being a great Hungry dog who had stolne from his Honours kitching a piteous lean scraggy shoulder of Mouton which his cook had surpizd and taken from the dog. wherefore the dog was brought before this Honourable Judge. who pronounced the Sentence of death on him. Mrs Cook being highly enrag'd. appears to be his accuser and a certain old fellow a neighbouring Cobler the executioner who holds the dog in a String. and has laid down an old pair of shoes he has new cobled for the Kt his Master. with many other incidents remarkable for the Subject

—all of which, Vertue concludes, "made this picture an entertainment for all that saw it." For (apparently according to Parsons' plan) it was advertised in the

newspaper "that a Curious and ingenius Painter. of reputation was painting a picture which when done would be hung up in justice Hall in the Old Baily." The advertisement in the *Daily Post* reads: "We hear an eminent Painter of this City is at Work upon a curious Piece of Painting, which is to be set up at Justice-Hall in the Old Baily."[61] It was in fact on display, Vertue comments, at the painter's, where the viewers "were mightily delighted with it"—implying, among other things, that Hogarth often opened his house during these years for such sights; the most famous such occasion was the showing of the first *Harlot* painting a year earlier. Hogarth had also found another use for newspapers.

Though Sir Isaac himself "was too grave or too old to resent the affront," Vertue recounts that "his son took it upon him and came to see the picture at Hogarths and it being explain'd to him as to others. it raisd his spirit of resentment that he drew his sword & swore he would Sacrifice the Author or Painter of it. and immediately with a Penknife cut the picture at least the head out of it."

It is probable that after seeing Hogarth's *Denunciation* with its portrait of De Veil, and perhaps also the *Harlot* painting that was on exhibit in the spring or summer of 1730, Parsons thought Hogarth the likeliest candidate to satirize another notable justice: one recalls the story of his being approached by doctors to draw Mary Toft. And who knows, perhaps Parsons suggested that he also portray the third notable justice of the time, Gonson, who by this time had found his place in the third painting of the *Harlot's Progress*.[62]

Hogarth's relations with his public at this time, as he began to consider a return from painting to engraving, must have been especially pleasant and intimate. He threatened a certain "uncommonly ugly and deformed" nobleman, who had refused to pay for his truthful likeness of him, with the same fate as Shard's, sending him a card that said:

> Mr. Hogarth's dutiful Respects to Lord ——. Finding that he does not mean to have the picture which was drawn for him, he is informed again of Mr. H's Necessity for the Money: If therefore his Lordship does not send for it in three Days, it will be disposed of, with the Addition of a Tail, and some other little Appendages, to Mr. Hare, the famous Wild-beast-man; Mr. H having given that Gentleman a conditional Promise of it for an Exhibition-Picture, on his Lordship's Refusal.[63]

Sir Isaac's example must have been still fresh, for the money apparently arrived, and "the picture was sent home, and committed to the flames."

There were, of course, other special commissions as well. The earliest and most notorious of these was from Mr. Thomson, probably the John Thomson (M.P. for Great Marlow) who was on the Commons Committee for the Fleet Prison and was associated with Sir Archibald Grant in the Charitable Corporation for the Relief of the Industrious Poor. This organization lent small sums

upon pledges, until the corporation members decided to define themselves as industrious poor and borrowed corporation money on sham pledges for speculation.

The pictures were the outdoor versions of *Before* and *After* (pls. 87, 88), which are consciously French (like the Watteauesque *Fishing Party*) in composition, color, and handling. The foliage is a much deeper green and blue-green than Hogarth's characteristic background. The boy is wearing a blue suit with gray socks, and the girl has a red dress and a blue ribbon in her bonnet; the rest of her outfit is white. The pictures, pretty as they are, contain the one detail in Hogarth's surviving work—revealed by recent cleaning—that might be classified as indecent. In *After* the boy's face has become very red—a brick red as if from heat exhaustion—and his trousers are open revealing pubic hair and a penis inflamed to match his face. Aside from the beauty of execution in these little pictures, they are chiefly notable for conveying their point by creatural realism, whereas the interior version of the same subject, painted not long after, displaces this realism to symbolic objects: an exhausted dog and a broken mirror (pls. 89, 90). Inscriptions are visible on papers in the girl's dresser drawer, one discernible as "will agree she did not die a maid." This safer, more Hogarthian version of *Before* and *After* also employs the more characteristic color scheme of his later works: a lighter green in the curtains on bed and window, salmon trousers on the man (reflected in the color of the falling powder box), and ivory dress with a greenish foliage design on the girl, with just a touch of blue in the ribbons on her and on the mirror. This second version, perhaps painted for the Duke of Montagu, was the one Hogarth selected to engrave a few years later.[64]

Thomson never picked up his *Before* and *After*. In October 1731 he made off with his embezzled profits and the company books, sailing to France and later turning up in Rome. Sir Archibald Grant stayed to face the music but, with Thomson, was discredited and declared bankrupt, and in May 1732 was expelled from the House of Commons. As a result, Sir Archibald never claimed his pictures from Hogarth either; *The Bambridge Committee* went to William Huggins, son of Bambridge's old master, as did *The Beggar's Opera,* paid for no doubt with old Huggins' ill-gotten gains from the Fleet Prison.[65]

The drinking scene, later engraved and entitled *A Midnight Modern Conversation* (pl. 91), may have been painted around 1730 too. Generically a "Merry Company" picture (though later, to suggest classical origins, Hogarth called it a Bacchanal), it nevertheless probably contains recognizable likenesses of a group of drinking companions. It may have been commissioned, or Hogarth may simply have done a picture of some of his friends. It bears a curious resemblance to the smaller conversation, *A Club of Gentlemen* (pl. 92), which has a group of friends sedately drinking, one gesturing perhaps a bit grandiosely, but which also includes an overturned chair and a drinker leaning over (away from the viewer) presumably to vomit. A dog, like the one sleeping in *Midnight Mod-*

87. Before (outdoor scene); 1730–31; 14 x 17½ in. (Fitzwilliam Museum, Cambridge)

88. After (outdoor scene); 1730–31; 14 x 17½ in. (Fitzwilliam Museum)

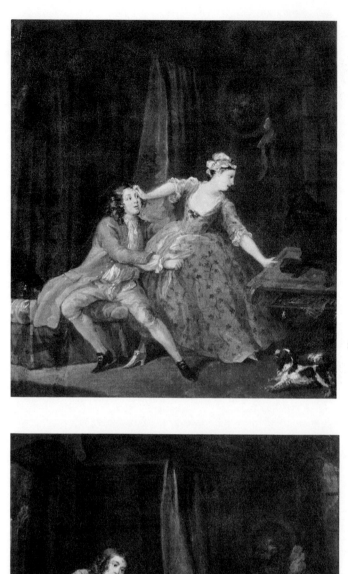

89. Before (indoor scene); ca. 1731? 15¼ x 13¼ in. (Art Properties, Inc., J. Paul Getty Coll.)

90. After (indoor scene). ca. 1731? 15¼ x 13¼ in. (Art Properties, Inc., J. Paul Getty Coll.)

91. A Midnight Modern Conversation; 1730–31? 31 x 64 in. (Mr. and Mrs. Paul Mellon)

92. A Club of Gentlemen; 1730–31? 18½ x 23 in. (Mr. and Mrs. Paul Mellon)

ern Conversation, is standing near him. By comparing these two pictures, it is easy to see how Hogarth moved from a portrait group, a "conversation" in that sense, to a picture with moral overtones as well as portraits. The title he chose for the picture a few years later may suggest, besides an irony in the sedateness of the word "conversation," a glance back at its origin and development.

This painting typifies Hogarth's work just before the *Harlot's Progress.* His characteristic olive green is present in the tablecloth and palely reflected in the grayish-green walls; the sprawling man's attire is a somewhat more garish version of the salmon red Hogarth used in so many of his later paintings. Hogarth still includes the theatrical curtain at the left (it was evidently painted over some architectural form), making the room look like a stage and the men like actors in a play. The large spaces around the figures recall the conversations and the final *Beggar's Opera* paintings rather than the works of the 1730s with their rigorously-filled picture space. Two tendencies are already apparent; first, the use of a large square or block, here a table, in some part of the picture. The perspective of the table is, characteristically, slightly inaccurate; like a Cezanne table, it does not quite close. Second, there is a restlessness in the figures, for example the standing man in the foreground, whose coat has been lengthened without all traces of the change being removed. Painting directly on the canvas, Hogarth often moved his figures about to achieve the right result. As the *Midnight* canvas was cleaned, a head emerged above the smoking parson and a door behind; also panels, a standing clock, and a different table, closer to those in the print of 1733. The shapes of the people were originally higher up on the wall. The change from a pillar or something similar to the curtain and the adjustment of one of the hats on the wall were made as the picture was being painted and before the pigment was dry.

It seems safe to say that Hogarth did not intend to engrave any of these paintings himself; but he may not have been averse to having someone else do it. The two Joseph Sympson, Jr., prints—*The Denunciation* and *The Christening*—can probably be dated between 1729 (when the latter painting was sold) and 1731 or '32, perhaps very near the time of the engraving of the *Harlot's Progress.*[66] The idea of reproducing *The Christening* in mezzotint may have occurred to Hogarth after seeing Elisha Kirkall's experiments, particularly his mezzotints after the young Heemskirk's animal-headed satires that were published around 1730.

Vertue makes Joseph Sympson, Jr., sound like a young man pushed by his ambitious and proud father. Certainly his surviving work is mediocre, less competent even than his father's, but in 1727–28 he attempted engravings of sublime histories like Niccolo dell' Abbate's *Mars and Venus* and "A Large Print of the Tenth Book of Milton's *Paradise Lost*," on a copperplate 25 by 23 inches, after Vanderbank's design. These were soon followed by a *St. Sebastian* after Filippo Lauri. At the beginning of 1728/9 he was working on another series, *The Actions . . . of the Riding School,* after Vanderbank's designs. It would

seem likely, then, that his work appeared suitable enough to Hogarth, or that Joseph Sr. urged his son upon Hogarth; and that an arrangement was made between Hogarth and the elder Sympson, who published the prints at his shop at the Dove in Russell Court in Drury Lane, and apparently in conjunction with the Overtons. The results were stiff and awkward—not at all what Hogarth could have desired.

In February 1730/1, not long before the subscription for the *Harlot's Progress* was announced, Joseph Mitchell published *Three Poetical Epistles. To Mr. Hogarth, Mr. Dandridge, and Mr. Lambert, Masters of the Art of Painting.*[67] The first was to "Mr. Hogarth, An Eminent History and Conversation Painter," and is dated 12 June 1730. One of the Scots circle that had connections with the poet Allan Ramsay and included Thomson and Mallet, Mitchell was the first to arrive in London, in October 1720. His extravagance ("a slave to his pleasures") soon put him in debt and left him "perpetually skulking to escape creditors," a situation from which Aaron Hill relieved him, and for which he effusively thanked him in verse. In 1729, in his *Poems on Several Occasions,* he was still expressing his gratitude, but was also making overtures to Walpole: he wanted to be governor of Duck Island in St. James' Park, Poet Laureate, and Secretary of State for Scotland.[68] Although he was granted no such reward, he became known as "Sir Robert Walpole's poet" and was alienated from his former friends of the Opposition, though he managed to retain delicate but apparently satisfactory relations with Pope and Hogarth (who of course had decorated the Walpole Salver). His epistle to Hogarth, together with those to Dandridge and Lambert, must have been personally, not politically, motivated; but there is no telling how much was repayment of a debt and how much sincere praise.[69] Hogarth responded with a design for a frontispiece to the printed edition of his ballad opera *The Highland Fair,* which was published in March 1730/1, only a month after the *Three Poetical Epistles.*

This epistle sums up the Hogarth who had put aside engraving to make a name as a painter. Mitchell claims to be a friend of Hogarth's: "Accept the Praise a Friend bestows, / A Friend, who pays but what he owes." He begins by emphasizing the fact that Hogarth is self-taught: "Hogarth, by Merit of your own, / A Candidate for first Renown . . . Self-taught, in your great Art excel." The most interesting passages are those characterizing Hogarth's work:

> The Labours of your Hand present
> Our various Sense and Speech in Paint.
> Such vital Instinct each receives,
> We think one joys, another grieves!
> Here, the fond *Lover's* Pains appear;
> The *Hero's* Fire and Fury there!

> The silent *Hypocrites* exert
> Such Pow'r, and play so well their Part,
> That different Passions they bestow,
> Affright with Fear, and melt with Woe,
> Themselves unconscious what they cause,
> And our Hearts the Master draws.
>
> You have the Skill to catch the Grace,
> And secret Meanings of a Face;
> From the quick Eyes to snatch the Fire,
> And limn th'Ideas they inspire;
> To picture Passions, and, thro' Skin,
> Call forth the living Soul within.

Mitchell likes to make comparisons, and compares Hogarth to Elijah inspiring Elisha, Christ and the fishermen, Pygmalion, and Prometheus. Then he turns to the just portrayal of nature, which was to be the usual defense made of Hogarth (and his friend Fielding), and ends with the conversation pictures in particular:

> Large Families obey your Hand;
> Assemblies rise at your Command;
> Your Pencil peoples where it goes
> And Worlds of new Creation shows.

Comparisons to Deucalion inspiring life in stones and Solomon impressing the Queen of Sheba lead to the peroration, with its somewhat invidious reference to Thornhill the father-in-law:

> *Shakespeare* in Painting, still improve,
> And more the World's Attention move.
> Self-taught, in your great Art excel,
> And from your Rivals bear the Bell.
> But, Rivals—you have none to fear—
> Who dares, in such a Style, appear?
> *Dutch* and *Italian,* wide Extreams,
> Unite, in You, their diff'rent Names!
> Still be esteem'd the First and Last,
> Orig'nal in your Way and Taste;
> Tho *Thornhill's* Self shou'd jealous grow,
> And try your Doings to out-do:
> But *Thornhill,* mingling Flame with Flame,
> Will view with Pride your rising Fame;
> Not, meanly hazarding his own,

Attempt to rival your Renown,
Lest He shou'd be by Fate pursu'd,
Like *Saturn,* whom his Son subdu'd.

One wonders how Thornhill liked being compared to Saturn. But Mitchell's poem is noteworthy as the first contemporary work to introduce the ubiquitous phrase "in your Way": Hogarth was the greatest painter "in his way." And Mitchell calls Hogarth a history painter on the strength of his modern histories, long before Fielding developed the idea in his preface to *Joseph Andrews.* Mitchell seems to recognize (unless he has been coached by Hogarth) that such works must be honored with the name of history painting, and then they become the highest kind of art. Implicit here is a radical definition, which would not have been acceptable to many contemporaries, but which Hogarth was preparing to exploit graphically in the *Harlot's Progress.*

11

A Harlot's Progress

GENESIS

A 9½ by 13 inch drawing (pl. 93) has survived of an old harlot and her peg-legged bunter in a shabby chamber, in the style of the *Hudibras* drawings, and, interestingly enough, approximately the same size and scale.[1] The picture fits nowhere in the *Hudibras* narrative, but it might represent an early attempt, which was then put aside, to pursue in another direction the lessons learned there. A cat and bundle of switches are on the floor; pictures are pinned to the wall; corsets and hoopskirts and a man's hat are lying about. On the whore's table lie a broken-toothed comb, a small mirror, prophylactic sheaths, and (also

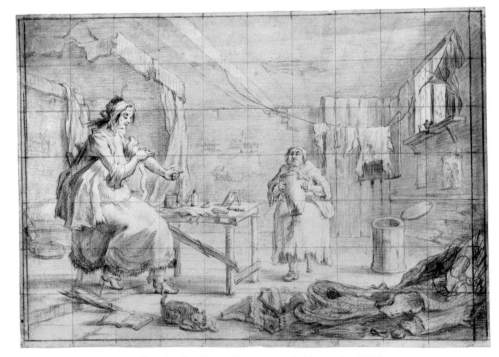

93. Sketch of a Garret Scene; 1730? 9½ x 13 in. (BM)

238

on the window sill) medicine containers. She is wrapping some sort of bandage around her arm.

We know this much: sometime in 1730 Hogarth reiterated the general idea of this drawing in an oil painting, but with a notable difference: the scene takes the mock form of a levee in low life and the harlot is now young and pretty. George Vertue recorded that "amongst other designs of his in painting he began a small picture of a common harlot, suppos'd to dwell in drewry lane. just riseing about noon out of bed. and at breakfast. a bunter waiting on her." As Vertue, one of those who saw the painting in Hogarth's studio, described it: "this whore's desabillé careless and a pretty Countenance & air.—this thought pleasd many."[2] At this point Hogarth had added to the Defoe or Gay subject matter and the squalidly realistic setting the contrast of youth, bloom, beauty, and apparent innocence.[3] His vivid contrast carries as noticeable reverberations of pornography as Richardson's a few years later in *Pamela* (1740), and tells something about the popularity of both works: in one the girl, looking lovely, fresh and unspoiled, has been corrupted; in the other she is only threatened with corruption. Richardson proceeds no further than Plate 1 of the *Harlot's Progress*. And of course what Vertue and others saw in 1730 was the first thought for the third plate, without the magistrate approaching in the background; it was this design that attracted attention and led Hogarth to paint a series. The source of this attention would of course have been much more evident in the painting (now destroyed), with Hogarth's rich creamy flesh colors and the pink of the Harlot's blooming cheeks, than in the print.

In the back of Hogarth's mind may have been Steele's sentimental defense of prostitutes in *Spectator* No. 266 (4 Jan. 1711/2), which projects the same mixture of pity, tenderness, and prurience. Mr. Spectator describes a young girl who stops him in the Covent Garden piazza:

> as exact Features as I had ever seen, the most agreeable Shape, the finest Neck and Bosom, in a Word, the whole Person of a Woman exquisitely beautiful. She affected to allure me with a forced Wantonness in her Look and Air; but I saw it checked with Hunger and Cold: Her Eyes were wan and eager, her Dress thin and tawdry, her Mien genteel and childish. This strange Figure gave me much Anguish of Heart. . . .

Although it is not likely that Hogarth's experience with London prostitutes was wholly literary, it is probable that he was indoctrinated by Steele's argument that the bawds are the villains and the girls are to be pitied. The "progress" of a harlot outlined by Steele is essentially Hogarth's: innocent and "newly come upon the Town," "falling into cruel Hands," "left in the first Month from her Dishonour, and exposed to pass through the Hands and Discipline of one of those Hags of Hell whom we call Bawds." The subject of Hogarth's first plate is described in detail, almost as instructions to a painter:

The last Week I went to an Inn in the City, to enquire for some Provisions which were sent by a Waggon out of the Country; and as I waited in one of the Boxes till the Chamberlain had looked over his Parcels, I heard an old and a young Voice repeating the Questions and Responses of the Church Catechism. I thought it no Breach of good Manners to peep at a Crevise, and look in at People so well employed; but who should I see there but the most artful Procuress in the Town, examining a most beautiful Country-Girl, who had come up in the same Waggon with my Things. . . . Her inno-cent *forsooth's, yes's, and't please you's, and she would do her Endeavour,* moved the good old Lady to take her out of the Hands of a Country Bumkin her Brother, and hire her for her own Maid.

Thus the whole situation of Plate 1, down to the clergyman—who no doubt re-flects Hogarth's natural feeling of impatience at Mr. Spectator's refusal, with all his awareness of the situation, to involve himself on the girl's behalf. He merely stays hidden in his box, as the clergyman does behind his piece of paper.

Sometime in 1730 then, I would guess before August, Vertue and many others saw Hogarth's painting of a harlot in his Covent Garden studio. "This thought pleased many," he writes, "some advisd him to make another. to it as a pair. which he did. then other thoughts encreas'd, & multiplyd by his fruitful inven-tion. till he made six. different subjects which he painted so naturally. the thoughts, & strikeing the expressions that it drew every body to see them—." If Vertue had drawn attention to the presence of Gonson and the Harlot one could date the picture quite easily. Since he does not, mentioning Gonson only as part of the finished series, one must assume that the Gonson-Harlot relationship was a later addition. With this in mind, it is possible to trace the germination of the series. The only assumption necessary is that Hogarth (as with every series of his prints) followed the newspapers closely. Like most Londoners of his day, he probably spent much of his time when away from his studio in a coffeehouse; his father's coffeehouse would have accustomed him to its advantages, which in-cluded access to all the papers. One need not attempt to solve the riddles of those months, to ascertain whether Colonel Charteris really raped Anne Bond, or whether Anne was a scheming minx. By simply reading what the newspapers said one may arrive on an equal footing with Hogarth, except of course that he could go to the courtroom itself to sketch Colonel Charteris, or to augment the newspaper reports with rumors and opinions passed by word of mouth.

A thief named James Dalton, whose wig box appears atop the Harlot's bed in the third picture, is the first character in this strange history to come before the public eye. Dalton was a robber with a long, checkered career that was drawing to a close at the beginning of 1730.[4] In December 1729 he attempted to rob the great Dr. Mead in his coach, but failed and was captured. His trial was put off till the next Sessions, by which time, the *Craftsman* noted, other charges may

94. A Harlot's Progress, Pl. 1; April 1732 (whole set, first state); 11¹³⁄₁₆ x 14¾ in. (W. S. Lewis)

95. A Harlot's Progress, Pl. 2; 11⅞ x 14⅝ in. (W. S. Lewis)

96. A Harlot's Progress, Pl. 3; 11 13/16 x 14 7/8 in. (W. S. Lewis)

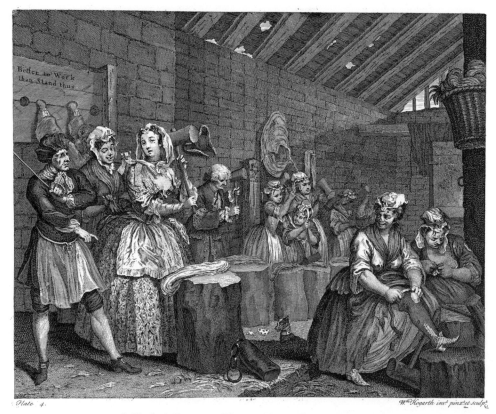

97. A Harlot's Progress, Pl. 4; 11 7/8 x 14 15/16 in. (W. S. Lewis)

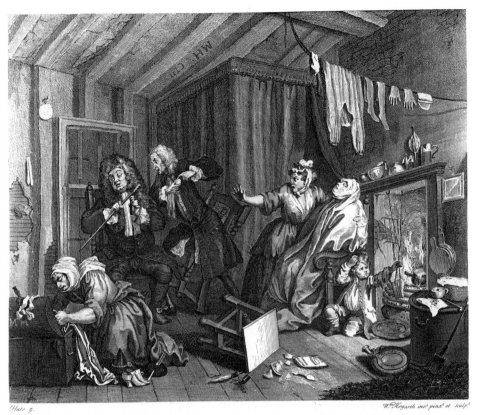

98. A Harlot's Progress, Pl. 5; 12 x 14¾ in. (W. S. Lewis)

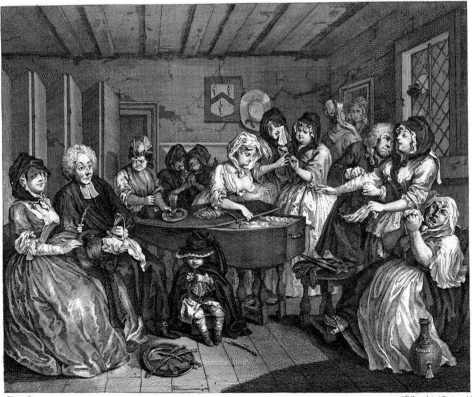

99. A Harlot's Progress, Pl. 6; 11¹³⁄₁₆ x 14⅞ in. (W. S. Lewis)

have been collected against him. In January of 1730, "The noted James Dalton being brought before the Court, to take his Trial, a Woman unknown took an Opportunity to throw a Bottle at his Head, which cut him very much, and caused such a Confusion among the Crowd, that two Fellons found Means to escape."[5] This lady's man was tried and found guilty of assaulting Dr. Mead with intent to rob him, but since he had stolen nothing his sentence was a mere three years and a fine of 40 marks and security for his good behavior for seven years. Meanwhile, however, having squabbled with a fellow prisoner on 19 January and cut him "in a desperate Manner with a Knife," he was to appear before the next Quarter Sessions. The *Daily Post* adds that "He behaved himself before the Court with uncommon Insolence and Impudence." Other crimes from the past were being dredged up, and on 23 February he was indicted for robbing a person in the street of a waistcoat and 25 India handkerchiefs, and his fate was sealed.[6]

At this point a second character enters the ken of the newspaper-reading Londoner. Nathaniel Mist, in *Fog's Weekly Journal* of 6 December 1729, wrote:

> It is reported about the Town, that a certain noble Colonel lately attempted to rob a Young Woman, a Servant Maid, of her Honour, and that to frighten her into a Compliance with his filthy Desires, he drew a Pistol upon her—He is to be sued for the Assault, and it is thought considerable Damages will be given against him, not only for putting the Young Woman in Fear of her Maidenhead, but for using a Weapon altogether unlawful upon such an Occasion.

A year earlier Mist had written in a similar vein:

> We hear a certain Scotch Colonel is charg'd with a Rape, a Misfortune that he has been very liable to, but for which he has sometimes obtain'd a *Noli prosequi*: It is reported now, that he brags that he will solicit for a Patent for ravishing whom he pleases, in order to put a Stop to all vexatious Suits which may interrupt him in his Pleasures hereafter.[7]

Any knowledgeable Londoner would have been aware of the identity of the "noble Colonel," and the only surprise would have been elicited by the news of 26 February that Colonel Francis Charteris (or Chartres) had "surrendered himself at the Old-Bailey in order to his Tryal, a Bill of Indictment having been found against him at Hicks' Hall for ravishing Anne Bond, his Servant-Maid."[8]

Colonel Charteris was a man whose movements were reported in the papers as a matter of course. Allegedly worth over £200,000, gained through gambling and worse, he was most famed for his violent pleasures, and had bought his way out of earlier prosecutions, including one conviction for rape. But to Hogarth, reading the papers in the winter of 1729–30, he would also have recalled bitter memories of twenty years earlier when his father was petitioning for release from debtors' prison and the Insolvency Bill was creeping along in the House of

Commons. In the winter of 1710–11 Charteris was being investigated by the Commons. A colonel who had reportedly won his commission at the gaming table, Charteris was augmenting his income by exploiting the act that allowed debtors to escape confinement by enlisting in Her Majesty's Armed Forces; he took large sums of money from ruined tradesmen to put their names on his roster. Exposed, with over a third of his company only names, Charteris was cashiered and taken into custody by the Serjeant at Arms of the House of Commons. On 28 February 1710/11, as the debtors' petition was pending, he was "brought to the Bar; where, upon his Knees, he received a Reprimand from Mr. Speaker; and was discharged out of Custody, paying his Fees"—to return to his evil ways with his pockets well-lined and no more than a verbal rebuke for cheating the government of thousands of pounds through his protection of fraudulent debtors, while innocent debtors still languished in confinement for honest losses. Or so it may have appeared to young William Hogarth.[9]

The author of *The Life of Col. Don Francisco,* a biography of Charteris published in March 1729/30, records that after leaving the army Charteris turned to gambling for sustenance. The more money he made, and the older he grew, the less rein he gave to his lust. He employed "some noted Procuress to furnish him from Time to Time with variety of fresh Country Girls, which were to be hir'd (to prevent any Suspicion) to live with him as Servants." The author of this life recites articles—probably imaginary—between the Colonel and the bawd: "*Imprimis,* That Colonel *Don Francisco* shall pay, or cause to be paid to Mrs. ——, for her Care, Diligence and Expences in waiting and attending the Waggons, to hire fresh Country Girls to serve him, for each the Sum of Five Pounds"; and if the girls proved to be virgins, he paid her an additional 10 guineas.[10]

An example was one Sarah Selleto, who came to London from the country, "a poor Country Wench, friendless and pennyless." One day as she was walking in Bow Churchyard, one Mrs. Prat came up to her and asked her what brought her to town. Learning that she wanted to go into service, Mrs. Prat offered to find her a position—and so she went to Charteris' house, where he made an attempt on her virtue, supported by a pistol clapped to her head. He kept her and gave her presents, but when he learned she was pregnant he turned her out.[11] This pattern is repeated in the other cases enumerated in *The Life of Col. Don Francisco:* a woman persuades a girl, often just off the Gloucester or York wagon from the country, to take a position at Charteris' house as a servant.

Charteris' trial for rape was held on 26 February 1729/30, and was attended by the Duke of Argyle, the Duke of Manchester, Sir Robert Clifton, "and others of the Nobility and Gentry."[12] Anne Bond, the plaintiff, testified

That she being out of Service, and sitting at the Door of the House where she lodged, a Woman, who was a Stranger to her, came to her, and ask'd her, if she wanted a Place? and told her, she helped Servants to Places. She ac-

cepted her offer, and on the 24th of *October,* she carried her to live with [Col. Charteris] . . . she was treated very civilly for about three Days: that then he tempted her to lye with him, and offer'd her a Purse of Gold; that he made the like offer to her several times, and told her, that he would give her fine Clothes and Money, and a House to live in, and also get her a Husband; she said, she refused all his offers, and told him, she would not give in to any such thing; and she did not know his right Name till the third Day, when a Servant knocked at the Door, and call'd him by his right Name; that having heard of his Character she would not have come to him if she had known his right Name. . . .

She could not escape: the street door was kept locked, and so she remained until 10 November, when the clerk of the kitchen sent her up at 7 o'clock in the morning to her master, who

bid her stir the Fire, and then he went to the Door, and shut it, and threw her upon a Couch, and had carnal Knowledge of her Body by force. She said, she cry'd out, and the Servants were in the Hall, which is the next Room, and might have heard her, but did not come to her Assistance; that upon her crying out, he stopped her Mouth with his Night-Cap; she said, the Room was next the Street, a Ground-floor, and the Window-shutters open; she said, after he had ravished her, and she had got from him, she told him, she would tell her Friends, and that she would prosecute him; that then he threaten'd he would be the Death of her, if she told it; but she persisted she would, and soon after he whipp'd her with a Horse-whip over her Back and Head, and then he unlock'd the Door. . . .[13]

Charteris' attorney argued that she made up the whole story to cover her discharge for stealing money; that she had known him in Lancashire (where he had large estates) and solicited the position herself, sending him a letter; that none of the servants heard any noises; and that she customarily slept on a truckle bed in his bedroom, some nights with another female servant. His witnesses' testimony, however, was shown to be full of inconsistencies and contradictions. After a trial of four hours, Charteris was capitally convicted and carried off to Newgate.[14]

Thus did justice apparently catch up at last with the so-called "Rape-Master General of Great Britain." The verses that accompanied a print, *Portrait of Col. Francis Charteris on his Trial,* are heavy with irony:

> Blood! must a Colonel, with a Lords Estate
> Be thus obnoxious to a Scoundrel's fate?
> Brought to the Bar, & sentenc'd from ye Bench
> For only Ravishing a Country Wench?

> Shall Gentlemen receive no more respect?
> Shall their Diversion thus by Laws be check'd?[15]

On the night of the trial constables attempted to take possession of his effects in his house in Great George Street, Hanover Square; one of his loyal servant girls fired a pistol out of an upstairs window, wounding a constable in the arm. In the days following the confiscation continued, though apparently only a fraction of his reported estate of £200,000 could be found.[16] Two days after the trial "His Man, John Gourly, (commonly called trusty Jack)" had "gone express" to Scotland to bring down the Earl of Weems, Charteris' son-in-law, and already there were reports of work toward a reprieve: "We hear great Intercession has been made to save the Colonel's life, but as yet without effect," wrote the *Gazette*.[17]

At this point a third strand appears in the story. On 25 February one Francis Hackabout, a highwayman, was convicted of robbing Aaron Durell and George Baily of money, a watch, and other items. On Saturday night, 28 February, sentence of death was passed on malefactors at the Old Bailey, and these included both Francis Hackabout and Colonel Charteris. The case of James Dalton, for robbing a Dutch merchant of £20 and other things of value, was postponed until the next session.[18]

On March 7 the *Life of Col. Don Francisco*, already alluded to, was published with a portrait for 1s.[19] March burgeoned with pamphlets and prints about Charteris and his trial, as well as reports on his attempts to gain a pardon, his illness, and his struggle to keep his property. At this time the *Grub-street Journal* began a series of attacks on the immunity of the rich from the laws ("it is more difficult to get a rich man hanged than to save a poor fellow from the gallows"). Charteris was the symbol used for those "Persons of considerable fortune, or quality, [who] tho liable to the same Capital penalties with those of a lower station, yet should not have those penalties inflicted on them"—with many references to "great men," a phrase which, for the *Grub-street Journal*, included Sir Robert Walpole.[20] On the twenty-eighth it was reported in the same periodical that a pardon would be forthcoming.

On 9 April news reached Charteris from Lancashire that none of his property there had been molested, and the same day James Dalton was capitally convicted at the Old Bailey for robbing John Waller on the highway. The next day he received sentence of death, and Charteris—his and his friends' endeavors having proved successful—was discharged from Newgate, pardoned by the King. He was freed on bail to plead his Majesty's pardon, a mere formality, at the next Quarter Sessions. The next day the Earl of Weems was at court to thank the King for his father-in-law's pardon. On 13 April Francis Hackabout the highwayman was ordered to be executed the following Friday, the seventeenth; and all Charteris' effects at Newgate were removed in a hackney coach to his new lodgings in fashionable Leicester Fields. (In the list of those ordered to execu-

tion appears "and Francis Hackabout likewise for the Highway. But Francis
Charteris, Esq; hath obtained his pardon.") On Friday, as scheduled, Hackabout
and four other malefactors were hanged at Tyburn.[21]

The day after Hackabout's execution, Charteris was reported to have set out
for Bath and Bristol,[22] but on 20 April the *Daily Post* reported him in hired
lodgings at Kensington Gravel Pits: "And last Saturday Night, as he was going
in a Hackney Coach to Chelsea, the Mob fell upon him and beat him in a
barbarous Manner, for no other Reason than that there were two Women with
him in the Coach." A print published shortly thereafter shows Charteris ascend-
ing from a prison door up steps covered with purses of gold, toward a car with
Venus and two nymphs she is offering to him.[23]

Dalton was executed on 12 May appearing "very resolute and undaunted,"
drinking "part of two Pots of Beer at the Place of Execution," and "utterly"
denying his guilt.[24] On the sixteenth Charteris successfully pleaded his Majesty's
most gracious pardon before the Sessions and was officially freed. On 2 June,
however, he was arrested in Fleet Street "at the Suit of a Messenger or Runner
at Newgate for 50 l. for Services pretended to have been done for the Colonel
during his Confinement in that Prison," but was freed on bond. On 23 June
Henry Fielding's farce *Rape upon Rape*, with patent allusions to Charteris, was
performed and published.[25]

Toward the summer of 1730, when the various random strands came together,
yet another character appeared on the scene, as famous in his way as Charteris.
As early as 1728 Sir John Gonson, the Westminster Magistrate, was well-known
for his charges to the Grand Jury at the Quarter Sessions of the Peace of West-
minster and was repeatedly chosen chairman of the Sessions for the year. His
charges seem to have been remarkable productions; the irreverent *Grub-street
Journal* compared them to sermons, and some claimed they were written for
him by Orator Henley.[26] But his greatest fame was as a law officer—he appears in
almost every issue of every paper zealously raiding gamblers and prostitutes,
whom he sent to Bridewell Prison in Tothill Fields to beat hemp. During the
spring of 1730 he was raiding gambling houses. By the summer he had turned
his attention to brothels. On the night of 1 August he and several other justices
of the peace for the City and Liberty of Westminster "met at the Vestry-Room of
St. Paul's Covent-Garden, and committed the Keepers of several disorderly
Houses (who were taken into Custody the Night before) to Tothill-Fields Bride-
well to hard Labour, in particular Katherine Hackabout, alias Wooten, and
Anne Lewis, alias Low, alias Brown."[27] The *Grub-street Journal* for 6 August
prints accounts of the raid from various newspapers, including this from the
Daily Post (3 August):

the 4th was the famous Kate Hackabout (whose brother was lately hang'd
at Tyburn) a woman noted in and about the Hundreds of Drury, for being

a very Termagant, and a terror, not only to the civil part of the neighbor-hood by her frequent fighting, noise, and swearing in the streets in the night-time, but also to other women of her own profession, who presume to ply or pick up men in her district, which is half one side of the way in Bridges-street.

Neatly juxtaposed in the adjacent column, the *Journal* prints a notice from the *St. James's Evening Post* of 4 August: "Colonel Chartres and his Lady being perfectly reconciled to each other, and having made proper dispositions for co-habiting together, he having cashiered his man trusty Jack and others of his evil agents; they are to be presented to their majesties one day this week on that occasion."

Here the apprehended prostitute Kate Hackabout, whose brother was con-demned and hanged, is placed in conjunction with the aged rapist, who started girls like Kate on their careers and was condemned along with her brother but, unlike him, escaped hanging. And together with the unsuccessful and the suc-cessful rogues was the indefatigable Justice Gonson who apprehended Kate Hackabout. For Hogarth, if he read the *Grub-street Journal*, two threads of irony must have coalesced. One was the inconsistent justice meted out to high and low, expressed in *The Beggar's Opera* but not with the particular emphasis Hogarth was to give it, and summed up by Fielding:

> Great whores in coaches gang,
>> Smaller misses
>> For their Kisses
> Are in Bridewell banged;
>> Whilst in vogue
>> Lives the great rogue
> Small rogues are by dozens hanged.[28]

The other was the unbalanced equation pitting Gonson and Justice against the vulnerable whore. It seems very possible that on this day, 6 August 1730, the various themes, conventions, and characters floating about in Hogarth's memory came together to shape a history for the pretty harlot in her Drury Lane garret.

The Harlot's name appears on a letter in an open drawer in the third scene "Md. Hackabout," and on her coffin in the final scene "M. Hackabout." The "M" was extended to "Moll" in the title of the pamphlet, *The Harlot's Progress or the Humours of Drury Lane* (1732), with no authority. "Md." is probably meant to stand for Madam; "M" could stand for Mary or Moll.[29] Hackabout was, of course, a good generalizing name for a harlot, as well as a name familiar to Hogarth's readers. So he puts a girl named Hackabout in her shabby room, with James Dalton's unclaimed wig box above her head and portraits on her wall of Captain Macheath, the robber who talked like a gentleman and got off scot-free,

and Dr. Sacheverell, the gentleman who toppled a ministry with an incendiary sermon and lived very well thereafter. (A writer in the *Free Briton* demanded as late as 15 July 1731: "Why was *Sacheverel* distinguished with a royal presentation, and why was that Parliament dissolved that condemned him?") And—the element that was not in the original drawing—through the door at the rear stalks Gonson and the other justices of the peace for the City and Liberty of Westminster. Then, returning to the Harlot's initiation in Plate 1, Hogarth shows the girl just off the York Wagon, met by a bawd, with Colonel Charteris and "trusty Jack" Gourly waiting in the background. All of these were easily recognizeable portraits: Vertue identified Gonson, Charteris, and the bawd Mother Needham; Gonson's initials appear on the wall of Bridewell in Plate 4; and given Charteris, "trusty Jack" is a logical inference for his companion.

The Harlot's initiation and her apprehension by justices are of course obvious and conventional scenes. Hogarth could have built the scene in the inn-yard on Steele's *Spectator* No. 266 or on descriptions in Richard Head's *The English Rogue* (1672) or any number of other fictional sources.[30] But only through the particular events and characters whose faces and names he used did his theme germinate and express itself. This survey, while tracing their impingement upon Hogarth's awareness, also provides the context that enabled a contemporary to appreciate the *Harlot's Progress*. The recognizable presences within the framework of conventional scenes and relationships attracted buyers, lending the prints a sense of contemporary realism (as later in Fielding's novels real inns and doctors are named); but they also came to represent a level of allusion to the world of the respectable, rich, and powerful—the rake who can rape with impunity and the magistrate who hunts prostitutes as others hunt hares.

Events did not come to a halt in August 1730. As the summer turned to fall, Gonson continued to raid brothels, his procedure becoming a refrain encountered in every few issues of a given newspaper: Gonson has a house raided, meets with his other justices, examines the prisoners, and commits them to Bridewell in Tothill Fields to beat hemp. As late as September 1731—the month of the Harlot's death according to the inscription on her coffin—Gonson arrested a woman "for keeping a notorious disorderly House in Drury-lane [where he arrests the Harlot], to the great Disturbance of the Neighborhood," and committed her to Bridewell for want of bail.[31] Charteris, though found guilty of felony and forced to pay large sums in recompense, remained a free man. On 5 September 1730 Charteris was reported to have "presented the R. H. Sir Robert Walpole with a horse-furniture of green velvet, curiously embroidered with gold of great value"—confirming a widely-held suspicion about the connection between these two "great men."[32]

Meanwhile, Anne Bond, the servant girl Charteris debauched, had been married in April "to Charles Heather, a Drawer at a Tavern in Westminster; and they have since taken a Tavern in Bloomsbury, and design to set up a well

painted Head of Col. Chartres for their sign."[33] On 19 September, Anne's husband (now called Major Smith) "was arrested in some sort of actions by persons employed in that affair [of the rape], viz. one action for 18 l. another for 1600 l. but the young man says, he owes them nothing, and hath given bail to the actions, being resolved to see them out. We are all assured that the Col. hath no hand in this affair." The *Grub-street Journal* adds, as editorial comment: "I wonder at the assurance of my Brethren in vindicating the Colonel's reputation by such an Innuendo."[34]

In the same paper, immediately below this notice, is an account of one Mary Muffet, "a woman of great note in the hundreds of Drury, who about a fortnight ago was committed to hard labor in Tothill-fields Bridewell . . . she is now beating hemp in a gown very richly laced with silver. . . . to her no small mortification . . . and bestows many hearty curses upon her lawyers, &c." The *Grub-street Journal* adds, *"This Lady's* Gown very richly laced with silver *does not well agree with* her no small mortification *in performing the Pennance of* beating hemp. . . ."—exactly the ironic contrast Hogarth brings about in his fourth plate, which shows the Harlot carried off from her garret in Drury Lane to Bridewell to beat hemp in the same fashionable gown she was wearing in Plate 2.[35]

Mary Muffet and her richly-laced gown fit into Hogarth's picture of his Harlot. It should be clear, recalling the actual details of Anne Bond and Kate Hackabout, that he has placed his Harlot somewhere between those extremes. She is not Anne Bond: the second plate is not her rape but her happy assumption of the role of kept woman. She is not Kate Hackabout: she never loses her air of gentility. With this pretty young girl, the gown worn in Bridewell indicates her remnants of gentlemanly keeping and, because she is still wearing it, her guiding motive: originating as part of a mock-levee, she tries to become a lady, manages only to be a harlot, and as a harlot thinks herself a lady. It may have been *Moll Flanders* that first planted in Hogarth's mind the image of a harlot as one who, like Moll, simply wants to be a "gentlewoman"—by which she means one who does not "go into service": like the lady down the street who "is a gentlewoman, and they call her madam" (the lady is in fact a prostitute). Moll's desire to be a "gentlewoman" is so stressed in the opening pages of Defoe's novel that it may very well have influenced Hogarth. Like Moll, too, the Harlot has no character of her own, only reflecting the society in which she finds herself, both in wanting to be a gentlewoman—to have a gentleman at whatever cost— and in disguising herself as a gentlewoman or a widow or whatnot in order to steal. Thus the Harlot keeps her gentlewomanly clothes, always has masquerade disguises around her, and ends with a funeral unprecedented for one of her trade.

For the bawd who seduces M. Hackabout in the inn-yard, Hogarth drew the most famous procuress of the time, Elizabeth Needham. In 1727 when Mrs.

Davys had needed a bawd in her *Accomplish'd Rake,* she called upon "Mother N—d—m" and showed her trying to peddle a girl "just come out of the country."[36] (In the 1756 edition she was replaced by the famous bawd of that time, Mother Douglas—to whom Hogarth also alluded in the 1750s.) As early as March 1722/3 Mother Needham was keeping her "Vaulting-School in Pulteney-Street" and was arrested with seventeen (or twelve in another source) "of her Daughters." She was committed to the Gatehouse and immediately freed on bail; the girls went to Tothill Fields Bridewell to beat hemp. In May she had moved her house, and on 21 July 1724 she was apprehended again; "the first time Mrs. Needham ever received Correction, since her being at the Head of Venal Affairs in this Town." But the next day she was again bailed.[37]

In October 1726 the first of a series of calculated reports of her death appeared, with an epitaph in verse about her dying from being pelted in the pillory—a grisly prophecy, as it happened. Again, on 5 October 1730, "a Woman notoriously known in that part of Town by the name of Mother Needham" died; to which the *Grub-street Journal* added, *"I think my Brother speaks too disrespectfully of this* venerable matron: *He might have said* well known to the young Quality in, &c. The Even. Post *justly calls her* the famous Mother Needham." But by March 1730/1 Gonson's inquiry had reached St. James, and persons of quality from Park Place testified against "a notorious disorderly House in that Neighborhood," which turned out to be Mother Needham's; and there she was caught, very much alive, and committed to the Gatehouse by Justice Railton. On 22 March at Quarter Sessions "the infamous Mother Needham, who has been reported to have been dead for some time, to screen her from several Prosecutions against her, was brought from the Gatehouse, and pleaded not Guilty to an Indictment found against her for keeping a lewd and disorderly House; but for want of Sureties was remanded back to Prison." On Saturday 24 April she was convicted, fined 1s, condemned to stand twice in the pillory, and required to find sureties for her good behavior for three years.[38]

On Friday 30 April, a month after Hogarth had begun his subscription for the *Harlot's Progress,* "the noted" Mother Needham stood in the pillory facing Park Place and was so "severely handled by the populace" that she died on 3 May without having to stand again in the pillory.[39] "She declared in her last words, that what most affected her was the terror of standing in the pillory tomorrow in New Palace-Yard, having been so ungratefully used by the Populace on wednesday." And the *Grub-Street Journal* adds, "They acted very ungratefully, considering how much she had done to oblige them"[40]—a statement that Hogarth would have found very interesting. The same day Gonson and his cohorts were again meeting, examining, and committing undesirables.

By this time Hogarth had probably completed most of his paintings, and Mother Needham's fate can only have confirmed feelings already at work in the series. She is of course the Harlot's original corrupter, the bawd who usually

escaped detention while her girls beat hemp; yet she is only an intermediary for the Charterises, and her death, analogous to the Harlot's, is an ugly one, with the very people she has served clamoring for her punishment.[41]

There are at least three circles of guilt in Plate 1: the girl herself; Mother Needham, who is exploiting her; and Charteris, who is exploiting Mother Needham, and will no doubt be one of those who pelt her in the pillory. Hogarth could easily have replaced Mother Needham's face in the print; his subscription had barely begun when she died. However, the fact and the circumstances of her death added a new dimension to his picture, or at least his own attitude toward it, and perhaps to the viewer's reaction as well.

The clergyman is also part of the guilt explored in Plate 1, turning his back on Hackabout, Needham, and Charteris, while his horse is casually knocking over a pile of buckets. The reason for his absorption is the address he is trying to make out on the paper in his hand: "to the Right Reverend Father in God . . . London." The reference is to Bishop Gibson of London, who was Sir Robert Walpole's chief adviser in the matter of ecclesiastical preferment: the clergyman is thinking about his advancement rather than his duty. Hogarth even incriminates the girl's "lofing cosen in Tems Street in London," to whom her luggage is directed, and who has failed to meet her, leaving Needham to fill the gap. As her antagonists, the forces of pleasure and corruption are augmented by the entire social structure of family ties, law, order, and religion.

Thus the Harlot suffers from lack of attention by supposedly humanitarian professional men. In Plate 5, she is ignored by doctors; and clergymen are shown ignoring her in both the first plate (where the ambitious cleric turns his back) and the last (where the officiant at her funeral is diverted by a female companion). Hogarth's attack on the clergy does not end here—in Plate 2, a priest is shown stabbing Uzzah (in the painting of the Ark of the Covenant), and Bishop Gibson is alluded to again in the third plate, where the Harlot uses one of his *Pastoral Letters* as a dish for her butter. His first *Pastoral Letter* had been issued in 1729, his second in April 1730, and his third in May 1731: all three were attacks on the Deists. The letters were satirized by many in these years as another sign of "Dr. Codex's" pomposity and self-esteem; but Hogarth evidently intends also to parallel the clergyman who does not help the Harlot in her moment of need and the Bishop (whom the clergyman is soliciting) who, spending his time writing about Deists, gives his flock as little help.[42]

There is something obsessive about Hogarth's references to clergymen in these early prints. In *The South Sea Scheme* and *Royalty, Episcopacy, and Law* they are more interested in money than in their spiritual charges, and the clergyman who supervises the purging of Lemuel Gulliver while his congregation worships Pan is exactly analogous to the one who studies the Bishop of London's address while the girl next to him is corrupted. The list could be extended to include Hudibras, a religious hypocrite who goes out after imaginary evils ignoring the

one at his elbow, and Cardinal Wolsey in *Henry VIII and Anne Boleyn,* who is doing his duty as a First Minister but not as a clergyman. Clergymen seem to epitomize the structure of authority that ignores the activities of Charterises and Needhams; perhaps it is significant that Hogarth regards them as the Puritans regarded Anglican clergymen, as time-servers, always more interested in something other than the spiritual welfare of their charges. The one who is carried away by his rhetoric while his flock snores in *The Sleeping Congregation* (1736; pl. 156) is a milder version, but his church, Hogarth makes quite clear by the truncated "ET MON DROIT" on the wall, does not contain God.[43]

It only remains to mention the pervasive background of remedies for venereal disease that spotted the back page of every newspaper. In the late 1720s they begin to crowd out respectable advertisements. Taking one issue of the *Craftsman* at random (10 July 1731), one finds on the back page "a transcendant, Balsamick, Restrictive Electuary," 6s a pot; "Mr. Nelson's most sure and long experienced Anti-Venereal Compound, or never-failing Electuary," the Montpelier little Bolus, the Anodyne Necklace cure, and at least two others that, treating the itch, imply a venereal-curing capability. The ads that are not specifically for venereal disease are for other troubles of the genito-urinary tract that, it is implied, will succor the "secret disease."

The two quarreling doctors in Plate 5 offer the basic choice of bottle or pill. Most are bottle cures—the "Anti-Syphilicon," 6s a pot, and the "Diuretic Cleansing Elixir" for "Gleets and Weaknesses," 5s a bottle. Another was Dr. Rock's "incomparable Electuary," "the only VENEREAL ANTIDOTE," 6s a pot, sold at the Hand and Face near Blackfriars Stairs; Hogarth inserts Rock's name in his revised plate of 1743. As to pills, besides Misaubin's famous brand (which however does not appear advertised in the papers until a later time) there were "the famous Montpelier little BOLUS . . . so immediate a Cure, That of those Numbers that daily take it, not one fails of having the Infection carried off by 1, 2, 3, or 4 of them, as the Distemper is more, or less upon the Person"; or "The long experienc'd Venereal little Chymical BOLUS"; or the "famous Italian Bolus." Hogarth's pill doctor, according to contemporary report, was a portrait of the French empyric, Dr. Misaubin, who also appeared frequently in the papers; typically, in December 1730, Misaubin, "in St. Martin's-Lane, gave a magnificent Entertainment to several Noblemen and Gentlemen, in which Company was Sir Robert Fagg, Bart. of Sussex."[44]

The other cure, besides the sweating treatment depicted in the Harlot's room, is the Anodyne Necklace. Its advertisements, which ran for decades in nearly every newspaper, derived from a shop at the Sign of the Anodyne Necklace, against Devereux Court outside Temple Bar, where two distinct remedies were sold: the necklace for teething children and for venereal disease. Thus the presence of the necklace could refer to the son or the mother or both.[45] Judging

only by the venereal disease ads, a reader might well conclude that the disease rate had appreciably increased and was parallel to those degeneracies Pope chronicled in *The Dunciad,* where indeed the parallel is suggested in Curll, the allegedly syphilitic bookseller. And this must be taken as part of the commentary of Hogarth's fifth plate, with its doctors and variety of cures coupled with the image of death and degeneration.

The final painting was presumably finished Thursday, 2 September 1731, the date on Hackabout's coffin; at any rate, Hogarth seems to have intended this date to signify the completion of the series, as an allusion or as a private memorial. Perhaps he was amused by the anniversary of the Great Fire of London on that day (noted in the newspapers of the third.).[46]

It is misleading to view the *Harlot* series as an anticipation of *Pamela,* Richardson's sentimental account of the sufferings experienced by a young girl threatened with sexual degradation. Although Plate 1 presents the piquancy of threat, Plates 2 and 3 the fall accompanied by poverty and squalor, Plate 4 the legal and Plate 5 the physical punishment, the cumulative effect is quite different from that of the sentimental novel. Hogarth's print is packed with complicating detail which establishes a reciprocal pattern of guilt and innocence, cause and effect. Not only do Charteris and Mother Needham appear, but also the parson studying the address of the Bishop of London. The behavior of the hungry, blinkered horse and its consequence—the falling pile of buckets—indicates what will follow from his master's self-concern (with overtones of Balaam and his ass). The girl herself is less a study of innocence than of eager gullibility. There is a distinct impression of eagerness in her attention to the bawd's words, and a notable resemblance between her profile and that of the goose hanging from her basket. Hogarth's scenes are constructed of such parallels and interdependencies: the parson and his horse, the girl and her goose, Mother Needham with the sign of the Bell (Belle) over her head; and in the second plate, the monkey's expression paralleling the man's as the girl—now the Harlot—kicks over the tea table in order to divert his attention. She has been corrupted, as Pamela never is; and there is no suggestion of Pamela's devout purity ("May I never survive, one moment, that fatal one in which I shall forfeit my innocence!") or Clarissa's gloom (measuring herself for her coffin after being raped). Rather, she appears with her keeper, a Jewish City merchant, gaily distracting him in order to allow a younger and more handsome lover to sneak out the door.[47]

The paintings that hang on the Jew's wall—old master renderings of Old Testament subjects—act as a commentary on their collector and his newest item. Directly over his head is Uzzah rashly touching the Ark of the Covenant, much as the merchant took the forbidden object, a Christian girl: the Ark was supposed to be carried only by Levites and Uzzah was not a Levite. The whole scene

below is a redaction of the painting with imaginary lines connecting each character with his biblical counterpart above. Most obvious, the tilting Ark of the Covenant becomes the tilting tea table; Uzzah reaching out to steady the Ark becomes the Jew steadying the table; the sportive oxen (*lasciviens* in the Biblical commentaries) who cause the Ark to tilt become the Harlot who kicks over the table. Hogarth has changed the story in 2 Samuel in one respect: he has substituted for the hand of God a priest who is stabbing Uzzah in the back. The Harlot, like the oxen, is kicking at her traces; she has taken a young lover, and Hogarth has placed him so that his sword, carried under his arm as he creeps toward the door, appears (by a characteristically Hogarthian false perspective) to be stabbing the Jew in the back. The stabbing priest has become the cuckolding young lover. (Antlers appear prominently in the pattern of the wallpaper.)

The other painting shows Jonah sitting next to a withered gourd with God's sun beating down on his head. God was punishing Jonah for wanting the people of Nineveh to be destroyed even after they had repented of their sins. As Jonah sat outside the city walls hoping to see the Ninevites destroyed, God sent a gourd to protect his head from the rays of the sun, and a worm to wither it so that he would feel the full force of the heat; then He asked Jonah to compare the gourd to Nineveh as a lesson in mercy. Hogarth's Jonah has his fists clenched in anger and is looking in the direction of Uzzah in the other painting. Whether Jonah is analogous to justice directed against the Jew or analogous to the Jew himself, the problem is one of human justice and divine mercy. For if the Jew is a victim of human justice, he is also an agent of it: like Jonah, he will pass rigorous judgment and banish the Harlot when he discovers her transgression. The paintings he collects reflect his own stern Old Testament justice; in the next plate he has cast her out and she is living in a shabby room in Drury Lane, the territory of prostitutes.[48]

Moving up into the print from bottom left, from monkey to Jew, from tilting table to Harlot, and thence up to the pictures, the painting of Uzzah reads as an extension of the action below, and the painting of Jonah as a commentary on that action. But if (following the early Hogarth commentators from Lichtenberg on) the paintings are read from left to right, they apply equally well to the Harlot, who is under the protection of the Jew as Jonah was under the shade of the gourd, which withered in the morning leaving him unprotected under a fierce retributory sun. The painting of Uzzah also applies in a way to the Harlot, for like her Jewish keeper she too is reaching out to touch something forbidden. Their situations are in a way parallel: both are climbing socially, he by picture collecting and taking a Christian girl for his mistress (I assume this was the reason for Hogarth's making him a Jew), she by presuming to rise above the status of a mistress and take a lover of her own; and both suffer particularly human punishments. Uzzah's error, *temeritas* or rashness, glossed by some of the biblical commentators as *ignorantia,* is her crime too. In her case the ma-

terialization of God's wrath in a priest connects with Justice Gonson in the next plate, in which the distinction between human justice and divine mercy is further underlined.

The contrast between Plates 2 and 3 is instructive: the same serving of tea, the same elegant dress, the same situation, transferred from a setting of comfort to one of squalor. The point of the contrast I take to be the Harlot's "air"—the inappropriateness of her dress, of being served in bed by her parody of a servant, in these grim surroundings, with her penny portraits and Old Testament engraving hanging on her wall in a sad parody of the Jew's art collection. What Hogarth is showing is a girl from the country (her essential innocence or *ignorantia* is suggested by the parallel with the cat playing at her feet) who comes to the city with the delusion that she wants to be a lady—a great lady. By the second plate she *is* a great lady in the sense that some great ladies dress well, are kept, and take lovers. In the third she is keeping up appearances, though she has come somewhat down in the world, and there is a suggestion of what is to follow in the servant woman's diseased nose, the medicine bottles on the sill, and the magistrate Gonson softly entering at the rear with his helpers. The world of consequences, already poised even in that proleptic first plate in the ominous figures of the corruptors, the dead goose, the falling buckets, and even the constricting verticals of the buildings around her, has now begun to close in. But there is another parallel, between Gonson and his assistants emerging from their doorway and Charteris and his pimp emerging from theirs. Hogarth's comment on the Harlot's plight, recalling the picture of Uzzah in the preceding plate, can be sensed in the other picture she keeps on her wall: Abraham about to sacrifice Isaac—as the magistrate approaches—and God's angel staying his hand.[49] Even the face that emerges from the knot in the bed curtain seems to cry out a warning.

In the fourth plate her pretension (to use Fielding's word, her affectation) is even sadder, juxtaposed with the threatening shape of the warder who is another representative of human justice and respectability; and in the fifth plate, as the consequences overwhelm her, though dying of syphilis she has in attendance two doctors who are quarreling over their respective fashionable cures; her gowns and masquerade costumes are still in sight, though being rifled in anticipation of her death. In the sixth and last plate she lies in her coffin surrounded by whores, bawds, a clergyman whose hand is under his neighbor's petticoats, an ogling mercer, and so on. Even in death the Harlot is pursued by "consequences," i.e., by the more respectable crowd—the "great"—who exploit her folly; and she is demonstrating the last signs of the aspiration toward gentility that brought about her end: the elaborate laying-out and the funeral escutcheon on the wall above the coffin.

While Pamela is a virtuous servant girl, Hogarth's Harlot is clearly a young girl on the make; in a sense she is the Pamela Fielding detected beneath her

virtuous protestations. The effect of virtue threatened, dominating Richardson's novel, is absent from Hogarth's print. Injured or threatened innocence is the subject matter of sentimental fiction; guilt, not innocence, is the subject matter of satire: the guilt of the bawd, roué, Jew, doctors, clergymen, and so on, as well as of the girl herself. The relationship is reciprocal, with more than one kind and degree of guilt indicated.

Here then is the pattern or structure of Hogarth's *Harlot's Progress:* an innocent encounters the ambiance of the "great," the fashionable, the respectable; turning against her own nature she imitates this "greatness," and comes to grief while the "great" themselves go on their merry way. What I have sketchily indicated are some of the more readily documented literary, social, historical, and biographical forces that contributed to the creation of this pattern: these can be distinguished as both private, perhaps pre-conscious sources, and public patterns of thought. It is, of course, impossible to separate one from the other—what appears to be personal may in fact be determined by some general social or literary pattern of thought in the period—but one may at least conclude by itemizing them.

The personal pattern would have to include, besides those details already given, Hogarth's father, who came down to London (perhaps with Edmund Gibson, perhaps on the same York Wagon used by the Harlot) and tried to live by London standards. The farm lad from the north country, attempting to be a Latin scholar and schoolmaster, ended as a literary hack and an inmate of debtors' prison, driven (as Hogarth recalled bitterly as long as 45 years afterwards) to his death by the exploitive London booksellers. Equally relevant is Hogarth's own experience: his refusal to accept his status as a silver engraver's apprentice, his rejection of his indentures, his struggle to survive against the same booksellers who ruined his father. A decade later all of this colored the day-to-day events he read of in the newspapers—Colonel Charteris, Kate Hackabout, and Justice Gonson.

But giving form to these vague experiences were public patterns of thought, most obviously the literary structure established with the imitation of "greatness" in *The Beggar's Opera* and explored by Hogarth himself in his paintings of the subject. To this must be joined the moral patterns imposed on Hogarth by his upbringing, by a father whose Presbyterianism must have given a greater emphasis to choice and unalterable consequences than Gay's comic form ever predicated. I hesitate to venture a guess as to whether the public or private was the more important, though I would suspect that the literary background of Gay, Swift, and Butler was essential and the current events incidental. A different set of events might have produced a not dissimilar progress, being colored by the same literary assumptions. But it is also undeniable that artists and writers adopt those traditional literary stances they find congenial. The *Harlot's Progress* depicts a literary theme sharpened by experience and public observa-

tion to a particular point: the individual's crime, if analyzed, is essentially his desire to emulate the behavior of the fashionable folk who guide him, use him, and destroy him.

More than any of his Augustan predecessors, however, Hogarth pits society as a whole against this individual; not just the forces of pleasure and corruption but also those of law and order, drawn like sharks by the smell of blood. The basic units of society, from the doctor to the clergyman, if they do not actively prey on the Harlot, simply ignore her; each, like the lecherous clergyman in the last plate, goes about his own business. This aspect of the series is open to speculation: to what extent is the portrayal of clergymen and police conventional, like the portrayal of doctors, and to what extent is it a reflection of Hogarth's own dark memories and experiences?

MODERN HISTORY PAINTING

By the beginning of 1731 all six paintings of *A Harlot's Progress* must have been far enough along to be shown in Hogarth's studio, though additions and changes were made, no doubt, during the next year. By early March 1730/1 the subscription ticket known as *Boys Peeping at Nature* (pl. 100) was etched and in circulation: an announcement, a lure, an elaborate joke, and a statement of aesthetic intention.

At the center Hogarth places the many-breasted image of Nature (Diana of the Ephesians) adapted from Rubens' *Nature Adorned by the Graces,* as a compliment to his father-in-law, who owned the original painting; but Rubens' three Graces, engaged in veiling the goddess, are transformed into putti fighting over whether she should be veiled or unveiled. Nature is also intended as an allusion to Gerard de Lairesse's well-known frontispiece to his *Art of Painting,* which showed her being portrayed by an allegorical figure representing Painting.[1] *Boys Peeping* should be contrasted with the frontispiece of *Hudibras,* Hogarth's earlier manifesto; here he has turned his back on a literary text to imitate Nature herself. One putto is shown painting her: his version reaches only a little below her bust and leaves out some of her numerous breasts (Lairesse, in his "Emblematic Table of the Art of Painting," specifies that Nature has five). A faun is concerned with those lower parts which are concealed by a shift hung around the statue; a second putto is trying to prevent or restrain the faun from lifting Nature's shift. A third is working on a drawing with his back turned to Nature, presumably drawing ideal forms from his imagination. The artist can thus expurgate Nature, ignore her altogether, or present her unadorned.

The scuffling faun and putto are conventional symbols of sensual and spiritual love: the former is to be the subject of this series. But the faun, a small satyr, also serves as Hogarth's self-identification. Where in the *Hudibras* frontispiece he has a putto copying a grotesque scene from a satiric text (held by a satyr),

100. Boys Peeping at Nature; 1730 /1 (second state); 3½ x 4¾ in. (W. S. Lewis)

here he has a satyr portraying Nature: a transition from an artist's version of satire to a satirist's version of art-nature. (Nature is a statue, the sort of model a student in an academy had to copy before he was allowed to work from life.) The first heroicizes satire, placing it in the context of history painting; the second satirizes heroic nature, as rendered by artists. Or, as the design suggests, it takes a satirist to get at this aspect of Nature, ignored by other artists.

Hogarth still presents his image in terms of history conventions, specifically decorative, and supports them by learned epigraphs from Vergil and Horace. From the Vergilian motto behind the putti—Apollo's words to Aeneas, "Antiquam exquirite Matrem" (seek out your ancient mother)—one infers that this unadorned Nature is going to be the artist's model, and (from Hogarth's pun) that the contemporary painter of history should seek inspiration *beneath* conventional appearances, in the most basic reality. The pun is also a wry adaptation of the old iconographical tradition of lifting the veil from Nature to see her true beauties long concealed by convention (which later in the century became a revolutionary symbol).[2] Perhaps he remembered Pope's complaint in the *Essay on Criticism* that most painters are not skilled enough "to trace / The *naked Nature*" and so cover her with ornaments (ll. 292–93). He is also, of course, alluding particularly to the subject of the series, a harlot—and more generally to the seamy side of life. Significantly, it is still a convention of history painting that lifts the shift. None of the grotesque figures introduced in the *Hudibras* frontispiece as a contrast to the baroque appear here; only the low gesture.

Lifting the veil is also, and perhaps most important, an allusion to the veil of allegory by which the poet traditionally protected the Truth he was conveying. Hogarth associates his plates with the double meaning—a "plain literal Sense" and a "hidden Meaning"—of epic allegory. Addison is once again our authority because he emphasizes the "ordinary Reader" and indicates the breadth of Hogarth's potential audience: "The Story should be such as an ordinary Reader may acquiesce in, whatever Natural, Moral or Political Truth may be discovered in it by Men of greater Penetration" (*Spectator* No. 315). There will be a plain story of a harlot, and then, for the "Men of greater Penetration," something more.

The quotation beneath the design is from Horace's *Ars poetica*—Hogarth's way of saying, Here is the text you will use to condemn my work, with Horace's generic distinctions and ridicule of the mixed mode; but notice that Horace also says: "necesse est / Indiciis monstrare recentibus abdita rerum, / . . . dabiturque Licentia Sumpta pudenter" (It is necessary to present a difficult subject in new terms . . . and license will be allowed if it is used with care).[3] Hogarth is playing with these old familiar Latin tags with the delight of a schoolboy. Horace means by *abdita rerum* a difficult, abstruse subject, but read literally and placed in the context of the putti the words could be construed differently: It is necessary to show the hiding place (*abdo:* hide, conceal) of things by new disclosures or uncoverings (*indico:* disclose, reveal, display). *Licentia* and *pudenter* also take on a sexual meaning: the licentious will be allowed if it is undertaken with modesty. In this context the most sexual of the meanings of "Antiquam exquirite matrem" also demands attention, and indeed, the putto's attempt to get under the shift is fulfilled in the last plate of the series by the clergyman, who does undertake licentiousness *pudenter* (the kitten in Plate 3 also seems to be peering under the Harlot's dress). One can imagine the fun Hogarth's contemporaries had with this ticket, as they did with the series itself. Another interpretation of "Antiquam exquirite matrem," for example, might be: "[If you want to get under female skirts,] seek out your old Mother"—"Mother" being the contemporary colloquial term for bawd.

The conjunction of the motto from Vergil above and the "dabiturque Licentia Sumpta pudenter" below, however, suggests that the modest putto is there to hinder (but not preclude) the revelation of this subject; his restraining actions temper the thoroughly immodest approach of the faun. Taken together, the two epigraphs suggest that Hogarth is attempting in the *Harlot's Progress* something new and at the same time old, that is, traditional: sanctioned by ancient authority and derived from original, now forgotten (or ignored) sources—the "old mother." His particular method in the ticket is to contrast the putti with the faun, their various actions with his, and implicitly (and by style) the high art of the baroque, which employed these conventional putti, and of Vergil and Horace with the realistic subject matter, the bawdy innuendos.

Hogarth himself seems to have considered the literature-painting analogy, perhaps implicit in his reference to the *Ars poetica,* as the common denominator between the *Harlot's Progress* and the tradition of history painting. (I should emphasize that in the following discussion I refer only to the prints of the *Harlot's Progress.* The paintings were destroyed in 1755, and the general case of Hogarth's *paintings* as history will be taken up in Chapter 14.)

Contemporary critics like Joseph Mitchell, who had already begun calling Hogarth the Shakespeare of painting, were writing from assumptions that he shared and indeed fostered. They echoed the belief of Jonathan Richardson, whose art treatises were influential among educated Englishmen of Hogarth's generation, that a history painter "must possess all the good qualities requisite to an Historian," and beyond that he must have "the Talents requisite to a good Poet; the Rules for the Conduct of a Picture being much the same with those to be observ'd in writing a Poem." The painter is ultimately superior to the poet because he must also be a "curious Artificer, whereby he becomes Superior to one who equally possesses the other Talents, but wants That. A Rafaelle therefore is not only equal, but Superior to a Virgil, or a Livy, a Thucydides or a Homer." Analyzing the Raphael Cartoons—the Englishman's prime example of history painting—Richardson asks the viewer to imagine words to go in the Disciples' mouths that would fit their actions.[4] With his constant references to the painter as a historian or a poet, and to the "story" he is telling, he offered a large sanction for the idea that the essential characteristic of history painting was storytelling. Hogarth, at the very outset of his career, on his shop card dated April 1720, balanced the allegorical figure of Art with a figure of History writing on a tablet. Art herself is empty-handed.

Richardson echoes Shaftesbury ("that in a real history-painter, the same knowledge, the same study, and views, are required, as in a real poet"), and both, of course, simply restated critical assumptions on history painting that went back to the Renaissance. Alberti had argued that the painter must be learned in history, poetry, and mathematics, and that history painting is the highest mark at which the artist can aim, not only because it is the most difficult genre, requiring proficiency in all others, but also because it portrays human activities like a written history: "And I may well stand looking at a picture . . . with no less delight to my mind than if I was reading a good history; for both are painters, one painting with words and the other with the brush."[5] The Renaissance painter, still considered a craftsman, wished to raise his status to equal the poet's; but lacking any body of aesthetic writings such as the poet enjoyed, he turned to literary criticism, and, beginning with a few analogies made between poetry and painting by Aristotle in his *Poetics* and Horace in his *Ars poetica,* he adopted all the rest as well. Du Fresnoy summed up this relationship in the seventeenth century when he opened his *De Arte graphica* (1695) with Horace's famous phrase, "Ut pictura poesis erit," and added, "similisque Poesi /

Sit Pictura"—which his interpreters translated: a poem is like a picture, and so a picture should try to be like a poem.[6]

The essential ideas involved here are that painting can render an action as completely as a poem, that it can attain the same moral end, and that its highest reach is, like poetry's, the representation of human action in its superior forms— the heroic and sublime. To say that a painter was literary meant that, educated not only in painting techniques but in the classics and Scriptures as well, he based his painting on a literary text; and, more generally, that his painting was based on literary rather than (or in addition to) graphic conventions—that his works could be *read*. Different schools of history painting emphasized the literary in one or the other of these senses, and—as Poussin, for one, complained— often painters simply decorated a text. Instead of showing human action and emotion to convey a moral, they used the story and the human forms as mere units in a decorative arrangement. The reactions and counter-reactions of Caravaggio, the Carracci, Domenichino, Poussin, Rubens, and Rembrandt, defined the course of the development of history painting.

A parallel between Hogarth and Poussin would seem unlikely; their intentions were exactly opposite—Poussin's highest aim was to recapture the glory of ancient painting, Hogarth's to find a modern art for Englishmen.[7] Both, however, sought a solution to the recurrent problem of how to breathe new life into history painting. Both found history painting of their day given over to what they considered decorative, operatic, meaningless conventions; and both reacted with pictures that emphasized a relative simplicity, compositional clarity, and expressive stagelike representation in which characters are caught, placed, related to surroundings—never lost in the swirl of a baroque crowd. Each epitomized in some sense a return to the original source: Raphael's relatively classical forms in the Stanze and the tapestry cartoons. At the same time they replaced the rhetorical imagery and the overblown designs of their contemporaries with dramatic psychological problems, emphasizing total significance as well as articulated form. Poussin must have known and appreciated the anecdote of the old woman who stood before Domenichino's *Scourging of St. Andrew* and explained every detail of the fresco to her child; but who, before Reni's counterpart, *St. Andrew led to Martyrdom,* could find nothing to say. He shared Domenichino's desire for clear expression, and he frequently refers to the "reading" of his pictures.[8]

If Hogarth never uses the term "read" (although he frequently calls himself "author"), it is probably because he thought of his pictures in terms of a stage representation—a succession of scenes, with characters speaking lines and gesturing—rather than a book.[9] Scene for scene, however, his effect could be summed up by Dryden's description of Poussin's *Institution of the Blessed Sacrament:* "the eye cannot comprehend at once the whole object, nor the mind follow it so fast; it is considered at leisure, and seen by intervals. Such are the subjects of

noble pictures; and such are only to be undertaken by noble hands." This effect confirms the meaning applied to "read" by Poussin and the French academicians, and the conventionality of the *Harlot's Progress* as history can be measured by its approximation to the familiar categories employed by Le Brun in his analysis of Poussin's *Fall of the Manna*.[10]

Taking Plate 3 as an example, one can trace the readability of its *disposition* by following the movement of the eyes from the Harlot and her bunter to the figures approaching behind, who are plainly law officers come to arrest her. But one does not stop there, as might be the case with a Poussin: one continues, literally reading the inscriptions and images on the pictures, papers, and wig box. The reader's eye moves from the Harlot to the magistrates; then to the pin-ups of Macheath and Dr. Sacheverell, which characterize her emulation of the false ideals offered by the "great" in her society; and then up to the print of Abraham about to sacrifice Isaac, which acts as a general comment on the whole scene. Lastly, if the eye is not allowed to leave the picture, it drops to the row of medicine bottles, then to other details, round and round into the nooks and crannies of the picture. (The eye is led, of course, to consider the interrelation as well as the continuity between this and the other plates of the series.)

Under *l'expression des passions*, Le Brun insists that the thoughts and emotions be revealed by facial expression and gestures. The different expressions of each figure must be dramatically related to the event by a direct causal connection—different reactions to a single stimulus, as in the various responses elicited by Paul's miracle in *Paul and Elymas* (above, pl. 9a). A contemporary with the art treatises in mind could have seen Hogarth's first plate as a study of responses to the young country girl, Plate 2 as responses to her kicking over the table, Plate 3 as responses to a harlot in squalor, and so on. Hogarth's relationships are, of course, more complex than this: he shows the Harlot's complete self-absorption (studying a stolen watch) as well as the justice's stealthy eagerness. Expression will be a cornerstone of his aesthetic, and his reputation rested to a large extent on his ability to convey shades of facial and bodily expression (as on his ability to catch likenesses). But he was also well aware of the limitations of the concept. The heavy emphasis it received goes back to Alberti's praise of the painter who can execute Paris' face so that the viewer recognizes at once "the judge of the goddesses, the lover of Helen and the slayer of Achilles."[11] Anyone who studies Le Brun's illustrations of the passions expressed in physiognomy will recognize the impossibility of conveying all this through a face. Hogarth's solution was to extend *l'expression* from face and body to attributes and surroundings, furniture and pictures. The cat's body is as expressive and significant in a reading of the Harlot's psychology in Plate 3 as her face; her costume (the same fashionable gown she wore in keeping in Plate 2) contributes to her expression, as do the pictures she keeps on her walls, the hatbox above her head, and her other possessions.

The commentators on history painting from Le Brun through Shaftesbury and Richardson dwell at length on the important moment, the theatrical quality; and hence—the final folly of the literary analogy—on the unity of action. In the *Fall of the Manna* Le Brun must therefore argue that the beginning, the despair of the starving Jews, is shown in one part of the canvas where the manna has not yet reached; the middle, the first awareness of the falling manna, in another; and the ending, the salvation, in yet another.[12] Le Brun believes that the painter as historian must sometimes join incidents from different times in order to get his beginning, middle, and end in a single painting. Of course, Poussin's *Fall of the Manna* does not in fact show different times but only different reactions from Israelites who are aware of the miracle and from those who are yet unaware (and so still hungry).[13] Using the Choice of Hercules as his example, the Earl of Shaftesbury argues more reasonably for a treatment in which the preceding moments as well as the succeeding ones are implicit. The sight of Hercules being swayed by Virtue's argument implies the previous stages: his being accosted by Virtue and Pleasure and their subsequent debate. Richardson, in his *Treatise on Painting,* applies Shaftesbury's criteria to the subject of Christ and the Woman taken in Adultery. The parallel of painting and the theater could of course be traced to Aristotle's analogy between the plot of a tragedy and the design of a painting; Dryden had remarked that painting is closer to drama than epic because bound by the unities of place and time as well as action, and Le Brun, Shaftesbury, and Richardson are saying that if painting is poetry it is dramatic poetry.

Hogarth seems to follow the instructions of these theorists quite literally. In Plate 1 he shows, from left to right, the York Wagon and the young girl who has just dismounted, the girl in conversation with a procuress, and the waiting figure of the aristocratic keeper: past, present, and future. In Plate 2 the Jew and his mistress are in the foreground, the escaping lover in the background, and the future prophesied in the pictures of Old Testament retribution on the wall. In Plate 3 the Harlot and her bunter are in the foreground; in the background, approaching but not yet there, the magistrates; and on the wall Abraham about to slay Isaac. And so on. There is usually a central group and one in the rear; the first represents the present, and the second (which, through the disposition, focus, light, and shade, one sees second) the next step in the action; the walls then convey exegesis, commentary, and prolepsis. Here is a rigorous attempt to relate a temporal story in a spatial genre, which shows how much further the term "reading" extends in the work of Hogarth than of Poussin.

The classic instance of "reading" a painting and placing different temporal stages of an action in a single spatial design is the *Tabula Cebetis,* used as a Greek and Latin textbook in many English schools (56 editions before 1800 are to be found in the British Museum) and repeatedly translated into English as well

(13 editions); considering Hogarth's background, the *Tabula* would very probably have come to his attention early in life. In this dialogue Cebes stands before a painting and "reads" it to his friends. Life is portrayed as a walled enclosure with various inner enclosures spaced along a hillside like the compartments in a comic strip, elucidating particular chronological aspects of human experience. A great crowd of people in the foreground, Cebes explains, represents men entering the Gates of Life, directed by Divine Genius but met by Deceit, who gives each a draught, more or less, of error and ignorance. Inside the gate these Everymen are faced with Fortune, a blind and distracted female who stands on a round stone and arbitrarily distributes honor, noble birth, children, tyranny, and so on. Already courtesans called Opinions, Desires, and Pleasures try to lead the crowd astray. In the second enclosure, which stands higher on the hill, men are shown surrounded by the courtesans Intemperance, Prodigality, Insatiableness, and Flattery. These seduce some men, taking away the gifts Fortune has given them, and then making them slaves, forcing them "to act a vile indecent part, and for their sake to do everything that is pernicious; such as to defraud, to plunder places that are sacred, to swear falsely, to betray, to rob, and all things that are of the like kind."[14] Then they are shown delivering their slaves over to Torture, Grief, Vexation, Anguish, and other unpleasant creatures.

There are other enclosures further up the hill—one presided over by False Learning—but only the first can have interested Hogarth, perhaps because it remained closest to the Puritan spiritual biography. Many artists attempted to portray Cebes' description, and in some of their efforts the choices offered Everyman were expressed through the Choice of Hercules motif. One dated 1670 by Romeyne de Hooghe, William III's propagandist, included vignettes close to scenes developed in the *Rake's Progress* and was engraved in a style similar to Hogarth's. Translations as well as prints of the *Tabula Cebetis* tended to interpret the "ancient" as (to use Hogarth's later phrase) a "modern moral subject": in Jeremy Collier's translation of 1701 the men dispatched by the courtesans Intemperance and Prodigality to Torture and Grief are called "the *Rakes*" and the place where they are "maul'd and mortified" is called "this *Bridewell*"; they are then "committed to Gaol, where *Unhappiness* is their *Keeper*."[15]

Years later, in the 1750s, the Scotsman James Moor was to use Hogarth's prints as his example of how different times and places were represented in pictorial space by the *Tabula Cebetis*.[16] Certainly this work is part of the context of Hogarth's *oeuvre*, especially of *The Lottery*, but Cebes' use of a city in which groups of people could be at once naturalistically themselves and allegorically different stages of experience in the progress of an Everyman was only a partial solution for Hogarth, with his focus on a particular protagonist. His own use of "reading" in *A Harlot's Progress* draws rather on the tradition of history painting, on its origins in religious depictions.

As Panofsky explains, the religious painter of the High Middle Ages, without

naturalistic objectives, could introduce into one picture any symbols he wished —from the past, from other stories, or from other areas of experience. But with the rise of naturalistic conventions such as perspective, the artist, no longer able to mix real and overtly symbolic objects, turned to real objects for his symbols. When a medieval artist wished to show Old Testament prophets as witnesses to the crucifixion he simply placed them at the foot of the cross; toward the same end, later artists would introduce artifacts: statues or painted images of them, on a window, a screen, floor tiles, or as the decoration on furniture.[17] Panels might appear carved into the architectural background to represent events before and after the central moment, as Hogarth used pictures on the walls of his rooms to foretell or to make a generalized comment on the life going on in the room; similarly, the *Judgment of Solomon* hung in the courtroom of Delft and sculptural reliefs of Death decorated the room where death sentences were passed in the city hall of Amsterdam.

The artist might also compose Old Testament subjects in such a way as to prefigure the life of Christ, or show the Madonna and Child in a pose proleptic of the Pietà, or add a pillar to the nativity shed to represent both the column on which Mary reputedly supported herself when the time of birth arrived and the column of the flagellation. Or he might simply place an apple, a bunch of grapes, and a beaker of wine on a table to represent the Fall through original sin and the Redemption through Christ's assuming human form and pouring out his blood for man. These strategies of presentation were based on the belief that physical objects are "spiritualia sub metaphoris corporalium" (corporeal metaphors of things spiritual).[18]

Hogarth is, of course, participating in a tradition of religious painting that was one channel into Netherlandish still-life and genre painting. If he retains something of the specific reference and hieratic quality lost in the secularized scenes of Steen and De Hooch, it is perhaps because objects had a special meaning for him through his Presbyterian forebears, who saw one of man's duties to be the spiritualizing of his experience. Hogarth's pictures represent, in this sense, the process of exposing the pre-established connections between facts of experience and spiritual referents. Viewing him in terms of artistic secularization, one might say that he produces a scene in which the objects are as important in relation to the people, though they do not take up nearly as much space, as in a painting of Pieter Aertsen like *Christ in the House of Martha and Mary*.[19] Secularization and the playful inversions of mannerism join to facilitate a particularly ironic kind of "reading" and define a particular attitude toward reality. Hogarth's excessive, perhaps consciously naive, use of objects would have reminded his contemporaries of the Dutch manner rather than the Italian. Shaftesbury allows for "certain enigmatical or emblematic devices, to represent a future time: as when Hercules, yet a mere boy, is seen holding a small club, or wearing the skin of a young lion." But he stresses that emblematic and realistic elements

must never be "visibly and directly intermixed" and that "the fewer the objects are, besides those which are absolutely necessary in a piece, the easier it is for the eye, by one simple act and in one view, to comprehend the sum or whole."[20] Hogarth keeps to the letter of the law in not mixing the real and emblematic, but Shaftesbury would have considered his pictures impossibly crowded with objects and disgracefully witty in their employment.

Like most of his contemporaries, Hogarth accepted the French academic interpretation of history painting, and in the *Harlot's Progress* he rejected only two of its chief precepts, one incidental and the other essential—the copying of a literary text and the representation of idealized nature. In both cases he was not only following his own inclination to draw comic reality but also reacting against the history painting of his time that overemphasized these qualities. Both amounted to an abandonment of the heroic subject and characters through an apparent sacrifice of the universal to the particular. The mask lying on a table in the second plate of the *Harlot's Progress* is a simple emblem of deceit, whose classical source can be found in emblem books or in paintings like Annibale Carracci's *Choice of Hercules* (Farnese Gallery) or Poussin's *Liber Pater, Qui et Apollo Est* (Stockholm). For Hogarth, however, it is also a bit of narrative information, showing how the Harlot met her escaping lover, and a topical and satiric reference to Heidegger's masquerades. For Poussin the use of such adventitious and local detail—geography, dress, identifiable faces—was at odds with the universal truth for which he strove. The reader of his *Flora* (Dresden) is required to know the fourth book of Ovid's *Fasti* and recognize the various figures by their poses and attributes; but these, he would have argued, are recognizable so long as the literary tradition continues, while Hogarth consigns these stories to the walls of his rooms and takes his primary representation from the daily newspaper. The reader must recognize Mother Needham, Colonel Charteris, Sir John Gonson, and grasp the significance of local references (Drury Lane, Sacheverell) and all the "furniture" of his scene.[21]

The essential difference between Hogarth and Poussin can be summed up in the heroes they portrayed. The central figure in Poussin's narrative pictures was either the typical Renaissance hero, idealized, greatly endowed and greatly rewarded by the gods, or the *honnête homme* who behaves properly when faced with temptation, defeat, or despair. That Hogarth's protagonist is the person who, faced with one of these tests, fails and is punished—a hero only by comparison with the knaves around him—indicates that he was following a different literary tradition than Poussin. The same applies to his use of contemporary detail, in which the universal is to be found in the particular, as the particular (named poets and critics of Pope's *Dunciad* or the particular Lord Hervey in Sporus) contributes to a generalized image of evil. The epic of Homer, Vergil, Ariosto, or Tasso is simply replaced in Hogarth's history painting by the satire of Butler, Swift, Pope, and Gay.

Less ambiguously than in the *Hudibras* plates, history painting serves two complementary functions in the *Harlot's Progress:* to heighten the importance of the Harlot's story, and to characterize the Harlot and the story's theme. The first of these embodies Hogarth's aim, expressed in the subscription ticket, to make his painting respectable by incorporating into the great tradition of history painting the depiction of the contemporary and commonplace. All remains the same—morality, literary allusions, and so on—but the heroic representation of stories from myth, Bible, or literature is replaced by contemporary content.

As Hilda Kurz has shown, Hogarth draws upon a popular tradition of print series in Italy that traced the rise and fall of harlots and rakes, drawing harsh morals about sin and its consequences.[22] The harlot series (e.g., "La Vita infalice della Meretrice," 1692) begins with the girl meeting her seducer, then goes on to a scene with the procuress he sends to her with enticements, ending with her decline and death. One such series which may have had a more direct influence on Hogarth was "Lo specchio al fin de la Putana" by Curio Castagna (published between 1655 and 1658; Kurz, pls. 32, 33), which even uses animal-human parallels of the sort employed by Hogarth: in Plate 2 the cat steals up on the chicken as the procuress approaches the innocent girl. The girl is met by a young rake (Plate 1), who sends a procuress in Plate 2; and a number of scenes carry on the harlot-rake affair, until she takes new lovers (as in Hogarth's second plate) and ends in poverty, disease, and death (Plate 12).

Hogarth uses the scenes with the procuress and the second lover, the prison and deathbed scenes, but with no trace of the composition, which at its best is based on stick-like figures and large empty spaces. Though Hogarth was influenced by this popular tradition and follows its general pattern from corruption to disease and death, he did not want to produce a popular print cycle; he clarifies his aim—to create a modern version of history painting—by using a much simpler and more monumental composition, simpler even than the *Hudibras* designs. He has built again on the model of the Raphael Cartoons, but with fewer figures than Raphael employed, and a less strenuous tendency to place them in a band across the middle of his plate.[23] Each figure is more fully and distinctly articulated, closer to the viewer, and larger in relation to the picture space than in *Hudibras*. Even when his figures are given a great sense of movement (and they are rounder, with a more Brueghelesque solidity, than Raphael's), they are balanced and held in check by powerful architectural forces— by verticals and horizontals in an arrangement that is nearly symmetrical, with the vanishing point near the center of the design; they are presented on a single plane, often produced by a piece of furniture like a table, a coffin, or a bed, with two or three figures on a second plane in the background, carrying the subject, and usually a repoussoir in the foreground. Hogarth follows the Cartoons in using architecture to hold the figures together, balance them, and restrain their baroque tendencies. (When a picture goes wrong, for example *Harlot*, Plate 4,

or later *Rake,* plate 1, it is because he has failed to define the architectural space as successfully as the figures.) He wants the constant of scale and size, the control of repetition, analogous perhaps to Pope's constant of the couplet. His basic form, first successfully expressed in the *Harlot,* involves human shapes, sometimes in bulging disarray, held in check by powerful horizontals and perpendiculars. People are pitted against the architecture of their rooms, streets, and society.

If that, in a sentence, is what Hogarth's *Harlot* is about, it is also important to remember why history painting showed heroic actions: such scenes were intended to inspire emulation, and this is why they appear along with portraits on Hogarth's walls. The outmoded Shaftesburyian concept of history painting as models of virtue supported Hogarth's theme concerning affectation and emulation. Like the great engraved series of histories of the 1720s—the lives and deeds of St. Paul, Marlborough, and Charles I—the *Harlot* was a "life." Though adopting their form, or that of Poussin's *Seven Sacraments* or Rubens' Marie de Medici cycle, or in a sense returning to the painted lives of Christ, the Virgin, and saints, Hogarth draws upon such cycles to show what his Harlot is not.[24] Instead of the object of uncritical emulation, these paintings become part of a subtle analysis of the whole subject.

Under the category *desein et proportion,* Le Brun praised Poussin's *Fall of the Manna* for employing appropriate classical prototypes such as a *Niobe* and the *Laocoön* as well as a *Diana* and the *Apollo Belvedere.* Le Brun's doctrine assumes that there are only a limited number of shapes, already discovered and perfected by the ancients, but, while the viewer need not recognize the *Apollo Belvedere,* the presence of *Niobe* and the *Laocoön* adds another dimension to the meaning of the painting.[25] Poussin's *Venus and Adonis* (Caen), for example, places these pagan figures in the pose of Magdalen and Christ, to suggest to his learned audience the mythological parallel. As particular models for his compositions and figures Hogarth seems to have followed certain compositions from the one narrative sequence that portrays the life of a woman: the Life of the Virgin. Plate 1 follows the typical *Visitation* composition, which shows Mary and Elizabeth embracing in the foreground and Zacharias watching from a doorway in the background (pl. 101).[26] Plate 3 uses the composition of the van der Weyden *Annunciation,* with Mary framed by a tester bed and the angel coming at her from the other side of the picture (pl. 102).[27] Even the Harlot's *Pastoral Letter* reminds one that the Annunciate always carried a prayerbook. The sequence of the *Life,* of course, is disregarded; only *The Annunciation*—with Mary the Harlot and the angel Justice Gonson—carries ironic overtones with any insistence (and one recalls that the Harlot's name was changed from Kate or Jane to M. Hackabout). Plate 5 resembles various deaths of the Virgin, and

Plate 6 her laying out, with the saints replaced by bawds, whores, and a renegade clergyman.

If a search for such parallels is extended to Plate 3, the biblical counterpart for the cuckolded Jewish keeper is only too obvious—as is that for the boy in Plates 5 and 6 who is certainly going to go about his father's business.[28] Hogarth himself, however, when he sought a classical analogue for the *Harlot's Progress*, and chose Plate 3 as "champion" in *The Battle of the Pictures* (1745, pl. 189), alluded to the other Mary, Mary Magdalen. She is the traditional representative of both prostitute and penitent sinner, hence some irony derives from his use of her here. But there was no pictured Life of Mary Magdalen, who was in fact a contrast to Mary the Mother, appearing with her at the crucifixion and the tomb. The two Marys are inextricably mingled in Christian iconography, and various popular lives of harlots were also lives of an anti-Mary, playing off her perfection against the inverted story of the harlot; as Pope, for example, played off Christ against Theobald, an anti-hero and anti-Christ, and set up the activity of Dulness and her forces as a black parody of God and his creation.[29]

In general, Hogarth's aim was to parallel his modern history with a recognizable analogue of history painting. In the *Rake's Progress* (1735) the early scenes imply mythological analogues, the second plate connecting the Rake's choice with Paris' and the third a brothel scene with a *Feast of the Gods* or a *Bacchanal;* the final scene in Bedlam shows the Rake in the arms of Sarah Young, in the pose of a *Pietà. The Battle of the Pictures,* the ticket for the sale of Hogarth's comic history paintings (1745), makes his aim clearer by pairing each of his works with its old master equivalent: the *Harlot* with a *Magdalen, Midnight Modern Conversation* with a *Bacchanal,* the *Rake's* brothel scene with a *Feast of the Gods.* In subsequent series the correspondence becomes more general: the prude going to church in *Morning* recalls a *St. Francis at his Devotions* and the second plate of *Marriage à la Mode* recalls the *Aldobrandini Marriage,* in which there is a thematic but no compositional relationship.

The use of compositions from *Life of the Virgin* cycles is also, however, a kind of subversion, or at any rate Hogarth's way of saying (as in the subscription ticket) that he is treating quite another kind of life. The same subversive play is at work in the first plate. If the Harlot–Mother Needham–Charteris group derives from *The Visitation,* the clergyman–Harlot–Mother Needham group refers wryly to the *Choice of Hercules* as a paradigm of the effective history painting: the Harlot is making her choice between virtue (the clergyman) and vice (Needham). The most famous, elaborate, and influential of the discussions of exactly how a history painting should be composed was the Earl of Shaftesbury's *Notion of the Historical Draught or Tablature of the Judgment of Hercules* (1713). Shaftesbury took the subject of Hercules at the crossroads choosing between Virtue and Pleasure (or Vice, as she was called by her enemies); the best-known

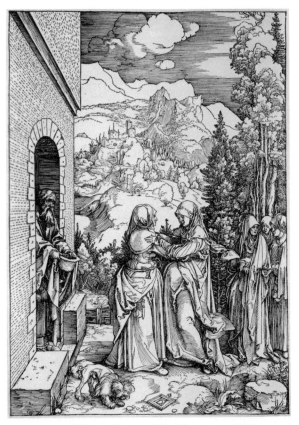

101. Albrecht Dürer, The Visitation (BM)

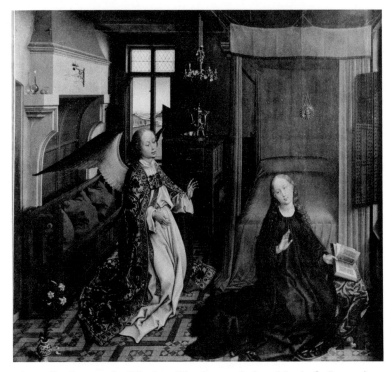

102. Rogier van der Weyden, The Annunciation (Musée du Louvre)

version was Annibale Carracci's in the Farnese Gallery, but there were others by Rubens and Poussin and numerous lesser artists, including Verrio and Laguerre and of course Thornhill. Shaftesbury had a version made by de Matteis to his own ideal specifications (pl. 103).

The story itself was an appropriate one for the *Harlot's Progress*, with Pleasure saying to Hercules, "Do you see, Hercules, by how difficult and tedious a road this woman conducts you to gratification, while I shall lead you by an easy and short path to perfect happiness?" "Wretched being," rejoins Virtue, "of what good are you in possession? Or what real pleasure do you experience, when you are unwilling to do anything for the attainment of it?"[30]

Shaftesbury presented the fullest treatment to that time of the "fruitful moment," the exact moment that will best convey the meaning appropriate to a history painting.[31] In fact, the sort of analysis Thornhill carried out on the problem of portraying the landing of George I probably derived from a reading of

Paulo de Matthæis Pinx: *Sim: Gribelin sculps:*

103. Paulo de Matthaeis (or Matteis), The Choice of Hercules, engraved illustration for Lord Shaftesbury's *Characteristicks;* 1714 (corr. 2d ed.) The painting is in Temple Newsam, Leeds.

Shaftesbury's treatise. An almost ridiculously analytic approach is combined with the most conventional of academic assumptions—almost a parody of Le Brun's *Conférence* on *The Fall of the Manna*. Taking the Choice of Hercules as the ideal historical subject, he says "The Education" is perhaps as proper a title as "the Choice or Judgment of Hercules": a hero's education through the dialogue of Vice and Virtue (Pleasure). Characteristically, he believes that the precise moment the artist should portray is either when the goddesses first accost Hercules, at the mid-point of their dispute, or when Virtue is beginning to win.[32]

In any case, Shaftesbury insists, Virtue, who should resemble Pallas Athena, must be shown arguing, using her reason to persuade Hercules. Pleasure, for whom Venus should serve as a model, is supposed to be silent, using only her eyes on Hercules. All the artist's means should be used to express "her inaction, her supineness, effeminacy, and indulgent ease. The head and body might entirely favour this latter passion. One hand might be absolutely resigned to it; serving only to support, with much ado, the lolling lazy body. And if the other hand be required to express some kind of gesture or action toward the road of pleasures recommended by this dame; the gesture ought however to be slight and negligent, in the manner of one who has given over speaking, and appears weary and spent." It might be noticed here that in *The Lottery* (pl. 30), one of Hogarth's earliest prints (though made after he joined the academy), he has applied the concept twice: on the right, as his inscription says, "Good Luck being Elevated is seized by Pleasure & Folly; Fame persuading him to raise sinking Virtue, Arts &c." Fame (Virtue) is indeed persuading; Pleasure is in exactly the supine pose recommended by Shaftesbury, and she even has the appurtenances Shaftesbury suggests: "certain vases, and other pieces of embossed plate, wrought in the figures of satyrs, fauns, and bacchanals . . . And certain draperies thrown carelessly on the ground. . . ."[33] Hogarth's modifications are already significant: he materializes the satyr and adds the figure of Folly, pitting three agents of Pleasure against the single reasoning figure of Fame. (Another characteristic touch is his inclusion of a mask; as *Harlot,* Plate 2 shows, masquerades are one aspect of pleasure-seeking in all his cycles.) On the left side of the print he shows "Misfortune opprest by Grief, Minerva supporting him points to the Sweets of Industry." Again the Virtue figure is associated with wisdom (here the Minerva-Athena figure Shaftesbury recommends) and the alternative is supine and passive. Suspense turns between hope and fear; the print is virtually constructed of such pairings.

It is altogether appropriate that Hogarth should begin his first series of modern history paintings with an allusion to Shaftesbury's paradigm of sublime history painting. But there are a number of other reasons as well. Choice is emphasized by Shaftesbury as the subject par excellence of history painting, but

Prodicus' "Choice of Hercules," from Xenophon's *Memorabilia*, was deeply rooted in the curriculum of the English schools and, indeed, in the English popular consciousness. Addison's paraphrase in *Tatler* No. 97 is only one of many redactions of the story. Richard Hogarth would doubtless have made his son aware of it following one of those sessions in which his small Greek scholars had to construe it.[34] Characteristically, Hogarth used a paradigm that drew sustenance and significance from both the art treatises and the reading of the ordinary educated Englishman.

Choice is the subject of the literature Hogarth was brought up on: from *Paradise Lost* (which he also illustrated) to Bunyan's *Pilgrim's Progress* and *Life and Death of Mr. Badman*. If one may believe his autobiographical notes of many years later, one of his own basic problems during his apprentice and early professional years was how to combine his "pleasures" and his "studies"—the problem he diagrammed in *The Lottery*. Behind the Choice of Hercules composition is a more general concern with choice and the problem of being poised between two areas of experience. The actor Spiller, caught between a tavern and a prison, is perhaps another version of the pleasure-virtue dilemma (pl. 16), but in Hogarth's own shop card (title page) figures of Art and History flank the name "William Hogarth" and indicate the dilemma he sought to work out in his private life and professional career. In the small *Rape of the Lock* illustration (pl. 19) he chooses the moment when the Baron is being asked by Sir Plume to return the lock to Belinda (Belinda is at her card table looking distraught), and he is presumably going over the alternatives in his mind. Or he depicts Henry VIII standing between Anne Boleyn and Queen Catherine (pl. 59). Even in the ticket for the undertaker Humphrey Drew (pl. 17) the gesturing man is placed between the funeral procession and the viewer in the implied crowd he is trying to control on this solemn occasion. There is always this struggle to hold together, or choose between, two opposing worlds.

Already in the *Beggar's Opera* paintings Hogarth had begun to play with the particular Hercules grouping. It is noteworthy that in his first ambitious painting he uses this as the basic compositional unit, with variations. Here Macheath is in the position of Hercules, choosing between Polly and Lucy, but unless one sympathizes with Lavinia Fenton as heroine of the play it is difficult to see any choice between virtue and pleasure. In fact, Macheath himself is aloof, not choosing; the daughters are choosing between Macheath and their fathers, and their fathers between vice that is virtue and virtue that is vice. Legal virtue in either case is to hang Macheath and legal vice is to free him; real virtue would be to accept their daughters' pleas and free him, real vice to hang him and pocket the reward. The Choice of Hercules appears again in the study for *The Bambridge Committee,* Hogarth's next important composition: Oglethorpe, chairman of the committee, may choose between Bambridge and one of his mis-

erably mistreated prisoners—as *The Beggar's Opera* offers an ambiguous choice between the prison official who is legally virtuous but really vicious and the prisoner who is legally guilty but relatively innocent.

If, with all this in mind, one returns to the first plate of *A Harlot's Progress,* it becomes evident that Hogarth has now completely reversed the Shaftesburyian paradigm. He treats the choice, not at the moment when Virtue is winning, but when Pleasure is about to win. Moreover, while Vice is supposed to be silent and Virtue to be arguing, persuading by words, Hogarth depicts the clergyman who represents Virtue with his back turned, and Pleasure, in the person of a bawd, is offering her blandishments. This reversal in his first plate demonstrates, like the iconography of *Boys Peeping at Nature,* that he knows the tradition of history painting and is quite consciously altering it.

Although he makes clear his reinterpretation, he also accepts choice as the proper subject, only viewing it more realistically (or contemporaneously) and emphasizing the girl's limited options with Virtue's back turned, the "lofing cosen in tems street" missing, and once again Pleasure supported by a satyr and a figure who could represent Folly. The theme reappears in the next plate with the Harlot's implicit choice between the old and young lovers. But once her original action has been taken, the series is focused primarily on the consequences that follow upon the choice of pleasure—documenting the course of the primrose path.[35]

The large aim of Hogarth's modern history painting, then, is to place the contemporary world in relation to conventions of biblical or mythological resonance; and for this he naturally turned, as a disciple of the literature of his day, to the Augustan mock-forms. The only way, he felt, to deal with the heroic in modern bourgeois-sentimental life was to depict it as a subversive force. In the process he relates Hercules to the Harlot, but his overall strategy is to connect the high-low contrast of the Augustan mock-heroic to the gentleman-criminal analogy of Gay's *Beggar's Opera* and the stories of Colonel Charteris and the Hackabouts (the gentleman who rapes and goes free, the robber and harlot who emulate the gentry and are punished) which he read in the newspapers. He accordingly displaces the heroic level to the false ideals that are embodied in fashionable aristocratic shapes, costume, swords, gestures, or stare out at his characters from the awful copies of old master history paintings on their walls; or simply to the portraits or penny prints of contemporary heroes and "great men." Unlike the composition of the whole, these pictures-within-the-picture offer no ideal against which to judge the characters; quite the contrary, they represent the false ideal to which she (or he) adheres. Hogarth is not criticizing the old masters' histories as heroic but as inappropriate, to modern life and to modern painters. The Harlot's aspirations toward gentility do not reflect on true gentility but rather on the false ideals of gentility to which she was exposed by the

critics and connoisseurs of society. (Hogarth may also be satirizing Jonathan Richardson's influential advice to gentlemen in his *Essay on the Theory of Painting,* to keep portraits of the great, so that they "are excited to imitate the good actions, and persuaded to shun the vices of those whose examples are thus set before them.")[36]

What then of the grotesque, caricature elements, apparent in the frontispiece to the *Hudibras* plates and in the series itself? In the *Harlot's* subscription ticket Hogarth wishes to dissociate himself from the grotesque as such, as a lower genre, incommensurate with history painting. There are in fact no grotesque Hudibrastic figures in the *Harlot:* they have been toned down (the bunter, whose chief peculiarity is her lack of a nose, suffers from natural causes) or, more importantly, displaced (as in the subscription ticket) to actions or to the behavior of animals—horses, monkeys, kittens—or to inanimate objects like the knot in a bed curtain.[37]

The heroic level usually tends to represent the ideals that men seek to emulate, attempting to rise above their natural inclinations; the grotesque tends to represent the irrational and subconscious: roughly speaking, the character's id, as opposed to the super ego expressed in those pictures hung on the walls or the other trappings of gentility. If the pictures indicate the level of pretension, the dogs and cats, the grotesque shapes of punishment, sickness, and madness, the gesticulating doctors and the faces detectable in natural objects indicate the level of nature or natural consequences. In between is the character (what Fielding was to call "character" as opposed to caricature) able to act for himself, but constantly drawn into heroic or grotesque attitudes or patterns of behavior that are inappropriate on the one hand or violent and uncontrolled on the other. Thus in metaphorical terms, he becomes a caricature. At any rate, instead of transforming his characters into animals as Rowlandson and Gillray were to do, Hogarth fragments them, keeping man separate from both the hero-villain and the animal.

Some sort of juxtaposition is predicated—a collision of realism and the poetic (the heroic, romantic, and so on)—in which the ideal is absorbed and given perspective in a realistic context, and reality itself is made poetic, or suitable for painting; more suitable, Hogarth would surely have argued, than in the Dutch drolls and genre pieces or the decorative histories of nymphs and satyrs. Hogarth's attitude toward history painting was deeply ambivalent. His natural instinct was to distrust this highflown, unrealistic, uncommonsensical rhetoric; his conditioned response was to work within that tradition. Hence, he sought out the clauses of classical criticism that supported a more realistic interpretation, and for the rest turned to the literary tradition of his day.

The reason that Hogarth was closer, at least in his early progresses, to the Raphaelite tradition and Poussin than to the great rebels like Caravaggio and the early Rembrandt was simple: the ideals of Raphael and the Carracci had

usurped the main tradition of art criticism from Bellori to Félibien and Du Fresnoy and to Shaftesbury and Richardson. Hogarth stays as close as he can to this tradition as it appeared in his time. According to the central concept of decorum, a painter in theory sinned equally by painting a humble subject in an exalted style and an exalted subject in a low style. But in fact the second misdemeanor was regarded as much the more heinous; Caravaggio and Rembrandt were attacked for treating a history in terms of a genre piece, for lapsing into vulgarity. Hogarth's procedure was to treat genre subjects—everyday occurrences—in terms of history. He was even being strictly orthodox in his subsequent attacks on "dark masters": the paintings he ridicules are usually offenders against decorum that introduce low elements into mythological or biblical subjects. It is the irreverent dog in Rembrandt's *Good Samaritan* or the urinating boy in his *Ganymede* that Hogarth criticizes, and he eagerly defends himself against the accusation of Joseph Warton that he allowed low, vulgar details or style to enter his own sublime histories. The other indelicacy, the introduction of horror or an extreme realism, was associated with Caravaggio and his portrayal of Judith cutting halfway through Holofernes' neck, Thomas with his finger deep in Christ's wound, or Isaac grimacing under the knife. Hogarth used his *Medusa* (of which Thornhill had a copy) in *Marriage à la Mode,* with numerous other scenes of horror and depravity; again, his sublime histories are for the most part free of such ghastly scenes, although he takes a grim and uncompromising approach to the diseases in his *Pool of Bethesda.*

"What gives the *Italians,* and their Masters the Ancients the Preference," Richardson insisted, "is, that they have not servilely follow'd Common Nature, but Rais'd and Improv'd, or at least have always made the best Choice of it."[38] The academic critics and Hogarth agreed that one should not merely copy nature; they because it did not aim at producing the ideal, he because it failed to reveal a meaning. Ideal and meaning are only different emphases. Hogarth covers his figures with as many attributes and accessories as the painters of the ideal, the difference being that his are more topical; both, however, aim at generalizing the particular. Instead of generalizing in the direction of the ideal, he "raises and improves" in the direction of moral significance, another aspect of Raphael and Poussin which, he would have argued, set them off from the Dutch.

Part truth, part rationalization, such assertions do not entirely conceal the fact that Hogarth was drawn in the direction of the non-academics, those "capricious" artists Michelangelo, Caravaggio, and Rembrandt, who would not conform to the academic system. Michelangelo, according to Vasari, was criticized because "he was not willing to be indebted for his art to any thing but himself,"[39] —a stance Hogarth epitomized, perhaps without really intending to. The works of both men were too individualistic to permit the generalization and imitation that defined the essence of the academic tradition.

Well aware of the status enjoyed by history painting, and unwilling to devote

himself to the alternative of showy religious art (though his training and abilities were not those of a history painter), Hogarth conscientiously explored all the possibilities open to him. One solution was to carry on seriously in the sublime tradition, and in the 1751 revision of *Boys Peeping at Nature,* used as a ticket for the engravings of *Paul before Felix* and *Moses brought to Pharaoh's Daughter,* he blotted out the faun peering at Nature's private parts, retaining the modest putto; the "abdita rerum" are now concealed by a blocked-in portrait of a classical head. Hogarth's sublime histories are Raphaelesque and—still following Steele's admonitions—broach no other subject than the Bible. The second possibility, which he considered his invention, was to treat the contemporary, local, and commonplace as history rather than genre.[40] The effect could be either to elevate the present or denigrate it. Within Hogarth's lifetime the former developed into Reynolds' heroicized portraits of the aristocracy and middle class, which made the portrait a popular and characteristically English equivalent of history painting by turning the nondescript middle-class Englishman into a heroic shape in the grand style, passing off a burgher as a king, hero, or saint. By the decade after Hogarth's death English history painters were portraying the death of General Wolfe as a *Pietà,* with none of the irony present in the final plate of the *Rake's Progress.*

The opposite solution was Hogarth's in his comic histories: to point out the *in*appropriateness of history painting to contemporary English life. In these works the middle-class man who adopts the pose of the hero, or even the aristocrat, meets disaster. While Reynolds and West attempt to show the harmony between eighteenth-century man and his ideals, Hogarth shows man violently at odds with them. This man is on his own, trying to rise above his present social position, or trying in some way to order his surroundings, and he is overcome by recalcitrant nature. Musicians are confronted by a society of noisemakers, and a poet is pursued to his garret by duns and hungry dogs. Even animals (faithful friends in Reynolds' portraits) either quietly mock their human masters or rebel against them. In this sense, for all his ties with the main tradition of history painting, Hogarth was a Caravaggist rebel who attempted to subvert its basic idealism.

PUBLICATION

The important engraving venture between *Hudibras* and the *Harlot's Progress* was *The Life of Charles I* (1728)—another subscription run, according to Vertue, by the printsellers. *The Marriage of Charles I* (by Cheron) is the closest to Hogarth's Raphaelesque compositions, but *The King's Declaration to his Gentry and Army* (by Tillemans) is reminiscent of the scenes that inspired *Hudibras and the Bear-Baiters.* Clearly Hogarth wished his audience to think of the *Harlot* as another in this impressive engraved series—a life, like the St.

Paul, Marlborough, and Charles I paintings, but one that ends with an apotheosis very different from that of Charles (this one painted by Vanderbank).[1] From the business point of view too, the *Harlot* was a continuation of these engraved series.

Subscription publishing was a very old thing. By the seventeenth century John Taylor, the Water Poet, was collecting subscriptions for almost every pamphlet he brought out, accumulating 1600 names for one. Subscription was usually limited, however, to books too luxurious or too esoteric for the publishers to take a chance on.[2] Walton's *Polyglot Bible* was published by subscription in 1654-57, Tonson's reprint of *Paradise Lost* in 1688, Anthony Wood's *Athenae Oxonienses* in 1691.[3] But the first important model of subscription publishing in England was Tonson's edition of Dryden's translation of the works of Vergil, which appeared in 1697. There were two series of subscribers: one paid five guineas and received a copy enriched with many engravings, with his own coat of arms printed beneath one of them; the other paid two guineas and got his name recorded on a list prefixed to the translation. Dryden was entitled to a proportion of the sums subscribed, so naturally went about recruiting subscribers; his total profit, which included the added earnings from sale of the manuscript, was £1400.[4] As Alexandre Beljame has observed, Dryden's *Vergil* was a landmark in linking writer and publisher, "the author [contributing] his talent, the publisher his commercial experience; the one risking his labour, the other his capital, and both according to their desert and to their luck, good or ill, would have their share of failure or success."[5] Subsequently, in 1716 Prior's poems, published by subscription, brought him 4000 guineas, and Gay made £1000 on his in 1720.

The next great advance occurred with Pope's *Iliad*. Bernard Lintot allowed Pope the entire revenue from subscriptions, and in addition paid him £200 for each volume. He reserved for himself the profit from all subsequent editions. In other words, the subscription rights and £200 a volume were Pope's pay, by which Lintot bought his property. There were 575 subscribers who took 654 copies, and Pope made £5,320 4s. The whole work, both *Iliad* and *Odyssey*, brought him nearly £9000.[6] Following Pope's example, writers saw their profits increasing: whereas the *Beggar's Opera* text brought Gay between £700 and £800, the subscription for the publication of *Polly* brought him £2000. Voltaire's English edition of *The Henriade*, published in London by subscription, brought in £6000, and Young's *Love of Fame* in 1728, £3000.[7]

Subscriptions were invited through advertisements in the newspapers, through mailing prospectuses to likely purchasers, and through the personal entreaties of the author and his friends. Partial payment was usually demanded with the subscription. One difficulty was that advertisements were too commercial for a proud poet, and the alternative, begging letters or calls upon the great,

was no better: "the author placed himself in the importunate position which he had occupied in the old days of patronage."[8]

The artist who wished to break with patronage had more to overcome than the writer, whose words were easily registered by any printer on any page; the artist had a unique object, impossible to duplicate. The engraver, in a still more precarious situation, had naturally less leverage with his printseller than the author with his bookseller because he was essentially a middleman between artist and publisher. The artist and engraver were dependent on each other, and how the profits were distributed usually depended on whether the artist or the publisher controlled the engraver and the subsequent copperplate. Subscription publishing, nevertheless, was by no means limited to the bookselling world. The major subscriptions of engravings in the period preceding Hogarth's emergence were the various versions of the Raphael Cartoons, Laguerre's *Battles of Marlborough,* and the Thornhill decorations for St. Paul's. In the 1720s Hogarth's own *Hudibras* series was successfully sold by subscription, with the advantage that he was both inventer and engraver; but as with Pope's *Iliad,* the plates were bought by the printseller Overton, with the artist's profit presumably limited to the subscription or a percentage thereof.

Hogarth's great advance with the *Harlot's Progress* was to eliminate the publisher, or rather assume the role himself. He kept not only all the profits from the subscription but also all subsequent profits, plus the profits from the sale of the paintings on which the prints were based and any cheap authorized copies.

Hogarth's conception was that of a painter, not an engraver. The idea of having engravings made after his own paintings and selling them in large editions, for financial advantage as well as fame and glory, can be traced back at least as far as Rubens, who published his works himself or through firms in which he was a partner. Rubens often labored over the proofs to make sure the engraver conveyed the correct impression of his painting. That his new assumption of roles combined the artist and the merchant was, however, an insight that Hogarth did not immediately grasp. When he started his subscription of the *Harlot's Progress* he did not envisage subsequent printings, nor regard himself as anything but an artist who was eliminating the middleman printseller in order to reach his patrons directly.

Now a well-known painter, commencing his subscription in the spring of 1731, Hogarth published no advertisements to announce his proposals.[9] He carried out his subscription, as Vertue noted admiringly, "without Courting or soliciting subscriptions all comeing to his dwelling in common [Covent] Garden," presumably by word of mouth, through the contacts he had already made in Parliament, and by exhibiting his paintings in his studio, which of course was in an area much frequented by people of all classes looking for something new (and, it might be added, theatrical). The sophisticated subscription ticket also

shows that he was aiming at a sophisticated audience, the same for which he painted his conversation pieces and his special subjects (*Before* and *After*), assuming perhaps that a combination of the two would appeal to a larger group than either by itself. His subscription price, as given on the ticket, was one guinea, half to be paid on subscription, the other half on receipt of the prints. This was the same price Thornhill had charged for his St. Paul's engravings. Indeed, Thornhill also had contrived to keep possession of the copperplates (they later passed to Hogarth, who sold impressions in his shop). The subscriptions were similar except for two fundamentals: Thornhill retailed his prints through printsellers, remaining unsullied by the merchandizing, and divided his profits with them; and the printsellers continued to sell the prints after the end of the subscription, only raising the price from a guinea to 25*s*.

Hogarth's original intention, then, was to disseminate reproductions of his paintings in a deluxe edition. He intended to print off as many as were subscribed for and no more. Something of the ethics of subscription publishing of prints is suggested by J. T. Smith's comments on Robert Strange:

> [N]or could any publisher boast of more integrity as to his mode of delivering subscription-impressions. He never took off more proofs than were really bespoken, and every name was put upon the print as it came out of the press, unless it were faulty; and then it was destroyed, not laid aside for future sale, as has been too much the practice with some of our late publishers. Impositions, I regret to say, amounting to fraud, have been recently exercised upon the liberal encouragers of the Art, by sordid publishers, who have taken hundreds of proofs more than were subscribed for, purposely to hoard them up for future profit. Nay, I am shocked, when I declare that some of our late print-publishers have actually had plates touched up after they have been worn out; and have taken the writing out, in order that impressions might be taken off, which they have most barefacedly published and sold as original proof impressions![10]

Hogarth may also have assumed that a subscription would exhaust the finer capabilities of the copperplates.

Further, he intended to have the series engraved for him—in the manner of Thornhill's St. Paul's paintings. His feeling about engraving when he began the projected *Harlot's Progress* were probably expressed in the *Spectator*'s remark, "an Engraver is to the Painter, what a Printer is to an Author." As his designs for book illustrations in this period show, he wanted to be a painter and not an engraver; he wanted to move above the craft. But he also needed to spend much of his time in 1731 (as his list of unfinished paintings indicates) finishing up work already contracted and half paid for. He may at this time have tried Joseph Sympson, Jr., as a mezzotinter, to see whether the most painterly of media would adequately transmit his paintings. But the samples Sympson produced in this

medium and in straight etching-engraving were disappointing.[11] He may have turned to Vandergucht, who had etched a number of his small designs, but Vandergucht's elegance was even less suitable to the *Harlot* than Sympson's crudity. Over the next ten months after his subscription began Hogarth must have searched in vain for an engraver and finally begun the job himself.

By eliminating the reproductive engraver as well as the publisher, he saved himself a great deal of money. To give some idea of the cost that would have been involved if he had paid another engraver to reproduce the *Harlot's Progress,* one might note that in 1725 Jacques Parmentier paid Dubosc £100 to engrave his *Solomon giving Directions to his Chief Architect Hiram,* and in 1726 John Wootton paid Bernard Baron £50 a plate and £3 for each copperplate for the *Four Prints of the Sport of Hunting.*[12] Hogarth's own engraving, once under way, proceeded slowly; a reproductive effect, a fully-covered plate that tonally resembled a painting, was called for, and this was quite a different thing from the *Hudibras* plates. The engraving of the *Harlot,* Hogarth's most carefully done work to date, was not improved upon until the 1750s.

On 14 January 1731/2 he announced in the *Daily Journal* and the *Daily Post:*

> *The Author of the Six Copper Plates,*
> representing a Harlot's Progress, being disappointed of the Assistance he proposed, is obliged to engrave them all himself, which will retard the Delivery of the Prints to the Subscribers about two Months; the particular Time when will be advertised in this Paper.
>
> N.B. No more will be printed than are and shall be subscribed for, nor Subscriptions taken for more than will receive a good Impression.

Identical notices were repeated on January 15, 18, 19, 20, and 21 and in the *Craftsman* for the twenty-ninth. It is interesting that neither in this nor in subsequent advertisements did Hogarth identify himself except as the "Author." In advertisements inserted by booksellers for works illustrated by Hogarth his name appeared prominently; but presumably he considered such emphasis indecorous in an ad inserted by the artist himself.

Beginning on 8 March he ran a new advertisement in the *Daily Post:*

> The six Prints from Copper Plates, representing a Harlot's Progress, are now Printing off, and will be ready to be deliver'd to the Subscribers, on Monday, the 10 Day of April next.
>
> N.B. Particular Care will be taken, that the Impressions shall be good. Subscriptions will be taken in, till the 3d Day of April next, and not afterwards; and the Publick may be assured, that no more will be printed off than shall be Subscribed for within that Time.

This was repeated on March 9, 10, and 11; it was picked up by the *Daily Journal* on the thirteenth and the *Daily Advertiser* on the fifteenth, and ran in all three

journals up to the last day of the subscription, 3 April. The *Craftsman* and *Fog's Weekly Journal* carried the advertisement on March 18 and 25. On 27 March, the following notice was added at the end: "N.B. The Hours of delivering out the Prints, will be from 9 to 12 in the Morning, and from 3 till 6 in the Evening."

Vertue emphasizes the wide base of the *Harlot's* popularity: it "captivated the Minds of most People persons of all ranks & conditions from the greatest Quality to the meanest."[13] By March Hogarth may have become aware of how wide a popularity his subscription was enjoying; but with the prints themselves on display, of course, the subscription was building to a climax. These advertisements, sounding like notices to already-enrolled subscribers, were in fact designed to solicit subscriptions; no address is given where the subscriptions may be taken, and the general impression of the individual advertisement is that a private party is inserting a personal column. The effect is very reticent, subdued, dignified, and detached; this is an artist speaking to his patrons, not a merchant soliciting strangers. But the effect loses credibility with the repeated printing of the advertisements. One might conclude that Hogarth considered it vulgar to advertise, but at the same time wanted to sell more subscriptions, and so promulgated a mystery which would create talk and curiosity ("What is this *Harlot's Progress*? Who is the 'Author'?"), like the earlier enigmatic notice in the paper about Sir Isaac Shard. His notices imply either a coterie audience or the assumption that *everyone* knows about the *Harlot;* their repetition suggests that he wants to reach beyond either to a much larger public—as large a public as possible.

He may have been encouraged, and his subscription boosted, by the remarkable success of George Lillo's *London Merchant* at Drury Lane during the summer of 1731. It too dealt with "low" subject matter, and Lillo in his dedication speaks of "the novelty of this attempt"; Theophilus Cibber remembered it as "almost a new species of tragedy, wrote on a very uncommon subject."[14] Although its ostensible protagonist was a London apprentice, George Barnwell, its most striking character was Sarah Millwood, the London prostitute who, in a climactic scene, turns upon her accusers (who are lamenting her "abuse of such uncommon perfections of mind and body") and exposes them as the origin of her evil: "If such I had, well may I curse your barbarous sex, who robbed me of 'em, ere I knew their worth, then left me, too late, to count their value by their loss! Another and another spoiler came, and all my gain was poverty and reproach." The scene has much in common with the message of Hogarth's *Harlot*. Lillo also shared with Hogarth the belief that the value of a work (for Lillo a tragedy) is directly proportionate "the more extensively useful the moral . . . it is more truly august in proportion to the extent of its influence and the numbers that are properly affected by it"—by which he means that a tragedy should focus

on ordinary people rather than princes because it will have a wider application and a wider audience.

On 1 January 1731/2 Henry Fielding opened his farce *The Lottery* (itself an allusion to Hogarth's print) at the Drury Lane Theatre. His hero Lovemore comes to London seeking his sweetheart, and when he finds her living in fine lodgings in Pall Mall, explodes: "Ha! by all that's infamous, she is in keeping already; some bawd has made prize of her as she alighted from the stage-coach.— While she has been flying from my arms, she has fallen into the colonel's." By this time the theater-going part of London—surely an important segment of Hogarth's buyers—could be expected to recognize an allusion to the pictures displayed in Covent Garden.[15]

According to Hogarth's friend William Huggins, Christopher Tilson, one of the four chief clerks of the Treasury, told him that at a meeting of the Board of Treasury "held a day or two after the appearance of" the third plate, "a copy of it was shewn by one of the Lords, as containing, among other excellences, a striking likeness of Sir John Gonson. It gave universal satisfaction; from the Treasury each Lord repaired to the print-shop for a copy of it. . . ."[16] Since it is probable that no prints would have been released before or after the subscription was over, it is likely that Huggins' story refers to the day Plate 3, or its painting, was first exhibited in Hogarth's studio (not yet his "print-shop"), that the account was brought by word of mouth, and that the Lords went over to subscribe. Whatever the facts, however, the story, like the reference in *The Lottery*, indicates something of the way Hogarth's *Harlot* was received.

Two newsworthy events probably sold further subscriptions. Just as Hogarth was finishing his prints, the town was talking about the case of the Jesuit Jean-Baptiste Girard and his "harlot" Catherine Cadière, about whom Fielding wrote a comedy that appeared that same spring. Transcripts of the trial were published, as well as pamphlets, and, more to the point, a series of prints portraying the couple's lovemaking. One, a series of 32 etchings, may have been partly after designs by Gravelot. These "obscene Pieces of Impiety," to be sold in printshops, were attacked by newspapers, and may have led Hogarth to remove the obscenities that appeared on early impressions of the fifth plate.[17]

Subscriptions in early March must also have been assisted by the death of Colonel Charteris, which had taken place on 24 February at one of his northern estates; he was buried on the thirtieth, leaving a fortune estimated at £80,000. While his death adds a curious irony that Hogarth could not have foreseen (even villains die), it was a natural death and can have had no effect on the artist's intention. The previous October Charteris had been reported ill in the *Grub-street Journal*: "Sat. last Col. Charteris was taken very dangerously ill, and still continues so at his house near Hanover-square, where he is attended by Dr. Pringle, and other Physicians." And the irreverent *Journal* adds its comments:

"*Had the* Col. *put on the infallible* Anodyne Necklace *some time ago, as was generally desired,* this dangerous illness had been prevented"[18]—perhaps Hogarth at this point added the Anodyne Necklace in the fifth plate. But news of the Colonel's death and disgraceful funeral, at which garbage and dead dogs and cats were thrown by the outraged populace into the grave after his coffin, combined with the likeness of the old sinner displayed in Hogarth's shop, must have sold subscriptions.

Although there was no further announcement in the papers, the finished prints were doubtless delivered as scheduled on 10 April.[19] If by the time the prints were delivered Hogarth had become aware that his true audience lay in the great mass of ordinary purchasers, he kept his promise to his subscribers. In his subsequent advertisements, he always notes that all his prints are available at his shop "except the Harlot's Progress." For twelve years he kept his word, and presumably the value of impressions rose steeply; and then on 8 November 1744 he announced in the *Daily Advertiser:*

> WHEREAS Mr. HOGARTH, in the year 1731, published by Subscription a Set of Prints, call'd *The Harlot's Progress,* and according to the Conditions of his Proposals printed off no more than were then subscribed for; and
>
> Whereas many of the Subscribers themselves, (having either lost, or otherwise disposed of their Prints; and being desirous of completing their Sets, and binding them up with his other Works) have frequently requested and sollicited him for a second Impression:
>
> The Author (in Compliance with their Desires, and presuming that he shall be indulged by the rest of the Subscribers, with their Permission to print the Plates again) proposes to publish a second Impression of
>
> THE HARLOT'S PROGRESS:
>
> And begs Leave to conclude, (unless it be otherwise signified to him before the 1st of December next) that he hath the general Consent of all his Subscribers to the present intended Publication.
>
> WILLIAM HOGARTH

He distinguished the second impression by a cross centered beneath the design on each plate, and by minor revisions.

It is also clear that when he engraved the *Harlot's Progress* he had no intention of vending his own wares. He still considered himself a painter, not a merchant, and when the subscription was over he remained a painter. His plan was to have an engraver-printseller, Giles King, make authorized copies. Although it is not impossible that King came to him with the plan, the particular form King's copies took shows Hogarth's guiding hand. Here he was consciously addressing a lower, less educated audience—the audience he turned to in the prints

of the late 1740s. The scenes were now graced with explanations and simple, moral captions, like those in *Industry and Idleness:* Plate 1 is glossed with *"An Innocent young Girl Just arriv'd from the Country in a Waggon to an Inn in* London *where a* Baud *Inveigles into the Service of a Debauchee {Co.¹ Ch——r who appears at some Distance"*; or Plate 3, *"At her Lodging in Drury Lane Indulging over last Nights Debauch where Informers {S.ʳ In.º G——n &c, appear to apprehend Her."* Plate 6 has the laconic title, *"Her* funeral *Properly Attended."* Even a picture like that of Jonah in Plate 2 has its inscription, "Ionah Why are thou Angry?"

The upshot was that King sold the non-subscription *Harlots* in a cheaper engraving (4s, 5s on "super-fine Paper," to Hogarth's one guinea) from his shop, and Hogarth presumably took a percentage. On 18 April appeared King's first advertisement, with the first mention in the papers of Hogarth's name in connection with the *Harlot's Progress:*

> Speedily will be publish'd, the Six Prints of A HARLOT'S PROGRESS: Copied from the Originals of Mr. Hogarth. By Permission. With Ornaments and Explanation to each Print.
>
> Specimens to be seen at the Engraver's, at the Golden Head in Brownlow-street, Drury-Lane.
>
> N.B. These being nigh compleated, if any other Copies are publish'd, or offer'd by the Hawkers or their Accomplices before the Publication of these, they will be Impositions and bad Copies, there not having been Time enough to finish them neatly.

Already the possibility of pirates exists, but they are scolded only for the unfinished quality of their work—a curiously roundabout attack. On 21 April, three of the prints were published, and on the twenty-eighth the other three.[20]

It is difficult to estimate how much Hogarth made out of the *Harlot's Progress* before his second impression in 1744. But it was clearly considerably more than 1200 guineas. If 1240 sets were actually printed, as Vertue was told by the printer, Hogarth received that many guineas. His only costs were his printing assistants and around 65 advertisements at 2s each. One can only speculate on the percentage and the size of sales from Giles King's copies. The many pamphlets, poems, stage productions, and the like which drew upon the *Harlot* must have stimulated sales that could be satisfied only by King or one of the pirate printsellers. On the other hand, as Hogarth must have recognized with regret, King's set had little to recommend it over the pirates'—Kirkall's deluxe mezzotint series was a distinct improvement. He must have seen how much money was slipping through his fingers because he could not sell any more of his original product. The lessons of the pirates and the viability of his own product were not lost upon him: within a year he had corrected his error.

The audience he had discovered with the *Harlot's Progress* went beyond the

connoisseurs and picture buyers; in fact the number that subscribed to these prints, with the number that must have bought King's and the pirates' sets, suggests an audience closer to that of the *Spectator,* which by mid-March 1711 had reached a daily distribution of 3000 (and a readership of 60,000).[21] As to the actual makeup of what he later called "the public in general," whose support he retained in large part until the end of his career, it included not only the ordinary purchasers of art prints—those who bought Dorigny's *Raphael Cartoons* and Vandergucht's engravings of Thornhill's *Life of St. Paul*—but also the wits who bought Swift and Pope, the clergymen who bought moral prints, and the professional- and tradesmen who bought occasional comic or political prints. He reached beyond the landed gentry to the lawyers, soldiers and sailors, teachers and scholars; and evidently his appeal with the commercial interest—the merchants, shopkeepers, and small businessmen—exceeded his anticipations. But the full range of his "public in general" extended to the great substratum of the servants, clerks, and apprentices who saw and appreciated these prints, bought the piracies when they could not afford the originals, for whom King's copies were intended, and who in time were often given sets by their employers for Christmas presents. The overwhelming significance of the *Harlot* lay in the fact that, as Vertue noted, its popularity stretched from the highest to the lowest. Within a short time Vertue was reporting a rumor (false as it happened) that the paintings were sold to a nobleman for 30 guineas each, and the grossest copies were being handed out for a few pence each.[22]

This was a mass audience never reached by an earlier printmaker, at least with any regularity, and by few English writers. The range of the audience is important because to retain it intact Hogarth had in the future to produce prints that worked on several levels, and yet keep them from being mutually contradictory. In the *Harlot's Progress* he set the pattern by attracting the most naive audience with his topicality and his simple moral tale, the art audience with his pretensions to history painting, and the witty literary audience with the interplay of the two and the general allusive readability of the series. This particular combination, expressing his own complex of intentions, was partly accidental and in the future would pose a difficult juggling problem. As time went on he would (so he thought) lose the art fanciers from his audience; and his prints would veer between the literary and the popular, sometimes meaning rather different things to each audience. The Augustan satirists in prose and verse habitually addressed two audiences, but one was false and the other true, and the irony excluded the former. Hogarth at his best derived his strength from reaching both simultaneously.

On 21 April, little more than a week after the *Harlot*'s publication, a shilling prose pamphlet appeared called *The Progress of a Harlot. As she is described in Six Prints, by the Ingenious Mr. Hogarth.*[23] This Grub-street work, the first of

such parasites to flourish on the *Harlot*'s popularity, had apparently been written by someone who knew that the series was in preparation but had not bothered to go to Hogarth's studio to have a look; or perhaps it was a typical harlot's life that was lying around awaiting an occasion for publication. The hack in question attached a title page alluding to Hogarth's series and changed the ending to conform with the *Harlot*'s—the practice Swift observed, of attaching to a work the name of "which ever of the Wits shall happen to be that Week in the Vogue."[24]

Three days later appeared *A Harlot's Progress, or the Humours of Drury Lane,* a shilling pamphlet based on Hogarth's series and including a series of small copies. This verse redaction defined all the implied grossness of the prints, and much more; and was so popular that it went through four editions in little more than two weeks, by which time its price had gone up to 2s.[25] The second edition, out on 6 May, added an epistle "To the Ingenious Mr. Hogarth," which ends with a reference to Thornhill, reminiscent of Mitchell's effusion:

> Happy Sir *James,* in such a Son,
> By whom *Apelles* is outdone;
> His Work is Marvellous, and fine,
> But not miraculous, like thine:
> Thy Canvas tells its Tale as plain,
> As can be told by Tongue of Man:
> Fame first design'd to make thee known,
> In being Sir *James Thornhill's* Son;
> Then Heav'n, its mighty Pow'r to shew,
> Gave thee Sir *James's* Genius too.

Encouraged by the success of this work, the author put together by 5 May *The Progress of a Rake, or the Templar's Exit,* in ten hudibrastic cantos this time—the logical transition from a harlot to a rake which Hogarth himself followed a year later.[26] In the same *Daily Journal* that advertised *The Progress of a Rake,* one Cox identified his shop as being in Covent Garden, "under the Middle-Piazza, near Mr. Hogarth's." By the end of June Mr. Gamble, at the Golden Fan in St. Martin's Court, was advertising in conjunction with Giles King: "Six Prints of the Progress of a Harlot on a Fan, three on each Side, curiously-Engrav'd; wherein the Characters are justly preserv'd, and the whole not varied from the Originals. Printed in divers beautiful Colours. Price 2s. 6d."[27]

Meanwhile, as early as 16–18 May, three days before the first of King's authorized copies appeared, the *London Evening Post* was advertising the Bowles brothers' copies as "this day published," "the same Size as Mr. Hogarth's"—engraved by Fourdrinier, who also engraved William Kent's designs for book illustrations, "and other the best Masters in Town"—adding that country booksellers could also be supplied. No price is given, but these were followed by pi-

ratings by the Overtons at 6*s* a set (King's sold at 4*s*). In November, also under the sponsorship of the Overtons, Elisha Kirkall issued his green-tinted mezzotints, with explanations under each plate, at 15*s*.[28] The result was, like many of Kirkall's works, attractive, but much too soft and painterly for the clear reading required by Hogarth.

Joseph Gay (i.e. John Durant Breval) dated his preface to *The Lure of Venus; or, A Harlot's Progress. An Heroi-comical Poem. In Six Cantos,* a 1*s* 6*d* pamphlet, 30 November 1732, not long after Kirkall's piracy appeared. He condemns piracy in art and literature, remarking that "whenever a curious painting is finished, we are sure of a number of paltry copies," but his own redaction includes copies of Hogarth's prints. Though dated in November, the earliest advertisement for the pamphlet was 1 May 1733.[29]

Progresses of all kinds followed, and it was inevitable that the Opposition should pick up the idea and use the analogy that offered itself. In April 1733 *Robin's Progress* was published "(With Eight curious Copper Plates) . . . in Eight Scenes; from his first coming to Town, to his present Situation." Other satires on Walpole that adopted Hogarth's form included *The Statesman's Progress; or, Memoirs of the Rise, Administration, and Fall of Houly Chan. Premier Minister to Abensadir, Emperor of China. In a Letter from a Spanish Father Missionary to his Friend at Madrid,* published on 7 June. This 6*d* pamphlet is no doubt the source of the story, first told by Horace Walpole, that the Opposition approached Hogarth after the *Harlot* was published and asked him to produce another series called *The Statesman's Progress,* and that he refused.[30] It seems quite possible that he was approached, and, not wishing to be limited by a connection with either party, refused; and that paid hacks then went ahead with the work.

The relation between Hogarth's progresses and the stage has often been pointed out. I have noted that two characteristics of the English theater in Hogarth's period were intimacy (the closeness and smallness of the stage) and frequent changes of scene, and in a sense Hogarth's works satisfied the viewer as a stage play might—whatever the exact degree of the stage's influence on Hogarth's conception of the *Harlot.* Certainly the *Harlot's* theatrical possibilities were quickly realized. On 13 November 1732 the *Daily Advertiser* noted that *The Harlot,* a comedy by Charlotte Charke, "shortly to be acted," had been printed by Curll. On 5 February 1732/3 the *Daily Advertiser* announced publication of *The Decoy, or The Harlot's Progress* (on 14 February called *The Jew Decoy'd*), a new ballad opera, said to be performed at Goodman's Fields. On 15 March there was a "new Pantomime Entertainment" at Sadler's Wells called *The Harlot's Progress;* and on 17 April Theophilus Cibber's *The Harlot's Progress, or The Ridotto-Al-Fresco* was performed at Drury Lane, and proved a great success that helped to bolster the shaky fortunes of the company through

the next year and a half.[31] These plays open with the tableau presented by Hogarth and then, like the explications, fill in all the implied action surrounding it.

Much more important, however, was the influence the *Harlot* exerted on Henry Fielding, whose next farce, *The Covent Garden Tragedy,* was played on 1 June. The *Covent Garden Tragedy* shows at once the impact and the popularity of the *Harlot.* Like Hogarth, Fielding includes a Mother Needham character: Mother Punchbowl, who makes her relationship to Needham obvious by rehearsing her sad end in the pillory. Stormandra summons up Plate 1 when she cries, "dost think I came last week to town, / The waggon straws yet hanging to my tail?" Lovegirlo recalls Plate 2:

> I'll take thee into keeping, take the room
> So large, so furnish'd, in so fine a street,
> The mistress of a Jew shall envy thee;
> By Jove, I'll force the sooty tribe to own
> A Christian keeps a whore as well as they.

Plate 3 is alluded to when Stormandra reminds Bilkum of all she has done for him: "Did I not pick a pocket of a watch, / A pocket pick for thee?" And the fourth plate is evoked by various mentions of hemp-beating, as when Mother Punchbowl observes that "The very hemp I beat may hang my son." Even the Harlot's funeral is in the air when news is brought in of Stormandra's "death":

> Stormandra's gone!
> Weep all ye sister-harlots of the town;
> Pawn your best clothes, and clothe yourself in rags.

There may also have been allusions in the sets and costumes. The *Grub-street Journal* noticed the similarity when, in its customary unsympathetic discussion of Fielding's new play, it linked Stormandra with Hackabouta as whores Fielding paraded on his stage; and in his introduction to the printed text of his play, Fielding added "A Criticism on the Covent-garden Tragedy, originally intended for The Grub-street Journal," in which he refers to "several very odd names in this piece, such as Hackabouta, &c." Either the *Grub-street Journal* introduced the Harlot's name as a hint that Fielding was playing on Hogarth's popularity, or Fielding had actually used the name in his play but changed it in the printed text.[32]

It is significant that in *The Covent Garden Tragedy,* Fielding for the first time has his characters consistently alluding to their social superiors as models. He employs the same simile that serves for a passing reference in his earliest plays: "our affair is grown dull as a chancery suit" (*Love in Several Masques,* I.1). By 1732, in *The Modern Husband,* the idea was becoming more insistent:

Lord Richly explains how he gave Mrs. Bellamant a hundred pound note for the payment of six. "And how did she receive it?" asks Mrs. Modern. "With the same reluctancy that a lawyer or physician would a double fee, or a court-priest a plurality" (IV.2): thus extending the satire to lawyers, doctors, and clergymen. But in these plays, he puts the analogies in the mouths of the great (or at least respectable) themselves, and they sound like conventional satiric elaboration; there is no sign of approbation on the part of the speaker. Only with *The Welsh Opera*, first produced 22 April 1731, are the low viewed as analogues of the great, and by then Hogarth had the *Harlot* well enough along to have started his subscription. Even in *The Welsh Opera* not much is made of the idea: the Apshinkens are of the country gentry, and the only low characters are the servants, Robin the butler, William the coachman, John the groom, and Thomas the gardener (equalling Walpole, Pulteney, etc.). Their language, though in general patterned after that of their masters, is more mock-pastoral than anything else; Fielding makes no attempt to suggest that these characters behave as they do in imitation of the royal family, the prime minister, and so forth. This idea becomes explicit only in *The Covent Garden Tragedy,* with the bawds, whores, and their clients assuming the poses and diction of their superiors without their superiors' success. Mother Punchbowl sets the tone with her opening speech:

> Who'd be a bawd in this degenerate age!
> Who'd for her country unrewarded toil!
> Not so the statesman scrubs his plotful head,
> Not so the lawyer shakes his unfee'd tongue,
> Not so the doctor guides the doleful quill.

Whether Fielding is puffing the *Harlot's Progress* or benefiting from it, the presence is heavily felt, and it remains in the poor characters who follow Fashion and imitate "greatness" in *Pasquin, Eurydice,* and the later farces, even more in *Jonathan Wild,* and in a modified form in *Joseph Andrews.*[33]

The relationship between the two men goes back at least to 1728, and to Fielding's first published work, *The Masquerade,* a poem informed if not inspired by Hogarth's *Masquerade Ticket.* Although Fielding's first plays were Congrevian intrigue comedies, produced between 1728 and '29, he very soon learned new techniques from Pope's *Dunciad,* and probably from Hogarth's emblematic, stagelike representations. In *The Author's Farce* and his subsequent "farces," he brought *The Dunciad* to the stage. The two may have known each other personally by this time.[34] Hogarth was a prodigious theatergoer, a denizen of the Covent Garden area, and he would certainly have pursued Fielding's dramatic career and soon made his acquaintance. On 24 April 1730 the immensely popular *Tom Thumb* appeared, and a year later, for the revised printed version, Hogarth supplied a design for a frontispiece (pl. 115), as later in the year in

which the *Harlot* appeared he furnished designs for two of the plays in the bi-
lingual edition of Molière with which Fielding was involved (published on 8
December 1732).

If Fielding's imitation in *The Covent Garden Tragedy* was in some sense a
recognition of what Hogarth was up to, his actual formulation of this theme did
not occur until the *Champion* essay of June 1740 and the preface to *Joseph
Andrews* in 1742. The earliest indication that Hogarth's intention was recog-
nized by contemporaries is James Ralph's essay on painting in his *Weekly Reg-
ister* No. 112, 3 June 1732.

> Now nothing is a greater Objection to the Genius of the Painters than
> their Want of Invention; few of them have Spirit enough even to touch
> upon a new Story, or venture on a Subject that has not been very often han-
> dled before. . . . But fewer still have commenc'd Authors themselves, that is
> to say, invented both the Story and the Execution; tho' certainly 'tis as much
> in their Power as the Poet's, and would redound as much to their Reputa-
> tion, as the late *Progress of a Harlot* by the ingenious Mr. *Hogarth* will
> sufficiently testify.

Almost these exact words were picked up by Ambrose Phillips in a letter to
"Joseph Gay," which was reproduced in the newspaper advertising *The Lure of
Venus,* and opposite the title page of the book.[35]

On Friday, 26 May, Hogarth and some of his close friends spent the evening
at the Bedford Arms Tavern, at the corner of the Little Piazza facing St. Paul's
Church. And they were in such high spirits that, instead of returning home for
the night, they merely stopped off at their respective houses for a change of
linen, set off on foot toward the Thames, and did not return until the thirty-first
—just in time for Hogarth to catch a breath and make the first night of Fielding's
Covent Garden Tragedy on 1 June. Around one in the morning they took a boat
to Gravesend, arriving at dawn after a rainy and windy trip down the Thames.
From there they proceeded, wandering on foot or by water, in the general di-
rection of the Kent coast. The first day they crossed Gad's Hill to Rochester and
Chatham, to Upnor, and over the hills to Hoo and Stoke. The next day they vis-
ited the Isle of Grain and crossed the salt marshes and the Medway to Sheerness
(this was on Restoration Day, and the batteries were saluting). Then to Queens-
borough, and the next day to Minster, and back to Sheerness, by boat to Graves-
end, back to Billingsgate, and finally to the water-gate behind Somerset House.
They ended again at the Bedford Arms, "in the same Good Humour wee left it
to Set out on this Very Pleasant Expedition."

The weather was probably good: it might have been one of those late English
springs when it suddenly becomes apparent that the weather has changed, and
one has to be outdoors. But it was, for Hogarth at least, a jaunt which celebrated

the completion and publication and extraordinary success of the *Harlot's Prog-
ress*. His actions throughout the trip suggest release from great pressure—but at
the same time, in the context of his friends, one might conclude that he was be-
having as usual.

This outing, preserved in a journal by one of the travelers, Ebenezer Forrest,
was no doubt one of many enjoyed by Hogarth and his friends. The plan was
evidently Forrest's, though it may have begun with Hogarth's sketching a porter
at Puddle Dock—a confirmation of the stories that describe him sketching an
interesting face on the spot. For the remainder of the trip, Hogarth drew pic-
tures of their stops, and Forrest kept notes, which he turned into a parody of an
antiquarian tour, transcribing inscriptions from monuments and old churches
and recording old wives' tales told them by the natives. Forrest was a lawyer with
literary inclinations. He shared Hogarth's love of the theater and was, like him,
inspired by Gay's *Beggar's Opera*, producing an imitation, a ballad opera called
Momus turn'd Fabulist; or, Vulcan's Wedding, which their mutual friend John
Rich produced and gave a successful run of two weeks in 1729. According to the
story that either he or his son told John Nichols (in the early 1780s), he finished
making a fair copy of the manuscript of the journey, had it bound, and read it
at the Bedford Arms two days after their return. The result is a long, thin folio
of nineteen sheets bound in brown leather and stamped in gold on the cover,
"TRAVELS, 1732. VOL. 1," as if other travels were to follow. On the title page it
is called a "Five Days' Peregrination," and this is what the trip has been called
ever since.[36]

Hogarth made five drawings and a head- and tailpiece; he was assisted in one
drawing by Samuel Scott, the marine landscapist, and two more were added.
Scott too was engaged on an important commission—the painting of six views of
East India Company settlements to decorate the Court Room of East India
House in Leadenhall Street. He comes through the clearest of the group: testy,
short-tempered, a natural butt for the jokes of the others. A longtime resident
of Covent Garden, he probably lived at this point with Robert Scott, a relative,
in the last house at the southeast corner. Like Hogarth, he was a little man, un-
der five feet, and, as Walpole noted somewhat later, "extremely passionate and
impatient."[37]

The fourth member of the "peregrination" was Hogarth's brother-in-law,
John Thornhill, who at this time was living in Red Lion Court, a block north
of Covent Garden. He must, in a vague way, have been interested in art: he fur-
nished the map that documents the route of the peregrination. Not long after
he returned to London, in July, his father resigned the Serjeant-Paintership in
his favor, and he held the position, living off its perquisites, until within a few
months of his death when he resigned it in favor of Hogarth. No clear picture of
him emerges from the journal.

The fifth member, the only altogether non-literary or artistic one, was Ho-

garth's old friend William Tothall, the woolen draper and rum dealer, with whom he had lived before and perhaps after his marriage. 1732 was a red-letter year for Tothall too: early that year he had bought out the woolen draper business from his retiring master, who allowed him to make his payments out of profits. (Tothall did the same with his own shopman, retiring when he was under 50 in 1746.) At the same time he took over a house next to Scott's in "Bedford Ground facing the Market."[38] Hogarth later gave his shop a free advertisement in the first plate of *A Rake's Progress* and may have portrayed him in *A Chorus of Singers*.[39]

This then is the party of five that sets out from the Bedford Arms on the night of 26 June. They clearly like to eat and drink a good deal—gin, beer, or whatever comes to hand; a typical meal consists of "a Dish of Soles & Flounders with Crab Sauce, a Calves heart Stuff'd And Roasted y^e Liver Fry'd and the other appurtenances Minc'd, a Leg of Mutton Roasted, and Some Green pease, all Very Good and well Dress'd, with Good Small beer and excellent Port."[40] They like equally well to sing and play games. Their favorite songs, which they sing whenever they need to demonstrate their vocal power (they are vanquished, toward the end, by some powerfully-singing sailors), are "Sir John got him an ambling Nag" to the tune of "John Dory" and something called "Pishoken." The games are generally scuffling contests. At one point Hogarth plays hopscotch with Scott, but more characteristic is the "Battle Royall with Stocks pebbles and Hog's Dung" at Upnor Castle, Tothall getting the worst of it ("this occasion'd Much Laughter"), and the series of skirmishes at Lower Stoke, first with water from a well and then "with Soft, Cow Dung," which leave Tothall and Scott in a sad condition.

If there is a main character it is Scott, complaining about the muddy ground, not wanting to show his companions the drawing he has made, getting his clothes soiled, being upset at the loss of a handkerchief lent him by his wife, losing his penknife, leaving behind a greatcoat he borrowed, and grumbling at his sleeping accommodation but making no objection when Tothall offers him his own.

With Scott the anti-hero of the trip, Hogarth is less visible (with one or two notable exceptions) but always calmly in control—an actor, not, like Scott, a victim. At the outset he sketches the porter at Puddle Dock and posts the drawing. On the boat down the Thames he falls asleep, "But soon awaking, was going to relate a Dream he had, but falling asleep again, when he awak'd had forgott he had Dream'd at all." Dreams return—a strange subject for Hogarth, one might think—and Sunday morning in Rochester he and Scott relate their dreams, and all "entered into a Conversation on that Subject in Bed, and," (Forrest adds, giving his own view of the affair) "left off, no Wiser than wee begun." So we have Hogarth dreaming, and talking with interest about his dreams; Hogarth emphasizing his own short, squat stature in his sketches; not to mention, follow-

ing the battle of sticks, pebbles, and cow dung, having a bowel movement in a churchyard. As with the dung-throwing in the shadow of Upnor Castle, Forrest again carefully transcribes the inscription on a wooden rail over a grave, and goes on "Hogarth having a Motion; untruss'd upon a Grave Rail in an unseemly Manner which Tothall perceiving administred pennance to ye part offending with a Bunch of Netles, this occasion'd an Engagement which Ended happily without Bloodshed and Hogarth Finish'd his Business against the Church Door." Similarly, at the Sheerness fort, "Scott was Laughd at for Smelling to the Touchholes of Some of the Guns lately Discharged and so was Hogarth for Sitting Down to Cutt his Toe Nails in the Garrison." Thus Hogarth fits quite readily into Forrest's juxtapositions of historic monuments and nature. In Queensborough, having discovered several pretty women with whom they conversed, they returned to their inn, "got a Wooden Chair and plac'd Hogarth in it in the Street where he Made the Drawing No. 6: and gather'd a great Many Men Women and Children abt. him to see his performance"—which was no doubt what they intended. Finally, both Scott and Hogarth get seasick in a squall.[41]

In the narrative compiled by Forrest, the erudite examination of churches and the antiquarian-like drawings made by Hogarth and Scott are constantly undercut by what appears to be the real focus of the trip: eating, drinking, defecating, and highjinks. As in so much of Hogarth's life, it is impossible to say where nature leaves off and art begins. The peregrination was primarily a vacation of dung-throwing and letting off steam; the occasional encounters with churches and landmarks, which curiosity made them view and Hogarth draw, were purely incidental. But when they got back and Forrest began to write up the narrative, the incongruity between the topographical drawings and the actual trip must have been evident; at any rate, they placed their journey in the context of a serious endeavor (anticipating Fielding and Smollett), and Hogarth's final comments were the head- and tailpiece which he added, altogether on his own authority, after the manuscript was complete.

He begins the manuscript with a picture of Mr. Somebody, who is surrounded with antiquarian objects, and ends with Mr. Nobody, who is hung with knives, forks, spoons, glass and bottle, all implements of the table (pls. 105–06). Puppets of Somebody and Nobody danced in Fielding's *Author's Farce* (1730), defining themselves to the melody of "The Black Joke," one of the bawdiest of ballads (to which Hogarth alludes in *Rake,* Plate 3). One extreme is Somebody, the representative of "knaves or fools, in coat or gown" (the "great"), and the other extreme is Nobody, the "jolly Nobody"

> Who during his life does nothing at all
> But eat and snore
> And drink and roar,

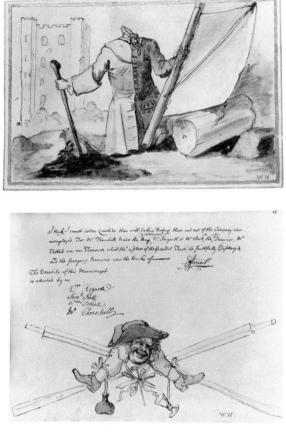

104. Breakfast, from the *Five Days' Peregrination;*
June 1732; 8½ x 12⅝ in. (BM)

105. Frontispiece, *Peregrination;* 7⅞ x 12 in. (BM)

106. Tailpiece, *Peregrination;* 7⅞ x 12 in. (BM)

> From whore to the tavern, from tavern to whore,
> With a laced coat, and that is all.
>
> (Air VII)

Hogarth associates Somebody with the antiquarian aspect of the peregrination
and Nobody with the pleasureable, but he does not see them as extremes: Some-
body is the one who gets all the credit, Nobody the underdog who, though
he only eats and drinks, sees the truth of life.[42] An early allusion to Nobodies in
relation to patrons and connoisseurs, these figures also represent Hogarth's gen-
eral feeling, reflected in the *Harlot's Progress,* about the little people in relation
to the respectable, the "great."

Hogarth's first response to the collapse of the relationship between great sub-
ject, great style, and patronage of the "great," as witnessed in the later career of
Sir James Thornhill, was to produce satires on false patronage and on the utter
inappropriateness of history conventions to eighteenth-century England. At the
same time he was responding with a series of experiments that edged toward an
alternative, a modern history, a new subject expressed in an adaptation, some-
times parodic and sometimes normative, of the old grand manner. He naturally

accompanied his alternative history painting with an alternative, much broader conception of patronage.

At first it appears that *Hudibras,* and the *Harlot* as well, were in fact conceived within the limited context of personal patronage. The conversation pictures, certainly, were an attempt to secure patronage, but even here, Hogarth aimed at a somewhat broader group than the Burlingtons; he produced a cheaper picture, a smaller one that could be turned out with greater speed and in greater quantity. One of the factors that caused him to abandon conversations was the repetitive drudgery, which he avoided with the *Harlot* by engraving a single copperplate from which hundreds or thousands of impressions might be taken. In short, he stooped to include a lower level of patronage in the *Harlot,* below the Burlingtons but above the printsellers and what he was later to call "the public in general." The success of the conversations had allowed him to hope that he might extend the sphere of patronage; thus the *Harlot* prints, illustrating his ambivalent feelings about the "great," were reproduced in a finite number for the less "great," but comfortably wealthy, to savor.

One may well question, in concluding this phase of Hogarth's work, his failure to directly attack the respectable folk, the ruling class, the "great," since it is clear that they were the real evil in the world of the *Harlot.* A variety of answers can be offered. One of the principles of satire is indirection: the best way to get at the nature of a social evil is through investigating its consequences. Presumably what Hogarth saw as uniquely pernicious in the "great" was precisely their influence on the lower classes. Perhaps he was more interested in the person who tries to behave like an aristocrat than in the aristocrat himself. But in the final analysis, one cannot altogether dismiss his probable desire to have his cake and eat it, to expose the evil of the ruling class without alienating it; and the way to achieve this was to make his sinner a member of the lower orders who tries to act like one of the upper with disastrous results. I am not suggesting that Hogarth is to be condemned for this solution, but only that it was worked out within a range of possibilities that was not unlimited: the satiric conventions of his day as well as the realities of the social structure, personal and public patronage, and his own personal concerns.

III. Challenge and Response
1732-45

Patron and Public

A highlight of the social season in which the *Harlot's Progress* appeared was the children's production of Dryden's *Indian Emperor* at the Conduitts' town house in St. George Street, Hanover Square. John Conduitt, a gentleman who had begun his career in the army, married Sir Isaac Newton's niece, Katherine Barton, shortly after the end of her long and ambiguous relationship with Lord Halifax; a genuinely learned man in monetary matters, he assisted Sir Isaac in his last years as Master of the Mint and succeeded him on his death in 1727. Mrs. Conduitt, admired in her youth by Swift and capable in later years of disturbing Pope, had good connections and no doubt arranged the party.[1] The center of attraction was the children's performance of Dryden's play, which had been successfully revived in 1731 at Drury Lane. The Conduitts' performance was directed by Drury Lane's Theophilus Cibber; their daughter Kitty played Alibech, Lady Sophia Fermor played Almeria, Lord Lempster Cortez, and Lady Caroline Lennox (daughter of the Duke of Richmond and later Henry Fox's wife) Cydaria: all the children were around ten years of age. The audience included the royal children, the Duke of Cumberland and his sisters the Princesses Mary and Louisa, and the daughters of their governess the Countess of Deloraine; among the adults present were the Countess of Deloraine, Stephen Poyntz (the Duke's governor), and the Duke and Duchess of Richmond.[2]

The performance must have pleased the Duke of Cumberland, who ordered a repetition before his own family at St. James' Palace, which took place on 27 April.[3] By the twenty-second, however, Mr. Conduitt had decided to commemorate the occasion with "a conversation piece drawn by Hogarth of the young People of Quality that acted at his house, and"—the writer, Dr. Alured Clarke, adds—"if he isn't mistaken hopes to have the honour of the Royal part of the audience in the Picture; and I doubt not the painter's genius will find out a proper place for Miss C[onduitt]."[4] Conduitt withdrew to his country seat at Cranbury Park, Hampshire, and his friend Thomas Hill kept him informed on the progress of the painting, telling him when Lady Caroline had agreed to sit to Hogarth and, on 20 June, commenting: "Hogarth has but in a manner made

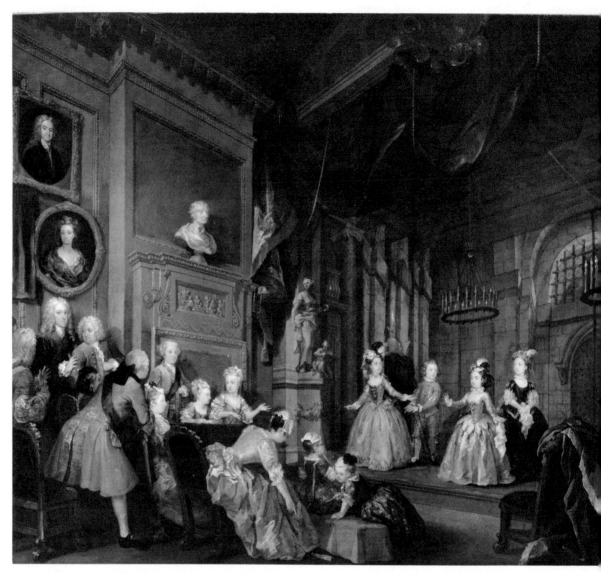

107a. A Scene from *The Indian Emperor* (or *The Conquest of Mexico*); 1732; 51½ x 57¾ in. (the Viscountess Galwa

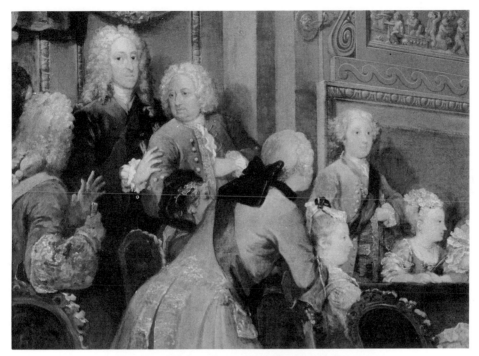

107b. Detail from A Scene from *The Indian Emperor*

108. The Duke of Cumberland; ca. 1732; 17½ x 13½
in. (the Hon. Colin Tennant)

a sketch of Lady Caroline. Nothing appears yet to any advantage. The next sit-
ting will, I hope, show something good. I think he has succeeded perfectly wel in
Miss Kitty's face and air."[5] Presumably Hogarth attended one of the perform-
ances, made a sketch, and then filled in those faces desired from separate sittings
like the ones recorded for Lady Caroline.

Conduitt's choice of Hogarth may have owed something to the particular
occasion, which would have recalled his *Beggar's Opera* paintings. In fact, the
scene he chose to paint (pl. 107a) was very like the one he painted in *The Beg-
gar's Opera*. The promptbook shows act IV, scene 4, where Cortez is "discovered
bound" and the rival princesses Cydaria and Almeria debate the captive con-
queror in much the same manner that Lucy and Polly debated Macheath, who
wore the same fetters. Of course, Gay's Macheath flanked by Polly and Lucy was
itself a parody of such scenes as this—or Antony between Cleopatra and Octavia
in *All for Love,* or Alexander between Statira and Roxana in *The Rival
Queens;* and one could add Tom Thumb between Huncamunca and the Queen
of the Amazons in Fielding's parody of heroic plays. (One must never lose sight
of the stage convention in the background of pictorial structures like the
"Choice of Hercules" employed by Hogarth.) The Conduitts' performance,
even more than *The Beggar's Opera,* gave Hogarth the opportunity to recall
Richardson's opinion that the stage suffered the disadvantage (vis-à-vis history
painting) of having to use real people in ideal roles, with the audience able to
detect the discrepancy. Here he can show Dryden's great Cortez and the two
princesses in one of the most heroic of English plays being acted by children,
watched by their parents.

Hogarth was also fortunate in this picture to have been assigned a relatively
small number of portraits. The children, the focus of attention whether on stage
or in the audience, are all fairly visible; but only three of the adults have faces
that show. The identifications made years later in Boydell's engraving seem ar-
bitrary, since they refer to averted heads. The woman in profile is probably the
Duchess of Richmond, and one of the men wearing an order must be the Duke.
The other figures merely fill in the composition, which is accordingly un-
crowded, without the usual awkward rows of heads all facing the viewer. The
host and hostess are discreetly portrayed in pictures hanging on the wall, near
the mantelpiece bust of Sir Isaac. All in all, this painting parallels Hogarth's
best conversations, depicting the psychological ties linking various orders of
experience: people, social event, stage and scenery; adults, children, and carved
putti; guests, players, busts, and painted portraits. In short, the real, feigned
(acted), carved, and painted are all related within a single picture. The richness
of literary content cannot be dissociated from the effect of the purely formal ele-
ments—the wedge-shaped audience balanced by the children on the stage, itself
balanced (as the eye moves up) by the mantelpiece, the bust, and the two por-

traits, and finally (completing the zig-zag path of the viewer's eye), the upper reaches of the stage set.

The use of pictures, sculpture, and architecture as an integral part of the cognitive as well as the formal composition was established and confirmed in the *Harlot's Progress* and suggests the continuing close relationship between Hogarth's conversations and his modern moral subjects. Indeed, *The Indian Emperor* shows that the *Harlot* itself was, in one sense, another step up the ladder of patronage. More portrait commissions followed that success, and Hogarth must have been busy with these for the rest of the year. Far from alienating his aristocratic buyers, the *Harlot* had confirmed his hold on them, and in 1732–33 he painted the most exalted sitters of his career and received a commission to paint a conversation of the whole royal family.

Still, Hogarth apparently made his reputation as a specialist in oddities: the performance of children in a play, with such homely details as the mother pointing to a fan on the floor which she desires her little girl to pick up. There is a distinct peculiarity too about the family group he was commissioned to paint by Lord Malpas (later third Earl of Cholmondeley). Lord Malpas had sat on the Gaols Enquiry Committee and may have been included in one of Hogarth's versions of the *Bambridge Committee;* it is not certain when he commissioned a portrait of his family, but the result suggests that it commemorated Lady Malpas. The eldest daughter of Sir Robert Walpole, she died of consumption in southern France late in 1731, and on 15 April 1732 the grief for her loss was deepened by news that the ship returning her body from France had gone down.[6] Hogarth's picture (pl. 109) shows the viscountess, looking very stiff and dead (not even quite on the same scale with the other figures), with angels fluttering over her head; this strange figure is balanced by the terribly alive boys playing on the other side of the picture.

Despite these commissions, by the fall of 1732 Hogarth must have decided that he needed another large print with which to follow up the success of the *Harlot's Progress;* but too busy to produce a new painting, he turned to one he had done a year or so before, of a drinking club (pl. 92), called it *A Midnight Modern Conversation,* added an inscription claiming that no portraits were intended, and this time advertised the subscription (pl. 110). On 18 December he inserted in the *Daily Advertiser:*

> MR. HOGARTH having engrav'd a large Copper Plate from a Picture of his own painting, representing a Midnight Modern Conversation, consisting of ten different Characters; in order to preserve his Property therein, and prevent the Printsellers from graving base Copies to his Prejudice, proposes to publish it by Subscription on the Terms following.
>
> The Price Five Shillings for each Print, to be paid at the Time of sub-

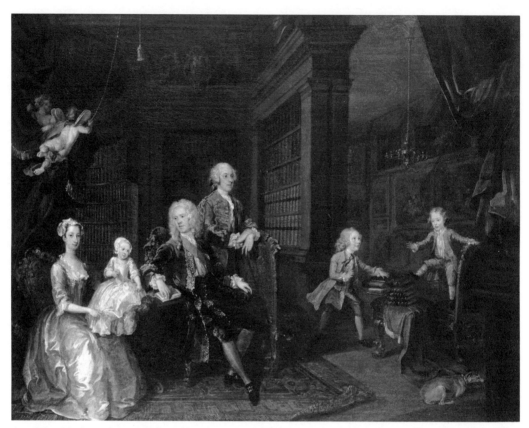

109. The Cholmondeley Family; 1732; 28 x 35¾ in. (the Right Hon. the Marquess of Cholmondeley)

scribing; for which the Author will give an etch'd Plate, with a Receipt to deliver the Print on the first of March next. But if the Number already printed be sooner subscrib'd for, then the Prints shall be sooner deliver'd, and Notice thereof given in the Papers.

The Picture and Print to be seen next Door to the New Play-house in Covent Garden Piazza, where Subscriptions are taken in.

He not only advertised, he used his own name and gave his address (Rich's new playhouse had just opened). His advertisement was repeated in every issue of *The Daily Advertiser* through December and (with slight changes) January. By 25 January Hogarth had come to an important decision: he deleted the last sentence of the second paragraph and replaced it with "after which Time they will be three Half Crowns each." It is possible, of course, that the subscription went badly, and he was only explaining what would happen to those impressions not subscribed for by the deadline; but it seems more likely, considering the great popularity of this print, that he decided to print up some more. He had probably discovered that his method of engraving-etching produced impressions by no means exhausted after some 1500 had been printed. By this time it had oc-

curred to him that he could increase the take by keeping both the profits of his subscription and all subsequent profits; so instead of limiting the printing to those subscribed for, he raised the price after the subscription.

The design itself was, in terms of the *Harlot's Progress,* a regression: the painting simply showed a drunken party, presumably portraits, the sort of thing he painted in the late 1720s. But he has engraved it in the light of the *Harlot's Progress,* enlarging the figures in relation to the picture space and rendering, for such a crowded plate, a relatively balanced composition: a man is leaning back on each side, like a supporter on a coat of arms; a clock is balanced by a fireplace; and the two men in the foreground, one leaning back, the other precipitately forward, balance each other. The bewigged head is in the center of the table and only slightly off the exact center of the wall paneling. The result is what Pope would have called "harmoniously confused." To suggest something of the ironies that characterized the *Harlot,* Hogarth added the title, *A Midnight Modern Conversation,* which suggests a contrast between "conversation" and what these men are actually doing, and between their view of themselves and the reality—the verses imply a further ironic relation between the artist's stated (no portraits) and real intentions. To underline this superimposed aspect, Hogarth made a subscription ticket showing a motley group of singers performing the oratorio of *Judith,* singing the words, mock-heroic in this context, "The World shall bow to the Assyrian Throne" (pl. 111). The reason for choosing this particular oratorio, soon to be performed with disastrous results, can be attributed both to Hogarth's friendship with the author, William Huggins, and to the more particular fact that Huggins had just purchased both the *Beggar's Opera* and *Bambridge Committee* paintings left unclaimed by the ruined Sir Archibald Grant.

The print's popularity can be documented by the piracies that immediately appeared and the infinite variety of copies and adaptations to be found on everything from snuffboxes and punchbowls to fanmounts. The latter were advertised in the *Daily Journal* for 24 May as sold at Mr. Chenevix's and other toy shops, with "a Description of each particular Person" attached "for the Entertainment of the Ladies." Some salt glazeware mugs, dated as early as March 1732/3, are evidence that pirates had already gotten the idea of going to Hogarth's house, looking at the original, and making a copy from memory.[7]

Hogarth's interests, like Thornhill's, extended straight down from the dukes and princesses of royal family groups to the lowest denizens of the London underworld. While he was conducting the subscription for *A Midnight Modern Conversation* he must have noticed in papers for 5 February 1732/3 the first account of a particularly grisly murder: two old women and their maid were found in their beds with their throats cut from ear to ear.[8] Next day the *Daily Courant* noted that the coroner's inquest had brought in a verdict of willful murder and that four laundresses in the Temple were committed to Newgate

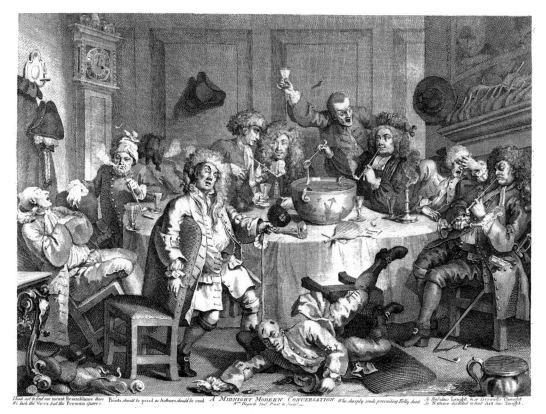

110. A Midnight Modern Conversation (engraving); March 1732/3 (second state); 12^{15}⁄$_{16}$ x 18 in. (W. S. Lewis)

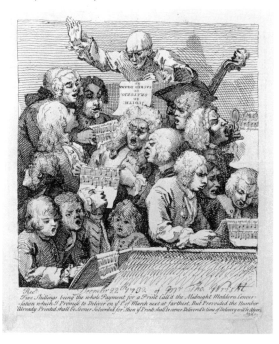

111. A Chorus of Singers; Dec. 1732; 6^{9}⁄$_{16}$ x 6^{1}⁄$_{8}$ in. (W. S. Lewis)

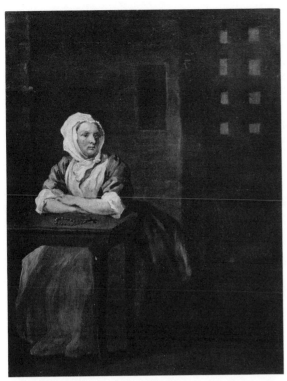

112a. Sarah Malcolm (painting); March 1732/3; 18½ x 14½ in. (National Gallery of Ireland, Edinburgh)

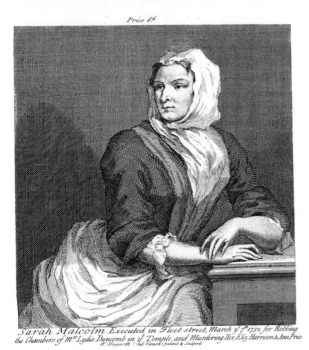

Price 6ᵈ

Sarah Malcolm Executed in Fleet street, March y 7ᵗʰ 1732 for Robbing the Chambers of Mrs Lydia Duncomb in ye Temple, and Murdering Her, Eliz: Harrison & Ann Price
W. Hogarth (ad Vivum) pinxit & sculpsit

112b. Sarah Malcolm (engraving); March 1732/3; 6⅞ x 6½ in. (W. S. Lewis)

for the crime, one confessing and impeaching the other three. Mention was also made of the plate and bloody linen, presumably that stolen, found in a nearby gentleman's chamber. The *Daily Journal* of the same day mentions Sarah Malcolm by name and adds details:

> Mrs. Duncomb had invited one Mrs. Love, an intimate Acquaintance, and who had the Care of all her Effects, to dine with her on Sunday last; she accordingly came, and knocking at the Door could make no body hear her, but immediately came up one Sarah Malcom, an Irishwoman, who was formerly a Servant to the old Gentlewoman, and at this Time went of Errands for her, and said, Madam, what can't you make them hear? To which Mrs. Love said, No: Why sure (says she) they are not dead; I will go and see what is the matter: upon which she opened a Window, and went out upon the Leads, and then opened the Window of the Deceased, went into the Room and opened the Door; Mrs. Love went in, and found them all three murdered. . . .

On Sunday night Sarah Malcolm was sent to the Compter on suspicion and on Monday she was examined by Sir Richard Brocas, the magistrate, and sent to Newgate. She confessed the murder, which she claimed she committed in conjunction with two Irishmen. "A Silver Tankard, a bloody Apron and Shift were found in a Close-Stool, and two Bundles of Cloaths, in her Master's Chambers, where she had hid them, and 45 Guineas concealed in her Hair."

On 6 February Malcolm was again examined by Brocas and this time confessed that "she and Mary Tracy, together with James and Thomas Alexander, both Brothers, had for some time contrived to rob the Chambers of Mrs. Duncomb"—telling how they sneaked into the flat, awakened the maid, and had to murder the women. Malcolm was "remanded to Newgate, with strict Orders for the Keeper not to let any Person have access to her, and to set a Watch over her Day and Night, lest she should make away with herself, she having refused any Sustenance since she has been there."[9] Late Thursday night, the eighth, the Coroner's Inquest brought in a verdict of willful murder against Malcolm only, refusing to accept her word about accomplices. (She had presumably expected to turn state's evidence and get herself off.)[10]

On 21 February was published a pamphlet called *A Full and Particular Account of the barbarous Murders of Mrs. Lydia Duncomb. . . . With a Narrative of the infamous Actions of Sarah Malcolm, now in Newgate for the said Murders,* price 2d, and a second edition with an account of the trial was out on the twenty-sixth. On the twenty-second Malcolm had been arraigned; she pleaded not guilty, and on the next day the trial took place:

> after a Trial of about five Hours, the Jury brought her in guilty. She be-

hav'd in a very extraordinary Manner on her Trial, oftentimes requesting
the Court for the Witnesses to speak louder, and spoke upwards of half an
Hour in her Defence, but in a trifling Manner. She confessed she was guilty
of the Robbery, but not of the Murder, only standing on the Stairs.

But no bill of indictment had been found against her so-called accomplices.
Upon hearing the sentence "she fell into Fits, but being recovered she was a
second Time brought to the Bar, and asked if she had any thing to say for her-
self, to which she answer'd, No."[11]

The next news of Malcolm is that she has declared herself a Roman Catholic
and "behaves very penitent and devout, but still denies the Murder; she is re-
moved out of the old condemned Hold into a Room, but one or two Persons are
always with her." On 4 March she attended chapel with the rest of the con-
demned, "and behaved in a most bold and impudent Manner; she still persisting
on her Innocence of being concerned in the Murder, and has given Orders for
a Shroud and a Pair of Drawers, which are making, in which Habit she resolves
to die; and the Sheriffs of the City of London have given Orders to the City Car-
penters for erecting a Gibbet at the End of Fetter-Lane in Fleetstreet, facing
Mitre-Court, for her Execution next Wednesday [the seventh]."[12]

The contrast between her bloody crime and her youth (she was just 22), sex,
and cool behavior after the murders, as well as her Roman Catholicism, must
have attracted Hogarth. Accompanied by Thornhill, he went to Malcolm's cell
on the Monday (5 March) before her execution and drew her portrait. The
event was reported by the *Craftsman* (with mention of Thornhill's presence)
and the *Daily Advertiser,* which follows its account of Malcolm with: "On Mon-
day last the ingenious Mr. Hogarth made her a Visit, and took down with his
Pencil, a very exact Likeness of her, that the Features of so remarkable a Woman
may not be unknown to those who could not see her while alive."[13] It is evident
that Hogarth's taking Malcolm's portrait was considered appropriate, this being
his public role in the community, and (if the notice is to be taken at face value)
that he sketched her in oils—"pencil" at this time denoting a brush. In the small
painting of Malcolm (pl. 112a), he balances her against the heavy bars of her cell
door, emphasizes her bare muscular forearms resting heavily on a table, and
places her rosary beads before her on the table. It is a powerful picture, whose
strength is dissipated in the etched version that quickly followed (pl. 112b).
Here he emphasizes the face, making her upper body fill the picture space, and
omitting her beads; the heavy arms are now delicate and rest lightly and rather
elegantly on a table that is off to one side. The face is still interesting, but the
body might as well be posing for a society portrait. According to one story, Ho-
garth supposedly said to Thornhill, "I see by this woman's features, that she is
capable of any wickedness."[14] This may have been the effect he attempted to

convey, to the exclusion of all else, in the print. But, as he was to discover when he turned to portraiture a few years later, a face alone was not an adequate vehicle for him.

Malcolm's hanging on 7 March was marked by the same kind of melodrama that characterized her trial and imprisonment. Dressed "in a black Gown, white Apron, Sarsenet Hood and black Gloves," she "appeared very serious and devout, crying and wringing her Hands in an extraordinary manner." To an attendant clergyman "she delivered her Confession sealed up, requesting it might be opened before the Right Hon. the Lord-Mayor and the Sheriffs, and desired that the Rev. Mr. Pedington [one of the clergymen] would cause the same to be printed and published, as her last dying Words: She likewise presented him and several other Gentlemen with Rings: She was in great Agony just before she went off the Stage, and fainted away twice, but was brought to herself again, when calling upon God for Mercy, the Cart drew away. . . ." Several of the scaffolds constructed for the crowd collapsed, "and several Persons had their Legs and Arms broke, and others most terribly bruised."[15]

All of this contributed to the lively interest in Sarah Malcolm, and in the same newspapers of 8 March that described her death appeared Hogarth's advertisement:

> *On Saturday next* [10 March] *will be publish'd,*
> A Print of SARAH MALCOLM, engrav'd by Mr. Hogarth, from a Picture painted by him two Days before her Execution. Price 6d.

This was repeated on the ninth, with the added information that it was "To be sold at Mr. Regnier's, a Printseller in Newport-street, and at other Print-shops." (In another part of the paper it was announced that Malcolm would be buried in the St. Bartholomew the Great churchyard.) It looks as if Regnier offered Hogarth a lump sum for his plate, so large that he could not refuse it. (One is reminded of the various stories of his being offered for a particular copperplate its weight in gold.) It is possible, however, that Hogarth still distinguished at this time between serious modern moral subjects, to be painted, subscribed, and sold at his house, and an ephemeral catch-penny print. The latter, at 6d, was almost as easily sold as a newspaper. As time went by, he accepted this source of income too.

Thus was Hogarth poised uneasily between the world of high society and the lowest depths; at this time he frankly wished to span the two worlds, suggesting (as in the *Harlot's Progress*) that in important ways they were one and the same. Whether his patrons would be as willing as the general public to accept an artist who portrayed both kinds of life, let alone implied a connection, was another question.

In 1733 Hogarth was commissioned to paint a conversation piece of the royal

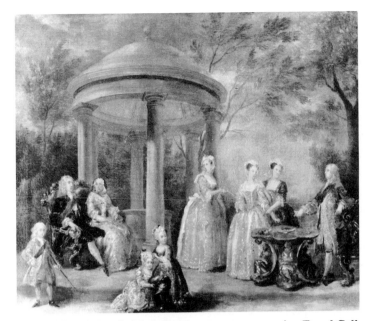

113. The Royal Family Modello (I); 1732–33; 25 x 30 in. (Royal Coll., copyright reserved)

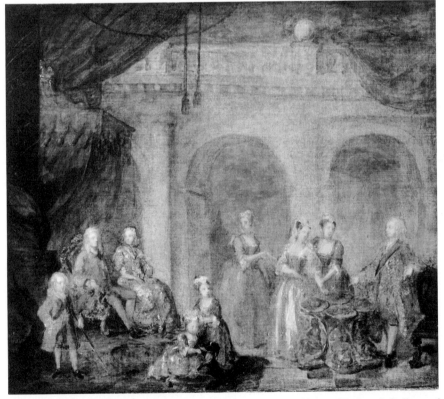

114. The Royal Family Modello (II); 1732–33; 14½ x 19¾ in. (National Gallery of Ireland, Dublin)

family and made two modelli to this end (pls. 113, 114).[16] The first was an out-
door scene, presumably a preliminary proposal before he was granted sittings;
the Duke of Cumberland was evidently drawn ad vivum, but whether this or the
full-length portrait (pl. 108) came first, or both were based on the figure in *The
Indian Emperor,* is uncertain. Hogarth then decided, or was asked, to move the
group indoors, and now the Prince of Wales' portrait appears to have been
based on a sitting (the rest of the faces are generalized).

At this point, riding the crest of his fortune, he looked to the most impressive
ceremonial that had yet come within his reach: the marriage of the Princess
Royal and the Prince of Orange, which was to take place that fall. According to
Vertue he "made application to some Lady about the Queen that he might have
leave to make a draught of the ceremony & chappel & paint it & make a print of
it for the public."[17] He was still balancing one patron against the other, trying
to have the best of both worlds: he would make the painting another *Wanstead
Assembly* or *Indian Emperor,* only grander, but he would engrave it as well.

Although Vertue specifically says a lady-in-waiting was Hogarth's go-between,
one wonders if Lord Hervey was not somewhere involved. A good friend of the
Duke and Duchess of Richmond, an intimate of the Queen, Hervey was Vice-
Chamberlain and effectively (though not technically) in charge of the ceremony;
soon afterward, he commissioned one of Hogarth's best conversations. More-
over, Hervey, with his deep sense of irony, especially concerning this particular
wedding, must instinctively have seen the marriage through Hogarth's eyes. It
is hard to imagine what would have resulted if Hogarth had rendered the scene
with the fat Princess and the horribly deformed Prince described by Hervey. He
comments that "the faults of [the Princess Royal's] person were that of being
very ill made, though not crooked, and a great propensity to fat." As to the
Prince of Orange, he

> was a less shocking and less ridiculous figure in this pompous procession
> and at supper than one could naturally have expected such an Aesop, in
> such trappings and such eminence, to have appeared. He had a long peruke
> like hair that flowed all over his back, and hid the roundness of it; and as his
> countenance was not bad there was nothing very strikingly disagreeable but
> his stature.
>
> But when he was undressed, and came in his nightgown into the room to
> go to bed, the appearance he made was as indescribable as the astonished
> countenances of everybody who beheld him. From the make of his bro-
> caded gown, and the make of his back, he looked behind as if he had no
> head, and before as if he had no neck and no legs.[18]

It is difficult to say what Hogarth, given free rein, might have made of this
pair—perhaps something like the sympathetic yet troubling, ambiguous por-

trait of Bishop Hoadly (pl. 164). But the situation, as writers were to say of later ones, demanded a Hogarth: a princess who, like Jane Austen's Charlotte Lucas, must marry this one or die a maid, and marries with the utmost dignity; a prince, deformed but noble and delicate of bearing; the king, appallingly rude, reminding the prince that his sole importance is as son-in-law to the King of England; the Prince of Wales, hating his father and mother and equally despised by them; and all the courtiers fawning on one side or the other. The picture might have been a cross between *Marriage à la Mode* and the Harlot's wake; but it was doomed from the start.

The undertaking may too have been clouded by the suspicion that Hogarth had caricatured Anne, the Princess Royal, in his frontispiece to Fielding's *Tragedy of Tragedies* in 1731 (pl. 115). In this second version of *Tom Thumb* (1730), Fielding strengthened and particularized the political allusions to Walpole and the Court. In act II, scene 1, between Grizzle (Lord Townshend) and Huncamunca, the princess who loves Tom Thumb, he made quite explicit a physical appearance which would have led contemporaries to connect her with the Princess Royal. Grizzle's famous line "Oh Huncamunca, Huncamunca! oh!" is followed by this description:

115. Frontispiece to Fielding's *Tragedy of Trage-dies* (engraving by Vandergucht); March 1730/1; 6¾₁₆ x 3¹¹⁄₁₆ in. (W. S. Lewis)

W. Hogarth inv. Ger. Vandergucht sculp.

> Thy pouting breasts, like kettledrums of brass,
> Beat everlasting loud alarms of joy;
> As bright as brass they are, and oh, as hard;
> Oh Huncamunca, Huncamunca! oh!

Later in the scene Grizzle adds: "One globe alone on Atlas' shoulders rests, / Two globes are less than Huncamunca's breasts. . . ." It was this figure Hogarth depicted in the frontispiece he drew for Fielding, adding the heavy arms, thick neck, and cherubic countenance mentioned in contemporary accounts of the Princess Royal and glossed over in her portraits.[19] In light of this frontispiece, Hogarth's projects of painting the princess at her wedding and among her family may have appeared to some as consummate gall.

His plans, however bold, ignored one important factor—unless they were indeed based on this knowledge, intending to precipitate a test of some sort. For the Master Carpenter, in charge of decorating St. James' Chapel for the ceremony, was none other than William Kent, and the Lord Chamberlain was the Duke of Grafton. Grafton had already distinguished himself in his office by conferring the laureateship on Colley Cibber: "And Graften, tow'ring Atlas of the throne, / So well regards a genius like his own," as Smollett later put it.[20] Kent could claim that Hogarth was impinging upon his prerogative, exactly as Thornhill had successfully done with Kent a few years before; and Grafton, Burlington's son-in-law and one of Kent's most prominent patrons, could claim that Hogarth had gone over his head and wrongfully secured the queen's permission, interfering with his prerogative.[21]

In October the papers were full of the preparations for the wedding. On the seventeenth it was revealed that "Her Royal Highness' Train is to be borne by four Ladies and two Pages of Honour, to and from the Altar."[22] And on the twentieth the *Daily Post* described preparations in the French Chapel adjoining St. James' Palace:

> Yesterday the Workmen took down all the Pews and the Pulpit . . . , in order to make Seats for the Reception of the several Nobility that will be present at the Solemnity, and part of the Garden-Wall that faces Marlborough-House will be taken down in order to make a Passage from the Palace, from whence the Procession will be made on Foot thro' the Garden to the said Chapel, when her Royal Highness will be attended by all the Ladies of her Bedchamber, the Maids of Honour, and all the Servants belonging to her Household.

On the twenty-fourth a scaffolding erected for the redecoration of the chapel fell down; one man fractured his skull, another broke a leg. The next day the Prince of Orange arrived after some delay, and the newspapers followed his

every move, though not recording the rudeness of the king and the Prince of Wales or the general awkwardness of the situation. On the thirtieth Philippe Mercier, now Gentleman Usher to the Princess Royal, was painting the pictures of the three eldest princesses, sittings being held every day.[23] Next day, the *Daily Journal* reported:

> The Painters have begun painting the Ceiling in the large Gallery, in which they are to walk in Procession at the Princess Royal's Marriage, and the King's Upholsterers are all at work in covering the Seats on each Side of the Gallery with red Bays [beige], and the Place on which they walk is covering with red Cheney.

Newspaper reports, unfortunately, were as close as Hogarth got to the scene. Vertue fills in the details:

> when Hogarth came there to begin his draught. he was by Mr Kents interest orderd to desist. Hogarth alledgd the Queens orders. but Ld Chamberlain himself in person insisted upon his being turnd out, and not to persue any such design. at least was deprivd of the oppertunity of persuing it of which, when the Queen had notice. she answerd she had granted such a leave but not reflecting it might be of use or advantage to Mr Kent, which she woudnt interfear with, or any thing to his profitt.[24]

This episode may have precipitated the announcement in papers of 6 November stating that the day before "Orders were given by his Grace the Duke of Grafton, Lord Chamberlain of his Majesty's Household, for shutting up the Doors of the Chapel and Gallery, that is preparing for the Marriage of the Princess Royal, by reason of the great Number of People who come there daily, and hinder the Workmen from their Business."[25]

Nor was this the end of Hogarth's distress: Vertue noted that "Mr Hogarth complains heavily. not only of this usage but of another, he had some time ago begun a picture of all the Royal family in one peice by order the Sketch being made. & the P. William the Duke had sat to him for one. this also has been stopt. so that he can't proceed." Vertue's conclusions should be stated in full:

> these are sad Mortifications to an Ingenious Man But its the effect of carricatures wch he has heretofore toucht Mr Kent. & diverted the Town. which now he is like to pay for, when he least thought on it. add to that there is some other causes relating to Sr James Thornhill. whose daughter is marryd to Mr Hogarth. and is blended with interest & spirit of opposition—

> Hogarth has so far lost the advantage of drawing portraitures from the life that he owns he has no imployment that way. but has mostly encour-

agement from the subscriptions for those designs of inventions he does.—
this prodigious genious of invention characters likeness. so ready is beyond
all others.[26]

The second paragraph, before the dash and Vertue's comment, sounds like Ho-
garth himself talking, seeing this as a turning point in his career, as in a sense
it was. Beyond the simple matter of Kent's prerogative was the increasingly
disturbing matter of Hogarth himself. One can imagine the Duke of Grafton
asking the queen: Do you want to be immortalized by the author of *A Harlot's
Progress* and the painter of *Sarah Malcolm?* Then one can visualize other com-
missions and potential commissions falling away: as the crown goes, so goes
the court.

Still, Vertue is overly pessimistic. Hogarth had already, by October, turned
to *A Rake's Progress* and *Southwark Fair,* and had finished their subscription
ticket, *The Laughing Audience.* And evidence points to a shift in his attention,
from the king and queen to the rival camp of the Prince of Wales[27]—continuing
to play in both leagues, public subscriptions and private patronage, but with
the former clearly occupying the greater part of his attention.

A few footnotes may close this intricately ironic episode. On 11 November
"a great Number of Workmen were imploy'd in covering the Floor of the Gal-
lery and chapel . . . which entirely completes that magnificent preparation."
Then about noon of the same day the Prince of Orange was taken ill, and the
marriage was postponed, and further postponed, and finally did not take place
until the next March 14. Then, "the whole Royal Family, the Nobility, also the
Gentry, and other Persons of Distinction, who sat as Spectators, and who were
very numerous, made the grandest Appearance that ever was seen in England on
the like Occasion." But not William Hogarth, who was that night probably
working on the *Rake's Progress.* On the twenty-fourth of the following October
the *Daily Advertiser* announced: *"This Day is publish'd,* A Print of the Cere-
mony of the Marriage of her Royal Highness the Princess Royal with his Serene
Highness the Prince of Orange in the Chapel at St. James's, from Mr. Kent's
Design. Engrav'd by Mons. Rigaud. To be had at several Print-shops."[28]

At the other extreme from the royal marriage procession in the Chapel Royal
at St. James' Palace was the procession led by a beautiful but plebeian drum-
meress advertising a show booth, surrounded by riffraff, beneath the towering
booths and signboards of Southwark Fair. An actor in ducal costume, perhaps
part of the same procession, is being arrested by a bailiff. Even a church is
present, and kings played by actors are falling off their rickety stage. Did one
not know the date of the painting one might conclude that it constituted Ho-
garth's attack on the ceremony he was prevented from painting. As it is, *South-
wark Fair,* much larger than Hogarth's earlier works of a similar nature, is a

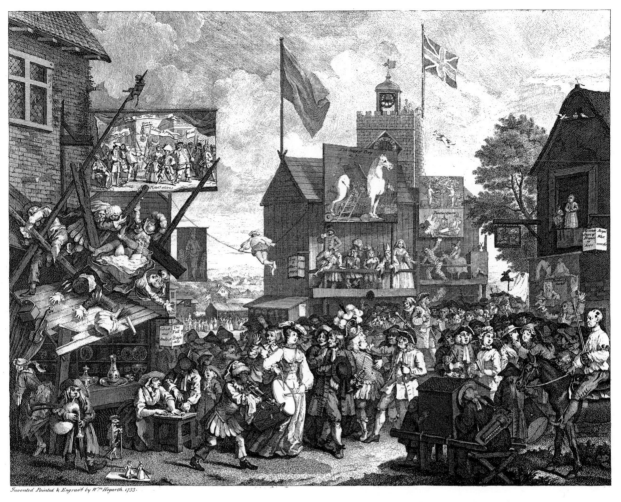

116. Southwark Fair (engraved version); Jan. 1733/4; 13½ x 17¹³⁄₁₆ in. (W. S. Lewis)

comment on the assemblies and entertainments of the aristocrats which he had been painting, and the reverse of *The Indian Emperor* (a painting of a similar size): the audience and performers are poor people, whose illusions are harrassed and threatened by bailiffs and by the shoddy construction that allows their stage to collapse. The scene divides into three distinct layers: at bottom moiling humanity, in the middle the dreams and illusions fostered by players and mountebanks, and at the top the church steeple and open sky and, through gaps between buildings, the open countryside. The picture shows a side of Hogarth that is suppressed in his fashionable portrait groups; at the same time it is the sort of "droll" Kent doubtless pointed to as evidence of Hogarth's unfitness to paint a royal marriage.

The painting (Lady Oakes' collection) was made sometime prior to 9 October, when the subscription for its engraving (pl. 116) was first advertised. Hogarth may have been planning if not working on it for years. His memory, and his stored visual impressions, went back to his early youth. It was to his advantage, however, to base a work on the fairs this particular year. Two versions of the *Harlot's Progress* (one "with the Diverting Humours of the Yorkshire Waggoner") were playing at both fairs throughout the season, and were still on the boards when he announced his subscription for what he called *The Fair* and a new progress, with eight (not just six) plates.[29] The events of that spring and summer were also responsible at least for the *Stage Mutiny* showcloth that fills the upper right corner of the painting.

It is worth asking why Hogarth chose Southwark Fair rather than Bartholomew, with which he was so much more familiar. On 25 August was published "A Curious Print of BARTHOLOMEW FAIR, printed on a large Elephant Sheet of Paper, representing its various Diversions and Humours; to which is added, an Historical account of it from its Original in King Henry IId's time."[30] The appearance of this print suggests that word of Hogarth's had leaked out, not that he took his idea from it; but he may have felt he should therefore turn to the other fair. It is also possible that some particular episode occurred at Southwark Fair—perhaps the affair of the drummeress that has come down in legend. Hogarth, who made a separate oil sketch of her, is supposed to have personally intervened between her and a ranting, insolent spectator.[31]

But the most valid conclusion to be drawn from his choice of Southwark over Bartholomew is that he was, as Nichols reported, spending his summer months on the Surrey side of the Thames, taking a good look at the Southwark equivalent of his old haunts in Smithfield. Bartholomew Fair offered him everything that Southwark did, including a church, except for the prospect of countryside. And this is the first, and virtually only, print that implies something in nature besides the human (i.e. the beautiful drummeress) as a norm against the alternatives of ugly day-to-day existence and the artificial fair (I assume the church to

be hardly less equivocal a norm than the fair). Perhaps his stay in Southwark had in fact engendered this insight. His regular renting of a villa in the country may date as far back as this time.

Aside from the congenial subject, and the contrasts offered by the temporary encampment on the Borough Street in Southwark, the inspiration of the work was the topos of the fall of kings—very possibly as he encountered it in the entries in Swift's *Bickerstaff Papers* that juxtapose the fall of a booth at Bartholomew Fair and the affairs of the Kingdom of Poland. But also in his mind was the falling puppet stage in Coypel's *Don Quixote* illustration, with its associations of delusion, and perhaps also the falling scaffoldings during the execution of Sarah Malcolm and the decoration of St. James' Chapel. Closer to home, his introduction of the rope dancers and rope-plunger from the church steeple derived from a long history of aspiration, success, and failure: Signor Violante sliding down the rope from St. Martin's steeple to the west side of the Mews, 300 yards in half a minute (3 June 1727, *Craftsman*). He attempted to do the same at Belsize House, but the vicar took down the scaffold (10 June 1727, *Craftsman*). Mrs. Violante "slid down a Rope from the highest Part of Vincent's-Rock, near the Hot Wells, cross the River into Somersetshire, being between 3 and 400 Yards, in less than half a Minute" (6 July 1728, *Craftsman*). In Cambridge, on 9 September 1732, a man flew down from St. Mary's Steeple to the shambles and up again "with great dexterity, firing 2 pistols, and tossed his flags when he was midway, and hung by his feet, and acted the Taylor and Shoemaker, to the great admiration of the spectators.—On the 16th he fixed his rope to the top of Chesterton steeple, and had like to have pulled part of it down; so they would not let him proceed" (28 September 1732, *Grub-street Journal*). Finally,

> On Tuesday the flying man attempted to fly from Greenwich church; but the rope not being drawn taut enough, it waved with him, and occasioned his hitting his foot against a chimney, and threw him off the same. . . . to the ground; whereby he broke his wrist and bruised his head and body in such a desperate manner 'tis thought he cannot recover.

And, as the *Grub-street Journal* (5 October 1732) added, "On Saturday [the third] he died."

In the spring of 1733, Hogarth must have watched with interest and some amusement the infighting at Drury Lane—perhaps not immediately relating it to his painting. The old patentees, Cibber, Wilks, and Booth, who had figured in *A Just View of the British Stage,* gradually slipped out of the picture through death and retirement until a wealthy young man-about-town named John Highmore, who had distinguished himself as an amateur Lothario with the Drury Lane company, was discovered to have bought up the patents and to be in control of the theater. His unprofessional and sometimes highhanded manage-

ment annoyed Theophilus Cibber (also annoyed because his father had sold his
share of the patent instead of passing it on to his son), who himself contributed
to the unease of the season. One of the controversial pieces, incidently, which
Cibber brought forward, a great money-maker that tided the company over its
hard times, was his version of the *Harlot's Progress*. A complete break came in
May with Highmore's "occupation" of Drury Lane and Cibber's exodus with
almost the whole company for the Little Theatre in the Haymarket.[32] Hogarth's
feelings must have been mixed, but his closest friends were on the loyalists'
side. John Ellys represented the widow Wilks' interests and was apparently a
friend of Highmore's; Henry Fielding, out of a sense of loyalty to the original
theater, continued to work with Highmore—he and the actress Kitty Clive being
the only members of importance to do so.

A satiric print by John Laguerre showing both sides poised for battle (pl.
117) was published on 4 July, and by the twenty-seventh a play of the same title
—the Stage Mutiny—was being performed at Covent Garden by the gleeful Rich
(it was published on the thirty-first). Laguerre, described in his obituary (1748)
as "a facetious companion, universally esteemed in every scene in life," could
afford to satirize both sides of the quarrel: he was Rich's principal scenery
painter at this time.[33] Hogarth copied Laguerre's print, with some changes, and
made a large showcloth of it to hang above Theophilus Cibber's booth—the one
in the process of falling with actors (performing *The Fall of Bajazet*) and all.
The showcloth may have been added after the rest of the composition, as a con-
venient parallel to, and up-to-the-minute commentary on, the collapsing booth;
it looks as if it has been painted over a smaller sign. Hogarth's version of *The
Stage Mutiny* underlines the Cibber parallel by adding "Pistol⁵ alive" under
Theophilus (noted for his bombastic portrayal of Ancient Pistol) and "Quiet &
Snug" under Colley. For his own amusement perhaps, he added a paint pot and
brushes near his friend Ellys. He does not take sides: the preposterous actors
are simply balanced by the amateurs—gentlemen and painters—on the other.

The mutiny remained in the air and no doubt contributed to Hogarth's sub-
scriptions: in September and October the ejectment suit against Highmore was
played out in Chancery; the affair came to a head in November when High-
more made the mistake of having Harper, one of the rival actors, committed to
Bridewell as a vagrant. Thereafter the papers attacked Highmore and Ellys,
compared Harper to Prynne or Sacheverell (depending on their editorial poli-
tics), and made much of "liberty." Harper was freed on 6 December, and by
February of the new year Cibber had taken possession of Drury Lane and High-
more sold his shares at a loss. On 1 January the print of *Southwark Fair* had
been delivered to subscribers.[34]

To return to 9 October 1733, the announcement of Hogarth's new sub-
scription read as follows:

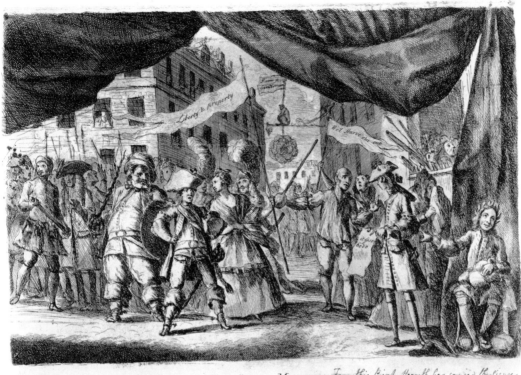

THE STAGE MUTINY. *From this Print Hogarth has copied the figures engraved on the Show Board in Southwark fair.*

L. Laguerre.

117. John Laguerre, The Stage Mutiny; 1733 (Royal Library, copyright reserved)

MR. HOGARTH being now engraving nine Copper Plates from Pictures of his own Painting, one of which represents the Humours of a Fair; the other eight, the Progress of a Rake; and to prevent the Publick being imposed upon by base Copies, before he can reap the reasonable Advantage of his own Performance, proposes to publish the Prints by Subscription on the following Terms; each Subscription to be one Guinea and a half; half a Guinea to be paid at the time of subscribing, for which a receipt will be given on a new etched Print, describing a pleased Audience at a Theater; and the other Payment of one Guinea on delivery of all the Prints when finished, which will be with all convenient Speed, and the time publickly advertised. The Fair being already finished, will be delivered to the Subscribers on sight of the Receipt on or before the first Day of January next if required; or it may be subscribed for alone, at five Shillings, the whole Payment to be paid at the time of subscribing.

Subscriptions will be taken in at Mr. Hogarth's, the Golden Head in Leicester Fields; where the Pictures are to be seen.[35]

Even the subscription ticket (pl. 118), which is announced as ready, concerned the theatrical audience—not, this time, at a fair, but at Drury Lane or

Covent Garden. Only the audience is visible, implying perhaps that the stage will be supplied by the prints themselves, and the members of the audience are distinguished by their expressions and gestures: the pleased lower-class denizens of the pit, the sour-faced critic, and the bored fops (aristocrats, but the allusion is not obtrusive) of the boxes. The effect parallels Fielding's schematic description fifteen years later of the audience he presupposed for the actors within *Tom Jones* and for the novel itself. One of Hogarth's links with Fielding is, of course, his constant playing on the artificial, feigned quality of a literary work.

Southwark Fair, like the subscription ticket, fits into the general pattern of the *Rake's Progress* cycle, and in fact its existence in October 1733 argues for the *Rake's* being pretty far along by that time. A kind of Vanity Fair, it meshes thematically with the conception of the *Rake* and acts as a prologue, announcing its juxtaposed themes of clothing and nakedness, acting and nature, tight-rope walking and falls of various sorts; and including such literal parallels as gambling, an arrest similar to that in Plate 4, and the broadsword fighter of Plate 2.

The year 1733 must have been largely devoted to the paintings of the *Rake's Progress* (pls. 120–27), though their conception may date back to 1732. A rake's progress was so obvious a sequel to a harlot's that a poem of that title was out a month after the publication of the *Harlot;* it is not necessary to suppose that Hogarth got the idea from this poem, or that the poet had heard that Hogarth

118. The Laughing Audience; Dec. 1733 (first state); 7 x 6¼ in. (W. S. Lewis)

intended to follow his harlot with a rake.[36] The sequence was conventional; the rake was the male counterpart of the harlot in popular picture stories and the like. Such series as "La specchio al fin de la Putana" were complemented with "La Vita del Lascivio."[37] The literary conventions came as readily to hand as the graphic. Hogarth no doubt had read Mrs. Davys' popular narrative *The Accomplish'd Rake* (1727) in which the protagonist, Sir John Galliard, is left alone in London: "The first progress he made in modern gallantry was to get into the unimproved conversation of the women of the town, who often care to drink him up to a pitch of stupidity, the better to qualify him for having his pockets picked." And Mrs. Davys sums up Galliard's "progress," as she calls it: "His drinking made him sick, his gaming made him poor, his mistresses made him unsound, and his other faults gave him sometimes remorse."[38]

A surviving oil sketch (pl. 119) offers an interesting study in Hogarth's method of composition. For one thing, it is clearly not, as a recent essay has argued, a first thought for the first plate.[39] If the young man came into his money by marrying a wealthy old lady before the viewer knew anything else about him, the typical Hogarth story line, already adumbrated in the *Harlot's Progress*, would be lost. As Mrs. Kurz noticed, Hogarth departs from the conventional elements of the rake series in which the protagonist is ruined by courtesans and the like;[40] like the Harlot, Tom Rakewell is ruined by his own extravagance, which takes the form of the middle-class youth imitating the aristocrat. Hence the first plate must establish his social class and origins, as the earlier series had begun with the Harlot's arrival from the country. If the sketch in question represented a first scene, it would have been for another series than the *Rake*—perhaps *Marriage à la Mode*. In fact, the painting seems alien in conception to the *Rake* as it finally emerged. Hogarth divided its elements between Plate 2 (the hangers-on in the next room, the jockey, and the idea of the pictures on the wall) and Plate 5 (the wedding with an old woman). The elaborate double-dealing shown here is not characteristic of the Tom Rakewell who (though his eye may wander from his old wife to a young bridesmaid) is determined to emulate the stereotyped rake; who would get a young girl pregnant and buy her off; ape all the latest London fashions; wench and gamble; be arrested for debt; recoup through a loveless marriage with a rich old hag; lose it all at gambling; go to debtors' prison; and die of chagrin and tertiary syphilis in Bedlam. His life is devoted to living up to the formula, and there is no time for either local intrigues or (another element of the sketch which is muted) excessive attention to fashionable art.

In the *Rake's Progress* those institutions that most dominated Hogarth's youthful memories, the "fair" (Plates 2, 3, 6), the church, the prison, and the hospital, all appear; and in the final analysis, all are escapes from the unsatisfactory self the protagonist is trying to change in Plate 1. By the wedding scene in the church, escape and consequences have become one, and so it continues in

119. Oil Sketch for *A Rake's Progress;* ca. 1733; 24¼ x 29¼ in. (Ashmolean Museum, Oxford)

the hellish gambling scene, the cell in the Fleet Prison (with the various means of escape devised by the prisoners, including alchemy and Icarus-wings), and the final escape through madness and death in Bedlam.

The topical and the functional continue to mesh: while the ending in Bedlam follows directly from the donnée, and appears inevitable, it is probably no coincidence that in 1734–35 the governors of Bethlehem Hospital were soliciting subscriptions to pay off the debt for the new wing built for female incurables. The hospital's historian writes of Hogarth: "I venture, therefore, to suggest that his 'Bedlam' picture represents something more than an inevitable episode in the progress of a rake from bad to worse; it looks as though it were also an endorsement of a subscription-book at that time being circulated through the city."[41] Hogarth's picture is, however, more ambiguous in its attitude than such an endorsement would be.

He must have visited Bedlam many times, looking at Caius Gabriel Cibber's statues over the stone piers of the great gate, like Michelangelo's Night and Morning: Raving Madness (or acute mania), chained, drawing in his breath

and about to bellow forth his anger, and Melancholy Madness with a vacant expression. Hogarth's epitome of Bedlam includes his versions of these statues and depicts the visitors as well: they offer the contrast that most impressed him in Bedlam. As he shows, gates of open ironwork (erected in 1729) kept the most violent patients separate. Off the gallery on both stories opened the cells or bedrooms of the patients, provided with narrow, unglazed windows high up in the wall. These patients were locked in their cells, occasionally taken out in the yards for air; some patients were allowed the "liberty of the gallery," but in general these were reserved for the visitors, who amused themselves by looking into the cells. While this voyeurism was acceptable to mid-eighteenth-century London, it was especially characteristic of the fashionable folk Rakewell emulated who now come to observe him.

All of the details work in this double way: as Hogarth reports, the mad were kept nearly naked to save clothes (it was cheap, and they might destroy clothing), and slept on straw which was easily cleared away; but these facts became symbols of Tom Rakewell's reduction to nothingness and connect with a metaphor of apparel that runs through the series. Plate 1 begins with the tailor measuring him for a suit, with the portrait of the closely-muffled miser in the background. From the elaborate dressing gown in 2, Rakewell descends to dishevelment in 3 and the elegant attire in which he is arrested in 4; from 6 to the end he is gradually stripped down to the bare forked animal he is in Bedlam—and significantly witnessed by two of the well-dressed denizens of the society he entered in the first plate. At the same time, while tracing the typical descent from folly to vice, from prison to madness and bestiality, one should notice that the prisoners in the Fleet and the madmen incarcerated in Bedlam are implicitly compared with the fashion-mongers of the earlier plates, who are still free. The madhouse acts as a reflection on the society that has appeared in the earlier plates—people madder than any of the inmates are allowed to come in and observe them; and, as one critic has remarked, "surely the girl, still faithful to her betrayer, is the maddest creature in Bedlam."[42]

It was the madhouse as a metaphor for society, which Hogarth himself generalized to all England in his final revision of the plate in 1763, that struck Dean Swift and elicited a compliment Hogarth must have cherished. The man he undoubtedly considered "the master of us all" ended his "Legion Club" (1736), a tour of the Irish House of Commons as if it were a madhouse, with this invocation:

> How I want thee, humorous *Hogart?*
> Thou I hear, a pleasant Rogue art;
> Were but you and I acquainted,
> Every Monster should be painted;
> You should try your graving Tools

120. *A Rake's Progress* (paintings: 1); 1735; 24½ x 29½ in. each (Sir John Soane's Museum)

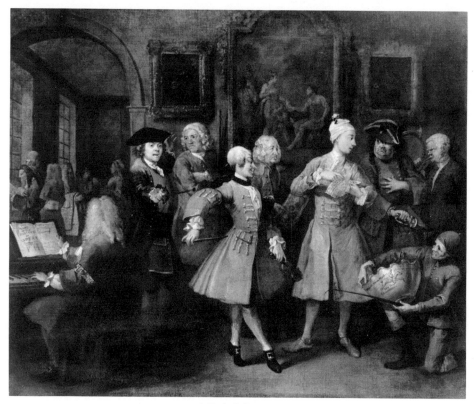

121. A Rake's Progress (2)

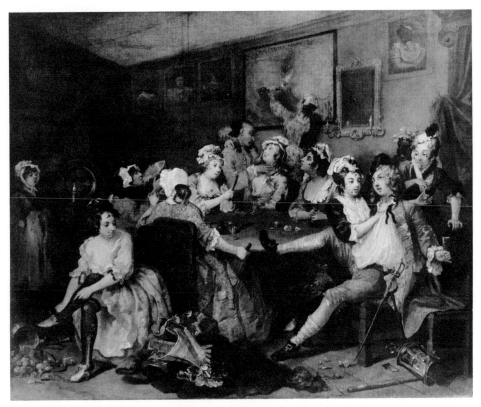

122. A Rake's Progress (3)

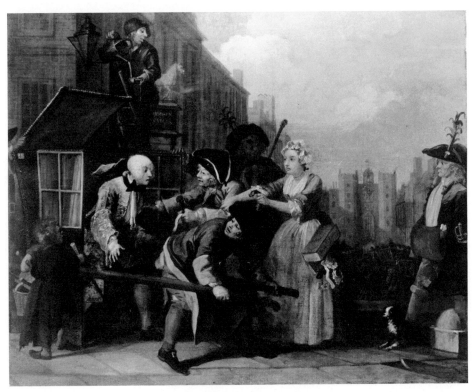

123. A Rake's Progress (4)

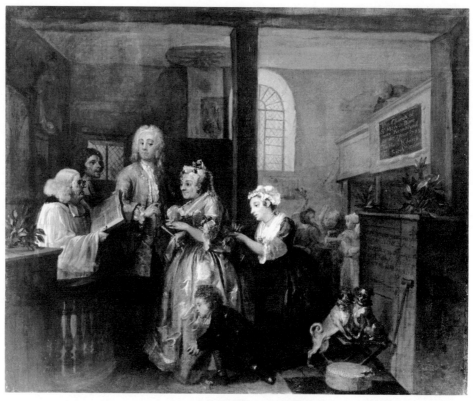

124. A Rake's Progress (5)

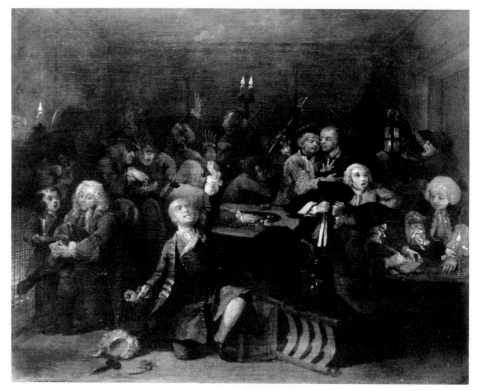

125. A Rake's Progress (6)

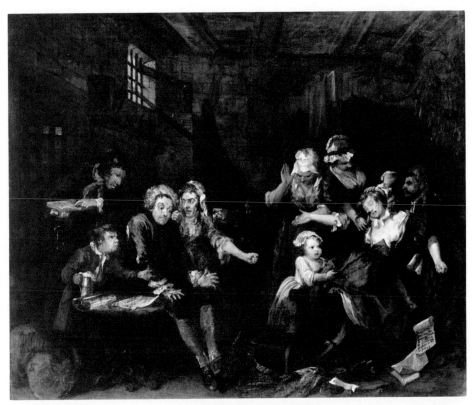

126. A Rake's Progress (7)

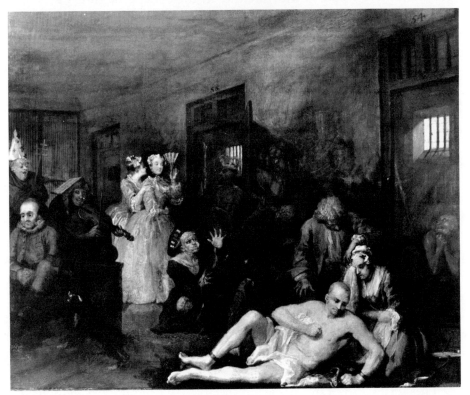

127. A Rake's Progress (8)

On this odious Group of Fools;
Draw the Beasts as I describe 'em,
Form their Features, while I gibe them;
Draw them like, for I assure you,
You will need no *Car'catura;*
Draw them so that we may trace
All the Soul in every Face.[43]

(ll. 219–30)

Plate 2, perhaps the *Rake's Progress* in general, is Hogarth's most Swiftean satire. He sent Swift a set of his prints, and in 1740 received a grateful reply from Swift's publisher, George Faulkner; Swift by this time was unable to reply himself.[44]

The painting, indeed the engraving, of the series is extremely uneven, as if Hogarth had many things on his mind at once. Certain of the scenes may have evolved from earlier sketches made for different occasions; a tendency toward violence (as in Plate 6), not so evident in the *Harlot,* may represent a natural development of the sort of scene portrayed in *A Club of Gentlemen* and *Midnight Modern Conversation.* Such a plate is more crowded as well as more independent than those in the *Harlot;* here in a single scene he shows all the stages of a subject or action. Characteristically, one's first impression is of total chaos, barely contained by the distant wall and ceiling lines. But within this chaos a careful pyramidal structure can be made out. The twin candles held high by the croupier, the night watchman's staff, the raised right arm of Rakewell, and the line of the overturned chair indicate the apex of the triangle. The movement of the eye in the plate is upward toward the fire, but held down by the crossings of lines going in other directions—especially the arm of the gambler drawing in his winnings, crossed by Rakewell's arm and clenched fist in a gesture of loss. The base of the pyramid is the four gamblers in the foreground, a progression (in the print, from left to right) from eagerness to passion to despair to apathy (or anticipation, if one reads this gentleman to be a highwayman).

As to the painting: parts of the finished work could fit into early paintings like *Falstaff Examining his Recruits* or the early versions of *The Beggar's Opera,* while others—the Rake's marriage and the brothel scene—are of a high order of painting. Some of the faces are labored, especially Sarah's in 1 and 2, as are the tailor's whole head in 1, the jockey's in 2, and the bailiff's and sedan-man's in 4. All the heads seem slightly out of proportion. Even the background figures, usually Hogarth's forte, are clumsy in 2. In short, there are some brilliant passages in almost every picture, but also some awkward ones, particularly—unheard of for Hogarth—in the facial expressions, which are either hit off just right or labored. This series also draws attention to Hogarth's habit, very evident in 3, of giving his women monotonously bright white-and-pink complexions; as though

he were unable to make the leap from society pictures, in which the women were always painted like this, to his métier where pasty off-shades are often preferable. He did not worry greatly about color as a reinforcer of his theme. The coloring in Plate 8, however, succeeds: Bedlam is suffused in a sickly yellowish-green light, with the visiting lady's dress the salmon color used previously in the Rake's dressing gown (Plate 2) and the curtains of his sedan chair (Plate 3); it is now complemented by a darker red on the warden bending over the Rake.

Some of the flaws of this long, ambitious series are epitomized in this striking final plate, which, in spite of its good qualities, reflects a difficulty of communication. Most commentators on the plate have recorded, based on what they see, that Rakewell is being chained after suffering a (perhaps suicidal) fit. Certain external evidence, however, argues for his death and the *unlocking* of the fetters, no longer needed: the line from the poetic inscription, "Behold Death grappling with Despair," suggests that he is at least sinking into death, and the pose after a *Pietà* also implies death.[45] The general gist of the progress also points to dying rather than struggle as the intention; the map of the world set afire by the whore in Plate 3 prefigures the Rake's being consumed not only by lust but by infection as well—part of the rake syndrome, and an obsessive consequence in Hogarth's works (the Harlot too died of syphilis).[46] Nevertheless, Hogarth has certainly put Rakewell in a peculiar posture: alluding to Cibber's statue of Melancholy Madness in the figure, while ironically alluding to a *Pietà* in the group. The confusion is evident in Hogarth's small revisions in the shoulders and even the head of the Rake, and in the hands of the warden; most strikingly, he changes the warden in the final state of the print (made many years later, in 1763) to a clergyman, as if he recognized the ambiguity.

From contemporary evidence, it would seem that the series of prints, when it finally appeared after many delays in 1735, was as well received as the *Harlot's Progress*. The unsympathetic Abbé Le Blanc, visiting England in the late 1730s, noted its universal vogue: "the whole nation has been infected by them," he remarks. "I have not seen a house of note without these moral [Le Blanc's irony] prints."[47]

Plate 2 of the *Rake* made its acid comment on patronage, from the viewpoints of both patron and dependent. The closest Hogarth came to a true patron in these years was Mary Edwards, one of those strange Hogarthian people who throughout his career seem to have found him a kindred spirit. In 1728 Miss Edwards inherited from her father, Francis Edwards of Welham, an enormous fortune completely unencumbered and at her own disposal (her mother, wealthy in her own right, renounced all claims). At twenty-four she became the greatest heiress in England, said to enjoy an annual income of between £50,000 and £60,000, with extensive land in Leicester, Northampton, Middlesex, Essex, Hertford, Kent, the City of London, and Ireland. She naturally attracted for-

tune hunters, and was dazzled by a young Scotsman five years her junior, re-
splendent in guardsman's uniform, with the fine name Lord Anne Hamilton
(after his godmother, Queen Anne) and the fourth Duke of Hamilton for his
father. He is said to have been encouraged by his family "to make up to the
heiress."[48] She was a country girl who had seen little of London or the great
world. Her family's fortune had come from the provinces—reclaiming a large
part of Lincolnshire from the sea, building dykes and draining fens, improving
properties and constructing new roads. She fell under the dashing nobleman's
spell and their romance led to a hasty Fleet wedding in 1731. To assure his hold
on the Edwards money, Lord Anne assumed the surname of Edwards and a grant
of the arms of Edwards.

Francis Edwards is said to have possessed paintings by Hogarth, but there
seems to be a confusion here with a later S. Edwards who owned the portrait of
Sir George Hay, *The Savoyard, The Bench,* and other paintings from his last
years.[49] It is more likely that this pretty, self-willed, and headstrong young girl
was attracted to Hogarth and his work as Mrs. Pendarves was about the same
time. On 4 March 1732/3 a son, Gerard Anne, named after Lord Anne and his
mother's family, was born, and within the year Mary commissioned Hogarth to
paint the child in his cradle (pl. 128).[50] There is also a single portrait of Lord
Anne, in his uniform of the 2d Regiment of Guards, which, if painted by Ho-
garth, is his earliest surviving head-and-shoulders portrait. In 1733 Mary Ed-
wards commissioned a conversation of her family. The result is a transitional
work, somewhere between the small crowded conversations and the more monu-
mental *Lord Hervey and his Friends* of 1738. They are posing on the terrace of
the Edwards' house in Kensington, and Mary holds a copy of the *Spectator* open
at a passage on the virtuous rearing of children (private collection).

The catastrophe of her marriage was by now apparent to Mary Edwards. Lord
Anne was spending her money like water; on 15 August 1733 he secured the
arms and crest of Mary Edwards to himself and "the heirs of his body"; this
grant had been ratified on 2 July under Mary Edwards' own hand and seal, giv-
ing, granting, assigning and transferring her coat and crest to her husband. By
22 September he had taken the name of Edwards in addition to his own, as seen
in the £1,200 of bank stock inscribed in the name of the "Right Honourable
Edwards Hamilton" which he transferred from his wife's account to his own.
Mary must have seen what was happening. There were the child's interests to
safeguard, and she had no apparent recourse: no married women's property act,
and of course no marriage settlement. One thinks of Hogarth, harried at about
the same time by pirates and seeking a way out of a hopeless situation. Both, by
ingenuity and perseverance, succeeded. While he turned to the law, however,
she made use of the fact that her marriage had been clandestine. There had
been no contract, and she simply effaced all record of the transaction, from the
registers of the Fleet Chaplains to those of the church where the child was bap-

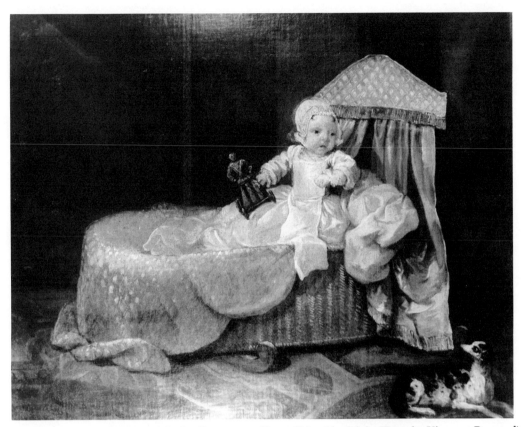

128. Gerard Ann Edwards in His Cradle; 1732; 12½ x 15½ in. (the Right Hon. the Viscount Bearsted)

tized. She replaced the latter with a notice in the register of the church of St. Mary Abbots, Kensington, on 28 March 1734, describing herself as a single woman and making her child a bastard. She was willing to assume this equivocal reputation to save her fortune for herself and her child. On 22 May 1734 Lord Anne signed a deed executed by "Mary Edwards, spinster, and the Honorable Anne Hamilton alias Anne Edwards Hamilton," which declares all the property returned to Miss Edwards. On 20 June the £1,200 of bank stock was transferred back to her account.

Having recovered her property, Miss Edwards carried on her own financial affairs, assisted by legal advisors—as is attested by the great mass of deeds, leases, and agreements that survived in the family. In 1734 or 1735, she bought from Hogarth the completed painting of *Southwark Fair*. This was a remarkable act for a woman and a spinster. She may have bought others as well that, like *Southwark Fair*, were not retained in the family after her death. To her more respectable heirs, only the portraits seemed suitable.[51] Sometime around 1740 Hogarth painted the splendid single portrait of her in an overwhelmingly red dress, strong and independent, with Lord Anne replaced by a faithful dog on whose

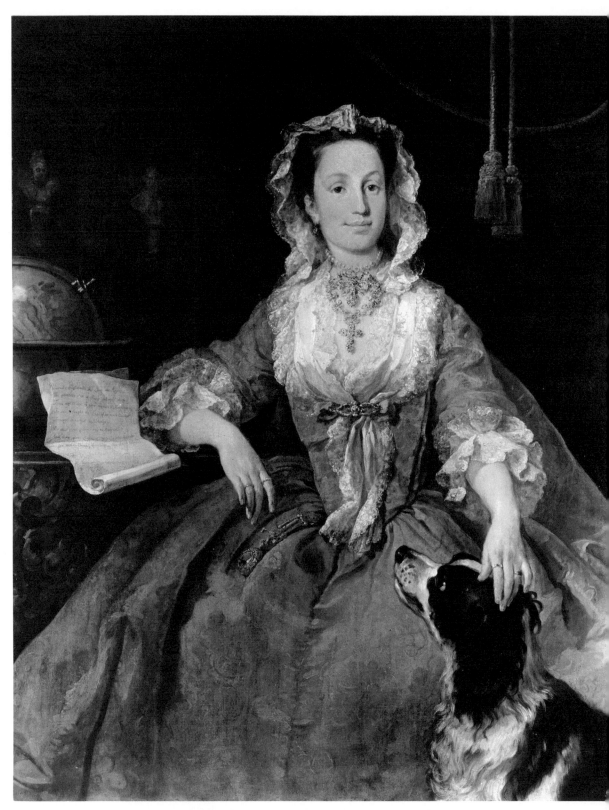

129. Miss Mary Edwards; ca. 1740; 49⅜ x 37⅞ in. (The Frick Coll., New York)

head she rests her hand (pl. 129). The happy relationship with Hogarth lasted until her death in 1743. One wonders how his career would have developed if there had been more than one Mary Edwards in England.

Although still a fashionable square, Covent Garden's reputation was no longer of the best. In 1730 its shopkeepers and tradesmen appealed to the Westminster Sessions:

> Several people of the most notorious characters and infamously wicked lives and conversation have of late . . . taken up their abode in the parish. . . . There are several streets and courts such as Russell Street, Drury Lane, Crown Court and King's Court and divers places within the said parish and more particularly in the neighbourhood of Drury Lane infested with these vile people. . . . There are frequent outcries in the night, fighting, robberies and all sorts of debaucheries committed by them all night long to the great inquietude of his majesty's subjects. . . .[52]

For drinkers and wenchers there were, within the purlieus of Covent Garden itself, Tom King's "coffeehouse" and Mother Douglas' bawdy house; and for gamblers, Mr. Stacie, owner of the Bedford, could be found at all hours presiding over a game of whist with Tiger Roach, his one-eyed bruiser, lurking behind him in the shadows. After debauchery there was the Hummums, the oriental baths on the southwest corner of Russell Street. In 1732 the house next to the Hogarths' had been converted into the entrance to Rich's new Covent Garden Theatre. Charles Macklin, the actor, arriving in 1733, remarked on the number of actors living nearby: "I myself, Sir . . . lived always about James Street, or under the Piazzas; so that . . . we could all be mustered by beat of drum; could attend rehearsals without any inconvenience; and save coach hire."[53] It was a neighborhood for actors, writers, theatrical hangers-on, and artists; the Hogarths, it seems, wished to move to a quieter, more fashionable area. Tradition has it that while making the *Rake's Progress* Hogarth was staying at Isleworth, near Twickenham, and amused himself by asking his neighbors and friends to identify the portraits.[54] This story, if true, probably refers to one of the houses he and Jane rented for the summer to escape the London heat and bustle.

The announcement on 9 October 1733 of his new subscription was also the announcement of his new address, the Golden Head in Leicester Fields. The rate books prove that he was in residence by 12 October at the latest, and that he might have taken over the house as early as April; a letter from Jonathan Tyers—probably, though not certainly genuine—is dated 1 May 1733 and addressed to him at Leicester Fields.[55] John Hoadly, some years later, wrote jokingly to Hogarth about his snobbish tendency to call it Leicester Square rather than Fields, but Macky, writing in the 1720s, remarks that it "was till within

these Fourteen Years always call'd Leicester-Fields, but now Leicester-Square."[56] Hogarth, however, continued to give his address as Leicester Fields in all his advertisements.

Leicester House had been built in the 1630s by Robert Sydney, second Earl of Leicester; here Elizabeth, Queen of Bohemia, died in the arms of her nephew, Charles II, and here in 1712 Prince Eugene was lodged and mercilessly entertained by both parties; the Whigs wanted to celebrate their hero, the Tories to keep him occupied and away from the questions of the peace treaty. Leicester House also served as the residence for the French Ambassador in Queen Anne's reign, and in the first years of George I was the residence of the German representative. In 1718, after the break between the King and Prince of Wales, it was bought by the prince for £6,000; in 1732 his son also took over the house as his anti-court residence. The house itself dominated the north of the square: two stories high, with tall windows facing on the square, implying the great reception rooms within. To the west, and forming one side of its courtyard abutting on the square, was Savile House, which was connected with Leicester House and served as the residence for the royal children and other relatives.

Macky thought the royal apartments were furnished "with a greater Air of Grandeur than the Royal Palace at St. James's. And in the rest of the Square are several Houses of abundance of the first Quality. The Middle is planted with Trees, and railed round, which gives an agreeable Aspect to the Houses."[57] The square had been developed by the earls of Leicester, and most of the houses were built in the later seventeenth century: some of those on the east side where Hogarth lived dated back to 1673 (pls. 130–31). It was one of the most fashionable and quietest of London squares in the 1730s, the noisy traffic of Coventry Street being cut off by the houses on its northwestern corner; the main entrance was at the southwest corner through Spur Street (now Panton Street). The garden with its walkways and grass plots had been enclosed in 1720, and from time to time in the 1730s the newspapers informed the public of the improvements being made in the square. "Leicester-Fields is going to be fitted up in a very elegant Manner, a new Wall and Rails to be erected all round, and a Bason in the Middle, after the Manner of Lincoln's-Inn-Fields, and to be done by a voluntary Subscription of the Inhabitants."[58] In 1743 the basin was replaced by a gilt equestrian statue of George I dressed in classical armor, which was acquired by the residents from the Duke of Chandos' garden at Cannons when that mansion was dismantled. It is impossible now to imagine what it once looked like. The quiet has been replaced by noise and the dignified houses by commercial buildings: the only sign of the famed former residents is a few shabby busts—Newton, Hogarth, Dr. Hunter, and Reynolds—and Hogarth's ironic memorial is in the cinemas that fill three sides of the square, producing, as a recent writer has wittily observed, " 'serial pictures' of a kind not contemplated by Hogarth."[59]

The five adjacent dwellings that included Hogarth's house were leased from

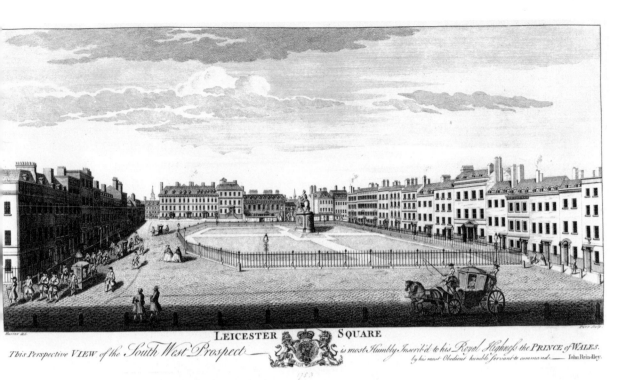

130. A view of Leicester Square; 1750. The house at the far right (east side) with the golden head of Van Dyck over the door was Hogarth's from 1733 to his death. The fifth house on the left, with obelisk lampposts in front, was Reynolds' from 1760–92.

131. The Leicester Square area, detail from John Rocque's map of London; 1746 (BM)

the Earl of Leicester's trustees to Thomas Cuthbert in March 1722/3 to run for fifty years, until midsummer 1772.[60] On 10 December 1732 Lady Mary Howard, who lived in the next-to-last house on the east side of the square (when numbered, No. 30), died, and her house went on the market.[61] Her relatives were still paying rates in April of 1733, and around that time Hogarth took up her sublease on the house. Its ratable value was £55: houses on the side streets went down to as little as £10, but on the east side of the square the lowest rate was £20, the highest £90. Though cut in half on the best-known prints of Leicester Square (pl. 130), the house was three windows wide and contained a basement and four stories. It was a plain but handsome house, its front broken by band courses above the second and fourth stories, and the door fairly elaborate with flanking pilasters and a cornice hood on carved consoles.

Above the projecting hood Hogarth placed his sign, the "golden head." In this, his one essay in sculpture, "he, out of a mass of cork made up of several thicknesses compacted together, carved a bust of Vandyck, which he gilt, and placed over his door. It is," Nichols writes at the end of the century, "long since decayed, and was succeeded by a head in plaster," perhaps after Hogarth took it down in anger following his unsuccessful auction in 1751; and that plaster in turn was followed by another. He is also supposed to have modeled a head of Van Dyck in clay.[62] He must immediately have raised the gilt cork bust, since it already identifies the house in his earliest advertisement. It proclaimed first, a business establishment of some kind, and second, the owner's profession of art, specifically portrait painting. Moreover, the choice of Van Dyck indicates that Hogarth was a proponent of the English tradition of portraiture with its northern antecedents (Rubens-Van Dyck-Lely-Kneller), rather than the so-called "foreign" schools from Italy and France.

Thus the new house was a handsome residence a step up (in location at least) from the Thornhills' house in Covent Garden, but at the same time distinguished by a shop sign; and out of sight, behind the house, Hogarth built a painting room, probably necessary since the house faced east and west, and he needed a good north light for his painting.[63] (In the 1750s Reynolds did much the same with additions to the back of his house across the square.) Some idea of the inside may be had from the ground plan of a neighboring house, No. 12 (later No. 28), inhabited in the 1770s by John Singleton Copley and in the 1780s by Dr. John Hunter. The hall and the main staircase were on the right as one entered, and the parlor and backstairs on the left; the house was bowed at the rear with two rooms shaped accordingly, which in Hunter's time served as a study and an afternoon bedroom.[64] Hogarth must have had a show room on the ground floor where he hung his modelli and samples, and at this time showed the paintings of *Southwark Fair* and as much as was completed of the *Rake*, together with engravings. The upper floors would have been living quarters for

the Hogarths, with servants on the top floor and kitchen and other servant quarters in the cellar (by the 1750s there were at least six servants).

When George and Caroline lived in Leicester House the area had been a center of intellectual activity. Newton lived on the south side of the square and was often carried in his chair to Leicester House to participate in the philosophical discussions; Clarke, Hoadly, Sherlock, and Berkeley met with Caroline there for this purpose. When Hogarth moved into the square, a scattering of high nobility remained, and some high-ranking army officers; for the rest, there was the magistrate Thomas De Veil, the painter Hans Hysing, and a few years later the writer Paul Whitehead. A fashionable tailor lived a few houses down the street from Hogarth. The Hogarth house, next to the last house on the bottom of the square, where the houses got smaller, was in fact almost into Green (now Irving) Street.

It is interesting to consider Hogarth living in this square, even then in one of the busiest parts of London, but cut off and a quiet, aristocratic haven; and just a block away from the long snake of St. Martin's Lane, the arts and crafts street of eighteenth-century London, where artists rubbed shoulders with musicians and writers, and booksellers with tavern- and coffeehouse-keepers. Here was the sphere of Hogarth's activity: he was of it and yet withdrawn from it—around the corner, so to speak. Slaughter's Coffee House, just south of Great Newport Street, was the center for artists. One wonders if Hogarth did not, in those years as he was painting the *Rake*, think of his morality play as the description of an alternative to his own path: he had risen like the Rake, though by his own effort, and faced the same temptations offered by society—slipping into the servility of fashionable portrait (or, more accurately, face) painting, adopting an expensive equipage, taking a fashionable and expensive house, and playing up to the nobility. At what point, he may have asked himself, does Hogarth end and Rakewell begin?

Artist and Activist

In view of Hogarth's multifold activities of the mid-1730s, his most freneti-
cally active years, one might imagine him a compulsive joiner and a very sociable
man; this is the Hogarth who frolics among his friends in the "peregrination"
and drinks with Frank Hayman in other anecdotes. Every relationship with a
group, however, proves on closer examination to be directed either to self-
advancement or to self-improvement. But this aim incorporates a generalized
desire for the advancement of the larger body of English engravers, of English
artists, of all Englishmen. Each enterprise, club, or friendship extends a personal
position into a public one. Hogarth was naturally gregarious and translated
thought into conversation and then into action. But he was also typical of the
vir bonus of his time: the member of the Kit Kat or Scriblerus Club whose life
was public, enacted in the context of the *polis*. Henry Fielding, who spent his
most vigorous years as a Westminster Magistrate, is the best example, but any
writer or artist of note between 1700 and 1750 would serve nearly as well. Any
personal action, to be meaningful, had to have a public significance.

One might begin with Freemasonry: Hogarth was a mason from the early
1720s onward. In 1731 he was a member of the lodge that met at the Bear and
Harrow in Butcher Row (far east of the Tower), later called the "Corner Stone"
Lodge.[1] As one masonic authority says, "its list of members shows it to have been
one of the most distinguished Lodges of the day."[2] First there were the great
names: Lord Montagu (who had been Grand Master in 1722), Desaguliers (an-
other former Grand Master), the Earl of Strathmore (Master of the Lodge),
Lord Tynham, Lord Montjoy, Charles Stanhope, and so on. More to the point
were the members who formed the nucleus of Hogarth's intimates, who crop up
repeatedly in the records of his life: the actors James Quin, Theophilus Cib-
ber, William Milward, and Henry Giffard; the musician Richard Leveridge;
the actor-artist John Laguerre; the artist John Ellys; and the lawyer-poet Eben-
ezer Forrest. Here Hogarth and his friends met in convivial seclusion, ex-
changed secret signs, and, sharing secret symbols and a slightly (though com-
fortably) subversive tone, rubbed shoulders with the greatest aristocrats.

Beyond the particular lodge the circle included all the other brothers, known by a secret handshake and encountered at the Grand Lodge dinners once a year. At the dinner held on Saturday 30 March 1734 at the house of the Earl of Craufurd in Great Marlborough Street, "mett a Splendid Appearance of Noblemen and Gentlemen of the first Rank (being Masons) all clothed in White Aprons and Gloves," who proceeded in

> regular manner in Procession to Mercers Hall in Cheapside, and being withdrawn into a Convenient Room the Masters and Wardens of the respective Lodges were called in
> Then the Deputy Grand Master proposed the Rt Honble The Earle of Craufurd to be Grand-Master for the Year ensuing who was unanimously accepted of with great Applause
> Adjourned to Dinner.

After the dinner the Deputy Grand Master led a procession to take leave of the Earl of Strathmore, the outgoing Grand Master and the Master of Hogarth's lodge, then invested the new Grand Master and elected other officers. Among others, the twelve present Stewards "were called up, and Thanks returned them from the Chair for the Care they had taken in providing such an elegant Entertainment for the Society and at the same time their Healths were drank and also desired to proceed for each Steward to name his Successor for the ensuing year which they did in manner following. . . ." The "present Stewards" included Charles Fleetwood, who had just bought Highmore's patent from him and now controlled Drury Lane, Dr. Meyer Schomberg, and Thomas Slaughter. The last (an appropriate steward, being the proprietor of Slaughter's Coffee House) chose as his successor Hogarth. "The general Healths being drank the Feast was concluded with great Harmony and Unanimity." At the dinner the next year, 17 April 1735 (as the Engraver's Act and the *Rake's Progress* were moving toward mutual completion), Hogarth and the eleven other stewards were thanked for their service. Hogarth's successor is not named, but one of those chosen was Isaac Schomberg, son of Dr. Meyer Schomberg, and Hogarth's friend and physician in later years.[3]

With the names of these Freemasons one may cautiously proceed to the center of Hogarth's social life as an artist. Old Slaughter's Coffee House, which Baron Bielfield in 1741 compared to Paris' Procope Coffee House (another analogue would be the Café Royal of the 1890s) was a center for artists: "The rendezvous of all the wits and the greatest part of the men of letters in town."[4] Thomas Slaughter had moved to this spot, on the west side of St. Martin's Lane (Nos. 74 and 75 when numbered), three doors from Newport Street, in 1692. His friendship with Hogarth, and his knowledge of him as a suitable steward, has been demonstrated; a man in his late sixties at this time, he died in 1740 and the business was continued by Humphry Bailey until 1749, when John Barwood

took over and added the bow front seen on most pictures of "Old Slaughter's." ("Young" or "New Slaughter's," a competitor, was founded in 1742 a few doors south.)[5] The other names associated with Slaughter's—Gravelot, Roubiliac, Hudson, Lambert, Hayman, John Pine, Jonathan Richardson, Fielding, and Garrick—come from much later lists, often manufactured, one suspects, on the basis of the artists and writers, physicians and "characters" known to have lived nearby.[6] Obviously, an important group among the Slaughter's habitués was that later connected with the St. Martin's Lane Academy, in many ways an off-shoot of the coffeehouse.

The most influential member of the group was Hubert François Gravelot, a young Frenchman of 33 (two years Hogarth's junior), who had come to England around 1732 to help Dubosc with his engravings for Picart's *Cérémonies et coutumes*. He was, as his apprentice Charles Grignion noted, "a designer; but could not engrave. He etched a great deal in what is called the manner of Painters etchings, but did not know how to handle the graver."[7] He served engravers as a designer, and it was as a designer (only one or two oil paintings have survived) that he influenced the Slaughter's group by introducing ways of using the rococo c- and s-curves as the basis for both decorative work and larger compositions.[8] With his appearance on the scene, Hogarth moved sharply to the left of the Raphaelesque classicism of his early *Hudibras* and *Harlot* plates to develop the sinuous, agitated compositions already implicit in some of his painted conversations.

The earliest rococo pattern book was published in 1736 by an Italian, Gaetano Brunetti, full of shells, flowers, crooked scrolls, and cartouches; intended, he explains, for "painters, sculptors, stone carvers and silversmiths"—who were, in fact, the promulgators of the style in England. But already in 1735 Gravelot had made his illustrations of royal tombs in Pine's *Heads and Monuments of the Kings* (1736), followed by decorative frames for Birch's *Heads of Illustrious Persons* (1738).[9] Almost at once he appears in collaboration with other artists of the Slaughter's circle. Besides the work with Pine, Vertue notes, he made designs for silver (it may also be significant that Lamerie began to experiment with rococo forms on his plate in the 1730s), and he is known to have worked with Francis Hayman on the illustrations for Hanmer's edition of Shakespeare (1743–44) and, most important of all, with both Hayman and Hogarth on the Vauxhall decorations. In October 1745 he left London for Paris, not to return, presumably because of the war between England and France.[10]

Hayman, who seems to have been one of Hogarth's closest friends, was apprenticed in 1718, at about fifteen years of age, to Robert Browne, a history painter of the Painter-Stainers' Company, and worked as an interior decorator and scene painter at theaters. Judging by the anecdotes that have survived, he was a good eating and drinking companion, noted for his extraordinary appetite.[11] One story places him with Hogarth in a brothel in 1733 or '34, where they

observed two prostitutes quarreling: "one of them, who had taken a mouthful of wine or gin, squirted it in the other's face, which so delighted the artist [Hogarth], that he exclaimed, 'Frank, mind the b—'s mouth!' "[12] Hogarth is consequently supposed to have introduced the incident into the third plate of the *Rake's Progress*. The anecdote is given less for its veracity than to illustrate the contemporary view of Hayman and his relationship with Hogarth and others. As an artist, Hayman was Gravelot's closest student, or at least the one who most directly and literally took over his small decorative patterns and applied them to large, even heroic compositions, especially at Vauxhall Gardens. After Hogarth he was the most various and experimental painter of the group—a fact sometimes obscured by the lively but crude product.

Perhaps the closest relationship of all was between Hogarth and George Lambert. Two years Hogarth's junior, Lambert is first mentioned by Vertue in September 1722 as a pupil of Warner Hassell, "a young hopefull Painter in Landskape, aged 22. much in Imitation of Wotton. manner of Gaspar Poussin." By 1726 he was painting sets for Rich, and continued to furnish Rich with sets for many years.[13] In 1727 he was prosperous or vain enough to have his portrait (painted by Vanderbank, 1725) published in a mezzotint by Faber. And around this time Hogarth made him a bookplate (see above, pl. 14), which "was stuck in all his books; and . . . his library consisted of seven or eight hundred volumes."[14] Hogarth had some fun with the design. The supporters are Music holding a flute, leaning a heavy elbow on the escutcheon as she rubs her forehead for inspiration; apparently in vain, for the other hand holds a book of blank pages. She looks enviously at the other supporter, the more active muse of Painting daubing vigorously at the coat of arms with her brush. The irreverent grin on Painting's face and her activity on the coat of arms, together with the spelling of Lambert's name as "Lambart" (was Lambert claiming a connection with the Lambarts who were Earls of Cavan, whose arms were similar to those presented?), may suggest that Hogarth is joking about Lambert's various pretensions. As Hogarth himself was a history painter who produced popular prints, Lambert was a landscapist who painted theater sets.

Like any judicious landscapist, aware of his position in the aesthetic hierarchy, Lambert heightened his scenes with figures "in order to give us Opportunity of employing our Reflections."[15] While Hogarth avoided landscapes—he was never adventurous in that direction—he painted figures for Lambert's landscapes in the 1730s. His figures are easily recognized in Lambert's *Landscape with Farmworkers* (pl. 132), four views of *Westcombe House, Blackheath* (Wilton House), *Ruins of Leybourne Castle* (dated 1737; private collection), and *Hilly Landscape with Cornfield* (dated 1733; Tate). Hogarth and Lambert apply paint in the same way and their foliage and architecture at times look so similar that it is difficult to say whether they shared a style or Lambert helped Hogarth out with background as Hogarth helped him with foreground. Lam-

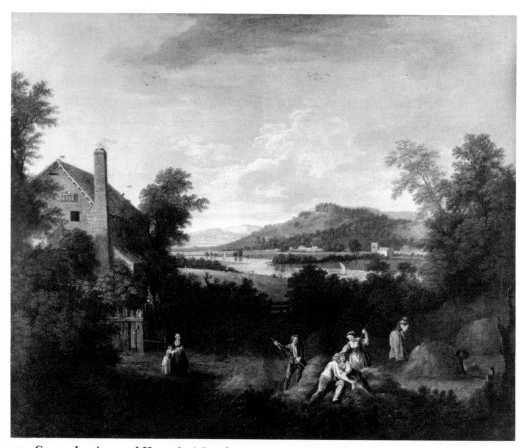

132. George Lambert and Hogarth, A Landscape; 1730s; 38½ x 48½ in. (Mr. and Mrs. Paul Mellon)

bert's country views with haystacks and cornfields, farmhands and dairy maids, belong in his own canon, but with the ratio of landscape and figures slightly altered some would be rural versions of Hogarth's comic histories.[16]

John Ellys (or Ellis) should also be mentioned. He had been apprenticed to Thornhill and may have assisted him at Greenwich. He and Hogarth first met, and their common attitudes were cemented, in the Vanderbank Academy.[17] They were Freemasons in the same lodge and fellow members of the Rose and Crown, another artists' club.[18] Ellys too was interested in the theater (he "had always been tampering with the Theatres," according to Benjamin Victor), and (as I have noted) he acted in the early 1730s as deputy for Wilks' widow in the management of her shares of Drury Lane.[19] He was apparently a man of independent means. As an entrepreneur, he had bought Vanderbank Senior's tapestry works and office of tapestry maker to the crown when they were sold to free the young Vanderbank, and as a painter he stuck to portraiture and made an easy living, though he is also reported to have done some genre subjects. Like Hogarth, he had painted Lavinia Fenton as Polly Peachum and Walker as Mac-

heath soon after *The Beggar's Opera* opened.[20] He was later Hogarth's staunchest supporter in the original founding of the St. Martin's Lane Academy, perhaps contributing financial assistance.

Slaughter's is never mentioned by George Vertue, and none of his circle of friends appears there. Vertue belonged to what he described as "the tip top Clubb of all, for men of the highest Character in Arts & Gentlemen Lovers of Art—calld the Clubb of St. Luke." This club, which traced itself back to Van Dyck (its founder), Lely, Riley, Verrio, Dahl, and Wren, was now made up of "the present set of Artists & Lovers of the best reputation living." The names can be partly filled in from a surviving list of its stewards and from the group painted by Gawen Hamilton: Vertue, Hysing, Dahl, William Thomas (described by Vertue as steward to the Earl of Oxford), Gibbs, Goupy, Sir Thomas Robinson, Bridgeman, Baron, Wootton, Rysbrack, Hamilton, and (somewhat later) Kent. These virtuosi, according to Vertue, met at the King's Arms, New Bond Street, and, a much closer artistic equivalent to the Dilettanti Society, they were a very different group from those who met at Slaughter's.[21] When Vertue raises his eyebrows at some practice of Hogarth he is probably reflecting the view of most of these vis-à-vis the decorators, craftsmen, scene-painters, writers, actors, and doctors who gathered at Slaughter's.

From all accounts, Hogarth appears to have been the first of the group to know Jonathan Tyers and grasp the potential of a public pleasure garden as a location for showing contemporary art. Tradition has it that Hogarth met him shortly after he went to Lambeth with his new wife in 1729, or during one of his early summers there. Tyers took a lease of Spring Gardens at Vauxhall in 1728 and reopened the gardens in 1732. In a letter dated Vauxhall, 1 May 1733, he wrote to Hogarth (then in Leicester Fields):

> My dear Friend,—Accept as a testimony of regard the accompanying gold medal, as a 'perpetuam beneficii memoriam' for your many past favours, also my likeness, done when in Paris. It was said to be very like, but your correct eye will discover any defect, and easily recognize the Frenchman's hand. The bouquet, with best respects, to Mrs. Hogarth.—
> Believe me, ever yours faithfully,
>
> Jona Tyers.[22]

The gold medallion, inscribed "IN PERPETUAM BENEFICII MEMORIAM" with Hogarth's name on one side and allegorical figures on the other, admitted "a coachful," i.e. six persons. The most reliable account of the affair, though undoubtedly improved in the retelling, comes from John Phillips, who had some family connections with the Hogarths and had the story from Mary Lewis (who would have had it from Hogarth):

On passing the tavern [i.e. at Vauxhall] one morning, which was then kept by Jonathan Tyers, and open, together with the gardens, as a place of recreation daily, Hogarth saw Tyers, and observing that he looked particularly melancholy said, 'How now, master Tyers, why so sad this morning?' 'Sad times, master Hogarth, and my reflections were on a subject not likely to brighten a man's countenance,' said Tyers, 'I was thinking, do you know, which would be likely to prove the easiest death—hanging or drowning.' 'Oh!' said Hogarth, 'is it come to that,' 'very nearly, I assure you,' said Tyers; 'then,' replied Hogarth, 'the remedy you think of applying is not calculated to mend the matter—don't hang or drown to day. I have a thought that may save the necessity of either, and will communicate it to you tomorrow morning: call at my house in Leicester Fields.' The interview took place, and the result was, the concocting and getting up the first 'Ridotto al Fresco,' under which denomination it was announced, and being then a novelty in England, proved a very successful hit; and from that time must be dated the commencement of that delightful and justly celebrated place of public amusement. Hogarth was then in prosperity, and assisted Tyers, more essentially than by a few pieces he painted for the decorations; and Mr. Tyers presented him with the gold medal in question, as a ticket of admission for his family and friends.[23]

From this one may gather that, at the least, Hogarth gave Tyers ideas for ways of attracting the public; and John Lockman's *A Sketch of the Spring-Gardens, Vaux-hall. In a Letter to a Noble Lord* (1752), after listing all the pictures, adds: ". . . the hint of this rational and elegant *Entertainment* was given by a *Gentleman,* whose *Paintings* exhibit the most useful lessons of *Morality,* blended with the happiest strokes of Humour"—the terms in which contemporaries identified Hogarth.[24] The debut of the newly decorated gardens was 7 June 1736: "On this occasion the Gardens were splendidly illuminated, and the entertainments consisted of a *Ridotto de Fresco* [sic], which was attended by about four hundred persons." An orchestra stand had been erected, and a number of pavilions and supper-boxes "adorned with interesting paintings by F. Hayman and Hogarth"; or, according to another edition, "ornamented with paintings from the designs of Mr. Hayman and Mr. Hogarth, on subjects admirably adapted to the place; and each pavillion has a table in it that will hold six or eight persons." Ultimately there were fifty supper boxes surrounding the central quadrangle, called the Grove, and each contained pictures, most of them eight feet wide.[25]

Hogarth's *Henry VIII and Anne Boleyn* hung in one supper box—but it was presumably a copy of the engraving; copies of his *Four Times of the Day* paintings graced another pavilion. There may have been a few actually painted by Hogarth;[26] it would be surprising if he acted only in a supervisory capacity, though it must have been painfully evident to him that the life of a painting at

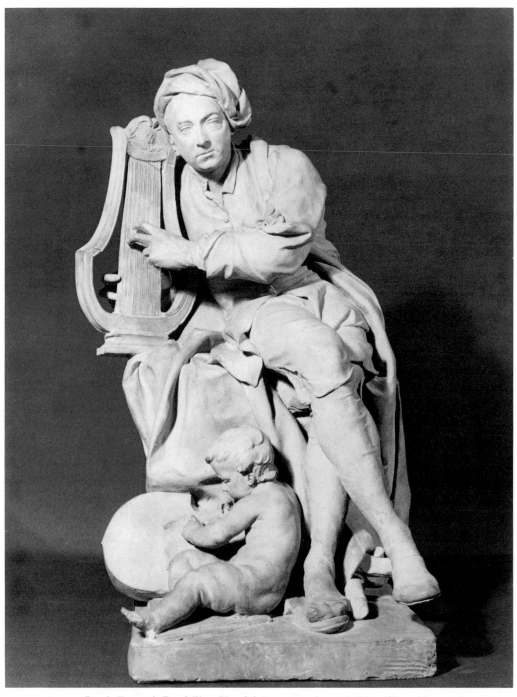

133. Louis François Roubiliac, Handel (terra-cotta); 1738 (Fitzwilliam Museum)

Vauxhall was precarious indeed, endangered by flying bottles or food.[27] But when engravings after eighteen of the Vauxhall pictures were published by Thomas Bowles in 1743–44, the original paintings were all attributed to Hayman (who also painted portraits of Tyers and his family). The paintings from this period were scenes from plays, illustrations to romances and (after 1740) to novels, and romantic pictures of rural festivals and games.

Another member of the Hogarth circle was an older man, the sculptor Henry Cheere, who sometime around 1737 introduced François Roubiliac to Tyers.[28] The result was Roubiliac's statue of Handel (pl. 133), the most important manifestation of the Slaughter's circle in its early days, unveiled at Vauxhall in 1738 —the first great informal portrait in English sculpture, catching its subject with wig off, vest unbuttoned, and slippers askew. Perhaps significantly, the only musical score among those Handel has by him that bears a precise title is *Alexander's Feast,* which had been published earlier in the same year with an engraved design by Gravelot. Within three years Hogarth had gotten Roubiliac to perpetuate his own face in the same style, with a separate terra-cotta of his pug, which again underlines the informality of the mode. Roubiliac later added statues of Harmony and Genius to complement his Handel at Vauxhall. Besides Hogarth, Hayman, and Gravelot, George Michael Moser decorated the Rotunda, Richard Yeo designed the medals used for admission, and it is likely that Lambert had a hand in many of the background landscapes. In 1737–38 Hayman and Gravelot designed vignettes and decorations for the music sheets of the Vauxhall Songs (the words were by Hogarth's friend John Lockman, who later wrote an early description of Vauxhall). Indeed, Vauxhall looks almost like a group project.

What these artists offered was a breath of fresh air in the stuffy world of English art in the 1730s. Gravelot supplied an elegant device for breaking sharply with the neat, orderly, and over-schematized "official" art of the day. But more generally, the group was unified by a mutual impatience with the authority and idealism of Renaissance-derived, French academic dogmas, and a desire to return to nature: human nature and English, empirical nature. In his manuscript notes Hogarth is constantly reiterating the characteristic approach of this group: a conviction that the artist should not filter his view of the world in the manner of Palladio or even Raphael, but should depict what he sees with his own eyes. The attitude is reflected in Isaac Ware's complaint that "the modern architects too strictly and scrupulously follow these antients" and Paine's comment on Palladio: "Experience daily convinces us, that the houses built by that great master, are very ill adapted to our climate, still worse to our present mode of living, and consequently are not proper models for our imitation."[29]

What the English rococo did to "recover nature" was to provide for it a shape and a subject: the present time, the ordinary place whether city or country, the ordinary person, and certainly the forthright approach. Hogarth had already

dramatized one form of this development in his *Harlot's Progress,* and (influenced more and more by Gravelot) was about to illustrate another in the *Rake's Progress.* His artist friends, decorating houses or pleasure gardens and painting stage designs or landscapes, were reacting to the new mode by replacing cherubs and satyrs with squirrels and foxes, abstract designs with oak and laurel leaves, or assemblies of gods with Hayman's swinging, dancing rustics.

The questions of academic theory, rules, and old stereotypes all came to focus for the Slaughter's group in the economic situation of the English artist. There was no dominating patron after Burlington: the artists who met at Slaughter's earned much of their living from book publishers and printsellers, gold- and silversmiths, manufacturers of pottery, cabinets, and furniture, and theater managers for whom they painted scenery. These outlets were adequate but hardly satisfactory to ambitious artists. They were fully aware that only by displaying their original works *as works of art* could they hope to undermine the prejudices of powerful connoisseurs; and facilities for display being meagre at best, the native artist was, in effect, trapped in his role of craftsman.

One night in 1734 or '35 Jonathan Richardson was present at Slaughter's and holding forth, according to one account: reading from his new work on Milton. In the preface he explains how he uses his son, Jonathan, Jr., as "my Telescope" through which he sees the old masters in Italy he has never seen himself.[30] Hogarth picked up the metaphor and sketched him looking through a telescope injected in his son's rectum; the son's eyes are directed upwards at a row of old master paintings, a copy of Vergil, and other items. The drawing, which Horace Walpole describes, survives only in a probably garbled etching.[31] When Hogarth showed the drawing to Richardson, according to Samuel Ireland's version, the artist perceived the old man's uneasiness; so "he threw the paper into the fire and there ended the dissatisfaction."[32] The drawing, however, was symbolic. What Richardson represented to Hogarth and his friends was the dilettantism which the ordinary Englishman was expected to consider the ultimate in good taste: the desire for a telescope when there was much to see under his very nose.

In 1715 Richardson Sr. had created the "connoisseur," who went to Italy equipped with the proper texts, looked at the proper pictures and statues, and returned a Roman. His *Theory of Painting* of 1715 was followed by *The Whole Art of Criticism in Relation to Painting* and *An Argument in Behalf of the Science of a Connoisseur* in 1719. To do him justice, he was as eager to see an English school of painting in the grand manner develop and flourish as to see the English aristocracy develop into connoisseurs. As soon became apparent, the English aristocrats took the second part of Richardson's challenge seriously but, ignoring the first part, simply bought "old masters" from the Continent with greater assurance. Finally, Jonathan Jr. went to Italy and published *An Account of the Statues, Bas-reliefs, Drawings and Pictures in Italy, etc.* (1722), which became a kind of Bible for the young Englishman who went abroad, telling him

what he should see, what he should like and dislike. With this guide he bought
pictures (usually copies, whether he knew it or not) and returned to England the
champion of this particular art and willing to buy more copies imported to
London. In 1734 connoisseurship and the Grand Tour received the sanction of
a club of their own, the Society of Dilettanti.[33]

In the face of the Richardsonian assumptions, there were two avenues open to
the English artist in need of an audience: thus Hogarth and others like him ex-
pended much energy on both the production of artistic propaganda and the
problem of exhibiting. Part of his particular genius was the ability to sense
where new patrons could be found and how the artist could exploit them. It is
noteworthy that his name is connected with the instigation of every new stage
in the English artist's emancipation: freeing the engraver from printsellers by
his own subscription; freeing the designer from the pirates by the Engravers'
Act; freeing the painter from patrons by turning to impresarios like Jonathan
Tyers of Vauxhall and to public buildings like St. Bartholomew's Hospital and,
a few years later, the Foundling Hospital.

This, however, gives only a general perspective of the 1730s and 40s; it is
time to follow the machinations of Hogarth and his friends year by year as these
attitudes took formal shape. The climate of English connoisseurship was still
favorable when Jacopo Amigoni (or Amiconi) arrived in 1730, followed a few
years later by Jean Baptiste Vanloo. After Thornhill's victory over the St. Paul's
commission in 1710, the Ricci uncle and nephew had continued doing profitable
work for Lord Burlington and his friends for a few years; since the elder Ricci's
departure in 1716, Amigoni was the first foreigner of note to try England. An-
other Venetian—"a still fainter imitation of that nerveless master Sebastian
Ricci," as Horace Walpole wrote[34]—by 1732 he had painted the ceiling of Rich's
new Covent Garden Theatre with *The Muses presenting Shakespeare to Apollo,*
and had decorated several stately homes; he had painted many portraits, includ-
ing the three princesses; and he had been hired by Benjamin Styles to paint
seven or eight panels at Moor Park to replace those by Thornhill over which
Styles had suffered his lawsuit. He was patronized by the English royalty and
nobility, and even had scenes hanging at Hampton Court: "Children Playing
with a Goat" and "Boys Playing with a Lamb." And in all, he was, for Hogarth
at least, a target in a personal as well as a general sense.

Ellys too, Hogarth's friend and Thornhill's pupil, would have seen the
danger Amigoni represented. He was at this time a friend of the journalist James
Ralph; probably Hogarth knew Ralph too, who was a friend of Fielding and a
few years later his assistant on the *Champion.*[35] Since January 1731 Ralph had
been editing a pro-ministerial newspaper called the *Weekly Register,* in which
he set himself the task of reforming the taste of the age. As early as February
1731 he included an "Essay on Taste in General"; on 3 June 1732 he turned to

painting, beginning, "There is no one Subject in the World that is more fre-
quently talk'd of, or less understood, than *Painting*." Throughout he sounds
the line to be reiterated by Hogarth and his friends, and singles out for praise
"the ingenious Mr. Hogarth" and his *Harlot's Progress*, which had just been
published.[36] Then, beginning in mid-October 1733 and running till April
1734, he published a series of some twenty essays called "Critical Review of the
Publick Buildings, Statues and Ornaments, in and about London and West-
minster," attacking the "gothicism" of Hawksmoor and defending palladianism.

At this point, probably early in 1734 when he was busy in the subscription
for the *Rake's Progress*, Hogarth learned that Amigoni was negotiating with
the governors of St. Bartholomew's Hospital (unofficially, since no word of this
reached the minute books) for the decoration of the new hospital building's
staircase and perhaps Great Hall. In 1734 the plaster work was finished in the
administrative or "ceremonial" block (the so-called first wing), which was more
elaborately decorated than the rest of the hospital, and the surfaces were ready
for painting. Amigoni had been approached by one or more of the governors.
Here indeed he was treading on Hogarth's home territory.[37] Hogarth seems to
have known John Lloyd, the "Renter," or rent-collector, of the Hospital, and
set straight to work exploring the situation. He must also have known James
Gibbs, the Hospital's architect, who had been part of the circle that included
Bridgeman and Thornhill and worked on Lord Harley's house, Wimpole Hall,
between 1721 and '24. Gibbs probably encouraged Hogarth (who later did a
portrait of him). The upshot was that Hogarth volunteered to decorate the stair-
way gratis, as an Englishman vs. a foreigner (echoing Thornhill's old cry), and
Lloyd, on behalf of the governors, agreed. It appears that Lloyd exerted some
influence for Hogarth since, in "acknowledgement for his services in connection
with this work," Hogarth offered to paint his portrait and, in 1738, did paint
his son John.[38] On 20 February agreement was reached, and on the twenty-
third Ralph could crow in his *Weekly Register:* "We hear that the ingenious
Mr. *Hogarth*, is to paint the Great Stair-Case in *St. Bartholomew's-Hospital*,
with the Histories of the *Pool of Bethesda* and the *Good Samaritan*."[39] Al-
though Hogarth can have done no more than sketches or perhaps the modello
of *The Pool of Bethesda* (pl. 140), on 27 April Ralph linked him with Thorn-
hill and asserted that he was "sure no Body can say they have not found their
Account in . . . [history painting] both in Interest and Reputation."[40] Hogarth
had cast down the gauntlet to foreign history painters.

Ralph's next move was as much a defense of English painters like Hogarth as
an attack on Amigoni. On 20 April he began a discussion of history painting, in
which he emphasized Steele's admonition on "the judicious Choice of a Sub-
ject," and in the issue for 4 May—the same day, as it happened, that Sir James
Thornhill died—he launched into an attack on Amigoni. He begins by allowing
that "when they neglect their own Countrymen in Favour of a Foreigner," the

English should have "undeniable Evidence, that he has real Merit to deserve the Preference"; but Amigoni has no merit—and to prove it Ralph examines the paintings on Lord Tankerville's staircase, on the ceiling of the Covent Garden Theatre, and on the staircase at Powis House.[41] Of the painting on Tankerville's staircase, he comments: "the Ornaments about it are neither proper Decorations of the Paintings, nor have they any Relation to the Stair-Case itself: So that both Paintings and Decorations might as well have been in a Dining-Room, Gallery, or Bed-Chamber, as there." Above all, he attacks the work in Powis House, which confirms him in his opinion "that the Paintings of that *Master,* are only calculated to please at a Glance by the artful Mixture of a Variety of gay Colours, but have no Solidity in them; and, of Course, will not bear an Examination." The three frescoes along the great staircase and on the ceiling were, he concludes, gibberish: they apparently showed Judith holding Holofernes' head, Antony supping with Cleopatra, David and Abigail in the wilderness, and (on the ceiling) the "first Out-set of the Morning, attended by Hesperus, Zephyr, and the Hours." They are confused, inappropriate, and in the story of Antony and Cleopatra, "Signor Amiconi seems to have copied the Gallantries of some fat rich Alderman, and his extravagant Spouse."[42] Unfortunately, Ralph's identifications were wrong: the three panels all told the story of Judith, and the ceiling showed the four seasons. The *Grub-street Journal* accordingly launched a counterattack, and so it went for some months.[43] It is a pity that Ralph did not think to emphasize the discrepancy between the alleged subject and these fanciful designs in which Old Testament figures were dressed in Roman togas in Venetian settings.

Although in general the *Grub-street Journal* merely ridiculed Ralph, in the issue of 27 June it faced the issue of English vs. foreign painters and solidly supported Amigoni against all English competitors.[44] Ralph, returning to the attack, concluded with the remark that "while the elder *Vanderbank* lives"—by whom he must have meant John as opposed to his younger brother Moses—"there is hardly a Foreigner in *Europe* will deserve such mighty Tenderness here."[45] Ignoring the question of Vanderbank's quality, "Bavius" in the *Journal* merely enquired whether or not he were an Englishman, and if not, why cannot another stranger deserve a share of tenderness as well?[46] Although John Vanderbank the painter (as opposed to his father, the tapestry weaver, who died in 1717) was born in London, it appeared that Ralph was defending one foreigner against another; in fact, as I have observed, Vanderbank represented the assimilated tradition of the north against the un-English Italianism touted by the "connoisseurs." Many years later Ellys responded to the Italianism of Reynolds' first paintings, exhibited in 1753: "Ah! Reynolds," he is supposed to have said, "this will never answer. Why, you don't paint in the least like Kneller." And when Reynolds tried to defend himself, Ellys—sounding very much the note

Hogarth must have sounded at times—cried, "Shakespeare in poetry, and Kneller in painting, damme!" And walked out of the room.[47]

It is evident that Amigoni's supporters recognized Ralph's hand and saw what he was up to, for they returned his fire in a poem sent to the *Grub-street Journal* and published in the same issue that caught his error on Vanderbank's Englishness—5 September: "You mention RALPH, dear BAVY, in your last . . . In painting, with the help of JACK, his crony, / Good lord! what work he's made with AMICONI!" "Jack" was clearly Ellys; and in the same issue Bavius remarks that an "eminent painter was privy" to Ralph's attack "and that they have more than once diverted themselves and others with the unmeaning manner" of Amigoni's histories. Either Hogarth (the better-known of the two as an "eminent painter") or Ellys may have been meant here, and both were included in the reference of 19 September (No. 247) to "those little painters, who were the *employers* of this admirable Critic [Ralph], and first *prescrib'd* to him this dirty work, or at least incouraged him in it"—which recalls Vertue's comment in 1732 that "I observe the most elevated Men in Art here now, are the lowest of stature"; he singles out Hogarth, among others.[48]

The death of Thornhill, the only recognized English history painter, while the controversy was raging, was symbolic of the plight of English painting. In fact, his illness during the spring may have been somewhere in the background of Ralph's polemic. Vertue records that he had

> been much out of Order the last twelve month sometimes afflicted with the gout but one of his leggs swelling as if dropsy the last years of his life, but alwayes a man of high Spirit. but not long before he died he had a more violent Illness in London that had taken away his Voice. but recovering a little better. (being fully resolv'd or not inclin'd to be a member of parliament if he coud) he resolvd to go to his Country seat of Thornhill near Weymouth. were being arrivd. but fatigued with his journey he did not survive many dayes. <Monday April. 29 he set out. & died the Saturday following> as is mentioned in the London News papers a long account of him.[49]

Vertue adds that "he died aged 57.—setting in his chair." The *Daily Journal* for 11 May called him "the greatest history painter this kingdom has in any age produced" (which the *Grub-street Journal* reprinted without comment); and Ralph's *Weekly Register*, No. 219, for 18 May, quotes the *Journal* and calls him "the greatest History Painter this Kingdom has in any Ages produc'd." On 6 July (No. 226) it praised his paintings at Greenwich. The *Gentleman's Magazine* printed a sympathetic account of him, so sympathetic that a recent writer has thought it "reads like Hogarth's own composition."[50]

But Thornhill's day was past: soon his name would signify the sad discrepancy

between the quality of native English history painting and the continental tradition. The surest signs of his reputation were not the respectful obituaries but the inactivity of his last years and the low prices brought early in 1735 by the auction of his own paintings from his collection. The set of small copies of the Raphael Cartoons went for 75 guineas; the large paintings went to the Duke of Bedford for 200 guineas, with Vertue's comment: "he was 2 or three years making these Coppies at Hampton—it was sold for less than cloth and colours cost."[51] If Hogarth did write the *Gentleman*'s obituary, he was beginning to exhibit the defensiveness that characterized his attitude toward Thornhill through the next three decades.

On Thursday 18 July Hogarth and a Mr. Jolliffe were nominated governors of St. Bartholomew's Hospital by Sir Richard Brocas, the president (and ex-lord mayor). A presidential nomination was reserved for a few people of exceptional merit and was not, unlike other nominations, contingent upon a donation of £50 or £100. It is clear, however, that a donation of a sort—his paintings—was behind Hogarth's election. At the next meeting, Thursday 25 July, Hogarth and Jolliffe were duly elected "and Green staves are ordered to be sent to them according to antient Custom."[52] The staffs were carried by the governors in the annual procession, preceding the annual dinner, which, as it happened, took place on this same day, and was no doubt attended by Hogarth with his staff.

The chronicler of St. Bartholomew's Hospital suggests that Hogarth's donation was "in memory of his birth near the hospital," and it is certain that he had many sentimental associations with the hospital, including his sisters' and mother's residence.[53] Undoubtedly his determination to capture the commission from Amigoni was another, and timely, incentive. Still another motive was probably the desire to be a governor of the Hospital—one of the 200 who included such influential Londoners as the Earls of Oxford and Orrery, the Duke of Chandos, and members of the banking families of Hoare and Child. Hogarth had contacts with at least the last two, and perhaps he wanted to bear the signs of bourgeois prosperity that included governorship of a public institution. St. Bartholomew's was, in fact, the first of a series of such governorships that came Hogarth's way.

He became part of quite a different organization on 11 January 1734/5 when John Rich, with twenty-three of his friends who included Ebenezer Forrest, George Lambert, Robert Scott, John Thornhill, William Huggins, William Tothall, and Gabriel Hunt, founded The Sublime Society of Beefsteaks. According to tradition, Lambert, working at his job of scene painter for Rich, had no time for a regular dinner, and so "he contented himself with a beek steak broiled upon the fire in the painting-room"—the room behind the stage, near the Bow Street entrance. Sometimes he was joined by visitors, and by and by the

Beefsteak Club was born; it assembled once a week in the painting room, and later in "a room in the play-house."[54]

This group met every Saturday from October to June, wearing the ribbon and badge of the society, shaped like a silver gridiron and dated 1735, with their motto "Beef and Liberty." It is not clear whether at this time they had taken to wearing blue coats and buff waistcoats with brass buttons bearing the gridiron design. Beefsteak was the only meat served, but in addition there were baked potatoes, Spanish onions, beets, chopped eschalot, toasted cheese, porter, port wine, punch, and whisky toddy. The President of the Day was under the "necessity of singing, whether he could or not, THE SONG OF THE DAY"; the newest member, the "Boots," served as "the fag of the brotherhood," bringing the steaks individually from the spit to each member and pouring wine. The Bishop sang the grace and the Anthem, and the Recorder "had to rebuke everybody for offences, real or imaginary" and deliver "the charge" to each new member. There was an elaborate set of rules, ceremonies, and traditions, masonic in its symbolism and complexity; but all was directed toward merriment and schoolboyish highjinks, very reminiscent of Hogarth's "peregrination," from which the Beefsteaks drew three members.[55] The club is most famous now for its beefsteaks and its hoaxes.

In 1743, presumably as an exercise of this club, Hogarth and his friends played a trick on John Highmore, the theatrical amateur whose performance of Lothario on stage (which had led him to purchase control of the Drury Lane Theatre) was paralleled by his amorous boasting off. They rigged up an assignation with an attractive young lady who, between courting and bedding, disappeared and was replaced by a black prostitute: whom Highmore discovered when he climbed into bed. The jokers evidently emerged from hiding, ragged him, and, not satisfied with his discomfiture, commemorated the event by having Hogarth etch a plate showing Highmore's discovery and his tormentors' glee, complete with an appropriate Latin motto from Ovid. A few copies were printed for private distribution (pl. 134).[56]

Although this plate was the only sketch Hogarth made for his friends to be printed, these sketches were often circulated or posted in coffeehouses. This is evidently what happened with the sketch of Jonathan Richardson (circulated) and the drawing of Benjamin Read asleep (posted), and there are also accounts of a pencil sketch of "a celebrated young Engraver (long since dead) in a salivation," wrapped in blankets like the figure in *Election*, Plate 3 (perhaps Luke Sullivan), and a drawing of a "corner of a street, with a man drinking under the spout of a pump, and heartily angry with the water, which, by issuing out too fast, and in too great quantities, had deluged his face." Contemporaries were not very sophisticated as to distinctions between drawings and prints, and the former often passed for the latter, as probably in John Wilkes' allusion to Ho-

Qui Color albus erat, nunc est contrarius albo.

134. The Discovery; ca. 1743? (second state); 6¼ x 7⁵⁄₁₆ in. (W. S. Lewis)

garth's caricature of Lord Hardwicke as a spider (*North Briton* No. 17). Nichols recalls that in 1745 Hogarth made a caricature of one Launcelot Burton, a naval officer at Deal: "on a piece of paper previously impressed by a plain copper-plate, [he] drew his figure with a pen, in imitation of a coarse etching." The "print" was sent to Burton in a letter, and his friends (who were in on the joke) claimed they had seen the print on sale in London shops.[57]

Such hoaxes and commemorations were the private side of Hogarth's activism during these years. The Sublime Society of Beefsteaks was the site where many took place, and the breeding ground for many carried out elsewhere; Hogarth, Rich, Lambert, and the others were a close-knit group. One clause of the rules allowed for wagers, and toasts were to be as satiric as possible so long as they were not repeated outside the meeting. Singing was a leading feature, especially among those who could not carry a tune.[58] But behind all the merriment was the assumption of xenophobia—half comic, half serious—inherent in the motto,

and a satiric twist that used the hoax as a vehicle for exposure in the tradition of the Scriblerus Club. The club also constituted another manifestation of the Hogarth circle's reaction to aristocratic trends: as this group drew together to counteract the Society of Dilettanti in 1734, so the Beefsteak Club probably saw itself as another version of "The Liberty or Rumpsteak Club" (founded in 1734), composed of 27 Whig peers who had been slighted by George II at his levees—i.e., who had been shown his meaty posterior.[59] Even at their most relaxed, Hogarth and his theatrical and artistic friends engaged in a kind of tendentiousness.

In 1733 a purchaser could go to Philip Overton and obtain prints of the *Harlot's Progress* at 15s, or to Giles King for the authorized copies at 4s (the originals, at a guinea, were unavailable); and *Midnight Modern Conversation* could be had for one shilling (as opposed to five for the original).[60] Hogarth was in a much stronger position than the ordinary engraver who was completely at the mercy of the printsellers' monopoly, but he suffered the double annoyance of seeing large sums of money he felt rightly his going to other parties, and of seeing wretched copies made of the works he had labored over with such care.

It is not certain when the idea of petitioning Parliament first occurred to him, but *The London Journal*, 2 November 1734, carried the following announcement:

> MR. HOGARTH hereby gives Notice, that having found it necessary to introduce several additional Characters in his Paintings of the *Rake's Progress*, he could not get the Prints ready to deliver to his Subscribers at *Michaelmas* last (as he proposed.) But all the Pictures being now entirely finished, may be seen at his House, the *Golden-Head* in *Leicester Fields*, where Subscriptions are taken; and the Prints being in great forwardness, will be finished with all possible Speed, and the Time of Delivery advertised.

He was probably, as he said, revising and rearranging, though perhaps whole pictures rather than figures, and also having his accustomed troubles with engravers (as the states of Plate 2 show). It is possible, however, that the "several additional characters" were part of a tactic to delay publication until a copyright law could be legislated.[61] There is little doubt that Hogarth had by this time begun to build up support and perhaps write, or have someone else write, the pamphlet that took the form of a petition to Parliament. Thornhill's advice may have seen him through the earliest stages of planning, the Slaughter's group acted as nucleus for the campaign, and William Huggins served as his legal consultant.[62]

Hogarth was the obvious person to lead such a campaign. His printmaking and publishing had been, as Lawrence Gowing has said, the "first serious experiment in finding how a modern society can support the art it needs."[63] Ho-

garth had helped to prove the assumption upon which the Engravers' Act was to stand: that the publication of a painter's work gave it a new value, altogether distinct from that it had on a patron's wall. With the proof in his successful print ventures, he could turn to the law: the artist's invention was now a valuable property, as open to theft as any other property, and thus in need of legal protection. The act, which came to be known as "Hogarth's Act," was needed to demonstrate that the artist's invention itself possessed a new and independent status.

The act Hogarth projected, presumably with the help of Huggins, was based on the literary copyright act of 1709 (8 Anne cap. 19), "An Act for the Encouragement of Learning by vesting the Copies of printed Books in the Authors or Purchasers of such Copies during the Times therein mentioned." The main provisions were that the copyright of works already published was secure to the present owners (whether authors or booksellers) for 21 years (from 1 April 1710); future authors had sole printing rights for 14 years, which they could assign to another (i.e. the bookseller) for an amount that would appear fair. After the first 14 years, the copyright returned to the author (if he were still living) for a second 14. Pirates had to forfeit all the offending books and were fined 1d a sheet for every copy found, half going to the Crown, half to the injured author. Thus the author could sell his copyright outright; or for a single edition, afterward bargaining for new conditions; or he could keep it entirely to himself.[64]

As the case was presented in Hogarth's pamphlet, the artists—designers and original engravers—are "oppress'd by the Tyranny of the Rich" (elsewhere referred to as "the Monopoly of the Rich"): "not the Rich, who are above them; not the Rich of their own Profession; but the Rich of that very Trade which cou'd not subsist without them."[65] These are the rich printsellers, who exploit the original designer, his engraver, and the wretched hacks who engrave their cheap copies—those "Men who have all gone through the same Distress in some degree or other; and are now kept Night and Day at Work at miserable Prices, whilst the overgrown Shopkeeper has the main Profit of their Labour." Moreover, if an independent printseller "should dare to exceed the stated Price for any Print he should think more valuable than ordinary; Copies are immediately procured by the others, and sold at any Price, in order to suppress such a Rebellion against the Monopoly of the Rich."

There is a strong sense of the personal in this pamphlet: Hogarth himself, though never named, seems to be the chief example. He is included among the artists who, like the Hogarth of 1724, lack "Houses conveniently situated for exposing their Prints to Sale" and so must resort to the printsellers; and also among those who, like the prosperous Hogarth of 1735, "have much more advantageous Ways of spending their Time, than in shewing their Prints to their Customers." Those needing protection are not only the inventive artists like

Hogarth, but also "those who take their Designs from Portraits, Paintings, Buildings, Gardens, &c. and consequently the whole Profession is entirely in the Power of the Shopkeeper."

The pamphlet's subject, however, is only partly the exploitive printseller. More important is the "Improvement of the Arts" in England, which can only be brought about if the English artist can receive his just profits and spread his wares and his fame through good engravings (not shabby copies). Then the purchaser too will have a greater choice of prints at a lower price, "for when every one is secure of the Fruits of his own Labour, the Number of Artists will be every Day increasing." Even the printseller will increase his profits, because he will have a greater range and better quality of prints to offer as alternatives to the imports from the Continent.

The solution, as the pamphlet argues, is simply to pass a law against one artist's copying the designs of another. By "copying" is meant a shape-for-shape, distance-for-distance, part-for-part reproduction, with "so many Marks of its being a direct Copy, distinguishable by the most common Eye, that it will be impossible for it not to be discover'd when compared in Court with the Original." And, the writer states specifically, it is still an actionable copy if the engraver merely adds or subtracts a figure from it when all the others are obviously copied.

The names signed to the petition that was presented to the House of Commons on 5 February 1734/5 were, besides Hogarth, George Vertue, George Lambert (who was now having his landscapes engraved), Isaac Ware, John Pine, Gerard Vandergucht, and Joseph Goupy (who carried with him the influence of the Prince of Wales). "Artists and Designers of Paintings, Drawings, and Engravers of original Prints, in behalf of themselves, and others" presented the petition to the House

alledging, That the Petitioners, and others, have with great Industry and Expence, severally invented, designed, or engraved, divers Sets of new Pictures and Prints, in Hopes to have reaped the Benefit of such their own Labour, and the Credit thereof; but that divers Printsellers, Printers, and other Persons, both here and abroad, have, of late, too frequently taken the Liberty of copying, printing, and publishing, great Quantities of base, imperfect, and mean, Copies and Imitations thereof; to the great Detriment of the Petitioners, and such other Artists, and to the Discouragement of Arts and Sciences in this Kingdom: And therefore praying, That Leave may be given for a Bill to be brought into the House, for preventing such Frauds and Abuses for the future, and securing the Properties of the Petitioners, as the Laws now in being have preserved the Properties of the Authors of Books; or in such other manner as by the House shall be thought fit.[66]

The petition was referred to a committee to examine and report on it, which met that afternoon in the Speaker's chamber. The engraver Bernard Baron was called by the petitioners as a witness "to prove the Allegations of the same."

> Mr. *Bernard Baron:* Who said, That he engraved Four Copper-plates of Hunting-pieces for Mr. *Wooton,* which, in Two or Three Months time, were copied by another Person; and that the Copies were sold at a very Low Rate, which hindered the Sale of Mr. *Wooton*'s Originals.
>
> And he further said, That, if the Plates of the Inventors and Designers were vested in them, the same Number of Hands would be employed; and the Copies would be more perfect, by being under the Direction of the Inventor, and would be sold at as reasonable Rates.

Then Henry Fletcher testified that he and two others designed and engraved a set of flower prints, which cost them £500; they sold them at two guineas a set, painted in color, but before long they were copied by another and sold for one guinea with color and half that without. Isaac Basire (father of the engraver who later worked for Hogarth) then produced these copies, which had been made by him, presumably at the instigation of a printseller. The committee concluded that the petitioners had proved their allegations and ordered that "Leave be given to bring in a Bill for the Encouragement of the Arts of designing, engraving, and etching, historical and other Prints, by vesting the Properties thereof in the Inventors and Engravers, during the Time therein to be mentioned." Their report, read by Sir Edmund Bacon, was presented on 14 February. Bacon, Mr. Thompson of York, and Mr. Plumptre were ordered to prepare the bill.[67]

The first reading of the Engraver's Bill took place on 4 March, the second on the thirteenth, and it was assigned to a committee meeting the same afternoon at five in the Speaker's chamber. On 2 April the bill returned from committee with report and amendments, which were read through first and then one by one, the question generally put, and the amendments agreed upon (with some amendments to them). The bill, with amendments, was ingrossed. On 11 April the bill was given its third reading, and the clause giving Hogarth's friend John Pine a monopoly on the engraving of the House of Lords tapestries (a project dear to Vertue's heart) was added at this time. It passed and was carried by Sir Edmund Bacon to Lords.[68]

The bill had its first reading in Lords on 15 April, and a committee went over it a week later: the prints after Wootton's hunting scenes were produced, as were also the inferior copies, and the various clauses were read and agreed to, including the one concerning Pine. After the latter was read, a lord proposed "to Amend the Bill & make it more general by extending it to prints Ingrav'd from old Paintings, provided the same be so Ingrav'd by the Consent of the Proprietors of such Paintings." Pine, who was present, explained that "the Ingravers would have been glad to have had the Bill more general, but that the House of

Commons were not inclined to make it so extensive which was the reason of his endeavouring to obtain the said Clause"—that is, the clause concerning his own monopoly of the Lords tapestries. And this was the way things remained: the committee adjourned for the day, and when it reconvened the next day the lord who had proposed the amendment "did not insist upon such Amendmt in regard as 'twas apprehended it might hazard the Bill." The clause on Pine was agreed to, and the rest of the bill passed. On the twenty-fourth Lords gave the bill a second reading, and on the next day a third; it was then returned, approved, to Commons.[69]

The Act that resulted ensured against unauthorized copies for a period of 14 years from the date inscribed on each print, and for every print discovered a five-shilling fine was to be imposed. The effective date given, however, was 25 June, which Hogarth may not have anticipated; to his advertisement of 3 May, he added

> N.B. Mr. Hogarth was, and is oblig'd to defer the Publication and Delivery of the abovesaid Prints till the 25th of June next, in order to secure his Property, pursuant to an Act lately passed both Houses of Parliament, now waiting for the Royal Assent, to secure all new invented Prints that shall be publish'd after the 24th of June next, from being copied without Consent of the Proprietor, and thereby preventing a scandalous and unjust Custom (hitherto practised with Impunity) of making and vending base Copies of original Prints, to the manifest Injury of the Author, and the great Discouragement of the Arts of Painting and Engraving.[70]

At this point a piratical printseller put into motion a strategy which Hogarth had evidently not foreseen—although there is evidence that someone may have employed a similar technique to copy *A Midnight Modern Conversation*. The plagiarist engraver presumably used a series of agents: one person would have aroused suspicion after many visits, and one visit would not have sufficed to memorize eight pictures. The agents cannot have been of the trade, or Hogarth would have recognized them; and, as he noted in his announcement of the fraud, being "mean and necessitous" they probably came only to look, not to subscribe. These men visited Hogarth's display room and returned to their employer with a description of what they had seen, from which copies of the yet unpublished *Rake's Progress* were made. The engraver or engravers (the style of the piracies suggests several) then worked by hearsay, from garbled and probably contradictory descriptions, as a police artist does in reconstructing the face of a criminal from eyewitness reports. The engraver must also have been plagued by the necessity for haste, borrowing earlier traditions or motifs from the *Harlot* whenever he met a snag (pl. 135).

On 15 May the Engravers' Act received the royal assent.[71] By the beginning of June the plagiarist engraver had done his work, and the *Daily Advertiser* for the

135. Piracy of *A Rake's Progress,* Pl. 1 (BM)

third announced: "Now printing, and in a few days will be publish'd, the Prog-
ress of a Rake, exemplified in the Adventures of Ramble Gripe, Esq; Son and
Heir of Sir Positive Gripe; curiously design'd and engrav'd by some of the best
Artists." The ingenious publishers were Henry Overton, John King, and
Thomas and John Bowles. Hogarth had by this time learned of the trick, and
the same day published his notice:

SEVERAL Printsellers who have of late made their chief Gain by un-
justly pyrating the Inventions and Designs of ingenious Artists, whereby
they have robb'd them of the Benefit of their Labours, being now prohib-
ited such scandalous Practices from the 24th Day of June next, by an Act of
Parliament pass'd the last Session, intitled, *An Act for the Encouragement
of the Arts of Designing, Engraving, Etching, &c.* have resolv'd notwith-
standing to continue their injurious Proceedings at least till that Time, and
have in a clandestine Manner procured [mean and necessitous—*added on
the seventh*] Persons to come to Mr. William Hogarth's House, under Pre-
tence of seeing his RAKE'S PROGRESS, in order to pyrate the same, and pub-
lish base Prints thereof before the Act commences, and even before Mr.

Hogarth himself can publish the true ones. This behaviour, and Men who are capable of a Practice so repugnant to Honesty and destructive of Property, are humbly submitted to the Judgment of the Publick, on whose Justice the Person injured relied.

N.B. The Prints of the RAKES PROGRESS, design'd and engrav'd by Mr. William Hogarth, will not be publish'd till after the 24th Day of this Inst. June: And all Prints thereof published before will be an Imposition on the Publick.

Only now did Hogarth decide to have cheap copies made (as he had with the *Harlot*): apparently he had not expected to. In the *London Evening Post,* 17–19 June, he added to his announcement:

Certain Printsellers intending not only to injure Mr. Hogarth in his Property, but also to impose their base Imitations of his RAKES PROGRESS on the Publick, he, in order to prevent such scandalous Practices, and shew the RAKES PROGRESS exactly (which the Imitators of Memory cannot pretend to) is oblig'd to permit his Original Prints to be closely copied, and the said Copies will be published in a few Days, and sold at 2s. 6d. each Set by Tho. Bakewell . . . all persons may safely sell the said Copies without incurring any Penalty for so doing. . . .

The Bakewell copies at 2s 6d were aimed at those buyers who could not afford either the originals at 2 guineas or the piracies at 8s; and were smaller than either of these.

The next issue of the *London Evening Post* (21–24 June) carried only the advertisement; and on the twenty-fifth—as the Act took effect—the genuine *Rake's Progress* was delivered to subscribers. But four days earlier the *Whitehall Evening Post* announced the Ramble Gripe piracy of the *Rake* as published. Having now seen it, Hogarth repeated his complaint in the *London Daily Post* for 27 June, with angry variations: the piracy is "executed most wretchedly both in Design and Drawing"; and he notes nervously that his own authorized copies will be ready "in a few days." There was, in fact, a delay of six weeks before his copies appeared on 16 August—again showing how late had been his decision to employ Bakewell. Finally, on 19 July (*Craftsman*) he opened the original *Rake's Progress* to the general public:

Pursuant to an Agreement with the SUBSCRIBERS to the RAKE'S PROGRESS, not to sell them for less than two Guineas each Set after Publication thereof, the said original Prints are to be had at Mr. Hogarth's, at the Golden Head in Leicester-fields, and at Tho. Bakewell's, Printseller, next Johnson's Court in Fleet-street, where all other Printsellers may be supply'd.

Next Week will be published,

Copies from the said Prints, with the Consent of Mr. Hogarth, according to the Act of Parliament, which will be sold at 2s. 6d. each Sett, with the usual Allowance to all Dealers in Town and Country; and that the Publick may not be impos'd on, at the Bottom of each Print will be inserted these Words, viz. Publish'd with the Consent of Mr. William Hogarth, by Tho. Bakewell, according to Act of Parliament.

N.B. Any Person that shall sell any other Copies, or Imitations of the said Prints, will incur the Penalties in the late Act of Parliament, and be prosecuted for the same.

Hogarth has now established his practice: after the subscription, the prints can be bought at a higher price; and they can be had "with the usual Allowance" by other dealers.

Either the Engravers' Copyright Act worked better than the writers', or was easier to enforce, or many pirated prints have vanished. The only ones that can be cited with any certainty are Dublin copies.[72] The exceptions were in the cheap "popular" prints like the portraits of Lovat and Wilkes, when copies appeared everywhere—in the *Gentleman's Magazine,* in newspapers, and as frontispieces to various pamphlets and books.[73]

The Act, of course, presumed that a pirate would have little interest in copying a fourteen-year-old print. This was to underestimate, however, the continuing popularity of Hogarth's prints, the copyright of which began to expire in 1750. He apparently made no complaints in the 1750s, and indeed in 1754 he issued a print in celebration of the Act's success in advancing English arts and industry, but at his death his widow noticed the damaging effect of piracies on her sales, and in 1767 the Act was revised to extend protection to 28 years from date of publication. For Mrs. Hogarth, protection was extended for another 20 years.[74]

Vertue's description of the engraver's sad lot, written long after the Engravers' Act was passed, shows that in the long run only unusual cases like Hogarth's were materially benefited by the Act; most engravers were still weighed down by handicaps. Dealers may have been forced to offer more advantageous terms to artists, but the ordinary copyist engraver like Vertue, who might be underbid by another copyist of the same unprotected subject, still had to rely on a patron who owned the work in question and allowed only him to engrave it. In Vertue's own case the Act left a bitter taste: it was he who suffered by John Pine's special permission to engrave the Armada tapestries in Lords. If he blamed Hogarth it would explain something of the growing asperity of his remarks over the years, especially his emphasis on Hogarth the intriguer; he is silent on the subject of the Act itself, as important as it was to the history he was writing. While Hogarth

136. Mrs. Anne Hogarth; 1735; 50 x 40 in. (private coll.)

137. Anne Hogarth; ca. 1735; 18¼ x 16 in. (Columbus Gallery of Fine Arts)

138. Mary Hogarth; ca. 1735; 18¼ x 16¼ in. (Columbus Gallery of Fine Arts)

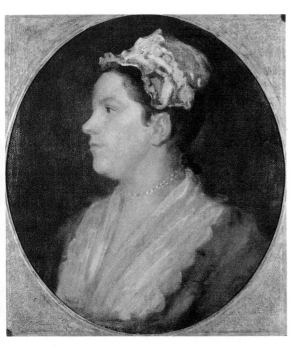

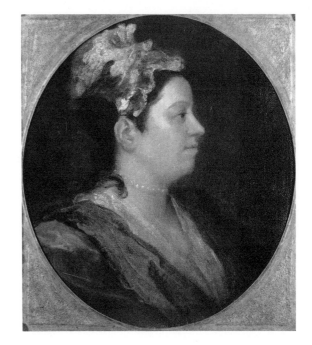

became increasingly independent as an engraver, Vertue continued to survive largely through personal patronage.

In the second week of June, while Hogarth was waiting outraged for the piracies of the *Rake's Progress* to appear, the whole problem was temporarily eclipsed by the death of his mother. His attachment to her may be judged by his dignified, almost monumental portrait, with the inscription, "His Best Friend" (pl. 136). Not long after William moved to Leicester Fields, his mother and sisters moved to a flat on the north side of Cranbourn Street, in St. Anne's Parish. On the night of Monday, 9 June, shortly before midnight, fire broke out in Duke's Court, St. Martin's Lane, a few blocks away from the Hogarths. By 3 A.M. nearly twenty houses were on fire, and the fire was still burning when the *Daily Journal* went to press. When the smoke cleared, it was ascertained that the fire

> broke out between 11 and 12 o'clock, at a Brandy-Shop in Cecil-Court, St. Martin's-Lane, and communicated itself into St. Martin's-Court, and continued with great Fury for the Space of two Hours, before Water could be got to supply the Engines. His Royal Highness the Prince of Wales, the Lord James Cavendish, Sir Thomas Hobby, and Mr. Cornwallis, were present; a Detachment of Foot Guards also assisted: His Royal Highness went on the Top of a House in St. Martin's-Court, to take a View of it, and then came down to direct the Engines, and animate the Firemen, &c. About 3 the Fire was got under, when about 15 Houses were destroyed, viz. 12 in St. Martin's-Court, and 3 in Cecil Court, besides a great many others much damaged: John Huggins, Esq; gave 20 Guineas to the Populace, to excite them to a Diligence suitable to the melancholy Occasion: His Royal Highness likewise gave a considerable Sum of Money to the Firemen and others.[75]

John Huggins, it should be noticed, owned property in St. Martin's Lane; the *Old Whig* observed that one of his houses was considerably damaged, adding that "The Thieves and Pickpockets were observed to be very industrious *in saving Things out of the Fire*, according to Custom."[76]

The Hogarth women must have been living on the spur of Cranbourn Street that runs directly into St. Martin's Court, or else Mrs. Hogarth was visiting with a friend in St. Martin's Court. All that is known is that she died the next morning, "at her House in Cranbourn-alley, of a Fright, occasion'd by the Fire in St. Martin's court. She was in perfect Health when the unhappy Accident broke out, and died before it was extinguish'd."[77] She is, in fact, the only person mentioned to have died as a result of the fire, although several others were seriously injured by falling debris. An Irishwoman, Mrs. Kelloway, who lived in the brandy shop in Cecil Court, where the fire broke out, was apprehended on Thursday the twelfth, taken before Justice De Veil on suspicion of willfully set-

ting the house on fire, and committed to Newgate, requiring protection from the angry mob assembled. The same night "was buried Mrs. Hogarth, Mother to the celebrated Mr. Hogarth," in the churchyard of St. Anne's, Soho.[78]

Exactly a year later, Hogarth and his sisters took out fire insurance policies on their respective properties with the Sun Insurance Company. The fire in St. Martin's Court may have influenced him, but a more specific reason was probably that in March 1736 he had begun to sell sets of his prints, and kept a large supply of impressions on hand. It was characteristic of him to take out policies for his sisters as well as himself.[79]

The year that began with the introduction of the engravers' petition ended with the reestablishment of an artist's academy, which had been in abeyance since the early 1720s. Vertue noted that "this Winter 1735 an Academy for drawing from the Life sett up in Sᵗ Martins lane where several Artists go to Draw from the life. Mʳ Hogarth principally promotes or undertakes it."[80] Elsewhere he says that Hogarth and Ellys were jointly the moving forces, and an English academy may be seen as a logical extension of the artist's circle at Slaughter's and of their attacks on Amigoni and foreigners. Vertue remarked that they established it "in the Same place Sᵗ Martins lane" where Vanderbank's academy had been, and he adds that each subscriber paid two guineas for the winter season the first year, and the next year would have to pay only one guinea and a half.[81]

Hogarth's own account, written almost thirty years later when threats to his academy's continuance had arisen in the form of a proposed state academy, is more specific: "Sʳ James Thornhill dying I became proprietor of his neglected apparatus and began by subscription that in the same place in Sᵗ martins lane which subsists to this day as it was founded." As he tells it, he secured "a room big enough [he has stricken out "of a middling size"] for a naked figure to be drawn after by thirty or forty people." He then "proposed a subscription for hire of one in St. Martin's Lane and for the expenses attending," and his plan was soon accepted and subscribed to "by sufficient number of artists. He presented them with a proper table for the figure to stand on, a large lamp, an iron stove, and benches in a circular form"—Thornhill's equipment—but he himself remained "an equal subscriber with the rest signifying at the same time that superior and inferior among artists should be avoided especially in this country." Looking back from the time of crisis, he remembered stressing even then that it was the presence of directors and other hierarchical elements, in imitation of the French Academy, that destroyed the earlier English academies—and he adds that his democratic plan did indeed work for thirty years. And, although rifts began to appear in the 1750s, it survived in some form till his death.[82]

The information concerning Thornhill's equipment makes it appear proba-

ble that *The Life School* painting, now in the Royal Academy (pl. 139), while not (as sometimes claimed) by Hogarth, does portray the St. Martin's Lane Academy. It shows, in particular, the circular benches to which Hogarth referred, the table for the figure to stand on, and the large lamp; only the iron stove is not in evidence. Instead there is a fireplace, which makes the room appear to be a large basement kitchen. The casts (including an *Antinous*), which must have come with Thornhill's equipment, are also present. The costumes in the painting can be dated between 1740 and '50. The room was evidently sublet, since there is no reference to it in the rate books: occupying a basement, the artists would have been tenants of the rate-paying householder, as basements were not usually assessed separately.[83] The model may have been John Malin, who posed for the St. Martin's Lane Academy for years and lived to become the first porter of the Royal Academy, where he continued to pose until his death early in 1769.[84]

Hogarth and Ellys were listed as the proprietors, and Vertue notes that before long Gravelot was teaching drawing and Hayman painting.[85] It was in this school that most of the artists of the period received their training. Here Hogarth's activism found its most important outlet in these years, in teaching,

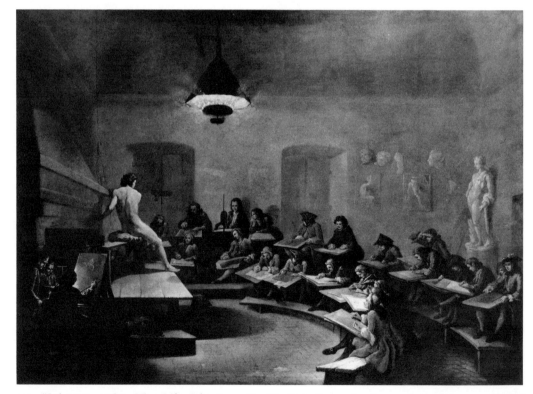

139. Unknown artist, The Life School or St. Martin's Lane Academy; date unknown (Royal Academy)

supervising, and advising young artists. He cannot have been a dogmatic teacher. Judging from his later writings, he would have urged the students to learn expression, movement, and the appearance of things from the model or from general observation—and to study commonplace objects as well as the classic casts. Only for some aspects of composition, such as arrangement of light and shade, would he have referred them to prints and casts. "While being forthright and sharp," Michael Kitson has speculated, "he would not have spent his time 'telling as they do (in the French Academy) the younger ones when a leg or an arm was too long or too short'; nor would he have considered himself, like Reynolds when President of the Royal Academy, above the day-to-day business of practical instruction. We can imagine him, rather, as being concerned with the principles of artistic creation. What were 'the effects of nature on the eye'? How should perceptions of these effects be translated into art? By what visual means can movement or character be expressed?"[86]

For Hogarth, however, the academy was also a means of consolidating the artists who had been loosely bound together by Slaughter's; it was in fact closer to guilds like the Painter-Stainers' Company than to continental academies (which were, of course, founded for the sole purpose of circumventing guilds), and was based on Hogarth's assumption that the future of English artists lay, not above with the aristocracy, but below, at Vauxhall, St. Bartholomew's Hospital, and the Foundling Hospital. Thus he was later to stress the democracy of the academy, as he also emphasized the great mass of buyers for whom he made his prints, and to eschew interference by the "great," the dilettantes who usually made themselves felt in such artists' academies. In the 1730s at least, Hogarth's idea of the academy's purpose must have been blurred: he saw it as a guild of artists, with mutual protection against patrons and picture dealers as its aim; yet it operated like the artists' academies, with a life class and theoretical discussions of art, toward enhancing the English artist's status. He was himself apprenticed to a guild, the Merchant Taylors', and yet avoided becoming a freeman.

The founding of the academy was the last in a series of actions that turned Hogarth (and, for the moment at least, his fellow artists) toward a middle-class audience, the professional and mercantile interests he had first welded into a base of strength with his moral prints. Without oversimplifying too much, one can mark a retreat from the "great" after the failure to paint the royal family and the Prince of Orange's wedding. These projects were themselves ambiguous, representing an attempt to circumvent the Burlingtonian patrons by going straight to the royal family (though, as he discovered, the Burlingtonians themselves, Kent and Grafton, blocked this avenue); and, with the Prince of Orange's wedding, an attempt to produce a painting for royalty that would be followed by an engraved version for the general public. From this failure Hogarth returned to his prints, to public gardens and hospitals (which of course housed pictures that might be seen by a great patron); passing the Engravers' Act to

protect his prints in the public domain; and founding an art academy, which followed logically from his assumption that patronage lay with those below not above the artist.

With the publication of the *Rake's Progress,* he conquers the booksellers and pirates and checks the patrons and connoisseurs who seemed to threaten his position. He has now exhausted the particular gloomy fiction of the Harlot and Rake. Thereafter, for a few years, his work becomes less mordantly satiric; the dark, unresolved world of the Harlot and Rake is replaced by a world of contraries, the respectable and the unrespectable balanced with a happy unconcern.

One other public pronouncement should be mentioned, though it means looking ahead to 1737. In the *Daily Post* of 2 June was an account from Paris of François Lemoyne's suicide, which said he died "of several Stabs he gave himself . . . with a Dagger; his Head was out of Order ever since the four Faults that were found by some rigid Cricks in that vast Work, which he had been four Years about." The reporter adds: "The Painter of the great Hall of Greenwich Hospital had much more Resolution; notwithstanding there are as many Faults as Figures in that Work he died a natural Death, tho' an Englishman."

Hogarth replied within the week in an essay signed "Britophil," published in the *St. James's Evening Post* of 7–9 June. English art, he says with sharp eloquence, is undervalued by the critics, who try to make reputations for themselves by showing up English pictures and by criticizing details instead of wholes, and by the picture dealers, who try to make their fortunes by selling foreign pictures. As his pseudonym suggests, he speaks as a "Well-wisher to Arts in England," and a defender of Thornhill.[87]

The importance of the essay lies in its being Hogarth's first substantially authenticated piece of writing: the reprint in the July *London Magazine* attributes it to "the finest Painter in England, perhaps in the world, in his Way." He probably drafted or supervised *The Case of Designers, Engravers, Etchers, &c.,* but "Britophil" set the tone for all the writings, and many of the pictures, that were to follow. Hogarth reveals a flair for drama, his best touch being an imagined scene between a dealer and a buyer. "Mr. Bubbleman," says the honest buyer, "that Grand Venus (as you are pleased to call it) has not Beauty enough for the Character of an English Cook-Maid."

Upon which the Quack answers with a Confident Air, 'O L—d, Sir, I find you are no *Connoisseur*—That Picture, I assure you, is in *Alesso Baldovinetto*'s second and best Manner, boldly painted, and truly sublime; the *Contour* gracious; the Air of the Head in the high Greek Taste, and a most divine Idea it is'—Then spitting on an obscure Place, and rubbing it with a dirty Handkerchief, takes a Skip to t'other End of the Room, and screams

out in Raptures,—'There's an amazing Touch! A Man shou'd have this picture a Twelve-month in his Collection, before he can discover half its Beauties.'

Hogarth demonstrates an ability to use words forcefully and, in a posture of attack, eloquently. The background villain is the connoisseur, a character, as Edgar Wind has remarked, "set apart by virtue of certain refinements of taste for which a French word seemed the right designation." This connoisseurship, exploited here by the dealer, involves attaching an impressive name to an anonymous painting, sounding very precise and scholarly (Alesso Baldovinetti's second period), drawing attention to a small detail in the painting as of the utmost significance, and suggesting that reasons are unnecessary in the face of the connoisseur's peculiar and unique perception.[88]

Hogarth's greatest eloquence in this essay, however, is reserved for a new object, the picture dealers. "There is another set of Gentry more noxious," he says, than the critics (who, with the false connoisseurs, were dealt with in the *Weekly Register* essays):

and those are your *Picture-Jobbers from abroad,* who are always ready to raise a great Cry in the Prints, whenever they think their Craft is in Danger; and indeed it is their Interest to depreciate every *English* Work, as hurtful to their Trade, of continually importing Ship Loads of dead *Christs, Holy Families, Madona's,* and other dismal Dark Subjects, neither entertaining nor Ornamental; on which they scrawl the terrible cramp Names of some Italian Masters, and fix on us poor *Englishmen,* the Character of *Universal Dupes.*

Ralph had referred to "the Multitude of Venus's and Madona's that have been produc'd in the Schools of Italy, and thence have wander'd all over Europe."[89] Hogarth may have remembered the sentence, but he has unerringly singled out the dealer, who had remained curiously free of attack. In Bramston's *Man of Taste* (1733), the hero remarks

> In curious paintings I'm exceeding nice,
> And know their several beauties by their *Price.*
> *Auctions* and sales I constantly attend,
> But chuse my pictures by a *skilful Friend.*
> Originals and copies much the same,
> The picture's value is the *painter's name.*

The dealer, of course, is in the background, but it took Hogarth to link critic and dealer (or "quack," as he terms the latter). He sees them, of course, as part of the paradigm of the *Harlot* and the *Rake:* the mediator in what has been called a "triangular desire," in which the ordinary man buys, dresses as, or imi-

tates something because he sees someone else doing so. The critic and the dealer are, of course, examples of such mediation, as the rakes, gamblers, "fine ladies," and the rest are in the print cycles. So also with Mr. Bubbleman in the "Britophil" essay, whose customer "(tho' naturally a Judge of what is beautiful, yet ashamed to be out of the Fashion in judging for himself) with this Cant is struck dumb, gives a vast Sum for the Picture."[90]

It is clear from *The Marriage Contract* (pl. 119), the sketch for one of the *Rake* paintings, that these ideas were beginning to come to the surface of Hogarth's mind before the need to defend Thornhill prompted the "Britophil" essay. The Rake's chamber is crowded with busts of Cicero and Julia (looking at each other) and Germanicus (looking away with a pained expression), each bearing a lot number. In the background are the "Holy Families, Madona's, and other dismal dark Subjects" the dealer has sold the Rake: paintings of a Madonna, a foot, a Holy Family, and a Eucharist Machine. Behind the three busts on the floor is a painting of Ganymede and the eagle similar to the one Hogarth used in *Marriage à la Mode,* Plate 4. The suggestion here and in the essay is strong that, as a poet of the time put it, "All his nicest pieces, [are] furnish'd by the hand / Of Angelo's, who studied in the Strand."[91] Hogarth would have personally known some of these copyists. Richard Wilson studied under one of them: Thomas Wright, who made copies of Van Dyck and other old masters, which, Farington noted in 1805, "may still be seen in some ancient houses in the country, and are very indifferent performances." The *Monthly Review* in 1756 referred to one Buckshorn as "one of the last good copiers we have had in England," and the Earl of Shaftesbury's correspondence includes many references to copies of Poussin, Salvator Rosa, and Claude by Closterman.[92] Hogarth himself was the only English painter of means in the eighteenth century who did not accumulate copies and originals willy-nilly; he collected only prints for purposes of reference.

These copyists of paintings were analogous to the hacks who copied prints, and the picture dealers were analogous to the print dealers in that both controlled the market, set prices for the artists, and made most of the profit themselves. Perhaps his victory on one front spurred Hogarth to turn with renewed vigor to the other. Looking back on this period from the 1760s, he remarks that as a result of his Engravers' Act he has seen London become as great a print capitol as Paris. "Such inovations in these arts gave great offence to dealers both in pictures and Prints"; and he acknowledges that their practice of making a profit at the artists' expense "has I own suffer[ed] much" by his Act. "If the detecting of Rogurys of these opressers of the rising artists and imposers on the public is a crime I confess myself most guilty."[93]

Once personal patronage was ruled out, the picture dealers became, of course, crucial to the artist's economic welfare. How to circumvent them became one of Hogarth's major problems, which he attempted to solve with his own auctions

(from which dealers were prohibited for fear they would band together to keep down the prices) and with recourse to public institutions like the hospitals. The founding of the St. Martin's Lane Academy can be seen, in this light, as an attempt to unite artists for their mutual protection, by formalizing the relationship of the Slaughter's artists. The "Britophil" essay marks the advent of a new phase, one in which Hogarth gradually becomes more concerned with educating the general public that buys his prints, teaching them how a painting as well as a moral act should be judged. One detects a strong urge to correct an abuse, to educate the benighted English and to chastise the charlatans who continue to deceive them with false art as with quack medicines.

As the rift with the aristocratic patrons grew, the broad permanent basis of Hogarth's reputation was established. Mrs. Lidell, living in the north country, wrote in 1736: "We never had a duller season, ye Gunpowder Plot against Law and Equity has been ye only subject of late and all allow the scene of confusion amongst the Gentlemen of the Gown was droll. I could like to see it represented by Hogart." In December 1735 Robert Ellison remarked that his lodgings in Cannongate resembled the Harlot's, and a *Grub-street Journal* of 1735/6 remarked: "Fame, the Hogarth of every age, can paint it an image of human life; yet still the grotesque figures create us mirth, and the distant resemblance to truth an agreeable astonishment."[94] Hogarth would probably not have appreciated the *Journal*'s condescension; however, it shows his name passing into common usage, as Thornhill's had fifteen years earlier, but with a much wider public. The "celebrated" or "ingenious" Mr. Hogarth to whom writers refer thereafter is essentially the Hogarth of the *Harlot* and the *Rake*, of the Engravers' Act (commonly known as Hogarth's Act) and the St. Martin's Lane Academy, and of important public positions like the governorship of St. Bartholomew's Hospital.

Comic and Sublime
History Painting

WAYS AND MEANS

In his second essay on history painting, Ralph raises the question of why English artists never venture beyond portraiture to history painting. He begins by reminding his readers that "Sir James Thornhill and Mr. Hogarth are almost the only Persons who have lately made it their Study, and," he adds, "I am sure no Body can say they have not found their Account in it both in Interest and Reputation."[1] The difficulty, he recognizes, is English Protestantism: "All Reformations run into Excess, and while we abolish what is criminal, we are too apt to trespass upon what is useful." Churches, in short, ought to be encouraged to commission paintings: " 'Tis my Opinion, that holy and devout Pictures are no Fault in themselves, and 'tis certain they have a very fine Effect in making the Face of Religion gay and beautiful," and he adds that "even Devotion itself might be made instrumental in the Encouragement of Taste and Politeness." The other possibility for commissions lies in public buildings, which he enumerates as "Hospitals, Courts of Justice, Theatres, City-Halls, &c." In fact, this essay almost programatically outlines the new areas of patronage being broached by Hogarth.

Where such a variety of patrons for paintings is involved, new and different kinds of history are implied. Laguerre and his French predecessors had painted a contemporary history that portrayed the battles of great generals, and Hogarth had adapted history painting to modern subjects of a much lower order: street scenes and interiors that could grace a supper box at Vauxhall or the foyer of a theater, or—as engravings—could be widely circulated, serving more or less the same function as a tapestry in relation to a Raphael Cartoon. I have found no attacks or denigrations, during these years, of Hogarth's modern histories. The English critics who wrote on history painting seemed to take the variety of possi-

376

bilities for granted. Ralph, in another of his history painting essays in the *Weekly Register,* distinguishes between "that which copies real Events, and that which feigns both Character, and Fable." The latter is either based on a text or, most difficult of all, invented by the painter:[2]

> Unless, therefore, the Painter has Genius, and Knowledge enough to form a compleat Tale, on the most delicate Principles of Nature, to support it with just and masterly Characters, to give those Characters a proper Share of the Business, and spirit the Whole with noble Attitudes, and bold Expression; unless, I say, he is perfect in all these Secrets of picturesque Narration, I would advise him not to trust his Imagination too far, but content himself with an Imitation of known Facts, or a Transcript of the celebrated Imaginations of others.

From the evidence that has survived, Hogarth seems to have been praised for his attempts at history, whether comic or sublime, in the 1730s. Ralph was admittedly a partisan, but in eighteenth-century London partisans were usually offset by fiercer denigrators; this was the case with Pope and Fielding, but not with Hogarth until a somewhat later date.

His desire in the mid-1730s to attempt sublime history cannot be attributed only to the shadow of his father-in-law: it was the natural, even inevitable step for any painter indoctrinated by the artists' manuals and treatises of the time. However original, Hogarth was still deeply rooted in the tradition of the art treatises; some part of him still believed what they had to say about sublime history. But he had already made clear his contempt for histories portraying heathen gods and heroes, and a religious subject, even given a commission, was a dangerous undertaking, since the artist had to cope with the English Protestant distrust of Catholic church decorations, images, and counter-Reformation iconography. The difficulty of painting a church altarpiece in England was distinctly apparent in November 1735, when the *Daily Advertiser* referred to an "extraordinary altarpiece lately set up in Clerkenwell Church . . . wherein, to the Reproach of Protestantism, *the Virgin Mary is painted with Christ in her Arms in the front, with Moses and Aaron on each side as her proper Guard."* The congregation petitioned the Bishop of London for its removal, just as the St. Clement's congregation had done with Kent's altarpiece. A sixpenny print of the altarpiece was advertised as sold along with "the late Bishop Fleetwood's Account of the Origin and Progress of setting up Pictures and Images in Churches, to the Scandal of Christianity, and the Promotion of Superstition and Idolatry."[3] That Hogarth, as a xenophobic Englishman and a Protestant, concurred with these sentiments is evident from his later print *Enthusiasm Delineated* (below, pl. 284).

The second possibility was a nobleman's house. Although Hogarth later noted the incongruity of some biblical subjects painted in a dwelling (on a ceiling or

along a staircase), his main deterrent, as with churches, was absolute lack of en-
couragement. A nobleman would think twice before commissioning the painter
of small conversation pictures to fill a large wall space. The only anecdote that
has survived of Hogarth's biblical subjects in a house sounds suspiciously like an
afterthought based on the ceiling in *Marriage à la Mode*, Plate 1, or a traditional
artist's anecdote.

> A certain old Nobleman, not remarkably generous, having sent for Ho-
> garth, desired he would represent, in one of the compartments on a stair-
> case, Pharaoh and his Host drowned in the Red Sea; but at the same time
> gave our artist to understand, that no great price would be given for his per-
> formance. Hogarth agreed. Soon after, he waited on his employer for pay-
> ment, who seeing that the space allotted for the picture had only been
> daubed over with red, declared he had no idea of paying a painter when he
> had proceeded no further than to lay on his *ground*. 'Ground! said Ho-
> garth, there is no *ground* in the case, my lord. The red you perceive is the
> *Red Sea*. Pharaoh and his Host are drowned as you desired, and cannot be
> made objects of sight, for the ocean covers them all.'[4]

Although Hogarthian in the tradition of the anecdotes about his treatment of
sitters for portraits, and perhaps suspect, the story conveys the situation of the
history painter desirous of being employed by country gentlemen, who were
satisfied with anything that would cover great spaces of wall, and preferred cop-
ies of reliable old masters. In 1736, as an example, Pope was helping Ralph Allen
choose subjects for history paintings to be hung in his new house, Prior Park:
LeSueur's *Discovery of Joseph to his Brethren,* Ricci's *Scipio's Continence,*
Poussin's *Death of Germanicus*—all copied from copies or engravings by a
wretched Bath (but foreign-born) artist, Johan van Diest.[5]

One solution had come through Hogarth's contacts with St. Bartholomew's
Hospital. His own account, written years later, was that before he devoted him-
self wholeheartedly (or so I interpret his ambiguous phrases) to "Engraving
modern moral Subjects, a Field unbroke up in any Country or any age," he made
an attempt at "the grand stile of History." This interpretation would fit with the
gap between the completion of the *Rake* in the spring of 1735 and the next print
in the fall of 1736. "I then as a specimen without having done any thing of the
kind before Painted the staire case at St Bartholomew Hospital gratis. . . ."[6] Else-
where he adds that "the puffing in books about the grand stile of history painting
put him upon trying how that might take so without haveing a stroke of this
grand business before." The "puffing" of "the grand stile," "this grand busi-
ness," is a rather derisive reference to Jonathan Richardson; prompted perhaps,
considering that Hogarth wrote the passage in the 1760s, as much by Reynolds'
Idler No. 79 (20 October 1759) as by his memory. The second emphasis, as later
with portraiture, is on his having done nothing of the sort before the St. Bar-

tholomew paintings: "immediately from family picture[s] in smal he painted a great stair case ..." with "figures 7 foot high ... this present to the charity he by the pother made about the grand stile thought might serve as a specimen to shew that were there any inclination in England for Historical painting such a first essay would Proove it more easily attainable than is imagined. . . ."[7] His aim, he explains, was not solely to paint sublime history himself but to insure that other English artists might also paint histories, that England might be decorated with English art, and that the English public might see it.

While he painted for a hospital, Hogarth had one eye on churches as well. The emphasis of the theologians who controlled the bishoprics, and those with whom Hogarth presumably sympathized (considering his friendship with the Hoadlys and other Latitudinarians), was not on religious mystery or devotion but on acts of charity. Through works, not faith, a Christian proved himself. It is significant, I think, that Hogarth chose (for he was not chosen) a public hospital as the place to donate a biblical subject, and chose as his subject two scenes of Christian charity: Christ healing the halt and lame and the parable of the Good Samaritan. The latter was subsequently employed by Fielding, whose sympathies too were tinged with Latitudinarianism, as the paradigm of his first novel, *Joseph Andrews*. The central episode of Joseph robbed and left in a ditch, with the reactions of a coachload of gentlefolk who find him, and of the poor postilion who helps him, was a modern retelling of the Good Samaritan story, and set the stage for the long series of similar encounters that followed in the novel. In a sense, of course, the progresses of the Harlot and the Rake were also versions of the parable in which no Good Samaritan appeared, unless one counts poor Sarah Young in the *Rake's Progress*. This subject, then, was both the safest one for religious history painting in Hogarth's time and the one most readily applicable to assumptions he had already illustrated in his modern histories.

Although the agreement with St. Bartholomew's went back to early 1734, and Hogarth was elected a governor of the hospital that summer, the *General Evening Post* of 15–17 July 1735 could still announce blandly that he was going "to make a Present of the Painting of a Stair-Case at St. Bartholomew's Hospital, of which he was lately chosen a Governor," but with no further information than the 1734 announcement in Ralph's *Weekly Register*. Presumably he had waited to begin the work until the *Rake's Progress* and the Engravers' Act were off his hands; and perhaps the July announcement followed from his having just set up his materials. It would appear, from the size of the canvas, that he painted it at the hospital, but not *in situ;* it would have been far too large for his studio.

True fresco as the medium for wall paintings (pigments applied with a water medium to a surface of wet plaster) was seldom used in England because of the damp climate. Since it was less affected by damp, oil was applied to plaster, wood, or canvas. Even the continental artists—Verrio, Ricci, and the others—brought up on either true fresco or *fresco secco,* turned to oil when they came

to England. The main disadvantage of oil is the glare produced in the light, avoided by water paints. Hogarth's murals were painted in oil on canvas, and the *London Evening Post* of 8–10 April 1736 announced the first part of the project as completed:

> The ingenious Mr. Hogarth, one of the Governors of St. Bartholomew's Hospital, has presented to the said Hospital a very fine Piece of Painting, representing the Miracle wrought by our Saviour at the Pool of Bethesda, which was hung up in their great Stair-case last Wednesday [i.e. 7 April].
>
> The same Gentleman is preparing another Piece, representing the Story of the Good Samaritan, which he intends to present to the said Hospital.

Vertue, exceedingly annoyed, wrote in his notebook that "this advertisement is his own,"—by which he presumably meant, inserted in the paper by Hogarth. Judging by the consistently-published news of St. Bartholomew's Hospital in the *London Evening Post*, it appears more probable that the Hospital and not Hogarth secured the publicity. But Vertue's general reaction may have been typical. He admits Hogarth's "extraordinary Genius," which up to now "has displayd it self in designing, graving painting of conversations charicatures. & now history painting—, joyn'd to a happy—natural talent a la mode.—a good Front and a Scheemist—but as to this great work of painting it is by every one judged to be more than coud be expected of him."[8] To judge by Vertue, the first reaction to the completed *Pool of Bethesda* was incredulity mixed with admiration.

Through the remainder of 1735 and into 1736 Hogarth worked almost exclusively on this enormous canvas. As soon as *The Pool of Bethesda* was finished, however, he seems to have felt a need to make up for the money he lost on that gift to the hospital. In fact, it is quite likely that he was engraving *Before* and *After*, as secular a subject as he ever attempted (based on the paintings of the indoor version, ca. 1730, pls. 89, 90 above) at the same time that he was painting *The Pool of Bethesda*—or at least shortly after he had finished. He returned to his popular audience, and in October published *The Sleeping Congregation*, in December *Before* and *After*, in January *Scholars at a Lecture*, in March *The Company of Undertakers* and *The Distressed Poet*, and at the same time issued the various small prints of faces (i.e., *Chorus of Singers*, *Laughing Audience*, *Scholars at a Lecture*, and *Company of Undertakers*) as *Four Groups of Heads*.

Hogarth's print market, by now considerably larger than that of the ordinary printmaker, was defining itself in these years. Via the advertisement for *The Sleeping Congregation* he was listing all his other works as well (always excluding the *Harlot's Progress*, which he could not reprint due to his contract with his subscribers), and had concluded some sort of an arrangement with Thomas Bakewell, the publisher of the cheap authorized copies of the *Rake:* all of his

prints were "to be had at the Golden Head in Leicester Fields; and at Mr. Bake-well's, print-seller, next the Horn Tavern, in Fleet-Street." Perhaps to avoid dealing directly with the retail booksellers, perhaps to cover a part of London further east, Hogarth used Bakewell as a second outlet as late as the 1740s. With the advertisement for *The Distressed Poet* at the beginning of 1736/7 he took the significant step of announcing bound volumes of his engraved works: "To be had either bound together with all Mr. Hogarth's late engraved Works, (except the Harlot's Progress) or singly, at the Golden Head in Leicester-Fields, and at Mr. Bakewell's, Printseller, next to the Horn-Tavern, Fleet-street."[9]

Thus began the accretion of a body of morality, with an implicit unity of its own, in the shape of a book. The major engravings would be included, the ephemeral ones excluded, and one of the greatest of eighteenth-century moral anatomies compiled, to which in time would be added a portrait of the "author" as frontispiece and eventually a tailpiece as well. It must have been galling for Hogarth to know that he could not include his *Hudibras* plates in his volumes or sell them at the Golden Head, for they were still on sale in Philip Overton's shop and frequently so advertised. The time was approaching when he would find a way to include the *Harlot's Progress,* and the remainder of the works he was to produce in the next twenty-five years were at least partly conceived with this repository, this structure in mind.

A general working procedure, at least for the major series of prints, also begins to emerge in these years: subscriptions are begun in the spring or the fall, at the beginning or end of the London "season." The subscribers Hogarth catered to tended to buy on arrival in September or October and again on departure between March and June. The series are almost invariably dated in the spring, a time when the buyers could take the prints back with them to the country. (These dates are true of London printsellers in general.) It is likely that the long, dark London winters, a time when Hogarth had nothing to do but work by an artificial light on his copperplates, were also a factor in this schedule.

During the lull at St. Bartholomew's, with one wall remaining empty, Hogarth was also planning and probably painting *The Four Times of the Day* as cartoons for larger designs for Tyers' Vauxhall, as well as *Strolling Actresses Dressing in a Barn.* All of this was far enough along for him to announce his subscription in the *St. James' Evening Post,* 10–12 May 1737:

PROPOSALS By Mr. Hogarth,
To publish by SUBSCRIPTION,

FIVE large PRINTS from Copper-Plates, now engraving, (and in great forwardness) after his own Paintings, viz. four representing, in a humorous Manner, Morning, Noon, Evening and Night; and the fifth, a Company of Strolling Actresses, dressing themselves for a Play in a Barn. Half a Guinea

to be paid at the Time of subscribing, and Half a Guinea more on the De-
livery of the Prints.

The Pictures, and those Prints already engrav'd may be view'd at the
Golden-Head in Leicester-Fields, where Subscriptions are taken in.

Note after the Subscription is over, the Price will be rais'd to Five Shil-
lings each Print.

The advertisement was repeated in six subsequent issues, the last for 21–23
June; then no more was heard about these paintings and prints until nearly a
year later, early in 1738, when the same advertisement was published, only add-
ing: "and no copies will be made of them."

What happened to delay the project is open to speculation. Whether waiting
for some initiative on the part of the hospital, or as the result of a quarrel or his
own lack of interest, Hogarth had been inactive a year on the St. Bartholomew
staircase. Suddenly, in the issue for 14–17 May 1737, the *London Evening Post*
announced: "A few Days since a Frame was fix'd in the Staircase of St. Bartholo-
mew's-Hospital, in order for painting the History of the good Samaritan, by that
celebrated Artist Mr. Hogarth." The same journal announced in the issue of
7–9 June:

> On Monday last the Masons began to lay the Stone-Work in the new ad-
> ditional Buildings in St. Bartholomew's Hospital, which is to contain
> twelve Wards; and on Tuesday [7 June] Mr. Hogarth began painting the
> History of the Good Samaritan, in the great Stair-Case in the said Hospital,
> and 'tis thought will be finish'd against the Governor's annual Meeting,
> which will be the last Week in July next.

The Good Samaritan was apparently painted *in situ* in order to sustain the
tone of the finished work next to it. The *Grub-street Journal* of 14 July noted
that "Yesterday the scaffolding was taken down from before the picture of the
Good Samaritan, painted by Mr. Hogarth, on the stair-case in St. Bartholomew's
hospital, which is esteem'd a very curious piece." On Thursday the twenty-first
the General Court met as scheduled, with an "elegant Dinner" (Henry Overton
was one steward), and it was "Resolved That the Thanks of this Court be given
to W^m Hogarth Esq^r one of the Governors of this Hospital for his generous & free
Gift of the Painting of the great Stair Case performed by his own Skilfull Hand
in Characters (taken from Sacred History) w^ch illustrate y^e Charity extended to
the Poor Sick and Lame of this Hospital."[10] Hogarth was himself absent from the
meeting, but the *London Evening Post* (admittedly a spokesman for the hospi-
tal), of 21–23 July reported that the paintings were "esteem'd the finest in
England."

The result (pls. 141–43) is not unimpressive. Hogarth himself, in recalling the
pictures, emphasizes the size of the figures ("7 foot high"), underlining the fact

that a painter of small conversations could do more.[11] And it is startling to move from one of his 1735 paintings to this huge wall: the figures are indeed larger than life-size, and they loom up as one ascends the staircase. From the top landing, outside the entrance to the Great Hall, lighted only by three windows and a chandelier, they are at eye level, but even at that distance one is impressed first by the color, the brilliance of execution, and the excellent state of preservation. All of these, including the last, are important characteristics of Hogarth's art. At its best, the laying on of paint recalls Rembrandt, especially in the figures that are not in clear focus; the least interesting parts result from the overelaboration and over-finishing of faces, as in the man with the bandaged arm.[12]

The use of painted decoration to support the architectural structure is reminiscent of Thornhill's when he worked with Gibbs at Wimpole, except that Hogarth's brushwork is much freer, imparting a rococo quality to his forms. The decorative borders and scrollwork around the painting are said to have been executed by a Mr. Richards; if so, he captured Hogarth's manner perfectly. The extensive landscape, out of Salvator Rosa, has been reasonably attributed to George Lambert.[13] Above the door to the Great Hall is a circular medallion profile of Galen, probably added after the unveiling in July 1731; and over the other door, which opens into the hall, is a medallion of Hippocrates, in reddish paint simulating bas-relief. These are matched by the simulated bas-reliefs below the large pictures: under *The Pool of Bethesda,* a sick man carried on a stretcher into the hospital; under *The Good Samaritan,* the monk Rahere, founder of the hospital, asleep and dreaming his vision of the hospital, his dog barking to awaken him; and again Rahere receiving gifts and beginning to build the hospital.

The two paintings are rather different. *The Pool of Bethesda,* with its many figures, complex arrangement, and many precedents (Murillo, Ricci, and others), is in sharp contrast to the relatively perfunctory *Good Samaritan;* all of Hogarth's interest and enthusiasm must have gone into the first. Although the governors' resolution praising Hogarth drew attention to the pictures as representations of charity, an unsympathetic critic might have viewed both as reasonable productions for the painter of the *Rake's Progress.* He could point to *The Pool of Bethesda* as the ideal subject for a "grotesque painter," its focal element being the various diseased and crippled people. They are patently a bit too lively against the static pose of Christ; they do not relate to each other or to Christ, whose stiff outstretched arm is the only contact. In this company, the angel and the female nude are decidedly out of place, drawn from another convention. Walpole noticed that "a servant to a rich ulcerated lady beats back a poor man that sought the same celestial remedy," and found this circumstance "justly thought, but rather too ludicrous." He might have noticed other details like the dog peering down over the painted architecture at the viewer. He apparently had not heard that, as "an old acquaintance" of Hogarth's (probably Forrest) in-

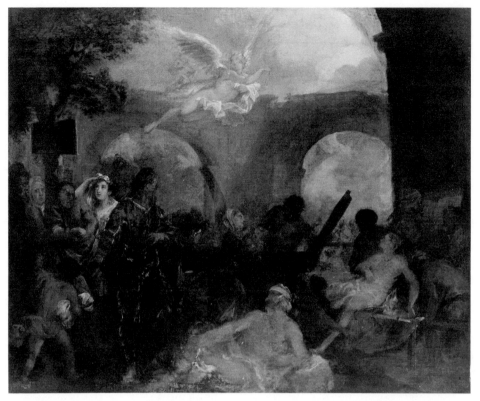

140. Sketch for The Pool of Bethesda; ca. 1735; 25 x 30 in. (Manchester City Art Galeries)

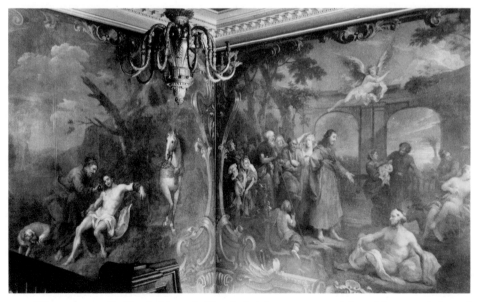

141. The stairway, St. Bartholomew's Hospital (pls. 141–43 reproduced by permission of the Governors of the Royal Hospital of St. Bartholomew)

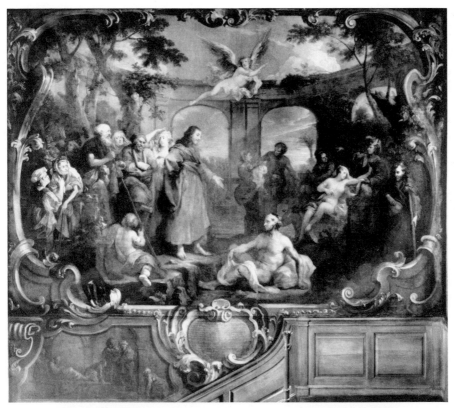

142. The Pool of Bethesda; 1736; 164 x 243 in. (St. Bartholomew's Hospital)

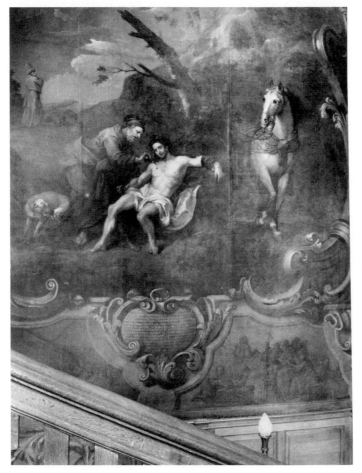

143. The Good Samaritan; 1737; 164 x 243 in. (St. Bartholomew's
Hospital)

sisted, the rich lady "is a faithful Portrait of Nell Robinson, a celebrated courtesan, with whom, in early life, they had both been very intimately acquainted."[14]

The subject of charity is secondary. What caught Hogarth's interest, and drew upon his long knowledge of the hospital, was the matter of disease and injury. He has realized the diseases cured by Christ in terms of those treated at the hospital, bringing the story up to date and, in this sense, creating another modern history in fancy dress with a puzzled-looking Christ in the middle. The patients are carefully observed: the infant with the prominent forehead, curved spine, and enlarged joints is a classic case of rickets, as first described by the hospital's Dr. Francis Glisson in 1650. Hogarth's source may have been his friend Dr. Freke, who wrote a chapter on rickets: "The rickets in children are discovered by the swelling of the joints and by the bones becoming so soft and tender as to yield and give way in all parts, but more especially in their heads and extremities, so that there is not a sufficient quantity of creta in proportion to the membranous parts to make them strong enough to bear the weight of the body." Also painted with clinical accuracy are a woman with inflammation of the breast, a man whose gouty hand has received a painful knock from the blind man whose staff is near it, a girl unhealthily fat, and an emaciated old crone. The arms of the last two are bare to illustrate hypertrophy and atrophy, processes of abnormal growth and abnormal waste.[15]

The main reaction to Hogarth's paintings may have been a small resurgence of interest in history painting among London artists. One example that has survived is Highmore's painting of *The Good Samaritan* (recently acquired by the Tate), which pilfers the injured man from Hogarth's *Pool of Bethesda* and the Samaritan himself (though woefully painted) from *The Good Samaritan*, as well as the figures in the distance (reversed). As to Hogarth himself, one or two special commissions may have followed, but from the great religious or state patrons there was no response. As he put it in retrospect, "religion the great promoter of this stile in other countries in this rejected it," i.e. did not offer him any commissions; and, "this failing," he was "still unwilling to fall into the manufacture," presumably ordinary hack work, so "next conceived morality." In other words, he turned once more to his "modern moral subjects."[16]

Nevertheless, Hogarth left large sublime histories on permanent exhibit, as accessible to the public as Thornhill's. One Sunday in April 1740 Mrs. Pendarves, who in 1731 had once sat to Hogarth for a portrait, set out with friends to have a day on the town. They left Whitehall in two hackney coaches at 10 A.M.

Our first show was the *wild beasts* in Covent Garden; from thence to St. Bartholomew's Hospital—the staircase painted by Hogarth, the two subjects the Good Samaritan and the Impotent Man; from thence to Faulkner's, the famous lapidary, where we saw abundance of fine things, and the manner of cutting and polishing pebbles, &c.; then to Surgeons' Hall to see

the famous picture of Holbein's of Harry the Eighth, with above a dozen figures in it all portraits; then to the Tower and Mint—the assaying of the gold and silver is very curious; saw *lions, porcupines,* &c., armour and arms in abundance; from thence to Pontack's to a very good dinner; and then proceeded to the round church in Stocks Market—a most beautiful building.[17]

Hogarth's pictures were one of the sights of London, their theme and mode central to the writers if not the artists of the 1730s and 1740s.

He remained a governor of the hospital. On 31 July 1735, when the second wing was begun, he subscribed £22 10s, but as a governor he appears to have been relatively inactive, attending few meetings and serving on no committees. The first meeting he attended was the general court (which met five times a year) held on 25 March 1737, with a very large gathering of governors. Although not mentioned in the minutes, he may have been there to explain why he had not gotten on with the second painting. The next meetings he appeared at were the general court of 1 December 1737, when Alderman Barber was chosen president; and a weekly meeting, Thursday 27 April 1738, to give his opinion on the painting by Mr. Richards of the benefactors' names on the tablets in the court room. As a result, it was "Ordered that the Ground Work of the Painting of the Benefactors Names in the Court Room be of a Darker Porphory Colour than that already laid and the Letters to be of Gold and Mr Richardson [sic] to go about the same as soon as possible." On 19 December of the same year, although absent from the meeting, he was mentioned in a consultative faculty. The large picture of King Henry VIII, the gift of Mr. Sweete, in the counting house, was to be moved to the great Court Room (the great hall), where the small picture of Henry VIII was hung;

> and Mr Gibbs and Mr Hogarth Two of the Governors, are desired to see the large Picture—properly framed and fixed with decent and respectful Ornaments.
>
> And Mr Gibbs and Mr Hogarth are also desired to give Orders for preparing a Busto of Rahere the first Founder of this Hospital to be taken from his Monument in Great St Bartholomew's Church to be fixed in the Great Court Room over the Middle Chimney.

And so it went, with little important activity. In 1751 the staircase paintings were cleaned by one John Williams, at Hogarth's own expense. He had also requested that his canvases never be varnished (though he may have wanted them treated with his own preparation of glair), but they were, repeatedly, after his death. On 17 May 1754 it was "Ordered that an Inscription be set up in some part of the Painted Staircase leading to the Court Room, Setting forth that the two Capital Pieces of painting were painted & given by Mr William Hogarth, &

all the Ornamental Painting there was done at his Expense." The inscription is over the door leading to the Court Room, a single line: "The Historical Paintings of this Staircase were painted and given by Mr. William Hogarth and the ornamental paintings at his Expense, A.D. 1736."

Even though there were no more commissions from church or state, one may be sure that the St. Bartholomew paintings were not Hogarth's only excursions into sublime history during these years. He never did things by halves. The *Scene from 'The Tempest'* (pl. 144), though undatable, was probably painted around this time. It was a serious equivalent of his earlier *Falstaff examining his Recruits,* an attempt to make Shakespeare a subject for history painting, a vein to be exploited by Hayman and others. It is built on the familiar triad, used in *The Beggar's Opera* and so many of Hogarth's other paintings: Miranda is in the center, with her father Prospero hovering behind her, flanked by Ferdinand and Caliban, each (in his own way) her suitor. Even more schematically than in the comic histories, the human beings—Ferdinand, Prospero, and Miranda—are bracketed between the aspiring spirit of Ariel above and the grotesque, crouching, half-animal Caliban beneath.

It may also have been in the mid-1730s that Hogarth began a history painting out of Milton's *Paradise Lost*. The Richardsons' *Explanatory Notes and Remarks on Milton's 'Paradise Lost'* appeared in 1734, and the elder Richardson read parts of it aloud to the Slaughter's group, which included Hogarth. In this book Richardson finds Satan, Sin, and Death to be the "Allegory which contains the Main of the Poem," an epitome of the whole argument.[18] Hogarth takes this as his subject, but he characteristically focuses on the psychological relationship of the triad of characters: Sin holds apart her father-lover Satan from her murderous offspring-lover Death, as, in the *Beggar's Opera* paintings, Polly Peachum stands between her father Peachum and her lover Macheath (see below, pl. 280).

Hogarth seems also in a few instances to have sought to treat history subjects in a blatantly "modern" manner. Unfortunately, one such instance is no more than hearsay and the other only a photograph. A painting of *Danaë* was sold at his 1745 auction, in which, according to Walpole, "the old nurse tries a coin of the golden shower with her teeth, to see if it is true gold. . . . It is a much more capital fault that Danaë herself is a meer nymph of Drury. He seems to have conceived no higher idea of beauty." From the sound of it, *Danaë* was not a "sublime" history but an attempt to show the crudity inherent in the Greek myth and in the tradition of history painting based on such stories, perhaps a response to Kent's *Danaë* painted on the ceiling of the King's Drawing Room, Kensington Palace. Hogarth would have seen Danaë as "a meer nymph of Drury," a glance at the other side of the Harlot's coin: one is the whore trying to talk like Danaë, the other Danaë showing herself to be nothing but a whore. He must

144. A Scene from "The Tempest"; ca. 1735? 31½ x 40 in. (Lord St. Oswald: Nostell Priory Coll.)

have been very pleased, however, when Dr. James Parsons singled out *Danaë* in his important lectures on the muscular structures of physiognomy in 1746 as an example of passion delineated by expression:

> But if the Passion of Desire be prompted and accompanied by any more engaging Circumstances, then the *Elevator* of the Eye will act strongly, causing the *Pupil* to turn up, at the same time that the Action of the *Aperiens Palpebram* is more remitted, whereby all the *Pupil*, except a little of the lower Edge, will be hid, and the Lids come nearer each other; the Mouth being a little more open, the End of the Tongue will lie carelessly to the Edge of the Teeth, and the Colour of the Lips and Cheeks be increased.
>
> Thus yielded *Danae* to the Golden Shower; and thus was her Passion painted by the ingenious Mr. *Hogarth*.

One aspect of Hogarth's humanizing of Danaë thus ties in with his clinical interest, indulged in his association with St. Bartholomew's Hospital and in his paintings there.[19]

The other painting is a *Samson and Delilah* with the familiar trinity at the center: Delilah in the middle, in a curtained bed, between Samson and a young man cutting off his hair. At the right, behind a screen, are the Philistines, spears bristling over the top. Everything except the Philistines is of the eighteenth century. A dressing table with a monkey is at the left, reminiscent of the *Harlot*, Plate 2; scattered on the floor are gin bottles, a jawbone of an ass, and playing cards. In the left corner is the inscription: "Who can say I have made my heart clean, I am pure from sin."[20] If this painting was indeed by Hogarth, it was an experiment that was not repeated.

One of the long series of literary documents that invoke Hogarth, disclosing the effect for which he was striving, appeared in a book of Latin poems, *Poematia,* in 1734—around the time he embarked on his experiments in history painting. This was the poem "Ad Gulielmum Hogarth," by Vincent Bourne, a master of Westminster School of about Hogarth's age, who wrote charming Latin verses about contemporary English subjects. Their relationship appears to have been friendly; a few years later in "Conspicillum" Bourne alluded to the clerk leering at the sleeping girl during the general somnolence in *The Sleeping Congregation,* and his "Usus Quadrigarum," with its description of a man crammed in a coach between fat women, seems to have been in Hogarth's mind when he made *The Country Inn Yard* in 1747, the year of Bourne's death. There may have been further connections: Bourne taught Cowper, Thornton, and their circle at Westminster, most of whom became close friends and associates of Hogarth in the 1750s, and his appointment in November 1734 to be housekeeper and deputy sergeant-at-arms to the House of Commons (as the result of his dedication of *Poematia* to the Duke of Newcastle) may have served Hogarth in his

campaign toward the Engravers' Act; the petition for it was introduced early in the next year.[21]

The most interesting tie between the two men, however, is once again symbolic. In Allan Ramsay, Hogarth had found a poet who joined traditional poetic subjects with the homely Scottish dialect; Gay had perhaps done something even more to his liking in *Shepherd's Week,* where the ordinary confusion of day-to-day existence was seen through the conventions of pastoral. Bourne was conveying an even purer effect when he described contemporary life—the interior of a stagecoach or a sleeping congregation—in classical Latin. "His diction all Latin," as Charles Lamb observed, "and his thoughts all English!"[22] A poem like "Cantatrices," on the ballad-singers of Seven Dials, conveys very much the sense Hogarth achieves by portraying ballad singers and their like as seen, not by the Dutch genre painters, but by the great history painters. Throughout these transitional years he was experimenting with different combinations of the real and the ideal, now an idealized subject treated in realistic terms, now a realistic subject portrayed in the heroic idiom of history painting. Bourne would naturally have been a sympathetic soul, somebody whose work, like Fielding's, in some sense paralleled his own.

It is worth noting that the prints concerned with physiognomy are concentrated during the time of Hogarth's painting at St. Bartholomew's Hospital: his fascination with the clinical, praised by Dr. Parsons, was evidently as strong a force as the desire to paint sublime history. The histories, as well as the *Groups of Heads* and even *Before* and *After,* are concerned with physical states or manifestations as they relate to the mental, and the moral is temporarily in abeyance. In fact, morality, one must conclude, was a secondary consideration for Hogarth during the last years of the decade.

The one "group of heads" which is topical and, as Hogarth was later to put it, "timed," was *The Company of Undertakers* (pl. 145, sometimes called *The Consultation of Physicians*). To begin with, this print is another offshoot of Hogarth's observations at the hospital; some of the Bartholomew's physicians have been identified among the physicians portrayed below the wavy line. The three quacks posing as figures on the "chief" part of the shield are John Taylor, Sarah Mapp, and Joshua (Spot) Ward, who were associated as a sort of medical triumvirate and were much in the news during the fall of 1736 (the print came out in March 1736/7).

> In this bright age Three Wonder-workers rise,
> Whose Operations puzzle all the Wise.
> To lame and blind, by dint of manual slight
> MAPP gives the use of limbs, and TAYLOR sight.

ET PLURIMA MORTIS IMAGO

The Company of Undertakers

Beareth Sable, an Urinal proper, between 12 Quack-Heads of the Second & 12 Cane Heads Or, Consul-tant. On a Chief Nebulæ, Ermine, One Compleat Docter issuant, checkie Sustaining in his Right Hand a Baton of the Second. On his Dexter & Sinister sides two Demi-Docters, issuant of the second, & two Cane Heads issuant of the third; The first having One Eye conchant, to-wards the Dexter Side of the Escocheon; the Second Faced per pale proper & Gules, Guardent.——— With this Motto ——————— Et Plurima Mortis Imago .

** A Chief betokeneth a Senatour or Honourable Personage, borrowed from the Greeks, & is a Word signifying a Head; & as the Head is the Chief Part in a Man, so the Chief in the Escocheon should be a Reward of such only, whose High Merites have procured them Chief Place, Esteem, or Love amongst Men . Guillim .*
*** The bearing of Clouds in Armes (saith Upton) doth import some Excellencie .*

Publish'd by W. Hogarth March the 3d. 1736

145. The Company of Undertakers; Mar. 1736/7 (second state); 8⅝ x 7 in. (W. S. Lewis)

> But greater WARD, not only lame and blind
> Relieves; but all diseases of mankind
> By one sole *Remedy* removes, as sure
> As Death by *Arsenic* all disease can cure.[23]

Although their association was emphasized in 1736 and '37, they had been individually attacked earlier, most notably in the pages of the *Grub-street Journal*. The question, however, is what they meant to Hogarth and what he did with them in his print. The quacks in the fifth plate of *A Harlot's Progress* are there not only because they are quacks but also because they represent the natural consequences of the Harlot's folly and the further reactions of the society she has chosen to emulate. Moreover, as Hogarth portrays them, it is evident that the dying Harlot herself is the consequence of their quackery.

Mrs. Mapp was simply a broadly comic figure—a female bone-setter; but Ward and Taylor were serious targets for satire and were so treated by the *Grub-street Journal*. Taylor, an oculist, was not, properly speaking, a quack. The *Journal* carefully emphasized the fact that he was a regular surgeon of talent, but one who subjugated his talent and profession to the demands of a commercial enterprise: defending him (on 2 December 1736) as a physician but attacking him as a self-puffer and ridiculing his commercialism and lack of professional dignity. In an earlier issue, a correspondent signing himself "Fair Play" tells of a patient who lost the sight of both eyes a few days after one of Taylor's operations; this, he says, was not the fault of Taylor's work but of his ridiculous advertising and pompous progresses through the countryside, which led incurables (this patient was seventy) to believe they were curable. In this sense, Taylor would have struck Hogarth as another mediator, like picture dealers, between fools and the proper aims of life. On 27 January 1736/7 both Taylor and Ward were described in the *Journal* as members of "The Trumpeters Club or Society of Puffers," in which "the present honorary professor is the worshipped Dr. T—r, well known for his various puffs all over the kingdom."

The point of Hogarth's presenting him on an escutcheon is plain. Taylor himself represented another example of pretension vs. reality; the arms, showing both what he thinks of himself and what the Crown thinks of him, become an imaginary projection of royal favor. Like Colonel and Mrs. Charteris, Taylor had been presented to the queen at Kensington "and had the Honour to kiss her Majesty's Hand, in consideration of his extraordinary Merit in the Sciences he professes." This was in September 1735, not too long after Hogarth had been snubbed by the royal family. In October Faber's mezzotint portrait of Taylor appeared, and the oculist was again at Kensington, this time to show the queen some of his inventions. She promised to call on him in a few days to be present at some of his operations. More currently, in May 1736 Taylor had been appointed oculist to the king and had the honor of kissing the hands of both king

and queen, and in August he conducted one of his triumphal progresses through the countryside with hundreds waiting for him and seeking his help. Also in August, Mrs. Mapp was performing her operations at Epsom and Kingston before persons of distinction, and was scheduled to perform before the queen at Hampton Court. (At the same time the news was confirmed that her husband had deserted her, making off with 102 guineas.)[24]

Joshua Ward, the most famous quack of his time, was attacked by the *Grub-street Journal* for creating the reputation of being—like Taylor—an apparent wonder-worker. But his claims were based only on a "Pill and Drop," made of antimony and arsenic, which had a powerful purgative effect and sometimes killed instead of curing. The *Journal* listed case after case which demonstrated the horrifying results of his "cure": blindness, paralysis, and death. The most dangerous of the three quacks, he was attacked as early as 1734 and remained one of the *Journal's* main subjects until it expired itself at the end of 1737.[25] On 28 November 1734 "Misoquackus" recounted cases of paralysis following from the use of Ward's "Pill and Drop," and attacks only intensified in the middle of 1736, when an anti-Ward pamphlet, Joseph Clutton's *A true and candid Relation of the good and bad Effects of Joshua Ward's Pill and Drop, Exhibited in sixty-eight Cases,* was published. Meanwhile, on 17 June, the news was printed that Ward and eight or ten of his cured patients had appeared before Queen Caroline and were examined, and Ward was congratulated and given money. Then the *Journal* set about investigating these cures and reported on 24 June that only seven had appeared and none could be called a real cure, either because it was not known what the patient had to begin with or because he still suffered from the same disease, only somewhat eased, after the treatment. On 15 July the attack became systematic, with communications from Clutton and large extracts from his book, listing case after case. On 11 November the attack turned to Ward's self-advertising, his hounding patients for affidavits, for which he sometimes bribed and threatened them.

At the beginning of 1736/7, Hogarth simply picked up the image of Taylor and Ward presented in the *Grub-street Journal* and projected it in his imaginary escutcheon, but with one important difference. He did not show the horrible consequences of the quackery, so clinically described in the *Journal*, but rather limited himself to the clinical examination of the quackery itself, a comic juxtaposition of feigned wisdom and actual folly, revealed in each abysmal physiognomy. The print mocked the discrepancy between the physicians' claims and their real accomplishments, and indirectly reflected public gullibility.

On 23 January 1737/8 Hogarth began to advertise his subscription for *Strolling Actresses* and *The Four Times of the Day* (pls. 146–150), first announced as "in great forwardness" in May 1737, using nearly the same words.[26] On 25 April he announced that the prints were finished and would be ready for delivery to

subscribers the next Monday, 1 May, at the Golden Head. (In the earlier advertisement he had mentioned that his other engravings, "either singly or bound up together," were available too, and in this one he adds, "Likewise compleat Sets of the Prints done from the Paintings of the late Sir James Thornhill in the Cupola of St. Paul's," referring to the inherited plates.) He did a great deal of advertising for this series, even after publication, changing the opening to "Mr. HOGARTH HATH just publish'd, . . . ," and continuing through most of May.[27]

Strolling Actresses dressing in a Barn (pl. 146), under way in May 1737, may have required some rethinking after Sir Robert Walpole at the end of that month pushed his Licensing Act through Parliament. At any rate, Hogarth added a paper labeled "The Act against Strolling Players" across the actresses' bed. This plate, by commemorating the closing of the theaters in 1737, represented a gesture toward Fielding, at whom the Licensing Act was originally aimed; it forced him to retire from the stage and live by the practice of law (and ultimately write *Joseph Andrews* and the other novels). *Strolling Actresses* presents in a single image all Hogarth's comments on society up to this point, but in Fielding's particular idiom. In his farces and burlesques Fielding showed shabby mortals acting the roles of gods and goddesses, kings and queens, but not in the Augustan manner: he attacked the gods and heroes as delusive, and the humans as low and gross only because they were imitators of those fraudulent gods. The Augustans, Swift and Pope, had emphasized the evil in man that made him think of himself as an Aeneas when he was obviously only a Shadwell or a Theobald; but Fielding emphasized the false heroes of his time who deluded perfectly decent men into changing themselves into something odd, inappropriate, and thus ridiculous. He could accomplish this especially well on the stage, depicting ordinary people—authors, critics, and the actors who are sometimes prevented by bailiffs or drink from reaching the theater—as they arrive, sit around and discuss the play, and then watch a rehearsal, not a performance: the actors suddenly appear in roles, often portraying people who imitate false ideals. This conception reached its highest art in *Pasquin* and *The Historical Register,* in 1736 and 1737, then came to an end with the Licensing Act; it is what Hogarth celebrates in *Strolling Actresses.*

He begins with an exaggeratedly baroque composition and a subject reminiscent of an assembly of the gods (perhaps recalling Kent's egregious painting in Burlington House); the gods, however, are theatrical poses and costumes assumed by contemporaries, merely roles in a play, and seen backstage. It is the situation Fielding described in his *Champion* of 10 May 1740, "of a man behind the scenes at your play-houses," who "is not so agreeably deceived as those to whom the painted side of the canvas represents a beautiful grove or a palace." Thus at the left is an actress dressing for the role of Ganymede, but with pants off, suffering from a toothache, and with a comically small eagle nearby.[28] One

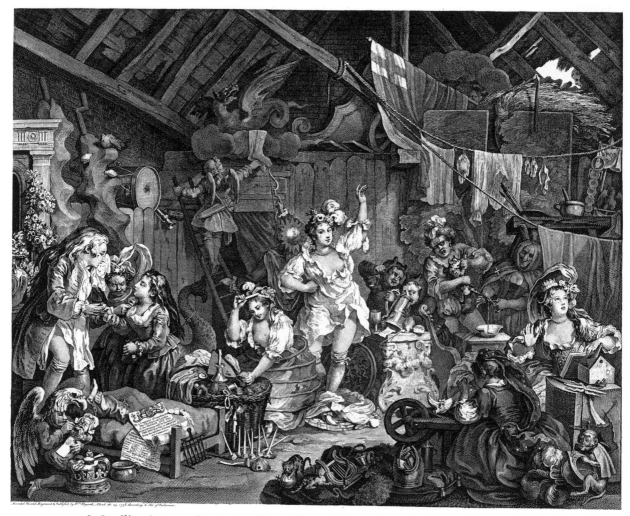

146. Strolling Actresses dressing in a Barn; May 1738 (second state); 16¾ x 21¼ in. (W. S. Lewis)

may view it all as a Lucianic travesty, the Ganymede with a toothache, probably in the manner of Hogarth's own *Danaë;* or as a reiteration of the *Beggar's Opera* statement, an actor with toothache preparing to play the role of Ganymede. A mother feeding her baby frightens it with her costume of Jupiter's eagle. Chickens perch on the waves of the stage ocean, Apollo points to his stockings hung on a canvas cloud to dry, a winged Cupid climbs a ladder to get them down for him, and so on. Hogarth's usual nod to Raphael appears in the two urchins in devil costume stealing a drink from the altar, alluding to the pair of angelic altar boys in *The Sacrifice at Lystra.*

The composition is a simple pyramid structure, with the Ganymede figure at one side, Juno at the other, and Diana at the apex. Juno, though decked with all the traditional goddess' attributes from lightning bolt and crown to the supernaturally-suspended cape over her head, is only an actress reclining as she tries to memorize her lines and an attendant (the queen of Night) patches a hole in her stocking. The center of attention is an actress in the traditional pose of Diana with one hand up to pull an arrow from her quiver and the other holding her bow, here rendered absurd by lack of either quiver or bow. In fact her only resemblance to Diana is the crescent and feathers in her hair. Unlike the goddess of chastity, she smokes a pipe and drinks ale (on the altar next to her), lets her neckline plunge and her thighs show enough to endanger an Actaeon who is spying from a hole in the barn's roof, and drops her protective girdles around her ankles: an attractive young girl but a most disreputable Diana.

Hogarth demonstrates here that he knows everything there is to know about the heathen goddesses: their attributes, their poses, their surroundings, as defined by the ancients (he is clearly familiar with Montfaucon and the other great archeological compendia). But he subverts them: they are appropriate and useful only in a theater, and probably worth no more there than in a history painting. What he produces is a dazzling assortment of variations on the relationship between gods and humans, roles and actresses, ideals and realities. He shows a human Diana striking a divine pose and a Juno with all the divine attributes relaxing in a human pose. Although two little boy-devils are present, and Apollo at least looks male, the scene is populated by goddesses, by actresses, by girls, as if the drummeress in *Southwark Fair,* among all those players and sharpers, had been multiplied. The effect is to establish the natural beauty of the individual as the unavoidable norm.

The satire is therefore not directed to the actresses themselves as people, nor to their pretensions, which are, after all, part of their job. Rather, Hogarth attacks the inappropriate ideals of a certain kind of art, and by extension the shibboleths or conventions of society: those crowns, orbs, mitres, heroes' helmets— the crown used by Jupiter's eagle as a stand for her baby's pap, the orb the plaything of kittens, the mitre for storing promptbooks, and the hero's helmet for a monkey to relieve himself in. As Hogarth echoes the morality play in the

structure of his progresses, here he plays on the contrast between man's foolish idea of Diana, of kings, of priests, and the reality. The *Vanitas* motif is behind the print, imparting reverberations deeply sympathetic to the popular mind. Though bred as Augustans, Hogarth and Fielding were both anti-Augustan in many of their basic assumptions. Their sympathy was clearly more with the individual than with the social unit itself, with the Adam untouched by the seductions of conventional society. The Augustans looked down from the point of view of the great lady or gentleman, and criticized the Shadwells and Achitophels who attempted to pass themselves off as poets or statesmen. Fielding and Hogarth look up from the point of view of the Shadwells and Achitophels, or at least the Absaloms, who have allowed themselves to lose their original and good selves and been corrupted by the ideals of great ladies and gentlemen into aping them.

In vague and uncertain ways Hogarth's whole project owes something to Fielding's *Tumble-down Dick, or Phaeton in the Suds* of 1736. This most flagrant of all Fielding's travesties apparently made a strong impression on Hogarth; many of its elements appear in one form or another in the five prints he published in 1738. It was, with its emphasis upon the reality of stage properties, the play of Fielding's that most inspired *Strolling Actresses:* the sun is a lantern, the Palace of the Sun is a round-house, Aurora is delayed going out to meet the sunrise because her linen is not washed, she is accompanied on her walk by girls carrying farthing candles to represent the stars, and Neptune is dressed as a waterman. The final chorus sums up a feeling that is one context of Hogarth's print:

> You wonder, perhaps, at the tricks of the stage,
> Or that Pantomime miracles take with the age;
> But if you examine court, country, and town,
> There's nothing but Harlequin feats will go down.

But Fielding's farce also introduces a rascally justice, once again (as in *Rape upon Rape*) based on the notorious Thomas De Veil, and in close proximity to him songs about gin and allusions to the Gin Act of 1736; the justice indeed ends the play as a merrily-singing Harlequin, materializing his true personality. There are also a barber shop and a cuckolded cobbler quarreling with his wife. *The Four Times of the Day* could have been put together from such hints.

The paintings were, according to tradition, originally made as designs for the Vauxhall supper boxes; copies hung there for years afterward.[29] Perhaps the most general of all Hogarth's moral subjects, they were perfect embodiments of the four ages of man, the seasons, or such topoi as would have been popular among the diners and strollers at Vauxhall. But even here particular allusions were not lost on the public of 1738. The drunken Freemason in *Night* was rec-

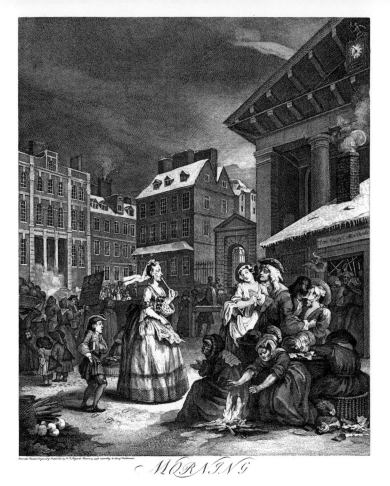

MORNING

147. The Four Times of the Day: Morning; 1738; 17⅞ x 14¹⁵⁄₁₆ in. (W. S. Lewis)

ognized as Justice De Veil—whom Hogarth had supposedly portrayed in *The Denunciation,* who was a member of Hogarth's first lodge which met at the Vine, and who, until recently, had lived nearby in Leicester Fields.[30] Indeed, De Veil, who took a major part in enforcing the Gin Act, but was known to many Londoners as a pleasure-loving man himself, appears appropriately drunk, a merrymaker with a gin-seller pouring brew into a keg directly behind him, and a woman pouring a less savory liquid on his head from an upstairs window.

The scene was no doubt conceived when the first advertisement appeared in May 1737, but substantiation of various sorts followed, perhaps causing Hogarth to add details and reshape the composition. On 16 August a "comical Affair" was reported as happening near Bow Street, and the reference to De Veil was obvious:

One who is known there by the Name of Michael, who sells things in a Barrow, being in Liquor, went to one Mrs. How, and desir'd her to let him have a Quartern of Gin, his Wife being sick, which he put into a Phial, and was carrying away with an Intent to inform against her; but being elated with the thoughts of the Reward, he could not keep the Secret, but told three or four of his Acquaintance, who met him by the Way, of his Design, and let them see the Liquor; they desir'd him to let them taste it, which he

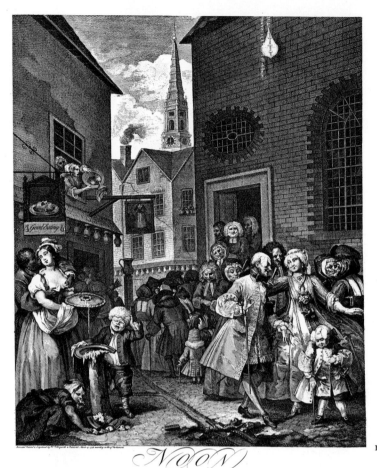

NOON

148a. The Four Times of the Day: Noon;
17¾ x 15 in. (W. S. Lewis)

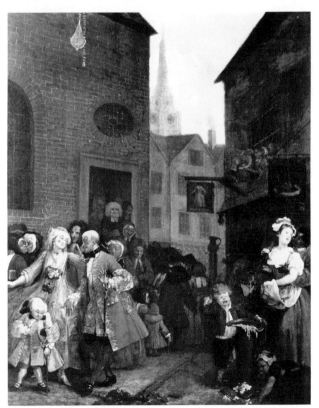

148b. The Four Times of the Day: Noon
(painting); 29½ x 24½ in. (the Right
Hon. the Earl of Ancaster)

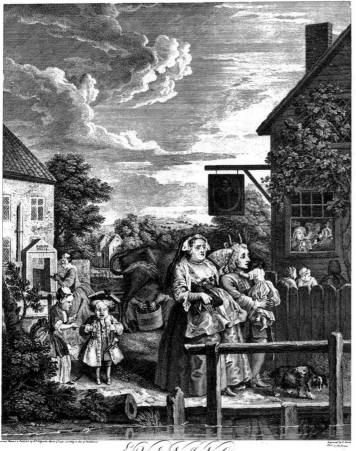

149a. The Four Times of the Day: Evening: 17⅞ x 14¾ in. (W. S. Lewis)

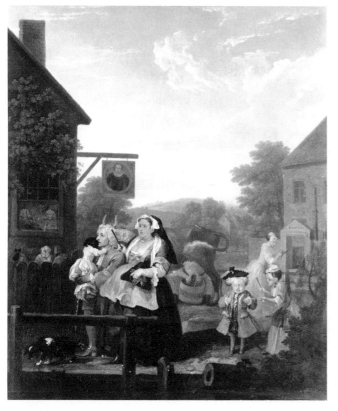

149b. The Four Times of the Day: Evening (painting); 29½ x 24½ in. (the Right Hon. the Earl of Ancaster)

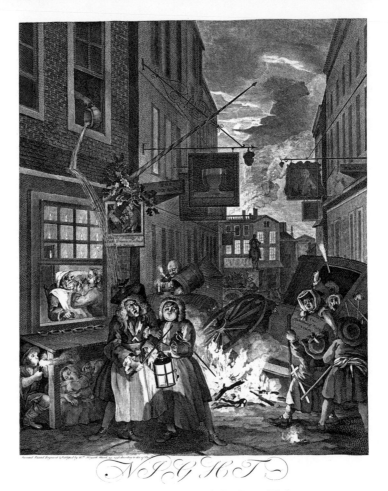

150. The Four Times of the Day: Night;
17⅝₆ x 14½ in. (W. S. Lewis)

did; some of them amus'd him whilst the others drank it up, and one of
them piss'd about the same Quantity in the Bottle and return'd it him,
which he carry'd to a noted Justice in Westminster, and told him he was
come to inform against a Person who had just sold him a Quartern of Gin,
which he had in his Pocket; whereupon the Justice order'd a Glass to be
brought, and some of the Liquor to be pour'd into it, which he tasted, but
soon finding what it was, he directly order'd him to be committed to Tot-
hill-Fields Bridewell for the Affront put on him. . . .[31]

The chamber pot is accordingly an even more appropriate punishment for the
gin-suppressor: the woman in the window is watching the effect of the action,
which appears premeditated.

Throughout the fall De Veil continued committing people for selling "spir-
ituous Liquors," and more than once was in some danger from mobs. In January
1737/8 a crowd of a thousand people assembled before his door, threatening de-
struction if he would not turn his informers, with him at the time, over to them:

Whereupon the said Justice read the Proclamation [the Riot Act], which
instead of dispersing the Mob encreased it greatly; but observing among
the rest a profligate Fellow, who was the great Encourager of this Tumultu-

ous Assembly, (one Roger Allen) and who encourag'd them to pull down the Justice's House and kill the Informers; had him seiz'd, and the said riotous Assembly remaining before the Justice's House above three Hours after he had read the Proclamation, his Worship sent for a strong Guard from the Commanding Officer at St. James's, and having sent away the Informers to Whitehall, under the Protection of part of the Guard, he took the Information of three Witnesses against the said Roger Allen, who is committed to Newgate....[32]

The trial of Roger Allen for inciting "a tumultuous Assembly of above 500 People to pull down Col. De Veil's House, in Frith-street, Soho, and to kill two Informers against Spirituous Liquors, which were then protected in the Colonel's House" took place on 23 January, the day Hogarth began to renew his advertising of *The Four Times of the Day.* It was demonstrated that Allen was feeble-minded, and he was found not guilty; nevertheless, the renown of the case is evident: "Westminster-Hall was so full one might have walk'd on the People's Heads; and the Mob on hearing of his being acquitted, were so insolent as to *Huzza* for a considerable time, whilst the Court was sitting."[33]

The print's details of disorder—an overthrown coach and sedan chair—were probably recalled from Gay's *Trivia,* certainly an important source for Hogarth's conception, which also ends with a spreading fire. The candles burning in windows and the ivy for the celebration of Restoration Day (De Veil was a noted supporter of the Hanoverians) were probably also present before these developments. But the fire in the distance, which appears only in the print, may have been added at this time as a reminder of the attacks on De Veil's house. At any rate, events boosted Hogarth's project if they did not in fact inspire this plate, and it can be no coincidence that the new advertisement for his subscription appeared, after a year's silence, on the day of Roger Allen's trial. The picture itself would have been on display at the Golden Head and recognized. It is also apparent that Hogarth is here decidedly on the side of the "tumultuous Assembly," anticipating the confrontations of *The Enraged Musician* and *The March to Finchley.*

The Four Times of the Day (pls. 147–50) represent the progress of a day, as his other series show the progresses of a harlot, a rake, a marriage, two apprentices, or an election. But the division into four times, instead of simply morning, afternoon, and night, suggests a parallel with the seasons that is emphasized by at least two of the plates depicting weather that could not have occurred on the same day: snow and extreme heat. The fourth plate may be dated May 29, the anniversary of Charles II's restoration. The same people do not appear in more than one print, though the same or parallel types do. The prints are not about a person or persons but about a phenomenon, in this case temporal; the only protagonist is an implied one related to the four ages of man.

In the first plate, the pious old maid stands alone, self-sufficient and unhelp-ful, outside the drinking, love-making, begging crowd that is trying to warm itself; in the same way, the face of the church is only another cold, geometrical façade above the makeshift, man-made hulk of Tom King's tavern. Hogarth is as firmly on the side of nature as he was in *Strolling Actresses*, and strongly against the cold rigid church, but the contrast seems more the point here than a judgment. In a sense, the plate simply represents a bonfire with people hud-dled around trying to keep warm in the great empty square of Covent Garden, with the church opposed to the tavern, the pious to the profane. In the second scene, *Noon*, a church and a tavern are again contrasted: the street, divided down the middle by the gutter, juxtaposes churchgoers with their pious faces or (alternatively) French customs and fashions, and the eating, lusting, sloppy people who ignore the church. Beyond piety and impiety, they are the structured and the unstructured. In each plate there is a sturdy, buxom, attractive girl with a man's hand in her bosom, perhaps less unequivocally normative than in *Stroll-ing Actresses*. (There is much symbolic play in these plates: for example, the squeezing of the girl's breast in *Noon*, which causes her to tip and overflow a stream from the dish she is holding, finds a parallel in the pair of hands milking the prominent udder in *Evening;* and perhaps grows into the torrents of gin and urine in *Night*).

The third and fourth plates offer one alternative each: order or anarchy, wifely control or husbandly escape to the Freemasons' lodge, drink, Jacobite fantasies (Restoration Day), and saturnalia. If the problem of *Morning* is how to stave off the cold, in *Evening* it is how to escape the heat. Warmth, no longer absent, has become oppressive. It is the crushing heat of the London afternoon, of marriage, of responsibility, perhaps of maturity. And in *Night* heat has be-come an outlet, a form of destructiveness (of the coach, and of houses in the dis-tance), and a light to see drunken Freemasons home from their lodge meetings. De Veil, ordinarily the representative of law and order (parallel to the prude in Plate 1), is himself drunk, now less a contrast to than a part of the disorderly celebration, the fires with the gin and urine pouring, and so on. As the Restora-tion Day decorations and the bonfires show, it is spring, and the row of pans on the barber-surgeon's sill is a reminder that bloodletting was popular as a spring tonic. Here Hogarth has recreated what must have been a central image for him: Restoration of the Merry Monarch and Burning the Rumps at Temple Bar (see pl. 50). (A surviving oil sketch, now in the Mellon Collection, shows Charles II himself progressing down Cheapside on the occasion of his Restoration.)

One way to describe the effect of *The Four Times of the Day* is to say that Hogarth no longer takes sides or condemns or admonishes. Another is to say that he has—unfashionably—taken sides with the revelers against the church, and prefers to leave it a draw rather than impugn his own orthodoxy.

THE PAINTING vs. THE PRINT

The painting of *Strolling Actresses* no longer exists, but the paintings of *The Distressed Poet* and *The Four Times of the Day* show that by this time Hogarth had reached a point where he could no longer express all that he wanted to say in his prints. In fact, he never produced better work than these paintings, as exemplified by *Morning* (pls. 151a and b). Whereas the engraving had to be uniformly clear, an important characteristic of the painting is the different degrees of focus, defined by highlights and details; varying from a soft, almost hazy quality to the fussy treatment of the "prude's" head. In the group to her left only the lovers, whose heads are above the others and in the light, are clear—the rest remain a brown indistinguishable mass. Equally important are the pale buildings in the wintry background, the salmon-colored houses, the drab brownish groups of people, the leaden sky, and the pale snow-covered roofs; these are opposed to the color and movement around the fire, especially the bright blue lining of one girl's hat. Most interesting, in the engraving the "prude" who is headed past all these people is simply a cold woman going to church; the painting adds another dimension by giving her an ermine muff and pale pink apron over a champagne-yellow dress with delicate sea-green trimmings, and above all, scarlet ribbons on her cap which link her with the flames of the bonfire. The engraving emphasizes the alienation of the two worlds, their utter separateness, while the painting emphasizes the similarities as well—suggesting an acceptance of both extremes.

At this time Hogarth must have felt the need for color even in his prints; for the only time in his career, he introduced a reddish ink in the third plate for the woman's flushed, hot face, and blue for her husband's ink-stained hands. Black and white were apparently no longer sufficient.

As far back as the *Hudibras* plates, the print itself was the crucial part of Hogarth's plan: a reproduction that implied a nonexistent painting—originally nonexistent simply because he had not yet learned to paint and was an expert engraver. The print also avoided the vexing academic controversies over color, fitted into the tradition of reproduced history paintings, and answered the requirements of history better than any actual history painting he could produce. Ordinary Englishmen, the bulk of Hogarth's audience, had no conception of the Stanze in the Vatican or even the Cartoons at Hampton Court, except in engravings.

Since the paintings of the *Harlot's Progress* were destroyed, leaving only the monochrome prints, the result appears no different from the *Hudibras* prints, which have only drawings as surviving prototypes. Only with *Southwark Fair* and the *Rake's Progress* is it possible to consider history painting as it appears on the one hand in an engraved reproduction and on the other in the painting

itself. Turning from the austere, still relatively classical engraving of the *Rake* to the paintings, it is something of a shock to discover that they are so small. The print still conveys a sense of kinship to Raphael and history painting, partly by implying large paintings, while the paintings themselves do not; and they raise the whole question of Hogarth's intention. The prints are, in a sense, only an allusion to the subject of history painting. One would expect an innovator in history painting to maintain the monumental size if not the subject matter. Pieter Aertsen and Franz Snyders, for example, drew attention to their modification of history painting into still life by the monumentality of their canvases. Hogarth begins with very small paintings (*Southwark Fair* is larger but the scale remains small) in which, as opposed to the engravings, he produces something close to genre. While small in size, they are painted with flair, and the viewer admiringly studies their color and texture.

A rough analogue can be detected in Thornhill, whose sketches, in oil or pencil, are baroque, but whose finished paintings, even when retaining the color of the sketches, always tend toward the classical. Hogarth's prints of the *Harlot* are in a classicized English baroque, like Thornhill's St. Paul's panels; characters stand out in full articulation, arranged planimetrically, and actions and objects are clear and meaningful. Furthermore, like Thornhill, whose most classicized pictures are usually grisaille, Hogarth's are in the black and white of engravings. But the earliest surviving "modern history paintings" are a different matter: one might call them Venetian in colors and shapes, in the handling of the paint, had Hogarth himself not suggested affinities with the tradition of Rembrandt and his "broken colors" in the large *Pool of Bethesda* painting. If his prints are attempts to remain somewhere within the classical tradition, his paintings strike out in a different direction.

The most interesting difference between his prints and paintings is that the clear focus of the prints, which helps to render the Raphaelesque effect, is replaced in the painting by a shifting focus: some faces, some costumes, some details are carefully finished and clarified, while other areas (sometimes as important for the story) are vaguely sketched in. There is no precedent for this technique in the Dutch drolls of Steen or Ostade, and very little in those of Brouwer, but a great deal in Rembrandt. Félibien, writing for the main tradition, argues that brushwork should be smooth, *lechée* (licked), and criticizes Rembrandt for his broad brushstrokes and impasto. His colors are broken and require the viewer to stand back; sometimes he places tones and half-tones next to each other, lights and shadows, so that the work looks like a sketch and falls to pieces if the viewer comes too close.[34] Félibien traces this technique to the Venetians also, but Hogarth would have inherited it from the Rembrandt-Kneller-Vanderbank succession. Houbraken, for instance, is puzzled by the variations in Rembrandt's paintings, some with carefully finished details and the rest

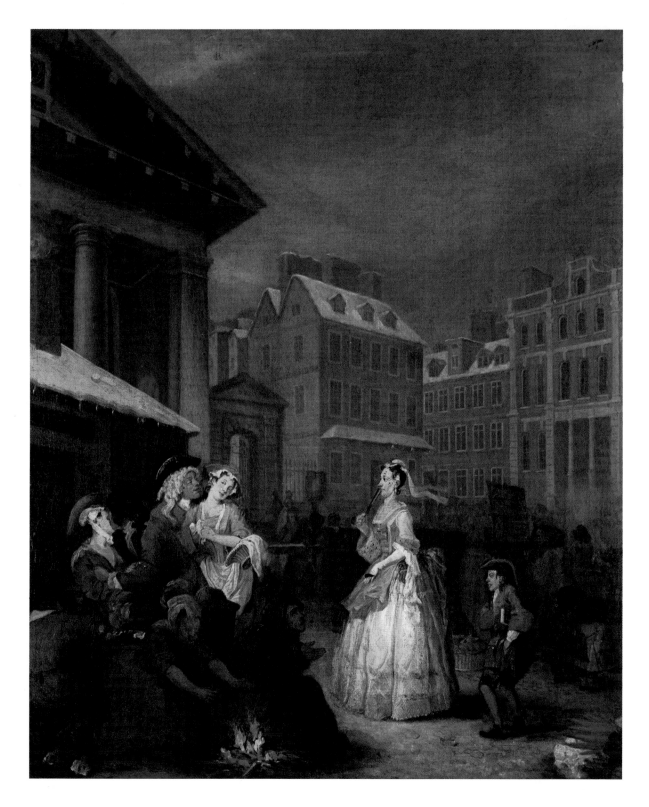

151a. Morning (painting); 1738; 29 x 24 in. (The National Trust, Bearsted Collection, Upton House)

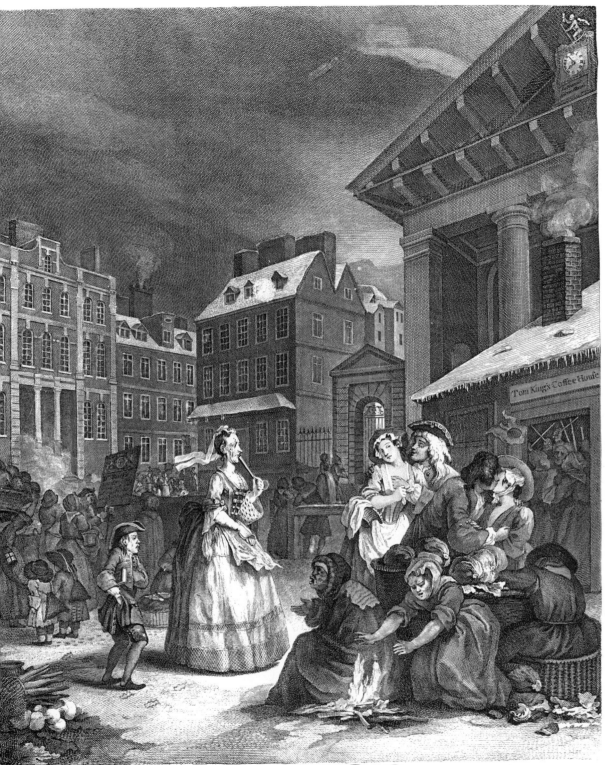

MORNING

151b. Morning (engraving, first state); Mar. 1738; 17⅞ x 14¹⁵⁄₁₆ in. (W. S. Lewis)

"smeared as with a rough painter's brush." He explains these "unfinished" canvases by Rembrandt's capricious character or a hasty execution.[35]

The use of clear and unclear focus, of "broken color," in *The Good Samaritan* and *The Pool of Bethesda* may remind one of Rembrandt, but on the small scale of the *Rake's Progress* and *The Four times of the Day* the effect is a peculiarly Hogarthian version of the rococo—before he began to decorate his paintings with the flourishes of s- and c-curves. The classicism of the prints therefore dissolves in the paintings, not only in color but in lack of uniform clarity, from sharp features to vague recessions; and the phenomenon is crucial to Hogarth's career. Either the term "modern history painting" applies only to the prints—a possibility denied by the manifesto of *The Battle of the Pictures* announcing the auction of the paintings a few years later—or it means something quite different in the prints than in the paintings.

Before exploring the relationship between print and painting, however, one should notice that with the *Rake's Progress* the prints too have changed: they are more crowded than the *Harlot* prints, with blurred demarcation of planes and less use of the frontal plane. The *Harlot* is almost frieze-like, and only in the fourth plate does a receding plane appear, while most of the *Rake* plates attempt this recessive effect and give a much greater sense of motion, with people surging from front to back. The Raphaelesque norm has disappeared. If the *Harlot* plates descend from the canons of classical history painting, the *Rake* owes much more to the northern "merry company" scenes, and in Hogarth's own work descends from *A Midnight Modern Conversation* and the drinking groups. *Southwark Fair* is also quite a different work from either *Hudibras* or the *Harlot:* the crowd of small people before the large architectural background and sky reminds one of the Netherlandish genre paintings, or of prints like those of Hans Bol. Of course, all the time he was developing the relatively monumental forms of his engravings Hogarth was utilizing in his conversation pictures the private, rather delicate serpentine style of Mercier and Gravelot; the two approaches exist side by side in *The Beggar's Opera,* at once a monumental composition and an elaborate conversation with small figures and delicate, finished painting.

The reason for the change in the *Rake* is probably related to the influence of Gravelot, but more importantly it shows Hogarth's continuing awareness of decorum and suggests that the Rake's story is on a slightly lower level than the Harlot's. Or, perhaps more to the point, he might have asked himself, why should the deluded Harlot be shown or see herself in the shapes of Raphaelesque history? Hudibras might be appropriately depicted in those forms, because he saw himself as a knight errant, a hero. But, as Hogarth must have realized by the time he began the *Rake,* the story of a merchant's son who sees himself as an aristocratic rake calls for less classicized and more baroque-rococo forms; so he relies on the shapes of *Hudibras and the Skimmington.*

The first important fact about Hogarth as printmaker *and* painter, whose product was both the engraving and the modello for the engraving, is that, faced with the engraver's problem of reversal, he chose to paint his modello in reverse rather than paint it straight and then engrave it in a mirror. While often careless in the painting of details of reversal like hands and buttons, he was careful to reverse the general "reading" structure of the design so that the print made his moral point. Studies of visual perception show that in "reading" a picture the eye moves from the lower left up and into the depth of the picture and toward the right.[36] It seems likely that Hogarth and his print-oriented audience naturally approached visual structures through the conventions of linear-verbal structures, reading—as they wrote—from left to right. To take as a random example the first plate of the *Rake's Progress* (pls. 152a and b), in the engraving one's eye moves from the objects in the lower left corner denoting miserliness up and into the picture, to the lawyer stealing and the Rake squandering the miser's estate, and to the pregnant girl whose silence the Rake is buying. The sequence in general moves from avarice to prodigality, as Pope moved from Old to Young Cotta in the *Epistle to Bathurst;* but also, more particularly, from action to consequence. The movement stresses causality: A produces B produces C. In the mirror image, however, one's attention is caught by the group of the Rake, the pregnant girl, and her mother, and, moving beyond this group (rather puzzling thus encountered) finds only emptiness at the right. Approaching the picture in this way, one sees everything from the pregnant girl's point of view, producing a sentimental effect that is quite absent from the print as Hogarth published it, and that seriously distorts the import of the whole series. Likewise, in Plate 3, the print forces one to empathize with the Rake; in the painting the subject is encountered through the undressing posture woman (pls. 153a and b).[37]

The Distressed Poet (pl. 154b), a print of only two years later, produces quite a different effect: the eye moves in the other direction, from the consequences of the Poet's folly—the dog eating his last chop and the milkmaid with her unpaid bill—to his wife and child, the innocent victims, and finally to the Poet himself, the guilty victim and the cause. The painting (pl. 154a) reverses this order, first establishing the nature of the Poet's folly and then forcing the viewer to follow to its consequences: he has withdrawn from the real world, leaving a trail of chaos in his wake. In the print there is still a kind of causality. One sees first the harsh world and then what it produced: the Poet's withdrawal. But for the most part the print stresses contrast rather than causality—the contrast of the real world with the Poet's isolated dream world at the far right; he is virtually encased in an alcove, surrounded with the illusions of poetic inspiration. Judging by the other prints of this period, one must conclude that the print rather than the painting again represents Hogarth's intention. He is now less concerned with the consequences of an action (indeed he has abandoned the

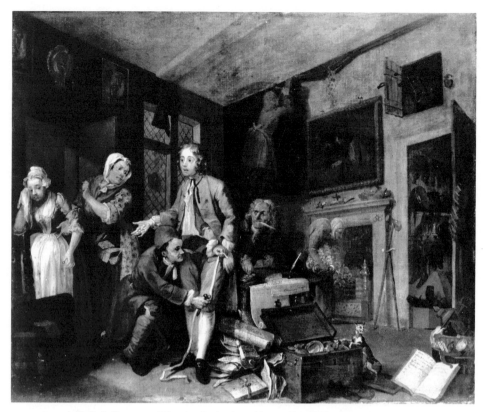

152a. A Rake's Progress, Pl. 1 (painting); 24½ x 29½ in. (Sir John Soane's Museum)

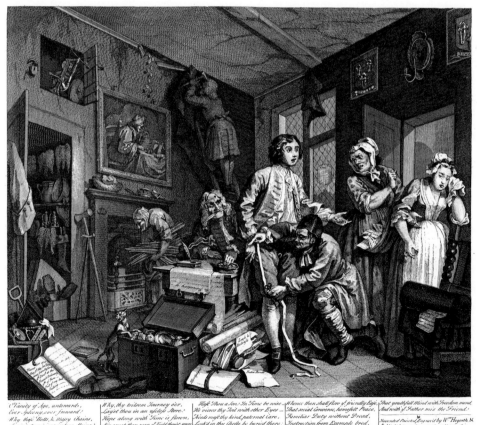

152b. A Rake's Progress, Pl. 1 (engraving, second state); 12⅝ x 15¼ in. (W. S. Lewis)

series of six or eight plates, which must stress causality or become a mere medley, for single or balanced plates) than with a contrast: between the real world and the Poet's, or elsewhere between desire and fulfilment, passion and prudery, order and disorder.

The matter of reversal suggests that Hogarth's prints are more expressive than his paintings as narrative and didactic structures. But while reversal produces two quite different images in the rococo compositions of the *Rake's Progress,* in a relatively balanced composition like *The Distressed Poet* one must look more closely to distinguish between rival readings. The colors in *The Distressed Poet* are neither obtrusive nor merely colorful: the monochromatic earth shades of the garret and the Poet are contrasted with the blue of his wife's dress and the one spot of bright red in the milkmaid. To the extent that the bright colors are associated with the outside world from which the Poet has withdrawn, the meanings of painting and print are generally parallel. Indeed the colors, like those in *The Four Times of the Day,* refine upon the print's meaning: the creamy complexion and rosy cheeks of the wife—in the print she is a faded, worn creature— may emphasize her Proserpina role in the Poet's garret.

The colors do alter the order of perception. While a simple reversal of the print conveys a causal pattern like that in Plate 1 of the *Rake's Progress,* the colors break and diffuse this pattern, emphasizing the contrast between the Poet's and the real world. And, although mere reversal draws attention toward the wife, placed as she is slightly to right of center, her blue dress and the red dress of the milkmaid firmly anchor the viewer to that side of the scene; only later does he return to the Poet at the left side for causal explanations. The eye probably still moves up and to the right, but the colors capture and hold it on the central figure of the wife—so central that, if the spacing were a little closer, she might remind one (observing her blue-green dress) of a madonna. The composition carries unmistakable overtones, more evident in the painting than in the print, of a nativity: the stable-like garret, Mary at the center with the babe behind her, Joseph to one side scratching his head in puzzlement, and the parody of gift–bearing to the other side in the dunning milkmaid and the dog. The painting could be titled "the Wife of the Distressed Poet." Even the cat nursing its kittens emphasizes her centrality: though present in both versions, in the print the cat seems to reflect on the poet's responsibilities to his large family, while in the painting it revolves, like everything else, around the wife.

As these examples show, the print conveys the moral point, and the painting something beyond. In his paintings Hogarth consciously sacrifices the story-telling function if not the compositional sense of his engraved design. On the representational level, the reversal negates the particular causal or juxtapository pattern of the print, replacing it with a less subordinated, and less tendentious, pattern. The addition of color and texture, even when directed toward the end expressed in the print, again diffuses the attention which in the print is coa-

lesced. The painting develops independently, more as a genre piece, a simple portrayal of manners.

But one is also aware of the sheer exuberance in the laying on of paint, as opposed to the outlining and mechanical crosshatching of the print. In this sordid scene, as in the *Rake* paintings, a sort of romantic glow is conferred on the subject; certainly there is none of the scruffiness of Ostade's paintings of drunken boors, nor gross details like the dirty soles of feet for which Caravaggio was famous. The technique of Hogarth's paintings—his bravura brushwork, his rich and creamy colors—seems to remove the scene from the harsh newsprint reality of the engraving.[38] Even in the grim world of the *Rake,* in scene after scene one is simply bewitched by the soft, lovely colors and texture—and distracted from the relentless message. Take the brothel scene (pl. 153a): surely something of Hogarth's point is lost as the eye glides from the soft pale greenish coat of the Rake to the rose-salmon dress, golden stole, and white gloves and bonnet of the whore next to him. The comment made by the color and texture relative to the moral purpose is on the false gentility of these characters, contrasted with their gross actions. But this is a very general point, and one that does not apply in other pictures where the same effect remains. In Plate 4 the green and russet of the chairman, the green, gold, and white of the Rake, and the crimson of his leggings and the sedan chair—with the white and russet of the girl—all stimulate a delight in pure color and form that preoccupies the viewer when (according to the moralist) he should be concerned with other matters.

When Walter Friedländer says of Poussin's *Massacre of the Innocents* that the figures' "sculptured nobility tempers the cruelty of their actions," he is pointing up this problem.[39] Such an effect can only detract from a work's moral purpose. Perhaps there is something inherently satiric or moral about the linear, black and white medium of the print. (When two viewpoints are diametrically opposed, we define the situation as black and white.) As a recent book on prints has argued, the vocabulary of printmaking corresponds to that of satire: cut, needle, acid, mordant (the name for etcher's acid), and bite ("the controlled corrosion of metal by acid which is the heart of the etching process").[40] Certainly Hogarth had not discovered how to paint a morality; he had not learned Goya's lesson, that a painting can be ugly. For Hogarth the lace or silk must charm, the female curls or complexion must allure. He had no convention in terms of paint and brushwork to correspond to the shapes of the black and white engraving, partly because the shapes themselves were purposely those of ordinary representational art—as Swift's conformed to a travel memoir or a project—while Goya's bilious colors and agitated brushwork correspond to his expressionist forms. Hogarth, avoiding the quality he referred to under the general term "caricature," had no expressionist forms. Moreover, Goya tries to show a world gone completely awry, while Hogarth is still dealing with assumptions of stability, order, and beauty—although sometimes he might question them. He

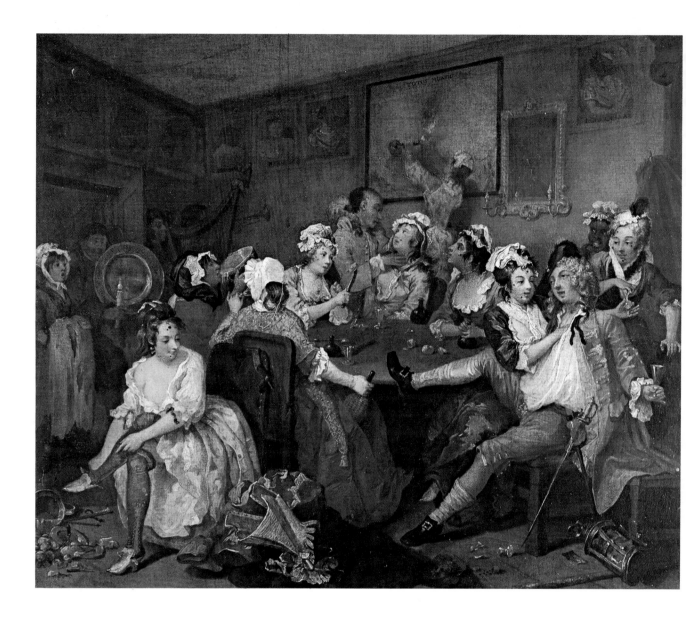

153a. A Rake's Progress, Pl. 3 (painting); 24½ x 29½ in. (Sir John Soane's Museum)

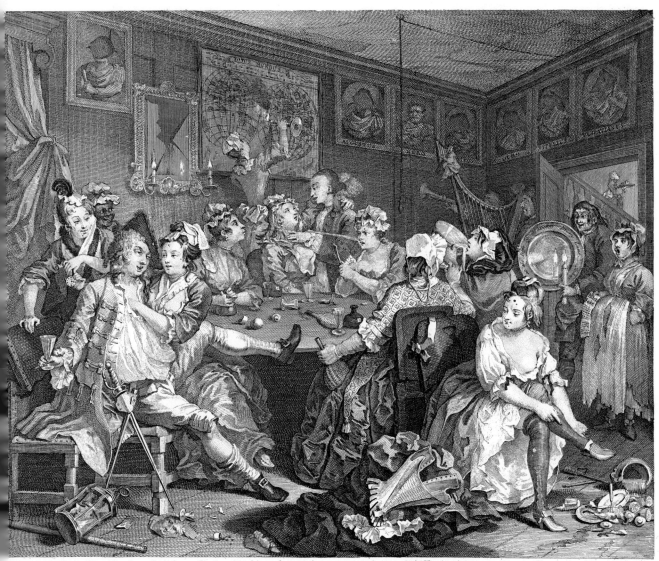

O, Vanity of youthfull Blood, | Soure of every Houshold Bleßing, | Guest Divine to outward Veiwing, | With Freedom led to every Part, | To enter in with covert Treason,
So by Misuse to poison Good! | All Charms in Innocence poßeßing: | Abler Minister of Ruin's! | And secret Chamber of y' Heart; | O'erthrow the drowsy Guard of Reason,
Woman, form'd for Social Love, | But turn'd to Vice, all Plagues above; | And Thou, no leß of Gift divine, | Dost Thou thy friendly Host betray; | To ransack the abandon'd Place,
Fairest Gift of Powers above! | Foe to thy Being, Foe to Love! | Sweet Poison of Misused Wine! | And Thou thy riotous gang y' Way; | And revel there with wild Exceß?

Invented, Painted, Engrav'd & Publish'd by W.m Hogarth June y.e 25 1735. according to Act of Parliment.

Plate 3.

153b. A Rake's Progress, Pl. 3 (engraving, second state); 12½ x 15¼ in. (W. S. Lewis)

Studious he sate, with all his books around, ⟶
Sinking from thought to thought, a vast profound! ⟶

Plung'd for his sense, but found no bottom there; ⟶
Then writ, and flounder'd on, in mere despair. ⟶

DUNCIAD . BOOK I . *line* 111.

154b. The Distressed Poet (engraving, second state); Mar. 1736/7; 12⅞ x 15⁵⁄₁₆ in. (W. S. Lewis)

154a. The Distressed Poet (painting); 1736; 25 x 30⅞ in. (Birmingham Art Gallery)

could not have used Goya's solution even if he had been aware of it. Like his contemporaries in literature, he still needed the context of beauty and order.

It might be argued that the print presents a satire, a moral and rhetorical structure, and the painting then offers Hogarth the opportunity to flex as well as elucidate his ideas (within the limits of the general composition). He surely realized the difference that color made, as he realized the effect of reversal. He could have painted straight and reversed his engraving; perhaps recognizing that he could achieve greater fluency with the brush than with the burin, he chose to block out the picture backwards and paint it freely, con amore, and then draw it carefully on the copperplate. His attitude toward the painting is therefore curiously ambivalent: it is an end in itself, and yet it is always painted with one eye on the print that will follow.[41] It is seemingly painted to please the artist himself, and also to appeal to a collector-purchaser. Color may have been intended as a bonus, something to make the paintings a more deluxe item than the prints. The paintings hung in his picture room with those prints that were finished as subscriptions were taken, and the prospective subscriber might compare them.

His coloring does not seem to have impressed his contemporaries; perhaps it shocked them. "But it is granted that colouring was not Mr. Hogarth's *forte*," says his close friend and admirer Thomas Morell.[42] Also his obituarist in the *Public Advertiser* (perhaps Morell) felt that he "must observe in general of this excellent Painter, that his colouring is dry and displeasing, and that he could never get rid of the appellation of a *mannerist*, which was given him early in life."[43] ("Mannerist" could have applied either to his rococo tendencies or to his subject matter.) Presumably, the bright colors and the "broken" brushwork were considered jarring in the way I have described.

Hogarth, I am sure, felt he was on the side of decorum. His clear demarcation of print and painting complies with the rule that demands sober colors for a sober scene, and with the Poussiniste demand for drawing instead of color in history painting. John Elsum summed up the first in his *Art of Painting after the Italian Manner* (1703), when he said of the artist that "in Painting Men that are Old, Philosophers, Poor, Melancholy, and Grave, he must use such Colours as are sad, and deprived of Vivacity. . . . Rose Colour, Light Green, and Light Yellow, appertain to Virgins, Young Men, Harlots &c. Fine and glaring Colours to Buffoons, Scaramouches, Mimicks &c."[44] Of course the same applies to brushstrokes: a solemn subject should not draw attention to its painting with a light, lively touch; a Raphael subject should not be painted by a Venetian.

The French academicians believed that drawing was superior to color because its appeal was more purely intellectual, while color appealed to the eye alone. A work that appealed strictly to the mind—if that is accepted as painting's chief aim—would indeed have to avoid distracting colors. Shaftesbury argued that although art "borrows help indeed from colours, and uses them, as means, to

execute its designs; it has nothing, however, more wide of its real aim, or more remote from its intention, than to make a shew of colours, or from their mixture to raise a separate and flattering pleasure to the sense." Thus his school holds that color can be distracting in history painting, like the fawns and satyrs of the operatic style decried by Steele. Color is what Addison most clearly associates with his category of the "beautiful," as opposed to the "great," which consists of primary qualities.[45] Thus an advantage of the print over the painting, as Richardson noted, is that in the painting "other qualities" like color and texture "divert, and divide our attention, and perhaps sometimes bias us in their favour throughout," while the print lets us see the master's design and intention "naked." (One of the peculiarities of Richardson's criticism is that he had seen most of what he described only in engravings or drawings, and so inevitably underestimated the value of color and texture.)[46] One of the background assumptions which may have influenced Hogarth, then, was that color is an additive, something separate from the immutable essence of things, apart from the moral being of Nature. In his prints he presented a world of primary qualities where reason "might see light pure, not discolored, refracted, or inflected."[47]

Is color no more than an aesthetic addendum in Hogarth's comic history paintings? It is perhaps less meaningful to say that the painting has some left-over form than to say that the artist appears in a different relation to his subject. In the print he is effaced, and form as such is less evident because the print is reproductive to begin with, a copy of a copy; the "idea" is all that remains. The "execution," the self-expression, pertains again in the painting. These "flourishes" produce a picture that relates both to the print's subject and to the artist who shapes his view of reality in this way. Experience is embedded in amber, and while one result is to draw attention to the artist who can make a beautiful thing out of it, another is to suggest that there is a beauty and vitality in even the most sordid events. This is the effect of Hogarth's best comic history paintings.

In these years Hogarth seems to have moved from the position that the engraving is the history, and the painting merely a modello like a cartoon for tapestry, to the position that the painting can be the real thing and the engraving in fact merely a copy. At any rate, this is one interpretation of the change in his work in the late 1730s, as the possibilities of Vauxhall and hospitals and the like arose; it must have been then too that the possibility of an auction of his paintings began to glimmer.

At the same time, with his attempts at sublime history painting at St. Bartholomew's hospital, Hogarth began to be interested in the artist and his problems. It was at this point that he produced his fables of the artist—of a poet, a musician, and actresses. He even announced one of a painter, though it has not survived.[48] The image of the artist that emerges is interesting: the poet is up in a

garret, remote from reality, unable to pay for food, wearing inappropriate clothes, and writing poems, thinking of a gold mine in Peru. The musician (pl. 155) is like the artist in Arthur Koestler's essay "The Novelist's Temptations" who closes his window to the outside world. To make music, Hogarth says, the artist must hear and take into consideration the hawkers and venders, the noisy children and screaming ballad singers outside his window. Whereas the poet has no opening into the outside world, the musician is actively trying to use his opening to quiet the noisemakers, who do not conform to his notes on a scale ordered according to intervals and harmonies. Perhaps with the putti of *Boys Peeping at Nature* in mind, Hogarth is treating the maladjusted artist who is cut off from reality or from his proper function—the artist as another form of the Harlot or the Rake.

The general trend in Hogarth's art in these years is analogous to the change from the print to the painting, from a strong causal pattern and left-to-right reading to balance and juxtaposition. The progresses, necessarily as a series but also as individual pictures, were constructed causally. The compositions themselves were causal, *this* leading to *that* and *that*. The prints of Hogarth's successful and contented middle age, however, are based on simple juxtapositions, this against that, and are less tendentious. In the engravings of *Before* and *After* the causal relation is, of course, paramount, yet it leads to no admonition—and is in fact only apparently the connecting link. Here it serves to produce the simple contrast which is the real point of the pair: not *this* produces *that* but the opposition of desire and fulfillment. In *The Four Times of the Day*, as I have noted, causal connection is ignored: a single cast of characters is abandoned for four casts, and London is the only common denominator. Each scene is constructed of juxtapositions—old and young, prudish and passionate, cold and hot, ordered and disordered—as the group of scenes balances the four times.

Brought up on the parallel and antithesis of the *Spectator*'s prose and Pope's couplet, Hogarth naturally thought in these terms in his pictures, placing parallel and contrasting pairs of figures and objects. His admitted method of composition was to add figure to figure to contrast their characters. Here the tradition of emblematic art comes fully to bear: the strong debt Hogarth owes to Brueghel becomes evident. One is reminded specifically of *The Battle of Carnival and Lent*, where the contrast is simplest, and of *The Peasant Wedding*, where the interplay between opposing worlds is most complex.

The pattern of parallel and contrast in the early progresses is also, however, reminiscent of the Puritan's heavy emphasis on choice, as in Hogarth's obsession with the Choice of Hercules paradigm as a basis for psychological relationships between characters. From the beginning, in the *Beggar's Opera* paintings, he leans on this structure, but reworks it into a group which can be seen as either A choosing between B and C, or B and C contesting A. In the first plate of the *Harlot's Progress*, the clergyman and Mother Needham flank the Harlot, serv-

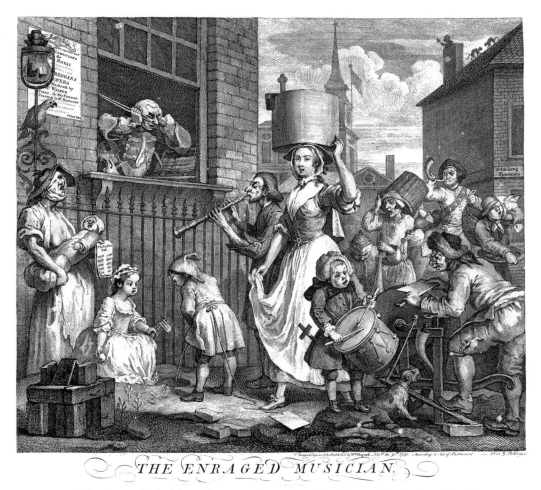

THE ENRAGED MUSICIAN.

155. The Enraged Musician; Nov. 1741 (second state); 13¹/₁₆ x 15¹¹/₁₆ in. (W. S. Lewis)

ing as both choices and contestants for her soul; in Plate 2, the choice is between her young and old lovers. In general, however, the five plates following the Harlot's initial choice recount the consequences. The first plate of the *Rake's Progress* is also a matter of choice: the Rake is poised between the lawyer counting his money and the girl he has gotten pregnant, and like the Harlot he chooses wrongly, according to fashion. In the second plate, with a variety of pleasures surrounding him, he appears beneath a painting of *The Judgment of Paris*, considered another version of the Choice of Hercules; Paris' choice of Venus (Pleasure) threw the ancient world into turmoil, leading to the fall of Troy,[49] and in the same way the Rake's choice of pleasure leads to chaos, the destruction of the gambling house, prison, and death in Bedlam. In Plate 3 he has whores to choose among, and in Plate 4 he stands between the bailiff and the wronged girl of Plate 1 (Sarah Young), in 5 between the old bride and the brides-maid (with Sarah in the background), in 6 between the gamblers and the highwayman, in 7 between Sarah and the old bride, and in 8 between Sarah and the warden (or clergyman). Each plate presents a choice to be faced or eluded, and consequences abound.

This subject also casts light on the sublime history paintings of the mid-1730s. The psychological knot of the comic histories is missing in *The Pool of Bethesda* because there is no relationship: Christ is gesturing at the sick man, but no connection is made. *The Good Samaritan*, though far less interesting in other respects, is more satisfactory—or more at one with the other histories—because the accustomed choice is present: the Pharisee, the Samaritan, and the wounded man as touchstone. *The Pool of Bethesda* is therefore a more purely decorative, or formal, construction than the comic histories: psychologically, one's attention is held only by the individual faces and diseases, much as in the *Four Groups of Heads*. Otherwise, one is free to follow the brushstrokes and the color relationships.

These sublime histories were symptomatic of their comic equivalents. In the mid-1730s, when Hogarth diminished the number of plates in a series to four, two, and one, contrast received the whole emphasis. The girl in *Before* is once again Hercules at the crossroads, flanked by the active lover and the passive agents of virtue, her dresser (containing "The Practice of Piety" but also "Novels" and the poems of Rochester) and her lapdog. Her choice in the sequel, however, proves no more important than her lover's: two attitudes beginning in contrast end in parallel *tristitia*. In the painting of *The Distressed Poet* the wife appears to be the central, choosing figure, with the two worlds of nature and art balanced against each other. She does not choose, of course, and in this and other prints of the late 1730s, culminating in *The Four Times of the Day*, the chooser is pushed out of the picture and the choice is given to the viewer—to opt for prude or lovers, churchgoers or lusty eaters and drinkers. The point is that there is no protagonist in this series. Here and in contemporaneous prints like *Before*

and *After* and *The Enraged Musician* the difficulty of choosing—the balance this difficulty implies—is the important characteristic. With the chooser removed from the picture, the viewer is more aloof, unwilling to take sides. He no longer wants to know which is right or wrong but rather to enjoy, at this point of rest, the drama of the alternatives, like that in the juxtaposed elements of the painted versions.

As the emphasis moves in the comic works from choice to contrast, the moral issues tend to be replaced by aesthetic ones. The Harlot or Rake becomes the Poet, who is a moral figure if the picture is read causally (he brought this squalor upon himself and his family by his folly), but who is merely a representative of art removed from reality, or of the unnatural, if the picture is read as a contrast between the Poet and the outside world. In *The Enraged Musician* there is nothing but the aesthetic choice between art and nature.

The idea of art as subject, and a judgment that is aesthetic rather than moral, was present in some of Hogarth's earliest work. From *The Beggar's Opera* onward, he was concerned with the relationship between the worlds of the artist and of reality. If Macheath is the center of the Choice of Hercules structures in the painting, Polly Peachum (actively gesturing, as opposed to the aloof Macheath) is the cynosure of the picture as she was of the play: she is choosing between Macheath and Peachum, and at the same time between Macheath and, in the audience, the Duke of Bolton. Her gesture, her loveliness, her pliancy, however, make it appear that she is mediating rather than choosing—is enabling the viewer to choose—between lover and father in the moral realm, between stage lover and real lover in the ontological or (if the actor-audience contrast indicates an art-nature relationship) the aesthetic realm. *The Beggar's Opera* thus juxtaposed the poet's (Gay's) creation with the real world of the stage and the audience, and the actress playing Polly acted as a mediator between the literary world of Macheath and the real one of the Duke of Bolton: she was both Polly within the play and Lavinia Fenton without. The significant fact is that Hogarth represented nature, which can be disguised by playwrights or artists, as a beautiful girl; a girl like Polly becomes almost a fixture of his subsequent paintings and prints.

Perhaps some of the popular success of the *Harlot's Progress* resulted from Hogarth's joining the protagonist who chooses between good and evil with the pretty young girl from the country, the mediator between art and nature, the unnatural and the natural. In this case, she is caught between the worlds of the clergyman (and implicitly her past) and the bawd, wanting to "rise" from one to the other; far from mediating, this natural creature has allowed herself to be changed and perverted by the forces of fashion. In the *Rake* she is replaced by a male protagonist and displaced to Sarah Young, his ever-faithful and unsullied lover: a moral mediator between the Rake and the world, an aesthetic mediator between his affectation and reality. Once detached, she remains a secondary

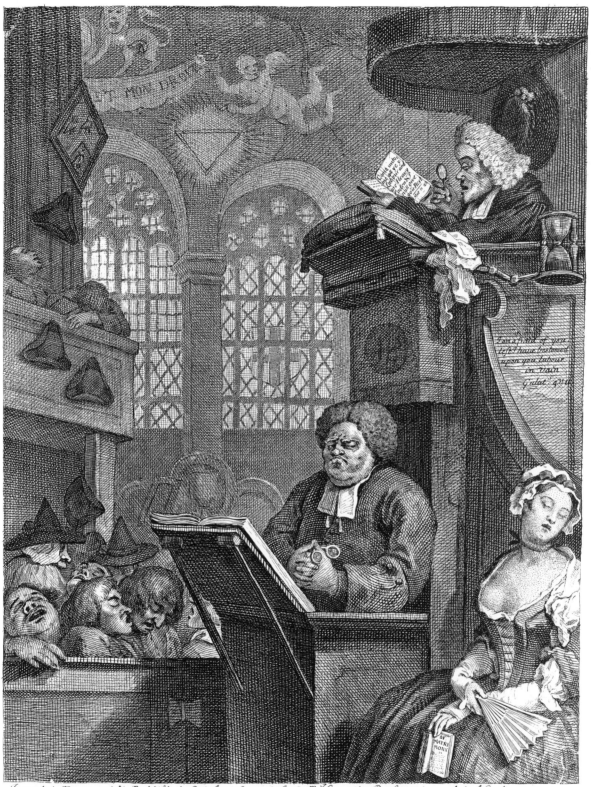

156. The Sleeping Congregation; Oct. 1736 (third state); 10 x 7⅞ in. (W. S. Lewis)

character standing somewhere between the protagonist and the world around him.

In *The Distressed Poet*, where causality is less well defined, the imaginary world of the Poet's garret cubicle, with his portrait of Pope (or, later, his map of Peru's gold mines) is opposed to the real world of the milkmaid and the dog: his beautiful wife is the mediator who tries to deal with—and has a role in—the outside world of torn trousers, unpaid milkmaids, and unfed babies. In *Strolling Actresses*, Hogarth returns to his original focus of actresses vs. their roles, costumes, and sets. Once again he juxtaposes the real people with their roles, and the beautiful girl who bridges the worlds of role-playing and of reality. She appears too in *A Scene from 'The Tempest,'* as Miranda between Ferdinand and Caliban, and in *Southwark Fair* as the girl drummer who infuses the sweaty reality around her with the dreams of the signboards and costumed actors above, and the natural hills of the countryside beyond.[50] In *The Enraged Musician* she is the beautiful milk girl, with bucket on her head, of both the orderly "artistic" world of the Musician and the discordant cacophonous world of nature—her beauty and grace are surely intended to suggest that her voice, which among the sounds of nature is art, is more beautiful than the Musician's because less constricted by rules and conventions, the impositions of treatises and connoisseurs.

One might even include *The Sleeping Congregation* (pl. 156) among Hogarth's fables of the artist: the preacher is a relative of the poet and musician. Here he is absorbed in himself, and so puts his audience to sleep. The beautiful girl is again present, dreaming of marriage, and a mediation occurs between the solipsistic preacher and the lecherous natural man, the reader, who steals a look at her bosom under cover of the general lethargy.[51]

In these prints the tragic figure of the person who is one thing and wants to be another has become the deluded artist, and the faithful Sarah Young has become an aesthetic norm which conveys Hogarth's ideas about the natural vs. the unnatural, and implicitly about the close relationship between beauty and nature, which he eventually formulated in his own treatise *The Analysis of Beauty*. It was his way of saying that true art is nature and that the true artist imitates nature, not whatever sort of art happens to be fashionable at the moment—an idea further clarified with each repetition. If the prints about artists were in one sense a continuation of the stories of harlots and rakes, in another they carried on the accusations of the "Britophil" essay. Perhaps one can also say that whenever Hogarth worked on sublime histories, his art tended to focus on the making of a picture: possibly a kind of self-defense. The prints dealing with the artist—augmented in 1742 by the unpublished one of the dancers Desnoyer and Barbarina[52]—continued into the years of portrait painting and included two portraits of artists, his own self-portrait and his portrait of *Garrick as Richard III*.

Portrait Painting

In 1733, when he moved into his house in Leicester Fields, Hogarth still designated himself a portrait painter by placing the sign of Van Dyck's Head over his door; and in 1734, in the *Gentleman's Magazine* obituary of Thornhill, he was identified as a painter of "curious Miniature Conversation Paintings." In late 1733, not long after his dismissal from the Princess Royal's wedding ceremony, he was painting heads of the Prince of Wales and some of his close associates.

Charles Jervas, Principal Painter to George II and a very mediocre artist who was much praised by Pope, had been commissioned to add the faces in the equestrian pictures of John Wootton, a successful horse painter but a poor portraitist. In August Vertue recorded that the queen and several noblemen went to Wootton's house in Cavendish Square "to see some horses belonging to the Prince & Ld Malpas lately painted by M' Wotton. also a great picture of his Majesty painted on horseback a grey horse. for Lord Hubbard the face of the King by M' Jarvis & all the other parts by M' Wooton—the Horse &c. was much approv'd off [sic], but the King's not thought to be like, was much spoke against. . . ." When she visited Jervas' studio in Cleveland Court and saw his full-length portraits of herself and George, the Queen stalked out in silence.[1] The "horses belonging to the Prince & Ld Malpas" may refer to a study for the large painting, dated 1734, which shows the Prince and Lord Malpas (his Master of the Horse) with four companions in the hunting field.

By this time Jervas' incompetence at catching a likeness had become common knowledge and he was not asked again to paint the royal family; Hogarth, on the other hand, was famous for his knack at catching likenesses.[2] Wootton, though a close friend of Kent's and unconnected with any of the academies Hogarth had frequented, was a canny businessman; he may have secured, and certainly did not oppose, Hogarth's appointment to paint the faces. It is probable, however, that Lord Malpas (now Earl of Cholmondeley), for whom Hogarth had recently painted a family conversation, was the moving force. He is mentioned on the bill for the painting as its sponsor, perhaps only because payment

was made through him as Master of the Horse; but it may be indicative that Hogarth (apparently) used the same sitting as the basis for Malpas' portrait in both pictures. Besides, for the Prince of Wales' party, Hogarth's humiliation by the king and queen in November might have been a mark in his favor. In any case, he obtained a sitting from the Prince of Wales and got a foot in the door of Leicester House patronage.[3]

This large work, which now hangs obscurely in St. James' Palace, was finished by 15 August 1734 when the bill ("for the Hunting Piece for the Earl of Cholmondeley") was drawn up. On 31 August a payment of £246 15s was made, of which £157 10s was paid "To Mr Wootton for the Landskape & Figures" and £31 10s "To Mr Hogarth for Painting Six Faces in the Picture at 5 Guineas Each Face." The remaining £57 15s went to Dufour for the frame.[4]

Back in 1732 or '33, following the painting of *The Indian Emperor*, and also perhaps the sitting for the royal family conversation, Hogarth had built his *ad vivum* sketch of the Duke of Cumberland into a small full-length portrait (pl. 108). It was not painted for the Duke, but for a private source or as a hopeful entrée to the Duke and his friends. He appears to have done the same with his head of the Prince of Wales. Two full-length portraits, of the prince (pl. 157) and the princess, are double the size of *The Duke of Cumberland* and datable sometime after their marriage on 27 April 1736—probably, indeed, intended as a commemoration of that occasion. It is not certain that these portraits are by Hogarth. The style is rather dry and cramped for 1737, but a careful yet lackluster picture at this time may be explained if one assumes that Hogarth was intimidated by his subject and afraid to let himself go.[5] He was at his worst when he fiddled and worried with a picture, at his best when he was completely at ease with his subject. Thus Hogarth's portrait of the Duke of Cumberland succeeds because the subject, though royal, was a child. Children, dogs, actors, merchants, friends, and servants he could paint sympathetically and often brilliantly. He seems to have tried hard to paint the aristocracy, even royalty; but when his restraint and lack of sympathy showed, the paintings failed, and he thereupon became less sympathetic than ever.

The possibility of these paintings' being authentic is strong enough to merit a study of the implications. From the newspaper notices of the time (when every action of the prince and princess was reported, sittings for other painters were recorded, and Hogarth's own activities were considered newsworthy), it seems almost certain that Hogarth had no personal contact with the couple. From the Prince of Wales' account books it is clear that he did not commission, buy, or own these paintings. It is possible that they were painted for a third party—Livery Companies commissioned such pictures, though they usually wanted them on a much larger scale. More likely, Hogarth painted them strictly as a speculation of his own, to show what he could do, to advertise the *ad vivum* sitting he had been granted by the prince, and in hopes of interesting the prince

or one of his intimates—the bases for Highmore's later royal family painting. Like Highmore, he supplied the deficiency of an *ad vivum* portrait of the princess from engravings or other artists' paintings. In this case the princess' face and her pose (though not her costume) appear to have been copied from the mezzotint of Charles Philips' portrait (now in Warwick Castle) which is dated 1737.

Another fact should be noted: by the fall of 1736 Philippe Mercier, who for the last decade had been the prince's Chief Painter, had fallen into disfavor, was dismissed, and retired to the country.[6] In early October Hogarth's friend John Ellys was appointed Principal Painter to the prince, a post he probably held until the prince's death. Ellys had undertaken artistic tasks for the prince since 1733 at least, and was securely in his favor.[7] If, however, it was Hogarth's intention to use Ellys as a contact with Leicester House, and the twin portraits as his entrée, he was disappointed. The only further connection that can be documented between him and the prince's household is the ticket he engraved for the masque of *Alfred* performed in 1740, celebrating the Princess Augusta's birthday, which may have been ordered by Mallet, the librettist (a member of the Scottish circle that included Hogarth's champion Joseph Mitchell).[8]

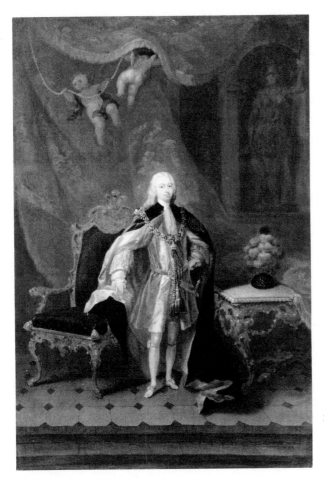

157. [Hogarth?] Frederick, Prince of Wales; 1736; 30 x 20 in. (Royal Coll., copyright reserved)

On the other hand, these single, full-length portraits may have inaugurated the series of single portraits that now began to emerge from Hogarth's studio. The summer of 1735 to the spring of 1738 (or at least the last months of 1737) was an intense period of painting and engraving in the modes of comic and sublime history. Then, except for the ticket for *Alfred,* there were no prints between May 1738 and the fall of 1741 when *The Enraged Musician* was engraved, based on a very rough monochrome oil sketch. The only major engraved work before *Marriage à la Mode* (published in 1745 but not engraved by Hogarth himself) was the portrait of Martin Folkes in 1742. The explanation for the absence of engravings and history compositions between 1738 and about 1743, when the paintings of *Marriage à la Mode* were begun, is that he was now devoting himself to portrait painting as singlemindedly as to conversation pictures in 1728–31 and to historical compositions in 1731–38. Moreover, aside from a few fine conversations, the period is dominated by single portraits, which were more readily commissioned, more remunerative, and easier and quicker to paint.

At about the same time as the portraits of the Prince and Princess of Wales were executed, Hogarth painted similar small full-length portraits of Harriet Lady Byron (National Trust) and Gustavus Hamilton, Viscount Boyne (pl. 158). However, the real, or at least the symbolic, signal for his singleminded activity as a portraitist appears to have been the challenge of Jean-Baptiste Vanloo's appearance in December 1737. Indeed almost every one of Hogarth's acts during this period can be seen as a self-appointed response to a challenge: the eight plates of the *Rake* were, among other things, an attempt to outdo the six-plated *Harlot;* the St. Bartholomew's paintings were an attempt to outdo Amigoni, who was just then in the news for his histories, and the foreign history painters in general; and now the portraits, at least one of which is signed "W. Hogarth anglus pinxit," were his reaction to the English aristocracy's wholehearted acceptance of Vanloo and the portraitists who were either foreign or foreign-influenced.

In December 1737 Vanloo arrived in London from Paris, a man in his late fifties, "tall well shaped and of good aspect" (by which Vertue indicates the courtliness that the English had come to expect of their portraitists since the time of Van Dyck). He had painted French royalty and nobility, but after the death of his patron the Regent, and a commission lost to his brother Carlo, he headed for London—without, as far as Vertue could discover, any invitations or connections at the English court. He set up a studio at the Crown and Ring, the house of his countryman Duhamel the jeweller, in Henrietta Street, Covent Garden, and to demonstrate his ability he began with portraits of Colley Cibber and Owen MacSwiney. These theatrical portraits not turning the trick, he tried a portrait of General Dormer, which Vertue noted was "very like—and soon

after being less than 3 or four months [he] had a most surprising number of people of the first Quality sat to him for their pictures."[9] Hogarth's own reaction can be sensed in his friend Rouquet's account, published in 1755:

> Scarce had he finished the pictures of two of his friends [Cibber and McSwinney], when all London wanted to see them, and to have theirs drawn. It is impossible to conceive what a rout they make about a new painter in that great town, if he has but any share of abilities. Crowds of coaches flock'd to Mr. Vanloo's door, for several weeks after his arrival, just as they crowd the playhouse. He soon reckoned the pictures he had in hand, by hundreds, and was obliged to take five sittings a day: the man who kept the list of these sittings, was very handsomely rewarded for putting your name down before it came to your turn, which was oftentimes six weeks after you had first presented yourself to have your picture drawn.[10]

The *London Evening Post* of 16–18 February 1737/8 noted that Vanloo was "now painting in the Portrait Way most of our English Nobility" and that Amigoni was decorating the additional buildings at Greenwich Hospital—both

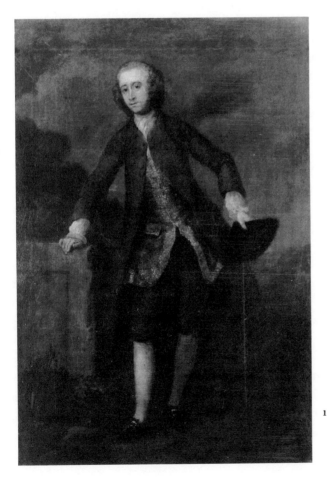

158. Gustavus Hamilton, second Viscount Boyne; ca. 1736; 22 x 16 in. (the Right Hon. the Viscount Boyne)

items which would have meant something to Hogarth. On 4 March the Prince and Princess of Wales (having the day before checked on English artists by seeing the collection of paintings belonging to Wootton in Cavendish Square and visiting Vanderbank in Holles Street) visited Vanloo's studio and looked at his paintings, "which they commended extremely; they did him the Honour to sit by him and see him paint two Heads, and afterwards order'd him to prepare the Cloths for the painting their Royal Highnesses and the Princess Augusta's Pictures."[11] By April and May Vanloo was granting five sittings a day, though his likenesses were said to be natural without flattery: "the great employment in six months from his first comeing exceeds any other painter that is come to England in the memory of any one living"; and Vertue adds: "but the English painters have had great uneasiness [that] it has much blemishd their reputation—and business—." Another foreigner, the Florentine Soldi, who had been in England for two years without notable success, now adopted Vanloo's mannerisms and also was soon in great demand, from April to August undertaking over thirty portraits large and small.[12] The *London Magazine* for 1738 observed that "the ridiculous imitation of the French is now become the epidemical distemper of this Kingdom . . . and what seems, at first sight, only very silly, is in truth the great national peril. . . ."[13]

The French tradition re-introduced by Vanloo offered a more mobile face, one with, as David Piper has said, "a waxier *chic,* and a more minute technique in the rendering of the features than any British painter then working," which pointed toward the "two-dimensional illusion of a wax tailor's dummy."[14] Vanloo's *General Dormer* (which is still at Rousham) merely shows, as Ellis Waterhouse has observed, "the style of Richardson seasoned with a little of the high French affectation. The pose is a little less placid and easy, hands and arms make a little for elegance: draperies and the tablecloth curl into a little more Frenchified folds—and that is about the whole difference."[15] But it was just "this tinge of modishness"—i.e., foreignness—that brought him his following and that he now injected into English portraiture. One might say that Vanloo served portraiture as Gravelot had the more decorative arts.

When Hogarth came on the scene and signed a portrait "W. Hogarth Anglus pinxit" (see pl. 173) he was reacting not only against Vanloo and Soldi but against the two hundred years in which the British had seen themselves through the eyes of foreign painters, or of British artists who imitated them; and against the aristocratic stereotype I examined in an earlier chapter, the elongated bodies and faces as regularized as masks. The example of Jervas shows that even the royal family sometimes reacted against this abstraction when it lost all sense of likeness. Zincke, the German enamelist and miniaturist, replaced him as the King's favorite producer of likenesses. As these facts indicate, England was not overly graced with good portrait painters. Of the older generation (the "old

masters" as Vertue called them), Michael Dahl still painted a little; Jonathan Richardson, at his best, could produce small informal faces (usually profiles) that were close transcriptions, but in his formal portraits this precision was lost. Though sometimes with features of a Hanoverian heaviness, the portraits of this period retain the slender, long Kneller shape and the Kneller mask, and the same poverty of poses: a stiff figure holds, if an author, a book; if a gentleman, a snuffbox; if a sculptor, calipers; if a lady with intellectual pretensions, a copy of Locke or Newton. The Abbé Le Blanc, an observant Frenchman who lived in England from 1737 to about 1744, remarked of this phenomenon:

> At present in London the portrait painters are more numerous and more unskilful than ever they were. Since Mr. Vanloo came hither, they strive in vain to run him down; for no body is painted but by him. I have been to see the most noted of them; at some distance one might easily mistake a dozen of their portraits for twelve copies of the same original. Some have their heads turned to the left, others to the right; and this is the most sensible difference to be observed between them. Excepting the single countenance or likeness they have all the same neck, the same arms, the same colouring, and the same attitude. In short these pretended portraits are as void of life and action as of design in the painter.[16]

Of the younger generation to which Le Blanc refers, John Vanderbank, who had been the most promising of the fashionable young portraitists after Kneller's death, had (to use Vertue's word) "blasted" his chances with his amiable carelessness and dissipation. But after clearing himself of debt in 1730, he picked up his fashionable portrait practice again and in 1736 finished his large full-length of Queen Caroline (now at Goodwood House). This was painted for the Duke of Richmond, to whom Sir Thomas Prendergast wrote in recommendation of Vanderbank: "I think there is no other in London who comes *so near* deserving the name of a painter."[17] At the height of his popularity but still in a precarious position, Vanderbank stood to lose most of all from Vanloo's arrival.

Portraits by Joseph Highmore, born two years before Vanderbank and four before Hogarth, can be traced back as far as the early 1720s, and a great many have survived from 1728 on. His study of law had endowed him with manners and an education, and he cultivated an aristocratic clientele. After his success in 1723 with his portrait of David Le Marchand, and Kneller's death in the same year, John Bunce wrote (in 1726):

> No more let Britain for her Kneller grieve
> In Highmore see a rising Kneller live
> Whose happy pencil claims as high a name
> If equal merit challenge equal fame.[18]

Though Highmore never achieved Kneller's or even Vanderbank's eminence, he introduced a calm realism into English portraiture that anticipated both Hogarth and Allan Ramsay.

Arthur Pond had returned from Italy in 1727 and had gained some reputation as a crayon portraitist as well as a virtuoso, connoisseur, and dealer; George Knapton was beginning his career as a portraitist in crayons and oils. Thomas Hudson, first mentioned by Vertue in 1733, was just emerging; like Hogarth, one of the Slaughter's-St.Martin's Lane group and influenced by Roubiliac's rococo portraits. Later he owned the original terra-cotta modello of the Vauxhall *Handel,* had a fireplace with two caryatids by Roubiliac, and in 1752 accompanied him and Hayman to Italy. His earliest surviving portraits, from the 1740s, display rococo elements, and, of greatest significance, in 1740 he became Reynold's teacher.

Hogarth himself had produced occasional portraits, but up to this point his experimenting with single portraits was confined to genre pieces like *Sarah Malcolm* and to members of his own family: his mother, his father-in-law, possibly by this time his wife and sisters, and a self-portrait. As early as 1730/1 (as recorded in his list of work at that time unfinished) he was painting a full-length of Sir Robert Pye, but it looks like little more than a depopulated conversation picture. The full-length portrait called *Gentleman in Blue* produces the same effect, as do the small standing portraits of Lady Byron and Viscount Boyne, which are datable around 1736. Only *The Duke of Cumberland* of about 1733 and *Thomas Western* of 1736 begin to look like single portraits in their use of the picture space.[19] The most forward-looking experiments, however, are pictures of family and friends. (Sarah Malcolm sitting in her cell, though a portrait, was essentially a cross between a depopulated conversation and a *Harlot's Progress* reduced to a single picture and person.) Hogarth's portrait of his mother (pl. 136), which, considering the date (1735) may have been painted after her death from memory, is the first to make the sitter dominate the picture space. Next comes the seated full-length of Dr. Benjamin Hoadly in 1737 or 1738, a small and as yet timid version of what he attempted in *Captain Coram* (pls. 159–160a and b). Then, either just before or just after the *Coram,* comes the small full-length of Bishop Hoadly (pl. 163), a very close ecclesiastical version of *Coram.*

His serious effort, however, was devoted to other kinds of painting, or portrait groups, which demonstrated his particular talent for rendering active crowds of people. He was no doubt aware that his strength lay in relating two or more figures, and that single portraits gave no scope to his particular talents. There was another reason as well. Richardson, as both theorist and practicing portraitist, had stressed how important it was for the English gentleman to have portraits of himself and of absent friends and relatives, to "keep up those sentiments which frequently languish by absence"; it was equally valuable, he insisted, to keep

portraits of the great nearby to inspire oneself with noble thoughts.[20] This was, of course, the idea at which Hogarth poked fun by having the Harlot keep near her bedside portraits of Macheath and Dr. Sacheverell, and it tells something about the *virtu* of the English gentleman as an aspirer to Roman and other perhaps inappropriate values (which may have kept Hogarth from being very interested in portraiture outside the circle of his family and friends) and also about the increasing demand for portraits in English homes in the 1730s.

If the tradition of portrait painting itself was singularly dim at this time, the first real break from the Kneller pattern came in the school of sculpture. From the point of view of the English gentlemen brought up on Richardson's treatises, the portrait was augmented if not superseded by the bust, with its echoes of antiquity, which meant much to the Englishmen who—with help from the Burlington circle—liked to think of themselves as reincarnated Romans. The Italian sculptor Guelfi had been imported for this purpose by Burlington, who then employed Rysbrack when he saw that he did the job better. Rysbrack made the busts of Inigo Jones and Palladio that flank the entrance to Chiswick House, of the great men in Queen Caroline's Grotto, and of the artistic and literary bulwarks of the Burlingtonian system, Kent and Pope. Sir Robert Walpole as a Roman senator made a flattering portrait, but Rysbrack also caught a good likeness, which the portrait painters then had to live up to. By 1730 Vertue was noting that the reputation of sculpture was higher than ever before; in 1732 Rysbrack, who did more than anyone else to introduce this kind of portrait, had some sixty sitters, and by 1738 Vertue believed sculpture had made "greater advances" than painting.[21]

Significantly, as is well known, it was the *Apollo Belvedere* that later served as model for Ramsay's *Chief of Macleod* (1748) and Reynolds' *Captain Keppel* (1753); and, closer to home, Scheemacker's statue of Shakespeare in Westminster Abbey (1741) introduced the long series of cross-legged figures leaning on pedestals in painted portraits. In 1738 Roubiliac produced his *Handel* (pl. 133), a more intimate and individual portrait than the Roman senators of Rysbrack, one depicting the person himself, not the person as if he were someone else. Roubiliac was, of course, catching his sitter in a particular moment as Hogarth had done in his conversation pictures, and in that sense continuing the tradition already inaugurated by the painter. But he shows how this effect can be achieved with a single figure, and it is to him that Hogarth owes something like the unbuttoned coat and comfortable pose of George Arnold or Martin Folkes. Even the liveliness of his application of paint tends to recall the sculptor's fingers in Roubiliac's terra-cottas, which are more like Hogarth's canvases than the finished marbles. It can be no coincidence that Hogarth began to be seriously interested in portraiture just after the unveiling of Roubiliac's first great success, his *Handel;* and his own first great success was his *Captain Coram,* which is very much the same sort of portrait, given the difference in media and professions. It

is, in the same sense as the *Handel,* sculptured, and quite a different object from those stiff painted icons of Vanderbank and the other contemporary portraitists. The words Margaret Whinney applies to Handel—"at once novel, informal, and topical"[22]—explain the popularity of Hogarth's early work as well.

Richardson, who wished to exalt the painter to the level of the poet, had used history painting as the obvious genre in which painter and poet could vie with each other; portraiture naturally suffered by comparison. Therefore, again following the Italian Renaissance theorists, and in particular Lomazzo, Richardson argued for a portraiture that would act as history painting and elevate the particular individual.

> Thus to raise the character: to divest an unbred person of his rusticity, and give him something at least of a gentleman. To make one of a moderate share of good sense appear to have a competency, a wise man to be more wise, and a brave man to be more so, a modest, discreet woman to have an air something angelical, and so of the rest; and then to add that joy, or peace of mind at least, and in such a manner as is suitable to the several characters, is absolutely necessary to a good face-painter. . . .[23]

This theory supported the practice of painting an apothecary as if he were a baronet, and his wife as if she were a king's mistress posing as a Magdalen or a St. Catherine. Shaftesbury, more objective than the interested portrait painter Richardson, simply dropped portraiture from the ranks of serious art, the only exception being small likenesses to serve as snapshots of friends. Otherwise, portrait painting could not, like history painting, be considered a liberal art, "as requiring no liberal knowledge, genius, education, converse, manners, moral-science, mathematics, optics, but merely practical and vulgar." Therefore it did not deserve "honour, gentility, knighthood conferred," as on Kneller.[24]

Hogarth, although he could not have read Shaftesbury's opinion, expresses a very similar one, with his own uncompromising logic. He sees no difference between the majority of examples of this genre and still-life painting, to which he more than once compares it. He uses the example of the crucifix-maker who all his life had made nothing but crucifixes and so, without genius, grew to make them tolerably well.[25] This mediocrity he considers essential to success in portraiture, where either imagination or "nature" might alienate the artist from his public. Here was the situation he himself had come to distrust and avoid: the third man, the sitter, with his self-interest and pride, interposing between the artist and the ordinary viewer.

"Portrait Painting," he wrote, "tho a branch that depends chiefly on much practice and an exact Eye as is plain by men of very middling natural parts having been at the utmost heights of it, hath always been engrossed by a very few Monopolisers whilst many others in a superior way more deserving both as men

and artists are everywhere neglected and some starving. . . ." Although he must
include English artists as "Monopolisers," he makes clear who he intends in this
instance: "Vanloo, a French portrait painter, being told by friends that the
English are to be run away with, with his grandeur and puffing monopolised all
the people of fashion in the kingdom. Down went at once —— & —— & ——[;]
men then in vogue, even into the utmost distress and poverty." At least one of
the blank spaces can be filled in with Vanderbank's name; Vanloo's popularity
cut into his trade, and the last year or so of his life saw him paying his landlord
with paintings of *Don Quixote*. When he died on 23 December 1739, aged 45,
he was again penniless, and everything in his studio was seized by his landlord.[26]
Other portraitists probably suffered too. It was at this time that Mercier left
London for York to seek a new clientele. One can imagine the indignation of
the author of the "Britophil" essay as he goes on to say:

> This monopoly was agravated by being by a foreigner. I exhorted the
> painters to bear up against this torrent and to oppose him with spirit—my
> studies being in another way. I spent my own in their behalf, which gave
> me enemies among his espousers, but I was answered by [the English paint-
> ers] themselves: "You talk, why don't you do it yourself?" Provoked at this,
> I set about this mighty portrait, and found it no more difficult than I
> thought it.

"This mighty portrait" sounds as if he means, or wants the reader to think, that
he set to work at once on the major portrait he shortly discusses, *Captain Coram*.
He recalls that

> upon one day at the academy in St. Martin's Lane I put this question, if
> any at this time was to paint a portrait as well as Van Dyck would it be seen
> and the person enjoy the benefit? They knew I had said I could. The an-
> swer made by Mr. Ramsay was positively No, and confirmed by about
> twenty who were present. The reason then given very frankly by Mr. R:
> "Our opinions must be consulted and we will never allow it."
>
> Upon which I resolved if I did do the thing, I would affirm I had done it.
> I found my advantage in this way of doing myself justice, reconciling this
> violence to my own modesty by saying Vanity consists chiefly in fancying
> one doth better than one does. If a man think he does no more than he doth
> do, he must know it, and if he says it in this art as a watchmaker may say,
> "The watch I have made I'll warrant you is as good as any other man can
> make you," and if it really is so the watchmaker is not branded as infamous
> but on the contrary is esteemed as an honest man who is as good as his
> word.[27]

Mr. Ramsay was Allan Ramsay, the young son of Hogarth's old friend Allan
Ramsay the poet. It is noteworthy that Hogarth should locate the beginning of

his portrait painting in a conversation with young Ramsay. Vanloo had arrived in December 1737, and his success had been followed by Soldi's in the spring of 1738; then in August the young Ramsay, just back from Italy, set up in the Great Piazza, Covent Garden, as a portrait painter, and by the twenty-second his father was writing to a friend: "I hear from my son that he is going on well in his business; he gets eight guineas a head," which was three guineas more than Reynolds charged when he first arrived in London fifteen years later. (Kneller had 15 guineas for a head, 20 if one hand was shown, 30 for a half length, and 60 for a whole length.)[28] In short, he arrived, with Italian training, just when the fashion for portraits was at its peak, immediately established a successful practice, and joined the St. Martin's Lane Academy, where he and his father's friend clashed.

Ramsay, according to Alastair Smart, wished "to be considered a man of reason who knew how to exercise a rigid control over his emotions. His temperament is mirrored in his portraiture, which is serene, urbane, altogether charming, but lacking in much passion. His was the antithesis of the rugged, untutored genius of his father, the poet."[29] The contrast could apply equally well to Hogarth's temperament, and Ramsay's puzzlement over the phenomenon of his father—"one of the extraordinary instances of the power of uncultivated genius"[30]—might also sum up his attitude toward Hogarth. Ramsay Sr. was a small, round, dark man (his son inherited his dark complexion and hair), whose pride in his "uncultivated genius" was large and ingenuous—he called himself one of "the world's wonders." Allan Jr. (b. 1713) would have seen Hogarth's prints in his father's shop, and at the impressionable age of 19 would have encountered the *Harlot's Progress*. He never lost his admiration for these works. At 20 he arrived in London (1734) and lodged in the house of Mistress Ross in Orange Court, Leicester Fields, so close to Hogarth that one wonders if Ramsay Sr. had written him about a place for his son to rent. Young Ramsay studied under Hans Hysing, but he is also thought to have attended the St. Martin's Lane Academy, and certainly came into contact with that other "vain little man" who was beginning to think himself one of "the world's wonders."[31]

He was only in London a few months, and returned to Edinburgh. In May 1736 he was back in London ready to make the Grand Tour, and on 24 July he and Dr. Alexander Cunyngham left on the Dover coach. In Italy he studied with Solimena and learned from Benedetto Luti the method of first modeling the head in red, which Vertue commented on with annoyance within a few months of Ramsay's return, but which apparently attracted commissions. He built up the head entirely of vermilion, then superimposed glazes and body color, which lent transparency to the flesh tints and kept the shadows soft and unobtrusive.[32] His first paintings on his return are in the "licked" Italian style, and when he wrote to Cunyngham in April 1740 that "I have put all your Vanloos and Soldis and Roscos [i.e. Ruscas] to flight, and now play the first fiddle myself," it is sig-

nificant that he never thought to mention an English name.[33] Not only did he apparently not consider other native artists as competition, but his style was intended to invite comparison with the continentals, not with the English, for whom Vertue was speaking when he accused Ramsay's portraits of being "rather lick't than pencilled . . . neither broad, grand nor free."

But Ramsay was not just the Italianate opponent; his style conveyed an intimate realism, and he possessed a remarkable ability to catch a likeness. Led by Ramsay, the new generation produced a kind of portrait that allowed for a good likeness, which effectively broke the Kneller mask but kept the aristocratic formality intact; after completing the face, the painter sent the canvas to Joseph Vanhacken to fill in the fashionable body, costume, and stage props.[34] Vertue attributed much of Ramsay's success to his drapery painter, and, indeed, in much of his work before Vanhacken's death in 1749 (and this included the great full-lengths of *Dr. Mead* and *The Chief of Macleod*), Ramsay painted only the head and worked out the composition, and Vanhacken filled in the rest—thus adding another desirable attribute to Ramsay's portraits, for Vanhacken was a genius at rendering silks and satins.[35] Added to his Italianism, Vanhacken, and the red underpainting, was the assistance he received upon his arrival from the Scottish colony in London—always a cause for annoyance among the English, to reach crisis proportions under the Bute Ministry.[36] Ramsay very soon had collected more fashionable sitters than Hogarth ever painted: the Dukes of Argyle and Roxburghe, and the Earls of Coventry, Stair, and Haddington.

Most of Vertue's derogatory opinions of Ramsay would have found their echo in Hogarth, who, whatever his feelings about Scotland, followed the "broken" brushwork of the Kneller tradition and refers to Ramsay in one of his notes as another "face painter from abroad" who succeeded "by some new strategem of painting a face all red or all blue or all purple at the first sitting" and by securing "one of the painter taylors" (drapery painters). Hogarth, Highmore, and a few others refused to turn out factory products, and as far as Hogarth was concerned a painter who did was not a true artist. The view of many contemporaries, however, was probably summed up by Northcote (no doubt echoing Reynolds): "The genius of Hogarth was too great, and his public employment too little, to require the assistance of a drapery painter, therefore he might safely point his satire at those who did."[37]

It is probable that, whether or not Hogarth remembers the sequence correctly, his boast did in fact receive the negative response he records from Ramsay—and the boast may have been directed at Ramsay in the first place. He saw Ramsay, at any rate, as a symbolic opponent. Hogarth's confidence in his performance, reflected in his own memory of his boast at the academy, must have spilled over into conversation; or perhaps the St. Martin's Lane artists had begun to make jokes about this "uncultivated genius." One well-known story, told by Dr. Belchier, an eminent surgeon, refers to this time:

Hogarth being at dinner with the great Cheselden [whom he had known since the days of Vanderbank's academy], and some other company, was told that Mr. John Freke, Surgeon of St. Bartholomew's Hospital, a few evenings before, at Dick's Coffee-house, had asserted that [Maurice] Greene was as eminent in composition as Handel. 'That fellow Freke,' replied Hogarth, 'is always shooting his bolt absurdly one way or another! Handel is a giant in music; Greene only a light Florimel kind of a composer.' —'Ay,' says our Artist's informant, 'but at the same time Mr. Freke declared you were as good a Portrait-painter as Vandyck'—'*There* he was in the right,' adds Hogarth; 'and so by G— I am, give me my time, and let me choose my subject.'[38]

By his "subject" Hogarth meant Coram. He emphasizes, in the autobiographical notes, the primacy of the Coram portrait: that he did it first, as a test, and "without the practice of having done thousands, which every other face painter has before he arrives at doing as well."[39] While for propaganda purposes it was appropriate that the Coram portrait should be his first as well as most famous one, there is a certain poetic truth in the assertion. Vertue makes no mention of Hogarth's portraiture of these years until at the beginning of 1741 he comments on "a picture at whole length of Mr Coram. the old Gent that proposd, & projector first of the hospital for foundlings—this was done and presented to the hospital by Mr Hogarth. and is thought to be very well. this," Vertue adds, "is *another* of his efforts to raise his reputation in the portrait way from the life" (italics added).[40] It was his first public portrait, his first portrait on a large scale and with a monumental composition that consciously invited comparison with Van Dyck. He had painted full-length portraits before this, though on a very small scale, and certainly not public nor in any sense advertised. But it is understandable that he remembered *Coram* as his first substantial portrait. Probably the arrival of Vanloo, and its effect, had caused Hogarth to begin painting as well as talking about portraits, but sometime in 1739 a scene like the one he describes must have taken place at the academy. It would be interesting to know whether this scene preceded or followed his first connection with the Foundling Hospital, or whether having associated himself with Coram for philanthropic purposes it occurred to him that here was the place for a great English portrait to be publicly exhibited in perpetuity.

Whatever the exact chronology, on 17 October 1739 Hogarth appears on the *Charter for Incorporating the Society of the Foundling Hospital* as a governor, and was present at the first meeting at Somerset House, Tuesday 20 November, to receive the Royal Charter (along with six dukes, eleven earls, and many other peers and famous Englishmen, including merchants, bankers, and such physicians as Dr. Richard Mead). It is also clear that he subscribed his money and attended the Courts of General Meetings as an active member (as opposed to the

great majority of the 375 governors named in the Charter). The Charter authorized the governors to appoint persons to ask for alms on behalf of the charity and to receive subscriptions toward the founding; Hogarth presumably did both, and his first known contribution was the headpiece he designed for the subscription forms, which was engraved by La Cave.[41]

But he had also been busily at work on the full-length portrait of his friend Captain Thomas Coram, the founder and moving spirit of the whole enterprise; so monumental a painting was clearly destined for a public building. On 14 May 1740, seven months after the granting of the Charter, at the annual Court of Governors, Martin Folkes, a vice president of the Hospital, "acquainted the Governors That Mr Hogarth had presented to them a whole length Picture of Mr Coram for this Corporation to keep in Memory of the said Mr Coram's having Solicited, and Obtained His Majesty's Royal Charter for this Charity." The Corporation voted its thanks to Hogarth.[42]

Captain Coram (pls. 160a and b) shows a decidedly plebeian man raised by his own moral strength to authentic greatness. Hogarth has painted him life-size, almost of a size with the figures of the St. Bartholomew's history paintings, and given him a beaming face, full of self-confidence and good nature—the "cheerfulness, frankness, warmth, affection and great simplicity of manners" noted by his friend Dr. John Brocklesby.[43] His body appears to be about to move vigorously forward, perhaps because of the fluttering motions made by his great red coat. The seal attached to the royal charter of the Foundling Hospital is firmly grasped in one hand, a symbol of his own accomplishment, as is the globe, turned to show England and New England linked by the Atlantic Ocean (he made his fortune by trading across that body of water), and the prospect of the sea studded with sailing ships. The viewer looks up at Coram—is forced to by the angle of vision—but there are no falsely aristocratic features, and instead of robes of state only his coarse coat.

This is, however, Hogarth's first great portrait, and he has not yet quite made up his mind about his treatment of the sitter. While maintaining Coram's true value as a moral agent, he gives the garments a wild fluttering look and places behind Coram the conventional pillar and other accessories of inflated French portraits like Rigaud's *Samuel Bernard* (pl. 161).[44] Too much may depend on symbolic attributes; and the involved pattern of light and shade which worked so well in the storytelling histories is distracting in a portrait where a single effect is required. In a few brief years he would reduce these elements to the splendidly simple shape of *Frederick Frankland* (pl. 167).

To understand the effect of *Coram*, however, it should be compared with Ramsay's full-length portraits of the period—*Viscount Deerhurst* and *The Hon. John Bulkeley Coventry*—that established his reputation, and his monumental *Dr. Mead*, which he presented a few years later to the Foundling Hospital. It is evident from the dates and from the story Hogarth recalled that he and Ramsay

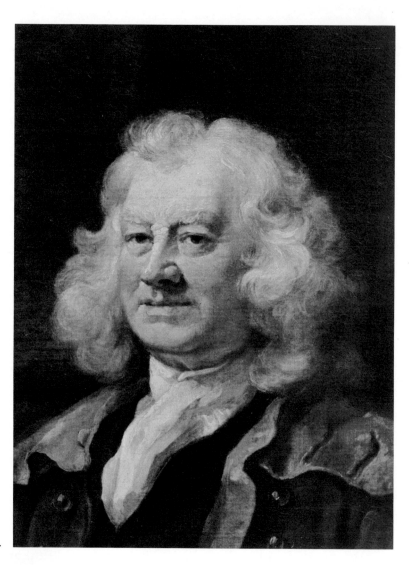

160b. Detail of 160a.

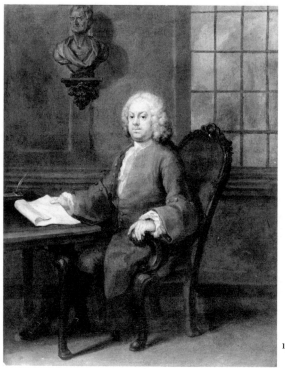

159. Dr. Benjamin Hoadly, M.D.; ca. 1738; 22¾ x 18¼ in. (Fitz-william Museum)

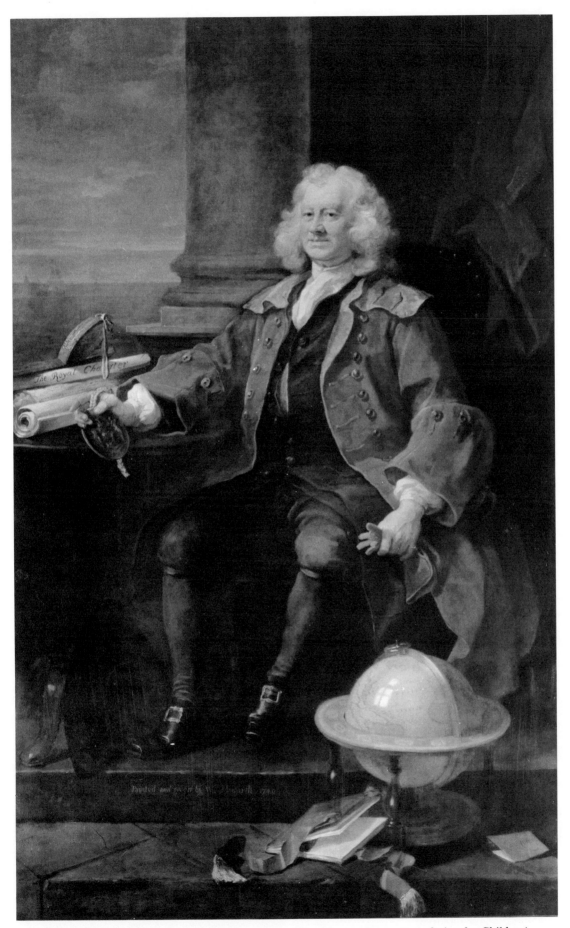

160a. Captain Thomas Coram; 1740; 94 x 58 in. (The Thomas Coram Foundation for Children)

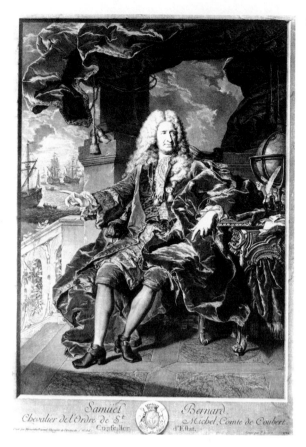

161. Hyacinthe Rigaud, Samuel Bernard (engraving by C. P. Drevet); 1729 (BM)

Samuel Bernard.
Chevalier de l'Ordre de S.^t Michel, Comte de Coubert.
Conseiller d'Estat.

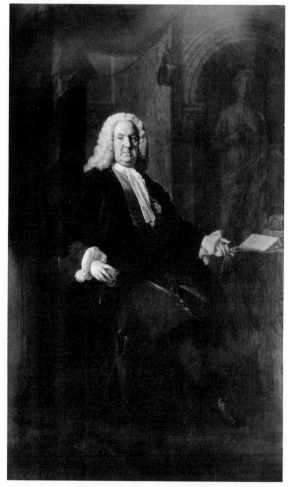

162. Allan Ramsay, Dr. Richard Mead; 1747 (The Thomas Coram Foundation for Children)

considered each other rivals. Ramsay's *Dr. Mead* (pl. 162) turns the rich physi-
cian into Rigaud's Louis XIV himself. Mead took a strong interest in the status
of physicians, and wrote an essay demonstrating that doctors in antiquity were
not, as was commonly thought, slaves but respected citizens held in high regard.
Waterhouse states the distinction very well: portraitists like Ramsay and Hud-
son "did not seek to appeal to the genuine virtues of the middle classes, as Ho-
garth had, or to their moral value—but rather to their instinct for 'climbing' "[45]
(the instinct satirized by Hogarth in the *Harlot* and the *Rake*).

With few exceptions Hogarth was able to be at once honest and benign in
portraying his sitters. Since there were few Corams, his large, heroic portraits
were limited to children, actors playing roles, and ecclesiastics who are either
genuinely impressive in themselves (Archbishop Herring) or mere vessels of
God, frail human beings surrounded with the robes of authority (Bishop
Hoadly). For the ordinary professional man, he used a smaller canvas and a half-
length or quarter-length pose; he added no fancy dress, no official robes, and
filled the picture space with details indicating the man's prosperity and com-
munity importance, but declined to raise him to a status he did not possess. If
he was responsible for what Waterhouse has called a "heroic middle-class art,"
it is clear that this applies only to *Coram* and a few other portraits like that of
Frankland, and that he regards these sitters as worthy of attention on his own
terms. He may occasionally beautify, but he seldom inflates.

In general, then, his portraits either center on the idea of disguise or present
middle-class sitters who have no aristocratic pretensions, and to whom he gives
none. They are his friends and relatives, and people from the professional
classes, with whom he could feel at ease, personally and ideologically—and whom
he had no need to transform. It is a kind of straightforward portrayal that would
not serve as a society portrait, and would seem out of place as a full-length. The
eloquently heavy torso that fills a large part of the picture space is the appro-
priate form. But the main reason that society did not seek portraits from Ho-
garth may have been that he shattered the Kneller mask, the standardized oval,
with the long nose and narrow eyes. He replaced these with round, beaming
faces, whose mood was most often cheerfulness and a kind of unaristocratic busy-
ness and vitality that makes them appear to be anxiously awaiting the end of the
sitting. David Piper notices how, as opposed to the Kneller oval, they "tend to
accumulate more roundly in an interplay of plump convexities, cheek, and chin,
and chin again, and popping eyes," with full and fleshy mouths.[46] Any potential
society clients probably felt that while his portraits were appropriate for his
particular sitters, the same approach would hardly suit them.

The fashion, set by Vanloo and the French school, was all in Ramsay's favor.
One can hear Hogarth criticized too in Peter Manigault's comment on an artist
named Keble. Manigault had been painted by Ramsay; but first, he says, "I was
advised to have it drawn by one Keble, that drew Tom Smith and several others

that went over to Carolina, but upon seeing his paintings I found that though
his likeness (which is the easiest part in doing a picture) were some of them very
good, yet his paint seemed to be laid on with a trowel, and looked more like
plaistering than painting." Besides the smooth, glazed texture, he also liked the
fact that Ramsay included an exact rendering of his own clothes.[47] Hogarth's
portraits supplied none of these requisites.

His evident need to fiddle with his pictures, his unwillingness to let them
leave his studio, and his occasional requests for their return while he made fur-
ther changes may also have deterred the more fashionable clientele. Further, the
determined straightforwardness of his portraiture was reflected in his studio
habits; later stories describe his impatience with long sittings and the baiting to
which he sometimes treated his sitters. He stressed integrity in every aspect of
his life. The Rev. William Cole provides a glimpse of the household in 1736
when he was sitting for the Western family group. "When I sat to him, near fifty
years ago," Cole recalled for John Nichols,

> the custom of giving vails to servants was not discontinued. On my taking
> leave of our Painter at the door, and his servant's opening it or the coach-
> door, I cannot tell which, I offered him a small gratuity; but the man very
> politely refused it, telling me it would be as much as the loss of his place if
> his master knew it. This was so uncommon, and so liberal in a man of Mr.
> Hogarth's profession at that time of day, that it much struck me, as nothing
> of the sort had happened to me before.[48]

Hogarth's prices have not survived from this period, but one may be sure
(judging by his later prices as well as by his temperament) that they were at least
eight guineas a head, or equal to Ramsay's and his other competitors'. On 7 No-
vember 1741 Lady Anne Cust wrote her son Sir John, who had approached Ho-
garth about a portrait group of Lady Cust and all her sons and daughters: "As
Mr Hogarth persists in his price I desire you will talk with Zeeman or some other
painter."[49] His prices in general may have made people hesitate, especially if
they could get a more fashionable portrait for the same amount or less.

After his *Captain Coram,* Hogarth received no flood of commissions for simi-
lar full-scale portraits. As with his sublime histories, his great portrait remained
a gift to a public building, an impressive display, and an unused prototype.
Aside from the portrait of Archbishop Herring a few years later, his commis-
sions for relatively ambitious works came from friends like the Hugginses and
Hoadlys—in itself an interesting fact, for these faces were made to be portrayed
by Hogarth. It was as if the fox sought out the hunter.

He had a small circle of patrons, those who owned a few of his paintings: the
Hugginses and Hoadlys, Mary Edwards, later Horace and Edward Walpole,
William Beckford, and a handful of others. It is never really certain whether

the painting or the friendship came first, but with these patrons both pertained: apparently the sort of man who liked Hogarth would like his paintings. They were an odd lot; only a few of them are relevant at this point, and the others will be described later. Some, like Horace Walpole and Beckford, never deigned to seek a portrait of themselves, collecting only what they considered his drolls. The Hugginses, who already owned two of his most important paintings, commissioned (some dozen years apart) two circular heads, father and son, which are utterly truthful: the tough old father and the weak-jawed, flabby son, recipient of his father's ill-gotten gains, a parallel to the father and son in the first plate of the *Rake's Progress*.[50] If Francis Edwards had still been alive when Mary met Hogarth, one may be sure there would have been as interesting a father-daughter pair of portraits.

The family that received the greatest benefits from Hogarth as portraitist, however, was the Hoadlys. Hogarth knew young Benjamin in the early 1730s when he painted the Betts family, into which Benjamin had married: a physician who wrote plays, a fat, jovial, and learned man who later polished Hogarth's prose in *The Analysis of Beauty*. Even before this he may have known Benjamin's mother, Sarah Hoadly, who had been a portrait painter of some reputation (a pupil of Mary Beale) before her marriage to the future bishop. The second brother, John, another dramatist and a poet to boot, was a friend by 1734 at the latest, when he composed the verses that accompanied the *Rake's Progress*. The verses were evidently inspired by the paintings and offered to Hogarth, who accepted them and cut them to fit under the designs; some years later Hoadly was urging Dodsley to print the complete verses in one of his *Miscellanies*. One reason for printing them, he says, is "that they will be yᵉ only Copy of mine, of a grave Turn of Thought."[51] Around 1738 Hogarth painted his full-length seated portrait of Dr. Benjamin (pl. 159), a small transitional work, and this was followed by the splendid pair of similar portraits of the Bishop (pl. 163) and (probably somewhat later) the second Mrs. Hoadly (Huntington Art Gallery).

The Bishop, most famous of the political prelates of the day, attached himself to the Whig cause, wrote pamphlets indefatigably for Walpole, and was rewarded with preferment. As Thackeray put it unsympathetically, he "cringed from one bishopric to another": from Bangor to Hereford (ca. £1200, to which was added the rectory of Streatham); to Salisbury (£3000); in 1734, with the friendship of Lord Hervey (whose daughter he baptized in March)[52] and Queen Caroline, to Winchester (£5000); and in 1740, to the Chaplaincy of the Garter. He lived well, kept a good table, and treated his friends with pomp and generosity.[53] As a host he sounds a bit like Pope's Timon: in Winchester House, Chelsea, as his chaplain Edmund Pyle commented, "Such easiness, such plenty, & treatment so liberal, was never my lot before . . . The danger I apprehend most is from the table, which is both plentiful and elegant." He adds that for every two dishes to which he was accustomed, Hoadly served ten.[54] This was the man

praised by Fielding in his poem "Of True Greatness" as blazing with true great-
ness " 'mid divines," in *Joseph Andrews* as writing "with the Pen of an Angel,"
and in *Tom Jones* as having a "great Reputation" in divinity.[55]

On the other hand, he was notorious (at least according to opposition pam-
phlets) as an absentee bishop, who because of his badly crippled legs could not
carry on his duties, could hardly even preach a sermon, but continued to enjoy
all the perquisites of profitable offices while residing comfortably in London. In
this he was the equivalent of Huggins *père,* and in another respect as well: he
took care of his sons as well as Huggins (or Sir Robert Walpole) did his. For ex-
ample, John, having finished his verses for the *Rake* and attempted some un-
successful plays,[56] was appointed Chancellor of the diocese of Winchester (of
which his father had just become bishop) on 29 November 1735, and the Bishop
ordained him deacon and priest on 7 and 21 December. On the twenty-sixth he
was appointed chaplain in the household of the Prince of Wales. In 1737 he was
made rector of Alresford, Hampshire, and a prebendary of Winchester. In 1743
he became rector of St. Mary's, near Southampton, and in 1746 vicar of Overton,
Hampshire. All of these, except Wroughton, were obtained by the gift of the
Bishop his father, and he held all of them simultaneously, with a number of
others added in the 1750s. "I am at Alresford for a Day or two," he wrote light-
heartedly to Hogarth, "to sheer my Flock & to feed 'em (money you know is the
sinews of War,). . . ."[57]

Whether one views Bishop Hoadly as a typical place-hunting clergyman of his
time, as most historians do, or (more sympathetically) as an important and
thoughtful Latitudinarian theologian who overcame crippling physical handi-
caps and saw that his contribution lay with his pen, one need not doubt that he
was a good husband, father, and friend. In Hogarth's first portrait (pl. 163, half
of the pair of Bishop and Mrs. Hoadly), he is dealing with a figure of ecclesiastic
importance, but he maintains a tension between the office and the man. One
hand rests lightly on the robe-covered arm of his chair, the other as lightly han-
dles his mortarboard; on him hang his robes and his garter insignia, with in the
distance the tower of Windsor Castle, the authority in relation to which he bears
these signs of office. There is no sense of pride in Hoadly; rather, he epitomizes
the frail mortal in a position of power, whose authority derives from his robes
and other accouterments. (Coram, by contrast, has the seal attached to the royal
charter of the Foundling Hospital firmly grasped in one hand.)

In the early 1740s Hogarth decided to make a print of this portrait and, as
he had done with *Sarah Malcolm,* cut it down to a large torso that almost filled
the picture space; he raised the hand in a blessing and replaced Windsor Castle
in the distance with a stained glass window. He did not take reversal into con-
sideration; thus Hoadly's left hand is raised in blessing, the order of the Garter
is on his right shoulder, and the motto is reversed. Hogarth must only have
etched this in, and then, dissatisfied, handed it over to Bernard Baron to finish

(pl. 164a). He must then have turned to a canvas and painted the new composition (whether he had a specific commission to do so is not known), using the print as his model, and naturally correcting the reversal of the motto, but leaving the rest. He could not, of course, change the hand without throwing off his composition.[58]

The painting (pl. 164b) is a masterpiece. Hoadly's body looms up, one hand raised, the face as hideous and moving as one of Velasquez's dwarfs, surrounded by billowing robes. It is a great and problematic ecclesiastical portrait—as if the Velasquez dwarf were dressed in the robes of his royal master; but it is something of an exaggeration to call it "perhaps the most savage indictment of the eighteenth-century Church. . . . 'The lust of the flesh, the lust of the eyes, and the pride of life' have seldom been depicted with such merciless candour."[59] Hogarth illustrates Hoadly's physical pain, his mortality, as much as his worldliness. The fact remains, however, that the portrait's power derives from the conflict between the frail human being and the robes of state in as incongruous a juxtaposition as Hogarth later employed in *The Bench*.

In 1740 he painted Benjamin's and in 1741 John Hoadly's head (pls. 165–66), and before he was done he had painted at least one more of each brother and of Benjamin's wife.[60] The brothers are shown in simple head-and-shoulder portraits, clearly though sympathetically drawn, and once again for the full effect they should be hung next to the Tate *Bishop Hoadly:* against that tough old man they have gone to a fat and delicate softness.

England was full of Hoadlys in the mid-eighteenth century, and it is a pity that so few of them went to Hogarth for portraits. One can see, however, why they did not: few could duplicate the Hugginses and the Hoadlys in their unique combination of a self-aware second generation and a strong-willed elder who in some sense saw himself whole, weakness and all, and was proud of what he had accomplished nevertheless.

These then were the sitters who ordered portraits that challenged Hogarth's abilities. The best of the head-and-shoulders portraits was (like Huggins) a personal friend, Martin Folkes (Royal Society). A scientist and president of both the Society of Antiquaries and the Royal Society, he was another devotee of the stage, and frequented Slaughter's.[61] He may have been the link between Hogarth and Roubiliac and the many scientists and doctors they portrayed. In Hogarth's painting Folkes rises up like a mountain, the broken column next to him suggesting something about his large brutal shape as well as his archeological interests. The column gets much more emphasis in the print (1742, pl. 168) that Hogarth made after the painting.

Nothing is known of the other great portrait of this period, *George Arnold*, but there may have been a personal connection here too, for one story has it that both Arnold and his daughter Frances (pls. 169a, b) were "painted by *Hogarth* whilst on a visit here," at Ashby Lodge, Northamptonshire.[62] Arnold was a re-

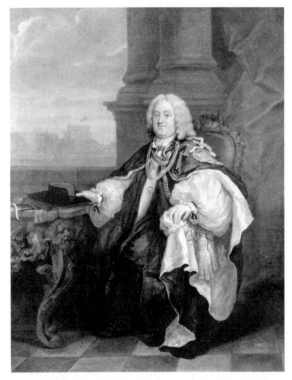

163. Benjamin Hoadly, Bishop of Winchester; ca. 1738; 24 x 19 in. (Henry E. Huntington Library and Art Gallery)

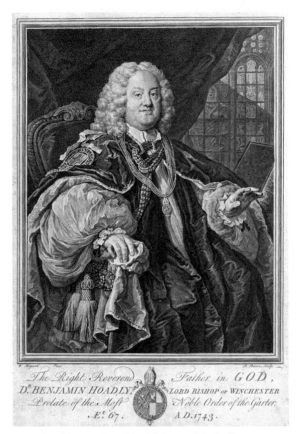

164a. Benjamin Hoadly, Bishop of Winchester (engraving by B. Baron); publ. July 1743; 13¹⁵⁄₁₆ x 11¼ in. (W. S. Lewis)

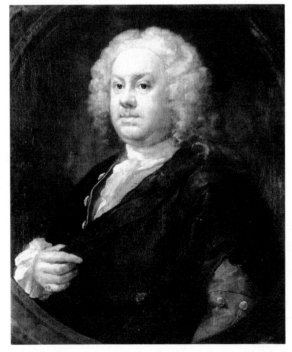

165. Dr. Benjamin Hoadly; 1740; 29 x 25 in. (National Gallery of Ireland, Dublin)

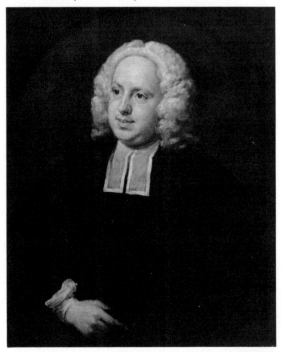

166. The Rev. John Hoadly, Chancellor of Winchester; 1741; 29 x 25⅞ in. (Smith College Museum of Art)

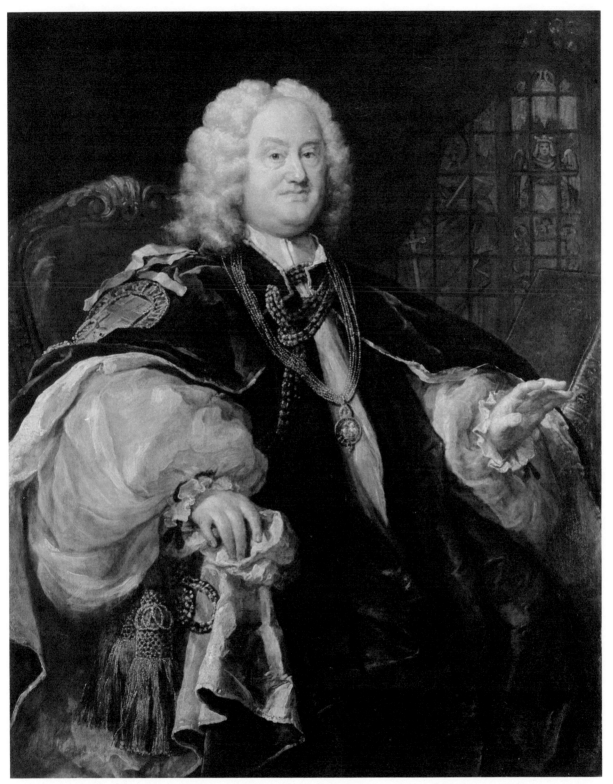

164b. Benjamin Hoadly, Bishop of Winchester (painting); ca. 1743? 49½ x 39½ in. (Tate Gallery)

tired merchant, who built Ashby Lodge in 1722 and collected pictures by the old masters, among them paintings attributed to Rubens, Veronese, and Teniers the elder. There is nothing unusual or interesting about Arnold himself—he has only his own bluff strength, which Hogarth has treated lovingly, pushing him back as if stretched out after a full meal. By unbuttoning his coat, he produced some more rococo lines as well as a sense of depth, a sense of the instantaneous as well as the casual, careless, wellbeing of the man. Paired with his daughter, Arnold has all the confidence and arrogance of the self-made man, and Frances the weak beauty of the succeeding generation. It is almost as though Hogarth needed the two generations for his portraits to take on some of the life and significance his history paintings possessed. One of the developments of the later 1730s may perhaps be considered the departure from the conversation to the set of portraits in which Hogarth explores the family relationships that interested him but would have been impossible or dangerous to depict in a conversation.

As with his full-length works, Hogarth's first three-quarters-length portraits were of his family, with Jane Hogarth holding an oval portrait of her recently dead father (pl. 67, reminiscent of the later portrait of Jane as Sigismunda, holding her father's portrait). His treatment of this size was much improved in the Arnold portraits and *Frederick Frankland* (pl. 167), reaching its climax in the Tate *Bishop Hoadly*. The half-length portraits culminated in the portrait of Martin Folkes. As if fully aware that he was ready to achieve the flawless modello, Hogarth saw to it that he obtained sitters like Hoadly or Folkes, important people whose portraits could be expected to be engraved and disseminated; and then took great pains perfecting the works. In the case of *Folkes,* as later of *Garrick as Richard III,* the apogee of another kind of portrait, he undertook the engraving himself. *Folkes* appeared in 1742, and *Bishop Hoadly* (engraved by Baron) not long after, in 1743. His chief portrait in full-length was of course *Captain Coram,* and this was engraved in mezzotint by McArdell in 1749, as *Archbishop Herring* was by Baron in 1750. Each was his best work in a particular line, a modello for other commissions.

These final great portraits were not, however, followed by similar works: Hogarth completed these patterns of his art in various lines, but they were not taken up. By the mid-1740s his portrait painting had come to a halt, with a brief resurgence in the later 1750s for a final ambitious group (of Garrick and his wife) and a number of head-and-shoulders commissions.

His most aristocratic sitters of these years were the Marquis of Hartington (pl. 172, later Duke of Devonshire) in 1741 and the Grey Children for the fourth Earl of Stamford in 1740. As I have noted, only with friends and children was he given much leeway to invent and create; otherwise, he was apparently approached for a likeness, little more than a face.[63] He never acquired more than a scattering of noble sitters, his clientele remaining clergymen, doctors, lawyers, dons, actors, soldiers, sailors, and merchants. And even with most of these, the

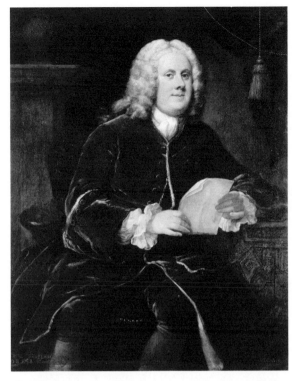

167. Frederick Frankland; ca. 1740; 49 x 39½ in. (Henry E. Huntington Library and Art Gallery)

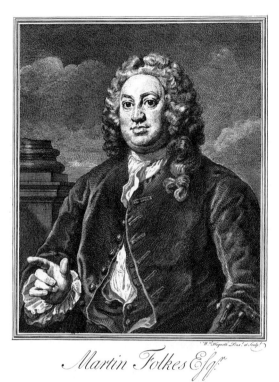

Martin Folkes Esqr.

168. Martin Folkes (the engraving); 1742; 11 x 8¹⁵⁄₁₆ in. (W. S. Lewis)

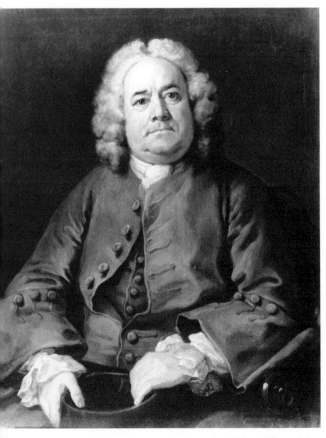

169a. George Arnold; ca. 1740; 35 x 27 in. (Fitzwilliam Museum)

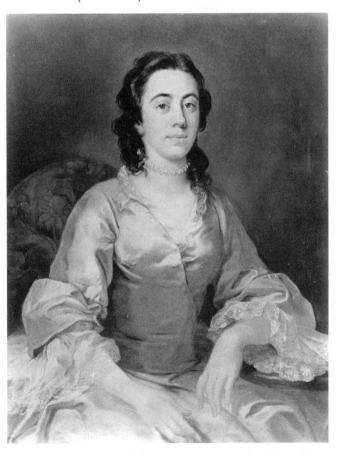

169b. Miss Frances Arnold; ca. 1740; 35 x 27 in. (Fitzwilliam Museum)

commission was not for a formal full-length portrait. The largest and most inter-
esting single group of sitters, indeed, is medical: from the surgeon Caesar Haw-
kins to Thomas Pellett, President of the College of Physicians, and to the biolo-
gist Edwin Sandys. Among the many unidentified portraits, one can only say
that judging by appearances they are professional men, with an occasional mem-
ber of the landed gentry thrown in.

The earliest head-and-shoulders portraits would appear to be *Sir James
Thornhill* (which at present survives only in Ireland's etching), painted some-
time before Thornhill's death in 1734, and the self-portrait in a wig (pl. 170).
As with the full-length of his mother, it is likely that Hogarth began with him-
self and his immediate family as sitters. Only these two relatively private, ex-
perimental portraits focus on the face, limiting the body to head and shoulders.
The self-portrait, in fact, is only a face, the rest very sketchily filled in.[64] The
style is that of the middle or late 1730s, the handling of the face consistent with
the other faces of those years. It bears a definite resemblance to the Roubiliac
bust of 1740 or '41 (pl. 171), which is undoubtedly an accurate likeness.
Strangely, however, it lacks the scar on his forehead, said to have been received
in childhood,[65] that is prominent in Roubiliac's bust. Hogarth himself empha-
sizes it in his self-portrait of 1745 (even moving it to the correct side in his re-
versed engraving), and John Ireland records stories of his wearing his hat cocked
back so that the scar was visible. Either he received the scar not in childhood but
in the late 1730s, or he chose to conceal it in his first self-portrait. Although the
style is of the mid-1730s, the portrait makes Hogarth look at most 30.

A contrast between this portrait and Roubiliac's bust is instructive. Hogarth
has caught his own likeness, but he is less interested in interpreting his character
than in the free and brilliant application of paint; it is largely an exercise in
painting. Roubiliac's bust, based as it must have been on long and personal con-
tact rather than a few sittings, is one of the primary sources of information on
Hogarth's character. Here he is as he appeared in life, caught in movement, with
his head sharply turned, jutting assertively, with incredibly sharp and observant
eyes. Pugnacious is the word to describe the face and its movement. Only with
his last self-portrait, in which he shows his face in profile, does Hogarth himself
catch anything of this. Significantly, Roubiliac included a separate statue of Ho-
garth's pug Trump to accompany the bust (pl. 171c).[66] In *Gulielmus Hogarth*
(pl. 190), painted in 1745, he accomplishes the interpretation of Roubiliac's bust
by surrounding his face, isolated in an oval, with symbolic objects: his pug, to
suggest the resemblance, punning as he often did on his own pugnaciousness or
doggedness; and his palette with the "Line of Beauty." As with the second ver-
sion of *Before* and *After,* symbolism is one way of conveying character. In his
progresses, though the expression of his characters is serviceable enough and
exhibits emotion (desire, terror), it does not expose deeper states of mind;

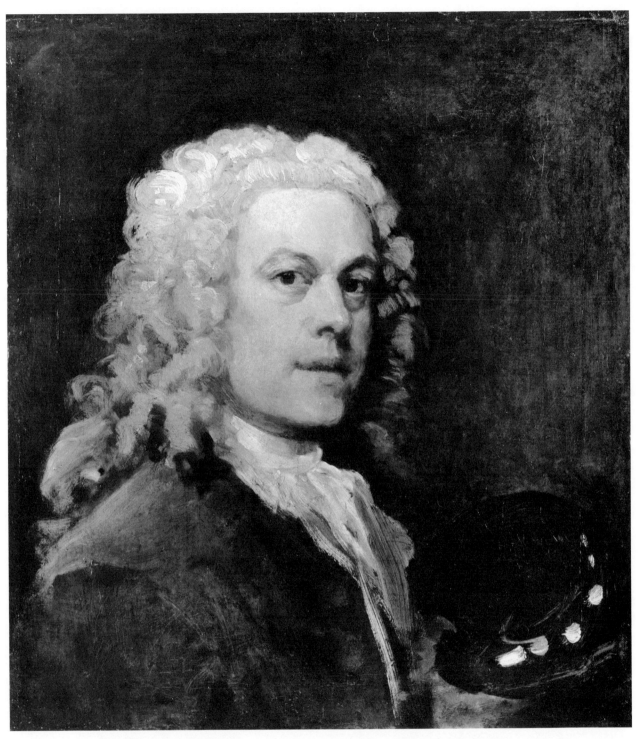

170. Self-portrait; 1735–40? 22 x 20½ in. (Mr. and Mrs. Paul Mellon)

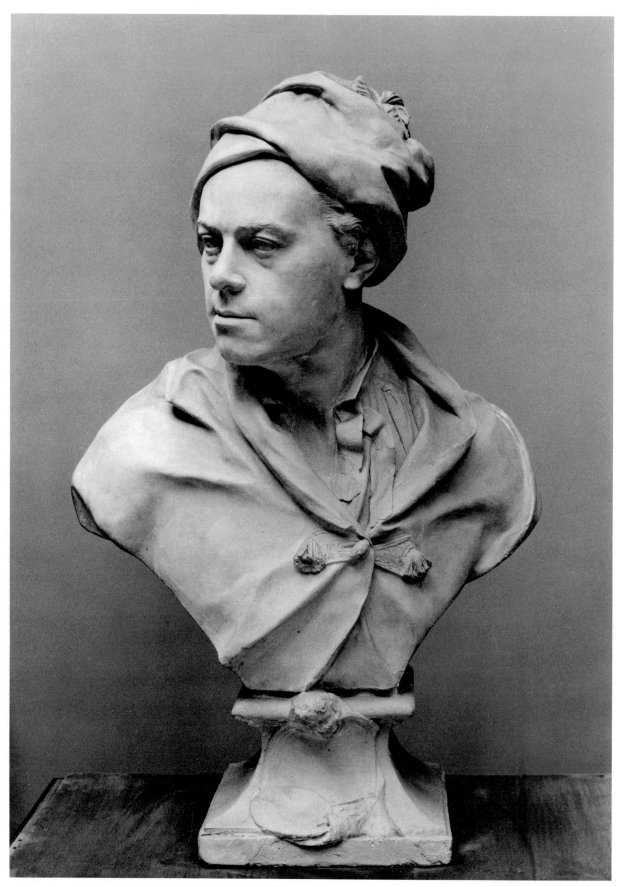

171a. Louis François Roubiliac, William Hogarth (terra-cotta; National Portrait Gallery, London)

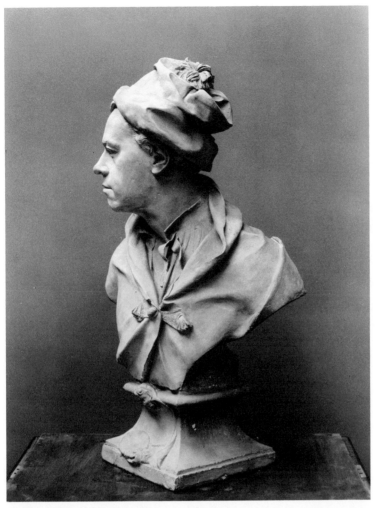

171b. Profile of 171a.

171c. Trump, porcelain copy of Roubiliac's terra-cotta (V & A)

rather, Hogarth conveys personality and motivation by displacing it to surrounding objects. Even an extremely expressive face and body like Captain Coram's requires also the seal of the royal charter, the globe, and the sea.

There can be a kind of drama in these portraits, but with the exceptions already noted of Coram, Hoadly, and a few others, the great majority of his simple head-and-shoulders portraits offered Hogarth no chance for his literary approach to painting. He was aware of how difficult it is to show only a face. On the one hand, he wrote, there was the problem that faces may "hide a foolish or a wicked mind till they betray themselves by their actions or their words," and though a fool may eventually reveal some traces of folly in his countenance, "the character of an hypocrite is entirely out of the power of the pencil, without some adjoining circumstances to discover him, as smiling and stabbing at the same time, or the like." On the other hand, there is the problem that the portraitist by definition portrays the good and exemplary. He remarks how strange it is

> that nature hath afforded us so many lines and shapes to indicate the deficiencies and blemishes of the mind, whilst there are none at all that point out the perfections of it beyond the appearance of common sense and placidity. Deportment, words, and actions, must speak the good, the wise, the witty, the humane, the generous, the merciful, and the brave.[67]

With a few exceptions like the actor Quin, with his head thrown back, pleasantly posing (Tate), Hogarth added nothing in pure face-painting to the compositions of Kneller and Richardson; his contribution was in the direction of humanizing, rather than particularizing, the sitter. For the most part, he does not emphasize the sitter's social life: they are good, competent, professional people, whether doctors or soldiers. A Marquis of Hartington has a bit more grace in his air, but that is all. If there is little social life, there is also nothing of that inner life Rembrandt gives his sitters—only good health and spirits, rosy cheeks and lips. In a sense they are mostly beautifully painted but perfunctory—and finally, if mentioned in the same breath with Rembrandt, must be judged repetitious and facile.

Nevertheless these head-and-shoulders portraits reveal better than the others his debt to Kneller. For, while he put Van Dyck's head over his door, attempted in *Captain Coram* to recapture the Van Dyck formula for his own time, and broke the fashionable mask of the Kneller portrait, he still continued to paint in Kneller's way. The meaty flesh, the corporeality of Hogarth's faces, and above all the evident brushwork, are Kneller's bequest. Kneller's brushwork is closer to the heavy, impasto effects of Rembrandt's portraits than to the brilliant light touch of Van Dyck or the glazes of the Italians. And this technique Hogarth acquired, so that in his last years when he actually produced some consciously Rembrandtesque portraits, he was in a sense fulfilling his natural development.

It was the broken color, however, and not the chiaroscuro, that accorded with his temperament.

He avoids the worst excesses of the school. Both Lely and Kneller—and to an outrageous extent Richardson—habitually emphasized the light on garments with violently obvious brushstrokes, often at odds with the execution of hands and face. Another of Kneller's mannerisms, carried on by Highmore and Ellys, that Hogarth bypassed, was allowing the grayish underpainting to show through as shadows. Richard Wilson recalled that when he was painting portraits Ellys once called upon him and "remarked upon my neglect of the grey ground saying 'Wilson there should be more of the Canvass seen.' " To which Wilson replied, "I ought then to be very popular for no painter has more canvass left than myself," meaning that he sold few.[68]

It is possible that Thornhill, in some ways Kneller's rival and a remarkably baroque portraitist himself, once more served Hogarth as a buffer or as a direct contact with the painting of Lely. Certainly there are Lelys that reflect the Hogarthian technique of portrait painting and applying paint at its best, with a thinner pigment than Kneller often used (e.g., the *Prince Rupert* in the Queen's House, Greenwich). Kneller's paint is often simply laid on every which way, while Lely's (and Hogarth's) creates a kind of aesthetic effect of its own, even if this sometimes tends to reduce the sitter's individuality.

If most of his portraits offered Hogarth no chance for his literary method, and little for elaboration or character-analysis (at which he was probably, without appurtenances, not as talented as he has been thought), they did provide him with an opportunity for pure painting. In this sense his five years of face painting follows from the growing joy in applying paint to canvas that is evident in the modern history paintings of 1735–38. The histories end and the portraits begin; to be enjoyed, the majority of those heads he painted after 1738, many of them in feigned ovals and intended primarily as decorative devices for overmantles, must be regarded as exercises in playing with paint. As such they are delightful, the color and brushwork exciting, and exude the sense of freedom Hogarth must have felt as he painted them (pls. 173–74).

The single portraits were an interval, and a necessary transition, between the last few conversations painted between 1735 and '38 and the great group portraits of the early 1740s, the real climax of Hogarth's portrait painting because they combine the best of his histories with all that he has learned about portraits. *The Strode Family* and *The Western Family* (both 1738, pls. 175–76), for example, contain somewhat larger figures; Hogarth seems to exceed the scale of a typical conversation piece. In fact, the scale has been influenced by the *Harlot's Progress* and the modern histories, and the people now bear about the same relationship to their rooms as do the Harlot and the Rake. The finale of the small conversation pictures (though no longer very small) was the group painted

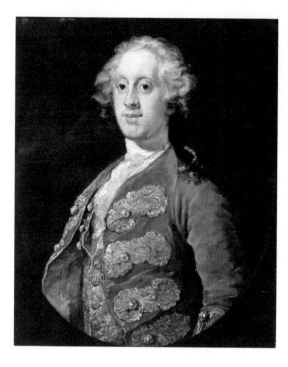

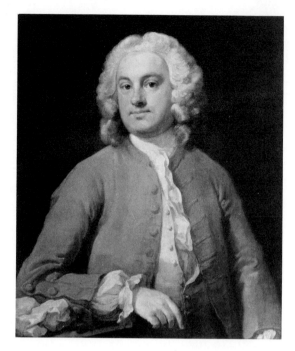

172. William Cavendish, Marquess of Hartington (later fourth Duke of Devonshire); 1741; 29¼ x 24¼ in. (the Baron Chesham)

173. A Gentleman in Red; 1741; 29¼ x 24⅝ in. (Dulwich Gallery)

174. A Gentleman in Grey; ca. 1740; 30 x 25 in. (Fitzwilliam Museum)

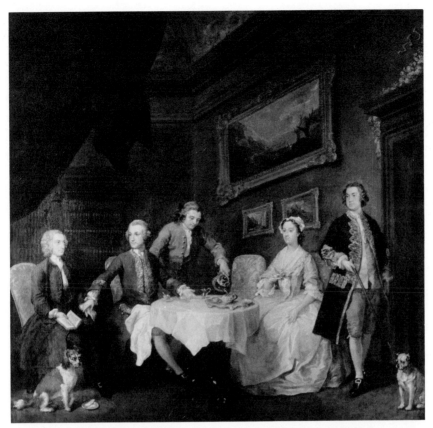

175. The Strode Family; ca. 1738; 34½ x 36 in. (Tate Gallery)

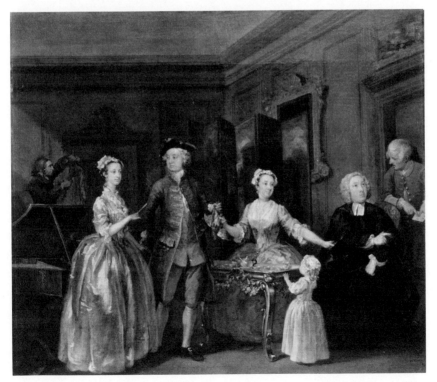

176. The Western Family; 1738; 28¼ x 33 in. (National Gallery of Ireland, Dublin)

for Lord Hervey around 1738 or '39 (pl. 177). It was probably made to com-
memorate the autumn of 1738 when Hervey and his friends hunted and ca-
roused together at the Foxes' house at Maddington.[69] Hogarth creates here the
same contrast between the spirit and the flesh found in his *Times of the Day:*
the Rev. P. L. Wilman (or Villemain) is standing on a chair, looking so intently
through a spyglass at a church steeple in the distance that he does not notice that
his chair is in the act of toppling with him backwards into a pond. The rest of
the company is concerned with a plan of a secular structure, and the lone clergy-
man in black contrasts with the brightly-colored Hervey, with the Fox brothers,
the third Duke of Marlborough, and Thomas Winnington, very much as the old
woman stood out against the revelers in *Morning.*

The Hervey group suffers, however, as most of Hogarth's early conversations
do: the lines defining Wilman's profile are too emphatic, and the other faces
(and figures too), though each is beautifully and delicately painted, are finished
as separate objects that do not seem related to each other. The careful painting
of individual portraits and the virtuoso brushwork have not coincided with the
overall conception of the painting, any more than the print and the painting did
in the modern histories. In all of these groups some parts are in a much broader
style than the rest (e.g., the messenger on the right in *The Western Family*) and
this effect also relates to the shifting focus of the modern history paintings.

The most ambitious portrait after *Coram* was *The Graham Children* (SD
1742), which, typically, was not the commission of a great nobleman, for whom
such scale would be plausible, but the apothecary at the Royal Hospital, Chel-
sea. Daniel Graham was appointed apothecary in 1739; he came of a family
that kept an apothecary's shop in Pall Mall, and one story has it that he owed his
place to the Duke of Newcastle in order "to get rid of a long apothecary's bill."
He prospered, and to show his prosperity he ordered the grand portrait of his
children—the choice of painter, I suspect, a sign of his *nouveau richesse,* for no
established family ever ordered such a portrait from Hogarth. It may be, in fact,
that Hogarth's picture, its monumentality and emblematic profusion, "deli-
cately satirizes the family's luxurious standard of living."[69a]

In a sense *The Graham Children* (pl. 178) is simply *The Strode Family*'s room
with the children grown much larger in relation to the picture space. I think,
however, that it is the intervening portrait of *Captain Coram* rather than the
earlier conversations from which the three great children groups, *The Graham
Children, The Grey Children* (Washington Univ. Gal., St. Louis), and *The
MacKinnon Children* (pl. 179) derive. These are essentially the Coram compo-
sition, size, monumentality, and heroic rendering extended to two or more fig-
ures. Looking forward to Reynolds, one might call this kind of work an heroic
conversation piece, though Reynolds makes his connection with the portraiture
of Titian and Van Dyck very clear while Hogarth builds his composition so that
no forerunner other than his own *Captain Coram* need be considered.

The Graham Children, though on a larger scale, is related to the Hervey conversation by its use of emblems; more precisely, it is a monumental version of the much earlier *House of Cards* and *Children's Party* (pls. 81, 82). The boy turns a bird organ or *sérinette*, which has a picture of Orpheus charming the beasts painted on its side. A tiny figure of Cupid with a scythe like Father Time's rests atop the clock at the left, and opposite him a cat eyes the bird in its cage—these, flanking the happy, smiling children, constitute an admonitory allegory. In this context, the boy's *sérinette* is a childish illusion that will eventually be destroyed by the real world, where birds are devoured by beasts who cannot be charmed by their singing.

The MacKinnon Children (pl. 179), in the monumentality of its composition and the complete sureness of its handling, marks the climax of Hogarth's portrait groups.[70] The symbolism again has to do with the children's future—with fleeting time, lost beauty, and lost innocence. The girl has been collecting fallen petals in her apron and the boy is reaching out for a butterfly poised on the sunflower, an emblem of transient beauty that appears in so many Dutch flower pictures. And, of course, the potted sunflower in the foreground, big as a tree and flanked by the two children with their attention on the butterfly, is the real center of the picture, endowing it with ironic overtones of Adam and Eve, their Tree of Knowledge (unpotted), and their lost Garden of Eden.

The color scheme, like the symbolism, is more subdued than that of *The Graham Children*. The pale violet of the sky is repeated in the girl's dress, rendered less noticeable by her large white apron. The buildings in the background, in Hogarth's characteristic olive drab, are related to the green of the sunflower stalk, and to the pot of the plant, in his particular shade of brown-gold. The boy's coat and trousers are brown and his vest a paler, grayer green than the leaves of the plant. Uniting the two figures, with their pale violets and brown-green-olive tints, is the pale gold of the huge sunflower.

Hogarth's failure to become a fashionable portraitist, in contrast to his success with conversation pictures a few years earlier, may be compared with the case of Amigoni. Even he, not finding full employment with historical subjects, "was persuaded to paint portraits which he did for many of the Nobility & Gentry"— and, Vertue adds, "at a good price." The full-lengths he adorned "with ornamental figures &c that made agreeable pictures. tho' the faces were not thought like generally. yet the whole was in a good taste. but when he only did a head which must depend on the merit of Likeness. colour air and habit of persons, there he had little success in Men's pictures and womens less."[71] Hogarth could be depended on for a likeness, judging by the number of heads he painted, and for charming pictures of some children, but for the "ornamental figures &c" Englishmen preferred to go to an Italian.

Vanloo, able to do both heads and full-lengths well (though Vertue thought

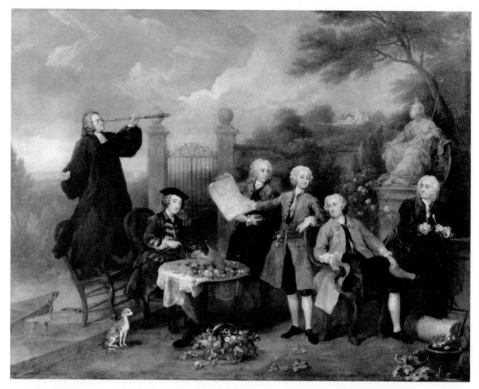

177. Lord Hervey and his Friends; ca. 1737; 40 x 50 in. (The National Trust, Bristol Coll., Ickworth)

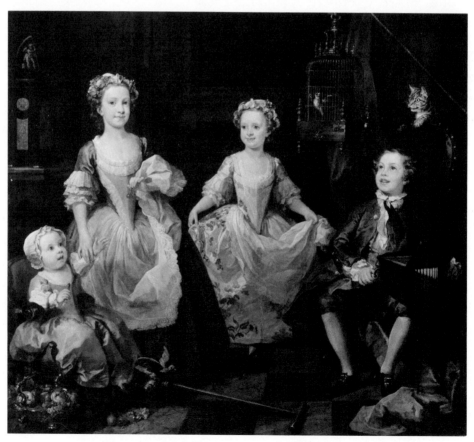

178. The Graham Children; 1742; 63¼ x 61¼ in. (Tate Gallery)

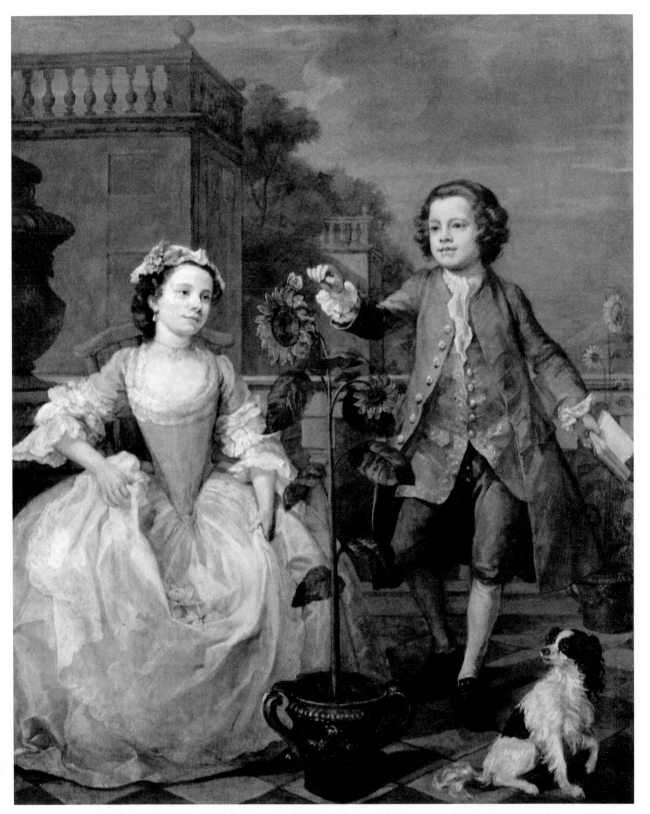

179. The MacKinnon Children; ca. 1742; 71 x 56½ in. (National Gallery of Ireland, Dublin)

CHALLENGE AND RESPONSE 1732-45

Amigoni "had something in composition more degagée—and lightsome"), cut
into Amigoni's commissions, and, sensing it was time for him to leave, Amigoni
departed for Venice to set up a print shop in August 1739 with £4000 or £5000
profit.[72] In November Vanloo was painting a large family group of Lord and
Lady Burlington and their two daughters, "all disposd in the Virtuosi way—the
whole picture is well drawn the faces like—the attitudes gracefull and natural,
the Colouring strong & a free pencil—this master peice will remain as a Testi-
mony here of his skill and knowledge in Art."[73] It was in 1739 too that Kent, of
all people, was chosen to succeed Jervas (now dead) as Face-painter to the King,
and these unkind verses were published:

As to Appelles, Ammons son
Would only deign to sit,
So to thy pencil Kent alone
Shall George his Form submit.
Equal your envied Honors, save
This difference, still we see.
One would no other Painter have
None other would have thee.[74]

In spite of Hogarth's efforts, and his public display of *Captain Coram*, most of
the important commissions went to Vanloo, with Ramsay and Hudson doing
best among the English artists. In 1741 Vanloo's health gave out, and suffering
from dropsy, gout, and rheumatism, perhaps aggravated by the London climate,
he stopped accepting new commissions. Finally, having finished all his work, in-
cluding the portraits of the Prince and Princess of Wales and Sir Robert Wal-
pole, he departed England for his native Provence on 16 October 1742.[75]

The week after Vanloo left, Vertue noticed a piece (he had originally written
"of news," but he struck these words out) printed in the newspaper "with a sting
in the tail." He refers to the *London Evening Post*, 21–23 October 1742:

We hear his Majesty has conferr'd the Honour of Knighthood on Mr.
Stephen Slaughter, Painter, in Rathbone Place, on account of an excellent
Performance lately begun for his Royal Highness the Prince of Wales,
which, by all Judges, is allow'd to be an extraordinary and uncommon Imi-
tation of Nature; and may justly be said to excel the famous French Painter
(lately gone abroad for the Recovery of his Health) as far as he did the
English Painters in general. It is farther to be observ'd, that Mr. Slaughter
is always happy in his Designs, and finishes the Whole with his own Hands—
not common.

Vertue remarks that "this peece of Wit or sarcasm. being stuffd with falsity. is sd
to be the [work] of Ho . . . a man whose high conceit of himself & all his opera-

tions, puts all the painters at defiance not excepting the late famous Sr Godf. Kneller—& Vandyke amongst them." That "Ho . . ." stands for Hogarth becomes evident if one compares this account with Vertue's description of him a few pages later, using almost identical language.[76]

Stephen Slaughter had returned from years abroad in Paris and Flanders in early 1736, and made portraits in the late '30s. The context of the news item suggests that he is to be taken as a bad painter, a proper successor to Vanloo (with perhaps as little connection with England), but one who is receiving patronage above his deserts. One can only speculate, regarding the king's knighting Slaughter for a portrait of his despised son, that the portrait must have been so bungled as to depict the prince as the king saw him. At the same time, the item uses Slaughter's virtue of painting his whole portrait himself to berate the painters like Ramsay and Hudson who employed Vanhacken.

The *London Evening Post* often ran such facetious notices as this; and if Hogarth was responsible for this one, he might also have been responsible for others with art references.[77] In 1741 he had published his *Enraged Musician,* which commented on the kind of artist who tried to cut himself off from nature, and had projected a parallel satire about a painter. He was accompanying his portrait-painting with comments on the works of his contemporaries.

Vertue's summary to the effect of Vanloo's departure is dated 1743 and was probably written between June and July: "since mr Vanlo, painter left England the most promiseing young Painters make most advances possible to be distinguisht in the first class—of those that make the best figure Hymore. Hudson Pond Knapton Ramsey Dandridge Hussey Hogarth"—to which he added, with a caret, the name of Wills. He goes on, however, to single out Hudson, whose portraits are "true fair and Easy, his draperys well disposed and his actions natural, his flesh colours well immitated & his manner agreeable without affected manner of painting. . . ."[78]

In May 1743 Hogarth set out for Paris, "to cultivate knowledge or improve his Stock of Ass[urance]," as Vertue put it. Although an important portrait resulted from the trip, he had in effect by this time returned to history painting. His portrait attempts thereafter are occasionally adventurous, but hardly designed to win the market. He must still have had some portraits going in the fall of 1743,[79] but in February or March 1743/4 Vertue gives the palm to Hudson as the most sought-after and prosperous of the English portraitists.[80] It would thus appear that, while Hogarth did his best and could be grouped with the portraitists who "make the best figure," he did not achieve the success that he wished for, and this may have decided him to return to comic history painting in 1743.

Looking back, Hogarth saw himself staking his reputation as a portraitist on *Captain Coram:* "and it has been left to the Judgment of the public these twenty years whether if the efforts are equal or not."

Yet as the current ran, it was not my talent, and I was forced to drop the going on, the only way by which a fortune is to be got, as the whole nest of phizmongers were upon my back, every one of whom has his friends, and all were taught to run down my women as harlots and my men as caricatures.

And so, he adds, "My graving and new compositions were called in again for employ, that being always in my power."[81]

This refers no doubt to *Marriage à la Mode,* but it is clear that he did not abruptly stop taking portrait commissions—probably did not even cease looking for them, but when the call was light returned to his certain means of support. As to the truth of his allegations about brother portraitists, subtracting a bit for his bitter old age, one should nevertheless recall the hostility of Kneller to Thornhill when he learned that the history painter was poaching on his grounds. "Harlot" and "caricature" were the words an enemy might have applied to Hogarth's healthy, blooming, but not terribly dignified portraits. On another occasion, remembering those years in a slightly different way, he wrote:

> He painted Portraits occasionally but as they require constant practice to be ready at taking a likeness and as the life must not be strictly followed, they met with the like approbation Rembrandt's did, they were said at the same time by some Nature itself by others execrable. So that time only can show whether he was the worst or best portrait painter living....

This paradox, he adds, "can no other way be accounted for but by the prejudices or fashion of the times in which he lived."[82]

As I have noted before, Hogarth—unless faced with a friend—was intimidated by the presence of the third party, the sitter; and above all by a single sitter. He refers himself at one point to Gay's *Fable* XVIII (first series), "The Painter who Pleased Nobody and Everybody," about a painter who (like himself) has the gift of catching likenesses. He paints truthfully and loses all his trade; nobody wants truth, and "In dusty piles his pictures lay, / For no one sent the second pay." Then he starts copying busts of Venus and Apollo for all his sitters, and for added effect, he

> talk'd of *Greece,*
> Of *Titian's* tints, of *Guido's* air;
> Those eyes, my lord, the spirit there
> Might well a *Raphael's* hand require
> To give them all the native fire....

His trade grows, he raises his prices, and he becomes a successful painter.[83]

16

Marriage à la Mode

In the *London Daily Post and General Advertiser* of 2 April 1743 appeared an advertisement:

MR. HOGARTH intends to publish by Subscription, SIX PRINTS from Copper-Plates, engrav'd by the best Masters in Paris, after his own Paintings; representing a Variety of *Modern Occurrences* in *High-Life*, and call'd MARRIAGE A-LA-MODE.

Particular care will be taken, that there may not be the least Objection to the Decency or Elegancy of the whole Work, and that none of the Characters represented shall be personal.

The Subscription will be One Guinea, Half to be paid on Subscribing, and the other half on the Delivery of the Prints, which will be with all possible Speed, the Author being determin'd to engage in no other Work till this is compleated.

N.B. The Price will be One Guinea and an Half, after the Subscription is over, and no *Copies* will be made of them.

When the advertisement next appeared, in the issue of 4 April, a parenthesis was added after "his own Paintings": "(the Heads for the better Preservation of the Characters and Expressions to be done by the Author;)." These notices were repeated in the *London Daily Post* and the *London Evening Post* off and on until the end of July. Hogarth lived up to his word, except for "with all possible Speed": the other precautions listed seem to have canceled out any idea of haste in the project.

As he grew older he put more of himself into his advertisements. The one for *Marriage à la Mode* is particularly revealing. In it he is careful to note that he is going to use French engravers, though he will do the heads himself "for the better Preservation of the Characters and Expressions" (a reference to his subscription ticket, *Characters and Caricaturas*); that there can be no objection to "the Decency or Elegancy of the whole Work," and that no particular contemporaries will be portrayed. Finally, he emphasizes that (appropriately, consider-

ing what has gone before) it will deal with "a Variety of modern Occurrences in High Life." One imagines Hogarth returning after a lapse of some years with renewed vigor to the field in which he had known his greatest triumphs, and—proud of his competence in a new area, lack of commissions notwithstanding—eager to demonstrate that he could appreciably raise the level of his subject, thus answering any critic who might believe his talents extended no further than low characters and striking likenesses. Beyond this, one might suspect, he was also out to show that except for attire and furnishings the high are no different from the low he treated in the *Harlot* and the *Rake*.

Apparently the ad was in part a reaction to the dearth of portrait commissions, or the inadequate revenue they brought in (as he himself claimed); but also Hogarth was in a sense answering the praise of his earlier works, and even the calls to return to prints, that appeared from time to time during the period of portrait-painting. In 1740 the author of *Satirical and Panegyrical Instructions to Mr. William Hogarth, Painter, on Admiral Vernon's Taking Porto Bello* called upon him to paint a picture of this affair, and in the same year William Somerville dedicated his burlesque poem *Hobbinol, or the Rural Games* to Hogarth, "being the greatest Master in the Burlesque Way." Hogarth's province, Somerville writes, is the town, while his own will be the country, but they will agree "to make Vice and Folly the Object of our Ridicule; and we cannot fail to be of some service to Mankind."

In 1742 he carried out a specific commission for a "modern moral subject," but, characteristically at this time, he only executed the painting and refused to have it engraved. Mary Edwards of Kensington, the wealthy heiress who seems to have been a particular patron of Hogarth's, wanted him to produce a satire on contemporary fashions of dress and furnishings (pl. 180). The story goes that friends had made fun of her old-fashioned dress, perhaps in general her strong-minded eccentricities (which numbered among them her patronage of Hogarth); so she paid him 60 guineas to portray the transience of the fashion, largely transplanted from France, of the year 1742. A tradition in the family attests that the design was made "from the ideas of Mary Edwards" herself.[1] If so, she may have called for certain figures (Lord Portmore has been identified as one) or certain objects to be satirized. However, the design, if it originated with her, was based on assumptions learned from Hogarth. Perhaps she demanded more wall pictures than Hogarth generally included (for the first time they dominate the composition; Plate 1 of *Marriage à la Mode,* a year later, continues this tendency).

Taste à la Mode (as it is usually called) is a transitional work, anticipating much that was to occupy Hogarth over the next decade. Here, more forcibly than in *Morning* or *Strolling Actresses,* he concerns himself with the constricting and finally damaging effect of fashion on the individual. The aspiration of the Harlot or Rake toward a "fashionable" ideal here becomes a symbolic dis-

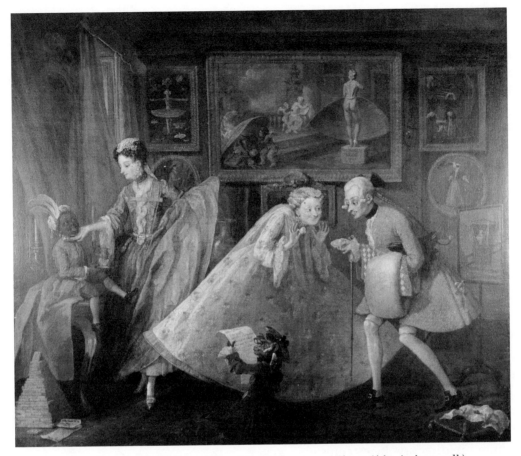

180. Taste in High Life, or Taste à la Mode; 1742; 24¼ x 29¼ in. (private coll.)

tortion of the individual by such specific contemporary artifacts as hoop skirts
and corsets. Whereas the Harlot made her own choice, the individual here is
innocent and simply imposed upon, twisted out of shape by a malign force
known as "fashion" or by others who (like the Harlot and Rake) accept its dic-
tates. In *Marriage à la Mode* this would become the situation of the couple
forced into an artificial mold, a contracted marriage, and the power of fashion
would be reflected more than ever before in the costumes and art objects crowd-
ing their rooms, in effect taking over both rooms and owners.

One wonders, in fact, if Miss Edwards was not seeing something of her own
relationship to fashionable London society in the oppressive character Hogarth
gives it in his painting. She may even have urged upon him the subject of *Mar-
riage à la Mode,* the story of a young heiress courted by a handsome, profligate
young lord and his title-heavy but purse-light family, and their subsequent un-
happy marriage. There are overtones of her own unhappy marriage in the first
plate—but the final conception (which she did not live to see) showed the de-
generation of both husband and wife.

Sometime in 1740 Hogarth painted a portrait of Miss Edwards (pl. 129) hold-
ing lines on English liberty ("Do thou great Liberty inspire their Souls"). She
made her will on 13 April 1742, leaving everything to her son, and characteristi-
cally ordering that her funeral be "without plumes or escutcheons on my hearse,
and in all respects as private as is consistent with decency."[2] She died on 23 Au-
gust 1743, as Hogarth was still working on the paintings of *Marriage à la Mode*.
She was 38 years of age. Whether or not she had a hand in Hogarth's excursion
into the subject of high life, she had encouraged him to return to his modern his-
tory mode. He had not engraved the painting she commissioned—perhaps be-
cause he felt it was too tailor-made a product; perhaps because it came closer to
caricature than any of his other works. Against his wishes, however, a print was
brought out in 1746, after Miss Edwards' death and the publication of *Marriage
à la Mode,* with the title "Taste in High Life" attached.[3]

On 10 June 1740, in the very middle of Hogarth's period of portrait painting,
Henry Fielding devoted an essay in his periodical *The Champion* to the subject
of satire, making two generalizations: the first (essentially that of Steele in his
Spectators on history painting) is that "the force of example is infinitely
stronger, as well as quicker, than precept; for which Horace assigns this reason,
that our eyes convey the idea more briskly to the understanding than our ears";
and second, "that we are much better and easier taught by the examples of what
we are to shun, than by those which would instruct us what to pursue." The
obvious example of these two generalizations is "the ingenious Mr. Hogarth,"
whom Fielding says he esteems

> as one of the most useful Satyrists any Age hath produced. In his excellent
> Works you see the delusive Scene exposed with all the Force of Humour,
> and, on casting your Eyes on another Picture, you behold the dreadful and
> fatal Consequence. I almost dare affirm that those two Works of his, which
> he calls the *Rake's* and the *Harlot's Progress,* are calculated more to serve
> the Cause of Virtue, and for the Preservation of Mankind, than all the
> *Folios* of Morality which have been ever written; and a sober Family should
> no more be without them, than without the *Whole Duty of Man* in their
> House.

The first sentences show that Fielding understood very well the operation of
Hogarth's progresses, and the description tends to fit his own practice in *Joseph
Andrews,* in which delusions are constantly being exposed, though dreadful
consequences are avoided.

Later in 1740, Samuel Richardson's *Pamela* appeared; in 1741 Fielding re-
sponded with his parody *Shamela,* and in 1742 at greater length with *Joseph
Andrews*. In his preface Fielding defines the "comic epic in prose" he projects

in terms of the extremes it avoids—of romance and burlesque, two different ways in which reality may be distorted, to glamorize and to vilify. He is, of course, reacting against *Pamela,* which he equates with the romances of *Jack the Giant Killer* and *Guy of Warwick;* but he is also steering clear of burlesques like his own early plays. By "burlesque," he means "the Exhibition of what is monstrous and unnatural": a Shamela, a Pistol in *The Author's Farce,* or a Queen Ignorance in *Pasquin.* Burlesque, he finds (perhaps recalling Somerville's attribution of burlesque to Hogarth), is the literary equivalent of caricature. In order to make his point clear, he uses Hogarth's works as an analogy. "Let us examine the Works of a Comic History-Painter," he begins, "with those Performances which the *Italians* call *Caricatura.* . . ." The one involves "the exactest copying of Nature; insomuch, that a judicious Eye instantly rejects any thing *outré;* any Liberty which the Painter hath taken with the Features of that *Alma Mater*" (he is probably remembering *Boys Peeping at Nature*). But the aim of caricature is "to exhibit Monsters, not Men, and all Distortions and Exaggerations whatever are within its proper Province."

> Now what *Caricatura* is in Painting, Burlesque is in Writing; and in the same manner the Comic Writer and Painter correlate to each other. And here I shall observe, that as in the former, the Painter seems to have the Advantage; so it is in the latter infinitely on the side of the Writer: for the *Monstrous* is much easier to paint than describe, and the *Ridiculous* to describe than paint. . . . He who should call the Ingenious *Hogarth* a Burlesque Painter [as Somerville had done], would, in my Opinion, do him very little Honour: for sure it is much easier, much less the Subject of Admiration, to paint a Man with a Nose, or any other Feature of a preposterous Size, or to expose him in some absurd or monstrous Attitude, than to express the Affections of Men on Canvas. It hath been thought a vast Commendation of a Painter, to say his Figures *seem to breathe;* but surely, it is a much greater and nobler Applause, *that they appear to think.*[4]

Hogarth had replaced the exaggeration of traditional history painting on one side and grotesque emblematic satire on the other with a more restrained delineation, closer to experience, and reliant on "character" rather than "caricature," on the variety rather than the exaggeration of expression. Fielding wished to do something similar in prose.

This is the only specific mention of Hogarth in the preface, but his presence hovers over the whole, and one senses that in other ways than "character" he offered Fielding the best model for what he intended in *Joseph Andrews.* Fielding's famous definition, "The only Source of the true Ridiculous (as it appears to me) is Affectation" (referring to that middle area between the behavior of paragon and devil which he says will be his subject), corresponds to the sub-

ject of Hogarth's progresses (the girl from the country affecting the airs of a lady, or the merchant's son of a gentleman). At one point, Fielding seems to allude to *The Distressed Poet:*

> were we to enter a poor House, and behold a wretched Family shivering with Cold and languishing with Hunger, it would not incline us to Laughter, (at least we must have very diabolical Natures, if it would:) but should we discover there a Grate, instead of Coals, adorned with Flowers, empty Plate or China Dishes on the Sideboard, or any other Affectation of Riches and Finery either on their Persons or in their Furniture; we might then indeed be excused, for ridiculing so fantastical an Appearance.

Both men are concerned with those ordinary people who act according to inappropriate ideas of themselves.

By calling Hogarth's productions "comic history painting," and his own "comic epic in prose," Fielding is trying, as Hogarth had done, to secure a place in the classical (and contemporary) hierarchy of genres higher than satire, the grotesque, or the comic would command. Hogarth never seems to have used the term "comic history painting" himself. Putting his thoughts on paper in the 1760s, he frequently called attention to the uniqueness of the form he had invented ("this uncommon way of Painting," "a Field unbroke up in any Country or any age"), which often echoed Fielding's similar claims for his form; referring to its combination of comic and moral qualities and its use of contemporaneity, he called his works instead "modern moral Subjects." His closest approach to Fielding's term was in references to his new genre as occupying an area between the accepted categories of sublime and grotesque. He commented sadly that painters and writers "never mention, in the historical way of any intermediate species of subjects for painting between the sublime and the grotesque," whereas he believes that the "subject[s] of most consequence are those that most entertain and Improve the mind and are of public utility," and that "true comedy" is a more economical and difficult genre, closer to reality, than highflown tragedy, which he tended to associate with sublime history painting.[5]

All the evidence points to the influence running from Hogarth to Fielding before 1742, and to Fielding's subsequent influence on Hogarth relating primarily to the verbalization of his theories. In 1726, before he even met Fielding, he had produced his polemical frontispiece to *Hudibras,* which sets forth his aesthetic intention in relation to history painting (very similar to Fielding's in relation to the epic), and in 1731 he issued a second print to explain his intention in the *Harlot's Progress.* Only with *Characters and Caricaturas* (pl. 181) in 1743 did he adopt Fielding's terminology and begin to add commentary ("for a farther Explanation . . . See yᵉ Preface to joʰ Andrews"), and by the time he engraved *The Bench* (1758) the commentary filled more space than the graphic design.

Fielding's immediate effect on Hogarth was perhaps to galvanize him into producing another series to prove the claims made in the preface to *Joseph Andrews,* and certainly to make the particular subscription ticket dealing with caricature; in the long run, Fielding's influence may indeed have made Hogarth more self-conscious and defensive, more verbal and polemical than he had been before.

In *Joseph Andrews* Fielding begins the complimentary allusions to Hogarth that continue through the remainder of his fiction (and were echoed by other novelists). Explaining the impossibility of describing Lady Booby's appearance after Joseph proclaims his love of virtue, he adds, "no, not from the inimitable Pencil of my Friend *Hogarth,* could you receive such an Idea of Surprize," and Mrs. Tow-wouse is so striking "that *Hogarth* himself never gave more Expression to a Picture."[6] Once he alludes to another aspect of Hogarth—the painter; though perhaps even here keeping in mind the relationship between Hogarth's comic, and other painters' sublime or bathetic, histories. In Book III, chapter 6, he has Joseph link Hogarth's name with homophones of Italian "masters": "Ammyconni" for Amigoni, whose success may have led Hogarth to turn to sublime history, carries overtones of "cony," and perhaps less presentable puns; "Paul Varnish" for Veronese, with the suggestion that his paintings were valued by Englishmen primarily because of their varnishing; and "Hannibal Scratchi" for Annibale Carracci, which speaks for itself. (Such corruptions were every day apparent in the auction lists in the papers which advertised works by Hannibal Carrots, and indeed Paul Varnish.) And in this dubious company Joseph puts the Italianate form of Hogarth's name, "Hogarthi." Although Fielding is having his little joke, joining Hogarth with his *bêtes noirs,* and giving them names that indicate Hogarth's reservations about the old masters, it is proper to see this as a compliment parallel to the praise of other English contemporaries in the same chapter—John Kyrle (the "Man of Ross") and Ralph Allen of Bath.

Fielding could be alluding to Hogarth's conversation pictures and portraits, which Joseph might have seen in Lady Booby's house.[7] Joseph, as a man about London, could also, however, have seen his histories at St. Bartholomew's—*The Pool of Bethesda* and above all the *Good Samaritan,* which may have suggested, and certainly supports, the paradigm for charity that informs the central part of *Joseph Andrews.* Even some of the modern moral subjects, like *The Christening* and *The Denunciation,* were in private collections, as well as un-engraved ones like Lord Boyne's *Night Encounter* and Miss Edwards' *Taste à la Mode.* Whatever the pictures referred to, W. B. Coley is correct in his conclusion that Fielding was complimenting Hogarth "by implying that he alone among English painters could breach the foreign monopoly in the arts."[8]

In the *Craftsman,* 1 January 1742/3, in a letter to Caleb D'Anvers, Fielding's contrast between caricature and character was distorted into one between carica-

ture and the beautiful: "The *Outré,* or Extravagant, requires but a very little Portion of Genius to hit. Any Dauber, almost may make a shift to portray a *Saracen's* Head; but a Master, only, can express the delicate, dimpled Softness of Infancy, the opening Bloom of Beauty, or the happy Negligence of Graceful Gentility." This misunderstanding may have been the specific goad that led Hogarth to produce in the next month or so the etching *Characters and Carica-turas* (pl. 181) as subscription ticket for his new series. As noted in reference to *A Harlot's Progress,* caricature was part of his art only in the sense that he portrays people caricaturing themselves; faces in his modern histories may appear at the moments when they become caricatures. He was probably aware that "caricature" was applied to the work of any artist who ventured very far beyond the Raphael formulae; the Earl of Chesterfield, not long after, wrote to his son: "I love la belle nature; Rembrandt paints caricaturas."[9] Hogarth's own explanation, written some years later, was that he had been plagued by misunderstandings of his purpose. "A Face <Foreign> Painter at whose house I was complemented me with saying he admird my charactures[;] looking around at his portraits I returned it by saying I admird his." So, he goes on,

> being plagued for ever with this mistake occationd among the more Illiter-ate by the similitude of the <Sound of> words [i.e. character and carica-ture] I explained it by the above print [*Characters and Caricaturas*] ten years ago, and as I was then publishing the marriage alamode wherein were char-acters of high life I added the great number of faces above <none of which are exaggerated beyond common portraits> varied at randome each of which had a likeness form'd to it to prevent if possible personal applications when the prints should come out which however did not prevent it. . . .[10]

Caricature to him means exaggeration "beyond common portraits" and so a kind of particularity that allows for "personal applications" when he prefers general. He quotes from Dryden's prologue to Etherege's *Man of Mode:* "we neither this nor that Sr Fopling call / he is knight oth shire and represents you all."

Hogarth's unease was increased by Arthur Pond's publication, since 1736, of caricature portraits in the Italian manner after Ghezzi; these had become very popular, drawing attention to the concept of caricature, one from which Hogarth was anxious to detach himself. The term and practice were Italian, from *caricare* (to charge or overcharge, i.e. with distinctive features; in French *char-ger*). Begun in the late sixteenth century by the Carracci brothers, caricature was implemented by the theoretical discussions of Agucchi (1646), Bellori (1671), and Baldinucci (1681), who defined it as the bringing to light of the victim's *faults.* It was one kind of portrait, and they argue that in spite of its exaggeration, the likeness may be truer to the person than is his actual appearance. The theory is, of course, related to the platonism of seventeenth-century

Italian humanism, and implies that the artist should not merely imitate nature but penetrate to the innermost essence of reality, the "platonic idea." If the idealism of history painting or heroic portraiture is one extreme that Hogarth tried to avoid, caricature is its equally pernicious opposite.[11] With Pond's publications, and the sanction of the art treatises, caricature appeared to Hogarth as a fashionable art form brought over from the Continent, practiced by amateurs and purchased by connoisseurs, which relied on distortion or reduction of the infinitely variable human face.

In *Characters and Caricaturas,* he portrays idealized heads of St. John and St. Paul and puts between them what would ordinarily have been considered a grotesque head of a beggar: all three are from the Raphael Cartoons, his constant referent for defending his histories—the undeniable example of great history painting. With these, he contrasts caricatures by Ghezzi, the Carracci, and Leonardo. Above them rises a cloud of faces that express the variety of character —like Raphael's beggar rather than the caricatures *or* the idealized faces. His point is to demonstrate that comic history painting, while not filled with "the opening Bloom of Beauty, or the happy Negligence of Graceful Gentility," is in fact part of the great genre of history painting, and not descended from caricature.

A glance at the print would have shown a contemporary connoisseur that Hogarth was departing from the classic treatise on expression, Le Brun's *Traité sur les Passions* (1698, tr. 1701), which reproduced innumerable heads (engraved by Picart), each classified as to expression illustrative of a certain passion. The faces were in the Raphael-Poussin tradition—types, rational and generalized. These would correspond to the idealized St. John and St. Paul; but Hogarth's faces are particularized and given a large range of everyday expressions instead of standardized passions. The facial structure and the muscles play a much larger part than in Le Brun; and this points to Hogarth's source, his friend Dr. Parsons, the assistant secretary of the Royal Society, whose *Human Physiognomy Explained* I have already mentioned. Parsons showed that the changes of expression following from passions were caused by the movements of muscles, and he illustrated this with a series of drawings of the same face with different passions (made by himself, engraved by S. Mynde).[12]

Hogarth goes much further than Parsons in the variety of his expressions, suggesting by the cloud of faces the infinite possibilities. If variety is one distinctive feature of his comic history as described in this print, the other is the fact that caricature and the ideal both function in it as well. The effect is the same in a much earlier print, *A Chorus of Singers* (pl. 111), the subscription ticket for *A Midnight Modern Conversation* (1733), where the contrast is between the singers and the grandiloquent words of their song, "The World shall bow to the Assyrian Throne." It is thus in the words of the song, and perhaps the pose of the conductor, that the extremes of heroic and grotesque enter into Hogarth's

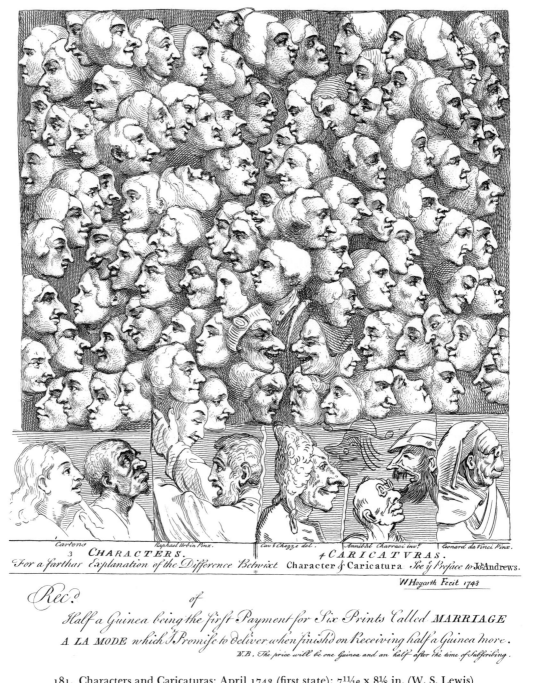

181. Characters and Caricaturas; April 1743 (first state); 7¹¹⁄₁₆ x 8⅛ in. (W. S. Lewis)

comic history. Even in *Characters and Caricaturas* the various heads only derive meaning from the contrast with idealized and caricatured heads beneath. Hogarth always includes the heroic shape *and* the grotesque in order to help define the middle area of "character." In short, while Fielding defines an intermediate genre between romance and burlesque—the comic—and between extremes of goodness and evil—the ridiculous—Hogarth defines his intermediate genre between sublime history painting and burlesque, the idealized and the caricatured, called "character."

These are the distinctive features of both Hogarth's and Fielding's work. The ideals of good and evil are presented as the externalization of mental states: in Hogarth's early progresses they appear in the portraits on the walls which offer standardized, usually inappropriate alternatives of action, and which the characters allow to dominate them. In *Joseph Andrews* they appear in the "examples" of the Cibbers and Pamelas on the one hand, and the biblical Joseph and Abraham on the other; all, however different qualitatively, amount to external patterns the characters allow to dominate and distort them. Joseph and Parson Adams act and are defined in relation to the stereotypes of both extremes.[13] All of the characters in the novel are defined in terms of these conflicting qualities, the natural inclination vs. the fashionable or prescribed code—whether Lady Booby's dedication to poses of heroic love, Joseph's to ideals of chastity learned from his sister Pamela, or Parsons Adams' to the authority of the Church Fathers. Throughout, Nature continues to assert her rights: it is "that violent Repugnancy of Nature" with which the hypocrite must "struggle," and even Joseph adds after Lady Booby's last assault, "But I am glad she turned me out of the Chamber as she did: for I had almost forgotten every word Parson *Adams* had ever said to me." As Fielding put it in *Tom Jones,* "if we shut nature out at the door, she will come in at the window."[14]

This is essentially the theme which makes *Marriage à la Mode* part of a cluster including *Strolling Actresses, Taste à la Mode,* and the works of Fielding that appeared in the interim. In this new series, the forces of society and fashion are played against the natural impulses of the individual: the fathers, chaining together their two children as two nearby dogs are chained, are symbolic of the social straightjackets and fashionable assumptions that force the children to disown their natural selves. The artificial vs. the natural becomes Hogarth's main theme, and he takes the side of the natural against fashion in all its forms, which comes to include art in general.

"Elegancy" and high life were evidently intended by Hogarth as the keynotes of the new series. The subscription was announced in April, and by the first of May he was on his way to Paris—"to cultivate or improve his Stock of Ass[urance]," according to Vertue.[15] It is strange that nothing is known about this trip, Hogarth's first visit to Paris and direct contact with continental art, save for its

possible influence on his works: in the LeSueur version (based on Titian) of *The Martyrdom of St. Lawrence,* and perhaps the other pictures shown in the first plate of *Marriage à la Mode,* and in the style of the portrait of Archbishop Herring, which seems to have been revised in the light of his French experience. It seems likely that he had not finished, or more than begun, the paintings of *Marriage à la Mode* before he left for France; from the evidence of the finished paintings, he picked up a new lightness and fluency of touch, in the French manner.

His primary purpose for visiting France, however, was to secure French engravers for his project. It was not long before Vertue was noting that "Mr Hogarth I am told has got over a young Engraver from Paris to assist him in his plates or to work for him—this according to custom was told to me—not to comfort me—so much as to shew (their malicious) envy."[16] Vertue's words strongly imply that he has felt all along that if Hogarth is using other engravers on his works they should include him; but he completely misses Hogarth's point. Whenever he had used engravers before—and one can only guess at the extent— he minimized (and perhaps even concealed) their share in the work. With *Marriage à la Mode,* with its Frenchified title and fashionable scenes, he advertised the fact and attached the engravers' French names to each print.

As usual, he had trouble with his engravers. Vertue remarked on the large amount of money he was forced to pay them, but in this case Hogarth apparently thought it was worth paying. According to George Steevens, he struck "a hard bargain" with Simon François Ravenet, who had come to England to work for him and had no other business there yet, and "the price proved far inadequate to the labour" of the two plates he engraved. "He remonstrated, but could obtain no augmentation." Years later when he had a large English clientele, he was asked by Hogarth to engrave *Sigismunda* and indignantly turned him down— though another report says he was under contract to Boydell at the time, and this was his excuse. It is true that Ravenet did no more engraving directly for Hogarth (he engraved various of Hogarth's designs for third parties).[17]

The *General Advertiser* of 24 April 1744 announced that the plates "are now Engraving" and "will be finish'd with all convenient Speed." Subscriptions would continue to be taken until the first of May, and the subscription did close on that day, the maximum number having been accepted, a year before the plates were finally completed.

It was at this time, as *Marriage à la Mode* was being prepared for publication, that war broke out with France; early in 1744 an invasion was feared. Hogarth had apparently intended, and arranged, to send his paintings to Paris to be engraved—evidently he had only finally finished them to his satisfaction around the time the war began. The long advertisement he printed in the *Daily Advertiser* for 8 November 1744 tells the rest. It begins with a stop-gap, an announcement of the republication of the *Harlot's Progress*—the public's first opportunity

to obtain the original work since its publication twelve years before; also perhaps a preparation for the eventual auction of the paintings. It goes on to explain the delay in the appearance of his new series.

> Note, the six Prints, call'd *Marriage A-la-Mode,* are in great Forwardness, and will be ready (unless some unforeseen Accident should intervene) before Lady-Day next; Notice of which will be given in the Papers.
>
> In the Month of June 1743, the following French Masters, Mess. Baron, Ravenet, Scotin, Le Bas, Dupre, and Suberan, had entered in an Agreement with the Author, (who took a Journey to Paris for that sole Purpose) to engrave the above Work in their best Manner, each of them being to take one Plate for the Sake of Expedition; but the War with France breaking out soon after, it was judged neither safe nor proper on any Account, to trust the original Paintings out of England, much less to be engrav'd at Paris: And the three latter Gentlemen not being able, on Account of their Families, to come over hither, the Author was necessitated to agree with the three former to finish the Work here, each undertaking two Plates.
>
> The Author thinks it needless to make any other Apology for the Engravings being done in England, than this true State of the Case, none being so weak as to imagine these very Masters, (who stood in the first Rank of their Profession when at Paris) will perform worse here in London; but more probably on the contrary, as the Work will be carried on immediately under the Author's own Inspection.
>
> And he begs Leave to assure the Publick, that this Work will not in the least be retarded by the Publication of the *Harlot's Progress,* those Plates being ready for printing off immediately, and not at all the worse for the Number formerly published: Neither has there been, or will there be any Time lost with regard to the present Work, the Gentlemen having agreed to engage in no other Business till this shall be finished.

At this time, then, Hogarth himself was adding the cross at the bottom of the *Harlot* plates and making a few revisions to distinguish the second from the first edition.

His advertisement, of a record length, did not go unnoticed. Orator Henley, always anxious to be topical and ridicule the ridiculous, published an advertisement for an oration on the subject, and Vertue noted both in his notebook:

> an Extraordinary Advertisement in the news paper. Nov. 1744. from M^r Hogarth about
>
> 6 Engravers at Paris he had Engaged to work for him. to graven his plates of Marriage a la Mode——
>
> the Warrs prevented their comeing to London—3 only here—came
> the Orator Henley—seeing this Puff. proposd at his assembly a Moral

Consideration of the little Game Cock of Covent Garden—against. 4 Shake-baggs—meaning four print sellers of London—2. M^r Bowles. & 2 M^r Overtons. who had sold & publisht. coppys always of Hogarths plates—now he defyes them—haveing an Act of Parliament on his side.—[18]

This oration (delivered in Henley's chapel at the corner of Lincoln's Inn Fields, near Clare Market, at 6 in the evening) was announced in Henley's advertisement in the *Daily Advertiser,* 10 November, and repeated 17 November. And among the news items in the issue of the seventeenth appeared: "We hear that Tomorrow Evening, at the Oratory in Clare-Market, some moral Observations will be made on the little Game-Cock of Covent-Garden, crowing in the Parish of St. Martin in the Fields against four Shake-Bags." Henley's lecture announcements, if they could all be deciphered, would offer a history of the up-to-the-minute news and scandals (and pseudo-scandals) of the time.

Finally, in the issue for 22 November, a further advertisement was published, addressed to Henley:

> *To the Aldgate* GAME-COCK *in* Tom o'Lincoln's *Pens.*
> We should be very glad to strengthen our Side of the Aldgate Match, by lending you our invincible little Favourite; but though the Shake-Bags of St. Martin's are *told out,* yet there is a Wright Stag or two that must be *pounded* before he is disengaged; besides, we have promised the next time we put on his Weapons, he shall fight a Battle Royal in St. Margaret's Pit, against the old Pastry-Cook's Custard-fed Smock-Cocks. From
> *The Covent-Garden True-Cocks.*
> Note, I suppose you know our Colour's Coal-Black.

The terms are from cock-fighting: the "Wright Stag" (i.e., male artificer) is only an allusion to those French engravers in Hogarth's advertisement; the last part is a way of saying that the authors wish Hogarth would turn his attention to the political cockpit.

In short, Hogarth seemed to be giving this ambitious series a great deal of fanfare. Joshua Reynolds, who was in London at this time, recalled that Hogarth had told him, "I shall very soon be able to gratify the world with such a sight as they have never seen equalled!"[19] He evidently wished to think of himself as a painter—the "comic history painter" of Fielding's designation—rather than as an engraver; and this explains his emphasis on the "French Masters" who were going to engrave his paintings, as well as the careful painting of the pictures, and the announcement that accompanied the last stages of the subscription that his paintings of this sort would soon be auctioned.

The paintings were made once again in reverse—which might mean that he had originally planned to engrave them himself; ordinarily a professional copy-engraver produced a direct image of the original, and must have been instructed

in this case to reverse the series. The difference is clear enough: Plate 1 has to direct the viewer's eye from the earl to the merchant to the children; it makes no sense read in the other direction. Plate 2 goes from husband to wife, deeper into the picture to absorb the great empty room in the background (emptiness, like the mantlepiece clutter, emblematic of the marriage), and stops with the back of the steward: his despairing shrug is a consequence of all this, while in the painting he serves merely as an introduction to the scene, in the genre manner.

The paintings themselves (pls. 182–87) can be explained as both an attempt to make a saleable object, a finished picture, brilliant and elegant, which the connoisseur would want to buy; and a precise cartoon for the foreign engravers to work from. Hogarth must have worried over them too long, trying to make them a clear masterwork that would fulfill Fielding's claims for him once and for all. Behind them too may have been the feeling that he must meet the criticism that his paintings for the progresses were merely sketches or modelli. This is the first series that is so carefully and uniformly finished, the last of the *Beggar's Opera* paintings being the closest precedent. It is even possible that as the years passed, and his various attempts to sell the paintings failed, he continued to touch them up.

Here and there the color may add a comment of its own—as in "the pale countenance of the husband" in Plate 2, contrasted (as Hazlitt noted) with "the yellow whitish colour of the marble chimney-piece behind him."[20] But in general the effect is merely colorful and decorative, and can be justified along with the stylish forms and gestures as indicative of the glossy aristocratic world that is being contrasted with the brutal reality of human passions. To my mind, at least, this particular use of form to illuminate content is more effectively and economically accomplished in the prints, where it is evident at a glance that the figures and their style of living are underlined by the elegant French engraving. The color and texture of the paintings are employed to some extent at least for their own sake, or for the sake of Hogarth's virtuoso performance, and they distract the viewer when (according to the moralist) he should be concerned with other matters, more clearly brought out in the print. It is as if Hogarth were trying to prove that these were indeed "comic history paintings," because Painting is given a capital P.

The title may have come from Dryden's old comedy, *Marriage à la Mode* (1672); its reprinting by Tonson in 1735 may have brought it to Hogarth's attention if he did not already know it.[21] The comic subplot concerns a husband and wife whose "marriage à la mode" means that each supports the sentiment

> Why should a foolish marriage vow
> Which long ago was made,
> Oblige us to each other now,
> When passion is decayed?

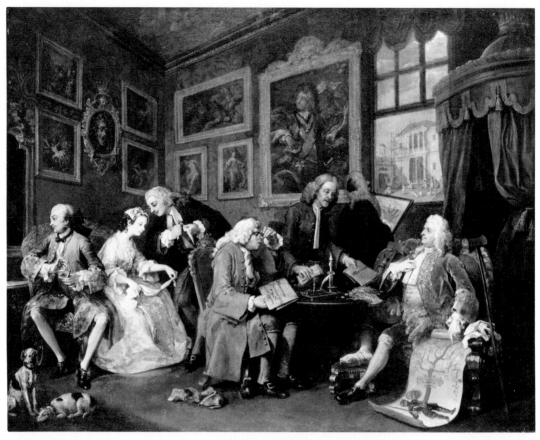

182. Marriage à la Mode (1); 1745; 27 x 35 in. each. (National Gallery of England, London)

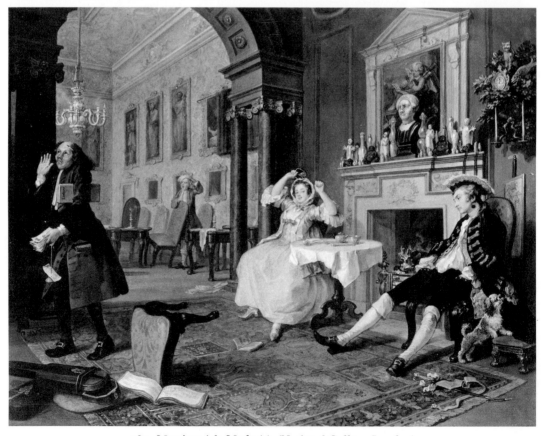

183. Marriage à la Mode (2). (National Gallery, London)

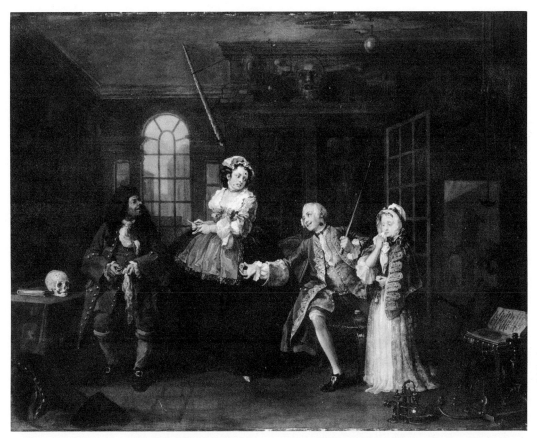

184. Marriage à la Mode (3). (National Gallery, London)

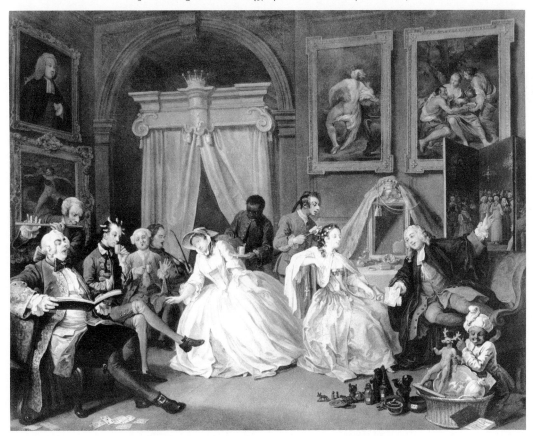

185. Marriage à la Mode (4). (National Gallery, London)

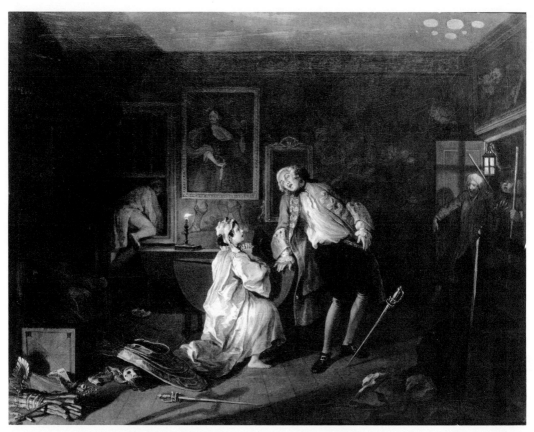

186. Marriage à la Mode (5). (National Gallery, London)

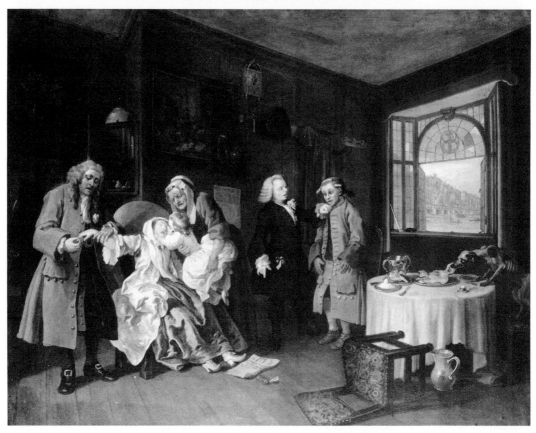

187. Marriage à la Mode (6). (National Gallery, London)

and takes a lover as remedy. Hogarth may also be indebted to another play, Garrick's *Lethe* (1740), in which Lord Chalkstone comments on marriages of convenience: "I married for a Fortune; she for a Title. When we both had got what we wanted, the sooner we parted the better—"[22] Hogarth simply showed what would happen if they could not part, if they were compelled by social forms to remain together. (Garrick later built his *Clandestine Marriage* on this proposition, acknowledging *Marriage à la Mode* as his source.) The subject, however, was conventional: the *Spectator* argues long and loudly that marriage can only be based on love (e.g., No. 268), that disaster follows upon marriages arranged by parents (Nos. 220, 533), and that marriages between a man of money without class and a lady of quality without money will end in unhappiness (No. 299). (And of course there were Steele's *Spectator* essays attacking dueling, which also figures prominently in Hogarth's series.) It was in early May 1744, just as Hogarth's subscription closed, that Henry Fox eloped with Lady Caroline Lennox, the daughter of the Duke of Richmond whom Hogarth had painted as a child in *The Indian Emperor*, posing a contrary example to that of the young couple in *Marriage à la Mode*. Fox, who later fought the Marriage Act (1753) that attempted to prevent such escapes from family control over marriages, may already have seen Hogarth's paintings for the series; at a later time he collected Hogarth's prints. The subject and the motifs, in short, were both commonplaces and at the same time in the air. Pamela, writing in her journal about marriage, its "misunderstandings, quarrels, appeals, ineffectual reconciliations, separations, elopements; or, at best, indifference; perhaps, aversion," adds: "Memorandum; *A good image of unhappy wedlock, in the words* YAWNING HUSBAND, *and* VAPOURISH WIFE, *when together: But separate, both quite alive.*"[23] In Plate 2 Hogarth has reversed the husband and wife—she is yawning—but otherwise the description is wonderfully apt and may have been in his mind. At the same time that he was painting his series Richardson was writing *Clarissa* and attacking the "property marriage," the economic pressures on young women, the "system" in which matrimony was a matter of money rather than affection, with overtones of chaining, martyrdom, and the perverting of nature.

Hogarth conveyed these concrete images through the parallels between his characters and chained dogs and martyred saints in the pictures on their fathers' walls. He went even further, suggesting in Plates 3 and 5 a parallel between contracted marriages and prostitution. He has indeed borrowed and injected a part of the traditional Harlot's story from the popular Italian print cycles that he did not use in the *Harlot's Progress*: the rivalry of lovers for the harlot's favors, which leads to a fatal duel. The pictures on the walls of the Countess' boudoir may have been suggested by those in the parlor of the whore, Sarah Millwood, George Barnwell's seducer, described in *The History of George Barnwell* as

suitable to the grade of the owner, for on one hand he espied Venus and Mars naked, embracing each other in Vulcan's Net, which he laid to catch them when they were at the height of their stolen pleasures; on the other hand a Satyr ravishing a Nymph; and again Jupiter transformed into a Bull, running away with Europa to deflower her, and other such-like fancies, to incite and stir up amorous delights.[24]

The bawd of the *Harlot's Progress* has now become the parent. But in the earlier series the Harlot was faced with the alternatives of the parson and Mother Needham, and this involved choosing a way of life. In *Marriage à la Mode* the way of life is already fixed, the boy and girl have no choice as to the marriage. Only after they are part of the adult world do choices arise—between husband and lover; and as Plate 5 shows, these are not choices but attempts to have both, which amount in terms of consequences to having neither. There is still, one might argue, a kind of choice made by the protagonists. In Plate 1 the girl, placed between the count and the lawyer, chooses the lawyer; and the count, standing between the girl and his own image in the mirror, chooses the latter; but the essential choices were made and fixed by their parents when this particular bride and groom were joined together. Unlike the earlier series, this one makes a more despairing comment on society—and specifically high society—than on the individual. Before, the individual was condemned for having made the wrong or inappropriate choice, for having been seduced by society into imitating fashion; as society was also condemned for having seduced and then exploited her. In *Marriage à la Mode,* one feels that the two protagonists were destined from the start to become what they are, formed by their parents and their respective societies.

It is the merchant who aspires, not the daughter, who has already been taught the way of the world by her father. And the series is about both the married couple and the fathers, who hang like malign presences over the plates in which they do not appear: the earl as we learn of his death, which prevents his deriving much benefit from the marriage he has arranged, and as we see his line dying out in the last plate in the syphilis-tainted girl child; the merchant as we see him in the last plate pulling off his dying daughter's wedding ring before rigor mortis deprives him of this meager salvage from a disastrous match.

To begin with, Hogarth shows a merchant selling his daughter to a lord, and all the rest may be seen as the aftermath of that one aspiration. But if this were the plot, the story would have been the girl's entirely. In fact, the progresses of the husband and wife are balanced almost as schematically as those of the apprentices in *Industry and Idleness*. In each scene they act according to type, she plebeian, he aristocratic. In Plate 2, her vulgar stretch is contrasted with his negligent slouch and his not bothering to remove his hat or conceal his mistress' laced bonnet hanging from his pocket ("in undisguised disregard for the pres-

ence of his plebeian partner," as Dobson says).[25] In 3 and 4, his vice is slumming, resorting to the lower classes for satisfaction, while hers is aspiring, collecting art objects, singers, and a lawyer for lover. In 5 too, where they both appear for the last time, she wrings her hands in as vulgar a gesture as her stretching in Plate 2, whereas he again slouches negligently as he dies an aristocrat's death.

Each child is conditioned by its father, and the father is shown conditioned by a single illusion of high society: for the earl it means keeping up with the fashion, building Palladian houses and buying old masters and having himself painted as Jupiter *furens;* for the merchant it means selling his daughter for a title. The fathers make the choices, and remain a heavy shadow over the children, but the children are the subject of the series. The emphasis has shifted from the individual and his responsibility for his acts, which makes the Harlot's and Rake's progresses so disturbing, to the fathers and to high society in general. Viewed unsympathetically, Hogarth might appear to be taking revenge once and for all, without surrogates, on the "High Life" (as he called it in his advertisement) that defines itself by its fashionable foreign portraits, its old masters, its family trees, its "connoisseurship," and its fashionable diversions. In this sense, the advertisement with its talk of "Decency and Elegancy" was profoundly ironic. But it was also typical of Hogarth that he should be clearly aiming—with his advertisements, his engravings, and his paintings themselves—at an audience approaching the aristocratic; yet the content of his series was decidedly anti-aristocratic, above and beyond the focus on contracted marriages. He was seeking the support of high society, but at the same time revealing what he thought of it.

The advance over the earlier series is in the direction of complexity. This is the first progress in which Hogarth employs two protagonists, anticipating the even greater bifurcation in *Industry and Idleness,* where the two protagonists take different courses of action. Here they still follow the same course, and causality remains all-important, the difference from the earlier series being the protagonists' relative lack of freedom of choice. The structure of the scenes is again a triangular arrangement of people: in 1, the earl, the merchant, and the usurer make one group, and Silvertongue, the groom, and the bride another. The first pivots on the usurer, the second on the bride, suggesting a parallel in the relationships. In the last plate the bride has become the dying countess flanked by her baby and the merchant her father, who is removing from her finger the wedding ring she was playing with in Plate 1.

In Plate 2 the young married couple sit with the yawning fireplace between them—its empty mouth topped with meaningless bric-a-brac, suggesting the emptiness of their marriage and the absent third party (implied by the cap hanging from the count's pocket, sniffed at by an inquisitive dog). In Plate 3 the triangle is realized in the feeble-looking child who is the count's mistress, the

count, and the bawd and quack who cater to his sexual wants. This is paralleled in Plate 4 by the countess' lover, lawyer Silvertongue, the countess herself, and the denizens of her world, hairdressers, fashionable ladies, eunuch singers, and the like. Then in Plate 5, where the count and countess are reunited, the countess is placed as in Plate 1, on one side of her the dying count and on the other the fleeing lawyer, his murderer.

This fifth plate will serve as an epitome of the complexity Hogarth's method has reached in *Marriage à la Mode* (pls. 186, 188). It is especially useful because it is also, in execution, the clumsiest of the six. The curiously awkward pose of the dying count calls for explanation: it can only be an echo, and a conscious one, of a *Descent from the Cross*. As if to bring the point home, Hogarth has outlined a cross on the door—a shadow thrown by the constable's lantern, which is much too close to the door to cast such a shadow without recourse to poetic license. Hogarth must have taken the count's pose straight from a painting, probably Flemish, seen in France on his 1743 tour, not even adjusting for the absence of the man supporting Christ's body under the arms.[26] In paintings and blockprints of the *Crucifixion* and *Descent from the Cross,* the female figure who, like the countess, "stood near" Christ wringing her hands, or spreading her arms wide, or kissing his feet, was Mary Magdalen; while Mary the Mother was some distance away silently watching or being supported by an apostle.

It is appropriate, of course, that in this context Hogarth produces a Magdalen —a prostitute—mourning Christ, who died for her sins. The traditional story of the Magdalen was actually rather close to that of the countess: she was born of a good family, but after her marriage her husband deserted her and she turned to a life of sin and was possessed by seven devils.[27] But Hogarth probably remembered too, as a student of English portraiture, how Charles II's mistress, the Duchess of Cleveland, had been painted in the pose of an erotically-stimulating but dubiously repentant Magdalen in a wilderness—etched and transmitted to the general public by Faithorne—as well as in the pose of St. Catherine, St. Barbara, Minerva, and others. Horace Walpole tells how one of these representations, this time with the Duchess as a Madonna holding one of her royal bastards, was sent by her to another of her children who was in a French convent, and was hung over the altar until its true subject was discovered.[28] With the countess, the Magdalen pose follows from her pictures of Io and Lot's daughters on the walls of her boudoir.

The tapestry on the wall of the bagnio shows *The Judgment of Solomon* (I Kings 4): appropriately, the story of two harlots who claimed the same baby. Solomon's judgment, of course, was to cut the baby in two and give each "mother" half, at which the true mother proved herself by giving way to the other. Prostitutes would be interested in stories of other prostitutes, especially sanctified by a biblical subject and the treatment of the old masters. But to continue to ponder the tapestry is to move from the court and the judgment to

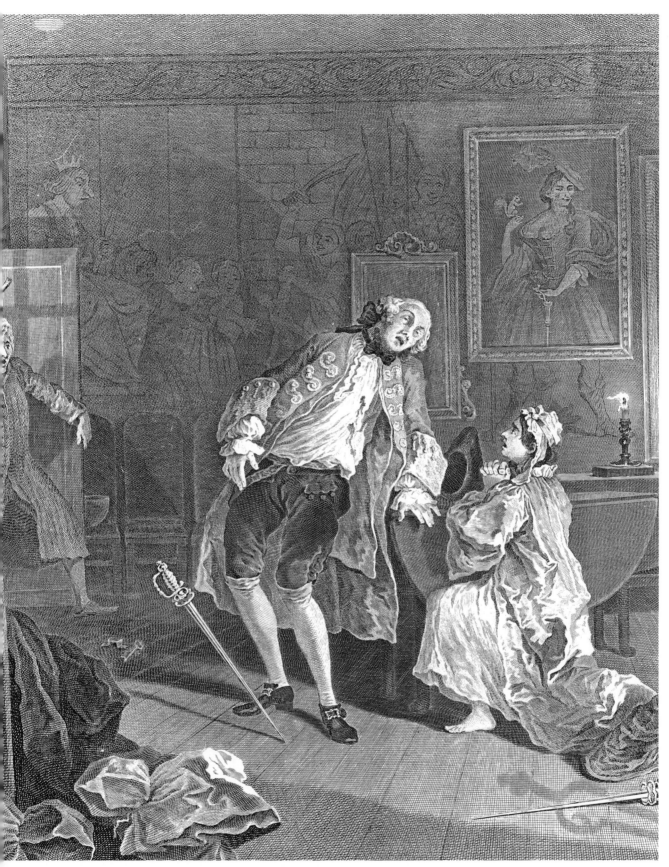

188. Detail, Marriage à la Mode, Pl. 5; engraving (Davison Art Center)

Silvertongue, a counselor by profession, who has in a sense given the countess Solomon's judgment; but she, unlike the true mother, has allowed the division to take place. By a curious redistribution, the tapestry has become an analogue to the scene, with Solomon equivalent to Silvertongue, the prostitute to the countess, and the sacrificial babe to the count. As the tapestry of Solomon and the "mothers" emphasizes the element of choice that has now, however much the characters may have originally been compelled, moved to the fore, the Deposition poses of the dying count-Christ (with his wound in his side) and the countess-Magdalen emphasize the element of sacrifice. The fragmentation of roles that is implied by these parallels is underlined by the portrait on the wall of a harlot in the pose and costume of a shepherdess, with all the associations of pastoral purity; showing beneath the frame of the picture are the hefty legs of a soldier.

Here we see at its most elaborate a characteristic which doubtless contributed to the popularity of Hogarth's prints. This is a sense of "to read" all Hogarth's own, which has much in common with the writers of his time, the Augustan poets, and their use of allusion. At one extreme Hogarth uses certain topical and historical prototypes, at the other he alludes to pictorial images from the tradition of popular or classical European art, and invites the reader to participate actively in the experience of the picture. That contemporaries were aware of Hogarth's borrowing of motifs from the continental tradition may be deduced from Paul Sandby's *Burlesque sur le Burlesque* (1753, pl. 236), in which Hogarth is shown painting at his easel, to which are attached "Old-prints from whence he steals Figures for his Design."[29] But Hogarth's effect goes much further, with the details constituting allusions that invite further interpretation to a point where only the individual reader can decide where to stop. A simple literary example: when at the end of the Voyage to Houyhnhnmland Gulliver quotes Vergil to prove his veracity as an author, he picks a speech the reader recognizes as one spoken by Sinon, the prototypical liar; but the reader who lets his mind pursue the allusion will also remember that the result of Sinon's lie was the introduction of a *horse* into Troy, the fall of a civilization, and so on.[30] Hogarth will himself try to define this effect in his *Analysis of Beauty,* and it remains a striking aspect of his engraved work, reaching its point of greatest complexity in *Marriage à la Mode.*

Plate 5 is also typical of *Marriage à la Mode* in that the rooms have become even more important than in the earlier series.[31] Each one defines and comments on its owner, in fact dominates him, reflecting his entrapment in the rut that leads to disaster. The first shows the earl's quarters with the old masters he collects, pictures of cruelty and compulsion from which his present act of compulsion naturally follows, his portrait of himself as Jupiter *furens,* and his coronet stamped on everything he owns. Plate 2 shows the next generation's house, with its fashionable Kent decorations, its saints and curtained pornography, its dis-

order and emptiness. Then follows the empiric's room, with his mummies and nostrums; the countess' boudoir with her pictures of the *Loves of the Gods* and the bric-a-brac she bought at an auction, including Romano's erotic drawings and a statue of Actaeon in horns; the bagnio with its attempts at gentility in the tapestry and paintings; and the merchant's house with its vulgar Dutch genre pictures, meager cuisine, and worn furnishings. Here art has become an integral part of Hogarth's subject matter: it is here for itself, a comment on itself, and also on its owners and on the actions that go on before it. In no other series is the note so insistent: it permeates the *Harlot*, Plate 2, or the *Rake*, Plate 2, to a degree, but here it dominates every room, every plate. The old masters have come to represent the evil that is the subject of the series: not aspiration, but the constriction of old, dead customs and ideals embodied in bad art. Both biblical and classical, this art holds up seduction, rape, compulsion, torture, and murder as the ideal, and the fathers act accordingly and force these stereotypes on their children.

The trends toward art as theme and reader as active participant are further underlined by the importance placed on viewing. In Plate 1 the Medusa looks down in horror on the scene. In Plate 2 the steward turns away, and his disdainful face is repeated in the Roman bust on the mantle, even to the broken nose of the one and the pug nose of the other. One is turning away from the scene with pious horror, the other is regarding it. (The steward's gesture makes the erect saints on the wall of the dining room appear to be averting their gaze in the same way from the naked foot protruding from a curtain drawn over the picture.) In Plate 3 the skeleton whispers to a stuffed man that is its companion, in 4 Silvertongue himself looks helplessly down from his canvas on the way events are developing, in 5 St. Luke and the Shepherdess watch. (St. Luke is painting the scene; according to such authorities as Theodorus Lector's *Ecclesiastical History*, he was noted for having painted the Virgin, who descended from heaven to sit to him.) Only in Plate 6, when it is all over, are the pictures unconcerned— the Dutchman turns his back on the scene to relieve himself as the doctor walks away, having given up the case.

These trends began with the change, noticeable in the prints of the late 1730s, from the protagonist as chooser to the reader as chooser; more complex reactions are expected of him as he pursues and tries to understand the meaning, the visual puns and allusions, and as he is linked with observers like Medusa and St. Luke within the scenes. Very similar is the elaborately contrived and underlined author-reader relationship in Fielding's novels of this decade.

The relevance of Hogarth's carefully-painted modelli, as well as his employment of French engravers, is also connected with the subject of art. While the engraving indicates the equation of artistic, social and moral corruption in the art that hangs in the rooms of the protagonists, with the painting the artist's medium becomes in itself a contrasting ideal of order and beauty to his subject.

With Hogarth, of course, the problem is always whether art or nature should receive priority: in the print, where art as such is minimized or transformed into part of the evil portrayed, nature is the norm, constantly combatting and exposing the rigidities and stylizations of art in *Marriage à la Mode*. But in the painting, whatever may have been Hogarth's original intention, art is in clear control. The art conveyed by the color and texture of the paint—the free hand of the painter as opposed to the mechanical operation of the engraver—introduces the other concern, art as a transformer of the ugliest, most transient, and disorderly reality into something beautiful and permanent.

It is characteristic of Hogarth that his painting is always a step or so ahead of his print. In the late 1730s the painting produced a sense of balance and acceptance of both sides of a question that was to inform the prints, and in the 1740s the painting introduced problems of art as theme and an emphasis on the artist himself that became obsessive in some of the later prints.

At the first of the new year, 1745, the second impression of the *Harlot's Progress* was announced as published, and the *Marriage à la Mode* plates were "in great Forwardness, and will be ready to deliver to the Subscribers on or near Lady-Day next," i.e. 25 March. On 25 January Hogarth issued a set of proposals for an auction of his "comic history paintings" and distributed them among his friends and visitors to the Golden Head.[32] In the *London Evening Post* for 31 January–2 February he began to advertise the auction. It seems likely that Fielding's preface to *Joseph Andrews* with its talk of "comic history painting," which emphasized the painting rather than the print, contributed to, if it did not inspire, the idea of the sale of the paintings from which the engravings were made. Hitherto, most paintings of this sort that he sold had been unconnected with the engraved product. *The Christening* and *The Denunciation* had been engraved, but not by Hogarth, and possibly after the paintings were sold; special commissions like those in Boyne's and Miss Edwards' collections were not engraved. But now, not long after the completion of the *Marriage à la Mode* paintings, themselves the most elaborately, elegantly, and colorfully executed of his works, Hogarth announced that he would sell at auction the paintings which preceded his prints of the 1730s.

The first set of proposals, dated 25 January (BM), begins:

Mr. HOGARTH's / PROPOSALS / For Selling, to the Highest Bidder, the Six Pictures call'd / The HARLOTS PROGRESS: / The Eight Pictures call'd / The RAKES PROGRESS: / The Four Pictures representing / Morning, Noon, Evening, *and* Night: / AND / That of a Company of Stroling Actresses Dressing in a Barn. / *All of them his Original Paintings, from which no other Copies than the Prints have ever been taken; in the following manner; viz.*

A BOOK will be open'd on the First Day of February next, and will be closed on the last Day of the same Month, at his House the *Golden-Head* in *Leicester-Fields;* in which, over the Name of each Picture, will be entered the Name of the Bidder, the Sums bid, and the Time when those Sums were so bid; so that it may evidently be seen at one View how much is at any time bid for any particular Picture; and whoever shall appear, at the time of closing the Book, to be the highest Bidder, shall, on Payment of the Sum bid, immediately receive the Picture.

N.B. The Six Pictures call'd *Marriage A-la-mode,* will be sold in the same manner, but the Book for that Purpose cannot be closed till about a Week after the Plates now Engraving from them are finish'd, of which public Notice will be given.

CONDITIONS of SALE.

I. That every Bidder shall have an entire Leaf, number'd, in the Book [of Sale,] on the Top of which will be entred his Name and Place of Abode, the Sum bid by him, the Time when, and for which Picture.

II. That on the last Day of Sale, a Clock (striking the Quarters) shall be placed in the Room, and, when it hath struck a Quarter after Ten, the first Picture mention'd in the Sale-Book will be deem'd as sold; the second Picture when the Clock hath struck the next Quarter after Ten; and so on, successively, till the whole Nineteen Pictures are sold.

III. That none advance less than Gold at each Bidding.

IV. No Person to bid, on the last Day, except those whose Names were before entred in the Book.

Then follows the list of the paintings, and a postscript: "As Mr. Hogarth's Room is but small, he begs the Favour that no Persons, except those whose Names are entred in the Book, would come to view his Pictures on the last Day of Sale."

His advertisement was repeated intermittently until the issue of 19–21 February when he announced the publication of revised proposals and first mentioned his subscription ticket, *The Battle of the Pictures* (pl. 189).[33] There are a number of interesting changes. For one, he has now decided that he should offer the possibility of breaking up sets of pictures. After "For Selling, to the Highest Bidder," he adds: "Singly (each Picture being an entire Subject of itself) or in Sets. . . ." It was originally intended that the sale would begin at 10 o'clock: as the clock struck the hour, bidders were given one last chance to bid, and when the quarter hour struck the first picture listed in the sale-book would be deemed sold to the highest bidder. This was changed to 12 o'clock and to five-minute intervals in the new proposals. He also added a final condition of sale: "If any Dispute arise between the Bidders, such Picture shall be put up again." In the newspaper advertisement which includes the new proposals, he adds:

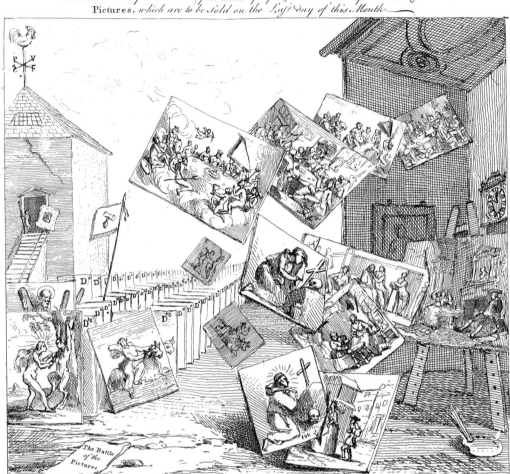

The Bearer hereof is Entitled (if he thinks proper) to be a Bidder for M[r]. Hogarth's Pictures, which are to be Sold on the Last Day of this Month.

189. The Battle of the Pictures; Feb. 1744/5; 7 x 7⅞ in. (W. S. Lewis)

"None will be admitted on the last Day of Sale, but those who are possess'd of engrav'd Tickets, which will only be deliver'd to such as before that Day shall have enter'd a Bidding in the Book, which is now open for that Purpose."

Having dealt in his ticket for *Marriage à la Mode* with the first point of Fielding's preface, the relationship between character and caricature, or comedy and burlesque, Hogarth turned in his next polemical etching—the ticket for the auction of his "comic history paintings"—to the second point, the term "comic history painter," which he seems to modify (judging by his images, for he uses no words) to modern history. For here he makes explicit the contrast he intended in the *Harlot* and the *Rake*, but which by this time he is unwilling to call a contrast, instead presenting it as an adaptation of Swift's *Battle of the Books*, with the "modernized" old masters being wantonly attacked by the old masters themselves: St. Francis at his meditations attacks the prude in *Morning*, Mary Mag-

dalen the Harlot, the *Aldobrandini Marriage Marriage à la Mode,* a *Feast of the Gods* the *Rake*'s "Rose-Tavern" scene (as he called it in his proposals), and a *Bacchanal* the *Midnight Modern Conversation.*

No balanced choice is offered the reader; the old history paintings are not eminent works (no Raphael here), but rather the aggressors trying to destroy his own modern histories. They are also, by implication, only repetitions of old themes and old pictures, copies of copies, and the chief advocate for their side is not an old master but Mr. Puff the picture dealer. If on the one hand Hogarth was explaining what modern history painting meant, he was also attacking the man he took to be the real culprit for the downgrading of modern art, and so drawing attention to the purpose of his auction: to circumvent the dealer as his independent subscriptions had circumvented the printsellers. By avoiding the dealer who set values on pictures and controlled public auctions, he thought he could encourage competitive prices and an open market.

The advertisement Vertue and Orator Henley had noted, the elaborate auction, and the subscription ticket—these public acts seem to have augmented certain private remarks like the one recorded by Reynolds, made at the St. Martin's Lane Academy and probably Slaughter's and elsewhere, and served not so much to support the idea of a new art form as to underline a kind of "gamecock" arrogance in Hogarth. At just this time Vertue wrote his first long and fairly passionate meditation on Hogarth as one whose success had gone to his head. This passage, written directly after the auction, on 1 March, is a remarkable one.

> as all things have their spring from nature. time and cultivation—so Arts have their bloom & Fruite &, as well in other places in this Kingdom. on this observation at present a true English Genius in the Art of Painting—has sprung and by natural strength of himself chiefly, begun with little & low-shrubb instructions, rose, to a surprizing hight in the publick esteem & opinion. as this remarkable circumstance is of Mr Hogarth whose first practice was as an aprentice to a mean sort of Engraver of coats of arms, wch he left & applying to painting & study drew and painted humorous conversations. in time with wonderful succes.—& small also portraits & family-peces &c. from thence to portrait painting at large, <& attempted History> thro' all which with strong and powerfull pursuits & studyes by the boldness of his Genious—in opposition to all other professors of Painting, got into great Reputation & esteem of the Lovers of Art, Nobles of the greatest consideration in the Nation. & by his undaunted spirit, dispisd under-valud all other present, & preceedent painters. such as Kneller—Lilly Vandyke—those English painters of the highest Reputation—such reasonings or envious detractions he not only often or at all times—made the subject of his conversations & Observations to Gentlemen and Lovers of Art But such like invidiuous

reflections he woud argue & maintain with all sorts of Artists painters sculptors &c—

But to carry a point higher. he proposd to sell his paintings 6. of the *Harlots progress* . . . those of the *Rakes progress* . . . and others of the Morning or 4 Times of the day . . . these alltogether, & the Strolling Actreses . . . <Danae. golden shower> by a new manner of sale, which was by Engravd printed tickets his own doing—& deliverd to Gentlemen Noblemen & Lovers of Arts—only—bidders, (no painters nor Artists to be admitted to his sale) and by his Letter and a day affixd to meet at his house. there the pictures were put up to sale, to bid Gold only by a Clock. set purposely by the minute hand—5 minutes each lott. so that by this means he coud raise them to the most value & no barr of Criticks Judgment nor—cost of Auctioneers. and by this suble means. he sold about 20 pictures of his own paintings for near 450 pounds in an hour <March 1. 1744–5>

admit the Temper of the people loves humourous spritely diverting subjects in painting. yet surely. *the Foxes tale*—was of great use to him. as Hudibrass expresseth

> yet He! that hath but Impudence,
> to all things, has a Fair pretence[34]

Vertue's stories probably go back to the arguments about portraiture, in and outside the academy; none of the names adduced would have entered Hogarth's conversation about his modern historical subjects. But *The Battle of the Pictures,* and the auction itself, implicitly extended his quarrel to the old masters as history painters. To contemporaries, the first plate of *Marriage à la Mode,* and perhaps its general tone, would have served the same purpose.

The auction took place at noon on the last day of February. One of those present was a young man named Horace Walpole, who had just returned to England from his Grand Tour in 1741. He went immediately into Parliament, and during the next few years he divided his time, until his father Sir Robert Walpole's death in March 1745, between Houghton Hall and a house in Arlington Street next to his father's. In August 1743 he had completed his first work of art history, *Aedes Walpolianae,* a catalogue of Sir Robert's art collection at Houghton, and in the introduction he discusses the merits of the various schools of painting, ending with the characteristic sentence: "In short, in my opinion, all the qualities of a perfect Painter, never met but in RAPHAEL, GUIDO, and ANNIBAL CARACCI." It was this young man, already set up for life by sinecures his father had secured him, who attended Hogarth's auction and purchased the small portrait of Sarah Malcolm for 5 guineas. He may already have begun collecting Hogarth's prints—he ended with the first of the great Hogarth print collections. He did not let Hogarth in any way interfere with his admiration for Guido and Annibale Carracci: he was only interested in Hogarth's modern

moral subjects, and the only paintings he collected were his small informal sketches like the *Malcolm*. He never asked Hogarth to paint his portrait, but in 1750 he commissioned him to go to the King's Bench Prison and paint King Theodore of Corsica, who was imprisoned there for debt. It is difficult to imagine them on any other than business terms, but Walpole claimed in later years to have been Hogarth's friend, and is said to have arranged a notable meeting at his house of Hogarth and Thomas Gray. The drawing room of his house at No. 5 Arlington Street is supposed to have been the model for the room in Plate 2 of *Marriage à la Mode*.[35] In one sense, Walpole is, like the young count, another of that series of sons of wicked, grasping, spectacular fathers, by whom they were completely overshadowed and provided for, who were Hogarth's friends and contacts with the classes above him. In another, he was an acute, narrow, critical intelligence who, coming into contact with Hogarth in the 1740s, may have reinforced his intention to devote himself to modern moral subjects instead of portraits or sublime histories, while at the same time offering him a challenge he could not refuse to prove again his competence at sublime history.

Horace Walpole provides the only glimpse of that auction; he tells of the "poor old cripple that I saw formerly at Hogarth's auction," who "bid for the *Rake's Progress,* saying, 'I *will* buy my own progress,' though he looked as if he had no more title to it than I have but by limping and sitting up." Walpole identifies this man in his MS. *Commonplace Book* as Mr. Wood, very possibly the same Wood who had commissioned portraits of his family, his daughter, and his dog Vulcan around 1730. William Beckford, another young man like Walpole with great parental funds and political ambitions, was the successful bidder for the *Rake's Progress*. Wood bought *Strolling Actresses* for 26 guineas after one Francis Beckford had decided against taking it.[36] (Francis may be a mistake for William, who already had fourteen paintings from this auction.) The purchases of both the *Harlot* and the *Rake* by Beckford for £273 (£88 4s for the one, £184 16s for the other) does not mean that Hogarth's paintings were being bought by merchants or men of the City.[37] Beckford was as yet neither. He had inherited large holdings in Jamaica sugar, but he was as much a gentleman-about-town (educated at Westminster, Oxford, and Leyden) as Horace Walpole. In two years he would take a seat in Parliament, for Shaftesbury, as a Tory supporter of the fourth Earl of Shaftesbury and the Prince of Wales. Only in the 1750s did he begin to connect himself to the City, and he did not break with the Tories until he attached himself to William Pitt late in that decade. Beckford seems to have shown no further interest in Hogarth: he appears in no subscription lists, and did not even notify the artist that the *Rake's Progress* had survived the Fonthill fire in 1755 that destroyed the *Harlot*. He probably bought them as Walpole did, as Dutch genre subjects.

Wood and the other buyers too were great landowners or, at the least, country gentry—the same people who bought pseudo-Correggios and Guidos and had

their portraits done by fashionable foreigners or their English equivalents (not by Hogarth). The Duke of Ancaster, who had connections with the Slaughter's circle, employing some of them to decorate his country seat, Grimsthorpe, bought the paintings of *Noon* and *Evening* and also the one sublime history on sale, *Danaë* (added after the proposals of 11 February).[38] Hogarth evidently also sold twenty-five heads from the Raphael Cartoons, either by Thornhill or by Hogarth and Thornhill; these too went to Beckford, but since the purchase does not appear on the receipt he made out to Hogarth, it may have involved a separate payment to Lady Thornhill.

Although Hogarth never sounded satisfied with the proceeds from this sale, it was a respectable amount, especially considering that the majority were sets and were not separated; and this sale probably represents the peak of his popularity as a painter of modern history. The *Harlot* and *Rake* brought him £273, *The Four Times of the Day* altogether £127 1s (*Morning* and *Night* went, for ten or so pounds less than their compeers, to the banker Sir William Heathcote), *Strolling Actresses* 26 guineas, *Danaë* 60 guineas, and *Sarah Malcolm* 5. The total proceeds were nearly £500. These were not contemptible prices if one considers what Sir Robert Walpole, one of the foremost collectors of his time, paid for old masters in the years preceding Hogarth's sale: in August 1735 he paid £320 for Poussin's *Holy Family,* the highest price paid up to that time for a Poussin; £315 for four small paintings by Murillo; £500 for a Salvator Rosa *Prodigal Son;* £700 for Guido's *Consultation of the Fathers;* £500 for his *Child in the Manger;* and £300 for Palma Vecchio's *Adoration.* Michael Dahl's collection of Italian, French, and Dutch paintings, sold at Cock's 9-10 February 1743/4, just a year before Hogarth's sale, brought in only £700, partly because at the moment the market was low. Hogarth would appear to have been paid well in relation to the old masters; but of course, he would not be satisfied until his prices equaled theirs, an utterly chimeric ambition in those days.

One "comic history" missing from the auction was *Southwark Fair,* which had been bought by Mary Edwards, presumably soon after it was completed. At her death, near the end of 1743, it was sold (it is not clear by what means) for a mere £19 8s 6d—as opposed to the 60 guineas she had paid Hogarth for *Taste à la Mode,* and the probably greater price for *Southwark Fair* itself.[39] This was an ominous sign of the price range Hogarth could expect from the sale of whole series of such paintings. Considering its size and scope, it should have brought more than any of the pictures in the auction, yet it brought less. At least one can see how comparatively successful Hogarth's method of selling was. If Mary Edwards had lived, the bids at the auction would probably have been higher.

The auction for the *Marriage à la Mode* paintings (one had even been included in *The Battle of the Pictures*) does not seem to have taken place. Could Hogarth, unhappy with the amounts he had received from the other pictures, have withdrawn this set? What happened is not known, but the set was not actu-

ally sold until another auction—described in grim detail by Vertue and others—
was held five years later.

Meanwhile, Lady's Day passed, and at the end of April Hogarth announced
that the prints of *Marriage à la Mode* would be ready for subscribers on the last
day of May; and at that time they presumably reached the subscribers.[40]

Abbreviations and Short Titles

Analysis	William Hogarth. *The Analysis of Beauty* (1753), ed. Joseph Burke. Oxford, 1955.
Antal	Frederick Antal. *Hogarth and his Place in European Art.* London, 1962.
Apology for Painters	Hogarth's '*Apology for Painters,*' ed. Michael Kitson. Walpole Society, vol. XLI. Oxford, 1968, 46–111.
Autobiographical Notes	William Hogarth. "Autobiographical Notes," in *The Analysis of Beauty,* ed. Joseph Burke. Oxford, 1955.
Beckett	R. B. Beckett. *Hogarth.* London, 1949.
Biogr. Anecd.	John Nichols, George Steevens, Isaac Reed, and others. *Biographical Anecdotes of William Hogarth.* London, 1781, 1782, 1785.
BM	British Museum
BM Sat.	*British Museum Catalogue of . . . Political and Personal Satires.* London, 1873–83.
Brown	G. Baldwin Brown. *William Hogarth.* London, 1905.
Croft-Murray	Edward Croft-Murray. *Decorative Painting in England, 1537–1837, I, Early Tudor to Sir James Thornhill.* London, 1962.
DNB	*Dictionary of National Biography,* ed. Leslie Stephen and Sidney Lee. 66 vols. London, 1885–1901.
Dobson	Austin Dobson. *William Hogarth.* London, 1907 ed.
Edwards, *Anecdotes of Painting, contd.*	Edward Edwards. *Anecdotes of Painters who have resided or been born in England . . . Intended as a Continuation to the Anecdotes of Painting of the Late Horace Earl of Orford.* London, 1868.
Farington *Diary*	Joseph Farington, R.A. *Diary,* ed. James Grieg. 8 vols. London, 1922–28.
Garrick Letters	*The Letters of David Garrick,* ed. D. M. Little and G. M. Kahrl. 3 vols. Cambridge, Mass., 1963.

Gen. Works	John Nichols and George Steevens. *The Genuine Works of William Hogarth*. 3 vols. London, 1808–17.
George	M. Dorothy George. *London Life in the Eighteenth Century*. London, 1925; 1965 ed.
GM	*The Gentleman's Magazine*.
HGW	Ronald Paulson. *Hogarth's Graphic Works: First Complete Edition*. 2 vols. New Haven, 1965; revised ed., 1970.
HMC	*Historical Manuscripts Commission*.
J. Ireland	John Ireland. *Hogarth Illustrated*. 3 vols. London, 1791–98; 1806 ed.
S. Ireland	Samuel Ireland. *Graphic Illustrations of Hogarth*. 2 vols. London, 1794–99.
LM	*The London Magazine*.
LS	*The London Stage 1660–1800, Part II: 1700–29*, ed. Emmett L. Avery. 2 vols. *Part III: 1729–47*, ed. Arthur H. Scouten. *Part IV: 1747–76*, ed. George Winchester Stone. 3 vols. Carbondale, Illinois, 1960–62.
Millar, *Early Georgian Pictures*	Oliver Millar. *The Tudor, Stuart, and Early Georgian Pictures in the Collection of Her Majesty the Queen*. London, 1963.
Mitchell	Charles Mitchell, ed., *Hogarth's Peregrination*. Oxford, 1952.
Moore	Robert E. Moore. *Hogarth's Literary Relationships*. Minneapolis, 1948.
J. B. Nichols	J. B. Nichols. *Anecdotes of William Hogarth*. London, 1833.
Nichols, *Literary Anecdotes*	John Nichols. *Literary Anecdotes of the Eighteenth Century*. 9 vols. London, 1812–15.
Oppé	A. P. Oppé. *The Drawings of William Hogarth*. London, 1948.
Phillips	Hugh Phillips. *Mid-Georgian London*. London, 1964.
Plomer	Henry R. Plomer. *Dictionary of the Printers and Booksellers who were at Work in England . . . from 1668 to*

	1725 and . . . from 1726 to 1775. 2 vols. Oxford, 1922–32.
Pye	John Pye. *Patronage of British Art.* London, 1845.
Quennell	Peter Quennell. *Hogarth's Progress.* New York, 1955.
Richardson, *Works*	*The Works of Jonathan Richardson, containing I. The Theory of Painting, II. Essay on the Art of Criticism, III. The Science of a Connoisseur.* Strawberry Hill, 1792. When relevant, references occur to the original editions.
Rouquet, *Lettres de Monsieur***	Jean André Rouquet. *Lettres de Monsieur** à un de ses Amis à Paris.* London, 1746.
Rouquet, *State of the Arts*	Jean André Rouquet. *State of the Arts in England.* London, 1755.
J. T. Smith	J. T. Smith. *Nollekens and his Times* (1828), ed. Wilfred Whitten. 2 vols. London, 1917.
Spectator	*The Spectator,* ed. Donald F. Bond. 5 vols. Oxford, 1965.
Survey of London	*London County Council Survey of London,* ed. J. R. Howard Roberts and Walter H. Godfrey. London, 1900–.
V & A	Victoria and Albert Museum, London.
Vertue	George Vertue. *Notebooks.* 6 vols. Oxford: Walpole Society, 1934–55.
Walpole, *Anecdotes of Painting,* IV	Horace Walpole. *Anecdotes of Painting in England,* IV (1771, released 1780), ed. James Dallaway. London, 1828.
Walpole, *Correspondence*	Horace Walpole. The Yale Edition of Horace Walpole's Correspondence, ed. W. S. Lewis. 34 vols. New Haven, 1937–. Where relevant, references to single volumes are supplied in detail.
Waterhouse, *Painting in England*	Ellis Waterhouse. *Painting in England, 1530 to 1790.* London, 1953.
Waterhouse, *Three Decades*	Ellis Waterhouse. *Three Decades of British Art, 1740–1770.* Philadelphia, 1965.

Wheatley, *Hogarth's London* Henry B. Wheatley. *Hogarth's London*. London, 1909.

Whinney and Millar Margaret Whinney and Oliver Millar. *English Art 1625–1714*. Oxford, 1957.

Whitley W. T. Whitley. *Artists and their Friends in England, 1700–1799*. 2 vols. London, 1928.

Notes

1. Daniel Defoe, *A Tour thro' the Whole Island of Great Britain,* I (1724), 124, 126; II (1725), 108.

2. Ibid., III (1727), 223.

3. See Appendix A.

4. See Edward Hughes, *North Country Life in the Eighteenth Century, II. Cumberland & Westmorland 1770–1830* (London, 1965), p. 7.

5. See Appendix A.

6. The full title describes the contents: "Thesaurarium Trilingue Publicum: Being an Introduction to English, Latin and Greek. In Two Parts. The First, Teaching Orthography, and the exactest Way of Pointing yet extant: also Two Lessons for every Day in the Week for Children, and an Alphabetical Table of most Primitive words, both Grammatically and truly divided; with a Catalogue of such words, as being the same in Sound differ in Spelling and Signification. The Second, containing a Method for the more Speedy attaining the Greek Tongue, and the true Accenting thereof; so plain that an English Scholar may (for the most part) Accent any Greek truly according to Grammar: With an Excellent Prosodia, and several other things fit for those that desire to learn Greek. [Quotations from Horace's sermones and Lucian's epigrams.] London. Printed by J. L. and are to be Sold by Randal Taylor, near Stationers-Hall. MDCLXXXIX." The only copy I have found is in the London Library (Safe 4); this copy was discovered by Austin Dobson (see his *Hogarth,* p. 11 n.). The *Thesaurarium Trilingue Publicum* was announced in the term catalogues for May 1689 and again for November of the same year (*The Term Catalogues,* 1668–1709, ed. E. Arber [London, 1905], pp. 261, 290).

7. A third letter writer, Richard Browne, a London physician, may have been the Richard Browne who in 1712/13 was advertising a cure for stone (*Post Boy,* 13–15 January).

8. *Thesaurarium,* p. 17.

9. Ibid., pp. 61, 63, 63–64, and 71. For examples of the sententiae, see Appendix C.

10. Full title: "Gazophylacium Anglicanum: Containing the Derivation of English Words, Proper and Common; each in an Alphabet Distinct: Proving the Dutch and Saxon to be the Prime Fountains. And likewise giving the similar Words in most European Languages . . . Printed by E. H. [Elizabeth Holt] and W. H. [W. Horton]; sold by Randall Taylor. London, 1689." This anonymous work fits the description of that mentioned on the left-hand page of Richard's letter to Noble in 1697 (see Appendix C). Above the address, and in a different hand, is the note: "Mr Hogarth writ of the Greek accents in English (recommended by Mr Noble Prebendary of York) and an abridgmt of Dr Skinners Etimologicon." The "Greek accents in English" refers to the *Thesaurarium Trilingue Publicum.* The other refers to a manuscript left by Stephen Skinner (1623–67) which was edited by Thomas Henshaw and published as *Etymologicon Linguae Anglicanae* in 1671, a work which Dr. Johnson acknowledged in his preface to his *Dictionary.* There is no record of a later edition of the *Etymologicon,* let alone an abridgement, except for the *Gazophylacium Anglicanum.* It was advertised as published in the *London Gazette,* 4–7 November 1689. A copy is in the BM (1480. aa. 27).

11. *Autobiographical Notes,* pp. 201 and 204.

12. Canon 77, promulgated by Convocation in 1604, required that every teacher in a public school or a private house obtain a license from the diocesan bishop or the ordinary of the place. Canon 79 adds that the teacher must instruct his pupils in the catechism, take them to sermons in the parish on holy days, instruct them in the Bible, etc.

13. The following information is based on the records of war tax assessment for St. Bartholomew the Great, 1689 (Guildhall Record Office, Box 12.15), 1690 (14.19), Jan. 1692/3 (41.3), 1693 (13.37), 1694 (15.5), marriage assessment for 1695 (taken in June, 99), and tax assessment for 1696 (34.23). During this period, St. Bartholomew the Great rate books exist

only for the years 1698 (Guildhall Lib. MS. 4047/4), 1700 (MS. 4047/5), and 1702/3 (MS. 4047/6). For an independent but undocumented use of many of these records, see William Le Hardy, "William Hogarth—A New Biography," in *The London & Middlesex Historian* No. 2 (December 1965), 1–10.

14. When the streets were numbered in the nineteenth century it became No. 58, and in 1921 it was absorbed into No. 60, the premises of Evans Sons, Lescher and Webb Ltd., now Dominion House. See E. A. Webb, *The Records of St. Bartholomew's Priory and the Church and Parish of St. Bartholomew the Great, West Smithfield* (London, 1921), II, p. 214; pl. 85 shows No. 60, corner building, which absorbed 58.

15. Guildhall Record Office, Box 14.19.

16. See Appendix B.

17. John Gibbons was buried 13 November 1692 (St. Bartholomew the Great Burial Register, Guildhall Library MS. 6780); he died intestate, and the administration of his estate was dated 9 November (Guildhall Lib. MS. 9054/1).

18. The various spellings of "Hogarth" question, if they do not disprove, Nichols' old story that Anne Hogarth persuaded Richard, before the birth of William, "to liquify it into *Hogarth*" (*Biogr. Anecd.*, 1781 ed., p. 7 n.).

19. In the tax assessment of 1692/3 (Box. 41.3) the maid is no longer listed, but the rest of the family is the same. By June 1695, according to the Marriage Assessment carried out in that year (Box 99), Mary Gibbons was still there, but young John had left home to be apprenticed to Thomas Hoskins, a cheesemonger in the Redcross Street Precinct of Cripplegate Without (Guildhall Record Office, 107d, f. 26). Elizabeth Peake, a servant or a boarder, and John and Elizabeth Brooke, boarders, were added to the household in the 1695 assessment. According to an entry in the St. Bartholomew's registry of nonconformist births, "Sarah Brooke was borne yᵉ 6ᵗʰ August 1695 in Bartholomew Closte att Mʳ Hogards house yᵉ schoolmasters" (Guildhall Lib. MS. 6780).

20. For the Hogarth children's births, see Guildhall Lib. MS. 6778/1.

21. They are identified in the Nonconformist Register (No. 4), Guildhall Lib. MS. 6780.

22. The stocks were installed, brand new, in 1695, and a cage (or lockup) too stood at the rear of the Smithfield Gate. See Webb, II, 325–26; on the history of St. Bartholomew's, see Webb, II, 57.

23. The news of the Peace of Ryswick reached London on 14 September (*Post Boy*, 14–16 Sept.); William III's birthday (ibid., 6 Nov.); St. James' Park celebration (18–20 Nov.). During this period the papers also daily reminded their readers of the £3000 lottery to be drawn on 20 November, which, however, was postponed till 9 December.

24. The *Post Boy* for 2–4 December reported that "There were Christened this week in this City, and within the Bills of Mortality, 323, and Buried 471, so that they increased in the Burials this week, 39."

25. Unlike the regular register, which has nothing in it but baptisms, the nonconformist register was apparently instituted only to register births; the children were baptized elsewhere, by their own clergy. One of the few exceptions, a birth entry for 12 October 1697, is followed by a separate entry for the child's baptism on 1 December "by a minister of yᵉ Parish Church"—that is, by an Anglican divine. This entry is immediately followed by the registry of William Hogarth's birth *and* baptism in a single entry. Only a few families, including the Hogarths, allowed their children to be baptized by the parish minister. For the then rector of St. Bartholomew's, see Webb, II, 324–31, 528.

26. Register No. 4, Guildhall Lib. MS. 6780, p. 17A; reproduced, Webb, II, pl. 95, p. 286. My reading, however, is based on the original. The squiggle after *born, Clost,* and *door,* presumably an "e," appears in all three cases. Mary Hogarth's birth was registered in Register No. 4 (MS. 6780, p. 50A): "Mary Hogarth was borne in Bartholomew Closte yᵉ November 23ᵗʰ [sic] 1699"; and notice of her baptism is in the regular register, No. 5 (MS. 6778/1, p. 79): "Mary yᵉ daughter of Richard & Anne Hogarth was baptized yᵉ 10ᵗʰ of December 1699." Webb errs when he says (II, p. 285) that the nonconformist register "was apparently intended for the registration of such nonconformist parishioners as were not baptized in infancy," and concludes that the Hogarth names were entered by mistake.

27. See, e.g., Frederick J. Powicke, *A Life*

of the Reverend Richard Baxter, 1615–1691
(London, 1924), pp. 210–11.

28. An index at the end of his *Disputationes Grammaticales* (1712). Although "Suffer'd Martyrdom for Religion and the Laws" sounds Anglican, it would not be foreign to the stance of the Presbyterians, who took pride in dissociating themselves from the murder of Charles I and opposing Cromwell. The presence of James II and the absence of William III is more troublesome: for a similar treatment of William, one may turn to Pope's *Windsor Forest* (1713). Thus the omission would seem to indicate that Richard intended the book as a text for St. Paul's or some other school of the established church. (Queen Anne was probably omitted because she was still living.)

29. See G. R. Cragg, *Puritanism in the Period of the Great Persecution, 1660–1688* (Cambridge, 1957). On conformism among the Presbyterians, see pp. 223–25; on the meaning of "Presbyterian" at this time, pp. 252–53; on the extent of toleration after 1688 and the Toleration Act, pp. 250–51.

30. It had been occupied by Independents during the days of nonconformist persecution and was noted for its secret doors through which parishioners could make quick exits in case of raids. From 1681 to 1706 it served as a meetinghouse for the Rev. John Quick's Presbyterian congregation. See *DNB;* Edmund Calamy, *Account* (1713), pp. xxv, 247 ff.; Calamy, *Continuation* (1727), I, 331 ff.

31. See Walter Wilson, *The History and Antiquities of Dissenting Churches and Meeting-Houses in London* (1808), III, 370; Webb, II, 167–71.

32. Richard Sibbes, *The Christian Work,* in *Works,* ed. Rev. Alexander Grosart (Edinburgh, 1862), V, 123; John Robinson, *The Birth of a Day* (1655), pp. 5–6.

33. Henry Lukin, *An Introduction to the Holy Scriptures* (1669), p. 174; *Pilgrim's Progress,* ed. J. B. Wharey (Oxford, 1960), p. 34.

34. For the complete Latin text and English translation, see Appendix C. This edition of Malpighi's *Opera Posthuma* was published in London in mid-December 1696 (when it was advertised in the *London Gazette,* 17–21 December), though dated on the title page 1697.

35. The early Hogarth commentators assumed that Richard had worked for one of the printers who lived in Bartholomew Close: William Downing, his next-door neighbor, or Samuel Roycroft, the King's Printer (Wheatley, *Hogarth's London,* p. 23; Downing was buried 3 January 1702/3 and the rate book shows his house empty in 1705 [Guildhall Lib. MS. 4047/8]). He may have known these men and made contacts through them with Churchill, who is referred to by Granger as the greatest bookseller and stationer of his time. See Plomer, pp. 69–70.

36. For Gale, see *DNB* and Nichols, *Literary Anecdotes,* IV, 536 ff. He was headmaster of St. Paul's from 1672 to 16 September 1697, and remained Dean of York till his death in 1702. He was a noted classical scholar, though his chief fame now rests on the notorious inscription he composed for the London Monument.

37. See Appendix C.

38. In the St. Sepulchre's tax assessment, taken in April 1700, they have not yet arrived; by the next one, in April 1701, they are in residence (Guildhall Lib. MS. 9109/38–39). Their assessment was 2s, as opposed to the Widow Gibbons' 10s. Their house can be located near the bottom of St. John's Street by the fact that it is registered in the St. Sepulchre's rather than the St. James' Clerkenwell rate books.

39. In 1702 a son, Timothy Helmesley (misspelled Hensley), was registered as "born ye 4th of May 1702 att widow Gibbons' house in Bartholomew Closte next door to Mr Donnans [Downing's] ye printer" (nonconformist register, Guildhall MS. 6780, p. 54A, repeated p. 55A). Timothy was followed by John (baptized 29 Nov. 1703), Frances (15 July 1705, buried 26 July), a second Frances (15 Aug. 1708), and another Timothy (born 14 April 1710, baptized 30 April, buried 18 Aug. 1711). A son Richard exchanged notes with William's brother Richard and his sister Anne in the family Bible (see I, 24 below); he must have been the eldest of the Helmesley children, born before they settled in the hospital cloisters around 1703. A third Timothy Helmesley, born presumably after 1711 when the second Timothy died, grew up to be a prosperous London merchant, a benefactor and, with William Hogarth, a governor of St. Bartholomew's Hospital, and died in 1765 (will, Somerset House, Rushworth, 57).

In 1703 the Widow Gibbons moved with the Helmesleys to the adjoining parish of St. Bartholomew the Less, probably living within the ancient precincts of the hospital. There she remained until her death in 1724. (See the Land Rate Books [Guildhall Lib. MS. 11316].) The Widow Gibbons is still listed as rate-payer in the St. Bartholomew the Great rate-books for 1698 (Guildhall Lib. MS. 4047/4), 1700 (MS. 4047/5), and 1702/3 (MS. 4047/6). In 1704 (MS. 4047/7) and 1705 (MS. 4047/8) she is gone, though a William Gibbons appears housed nearby in Duck Lane. The Widow Gibbons died in 1724, her estate administration dated 26 October, and her address given as the parish of St. Bartholomew the Less (Guildhall Lib. MS. 9054/2). She was buried in the St. Bartholomew the Less churchyard on 28 October (Parish Register, St. Bartholomew's Hospital archives).

40. St. Sepulchre's Baptismal Register, Guildhall Lib. MS. 721/3.

Another book perhaps by Richard was published in November 1701: "A Compendium of Geography; containing a Description of most Kingdoms and Countries in the World, with short Historical Observations of each Kingdom: designed as an easie Preparatory for Youth and others to understand History. Also an Account of the Lines of Succession from Adam till this time, and the Succession continued; with an Account of the Protestant Line. By R. H., Philomath. Price 1s. Printed for G. Conyers, J. Sprint, and T. Ballard, in Little Britain" (*Term Catalogues*, III, 276). The "Lines of Succession" remind one of the "short Chronological Index of Men and Things" at the end of Richard's *Disputationes Grammaticales*. I have not uncovered a copy of the *Compendium*.

41. The Hogarths paid their rates in 1702 and 1703, and were still living in St. John's Street on 20 April 1703, but Richard's name was crossed out sometime before 13 June 1704, when the list was checked over (Guildhall Lib. MS. 9101/40–41). For Thomas' baptism, see *A True Register of All the Christenings, Marriages, and Burialles in the Parishe of St. James, Clerkenwell,*. ed. Robert Harenden (London, 1885), II, 15. The rate books for Clerkenwell in this period, still available to W. J. Pinks in the early nineteenth century,

were all lost or misplaced when the records were taken into the custody of the Borough Council in 1900.

42. The coffeehouse advertisement, originally noticed by W. J. Pinks, *The History of Clerkenwell*, 2d ed. (1881), p. 745, is also in Bryant Lillywhite, *London Coffee Houses, A Reference Book of Coffee Houses of the Seventeenth, Eighteenth and Nineteenth Centuries* (London, 1963), No. 570, pp. 269–70; the quotations, however, are from the original newspapers.

43. There was at this time a school in St. John's House, in nearby St. John's Court, which employed a Latin teacher. Its advertisements, beginning in 1699, emphasize French, Greek, and "the *Propriety* of the *Latin Tong*, (pretended to by many, understood by few:) In a Method adapted to the Education of Gentlemen, whether design'd for *Travel*, the study of *Law*, or other superior Faculties, or further Improvements in an University." It is possible that Richard may have gone to this area originally in 1701 to be the Latin master.

44. See GM, XXI (1752), allegorical frontispiece; XXII (1753), 383; LVIII (1788), 853; Benjamin Foster, *Ye History of ye Priory and Gate of St. John* (London, 1857); and Pinks, *The History of Clerkenwell*, pp. 241–57. "Mr. Foster," says Pinks (p. 256), "found a three-quarter length portrait of Cave in a room which adjoins the great chamber over St. John's gateway on the south side. It represents Cave's true features, and being an excellent painting Mr. Foster ventured, at the suggestion of the gentleman who cleaned it, to place on the frame the name of Hogarth."

45. *Daily Advertiser*, 26 March 1735, an advertisement for the sale of J. Verelst's collection of pictures at Harvey's; a newspaper of November 1771, quoted by Pinks, p. 745.

46. Lubinus, "Epistolary Discourse" to his edition of the *New Testament, Englished in The True and Readie Way to Learn the Latin Tongue*, ed. Samuel Hartlib (1654). See C. Foster Watson, *English Grammar Schools to 1660* (London, 1908), pp. 5–7.

47. Quoted (but unidentified), Aytoun Ellis, *The Penny Universities: A History of the Coffee-Houses* (London, 1956), pp. 44, 46–47.

48. Ned Ward, *The London Spy* (1703), ed. A. L. Hayward (London, 1927), p. 10.

CHAPTER 2

1. *The Character of a Coffee-House* (London, 1665).

2. See Henry Morley, *Memoirs of Bartholomew Fair* (London, 1859), pp. 144 ff. The announcements, advertisements, etc., that follow are reproduced in Morley from the BM collection of Fair clippings.

3. *Autobiographical Notes*, p. 204.

4. *The London Spy*, ed. A. L. Hayward (London, 1927), pp. 177–99.

5. *Spectator* No. 44, 20 April 1711; I, 191.

6. Samuel McKechnie, *Popular Entertainments through the Ages* (London, 1931), pp. 33, 47. Sir Robert Southwell's letter to his son Edward, dated 26 August 1685, is quoted in Morley, pp. 288–91.

7. Order of the Court of Common Council, 2 June 1708.

8. See Edward Hatton, *New View of London* (1708); W. J. Pinks, *The History of Clerkenwell* (1881), p. 13. See also Defoe, *Tour thro' the Whole Island of Great Britain*, II (1725), 116–17.

9. Charles Howard, second Earl of Carlisle, lived in the Square, and it seems probable that his family kept the house there (rated at 8s per month in 1661) after his death in 1684. There may still at this time have been some connection between the Carlisles and Richard Hogarth.

10. Burnet, *History of his Own Times* (London, 1838 ed.), p. 849.

11. Pinks, p. 331.

12. Hatton, p. 283. The present church was built in 1788.

13. *A True Register of all the Christenings, Marriages, and Burialles in the Parishe of St. James, Clerkenwell*, II, 24. For the burial of Richard the younger: V, 221. The minister at this time was Dewel Pead, M.A., licensed 5 December 1691 (d. 1726/7).

14. *Post Boy*, 6–14 Sept. 1699.

15. *Proposals for establishing a charitable Fund in the City of London* (1706), p. 19.

16. BM, Harleian MS. No. 5931.

17. *Flying Post*, 17–20 Sept. 1709.

18. *Daily Post*, 10 July 1700, 22 March 1701. See Dobson, p. 207, for the portrait of Broughton, and Oppé, cat. nos. 79a and b, for Taylor (Mellon Coll.).

19. Records of the Parish of St. Magnus the Martyr (this information first appeared in Col. William Le Hardy's "William Hogarth—a New Biography" [1965]); records of the Haberdashers' Company; Bishop of London's Register, *The Publications of the Harleian Society*, XXVI (1887), 336; Joseph Foster, ed., *London Marriage Licenses* (London, 1887), p. 694; Marriage Records of All Hallows-in-the-Wall. The exact location of his shop can be found in the insurance policy he took out from the Sun Company: on his shop, 14 September 1713 (vol. III, policy no. 3288) and on his dwelling house, without a different address, 14 May 1714 (vol. III, policy no. 3947).

20. *London Spy*, p. 41.

21. See Hugh Phillips, *The Thames about 1750* (London, 1951), p. 58.

22. *Autobiographical Notes*, p. 204.

23. Let us hope it was not a charity school. The drawings William says he made in his margins would have been a heinous offense in a school where even singing was forbidden as a distraction from the one aim of being an obedient and industrious servant. The curriculum was relentlessly restricted to the three R's, religion, and morals, and reading was mostly from the Bible. However, it should be noted in passing that charity boys and girls appear in Hogarth's prints, and invariably as being neglected by the governors of their school. Students were drawn mainly from the laboring poor, many on poor relief. See M. G. Jones, *The Charity School Movement* (Cambridge, 1938), pp. 74–84.

24. C. Foster Watson, *English Grammar Schools to 1660* (1908), p. 295, summarizing the views of John Brinsley, *Ludus Literarius or the Grammar Schoole. Shewing how to proceede from the first entrance into lerning to the highest perfection in the Grammar Schooles* (London, 1612).

25. *Autobiographical Notes*, p. 204.

26. Ibid.; E. A. Webb, *Records of St. Bartholomew's* (1921), II, 528; Burke and Colin Caldwell, *Hogarth, The Complete Engravings* (London, 1968), p. 11, identify this "Mr. Woolaston" as William Wollaston (1660–1724), the philosopher. By letting their eyes slip down one line in the index to Vertue's notebooks,

they mistook his name for John Wollaston's. See Vertue, II, 67; V, 95–96 (on Wollaston's portrait of Britton).

27. See Pinks, *The History of Clerkenwell,* p. 255. For what little is known about Heemskirk, see Vertue, II, 128–29 (and Roger De Piles, *The Art of Painting and the Lives of the Painters* [London, 1798 ed.], p. 383). See also F. Saxl, "The Quakers' Meeting," *Journal of the Warburg and Courtauld Institutes,* VI (1943), 214–16; William I. Hull, "Egbert van Heemskirk's 'Quaker Meeting,'" *Bulletin of the Friends' Historical Association,* XXVII (1938), 17–33, 57–58. Paintings by Heemskirk are frequently listed in sales during the first two decades of the century and would have been known to Hogarth (see, e.g., *Post Man,* 10–13 December 1709).

28. Heemskirk II was the author of satiric plates with animal-headed figures (signed "E. Heemskirk inv. et pinxt" and mostly engraved by Toms, but not dated): at an auction, in a barber shop, in a quack physician's chamber, at a concert, "Beating up for Volunteers," in a brothel, a school, and a tavern. Each has verses underneath. The advertisement for the mezzotint of *The Midnight Magistrate,* which is one of the series, names Kirkall, the mezzotint-engraver, as "author" and does not mention Heemskirk (*Daily Post,* 12 Feb. 1730/1). Vertue makes no mention of him. He does appear listed as a singer at Sadler's Wells in the mid-1740s (e.g., 6 May 1742, *Daily Post*), but the only mention of him as a painter is in J. T. Smith (II, 271): among painters whose work is confused with Hogarth's, he lists "that drunken pot-house Painter, the younger Heemskirk, who was a singer at Sadler's Wells." In 1734 Heemskirk II published a series of drolls and poems called *Nothing Irregular in Nature; or, Deformity, a mere Fancy. Being a New Set of Original Beauties, Design'd by the Celebrated E. Hemskirk, curiously etched on Twelve Copper Plates. Likewise short Poems on the Variety of Beauty, adapted to each Print* (the engraving was by Toms). As to his possible influence on Hogarth: Antal has pointed out the similarity of the *Quack* to the *Reward of Cruelty,* and the brothel scene to *Rake,* Pl. 3; I might add that the drunks in the tavern scene remind one of Hogarth's painting, *Charity in the Cellar.* Among the pictures and drawings in Thomas Gwennap's sale (Greenwood's, 13 June 1806, no. 610) was "Hogarth . . . Portrait of Heemskirk and Family," sold for £1 18s.

CHAPTER 3

1. The announcement was made in the *Daily Courants* of 23 and 25 June 1707; "Any Gentleman or Lady that is desirous of having any short Poem, Epigram, Satyr, &c., if they please to communicate the Subject to the Authors of the Diverting Muse, or the Universal Medly, now in the Press and will be continu'd Monthly; or if they have any Song or other Poem of their own that is New and Entertaining, if they please to direct them for Mr. George Daggastaff, to be left at Mr. Hogarth's Coffee-house in St. John's Gate-way near Clerkenwell, the former shall be done Gratis, and inserted in the Miscellany above mention'd, as also the latter, both paying the Postage or Messenger." (See *Post Man,* 28 June–1 July; *Daily Courant,* 30 June [shortened]; also in the *Term Catalogues,* July 1707 [ed. E. Arber, III, 563], where Hogarth's coffeehouse is also mentioned.)

2. *Daily Courant,* 13 January 1708/9.

3. *Daily Courant,* 19 March 1708/9, for a sale on the twenty-eighth at 5 P.M.

4. See below, I, 35 and Appendix C.

5. See W. S. Holdsworth, *A History of English Law* (London, 1903), VIII, 229–45.

6. Edward Hatton, *New View of London* (1708), II, 745. See also Charles Gordon, *The Old Bailey and Newgate* (London, 1902), and John Ashton, *The Fleet: Its River, Prison, and Marriages* (London, 1870).

7. Ibid. See *A Short View of some Complaints Against the Warden of the Fleet-Prison* (1705?), Guildhall Lib. C.43/FLEET/T.1705?, which prints a complaint from the parishioners of St. Martin's Ludgate: "That several Persons enter'd as Prisoners in the *Fleet,* take Houses within the pretended Rules, and refuse to pay the Parish-Duties, bidding Defiance to Demands thereof. That some Prisoners keep Shops within the Rules, and by their Accomplices procure Goods and Merchandizes thither,

and when there, keep them by force, without paying for the same, to the great damage of their Creditor so decoyed, and to the Scandal of the City of *London*."

8. *A Report from the Committee Appointed to Enquire into the State of the Gaols of this Kingdom: Relating to the Fleet Prison* (London, 1729), p. 5; John Mackay, *A True State of the Proceedings of the Prisoners in the Fleet-Prison, in Order to the Redressing their Grievances before the Court of Common Pleas* (London, 1729), pp. 5–7. See also BM Pamphlets and Clippings on the Fleet Prison, pressmark 11633.h.2.

9. Old Bailey Precinct, St. Sepulchre's Parish, Land Tax Books, Guildhall Lib. MS. 11316.

10. The early Hogarth commentators insisted that he had a school in Ship Court, west of Old Bailey Street, named after the Ship Tavern, and one writer specifies a house "three doors from Newgate-street on the west side." (See Peter Pindar [John Wolcot], in a letter of correction to the 1782 ed. of *Biogr. Anecd.*, in *GM*, LV, pt. 1 [1785], 343; Nichols repeats the story in the 1785 ed. of *Biogr. Anecd.*, p. 4, and in *Gen. Works*, I, 12. H. B. Wheatley, in *London Past and Present, based on Peter Cunningham's Handbook of London* [1891], II, 612, adds the precise location. S. Ireland [I, 1] says that Richard resided in the parish of St. Martin's Ludgate for several years as a schoolmaster, "and occasionally superintended a literary publication." The story is also repeated by Gordon, *The Old Bailey and Newgate*, p. 325.) Peter Pindar, with whom the story originated, dated the school 1712, which might imply that Richard kept a school there for a time after being released from the Fleet; but it could also suggest that Pindar had seen the title page of Richard's *Disputationes Grammaticales*, which is dated 1712, identifies him as "Schoolmaster," and was published "at the Ship in Pater-Noster-Row." None of these writers was aware of Richard's confinement in the Fleet.

11. See Defoe's *Review*, 8 March 1708/9; *Commons Journals*, 28 February 1710/11, XVI, 528; *History and Proceedings of the House of Commons* (London, 1742), IV, 184–86. For contemporary arguments pro and con, see *The Case of Lieutenant-Colonel Charteris* and the other pamphlets relating to the case collected in the British Museum (pressmark 816.m.7 [11–21]).

12. See Appendix C for the Latin text.

13. *Commons Journals*, XVI, 445.

14. 12 January (*Commons Journals*, XVI, 455), 16 (457), 17 (458), 19 (461–62), 22 (463–64), 26 (467), 31 (471), 3 February (476), 2 April (569), 20 (605), 21 (608), and 30 (620).

15. Another petition from the debtors in the Fleet, 20 April (p. 483), asked the House to extend the coverage beyond £20, but the petition was rejected.

16. See *Commons Journals*, XVI, 624, 637; *Lords Journals*, XIX, 302, 308, 315, 414, 418, 424, 430, 445; *Commons Journals*, XVII, 224, 235.

17. *Public General Acts, 8–10 Anne, 1709–11*, pp. 307–11.

18. *Sessions Books, special ledger for Insolvent Debtors, 1712*, in the Guildhall Record Office. William Gibbons was born in 1669 (see below, Appendix B) and died intestate in 1717; administration of his estate was proved 12 December 1717, at which time he was identified as a citizen and cutler of St. Thomas, Apostle, Parish; his wife, Ruth, was to administer the estate (Guildhall Lib., MS 9050/20, f. 205; *Act Book*, XX). Helmesley was a shopkeeper in St. Bartholomew's Cloister (see records of St. Bartholomew the Less, now in St. Bartholomew's Hospital). He died 15 February 1718/19, according to the Hogarth family Bible, but there is no record of it in either St. Bartholomew's or St. Sepulchre's registers or in the will indexes. His general absence from records makes one suspect that he was a nonconformist.

19. If they had died before the Hogarths left Clerkenwell they would have appeared in the St. James' register. They do not appear in the St. Bartholomew's registers, which include the Hogarths again after their return from the Fleet.

20. The title page is in parallel columns of Latin and English; the English half reads: "Grammar Disputations: or, an Examination of the Eight Parts of Speech by way of Question and Answer, English and Latin, Whereby Children in a very little Time will learn, not only the Knowledge of Grammar, but likewise to Speak and Write Latin, as I have found by good Experience. At the end is added a short Chronological Index of Men and Things of

the greatest Note, Alphabetically digested, chiefly relating to the Sacred and Roman History, from the beginning of the World to the Year of Christ 1640, and downwards. Written for the Use of the Schools of Great Britain. By Richard Hogarth, Schoolmaster. London: Printed by J. G. for W. Taylor at the Ship in Pater-Noster-Row, MDCCXII." The book was announced "This Day publish'd" in the *Post Boy* for 18–20 December 1711, The publisher, William Taylor, was bringing out a number of Latin and Greek texts at this time and gave Richard's a good deal of advertising support (*Post Boy*, 20–22, 22–25 December; *Post Man*, 14–16, 23–26 February, 15–18 March 1711/12). Taylor was the son of John Taylor (and possibly a relation of the Randall Taylor who had published Richard's *Thesaurarium*), one of the largest publishers of the period; he joined his father in partnership in 1700, and in 1711, the year he published Richard's new book, set up for himself in Paternoster Row.

21. See Appendix C for the whole passage.

22. Reprinted, C. Foster Watson, *English Grammar Schools to 1660* (1908), pp. 288–89.

23. *Daily Courant*, 21 April 1713.

24. The book was published by John Wyat who, in the publishing of this book and its source, William Walker's *Dictionary of English and Latin Idioms* (1670), was in direct competition with Richard's former publisher, William Taylor. Walker's popular *Dictionary* must have been copyright free, for in 1708 it was being published by Pawlett at the Unicorn in Paternoster Row; then in 1711/12, just after he published Richard's *Disputationes Grammaticales*, Taylor brought out a so-called sixth edition, "Corrected and Improved with above 3000 Phrases, collected from the best Authors" (*Post Boy*, 5–8 January 1711/12). Wyat (or Wyatt) sold at the Golden Lion, St. Paul's Churchyard, 1691–1711(–20?). Plomer (p. 322) says he was a publisher for the nonconformists.

The rest is supposition: but the correcting and improving may have been accomplished by Taylor's chief Latin expert, Richard Hogarth, who apparently did this sort of thing. If so, Taylor may have used Richard's work unacknowledged, driving Richard to John Wyat for his own publication. Unfortunately, no copy of the *New School Dialogues* has been found, but another advertisement of Wyat for 1715 notes that *School-Boys Dialogues* has been adopted by St. Paul's (*Post Boy*, 31 March–2 April 1715).

25. See below, chap. 4, n. 27.

26. Judging by his own words in his letter to Harley, Richard also drew on *Prosodia Henrici Smetii . . . promptissima, quae syllabarum positione & diphthongis carentium quantitates, sola veterum poetarum auctoritate, adductis exemplis demonstrat* (London, 1615). This popular textbook was published in Paris in 1621 and Amsterdam in 1630; it was reprinted in London in 1628, 1635, 1640, 1648, 1650, 1654, 1657, 1674, 1681, and 1705, to cite only the copies in the British Museum.

27. The first volume of the dictionary belonged to John Ireland, the second to one James Bindley (*Gen. Works*, 1, 67). One of these was sold at Puttick's (lot 924), 13 December 1850. The present location of both volumes is unknown.

28. *Autobiographical Notes*, pp. 204–05.

29. Quennell, p. 27.

CHAPTER 4

1. Gamble was not, as the authorities on gold- and silversmiths have claimed, the son of William Gamble, a well-known London goldsmith. See William Le Hardy, "William Hogarth—a New Biography" (1965), p. 1. I am grateful to Mr. J. W. Woolley of the Merchant Taylors' Company for verifying the dates in the Merchant Taylor records.

2. *Matrimonial Allegations before the Bishop of London*, Guildhall Lib. MS. 10091/46, f. 525; St. Martin's Marriage Register: both on 15 September 1710. In the Allegations Gamble is said to be around 25 years of age.

3. *Autobiographical Notes*, pp. 201, 205.

4. See O. J. Dunlop, *English Apprenticeship and Child Labour* (London, 1912), pp. 33–49, 351–53.

5. C. M. Clode, *Memorials of the Guild of Merchant Taylors* (London, 1875), p. 208. My main source for this information is Dunlop, pp. 157–71, and for the treatment of apprentices in the master's home, pp. 172–98. The fee

charged for emolument was fixed by statute at a maximum of 2s 6d, but was often more. The Merchant Taylors in London charged 30s in 1661. But "Nil" is written opposite William Hogarth's name and many others.

6. Edward Hatton, *New View of London* (1708), II, 611-12.

7. Dunlop, pp. 157-71.

8. The St. Martin in the Fields poor rate books (Charing Cross Division), in the Westminster Public Library, contain the following entries. For Blue Cross Street: 1715, "Eliz. Gambell," house assessed at 12, rated 0/6/0 per half year; 1718, "Elizabeth Gambell," 0/12/0 per half year; 1719/20, "Ellis Gamball," same rate; 1721, "Isabella Gambell," same rate; 1722, "Eleazer Gambell," at 12 and 0/8/0; 1723 (Scavenger Rate), "Ellis Gambell," 12, 0/3/0; 1724 (Scavenger Rate), Gamble is replaced by John Postin by 6 April 1724, when the rate was taken. Gamble's master, Hopthrow, is listed in Orange Court until 1722, when his name is crossed off at the second rating. (MSS. F.445-8, 450, 452, 454, 5536, 5554).

9. *Boyd's Register of Apprentices*, Guildhall Lib.: Stephen Fowler, son of Benedict, a waterman of St. Margaret Westminster, £15, in 1713 (p. 2017, ref. P.R.O., Inland Revenue Records, 2/170) and again £15 in 1716 (p. 2017, ref. 5/184). Felix Pellett, son of Pet, minister of Grode, Dutch Flanders, £30, 1717 (p. 4501, ref. 5/194). Hogarth does not appear in this index, not having completed his service.

10. Gamble first appears in 1724 in the margin opposite the entry for Thomas Rayner. St. Martin in the Fields poor rate books (Charing Cross Division), Westminster Public Library.

11. Gamble appears in voter lists for the Merchant Taylors' Company, e.g., *Daily Journal*, 7 December 1724 and 31 October 1727. His bankruptcy was announced in the *London Gazette* of 2-6 January 1732/3, where he was instructed to appear at the Guildhall 11 and 18 January and 17 February and list his estate and effects. The notice was repeated on 16-20 January, when the date was changed from 18 to 24 February in order to decide when and where the creditors were to come prepared to prove their debts and choose assignees. See also *GM*, III (1733), 48. Le Hardy notes Lamerie's responsibility for the bankruptcy, but he gives no reference, and I have found no record of it.

12. Defoe, *Complete English Tradesman* (1738 ed.), p. 143. For runaway apprentices: *Daily Courant*, 27 February 1717/18, 10 September 1714 (he stole gold, silver, and "a parcel of linen and other goods") and 11 September 1714; *Flying Post*, 14-16 September 1714; *Post Boy*, 23-25 September 1714 (this apprentice had a long right thumbnail which he used for "inlaying of Gold and silver") and 5-7 October 1714; and *London Gazette*, 30 March-2 April 1717.

13. *Autobiographical Notes*, p. 201.

14. *Post Boy*, 17-19 December 1713.

15. Nichols, *Gen. Works*, I, 24; also in the earlier editions.

16. Ibid., pp. 13-14.

17. All such stories, of course, must be qualified by the natural tendency to read back into the past what one knows of the present. Old Nollekens' recollection of "frequently" having seen "Hogarth, when a young man, saunter round Leicester-fields, with his master's sickly child hanging its head over his shoulder" must be judged against the facts that old Nollekens did not come to England until 1733 and that Gamble appears to have had no children before or during Hogarth's apprenticeship, though there were some in the 1720s. (Told by J. T. Smith, never too reliable himself, II, 270.) As to the Gamble children: St. Anne's Baptismal Register shows that Thomas Gamble was born 29 March 1725 and baptized 6 April; and Margaret Gamble was born 19 February 1725/6 and baptized 20 February (Westminster Public Library).

18. See J. F. Hayward, *Huguenot Silver in England, 1688-1727* (London, 1959), p. xx; Charles Oman, *English Domestic Silver*, 4th ed. (London, 1959), pp. 8-9; Joan Evans, "Huguenot Goldsmiths in England and Ireland," *Proceedings of the Huguenot Society of London*, XIV (1933); William Chaffers, *Gilda Auri fabrorum: a History of London Goldsmiths and Plate-Workers and their Marks stamped on Plate* (London, 1883); Walter S. Prideaux, *Memorials of the Goldsmiths Company, 1335-1815*, 2 vols. (1896-97).

19. Vertue, VI, 190. For economic aspects, see C. Oman, "English Engravers on Plate. I—Benjamin Rhodes," *Apollo*, LXV (1957), 173-76; Oman, *English Domestic Silver*, p. 223; Hayward, pp. 72-73. For current salaries, see George, *London Life in the Eighteenth Century*, pp. 164 ff.

20. Cf. the goldsmiths' petition, Minute Books of the Goldsmiths' Company, quoted, Hayward, pp. 20–21.

21. Hayward, pp. 30–31, 66–68.

22. The designs of Paul Ducerceau (ca. 1630–1713), Jean Berain (1637–1711), and Jean Lepautre (1618–82) were transmitted by books like M. P. Moutons's *Livre de desseins pour toute sorte d'ouvrages d'orfèvrerie* and Sieur de Masson's *Nouveaux desseins pour graver sur l'orfèvrerie*. Reproductions can be found in *Oeuvres de Bijouterie et Joaillerie des XVIIᵉ et XVIIIᵉ Siècles* (Paris, n.d.). The first French pattern book reissued in London was *A New Booke of Fries Work Invt. by J. Le Pautre* (1676). See also Simon Gribelin, *A Book of Ornaments usefull to Jewellers, watch-makers and all other Artists* (1697)—designs intended for the decoration of watch-cocks, watch-cases, snuffboxes, etc; and *A Book of Ornaments usefull to all Artists* (1700). In both cases his ornaments are based on the classical acanthus ornament of the Louis XIV period.

23. Full title: *Livre d'architecture d'autels, et de cheminées, dédié à monseigneur, l'éminentissimé cardinel, duc de Richelieu, de l'invention et dessein de I. Barbet . . .* (Paris, 1641).

24. Oman, p. 13. See also Ann Forester, "Hogarth as an Engraver on Silver," *Connoisseur,* CLII (1963), 113–16.

25. *Autobiographical Notes,* pp. 201–02, 210, 206.

26. Rate Books for St. Bartholomew the Great, Guildhall Lib.: "Richard Hoggarth" (sic) first appears in 1716; he is not in the 1714 book, and the 1715 is missing. He is in the 1717 book, same spelling, assessed at 13s again, and in 1718 he is replaced by "widow Hoggarth." St. Bartholomew's Burial Register, Guildhall Lib. MS. 6781/1, p. 5: "Richᵈ Hogarth from Long Lane"—11 May 1718. His burial at St. Bartholomew's proves that he lived on the south side of Long Lane, the only part that lies in the St. Bartholomew's parish. Administration of his estate was dated 23 May 1718, and Anne was named his executor (Guildhall Lib. MS. 9050/20, p. 237). "Widow Hoggarth" is assessed 0/15/2 in 1718; 1720, 0/6/6; 1723, 0/10/10; and 1724, 0/10/10. There are no more poor rate books until 1734, by which time she had gone. But she continues to appear in the Land Tax Books as late as 31 August 1728; she is gone by the next assessment, 20 September 1729. Guildhall Lib. Mss. 11316/80: 1725, assessed 8s; 11316/83: 1726, 8s; 11316/86: 1727, 15s; 11316/89: 1728 (31 Aug.), 12s; 11316/92: 1729 (20 Sept.), her name has been replaced by a Wm. Jarvis, at 12s.

27. Edmund Hogarth's will was probated 27 February 1718/19 (Records of the Archdeacon's court; Guildhall MS. 9051/11, f. 119–22). He writes, "being sick and weak in body" but of sound mind, he bequeaths to his niece Ann Arey, £30; to niece Abigail Arey, £10; to Brother William Hogarth "one Shilling if lawfully demanded and nothing else of mine"; to sister Anne, "one Shilling if lawfully demanded and nothing else of mine"; to "Anne Hogarth late Wife of my Brother Richard Hogarth one Shilling if lawfully demanded & nothing else of mine"; and also to sister Agnes, wife of Richard Rose, 1s. All the rest went to his wife Sarah, and the will was signed and witnessed 14 February 1718/19. Sarah Hogarth's will, signed and witnessed 9 June 1719, was probated 12 June 1719 (ibid., ff. 198–201).

28. For the bookplate, probably made for *Alexander* Gamble, see *HGW,* cat. no. 256, and 2d ed., I, 327–28.

CHAPTER 5

1. Vertue, I, 1.

2. Vertue, III, 146–47.

3. Lairesse, *Het Groot Schilderboek* (1707), tr. *Art of Painting,* by J. F. Fritsch (London, 1738), Bk. XII, p. 630; Richardson, "The Connoisseur: an Essay on the Whole Art of Criticism as it relates to Painting" (1715), in *The Works of Jonathan Richardson* (Strawberry Hill, 1792), p. 165. See also Roger De Piles, *Art of Painting* (1798 ed.), pp. 55–56; J. B. du Bos, *Refléxions critiques sur le peinture et la poésie* (1719; tr. 1747), I, 392.

4. William M. Ivins, *Prints and Visual Communication* (London, 1953), p. 66.

5. Ivins, p. 67.

6. *Analysis,* p. 9.

7. Nichols, *Literary Anecdotes,* II, 250, 247.

8. *Daily Courant,* 26 January 1711/12; or to

be viewed in the "Great Masquerade-Room in Spring-Garden near Chairing [sic] Cross" (*Daily Courant*, 2 Feb. 1711/12).

9. *Post Boy*, 29 August–1 September 1713; 15–17 December 1713.

10. *Post Boy*, 21–24 February 1712/13.

11. *Post Man*, 14–16 February 1711/12.

12. Vertue, VI, 187. The subsequent references are also from Vertue's history of engraving in his time, VI, 184 ff.

13. Ibid., VI, 188.

14. *Analysis*, p. 9.

15. Vertue, VI, 184.

16. Quoted, Nichols, *Literary Anecdotes*, VIII, 653.

17. William Faithorne, *The Art of Graveing, and Etching, wherein is exprest the true way of Graveing in Copper. Also the manner & method of that famous Mr. Callot, & Mr. Bosse, in their Severall ways of Etching* (1662), opp. p. 22.

18. See *HGW*, I, 91.

19. S. Ireland, I, 9.

20. See the *Weekly Journal or British Gazetteer*, 9 April 1720. I am indebted to John Carswell, *The South Sea Bubble* (London, 1960), pp. 141–42.

21. See *Applebee's Journal*, 2 and 30 April 1720, and Steele, *The Theatre* No. 21.

22. Receipt, advertised in a Maggs Bros. catalogue (1925), no. 2413; in Whitley Papers, BM Department of Prints and Drawings.

23. Carswell, *The South Sea Bubble*, p. 144.

24. Ibid., p. 191.

25. BM Sat. 1620, 1621; 1610, 1611. They were advertised together on 11 March 1720/1 (*Weekly Journal or Saturday's Post*).

26. *Weekly Journal or British Gazetteer*, 13 May 1721. The "original" is advertised in the *Weekly Journal or Saturday's Post* for 13 May, "as cheap as the Counterfeit which is sorrily Engrav'd and printed on Coarse Paper."

27. Significantly, Ostade apparently had no

influence on Hogarth's engraving or etching style, or on his composition or figure drawing. There is a slight tendency to Brueghelish roundness and solidity; but Ostade is drawing nearly subhuman types, and Hogarth never slips into the Brouwer-Ostade convention.

28. Vertue, III, 41. See *HGW*, cat. nos. 19–33, pls. 22–36.

29. Hogarth would also have been familiar with the many Dutch engravings of interiors, but he probably learned most from Abraham Bosse, whose manual on engraving he surely knew. Although Bosse's stiff, uniformly textured figures, crudely related to the space in which they move, bear little resemblance to Hogarth's lively, often grotesque representations, his subject matter and general composition may have contributed to Hogarth's. Above all, Bosse never allows his figures to be isolated like those of Callot, without background or milieu. He fills every inch of space in the print with focused, though not always significant, detail. One senses that Hogarth must have seen Bosse's *Ensevelir les Morts* before making his funeral ticket for Drew; only the architecture in the upper background bears a direct resemblance, but the prints as a whole share the same shape and composition as well as subject. A direct correspondence may be suspected between Bosse's *Visiter les Prisonniers* and Hogarth's *Rake*, Pl. 8, especially in the way the prisoners are played off against their visitors; the whole *Prodigal Son* series is similar to the *Rake*, especially the scenes of the Prodigal Son and the Rake in brothels; and the marriage contract in *Le Mariage à la Ville* anticipates *Marriage à la Mode*, Pl. 1.

30. *Daily Courant*, 18 February 1723/4; *Daily Post*, 17 March.

31. Reprinted in *Universal Museum* (1764), 549, and in Nichols, *Gen. Works*, I, 15.

32. *Gen. Works*, I, 15.

33. Vertue, VI, 170.

CHAPTER 6

1. *Autobiographical Notes*, p. 205.

2. William Aglionby, *Painting Illustrated* (1685), p. xiv.

3. The day is given on the portrait sketch by

Richardson in the BM. The basic work on Thornhill's life is the unpublished dissertation by W. R. Osmun, *A Study of the Works of Sir James Thornhill* (Univ. of London,

1950), which utilizes most of the sources for a biography. The earliest contemporary biography is contained in Antoine Dézallier d'Argenville's *Abregé de la vie des plus fameux peintres* (Paris, 1745), II, 227–30. Dézallier knew Thornhill in London (he gives his birthdate as 1676) and describes his father's gentlemanly poverty. The second life of Thornhill, in "J.B." 's *The Lives of the Most Eminent Modern Painters who have lived since, or were omitted by, Mons. De Piles* (London, 1754), pp. 136–39, is merely a translation of Dézallier with a few added facts and corrections (e.g., that Thornhill had a son and daughter, not daughters only). See also Edgar de N. Mayhew, *Sketches by Thornhill in the Victoria and Albert Museum* (London, 1967).

4. The Binding Books of the Company of Painter-Stainers, London, 1666–1795, Guildhall Lib. MS. 5669; Croft-Murray, I, 69–70. That the Highmores and Thornhills were Dorset families and related: *GM*, L (1780), 176.

5. Minute Book of the General Court and the Directors of Greenwich Hospital, in the P.R.O., Admiralty Papers.

6. Vertue, I, 45. "Quite early on," as Michael Levey puts it, "England became the goal of many [Venetian painters], chiefly in the hope of getting the commission to paint the interior of St. Paul's" (*Painting in XVIII Century Venice* [London, 1959], pp. 19–20). The Venetian history painters were no longer getting government commissions for their work, and little from the nobility, and so they traveled to foreign lands.

7. Vertue, I, 125.

8. *GM*, LX (Nov. 1790), 992.

9. Vertue, I, 39, 34; Minute Book, 13 September 1715, *Wren Society*, XVI, 119.

10. *The Diary of Dudley Ryder, 1715–1716*, ed. William Matthews (London, 1939), pp. 306–08. Reprinted by permission of Methuen & Co., Ltd.

11. The first story is in Mark Noble (Granger), *Biographical History of England* (1804), III, 371; Whitley, I, 47, tells the second.

12. In 1717, for example, he insisted, before starting on the Upper Hall, on further payment for the Lower Hall, for which he had received only £635. See Minute Book, 27 July 1717, v, 63; Hawksmoor and James are to consult on payments to other artists. 10 August 1717, v, 65: report favorable to Thornhill. 24

August 1717, v, 67–68: Thornhill's letter (publ. *Wren Society* [1929], VI, 77–78; also John Cook and John Maule, *Historical Account of Greenwich Hospital* [London, 1789], pp. 97–98). 21 September 1717, v, 71: price settled on; and 9 December 1717, v, 82–83: approval by General Court.

13. "Neither is Mr. Thornhill to be surprised if he should be entreated by *Long* to paint the Out-side of a *Female-cupola*" (*Freethinker* No. 35, I, 170).

14. P.R.O., Patent Rolls No. 15, Third Series, 13 April 1720, 6th Year of Geo. I. Index/6821; also Patent Rolls, 13 April 1720, c66/3535, and Privy Seal, Index/6760. See also *Political State,* 31 March 1720, XIX, 348: "About the Middle of the month . . . J. Thornhill Esq., History painter to his majesty was appointed Sergeant Painter in the Room of Thomas Highmore Esq. deceased." For his profits, see e.g. the *Declared Accounts of the Paymaster of the Works listing all payments to the Sergeant Painter for the Year 1723,* P.R.O., Record Office, Audit Office Index 2450/154, pp. 167–69 and his own account book for the years 1726 to 1732 (when he retired), Huntington Library, 9230.

15. Vertue, III, 114.

16. He wrote on one of his drawings, now in the Witt Collection, "Library Ciel. for Huggins, for a lady &c." (Croft-Murray, I, 270); see *Gen. Works,* I, 44. The date of the work is unknown, and it may have been done for son William, to whom John gave Headley Park ca. 1725. See L. F. Powell, "William Huggins and Tobias Smollett," *MP,* XXXIV (1936), 183.

17. Minute Books of the Painter-Stainers' Company, II, 1649–1793 (Guildhall Lib. MS. 5667/2), pp. 430–32. Thornhill obtained membership for his son John by redemption, but Hogarth, despite his close connection, never involved himself with the Painter-Stainers. (He is not to be confused with the William Hoggard, a tea-warehouseman of Bow-Lane, who was admitted 18 November 1729 [op. cit., p. 470].)

18. *Members of Parliament 1705–1800,* pt. II, p. 52. With William Betts, Thomas Pease, and John Ward, he represented Weymouth and Melcombe Regis Borough. He was again returned to the first parliament of George II, summoned 28 Nov. 1727 (ibid., p. 63), when Edward Tucker replaced John Ward.

19. John Hutchins, *The History and Antiquities of the County of Dorset*, 3d ed. (London, 1861–73), III, 675.

20. Vertue, I, 65. The advertisement, in the *Daily Courant* of 30 October 1719, says: "The Cupola of the Cathedral Church of St. Paul, painted by Mr. Thornhill, representing eight of the principal Histories of the Acts of that Apostle, and so many Prints thereof by his Direction being near finished by the best Engravers, viz. Simondau, Vandergucht jun., Beavais, Baron, and Dubosch, will be ready to be delivered about Christmas next to Subscribers only, no more being to be printed than shall be subscribed for. Subscriptions are taken in at half a Guinea down, and half a Guinea at Delivery, by E. Cooper in Halfmoon-street in the Strand, at the great Print-Shop of Hemmingsrow in St. Martin's-lane, J. Round in Exchange Alley, B. Cowse and T. Bowles in St. Paul's Church yard, Mr. Clements, Bookseller in Oxford, Mr. Crownfield in Cambridge, the Royal Hospital Coffee-house in Greenwich, and Mrs. Lyndsey at Bath; at which Places a Proof Print may be seen." The *Daily Courant* of 5 February 1719/20 adds: "N.B. If any are printed after, not to be sold under 25s."; publication was 9 May 1720 (*Post Boy*, 3–5 May).

21. Vertue, III, 7; VI, 168–69.

22. Whitley, I, 13; though, as usual, Whitley does not give his source, and I have not found it.

23. Lord Michael Morris Killanin, *Sir Godfrey Kneller and his Times, 1646–1723* (London, 1948), p. 26. Again, no source is given.

24. Walpole Society, XXII (Oxford, 1934), 92; Whitley, I, 12–13.

25. Vertue, III, 74. Vertue also notes that there were included in the sale of Thornhill's collection after his death "Many draughts Plans &c. by S^r James Thornhill. proposed Schemes to Ld. Hallifax for to Build an Accadamy for Paintings at the upper end of the Meuse. his Computation for the whole fabrick. consisting of many apartments convenient for such a purpose and affixt to his designs. £3139. pounds." He probably projected a national academy along the lines of the French Academy, founded by Richelieu (in his mind, Halifax's equivalent), with himself at its head.

26. Whitley, I, 14.

27. *Apology for Painters*, p. 93; Vertue, VI, 170.

28. Vanderbank was born 9 September 1694 (Baptismal Register of St. Giles in the Fields, 16 September); Vertue, III, 15; VI, 170; H. A. Hammelmann, "A Draughtsman in Hogarth's Shadow: The Drawings of John Vanderbank," *Country Life*, CXLI (1967), 32–33; Hammelmann, "Eighteenth-Century English Illustrators: John Vanderbank," *Book Collector*, XVII (1968), 285–99. The portrait of Sanderson was painted for Martin Folkes, engraved by Faber (Chaloner-Smith, no. 316); for the staircase of No. 11 Bedford Row, see Croft-Murray, I, 260, pls. 122–24. A self-portrait, a pen sketch, is in the V & A.

29. Vertue, III, 22; Croft-Murray, I, 244; will, in French, dated 25 January 1723/4, codicil 14 January 1724/5 (P.C.C., Romney, 1301). Vertue says he was an original member of Kneller's academy (III, 68), but does not include him in his list (VI, 168–69).

30. Rate Books, Parish of St. Martin in the Fields, Westminster Public Library.

31. Vertue, II, 126, 150–55; see also Thomas Page, *The Art of Painting* (1720), preface, pp. 3–17.

32. Page, *Art of Painting*, p. 17.

33. Perhaps most readily available to Hogarth in *Conférences . . . sur l'expression générale et particulière, enrichée de figures gravées par B. Picart* (Amsterdam and Paris, 1698; tr. London 1701). Hogarth comments on LeBrun's "Characters of the Passions" in his *Analysis of Beauty*, p. 138.

34. Page, op. cit., p. 17.

35. Anthony Blunt, *Art and Architecture in France 1500–1700*, 2d ed. (London, 1957), p. 201.

36. Quennell, p. 27 (cf. above, I, 42).

37. *Analysis* (rejected passages), p. 185.

38. Ibid., p. 184; *Autobiographical Notes*, pp. 207–08, 202.

39. *Gen. Works*, I, 242, 24; Oppé, Introduction, especially p. 13, and cat. nos. 30, 88.

40. *Analysis* (rejected passages), p. 185.

41. Ibid., pp. 185, 195.

42. John Elsum, *The Art of Painting after the Italian Manner* (1703), pp. 66, 138.

43. Lairesse, *Het Groot Schilderboek* (Amsterdam, 1707), tr. J. F. Fritsch, *The Art of Painting in all its Branches* (London, 1738), chap. 2, p. 102.

44. Richardson, *Works*, p. 20.

45. Vertue, III, 138.

46. Ibid., III, 62.

47. Ibid., III, 39, 54.

48. Ibid., III, 33, 37.

49. The advertisement says the lectures are to be held in Crane Court, Fleet Street, to begin 28 March at 6 P.M. (e.g. in the *Daily Courant*, 21 March 1720/1). As members of the academy, Hogarth and Cheselden would have known each other, and in the late 1720s, when Cheselden was preparing his *Osteographia, or The Anatomy of the Bones* (published in 1733), he posed his skeletons as the famous drawing school statues. An excellent draughtsman, Cheselden shows one skeleton in the pose of a man praying (reminiscent of the *St. Francis* Hogarth uses in *The Battle of the Pictures*), others with the pose and proportions of the *Apollo Belvedere* (pl. 35) and the *Venus de Medici* (pl. 34). Hogarth used the same statues to illustrate his own treatise, *The Analysis of Beauty*, in 1753. See Sir Vincent Z. Cope, *William Cheselden* (London, 1953), pp. 9, 73–74.

50. Richardson, *An Argument in Behalf of the Science of a Connoisseur* (1719), p. 6.

51. Vertue, III, 14. Burrell Massingberd wrote back to Kent on 4 August 1713, "The French newspaper said it was a German yt won it, but I showed my letter to Mr. Gale and he gott it altered in English News and added ye place of yr birth." Indeed, in the *British Mercury* for 5 August: "Mr. W. Kent, born at Bridlington in Yorkshire, is said to have gained the annual prize given by the Pope in the Capitol for painting." Further biographical materials are reprinted in Margaret Jourdain, *Work of William Kent* (London, 1948). See also Ulrich Middeldorf, "William Kent's Roman Prize in 1713," *Burlington Magazine*, XCIX (1957), 125; on Kent's study under Benedetto Luti, and his decoration of the ceiling of S. Giuliano dei Fiamminghi (1717), see Croft-Murray, "William Kent in Rome," *English Miscellany*, ed. Mario Praz, I (1950), 221–29; Hugh Honour, "John Talman and William Kent in Italy," *Connoisseur* (Aug. 1954), 3–7.

52. James Lees-Milne, *Earls of Creation, Five Great Patrons of Eighteenth-Century Art* (London, 1962), pp. 227–28.

53. Ibid., pp. 104–12, 229–30.

54. Jourdain, p. 31.

55. Vertue, III, 139.

56. Ibid., I, 100; III, 139.

57. The "letter concerning Design" was not published until it was appended to the fifth edition of the *Characteristics* in 1732. One can assume, however, that it was read in manuscript by the dedicatee, Lord Somers, and his circle; and that its contents were known to a larger circle. (See Benjamin Rand, ed., *Shaftesbury's Second Characters* [Cambridge, 1914], pp. xvi–xvii.) The question of influence can only be speculated upon. Kent met Coke at Naples in May 1714, when Shaftesbury was also there; thus Kent may have known Shaftesbury and communicated his new doctrine to Burlington.

58. *Second Characters*, ed. Rand, pp. 20–22.

59. For Kents' history paintings for Burlington House, see Croft-Murray, "Decorative Paintings for Lord Burlington and the Royal Academy," *Apollo*, LXXXIX (1969), 14–16, figs. 6–8. For the replacement of Gibbs by Campbell on Burlington House, see Howard E. Stutchbury, *The Architecture of Colen Campbell* (Cambridge, Mass., 1967), p. 23.

60. Hussey, Introduction, to Jourdain, *Kent*, p. 20. I am, of course, viewing Burlington from the limited perspective of Hogarth–Thornhill. For a broader view, see R. Wittkower, "Pseudo-Palladian Elements in English Neo-Classical Architecture," *Journal of the Warburg and Courtauld Institutes*, VI (1943), 154–64; "Lord Burlington and William Kent," *Archaeological Journal*, CII (1945), 154–55; and *The Earl of Burlington and William Kent*, York Georgian Society, Occasional Papers, No. 5 (1948).

61. Vertue, II, 125–26. The play was "for the Benefitt of his son," Jack Laguerre, "who was newly entred to sing there," but who also painted (see below, chap. 13).

62. Vertue, III, 139.

63. Although he may have had a hand in the designing of Moor Park near Rickmansworth, the only building for which he was undoubtedly responsible was Thornhill Park, near Stalbridge, Dorset. His pottering there cannot be called the work of a trained architect but only the experiments of someone modernizing his family's ancient seat. (See J. Hutchins, *History of Dorset*, 3d ed. [1861–73], III, 672ff.) His dilettantish interest in architecture emerges in his wall paintings; at Wimpole he created a whole room in painted architecture.

64. In one sense, at least, Vanbrugh's in-

dignation was not really warranted; in 1704 he was made Clarenceux King of Arms over the deserving candidate, Gregory King (see Laurence Whistler, *Sir John Vanbrugh, Architect & Dramatist* [London, 1938], pp. 97–98).

65. Vertue, III, 55.

66. P.R.O., Treasury Papers, vol. CCXLIII, 1723, Jan.–June.

67. P.R.O., Audit Office Index, 2450:156. For subsequent years, see: A.O.I. 2451:157 (1723), 2451:158 (1724), 2451:159 (1725), 2451:160 (1726), and 2451:161 (1727).

68. Whistler, p. 278.

69. Vertue, III, 11.

70. Vertue, VI, 170; Hogarth, *Apology for Painters*, p. 93.

71. Vertue, III, 20; *Daily Post*, 12 November 1724.

72. *Apology for Painters*, pp. 93, 95. See also Vertue, III, 21.

73. *Daily Courant*, 13 March 1715/16.

74. A. P. Oppé, *Print Collector's Quarterly*, XV (1928), 65–70.

75. Thornhill is mentioned every year in the Poor Rate books from 1722 till his death in 1734 as living on the north side of Covent Garden east of James Street. Until 1726 the house next to him was owned by George Bubb Dodington (Overseer of the Poor Accounts, 1722–35, Westminster Public Library). Thornhill appears listed in the Freeholder's Book for 1728 (Middlesex County Record Office), so must have owned the property by that time. The room that he added, according to Chancellor (*Annals of Covent Garden* [London, n.d.], p. 249), faced on James St. But this is impossible to connect with the house attributed to him in the rate books.

76. Vertue, III, 30 (written in 1726).

77. From "A Hue and Cry after Four of the King's Liege Subjects," *Wren Society*, XVII (1940), 12. Thornhill made portraits of the "club"—besides Prior, the second Earl of Oxford, Christian the seal engraver, Tudway the musician, Gibbs the architect, and Bridgman the gardener; and Prior wrote verses under the drawings. (See Sir John Hawkins, *A General History of . . . Music* [London, 1776], v, 93; Vertue, III, 27.)

78. *Times Literary Supplement*, 9 February 1967, p. 99.

CHAPTER 7

1. *Pasquin*, 18 February 1723/4; *Daily Courant*, 24 February.

2. See *Analysis*, pp. 130–31; *HGW*, I, 242.

3. *Spectator*, I, 22–23, 123.

4. Paul Henry Lang, *George Frideric Handel* (New York, 1966), pp. 151, 148–49.

5. *Weekly Journal or Saturday's Post*, 2 March 1722/3.

6. *Spectator* Nos. 8 and 14. Cf. Fielding, *The Masquerade* (1728), p. 3.

7. For a description, see *Mist's Weekly Journal*, 15 February 1718; see also Phillips, *Mid-Georgian London*, figs. 111, 366; "Memoirs of J. J. Heidegger" *LM*, XLVIII (1779), 452–53. A painting attributed to Guiseppi Grisoni in the V & A shows a masquerade on the stage of the King's Theatre, Haymarket, ca. 1724.

8. *Weekly Journal or Saturday's Post*, 21 September 1723.

9. *Daily Courant*, 28 December 1723; *Weekly Journal or Saturday's Post*, 2 February 1722/3.

10. *London Journal*, 2 February 1722/3 and 2 March 1722/3.

11. Thomas Davies, *Memoirs of the Life of Garrick*, 3d ed. (1781), I, 331, 92; cf. Fielding, *Tom Jones*, Bk. v, chap. 1.

12. See the contemporary pamphlet by Gabriel Pennel, *Tragi-Comical Reflections, of a moral and political Tendency, occasioned by the present State of the two Rival theatres in Drury Lane and Lincoln's-Inn Fields* (ca. 1724), pp. 12–13.

13. It is important to notice that Hogarth shows the Lincoln's Inn Fields Theatre, with its western entrance, which stood in the center of the south side of Lincoln's Inn Fields (see Phillips, p. 192 and fig. 262). He does not show Drury Lane, as he might have been expected to, considering the books being carted away. The question of Drury Lane's particular problem apparently did not engage his interest until the fiasco of *Harlequin Sheppard*.

14. *Weekly Journal, or Saturday's Post*, 9 March 1722/3 and 24 August 1723.

15. *London Journal*, 19 October 1723.

16. *Daily Post*, 1 March, 18 May; *Daily Cour-*

ant, 18 October; *Daily Post,* 16 December 1723.

17. *Spectator* No. 31, 5 April 1711.

18. *A Sermon preached before the Societies for the Reformation of Manners,* 6 January 1723/4; quoted, Norman Sykes, *Edmund Gibson* (1926), p. 188.

19. Cf. I, 96 above. Roger De Piles, *The Art of Painting* (London, 1798 ed.), p. 18, refers to the "grand gusto," the quality a talented artist must impart to his copies of the ancients: "something great and extraordinary to surprise, please and instruct." See also *Spectator* Nos. 229, 244, 592.

20. See "List of Subscribers to the Royal Academy of Musick," P.R.O., LC. 7/3; *Gen. Works,* II, 26.

21. *Autobiographical Notes,* p. 205.

22. *The Case of Designers, Engravers, Etchers, &c. stated. In a Letter to a Member of Parliament* (n.d., probably late 1734 or early 1735); a copy is in the V & A.

23. In April 1720, according to his shop card, Hogarth was living and working "Near the Black Bull, Long Lane," i.e. in his mother's house. By February 1724 he was "at yᵉ Golden Ball yᵉ Corner of Cranbone Alley little Newport Street," according to a later state of the shop card and the advertisement for *Masquerades and Operas* (GHW, I, 92; *Daily Courant,* 24 February 1723/4). No record, of course, survives in the rate books since Hogarth would have been a sub-tenant. There are unsubstantiated traditions that he spent some time in 1719 in Cirencester at the Ram Inn (*Notes & Queries,* 6th series, LXIII [1881], 25, 71, 72, 136, 156) and at the Elephant and Castle in Fenchurch Street (a print, showing the housefront, was published by A. Beugo, 38 Maiden Lane, Covent Garden, 6 April 1812; in the Nichols Collection, Fitzwilliam, vol. 5). He is also supposed to have lived at one time over the shop of a colorman named Robb at No. 64 St. Martin's Lane (Holden Macmichael, *Charing Cross* [1906], p. 321) and has been connected with the "Bull and Bush" Inn at North End, Hampstead, where a yew bower in the garden was attributed to his planting (W. Baines, *Hampstead* [1890], p. 233).

24. Steele's visit to Greenwich Hospital and his description of Thornhill's work appeared in the *Lover* No. 33, Tuesday 11 May 1714 (reprinted in *Richard Steele's Periodical Journalism, 1714–16,* ed. Rae Blanchard [Oxford, 1959], pp. 117–20). Steele, as a Director of the Academy of Painting (since 1712), apparently attended an official inspection of this "Piece of Painting of *Mr. Thornhill's,* which is an Honour to our Nation," as he calls it in No. 34 (p. 121). Thornhill had painted Steele's portrait in 1713 (later, engraved by Basire, used as frontispiece for editions of Steele's journalism in 1789). The official *Explanation,* published by the Hospital, follows Steele's (limited, of course, to the Lower Hall).

25. Thornhill got the general idea for his oval from Rubens' Banqueting Hall ceiling (engr. Gribelin ca. 1712), though he has reposed and rearranged the figures; but he keeps Hercules and Envy, Minerva and Ignorance, and the general idea of the apotheosis of the king. He also uses a Hercules in his paintings for the Sabine Bedroom, Chatsworth.

For the William III–Hercules iconography, see BM Sat. 1178, 1197, 1206, 1218, 1252, etc. For background of the iconography, see Corrado Vivanti, "Henry IV, the Gallic Hercules," *Journal of the Warburg and Courtauld Institutes,* XXX (1967), 176–97.

26. William Whiston's *The Transit of the Shadow of the Moon over Europe in the Eclipse of the Sun May 11, 1724, in the Evening,* was advertised in the *Daily Courant,* 29 April, and *Daily Post,* 30 April; and pamphlets by Thomas Wright, identified as Mathematical Instrument Maker to the Prince of Wales, and Edmund Halley appeared in various journals. Glasses were advertised by William Rodwell (*Weekly Journal or British Gazetteer,* 9 May) and the Bowles brothers (*Daily Journal* and *Daily Post,* 11 May).

27. See "The Minutes of the Grand Lodge of Freemasons of England 1723–1739," introduction and notes by W. J. Songhurst, in *Quatuor Coronatorum Antigrapha,* X (1913). Thornhill appears in the MS. List of 27 November 1725 as Master of the lodge that met at the Swan in East Street, Greenwich (Lodge No. 25 in the Engraved List of 1729; p. 40). This lodge was constituted in 1723 but does not appear in manuscript lists until 1725 (p. xiii). It is safe to assume that Thornhill had been a member since its organization, and further, that he chose Greenwich because he had lived there while working on the Hospital.

At the meeting of the Grand Lodge, 27 December 1728, Thornhill was chosen Senior Grand Warden (p. 69; and in list, p. 198).

28. R. F. Gould, *A Concise History of Freemasonry* (London, 1903), pp. 282–89.

29. The *Constitutions* were advertised as published in the *Post Boy*, 26–28 February 1722/3.

30. *Daily Post*, 22 August; *Daily Courant*, 8 September; *Dublin Gazette*, 8 September; *British Journal*, 12 September; *Daily Courant*, 28 September. See Gould, "Masonic Celebrities: No. VI.—The Duke of Wharton, G. M., 1722–23; with which is combined The True History of the Gormogons," *Ars Quatuor Coronatorum*, VIII (1895), 114–55.

31. Announced, *Daily Post*, 4 January 1723/4.

32. Twickenham ed., VI, *Minor Poems*, ed. Norman Ault and John Butt (1954), 143.

Pope's lines on Addison had been first published in 1722, but Hogarth follows the version published in 1723 in *Cythereia: Or, New Poems upon Love and Intrigue*:

> Who would not laugh, if such a Man there be?
> Who would not weep, if A——n were He?

33. The first MS. list in which Hogarth appears is that of 27 November 1725, in the lodge that met at the Hand and Appletree, Little Queen Street. (Lodge No. 41 in the Engraved List of 1729; p. 43).

34. If the print had been taken as more than a reproof, and Hogarth were not yet a mason, it seems unlikely that he would have been admitted to a lodge afterward. The alternative—that Thornhill converted Hogarth, or that he saw that it was to his advantage to become a mason, and later joined—seems less likely.

35. Eric Ward, "William Hogarth and his Fraternity," *Ars Quatuor Coronatorum*, LXXVII (1964), 1.

36. *Daily Post*, 22 October 1724. Quotations are from Gould, "Masonic Celebrities," p. 125.

37. It has also been suggested (Gould, *Concise History*, p. 288; repeated by Ward, p. 15) that the figure kissing the old gentlewoman's posterior is James Anderson, ridiculed by Verus Commodus as author of the *Books of Constitutions;* that the "old gentlewoman" is meant for a portrait of Theophilus Desaguliers, a past Grand Master, and with Anderson responsible for the *Constitutions* (there is a distinct resemblance to Hysing's portrait); and that Don Quixote resembles the Duke of Wharton. There is no resemblance to any portrait of Wharton known to me, though this would have been an appropriate form to give him, especially considering that Hogarth cannot have approved of the Gormogons.

38. See, e.g., Alciati's *Emblemata* (Patavii, 1661), emblem 7; Apuleius, *Metamorphoses*, 8.

39. *Daily Post*, 2 December 1724.

CHAPTER 8

1. *Weekly Journal or Saturday's Post*, 24 October; *Daily Journal*, 10 November 1724.

2. The most Hogarthian composition in the Thornhill sketchbook in the BM (Dept. of Prints and Drawings 201.6.8) is on f. 52r (pl. 38a). Others that might be mentioned include a sketch of a Good Samaritan composition, not unlike Hogarth's, in St. Bartholomew's Hospital (f. 13v.), small genre subject sketches (f. 20v.), a Dutch scene with a smoking man, a man fondling a woman, etc. (f. 35v.), an Ostade-like outdoor tavern scene (f. 51v.), and a sketch of card players very like some of the small paintings of this subject attributed to Heemskirk (verso of f. 52).

3. The portraits are essentially of two kinds: the small intimate portraits like the three he made for Bentley for Trinity College, Cambridge, or (drawings) of Prior and other members of that circle; larger portraits which are essentially extensions of his decorative painting, such as the three life-size works in the Hall of All Souls, which, W. R. Osmun observes, "perform exactly the same function that Thornhill's painted walls exercise in saloons and stair halls. Whether by design or accident these three paintings embody the ecclesiastical, military and civil at their most decorative" (*A Study of the Works of Sir James Thornhill* [Univ. of London, 1950], p. 130).

Sheppard, of course, most nearly approaches the first of these categories. The second represents what have been called "the most truly Baroque essays in portraiture by an English painter" (David Piper, *The English Face* [London, 1957], p. 182).

4. The drawing in the BM (1411-10-18-4) is of head and shoulders only; I know of no other surviving drawing, and there was apparently no painting.

5. *Weekly Journal or Saturday's Post,* 5 December.

6. Ibid.; also *Daily Journal,* 5 December, and *Daily Post,* 9 December, which adds "Price 1 s."

7. *Daily Post,* 30 November.

8. See John Loftis, *Steele at Drury Lane* (Berkeley and Los Angeles, 1952), pp. 74–85.

9. Loftis, pp. 88–89.

10. Taking Hogarth's print together with George Farquhar's lines in his epilogue to *Love and a Bottle* (1699), "Vivitur Ingenio; *that damn'd Motto there / Seduc'd me first to be a Wicked Player,"* it appears that the motto was displayed above the Drury Lane stage; and, moreover, that Hogarth's print is a portrait of that stage. See Burton Egbert Stevenson, ed., *Macmillan Book of Proverbs, Maxims, and Famous Phrases* (1965), p. 941. A print called *Muster of Bays's Troops Anew* (1745) also shows Drury Lane's stage with the motto in the same place.

11. BM Dept. of Prints and Drawings, 1865-6-10-1327.

12. Thornhill's dilemma as history painter was perhaps more complex than I have suggested: seventeenth-century academic theory of decorum required a certain degree of accuracy. If George had landed in the winter, ice should be on the water, and the number of those landing with him should not be falsified (see, e.g., Félibien, *Entretiens,* 2d ed. [Paris, 1685–88], II, 382).

13. See Osmun, pp. 59–60.

14. *The Theory of Painting* (1715), pp. 165, 122. For the preeminence of Raphael, evidently accepted by Hogarth: see Fréart de Chambray, *An Idea of the Perfection of Painting,* tr. J[ohn] E[velyn] (London, 1668), preface; Du Fresnoy, *The Art of Painting,* tr. Dryden, 2d ed. (London, 1716), pp. 225, 288; André Félibien, *Des Principes de l'Architecture . . .* , 2d ed. (Paris, 1690), p. 397; P. Mo-

nier, *History of Painting . . .* (1699), pp. 118–22; William Aglionby, *Painting Illustrated in Three Dialogues* (London, 1686), pp. 76, 123, 80, 82, 125; Roger De Piles, *Art of Painting* (London, 1798 ed.), pp. 294–300.

15. *Spectator* Nos. 172, 142 (feigned letter).

16. For an earlier account, see *Tatler* No. 209 (8–10 August 1710), where he says a painter should paint not "the Battles, but the Sentiments of *Alexander."* He argues that History painting should "not for the future have so Romantick a Turn, but allude to Incidents which come within the Fortunes of the ordinary Race of Men."

17. *Autobiographical Notes,* p. 215; also p. 230.

18. Defoe, discussing the Cartoons in his *Tour* (I, 10–11), singles out *Paul Preaching* and the *Death of Ananias* because of the passions depicted; Sir Richard Blackmore also draws attention to Ananias "struck dead in an Instant by the Breath of an Apostle," which serves to give the viewer "awful Impressions of Divine Vengeance" ("The Parallel between Poetry and Painting" in *The Lay Monastery* [1714], p. 188).

19. When Hogarth's *Hudibras* prints appeared, Overton advertised them with the *Quixote* prints, and continued to do so as late as 1728 (see *Post Boy,* 13–16 July 1728).

20. See above, I, 67.

21. Thornhill made small modelli for the "Vinegar Bible," printed by John Baskett (1717): the frontispiece engraved by Claude Dubosc, and a few headpieces in vol. 1 engraved by Du Guernier and Dupuis. The rest were after Cheron and Laguerre, engraved by M. and G. Vandergucht and others. All of these were printed by subscription. See also C. H. Collins-Baker, "Sir James Thornhill as Bible Illustrator," *The Huntington Library Quarterly,* x (May 1943), 323–28.

22. A very few etchings have survived: one of a display of fireworks on 7 July 1713 to celebrate the Peace of Utrecht, later published reduced in *GM,* xviii (May 1749), 202; and an invitation to celebrate St. Luke's Day at Thornhill's house in Covent Garden in 1718. On one impression is written: "N.B. J. Thornhill etch'd this plate Nov. 5th between 6 a clock in ye Evening & 11 ye same night over a Bowl of Punch in commemoration of Sagitarius's having stolen St Luke from Scorpio"

(BM. 1874-8-1022, publ. by Oppé, *Print Collector's Quarterly,* xv [1928], 65–70). This suggests how little Thornhill was interested in printmaking.

23. They were presumably intended for Tonson's edition of *Paradise Lost* and *Regained,* in two volumes [12 mo], announced for publication the week of 20 September 1725 (*Daily Post, Daily Courant,* 17 Sept.).

24. In the engravings of the Farnese decorations Hogarth found many motifs, from the *Judgment of Hercules* to the satyr in *The Beggar's Opera* and the *Flaying of Marsyas* and *Europa and the Bull* in *The Battle of the Pictures.*

25. Some of the names from the subscription list for *Hudibras* are reprinted in *Gen. Works,* III, 321. These include Lord Compton, the Earl of Derby, Sir Arthur Haslerigge, and Lord Newell; Alderman John Barber and other City names, and the engravers Kirkall, Vandergucht, and George White.

26. See Burns Martin, *Allan Ramsay, A Study of his Life and Works* (Cambridge, 1931); Alastair Smart, *The Life and Art of Allan Ramsay* [the younger] (London, 1952), pp. 1–17.

27. See *Christ's Kirk o' the Green,* III, 1–9, in *Poems of Allan Ramsay* (London, 1800), I, lxxxiii–lxxxiv, 82.

28. William Ward was the son of Thomas Ward of Houghton and matriculated at Trinity College, Oxford, 25 May 1688, aged sixteen (so was born ca. 1672). He was a student of the Middle Temple in 1696 and became a London barrister. He married Catherine Last sometime before 1695, when her father, Andrew Last of Thor-Underwood, died and left her his manor house of East Haddon Hall, Northampshire. Ward was evidently dead by 1737 when his son Thomas sold the house and furnishings. See *Foster's Inns of Court Register;* George Baker, *History and Antiquities of Northampton* (1822–30), I, 163–64.

29. *The Evening Post,* 5–7 October 1725. The other references that follow are to the *Post Boy,* 30 November–2 December, 4–7 December, 3–5 February, 26 February–1 March (1725/6), 30 April–3 May (1726).

30. *Analysis,* p. 132 n.; see also Dézallier, *Abregé,* p. 229: "Ces grands ouvrages seroient assurément plus estimés s'ils étoient tout de la main de *Thornhill;* ils sont toujours de son

dessein, & l'on ne peut s'empêcher en les voyant, de critiquer leur incorrection, & leur coloris troppeu châtié: on souhaiteroit même qu'il y eût moins de figures. . . ."

32. P.R.O., Treasury Minute Book, vol. xxv, 1725–May 1727, p. 113. Kent made Master Carpenter and Surveyor: ibid., June 1726–May 1727.

33. Announced, *Daily Courant,* 10 September; I have used the text printed by Nichols, *Gen. Works,* I, 457–63.

34. That Kent's altarpiece remained in the vestry room and was there in 1789 is attested by *GM,* LIX (1789), 391.

35. In Yale University Library; reproduced, C. F. Burgess, *The Letters of John Gay* (Oxford, 1966), pp. 53–54.

36. Kent's close association with Gay and Pope was not without effect. As Jeffrey P. Eicholz ("William Kent's Career as Literary Illustrator," *Bulletin of the New York Public Library,* LXX [1966], 620–46) has argued, Kent as an illustrator grasped and conveyed Gay's intention in his plates for *The Shepherd's Week*—an intention not unlike Hogarth's in some of his independent plates. See also Croft-Murray, "William Kent," *English Miscellany,* ed. Mario Praz, I (1950), 221–29.

37. H. S. Ashbee, in *Transactions of the Bibliographical Society,* I (1893), 123–24. See H. A. Hammelmann's extremely valuable article, "John Vanderbank's 'Don Quixote,'" *Master Drawings,* VI (1969), 3–15, and pls. 1–10.

38. Announced, *London Journal,* 27 March 1725. Vandergucht was advertising 22 *Don Quixote* prints for sale in his shop in 1728 (*Daily Post,* 6 December).

39. Carteret to Sir Benjamin Keene (ambassador in Madrid), accompanying a copy of Oldfield's "Advertisement" and a set of the prints, 24 August 1737, in *Private Correspondence of Sir Benjamin Keene,* ed. Sir Richard Lodge (Cambridge, 1933), p. 7.

40. One wonders why he engraved his own designs and Vanderbank passed his on to Vandergucht: whatever the reason, this may have been one motive for not continuing, and would certainly have ruled out collaboration, for his style is plainly at odds with Vandergucht's. A possibility that should not be overlooked is that Hogarth withdrew to give Vanderbank the whole commission. The latter was so seriously in debt between 1724 and

1729 that he was arrested several times and was forced to live within the Liberties of the Fleet, a situation that would have struck a responsive chord in Hogarth. By 1729 Vanderbank was lodged in the Marshalsea Prison. His mother had died at the end of 1727, and to keep away his creditors she left everything to his brother Moses, who once he had the property sold the workshop in Great Queen Street and his office of Yeoman Arras Worker to the Wardrobe, and with John's part of the proceeds discharged his brother's debts, freeing him by the end of 1729. Vertue has unfavorable things to say about Vanderbank as a friend, and we have no way of knowing how his friendship with Hogarth continued, but Vanderbank must have represented to him an example of wasted talents.

41. These six plates have always been attributed to 1738 because it was only in April of that year that Carteret's *Don Quixote* finally appeared. Carteret had a copy of 20 April (*Correspondence*, p. 11); the subscription was over by 7–9 February 1737/8 (*London Evening Post*); and it was published on 28 April (*Daily Gazetteer*). The delay was partly due to the expense of such a large undertaking, and perhaps to Carteret's multifold activities of those years; also, there were 68 illustrations, and Vandergucht's engraving of them must have taken some time, though not ten years. The excessively long delay was apparently due to the "life" of Cervantes that had to be compiled and written (Jacob Tonson's edition of Racine had also included a "life"). Carteret entrusted the task to Don Gregorio Mayans y Siscar, the librarian to the King of Spain, who did not deliver his manuscript to the editor until 18 February 1736/7. (See Carteret to Keene, 20 April 1738; 26 March 1737, in *Correspondence*, pp. 11, 7.)

42. Letter from Richard Livesay to Lord Charlemont, 18 September 1786, *HMC, 13th Report*, Appendix, pt. VIII, vol. II, 40.

43. See Carteret to Keene, *Correspondence*, p. 11; and Carteret's "Dedication."

44. Nor did he stop when he had finished his designs for Carteret's edition. Perhaps because of the inordinate delay in publication, perhaps because he could not let the subject alone, he elaborated his subject further in a version of 23 more (BM), larger and different in format; and he continued to paint versions in oil, which could not have appealed to the patrons whose portraits he painted, up to the time of his death. Perhaps he planned to bring out a series of his own, issued like Hogarth's *Hudibras*; perhaps, like Thornhill, only as an outlet.

45. Vertue, III, 98.

46. See H. A. Hammelmann, "Early English Book Illustrators," *Times Literary Supplement*, 20 June 1968, pp. 652–53.

47. Quoted, *Lord Hervey and his Friends, 1726–38*, ed. Earl of Ilchester (London, 1950), p. 82 n. Reprinted by permission of the publisher, John Murray.

48. *Weekly Journal*, 19 November 1726.

49. *British Journal*, 3 December, 1726.

50. *Weekly Journal*, 10 December 1726.

51. *Daily Journal*, 12 December 1726; *Daily Courant*, 14–15 December; *London Journal*, 17 December; *Daily Courant*, 20 December; *Daily Journal*, 23 December, 11 January 1726/7; *Daily Post*, 16, 27 January.

52. *Post Boy*, 22–24 December 1726.

53. See Charles B. Realey, *The Early Opposition to Sir Robert Walpole, 1720–1727* (Lawrence, Kansas, 1931), pp. 187–92, 193–95.

54. Archibald S. Foord, *His Majesty's Opposition, 1714–1830* (Oxford, 1964), p. 120; *Observations on The Craftsman* (1730), p. 11.

55. *Daily Post*, 3 December 1726 and *Evening Post*, 8 December. *Gulliver's Travels* was announced as published 28 October (*Daily Journal, Daily Post*, etc.). There was no advertisement for *The Punishment of Lemuel Gulliver* in the *Craftsman*, but then the *Craftsman* published no advertisements to speak of at this time.

56. *Daily Journal* and *Daily Post*, 5 December; *Daily Journal*, 8 December.

57. *Correspondence of Jonathan Swift*, ed. Harold Williams (Oxford, 1963), III, 181, 183.

58. See *HGW*, I, 137.

59. There is no sign that Heidegger was made Master of the Revels, as the *DNB* and other writings on him state. The only record I can find is that Francis Henry Lee was made Master of Revels in place of Sir Richard Steele in August (*London Journal*, 12 August 1727), and Charles Lee succeeded Francis Henry Lee, deceased, in October 1731 (*Daily Journal*, 6 October 1731).

60. *Craftsman*, 27 January 1727/8, announcing publication on Monday 29 January.

61. See J. F. Hayward, *Huguenot Silver in England, 1688–1727*, p. 75. Hogarth's commissions for engraving silverplate were not, however, insignificant. In 1723 or '24 he had engraved arms for the Duchess of Kendal (*HGW*, I, 85, 98–99, 293–94).

62. See C. Oman, "English Engravers on Plate—Joseph Sympson and William Hogarth," *Apollo*, LXV (1957), 286–89.

63. *An Explanation of the Paintings in the Royal Hospital . . .* , p. 8.

64. See *HGW*, cat. no. 18, pls. 20, 21.

65. Vertue, VI, 190.

CHAPTER 9

1. Vertue, III, 41.

2. See J. B. Nichols, *Anecdotes* (1833), pp. 349–50. The location of the *Hudibras* paintings owned by William Ward is now unknown, though others have come to light that have been tentatively attributed to Hogarth. One set, now in the Mellon Collection, is copied from the engravings with many variations. If these paintings are by Hogarth (which I doubt), they illustrate a shift in direction from the Raphaelesque bent of the prints to the low-life convention of Heemskirk, Ostade, and (closer to home) Francis Le Pipre, whose set of *Hudibras* paintings was known to the painter of these panels (most of Le Pipre's are now in the Tate Gallery). Though differing widely in quality of execution, and for this reason suggesting a painter teaching himself, the panels are nevertheless the works of a talented painter.

3. These unauthenticated works are a body of very crude paintings, two or three of them shop signboards and others in the same rough style; their attribution to Hogarth cannot be taken seriously until at least one painting from the period before 1728 can be definitely authenticated. For this reason, I have not reproduced any of them; at present they belong not in a biography of Hogarth but in the "questionable" section of a *catalogue raisonné* of his paintings.

The bases for attribution are their subject matter—they show people working at professions, sometimes in what seem to be Hogarthian poses—and the fact that they are painted in an impasto version of the sketchy style of the early authenticated paintings like the Capel Cure *Beggar's Opera*. To accept these works, one need not suppose that Hogarth painted much before 1727; the supposition required is that he began to paint in thick paint in the "bold manner" he later used with thin paint.

For example, in *The Doctor's Visit* and *The Carpenter's Yard* (Tate Gallery) paint has been applied as in the authentic sketches, but with a heavier pigment; and the subject is professions. Also, these works illustrate a discrepancy typical of Hogarth, between the knowledgeable, careful handling of bodies and the perfunctory approach to architecture: the vague, haphazard bed and room in the *Visit* and the carelessly shaped houses around the carpenter's yard. Finally, the pinks of the *Yard* and the orange-red bedding of the *Visit* suggest the colors Hogarth learned from Thornhill. But these similarities do not suffice for attribution.

4. Thornhill was paid over £230 between Dec. 1727 and June 1728 for furnishings for Cannons. See C. H. Collins Baker and Muriel I. Baker, *The Life and Circumstances of James Brydges, First Duke of Chandos, Patron of the Liberal Arts* (Oxford, 1949), p. 92. For Morris, see V & A, *Catalogue of Tapestries* (1924), pp. 19, 20; *Country Life*, LV, 656; A. F. Kendrick, *English Decorative Fabrics* (1934), pp. 74, 76, 82; *Burlington Magazine*, XXX, 147; XXXI, 157; XXXXII, 210–17; W. G. Thomson, *History of Tapestry* (1930), pp. 491–92.

5. The brief of the defendant (i.e., Morris) in the case that followed, from which I quote, is reproduced below in Appendix D.

6. A large lot of tapestry hangings, chairs, and fire screens belonging to Morris was advertised to be sold 15 May 1729 next door to the Golden Ball in Pall Mall (*Daily Post*, 15 May 1729). This may have included Hogarth's ill-fated painting, which at any rate has never come to light.

7. On the other hand, Moses, said to be even more profligate than John, can have had little to do with the business, which he sold in or around 1729. His only known work is an

altarpiece in Yorkshire and a single book illustration. He went bankrupt in 1734 (Hammelmann, "Vanderbank," *Book Collector*, XVII [1968], 299). John seems the more likely, assuming he was out of debtors prison at the time.

8. The story was told Vertue by Cock the auctioneer (III, 27): "when the affairs of the Southsea Directors. came to be examin'd by yᵉ Commissioners. Sʳ J. Thornhill demanded 1500 pounds for painting a stair case & little hall. for Mʳ Knight which they thinking an unreasonable demand employ'd a person to view it & give in an estimate the best he could . . . by means of Mʳ Broderick. they got from the Dutchess of Marlborough an account of the agreement made between her Grace & Sʳ James Thornhill for painting of Blenheim Hall. which was actually at 25 shilling p yard. which price & no more they would allow Sʳ James for what he had Done for Mʳ Knight." (See above, I, 71).

9. Vertue, III, 35–36, 46. No record of a trial between Styles and Thornhill appears for the years 1727–30 in the Docket Books of Plea Rolls at the P.R.O.

10. Vertue, III, 63, written in 1732. At some later time the Thornhill canvases, now cut into segments, were framed and hung along the gallery above the Hall. They were not mentioned at all by Horace Walpole in his *Visits to Country Seats* (Walpole Society, XVI [1927–28], p. 24). For views (not facts) see H. A. Tipping, *English Homes, Early Georgian, 1714–60* (London, 1921), pp. 169–82; and *Victorian Country Houses: Hertfordshire* (London, 1908), II, 377.

11. See above, Chap. 6, n. 16.

12. Thornhill's one known assistant was Dietrich Ernst André (ca. 1780–1834?), the T. Andrea mentioned by Vertue (IV, 145) as etching an opera ticket: "this was the man that worked for Sr. J. Thornhill"; together with Servandoni he painted a staircase for the Duke of Queensbury's London House (III, 68), and there were pictures by him in Thornhill's collection (III, 74). He painted the west wall of the upper Hall ("Britophil" essay, see below, Appendix F), because Thornhill was not paid enough to do it himself (*Analysis*, p. 132 n). (He is also referred to by Antoine Dézallier, *Abregé de la vie des plus fameux peintres* [1745], II, 229; and "J. B.", *Lives of the Most Eminent Modern Painters* [1754], p. 137.) John Ellys also seems to have worked for Thornhill in a similar capacity (Vertue, III, 47).

13. Boswell, *Life of Johnson*, under date of 1775 (ed. G. B. Hill, New York [1889], II, 422); cf. Macklin's account, W. Cooke, *Life of Macklin*, 2d ed. (1809), p. 57. For general background, see W. E. Schultz, *Gay's Beggar's Opera* (New Haven, 1923).

14. *Daily Journal*, 1 February 1727/8; Pope, note to *Dunciad*, III, l. 330; Vertue, III, 58 (see below, Chap. 11).

15. *Daily Post*, 12 March 1728.

16. *Autobiographical Notes*, pp. 178, 180, 186, 187; HGW, cat. no. 6, pl. 8. Hogarth has misquoted Shakespeare, confusing the line in question ("Wait close; I will not see him," *Henry IV, 2*, I.2.64) with the stage business that traditionally accompanied it; and he has substituted "lord Chancellor" for the Lord Chief Justice.

17. Richard Southern, *The Georgian Playhouse* (London, 1948), p. 20.

18. See the print, *Berenstadt, Cuzzoni, and Senesino*, first state, HGW, pl. 310.

19. Richardson, *Works*, p. 6. Cf. DuBos' *Critical Reflections on Poetry, Painting and Music* (1719; tr. Thomas Nugent, 1748), I, 131–42. The influence of Watteau's theatrical scenes should be mentioned: he had been in London, painting busily, in 1720–21, and if Hogarth saw his *French Comedians* (with its central, Macheath-like figure) and *Italian Comedians* at Dr. Richard Mead's, he would have had a starting point for his first version of the *Beggar's Opera*; if he had seen one of the versions of the *Bal champêtre*, he would have had a precedent for the large stage structure of the final version. Of course, Claude Gillot, Watteau's master, would also have been known to him through his theatrical prints.

20. There were contemporary productions of *Henry IV Part 2* at Drury Lane on 9 September 1727, with Harper as Falstaff, and on 18 October and 3 and 30 December 1728, with the same cast (*LS*, pt. 1, II, 933, 993, 1001, 1004–05). Cf. Antal, p. 61, who thinks that both drawings are of "an actual performance . . . an exceptional procedure for Hogarth, who usually relied on his memory, omitting all preparatory studies for paintings." See below, n. 31.

21. See I, 275–76, for further discussion.

22. See Hogarth's MS. list of January 1730/1, BM Add MS. 27995, f. 1. Rich must have had the *Beggar's Opera* painting by January 1730/1 or it would have been on Hogarth's list. The six paintings may for convenience be numbered I (W. S. Lewis Coll.), II (Brigadier Sir Richard H. Anstruther-Gough-Calthorpe), III (Lord Astor of Hever), IV (Nigel Capel Cure), V (Mr. and Mrs. Paul Mellon), and VI (Tate Gallery). I reproduce only I, II, IV, and V. All the versions are reproduced by W. S. Lewis and Philip Hofer in *The Beggar's Opera* (New Haven, 1965), except for a small sketch Hogarth made as a benefit ticket for William Milward, the Macheath of the original production, in April 1728, which is independent of the other versions (*HGW*, cat. no. 113, pl. 118). Nichols claims that Rich also had a painting by Hogarth of Macheath going to execution (*Biogr. Anecd.*, p. 19).

23. Walpole's identification is attached to the stretcher of I, reproduced in Lewis and Hofer, no. II. For identifications of Paunceford and the other people in V, see Boydell's "key" attached to Blake's engraving for the Hogarth folio of 1790. Walpole owned this "key" and it is possible that his identifications were based on it. At any rate, the figures, moving from caricature to portrait, are the same.

24. Antal, p. 60. Antal also notices the "slightly symmetrical" arrangement of the principal actors, which is natural since Polly and Peachum balance Lucy and Lockit. He observes that the planimetric composition, as well as the symmetry, derives from the stage itself and from the nature of stage representations. He sees the possibility of influence from Watteau's *Italian Comedians* (National Gallery, Washington), painted in 1720 for Dr. Mead and engraved by Baron (p. 61). He is probably right to consider the earlier versions "fundamentally more baroque" than the later.

25. For pictures on fans, see *Daily Journal*, 23 May 1728; for screens, *Daily Journal*, 2 July 1728. Gay mentions a mezzotint of Polly in a letter to Swift of 29 March 1727/8 (*Correspondence of Jonathan Swift*, ed. Harold Williams [Oxford, 1963], III, 272). See also *Memoirs concerning the Life and Manners of Captain Macheath*, published 14 May 1728 (*Craftsman*, 18 May).

26. *Thievery A-la-mode*, pp. 23–24. Similar attacks on *The Beggar's Opera* include Thomas Herring's in *Mist's Weekly Journal*, 30 March 1728; see also *Letters from Dr. Thomas Herring to William Duncombe* (London, 1777), appendix, with two letters to the *Whitehall Evening Post* on *The Beggar's Opera*, 30 March and 20 April 1728.

27. Hogarth's affinity with Gay may have established itself even before *The Beggar's Opera*, for Gay's particular use of the mock form can be seen as early as his *Shepherd's Week* (1714), in which real shepherds are shown behaving according to the artificial pastoral conventions poets expect them to follow. "Love" for example causes Lobbin and Cuddy to awaken before nature (the "welkin") or work (the "swelling udder") dictates. The convention never manages to contain them: Sparabella, lovelorn, knows that she should die but puts off her suicide until the next day: "The prudent maiden deems it now too late, / And till to morrow comes defers her fate." The conventions are too artificial, the shepherds too full of life. Behind both Gay and Hogarth are probably those "rude mechanicals" in Shakespeare's comedies who play roles that are unsuited to their characters and thus are unable to sustain the illusion. Gay, however, specifically demonstrated for Hogarth, perhaps better than anyone else, that in literature as well as art the low cannot be portrayed by itself; it must be defined in relation to high norms—in the old plays in juxtaposed high and low plots, and in Gay's *Beggar's Opera* in the low characters' imitation of high words and actions.

Hogarth must also have known Gay's *Trivia*, originally published in 1716 during the early years of his apprenticeship. The London described with realism but fondness is Hogarth's London, defined in relation to conventions of Virgilian georgic. One result in *Trivia* is the same attitude toward the great and the small later expressed in *The Beggar's Opera*. More pertinent to the conception of the *Harlot's Progress*, Gay constantly refers to the young girl who is ruined because she aspired above her station: "Let the vain virgin, lur'd by glaring show, / Sigh for the liv'ries of th' embroider'd beau" (II. 569–72).

28. Croft-Murray, I, 70.

29. *Art of Painting*, p. 2.

30. It is very difficult to conceive the original appearance of Thornhill's masterpieces.

The Greenwich work was being repainted even in Hogarth's lifetime, and when the St. Paul's dome was cleaned in 1936 by Professor E. W. Tristram, an inscription was discovered on the panel of *The Burning of the Books at Ephesus:* "The paintings in the Dome were originally designed & executed by Sir James Thornhill, 1720. The lower part destroyed by damp 25 ft all around. Entirely repainted by E. T. Parris without any assistance 1853–56"

(W. G. Allen, "Cleaning St. Paul's," *Journal of the Royal Institute of British Architects,* ser. 3, XLIII [5 Sept. 1936], 1038).

31. Royal Collection; Oppé, cat. nos. 23, 24, pls. 20, 21.

32. J. Ireland, III, 337; *Autobiographical Notes,* p. 210.

33. Oppé, p. 12; Antal, p. 77.

34. Roger De Piles, *Art of Painting* (1798 ed.), p. 46.

CHAPTER 10

1. *Report of the Committee on the Fleet* (1729), in Pitt Cobbett, *Parliamentary History* (London, 1810–), VIII, 708–31; J. S. Bunn, *Fleet Registers* (London, 1833); *A Brief Account of the Ancient Prison called 'The Fleet'* (London, 1843), p. 9. For a general account, see John Ashton, *The Fleet: Its River, Prison, and Marriages,* 2d ed. (London, 1888), pp. 230–35.

2. "John Huggins, Esq; High-Bayliff of the City and Liberty of Westminster, having discover'd great Abuses which have been of late committed, as well by his own Officers as others, in arresting of Persons and seizing of Goods without any lawful Warrant or Power for so doing: Doth hereby give Notice, That all Arrests and Seizures on Action or Execution made within the said City and Liberty, without the especial Warrant of the said John Huggins, are an Infringement on his said Liberty, as well as an Abuse to the People, and therefore desires, that Notice may be given of all such Officers or others, who shall be guilty thereof, to his Office in St. Martin's Lane, in Order to their being prosecuted for the same" (*Pax, Pax, Pax, or a Pacific Post Boy,* 2–5 May 1713).

3. See John Mackay, *A True State of the Proceedings of the Prisoners in the Fleet-Prison, in Order to the Redressing of their Grievances before the Court of Common Pleas* (London, 1729), which consists of prisoners' petitions to the Lord Chief Justice and Huggins' replies.

4. Ibid., p. 32.

5. See Sidney and Beatrice Webb, *English Prisons under Local Government* (London, 1922), p. 18.

6. *Report of the Committee,* Cobbett, VIII, 710.

7. Cobbett, VIII, 711; see *Weekly Journal of the British Gazetteer,* 14 September 1728. William Huggins, who did not accept his father's guilt, believed that politics had led to the inquiry and trial of Huggins and Bambridge; Lord Hardwicke also pointed to political motivations. See Powell. "William Huggins and Tobias Smollett," pp. 179–92; Smollett, *History of England* (1758), IV, 527–28, and (1790 ed.), II, 480; Sir Lewis Namier, *England and the Age of the American Revolution* (London, 1930), pp. 216–17.

8. Cobbett, VIII, 710–11; he was buried in the precincts of St. Paul, Covent Garden, 23 October 1725 (W. H. Cummings, *Dr. Arne and Rule, Britannia,* London [London, 1912], pp. 3–5).

9. Cobbett, VIII, 716–17; A. A. Ettinger, *James Edward Oglethorpe* (Oxford, 1936), p. 90.

10. *Daily Post,* 29 January; the encounter took place on the twenty-fifth.

11. Cobbett, VIII, 719.

12. *Daily Post,* 8 February; *Daily Journal,* 11 February.

13. *Commons Journals,* XXI, 237–38.

14. *Daily Journal,* 28 February; *Craftsman,* 1 March; *Craftsman,* 8 March; *Commons Journals,* XXI, 247; Cobbett, VIII, 707 n.

15. *Craftsman,* 8 March.

16. *Weekly Journal,* 15 March.

17. Cobbett, VIII, 719.

18. Quennell asserts (p. 77), without evidence, that Sir Archibald Grant arranged Hogarth's admittance, presumably based on the assumption that he had already commissioned

the picture. While this is of course possible, the only evidence is Grant's commission in November 1729 for this picture and a *Beggar's Opera* painting.

19. There is no reason to think, as Edgar Wind does, that there was a specific occasion for the *House of Commons* picture ("The Revolution of History Painting," *Journal of the Warburg Institute,* II [1938–39], 123).

20. Another version, copied in *Gen. Works,* III, opp. p. 90 (then in the collection of Robert Ray), has an added figure beside Bambridge.

21. On the National Portrait Gallery painting the men are identified as follows: Oglethorpe, Lord Morpeth, Lord Inchiquin, Lord Perceval, Sir Gregory Page, Sir Archibald Grant, Sir James Thornhill, Sir Andrew Fountaine, General Wade, Capt. Vernon, Francis Child, and William Hucks. This is purely conjecture: they are not easily identifiable. Nichols (*Gen. Works,* III, 94) only says that the prominent figure in the foreground (?) is Sir William Wyndham; Sir Andrew Fountaine is on the chairman's left, and Lord Perceval behind him. Besides Oglethorpe, the figure to his left, fingering the instrument, resembles Perceval's portraits of about that time, but the one Nichols points to is possible. If Sir Andrew Fountaine appears in *The Fountaine Family,* he is not the fat man next to Oglethorpe. The man on the far right might be Lord Malpas, who later commissioned a picture from Hogarth. Thornhill need not be supposed to be present, since he was not on the committee at the time of the Fleet investigation.

22. See above, I, 144–45.

23. Clipping in the Forster Collection (V & A, F.10E.3.No. 174), undated.

24. Sir R. Phillips, *Morning's Walk from London to Kew* (London, 1817), p. 213.

25. *Publications of the Harleian Society,* XXIX (1886), 252.

26. Marriage Register, Paddington Parish Church, in London County Council Record Office: "Married William Hogarth and Jane Thornhill both of the Parish of Saint Paul Covent Garden in the County of Middlesex by License."

27. Vertue, III, 38; *Biogr. Anecd.,* 1782 ed., pp. 23–24.

28. I have found notices in no other paper. The marriage is mentioned in the *Historical Chronicle* for March 1728/9, p. 21, calling Hogarth again "an eminent Designer and Engraver," but its account is copied from the *Craftsman.*

29. According to H. B. Wheatley (*London Past and Present* [London, 1891], II, 364), they resided in Lambeth Terrace, Lambeth Road. The story of living in South Lambeth goes back to Nichols (*Gen. Works,* I, 46), who, however, only says that Hogarth spent his summers there.

30. *Gen. Works,* I, 43–44.

31. Vertue, III, 58. On 5 May 1732 one N. Cox, a bookseller, advertised his shop as "under the Middle-Piazza, near Mr. Hogarth's" (*Daily Journal*).

32. *Gen. Works,* I, 522–23. One Mr. Monger had an auction room over the broadcloth warehouse in 1732 (*Daily Journal,* 17 November).

33. Records of St. Bartholomew the Less, in St. Bartholomew's Hospital. My reason for concluding that "Anne" and "Mrs. Hogarth" are two different people, daughter and mother, is that in the entry for 1727 both names appear, "Ann Hogarth" and "Mrs. Hogath" (both sic). The first tenement was appraised at 6s, the second at 8s for the poor rate. The references appear in the poor rate books for 1725 and 1726, the scavengers payment for 1729, and the constable books for 1725, 1726, and 1727.

34. *Calendar of State Papers,* 1668–69, p. 139; James Peller Malcolm, *Anecdotes of the Manners and Customs of London during the eighteenth century* (1808), p. 313; E. A. Webb, *St. Bartholomew the Great* (1921), II, 286. Ned Ward commented on the "Parcel of nimble-tongued sinners" who leaped out of their shops "and swarmed about me like so many bees about honeysuckle" when he entered Long Lane on his way to the Fair (*London Spy,* p. 91). For the shop signs, see the entry in the Journals of the Meetings of the Governors of St. Bartholomew's Hospital, for 19 May 1728 (Hal/10).

35. Journal of the Meetings of the Governors for 25 July 1723, 12 September 1728, 1 May 1729, 24 July 1729.

36. Norman Moore, *The History of St. Bartholomew's Hospital* (London, 1918), II, 845.

37. Journal of the Meetings of the Gov-

ernors, 25 September 1729. See *Fog's Weekly Journal,* Saturday 25 April 1730: "Monday last [20 April] the Workmen began to pull down Part of St. Bartholomew's Hospital; the Shopkeepers in the Cloisters have taken Shops in the Long Walk (as it is call'd) between the said Cloisters and the Blue Coat Hospital; but there will be a free Passage kept open, and clear from Dust, during the time the Workmen are employ'd there."

38. Vertue, III, 38, 39.

39. Ibid.

40. See *HGW,* I, 136–37; and in the V & A a box of small (appx. 17.5 × 11 cm.) drawings; for a set of large tracings, see *N & Q.* Ser. VII, VII (20 April 1889), 306.

41. Vertue, III, 38.

42. BM Add MS. 27995, f. 1. The bottom part of the list, cut off by someone offended by mention of *Before* and *After,* is now in the Huntington Library. The whole is reprinted in J. Ireland, III, 21.

43. See Fisk Kimball, "Wanstead House," *Country Life,* LXXIV (1933), 605; Howard E. Stutchbury, *Architecture of Colen Campbell* (Cambridge, Mass., 1967), pp. 27–30; Margaret Jourdain, *Work of William Kent* (London, 1948), p. 93.

44. Vertue, III, 40–41.

45. The best work in English on the critical background to portraiture is still Wilhelm Nisser, *Michael Dahl and the Contemporary Swedish School of Painting* (Uppsala, 1927). The best work on English portraiture as a whole is David Piper, *The English Face* (London, 1957); another work on the general background is John Pope-Hennessy, *The Portrait in the Renaissance* (New York, 1966).

46. Piper, p. 136; and, for what follows, pp. 44, 104.

47. Piper, p. 130.

48. Vertue, III, 128, 81.

49. G. C. Williamson, *English Conversation Pictures* (London, 1931), p. 1; Ralph Edwards, *Early Conversation Pictures* (London, 1954), p. 9.

50. Piper, p. 174.

51. See Robert Raines, *Philip Mercier, 1689–1760* (1969); Paul Wescher, "Philippe Mercier and the French Artists in London," *Art Quarterly,* XIV (1951), 179–92; also R. Rey, *Quelques satellites de Watteau* (Paris, 1931).

52. Richardson, *Works,* p. 55.

53. Edwards, p. 8.

54. *Autobiographical Notes,* p. 202.

55. Mary Delany (then Mrs. Pendarves) to Anne Granville, 13 July 1731, in *The Autobiography and Correspondence of Mary Granville, Mrs. Delany,* ed. Lady Llanover (London, 1861), I, 283.

56. For copious Henley ads and newspaper cuttings, see Daniel Lysons' *Collecteanea,* BM pressmark 1889.3.6.

57. *Memoirs of the Life and Times of Sir Thomas Deveil, Knight, of His Majesty's Justices of the Peace* (London, 1748), p. 22. See *Biogr. Anecd.* (1782), p. 340, for the identification of DeVeil in Hogarth's painting.

58. *Memoirs,* pp. 72–75.

59. Vertue, III, 50.

60. For Shard (d. 1739), see *Burke's Landed Gentry* (London, 1937), s.v. Shard. Shard's enquiries are mentioned in the *Daily Journal,* 21 October 1730. Again, 9 January 1730/1: Shard and another sheriff went to the Wood Street Compter and distributed "a very considerable Sum of Money to the poor Prisoners confined in the said Prison for Debt."

61. *Daily Post,* 13 March 1730/1. (This was, of course, just about the time the subscription for the *Harlot's Progress* was begun. See chapter 11.)

62. Something of the sort is also presumably intended in Hogarth's reference to Parsons in the advertisement announcing the *Enraged Musician* (*London Daily Post and General Advertiser,* 24 November 1740): that Hogarth intends to make a print about a painter too, "which will compleat the Set; but as the Subject may turn upon an affair depending between the Right Hon. L—d M——r and the Author, it may be retarded for some time." Parsons died shortly after.

63. Recounted in the *Public Advertiser,* 18 July 1781.

64. The indoor *Before* and *After* may be the "two little pictures" commissioned by the Duke of Montagu that appear in the same list of January 1730/1 above the "two little Pictures called Before & After" for Thomson. My rough dating, however, is based on the style of the original.

65. For Thomson, see the *Daily Post,* 30 October 1731; *Daily Journal,* 1 November;

London Evening Post, 4–6 May 1732; *Daily Post,* 9 November. His bankruptcy sale was announced in the *London Gazette,* 24–27 February 1732/3. Sir Archibald Grant, second Bart. (1696–1778), about Hogarth's age, had represented Aberdeen County, Scotland, in Commons since 1722 (and may be another sign of Hogarth's Scottish connections). For his expulsion from Commons, see *Commons Journal,* XXI, 915.

66. See *HGW,* pls. 334–35. I have found no advertisement for their publication, though Sympson's other works, mostly engravings of sublime history paintings, were advertised. They were in circulation by 1733, however, when a reference to their purchase appears in a bill for prints (dated 10 May 1733) from Philip Overton to Lord Bruce, for, among others, "the Christening and the Justices Shop," 2s 6d (*HMC, 16th Report,* Appendix, Pt. VII, 1898, p. 233). For the Sympsons, see Vertue, III, 77; *HGW,* I, 309–11. For advertisements of the engravings of history paintings, see *Daily Post,* 15 Jan. 1727/8, 28 May 1728, 29 November 1728, 9 January 1728/9.

67. Advertised as published, 13 February 1730/1, *Daily Journal.* Mitchell's *The Highland Fair,* advertised "With a curious Frontispiece, design'd by Mr. Hogarth," was published 23 March (*London Evening Post,* 20–23 March).

68. Theophilus Cibber, *Lives of the Poets* (1753), IV, 347 ff., V, 197; David Erskine Baker's *Biographia Dramatica* (1782), I, 520; Alexander Chalmers' *Biographical Dictionary* (1812–17), XXII; James Johnson's *Scots Musical Museum,* IV, ed. David Laing (1853); Dorothy Brewster, *Aaron Hill, Poet, Dramatist, Projector* (New York, 1913), p .170.

69. Antal (p. 14), without documentation, asserts that Hogarth "appears to have commissioned a poet, Joseph Mitchell, to write an epistle in his honour in which he is placed above his rivals."

CHAPTER 11, § GENESIS

1. See Oppé, cat. no. 32, fig. 17.

2. Vertue, III, 58 (written in 1732).

3. One should recall, however, the *Beggar's Opera* pictures and the fact that it was the pretty, pathetic Polly who assured the play its success on opening night. See Chap. 9 above, note 13.

4. Back in 1728 Dalton was notorious enough to prompt a book about himself advertised from his cell in the Wood Street Compter: "A promiscuous Mixture of Iniquity, Ingenuity, and facetious Drollery, being A Genuine Narrative of all the Street-Robberies committed since October last, by James Dalton and his Accomplices, who are now in Newgate, to be try'd next Sessions, and against whom Dalton (call'd their Captain) is admitted an Evidence: Shewing 1st the Manner of their snatching off Women's Pockets; with Directions for the Sex in general how to wear them, so that they cannot be taken by any Robber whatsoever. 2ndly. The Method they took to rob the Coaches, and the many diverting Scenes they met with while they follow'd those dangerous Enterprizes. 3rdly. Some merry Stories of Dalton's biting the Women of the Town, his detecting and exposing the Mollies, and a Song which is sung at the Molly-Clubs: With other very pleasant and remarkable Adventures Taken from the Mouth of James Dalton" (*Daily Journal,* 29 April 1728). In May one John Hornby was condemned to death "for Street Robbery, on the Information of James Dalton," and in July Dalton and Thomas Neeves, "the two Street Robbers, who were Evidences against their Accomplices lately executed, were discharged upon their producing his Majesty's most gracious Pardon" (*Daily Journal,* 8 May, 20 July 1728).

5. *Daily Journal,* 1 December, 6 December 1729; 17 January 1729/30.

6. Ibid., 21 January; *Daily Post,* 21 January; *Daily Courant,* 25 February 1729/30.

7. *Fog's Weekly Journal,* 28 December 1728.

8. *Daily Courant,* 27 February 1729/30.

9. See above, I, 34 and 511 n. 11.

10. *Life of Col. Don Francisco,* p. 18.

11. Ibid., p. 48.

12. *Daily Courant,* 27 February 1729/30.

13. *The Proceedings at the Sessions of the Peace . . . upon a Bill of Indictment found against Francis Charteris, Esq.; for committing*

*a Rape on the Body of Anne Bond, of which
he was found Guilty* (1730), pp. 4–6.

14. *Daily Courant,* 27, 28 February 1729/30;
Grub-street Journal, 5 March 1729/30, carried
notices from several papers.

15. *BM Sat.,* No. 1840.

16. *Post Boy,* 28 February 1729/30.

17. 28 February, reprinted in the *Grub-
street Journal,* 5 March 1729/30.

18. *Post Boy,* 2 March 1729/30.

19. *Daily Journal,* 7 March 1729/30, which
also advertised *The Whole Trial at large of
Colonel Francis Charteris* (2 March), *The
Rape. An Epistolary Poem. Addressed to Colo-
nel Francisco* (3 March), and *Some Authentick
Memoirs relating to the Life, Amours, and
other notable Actions of Col. Ch——s, Rape
Master General of Great-Britain. By an Im-
partial Hand* (10 March), *An Emblematic
Print, entitled Col. Francisco; or the British
Satyr* (17 March, *Daily Post*), *The History of
Col. Francis Chartres* (18 March, *Daily Jour-
nal* again), *Col. Don Francisco's Letter of Ad-
vice to all his Beloved Brethren the Votaries
of Venus* (20 March), and *The Art of Pimping,
in Imitation of Horace's Art of Poetry* (21
March, *Daily Post*). *The History of Col. Fran-
cis Chartres* included a mezzotint portrait of
Charteris by Francis Kirkall, which confirms
the likeness of Hogarth's portrait.

20. *Grub-street Journal,* 12 March 1729/30.

21. *Daily Post,* 9, 11, 13 April; *Daily Jour-
nal,* 10, 15 April; *Daily Courant,* 11, 14 April;
Grub-street Journal, 16 April 1730.

22. *Daily Post,* 18 April 1730. On the twen-
tieth was published *The Reprieve: An Epistle
from J–ck K–ch to C–l C——s* (*Daily Journal*).

23. *BM Sat.* 1841. See also James Miller's
Harlequin Horace and Swift's "An Excellent
New Ballad: or the True English Dean."

24. *Weekly Journal, or the British Gazet-
teer,* 16 May; *Craftsman,* ibid. On 29 April
the *Daily Journal* announced publication of
the second number of *The History of Execu-
tions,* which included an account of "Francis
Hackabout, a Footpad . . . Likewise how Col.
Charteris was pardoned for a Rape committed
on Anne Bond."

25. *Post Boy,* 17 May, *Grub-street Journal,*
15 May, *Weekly Journal,* or *British Gazetteer,*
6 June. The *Daily Post* for 3 May 1730 notes
that two justices of the peace who visited

Charteris in Newgate have died of fever caught
while visiting him; the third gentleman who
had been along also took ill but recovered.
"The friendship of some persons is frequently
more fatal than their enmity," the *Grub-street
Journal* commented (7 May). For *Rape upon
Rape,* see the *Daily Post,* 23 June.

26. *Grub-street Journal,* 8 January 1729/30;
Fielding puts him in the 1734 version of *The
Author's Farce* as Sir John Bindover, who re-
places Murdertext in the original version and
ends by dancing with Dr. Orator. For samples
of Gonson's "Charges," see *Political State,* xxv,
50; and xxxvi, 314, 333.

27. *Daily Journal,* 3 August; *Daily Post,* 3
August 1730.

28. *The Grub-street Opera* (July 1731), Air
xxxv; used again in *Tumble-down Dick* (1736),
Air ii.

29. The name Hackabout served in the
same year (1730) as a source for the name given
to Moll Flanders' "governess" in a chap-book
plagiarism of Defoe's novel called *Fortune's
Fickle Distribution. In three parts. Contain-
ing, First, The Life and Death of Moll Flan-
ders* (Dublin, 1730). The second part (touted
in the preface as a sequel to Defoe's novel)
concerned Moll's "Governess, who was an At-
torney's Daughter, a Lady's Woman, a Whore,
a Bawd, a Pawn-broker, a Breeder-up of
Thieves, a Receiver of Stolen Goods and at
last died a Penitent." In Defoe's novel she
had been nameless, only once referred to as
"Mrs. B——"; but here she is called Jane Hack-
about. Hilda Kurz ("Italian Models of Ho-
garth's Picture Stories," *Journal of the War-
burg and Courtauld Institutes,* xv, 1952, 149)
thinks Hogarth combined Moll Flanders and
Jane Hackabout to obtain Moll Hackabout;
but this presupposes Hogarth's connection
with the pamphlet *The Harlot's Progress or
the Humours of Drury Lane,* which is most
unlikely. The only interesting similarity be-
tween Hogarth's prints and the chap-book is
that Jane Hackabout comes from Yorkshire
—but she has been corrupted before she ar-
rives in London; she also spends a stretch in
Bridewell and sets up as a procuress in Drury
Lane, but these are also present in the Hack-
about news items.

30. *The English Rogue,* i, chap. 55, p. 23;
iv, chap. 11, p. 197.

31. *Daily Post,* 30 September 1731.

32. *Daily Journal,* 31 August; *St. James' Evening Post,* 5 September; *London Evening Post,* 5 September; all cited in *Grub-street Journal,* 10 September, 1730. According to one story, Charteris was "one of the Runners of Sir Robert Walpole, and defended him in all places of resort, which drew the wrath of the Tories upon him" (Alexander Carlyle, *Autobiography* [1860], Chap. 1). The *Craftsman* of 8 August called Walpole the "Friend, Confidant, and Patron" of Charteris.

33. *Grub-street Journal,* 23 April 1730.

34. Ibid., 24 September 1730 (commenting on the *Daily Post*).

35. A different person with similar tastes is described in the *Daily Journal* of 28 November under the name of Mary Freeman, alias Talboy. Another of Gonson's apprehensions, "She beats hemp one day in velvet, and another day in a gown richly trimm'd with silver." She "is supported by several noted gamesters and Sharpers about Covent Garden, who usually dress her in a very fine habit, the better to get acquainted with, and draw in young cullies, in order to make a prey of them" (*Daily Post;* both cited, *Grub-street Journal,* 1 December 1730). This lure to "young cullies," however, is portrayed quite differently from Mary Muffet.

36. Mary Davys, *The Accomplish'd Rake* (1727), in W. H. McBurney, *Four Before Richardson* (Lincoln, Nebraska, 1963), p. 301. Vertue identifies Mother Needham (III, 58) but it should be mentioned that *The Harlot's Progress or the Humours of Drury Lane* (April 1732), perhaps because Needham was dead, calls her Mother Bentley.

37. *London Journal,* 16 March 1722/3; *British Journal,* 16 March 1722/3; *Daily Journal,* 21 July 1724; ibid., 22 July; ibid., 2 September.

38. *Weekly Journal,* 15 October 1726; ibid., 20 March 1730/1; *Daily Courant,* 23 March 1730/1; *Grub-street Journal,* 29 April 1731, citing *Daily Post,* 26 April and *Daily Courant,* 26 April.

39. The papers variously reported the event: she "was severely handled by the populace"; "She was so very ill, that she laid along under the pillory, not withstanding which she was severely pelted, and it is thought she will die in a day or two"; "she was screened by a mob of hired fellows, and lay along on her face on the pillory, and so evaded the law, which requires that her face should be exposed"; "being much indisposed, [she] was suffered to sit on the Pillory. . . ; at first she received little Resentment from the Populace, by reason of the great Guard of Constables that surrounded her; but near the latter End of her Time, she was pelted in an unmerciful Manner." (*Grub-street Journal,* 6 May 1731, citing *Daily Journal, Post Boy,* and other papers for 1 May.)

40. *Grub-street Journal,* 6 May, citing papers for 4 May. On 8 May was published *Mother Needham's Lamentation,* price 6d (*Daily Journal*).

41. Some idea of the basis for Hogarth's ambivalent feelings about the crowd, and about the malefactor vis à vis the crowd, can be gleaned from the newspaper account, two months after the Harlot was published, of one John Waller, who stood in the pillory at Seven Dials (only a few blocks from Hogarth's residence) "for wilful and corrupt perjury, in swearing a robbery on the highway against several persons whereby they had been convicted. The populace was so exasperated against him, that they broke in upon the Peace Officers, got upon the pillory, and beat him in such a violent manner, that in less than 5 minutes he was taken down for dead, and carried to the Round house, and from thence to Newgate, where he lies in a dangerous condition." Other reports said that "The mob pelted him so severely, that he was knock'd on the head, and dropt off the pillory dead"; and: "They stripp'd him naked, and beat the pillory flat to the ground, then stamp'd upon him and terribly bruised him, he was carried to S. Giles's Round-house, and a Surgeon sent for to bleed him, but before he got to Newgate he expired." (*Grub-street Journal,* 16 June 1732.)

42. The *Second Pastoral Letter* was published 11 April 1730 (*Daily Journal*), the *Third Pastoral Letter* on 11 May 1731 (*Daily Journal*), and by 3 September the latter had reached a fifth edition; on 25 November all three *Pastoral Letters* were published "in a neat Pocket Volume, Price 2s. 6d." (*Daily Post*). It should also be noted that Gibson's solution to the Deist problem was coercion, and Hogarth may have had this aspect in mind

(Sykes, *Bishop Gibson,* pp. 260–61). The *Pastoral Letters* were widely circulated, and there were many satiric allusions to them (e.g., *The Bishop or No Bishop,* and the *Craftsman,* 16 November 1728; see Sykes, *Gibson,* pp. 254–55).

43. Two of the deistically-inclined writers attacked by Gibson in his pastoral letters were Thomas Woolston and Samuel Clarke. A proof of Plate 2, described by George Steevens, contained a labeled portrait of Woolston on the wall, and in Giles King's copies, authorized by Hogarth, portraits of both Clarke and Woolston appear on the wall (*Gen. Works,* II, 101). Woolston's *Discourse on the Miracles of Our Saviour* (1727), a humorous, sometimes buffoonish ridiculing of miracles, was dedicated to Gibson, who replied with his first *Pastoral Letter.* Woolston's portrayal in Plate 2 is also appropriate because of his ambiguous connection with the Jews. In *A Sixth Discourse on the Miracles of our Saviour* (1729) he conveyed part of his argument by publishing two letters supposedly written by a Rabbi against the truth of the Resurrection; this was quickly answered in a series of pamphlets. The Jewish merchant may have been expected to display Woolston's picture on his wall. See Thomas Woolston, *Life of Mr. Woolston* (1733), pp. 11, 17; W. Whiston, *Memoir of William Whiston* (1713), I, 233; *Grubstreet Journal,* 2 April 1729/30, 2 July, 9 July, 15 October.

44. *Daily Advertiser,* 13 July 1731; *Craftsman,* 17 July; *Read's Weekly Journal or British Gazetteer,* 10 July; *Daily Advertiser,* 13 July; *Craftsman,* 20 March. Dr. Rock's ads begin to appear in 1732/3, e.g., *Craftsman,* 24 February. For Misaubin: *Daily Journal,* 1 January 1730/1.

45. *Daily Journal,* 7 January 1730/1.

46. G. C. Lichtenberg, who reads the date as 3 September, speculates facetiously that if Hogarth had the Great Fire in mind he would "have chosen the day on which the fire was extinguished" (*GM,* 1, 1731, 301; *The World of Hogarth: Lichtenberg's Commentaries on Hogarth's Engravings* [New York, 1966], p. 68 n.). The date, however, appears to be the second.

47. The Jewish merchant is also probably identifiable, but without contemporary testimony and portraits to go on, a guess will have to suffice. Sampson Gideon, the greatest Jewish merchant in London during the first half of the century, was born in 1699 and would have been the right age for the Harlot's keeper in the 1730s. He began business when only twenty with £1500, which in less than two years he had increased to £7,900 and he was admitted a sworn broker in 1729 with capital of £25,000, which he had made mostly from speculating in lottery tickets and stocks. He was later well-known as an art collector. One of the satires produced during the controversy over the "Jew Bill" in 1753 referred to his collection as including "The Triumph of Gideon," "A Sampson in miniature," as well as "Peter denying his Master" and "Judas betraying him for thirty pieces of silver" (*Connoisseur,* 7 Feb. 1754). The caricatures of him at this time are not at odds with the face in *Harlot,* Pl. 2: see Israel Solomons, "Satirical and Political Prints on the Jews' Naturalisation Bill, 1753," *Transactions of the Jewish Historical Society of England,* VI (19-8-10), 217 (No. 3 and plate, also in BM Sat. 3203). See *DNB* and Lucy Sutherland, "Samson Gideon: Eighteenth Century Jewish Financier," *Transactions of the Jewish Historical Society of England,* XVII (1953), 79–85.

48. 2 Samuel 6:6–7; 1 Chronicles 13:9–10; Jonah. 4: *Criticorum Sacrorum sive Annotatorum* (1698 *et sec.*), II, 981; Lichtenberg, pp. 23–24; J. Ireland, III, 327–28. Lichtenberg (p. 23) was the first commentator to notice the detail of the stabbing and to draw attention to the paintings on the wall as somehow related to the action of the plate. Hogarth's picture of the *Ark of the Covenant* is a memory of Louis Laguerre's headpiece for *Second Samuel,* engraved by Charles Dupuis, in the "Vinegar" Bible (J. Baskett, 1717) in which Thornhill's designs also appeared. In Giles King's authorized copies of the *Harlot,* words come down out of the sky to Jonah: "Ionah Why are thou Angry."

49. Kurz (op. cit., p. 152) thinks the angel represents the action of law "preventing the harlot from sinning further"; Lichtenberg's opinion that the picture says "God sees all" is perhaps a bit closer to the mark (p. 36). But the parallel between Abraham and Gonson, Isaac and the Harlot is unavoidable.

CHAPTER 11, § MODERN HISTORY PAINTING

1. Now in the Glasgow Art Gallery, it was evidently the most celebrated or prized picture in Thornhill's collection. The detail of Nature was used on the cover of his sale catalogue following his death, two years after the *Harlot* appeared. One of Thornhill's headpieces for *Addison's Works* (1721, II, 187) also copied this motif from *Nature adorned by the Graces.* For Lairesse's frontispiece, see above, I, 98.

2. This version of Nature (as the many-breasted Diana) is usually shown surrounded by the arts and sciences, which derive their nourishment from her, as in *Nature adorned by the Graces.* For the tradition of unveiling Nature, see Plutarch, *Isis and Osiris,* Chap. 9; but there may also be a separate tradition of peeking under the skirt. See the frontispiece to Pierre Le Lorrain, abbé de Vallemont's *Curiositez de la nature et de l'art sur le végétation* (1703, tr. 1707); cf. Shelley's reference —possibly a memory of Hogarth's print—in *Peter Bell the Third,* ll. 315–17. For a general discussion, see Michael Murrin, *The Veil of Allegory* (Chicago, 1969), pp. 10–13, and Frank Manuel, *The Eighteenth Century Confronts the Gods* (Cambridge, Mass., 1959), p. 268.

3. *Ars poetica,* ll. 48–49, 51. He pointedly ignores Horace's famous lines (128–30) discouraging the creating of a new subject: "Difficile est proprie communia dicere; tuque / rectius Iliacum carmen deducis in actus / quam si proferres ignota indictaque primus." The lines from Vergil (*Aeneid* III.96) may have been picked up from Dryden's *Hind and the Panther,* where they served as epigraph.

4. *An Essay on the Theory of Painting* (1715), pp. 20, 21, 35–36, 44–45, 70. Among other contemporary writings that emphasize the painter-poet analogy, see the *Free-Thinker* No. 63 (1718); *St. James's Journal,* 20 April 1723; Walter Harte, "Essay on Painting," in *Poems on Several Occasions* (1727), p. 3; James Ralph, *Weekly Register* No. 122, 3 June 1732. For the famous pronouncements by later critics on "reading" Hogarth, see Horace Walpole, *Anecdotes of Painting,* ed. James Dallaway (1828), IV, 126; Charles Lamb, "On the Genius and Character of Hogarth," *Reflector* No. 3 (1811); William Gilpin, *Essay upon Prints,* 2d ed. (1768), pp. 24, 164–71; and James Barry,

An Account of a Series of Pictures in the Great Room of the Society of Arts (1783), pp. 162–64.

Part of the following pages originally appeared, in a different form, in my essay, "The *Harlot's Progress* and the Tradition of History Painting," *Eighteenth-Century Studies,* I (1967), 69–92.

5. Shaftesbury, *Notion of a Draught,* in *Shaftesbury's Second Characters,* ed. Benjamin Rand (1914), p. 59; Alberti, "Della Pittura," in *Leone Battista Albertis Kleinere Kunsttheoretische Schriften,* ed. H. Janitschek (Eitelberger's *Quellenschriften fur Kunstgeschichte* [Vienna, 1877]), p. 145; *De Re Aedificatoria,* German tr., M. Theur (Vienna, 1912), Bk. VII, Chap. 10, tr. and cited by Sir Anthony Blunt, *Artistic Theory in Italy 1450–1600* (Oxford: Clarendon Press, 1940; reprint, 1964), p. 12. For an excellent general study of *ut pictura poesis* as it affected history painting, see Rensselaer W. Lee, "Ut Pictura Poesis: The Humanistic Theory of Painting," *Art Bulletin,* XXII (1940), 197–269.

6. See *Ars poetica,* l. 361. From Horace also came the admonition that painting like poetry should instruct as well as delight (ll. 333 ff.). There is no way of knowing whether Hogarth ever completely believed the propaganda of the artists; his work supports the alternative explanations that he wished to push their view as far as it could possibly be pushed, or that he agreed with the poets that "the Pen is more noble, then the Pencill. For that can speake to the Understanding; the other, but to the Sense" (Ben Jonson, *Timber or Discoveries, Works,* ed. C. H. Herford and Percy and Evelyn Simpson [1954], VIII, 610; cf. John Dryden, "Parallel of Poetry and Painting," *Works,* ed. Sir Walter Scott [1808], XVII, 301).

7. Hogarth must have heard much about Poussin from Thornhill, who admired him and owned one version of his *Tancred and Erminia.* Richardson used the latter and closely analyzed it as an ideal history painting in his "Connoisseur" (*Works,* pp. 131–38). Hogarth shows neither admiration nor antipathy toward Poussin in *The Analysis of Beauty* (see pp. 26, 132).

8. Walter Friedlaender, *Nicolas Poussin, A*

New Approach (New York, n.d. [1965]), pp. 30–46. For Poussin's use of the term "read," see, e.g., his letter to Chantelou, 28 April 1639: "Lisez l'histoire et la tableau afin de connaître si chaque est appropriée au sujêt" (modernized text, ed. Pierre du Colombier [Paris, 1929], p. 12; original text, *Correspondance de Nicolas Poussin,* ed. Charles Jouanny [Paris, 1911], p. 21).

9. He refers to himself as "author" in the advertisement for almost every one of his cycles, but one should not place too much emphasis on this fact. The first sense of "author" in Johnson's *Dictionary* is "the first beginner or mover of any thing; he to whom any thing owes its original," and only the third meaning specifically involves a writer. Only once does Hogarth discuss his works in literary terms: "Subjects I considered as writers do" (*Autobiographical Notes,* p. 209). He remarks (p. 229) that the idea that his works are "historical" may have "proceeded from their being designd in series and having something of that kind of connection which the pages of a book have." His references to the analogy between his works and the stage, however, are more frequent (e.g., pp. 210, 211, 212).

10. See Dryden, "Parallel of Poetry and Painting," *Works,* ed. Scott, XVII, 305. *Les Israélites recueillant la manne dans le désert* was finished in 1639. The Academy's critique was held on 5 November 1667; see H. Jouin, *Conférences de l'Académie Royale de Peinture et de Sculpture* (Paris, 1883), pp. 48–65. One could establish the same relationship between the *Harlot* and Richardson's categories, Invention, Expression, Composition, Drawing, Coloring, Handling, and Grace and Greatness (*Essay,* pp. 38 ff.).

11. *Della pittura,* tr. John R. Spencer (New Haven, 1956), p. 77. Le Brun's conference on expression was translated by J. Smith in 1701 and John Williams in 1734. The latter, *A Method of Designing the Passions by Mr. Le Brun . . . ,* includes a partial translation of Le Brun's separate treatise *On Physiognomy.* Hogarth refers to one or both in the *Analysis of Beauty,* p. 138. See also Du Fresnoy, *The Art of Painting,* tr. Dryden (*Works,* 1808 ed.), XVII, 359.

12. *Conférences,* pp. 62–64. See also, on the significant moment, Shaftesbury's *A Notion of the Historical Draught or Tablature of the Judgement of Hercules* (1713) and Richardson's *Essay,* pp. 56–61; also Etienne Souriau, "Time in the Plastic Arts," *Journal of Aesthetics and Art Criticism,* VII (1949), 294–307.

13. See Lee, "Ut Pictura Poesis," p. 258.

14. The translation, MS. in the P.R.O., was probably dictated or made under the supervision of Shaftesbury (*Shaftesbury's Second Characters,* ed. Rand, p. 69; see pp. xvii–xviii).

15. *The Emperor Marcus Antoninus His Conversation with Himself . . . to which is added the Mythological Picture of CEBES the Theban, translated into English from the respective Originals by Jeremy Collier, M.A.* (1701), p. 248; cited, E. H. Gombrich, "A Classical 'Rake's Progress,'" *Journal of the Warburg and Courtauld Institutes,* XV (1952), 254–56. For a survey of illustrations for the *tabula,* see M. Boas, "De illustratie der Tabula Cebetis," *Het Boek,* XII (1920), 1, 105.

16. See below, II, 95.

17. Irwin Panofsky, *Early Netherlandish Art* (Princeton, 1953), I, 140–41.

18. St. Thomas Aquinas, *Summa Theologica,* I, qu. I, art. 9, c. As Panofsky, p. 144, puts it, "all meaning has assumed the shape of reality; or, to put it the other way, all reality is saturated with meaning." It is also related in a general way to the typological or emblematic way of writing—and thinking—followed by Defoe and the English writers of the Puritan tradition; see, e.g., J. Paul Hunter, *The Reluctant Pilgrim* (Baltimore, 1966), Chap. V; and Victor Harris, "Allegory to Analogy in the Interpretation of Scriptures," *Philological Quarterly,* LXV (1966), 1–23. The portrait of Woolston Hogarth had contemplated adding in Plate 2, and did add in King's authorized copies, may have been a commentary on how he wanted the Jew's pictures read. The aspect of Woolston's heresy that most amused the *Grub-street Journal* was his allegorical interpretations of Scripture. In the *Journal,* this takes the form of frequent interpretations "of current happenings in the Woolstonian manner"—e.g., of a thunderstorm (11 June 1730). Thus his confinement in the King's Bench Prison was merely an allegorical statement that he had bought a suit of clothes too small for him (9 July 1730). And when he was reported to have secured a

writ of habeas corpus, "It is disputed whether this is to be taken figuratively or literally."

19. See Ingvar Bergström, *Dutch Still-Life Painting in the Seventeenth Century* (New York, 1956), esp. pp. 16–26.

20. "Notion of a Draught," in *Shaftesbury's Second Characters*, pp. 36, 55, 56.

21. Walpole, *Anecdotes of Painting*, IV, p. 74. Hogarth recognized that his prints must be annotated to be understood "in future times, when the customs manners fasheons Characters and humours of the present age in this country may be alter'd and perhaps in some respects be otherwise unknown to posterity" and emphasized the fact in his notes for a continuation of Rouquet's commentary (*Autobiographical Notes*, p. 206; also pp. 201, 207, 208). As to the identifiable figures in the *Harlot*, however, Hogarth had probably read the accounts of Raphael's making Heraclitus, Aristotle, and other figures in his Stanze paintings portraits of contemporaries, and he may have thought of Needham and Charteris as further aspects of his adaptation of classical history.

22. Hilda Kurz, "Italian Models of Hogarth's Picture Stories," *Journal of the Warburg and Courtauld Institutes*, XV (1952), 136–68.

23. His "classicism" is, however, far more realistic than Poussin's and lacks his almost suffocating unity; for comments on "classicism" in his later work, see Antal, pp. 27–28.

24. There is an interesting passage in Hogarth's obituary written by one of his friends within a month of his death (*Public Advertiser*, 8 December 1764). The writer explains the originality of the *Harlot's Progress* as an answer to the Abbé Du Bos' complaint that no history painter of his time "went through a series of actions, and thus, like an Historian, painted the successive fortunes of an Hero, from the cradle to the grave. What Du Bos wished to see done, Hogarth performed," concludes this writer. One wonders if he means that Hogarth was (or told him he was) in some sense responding to Du Bos' complaint. He presumably knew no French, and Du Bos' *Réflexions critiques sur la poésie et sur la peinture* (first published in 1719) was not translated into English until 1748; but Du Bos' title was one that would have interested

him, and a friend—perhaps Thornhill—could have told him about it and pointed out the appropriate passages.

25. *Conférences*, pp. 54–55.

26. Cf., e.g., Dürer's version in his *Life of the Virgin* woodcuts, or Fra Angelico's in the Museo del Gesu, Cortona, or Rembrandt's, now in the Detroit Institute of Arts.

27. E.g., *The Annunciation* of Roger van der Weyden in the Louvre and the Columba Altarpiece in the Alte Pinakothek, Munich, which transforms the small shrine or pavilion in which Mary usually appears into a deep red tester (Panofsky, *Early Netherlandish Art*, I, 87). Other examples are by Petrus Christus (Kaiser Friedrich Museum, Berlin), and Joos van Cleve (Metropolitan Museum, New York).

28. The boys' mysterious father is presumably indicated by the hatbox James Dalton left behind him (pl. 3). That Hogarth was playing around with ironic memories of other religious paintings is suggested by the last plate where there are precisely twelve "mourners" around the coffin, which resembles a table, and the son is isolated in the center on the viewers' sides of the coffin.

29. In Christian writings Mary Magdalen is often paralleled with Mary the Mother, although Mary Magdalen's life finally represents the life made white after sin, "the most faithful witness to His name" (see Helen M. Garth, *Saint Mary Magdalene in Medieval Literature*, in *Johns Hopkins University Studies in Historical and Political Science*, LXVII [1950], Pt. 3, pp. 80–81).

30. Xenophon, *Memorabilia*, II,i.21. See E. Wind, "Shaftesbury as a Patron of Art," *Journal of the Warburg and Courtauld Institutes*, I, (1938), 185. For a discussion of the Choice of Hercules tradition, see Erwin Panofsky, *Hercules am Scheidewege und andere Antike Bildstoffe in der neueren Kunst* (Leipzig, Berlin, 1930); Hallett Smith, *Elizabethan Poetry* (Cambridge, Mass., 1952), pp. 293–302; Theodore E. Mommsen, "Petrarch and the Story of the Choice of Hercules," *Journal of the Warburg and Courtauld Institute*, XVI (1953), 178–92.

31. See W. G. Howard, introduction, *Laokoon: Lessing, Herder, Goethe* (New York, 1910), p. lxxvii; and *Shaftesbury's Second Characters*, p. xxii.

32. *Second Characters*, pp. 33-34.

33. Ibid., pp. 48, 58.

34 See E. R. Wasserman, "The Inherent Values of Eighteenth-century Personification," *PMLA, 65* (1950), 437-39.

35. Hogarth may have remembered Cicero's version of the Choice of Hercules in his *De Officiis*, a manual of ancient conduct and morality which was a staple of Latin classes and a source of the history painters' reliance on the paradigm. For Cicero distinguishes the hero Hercules' ability to choose Virtue from the ordinary man's: "This might, perhaps, happen to a Hercules, 'scion of the seed of Jove'; but it cannot well happen to us; for we copy, each the model he fancies, and we are constrained to adopt their pursuits and vocations." Some travesty versions of the story even showed Hercules himself as subject to the same fashionable imitation as modern non-heroes. The history painter was, by definition, concerned with heroic virtues and painted types of Hercules. This Hercules was a figure Hogarth himself had portrayed more than once among the "monsters of heraldry" he engraved on silver as an apprentice and a young engraver; but now he was free to look at his contemporaries. In the terms of *A Harlot's Progress,* Moll Hackabout may imitate either Mother Needham or the clergyman; being no Hercules but one of us, embedded in the world of fashion, she merely imitates and so chooses Pleasure. (See Cicero, *De Officiis,* I, xxxii, 118, tr. Walter Miller [Loeb Classical Library, 1913], p. 121 e.g., Thomas Heywood's *Apologie for Actors* (1612), Sig. B3r.) Among the many emblem book representations of the Choice of Hercules, one might single out Geoffrey Whitney's *Choice of Emblems* (1586), which shows Hercules not in the usual desert, but on a Palladian stage with houses on either side of the street and a temple in the distance (p. 40).

36. *Essay on the Theory of Painting,* p. 7.

37. Although Egbert van Heemskirk the younger's animal caricatures may have played a part, Antal is probably right in suspecting that Hogarth had studied G. B. della Porta's *De Humana Physiognomonia* (1586), which compares human and animal expression (Antal, p. 132), or Le Brun's *Conférence . . . of Painting and Sculpture* (London, 1701).

38. *Essay on the Theory of Painting,* 2d ed. (London, 1725), p. 171.

39. Vasari, *Art of Painting,* p. 161. Cf. Roland Fréart, Sieur de Chambray, *An Idea of the Perfection of Painting Demonstrated,* preface; he uses Raphael as his ideal and Michelangelo as exemplar of "the *Ignorance* and *Temerity* of those *Libertines,* who trampling all the *Rules* and *Maximes* of Art under their feet, pursue only their own *Caprices."*

40. There was a precedent in painters like Aertsen and Snyders who heroicized commonplace objects; Aertsen retained a biblical story somewhere in the background, but Snyders simply painted his still-lifes as if they had been Rubens' sublime histories. The difference, of course, is that Hogarth was aware of, and exploited, the irony in showing cabbages and skinned rabbits in the style in which the Choice of Hercules was portrayed.

CHAPTER 11, § PUBLICATION

1. Vertue, VI, 191. The paintings are in the collection of Lord Brocket, Carton Castle, Maynooth; the subscription, conducted by the Bowles brothers and other printsellers, was concluded in the spring of 1728, the prints delivered in May (*Mist's Weekly Journal,* 9 March 1727/8). In February 1730/1, just before Hogarth announced his subscription, the engraver John Pine (probably now, and certainly later, a friend of Hogarth's) advertised proposals for a subscription for an illustrated edition of Horace. The price to subscribers was two guineas—one on subscribing, a half at delivery of the first volume, and the remaining half guinea at delivery of the second. Subscribers were to be given first impressions and have their names prefixed to the work. Subscriptions were taken by Pine at his house against Little Britain in Aldersgate Street, and for him at the Smyrna Coffee House in Pall Mall, where a specimen could be seen (*Grub-street Journal,* 25 February 1731/1).

2. P. A. B. Sheavyn, *The Literary Profession in the Elizabethan Age* (Manchester, 1909), p.

85; Marjorie Plant, *The English Book Trade*, 2d ed. (London, 1965), p. 227; Sarah J. C. Clapp, "Subscription Publications prior to Jacob Tonson," *The Library*, 4th ser., XIII (1932), 158–83.

3. Nichols, *Literary Anecdotes*, IV, 8; Edmund Malone, *Life of Dryden* (1800), p. 234.

4. *N & Q*, 19 May 1877, p. 386.

5. Alexandre Beljame, *Men of Letters and the English Public in the Eighteenth Century*, tr. E. O. Lorimer (London, 1948), p. 363.

6. George Sherburn, *The Early Career of Alexander Pope* (Oxford, 1934), pp. 188, 253–59.

7. Letter from Gay to Swift, 20 March 1728, in *Letters of John Gay*, ed. C. F. Burgess, p. 72; Johnson, *Lives of the Poets*, "Gay"; Voltaire, *Oeuvres*, ed. Garnier, VIII, 5; Johnson, *Lives*, "Young."

8. Plant, *English Book Trade*, p. 230. See the letter written by J. Twells to Dr. Grey in 1734 seeking subscriptions; quoted, Nichols, *Literary Anecdotes*, I, 466.

9. One can be virtually certain of this: none appears in any of the papers he later used for advertising the end of the subscription.

10. J. T. Smith, II, 181.

11. *Spectator* No. 226; for Sympson, Jr., and the engravings of *The Christening* and *The Denunciation*, see above, I, 234–35.

12. See Vertue, III, 28, 29; *Daily Courant*, 2 June 1725, *Daily Journal*, 14 January 1726/7. Vertue's note that Hogarth tried to employ engravers but was dissatisfied with their work (III, 58) may have been derived from Hogarth's advertisements rather than personal contact.

13. Vertue, III, 58.

14. Cibber, *The Lives of the Poets of Great Britain and Ireland* (London, 1753), v, 339.

15. See *Daily Post*, 31 December 1731.

16. *Gen. Works*, I, 56.

17. BM pressmark P.C. 31.k.14: *Reed's Weekly Journal, or British Gazetteer*, 29 January 1731/2; *Gen. Works*, II, 101.

18. See *Reed's Weekly Journal*, 11 March, which says he died at his house of Stony-Hill near Edinburgh; *Craftsman*, ibid., which says he died on 19 February at Hornby Castle near Lancaster. For the earlier report: *Grub-street Journal*, 15 October 1731.

19. For the happenings of that uneventful day, see *Daily Advertiser*, 11 April 1732.

20. *Daily Journal*, repeated 12, 20 April; *Daily Advertiser* and *Daily Journal*, 21, 28 April, and frequently repeated thereafter.

21. See Calhoun Winton, *Captain Steele* (Baltimore, 1964), pp. 132, 151.

22. Vertue, III, 58. The little painting of the Harlot taken from Plate 3 (later with Charlemont, now in the Mellon Collection) was presumably painted for someone who wanted a memento beyond the prints.

23. *Daily Journal*, 21 April; *Grub-street Journal*, 27 April.

24. *Tale of a Tub*, ed. A. C. Guthkelch and D. Nichol Smith, 2d ed. (Oxford, 1958), p. 207.

25. *Daily Post*, 24 April; 2d ed., *Daily Journal*, 4 May; 4th ed., which now has the cuts ("N.B. Any Gentleman who has bought the former Editions, may have the cuts alone, for 1 s."), *Daily Journal*, 15 May; 5th ed., *Daily Journal*, 29 November. The bawd is here identified as Mother Bentley, perhaps because Mother Needham was dead; Charteris and Gonson are identified. The second plate is based on Giles King's copies, with the two extra portraits on the wall, and mentioned as Woolston and Clarke in the text.

26. *Daily Journal*, 5 May 1732.

27. *Daily Advertiser*, 20 June; *Daily Journal*, 3 July.

28. *London Evening Post*, 16–18 May; *Craftsman*, 18 November.

29. *Daily Journal*, 1 May 1733. This pamphlet, following *The Humours of Drury Lane*, identifies the bawd as Mother Bentley, also Charteris, John Gourly, Woolston, and Clarke; Misaubin is identified as the "meagre Quack" in Pl. 5, and Mother Bentley is again identified in Pl. 6.

30. *Daily Journal*, 7 June; Walpole, *Anecdotes of Painting*, IV, 79, and MS. note in his copy (Lewis); later told by Sir John Hawkins in his *Life of Johnson* (1787), p. 500 n. Hogarth had, perhaps, opened the door to political innuendo in the *Harlot* by the introduction of Walpole's "friend" Charteris.

31. *Daily Advertiser*, 13 November 1732; *Daily Advertiser*, 15 March 1732/3; see also Moore, p. 36.

32. *Grub-street Journal*, 8 June 1732; see also Moore, pp. 97–99.

33. See my *Satire and the Novel* (New Haven, 1967), pp. 78–85.

34. A meeting could easily have been arranged through the intermediary Thomas "Hesiod" Cooke, a friend and defender of Fielding (and certainly an acquaintance of Hogarth, who had etched the frontispiece to his translation of Hesiod [1727/8]) and of Hogarth's friend John Ellys, whom he complimented in "An Epistle to Mr. Ellys the Painter" in 1732. But there is no need to suppose an intermediary. The defense of Fielding was in the *Comedian, or Philosophical Enquirer* (June 1732), pp. 11-15; on Ellys, ibid. (August 1732), pp. 36-38. See also the lines on Ellys in "An Epistle to Sir Robert Walpole," *Comedian* (June 1732), p. 19, and, on their friendship, a letter dated "The Grave, Aug. 19, 1733," from Anthony Henley to Cooke, in Leonard Howard, *A Collection of Letters, and State Papers, from the Original Manuscripts* (London, 1756), II, 599.

35. *Daily Journal,* 1 May 1733: "It has been well observ'd, that a great and just Observation to the Genius of Painters, is their Want of Inventions; from whence proceeds so many different Designs or Draughts, on the same History of Fable. Few have ventur'd to touch upon a new Story: But fewer still have invented both the Story and the Execution, as the ingenious Mr. Hogarth has done, in his Six Prints of a Harlot's Progress."

36. *Biogr. Anecd.,* 1781, p. 68; in the 1785 ed. Nichols gives the source "Mr. *Forrest*—dead," which by this time could have been either Ebenezer the father (d. 1783) or Theodosius the son (d. 1784). The manuscript of the *Peregrination* is in the BM; I follow Mitchell's edition of 1952.

37. A daughter, Anne Sophia, was baptized at St. Paul's Covent Garden, 6 May 1724 (*Registry,* ed. W. H. Hunt, I, 201); for Robert Scott, see St. Paul's Covent Garden Poor Rate Book (Westminster Public Library). Scott is not mentioned himself in the books till 1739, and remained then till 1747, when he moved to Southampton St. and Richard Wilson took over the Covent Garden house. For indications of Scott's personality, see Walpole, *Correspondence,* IX, 61; X, 329-31. Scott owned some of Hogarth's *Hudibras* drawings.

38. St. Paul's Covent Garden Poor Rate Books. For the "Memoir of Tothall," see *Gen. Works,* I, 522-23.

39. *HGW,* I, 160-61, 150.

40. Mitchell, p. 5.

41. Mitchell, pp. 3, 5, 7, 10, 12, 16.

42. Mitchell, pp. xix-xxxi.

CHAPTER 12

1. Swift, *Correspondence,* ed. Harold Williams (1963-65), IV, 391-92; Pope, *Correspondence,* ed. George Sherburn (1956), III, 436.

2. See Boydell's print of Hogarth's *Indian Emperor* (1791), which says the performance was held in Conduitt's house in 1731, before the younger members of the royal family. The original contents of the room, including the bust of Newton, were sold on 27 December 1750, by John Heath at the Exeter 'Change (*Daily Advertiser;* cited, Phillips, *Mid-Georgian London,* p. 244).

3. *London Evening Post,* 27-29 April 1732, tracing the Duke of Cumberland's week (11 years old at this time): "On Thursday Night [27 April] a Play call'd, The Indian Emperor, or The Conquest of Mexico by the Spaniards, was perform'd in the great Ball Room at St. James's, by several young Persons of the first Rank, before their Majesties and all the Royal Family who express'd their intire Satisfaction at the same; and the Company of young Soldiers belonging to his Royal Highness the Duke, were under Arms during the whole Performance, and his Royal Highness, as a Corporal, relieved and posted his Men on Duty at the End of every Act; and afterwards they were drawn up, and the Officers paid their Compliments to their Majesties as they pass'd through the Royal Apartments; and the King and Queen were so well pleased with the Performance, that they saluted the young Actors and Actresses, who had been severally instructed by Mr. Theophilus Cibber."

4. Letter of Dr. Alured Clarke to Mrs. Clayton, 22 April 1732, in National Library of Scotland, MS. 826, f. 45v.; reprinted in Katherine Thomson, ed., *Memoirs of Viscountess Sundon* (London, 1847), II, 112. See also, for an account of the picture as it hung in Holland House, identification of the sitters, etc., Katherine Thomson, ed., *Recollections of Lit-*

erary Characters and Celebrated Places (1854), I, 112.

5. Letter from Thomas Hill to John Conduitt, London, 20 June 1732, in Earl of Portsmouth MSS., *HMC, 8th Report,* Appendix, Pt. I (1881), p. 62b. Hill later commented, in an undated letter to Conduitt: "Lady Caroline has complied with your request, and I hope Hogarth has done you justice and her too" (ibid., p. 63b). While the picture was commissioned by the Conduitts, it is first heard of in 1778 in the second Lady Holland's collection. Beckett, unaware of the letters connecting Conduitt with the picture, inferred that it had been commissioned by the Duke of Richmond (p. 42). I would guess that it passed to Kitty Conduitt in 1740 when she married Viscount Lymington (John Conduitt died in 1737 and was buried in Westminster Abbey at Sir Isaac Newton's right hand), and that she gave it or willed it to her friend Lady Caroline Lennox, who in 1743 married Henry Fox and in 1762 became first Lady Holland.

6. *London Evening Post,* 1–4 January 1731/2; *Universal Spectator,* 15 April 1732 (that on 13 April Lord Malpas had received word that his wife's body, two footmen, and valuable baggage were lost in an English ship returning to London, which ran up onto the coast of France).

7. Salt glazeware mugs with the *Midnight Modern Conversation* on them, one dated 1732 (with R M to the sides and a B over the design), are in the Williamsburg (Virginia) Museum. The latter must be either March 1732/3 or based on the painting rather than the print.

8. *Daily Courant,* 5 February 1732/3.

9. *Daily Courant,* 8 February 1732/3.

10. *Daily Journal,* 8 February, 10 February; *Daily Post,* 16 February.

11. *Daily Journal,* 21 February, 26 February; Daily Courant, 22 February, 23 February.

12. *Daily Journal,* 27 February; *Daily Courant,* 4 March.

13. *Craftsman,* 10 March: "Monday Sarah Malcolm sate for her Picture in Newgate, which was taken by the ingenious Mr. Hogarth: Sir James Thornhill was likewise present"; *Daily Advertiser,* 7 March.

14. *GM,* LV (1785), 345.

15. *Daily Post,* 8 March; *Daily Courant,* ibid.; *Daily Journal,* ibid.

16. Vertue, III, 68; see also Millar, *Early Georgian Pictures,* pp. 184, 559.

17. Vertue, ibid.

18. *Lord Hervey's Memoirs,* ed. Romney Sedgewick (London, 1952), pp. 58, 77.

19. See, e.g., the portraits by Mercier (Shire Hall, Hertford; engr. Simon, 1728) and Amigoni (Royal Coll.).

20. *Advice* (1746), ll. 17–18. Kent himself was paid for "making designs to adorn the Royal Chapel at St. James's for the marriage of the Princess Royal" (1734, P.R.O., L.C. 5/150).

21. Moreover, if Kent had forgotten about Hogarth, he was reminded at the very beginning of the year when the *Daily Journal,* in which Hogarth was advertising his subscription for *A Midnight Modern Conversation,* announced on 3 January: "A Print representing an Epistle on Taste. Written by M. P–pe. Which may serve for its Frontispiece. . . . Price 1 s." While this print (*HGW,* cat. no. 277, pl. 321) does not remotely resemble Hogarth's style, it is evident that many contemporaries attributed the anti-Pope, anti-Burlington, anti-Kent satire to him on the basis of the Burlington Gate taken from *Masquerades and Operas,* with Kent still astride its top. Even if Kent did not believe Hogarth made this print, he would have been reminded of the earlier one. The pamphlet *The Man of Taste,* which used a copy as frontispiece, also kept the print in the public eye.

22. *Daily Post,* 17 October.

23. *Daily Journal,* 25 October 1733; *Daily Post,* 27 October; *Daily Post,* 30 October.

24. Vertue, III, 68.

25. *Daily Journal,* 6 November. The order was not aimed only at Hogarth and apparently was not immediately obeyed. On the tenth (*Daily Journal*), orders were again issued "that no Person whatever should be admitted into the Gallery and Chapel that is prepared for the Marriage of the Princess Royal, by reason of the Mischief that was done in the Chapel the Day before [i.e., the eighth], by the Great Crowd of People, some of the Sconces being stole, and the Hangings tore in several Places, besides other Damage."

26. Vertue, III, 68.

27. See I, 424.

28. *Daily Courant,* 12 November, 14 November; *Daily Journal,* 29 December; *London*

Journal, 2 February 1733/4, 16 March, 23 March; *Daily Advertiser,* 24 October 1734.

29. *LS,* Pt. 3, I, 312–14. In September, the *Harlot's Progress with the Diverting Humours of the Yorkshire Waggoner* was playing in Yeates' Booth; another version, with *Jephtha's Rash Vow,* was playing at the Lee-Harper Booth. The same had appeared earlier in the summer at Bartholomew Fair, except that the *Fall of Bajazet* was also playing there, at the Cibber-Griffin-Bullock-Hallam Booth, and apparently did not continue at Southwark Fair.

30. *Daily Advertiser,* 25 August 1733.

31. See S. Ireland, I, 110. The oil sketch is in the collection of S. Fatorini.

32. *Daily Post,* 29 May 1733; see *An Apology for the Life of Mr. T[heophilus] C[ibber], Comedian. Being a Proper Sequel to the Apology for the Life of Mr. Colley Cibber, Comedian* (London, 1740), pp. 16, 85–89; Benjamin Victor, *The History of the Theatres of London and Dublin, from the Year 1730 to the Present Times* (London, 1761), I, 4.

33. *Daily Advertiser,* 4 July 1733, 27 July, 31 July (for Saturday, 4 August), *General Advertiser,* 29 March 1748. In Rich's account books for 1735–47 (BM) Laguerre is shown to have been paid £1 per week as a basic fee but with extra, often double this amount, according to work done. In 1735, however, Laguerre was declared bankrupt (*GM,* v [June 1735], 333). For speculations on his decorative and theatrical painting, see Desmond Fitzgerald, "The Mural from 44 Grosvenor Square," *Victoria and Albert Museum Year Book* (London, 1969), pp. 145–51.

34. *Daily Post,* 13 November 1733; *Daily Post,* 13, 14, 16 November; *Grub-street Journal,* 6 December; *Daily Journal,* 1 February 1733/4; *GM,* November 1733 and March 1734. The announcement of *Southwark Fair* was in the *Daily Journal,* 22 December 1733 and again on 19 and 26 January 1733/4.

35. *Daily Advertiser,* 9 October 1733; repeated 10 October and 7 December. On the eighth the date was changed to "on the 1st," and from the tenth it ran in every issue through the twenty-third, and again from 27–29 December.

36. *The Progress of a Rake: Or, The Templar's Exit* (1732). One of the wrong guesses in David Kunzle's essay on the *Rake* piracies is his thought that the poem was inspired by knowledge or rumor that Hogarth was at work on the progress of a rake, and that the presence of ten cantos proves that Hogarth originally projected that number of plates. The date of the pamphlet's publication, presumably unknown to Kunzle, shows that it was an immediate response to the *Harlot*—a rake being an obvious sequel. ("Plagiaries-by-Memory of the Rake's Progress," *Journal of the Warburg and Courtauld Institutes,* XXIX [1966], 313.)

37. Kurz, "Italian Models of Hogarth's Picture Stories," pls. 35, 36.

38. *Accomplish'd Rake,* in *Four Before Richardson,* ed. W. H. McBurney (Lincoln, Nebraska, 1962), pp. 277, 301. Hogarth may also have been intrigued by the scene at the Covent Garden masquerade, which leads to a bagnio (cf. *Marriage à la Mode,* Pl. 5).

39. Kunzle, p. 322. It is, however, connected with the series and is of the same size. Another oil sketch, somewhat larger (25 × 39 inches, as opposed to 19 × 25), in the Atkins Museum, Kansas City, may be by Hogarth (see Ross E. Taggart, "A Tavern Scene: An Evening at the Rose [Study for Scene III of 'The Rake's Progress']," *Art Quarterly,* XIX, 1956, 321–23). If it is by Hogarth, it probably antedates the *Rake* series as such, its size and style being different. What is puzzling is that X-rays show that the underpainting is closer to the finished painting in the Soane Museum than to the finished Atkins Museum picture. The main differences are the perspective of the room, seen straight on in the sketch, at an angle in the final version and the underpainting; and the pictures, the map, and the girl setting fire to it, which are also present in the final version and the underpainting. If it is by Hogarth, it shows that he contemplated a more classical composition before returning to the baroque one he actually employed (see below, Chap. 14); or that after finishing the prints he went back to the painting to see whether he should correct the shape. Otherwise, one must conclude that it is by somebody who copied Hogarth's picture and then made a few changes to make it appear a preliminary sketch.

40. Kurz, p. 155.

41. Edward G. O'Donoghue, *Story of Bethlehem Hospital* (London, 1913), p. 244.

42. Frank and Dorothy Getlein, *The Bite of the Print* (New York, 1963), p. 152.

43. *The Poems of Jonathan Swift,* ed. Harold Williams (Oxford, 1937), III, 839. The poem was published in June 1736.

44. "I have often the Favour of drinking your Health with Dʳ Swift, who is a great Admirer of yours, and hath made mention of you in his Poems with great Honour, and desired me to thank you for your kind Present, and to accept of his Service" (Faulkner to Hogarth, 15 November 1740, BM. Add MS. 27995, p. 4; transcribed in Ireland, III, 59). From this same letter, it appears that Hogarth kept up some connection with Mrs. Pendarves, who was now Mrs. Delany, wife of one of Swift's close friends; and that Faulkner retailed 50 sets of the *Four Times of the Day* in Dublin.

45. See Kurz, p. 154, and Kunzle, p. 340.

46. To fire meant in contemporary idiom to become lustful, but I have no doubt that it also carried the idea of infection; for one thing, Hogarth was too physically-oriented to have sent the Rake to Bedlam only on the basis of his mounting troubles. G. C. Lichtenberg, though he belabors the pun and then admits it only exists in German, is nevertheless essentially correct in his analysis of Pl. 3 (*The World of Hogarth* [New York, 1966], p. 221).

47. J. B. Le Blanc, *Letters on the English and French Nations* (Dublin, 1747), I, 161. Horace Walpole remembered the Rake as having had less success than the *Harlot* "from want of novelty" (*Anecdotes of Painting,* IV, 138). It could not have had the full impact of the first series, but, on the other hand, Walpole was only eighteen at the time and not in London. For the *Rake's* publication, see below, Chap. 13.

48. *The Scots Peerage,* ed. Sir James Balfour Paul, IV, 385. For the information on Mary Edwards I follow W. F. N. Noel, "Edwards of Welham," *The Rutland Magazine and County Historical Record,* IV (1909–10), 209–12,243–44. much abbreviated, this material was reprinted in Emilia F. Noel, *Some Letters and Records of the Noel Family* (London, 1910), pp. 30–31.

49. W. F. N. Noel, "Edwards of Welham," p. 210.

50. For the marriage, see *GM,* I (1731), 311; for the birth of Gerard Anne, see *GM,* III (1733), 156.

51. Vertue, IV, 68. I am very dubious of the other picture Noel lists (p. 211), "by Hogarth, of the interior of a barber-surgeon's shop, in which monkeys are shaving and bleeding cats," which was retained by the family. This may have been the *Barber Shop of Monkeys,* attributed to Teniers in her sale catalogue (Cock's, 38, 29 May 1746). She owned four Heemskirks, but also paintings by Rubens (Thornhill's *Nature Adorned*), Guido, Sarto, Raphael, Van Dyck, and Kneller.

52. Middlesex Records, Orders of Court, Westminster, June 1730 (Middlesex County Record Office).

53. Macklin's *Diary,* 1733 (Folger Library), f. 117; William Cooke, *Memoirs of Charles Macklin* (London, 1804), p. 72.

54. *Biogr. Anecd.,* 1781 ed., p. 14; *Gen. Works,* I, 26.

55. St. Martin's in the Fields Collection Book for the Poor Rate, 1733 (Westminster Public Library F486), shows only that Hogarth's name has been added over Lady Howard's, which has been boxed, when the insertion was made cannot be determined. The first collection was on 6 April, the second on 12 October; so he was definitely in residence by 12 October. The date can be narrowed down by a look at the Scavenger Rate Book for 1733 (New Street Ward, F5677): the collection took place on 12 April 1733 and Lady Howard (though dead) is still listed as householder (£50, rated at 16s 8d). Thus one can safely conclude that Hogarth was not installed by 12 April; he must have moved in between then and 12 October. Tyers' letter, dated 1 May, was in the Forman Collection; published in *Catalogue of the Works of Antiquity and Art Collected by the late William Henry Forman, Esq. . . . by Major A. H. Browne* (Privately printed, 1892), p. 24; also published in the Dorking *Inventory* (1869), p. 157.

56. BM Add. MS. 27995, f. 23; I. Macky, *A Journey through England,* 4th ed. (1724), I, 178.

57. Macky, 1732 ed., I, 205.

58. *London Evening Post,* 9–12 April 1737.

59. Derek Hudson, *Sir Joshua Reynolds, A Personal Study* (London, 1958), p. 72. His portrait (pl. 190) also appears in mosaic on the entrance to the Leicester Square comfort station (men).

60. Westminster Public Library, Deed 67/4; Middlesex Land Register, 1723/1/124.

61. *Craftsman,* 10 December 1732; *GM,* II (1732), 1125.

62. *Gen. Works,* I, 398.

63. Tom Taylor, *Leicester Square* (London, 1874), p. 281.

64. "Hunter Album," Royal College of Surgeons, pp. 38–39, 163, including on p. 39: William Clift, "Ground Plan of 28 Leicester Square as it appeared in 1792, drawn in 1832." Hogarth's maulstick and palette, the latter a shovel-shaped board, now badly warped, are in the Royal Academy, opposite Reynolds' palette. The palette, however, if genuine, was one of several: the one shown in *Gulielmus Hogarth* and *Hogarth Painting the Comic Muse,* and on his own seals, is the more conventional shape, conforming to the Line of Beauty. His painting chair was said to have been "a large affair running on wheels," still extant in 1867 when Alfred Dawson saw it, but now lost (*The Chiswick Times,* cited Warwick Draper, *Chiswick,* p. 106). From Mrs. Hogarth's catalogue, we learn that he had a large color cabinet with fifty-four drawers for colors, "a large press, with glazed doors and sliding shelves, painted mahogony," and a telescope (Nos. 59, 60, 65). He also owned a cast of Rysbrack's bust of Newton (No. 56); from this one may infer either that his portrait of Dr. Benjamin Hoadly seated beneath the Newton must be a view of a room in his own house in Leicester Fields, or that Hoadly owned the bust and bequeathed it to Hogarth. His lay figure is now in the Bath Academy, Corsham Court (donated by Walter Sickert). See also *European Magazine* (June 1801) p. 442; and *Survey of London,* XXXIV (London, 1966), 501–02, 505.

CHAPTER 13

1. "Minutes of the Grand Lodge of Freemasons of England 1723–1729," introduction and notes by W. J. Songhurst, in *Quatuor Coronatorum Antigrapha,* X (1913), p. 43.

2. G. W. Speth, "Hogarth's *Night,*" *Ars Quatuor Coronatorum, Transactions of Quatuor Coronati Lodge No. 2076, London,* II (1889), 116.

3. "Minutes," pp. 239–40, 254. Vols. XI and XII contain minutes for the years following, but there is no further mention of Hogarth. For more speculation on Hogarth and his masonic connections, see Eric Ward, "William Hogarth and his Fraternity," *Ars Quatuor Coronatorum,* LXXVII (1964), 1–18. For Isaac Schomberg, see below, II, 470.

4. *Letters of Baron Bielfield* (1741), quoted, Phillips, *Mid-Georgian London,* p. 107. Contemporaries do not seem to have regarded Slaughter's as simply a hangout for artists. The *Westminster Journal,* 27 February 1741/2, says it is inhabited by "the neighbouring Tradesmen who meet there early for their Dish of Chocolate and Dish of Politics," and Goldsmith refers to it as a place where "old orators" collect to "damn the nation because it keeps [them] from starving" (*Busy Body,* 13 October 1759; see also issue of 20 October 1759; in *Goldsmith's Collected Works,* ed. Arthur Friedman [Oxford, 1966], III, 6, 20).

5. Lillywhite, *London Coffee Houses,* No. 937, p. 421; Phillips, *Mid-Georgian London,* pp. 107–08.

6. According to J. T. Smith (pp. 144–51), who seems, however, to be doing little more than listing the artists who lived nearby, these included Isaac Ware, Gravelot, John Gwynn, Hogarth, Roubiliac, Hudson, McArdell, Luke Sullivan, Theodore Gardelle, G. M. Moser, Richard Wilson, the blind Welsh harpist John Parry, Nathaniel Smith (J. T.'s father), and William Rawle. Many of these are, of course, from a somewhat later period.

Ephraim Hardcastle, Citizen and Dry-Salter (William Henry Pyne), has much material on the Slaughter's group in *Wine and Walnuts; or, After Dinner Chit-Chat,* 2 vols. (London, 1823), and mentions (I suspect at random) Jonathan Richardson, Fielding, Lambert, Hogarth, Garrick, John Pine, Folkes (pp. 104–21). His book is the source of most of the spurious anecdotes concerning Slaughter's. Mark Girouard also speculates on the Slaughter's group in a series of articles called "English Art and the Rococo," in *Country Life:* I, 13 January 1966, pp. 58–61; II, 27 January 1966, pp. 188–90; III, 3 February 1966, pp. 224–27.

7. *Farington Diary,* III, 267. For an anecdote of Gravelot's timidity and his absorption into the English artistic community, see pp. 267–68.

8. H. A. Hammelmann ("Early English Book Illustration," *Times Literary Supplement,* 20 June 1968, pp. 652–53) traces the origin of rococo to Vanderbank's *Don Quixote* illustrations in the late 1720s, to the Coypel *Don Quixote* illustrations, and to work of the foreign illustrators introduced to England by Jacob Tonson in his editions of the classics and the English dramatists. There is much truth in this view, and Gravelot's position in the Slaughter's circle may have been more a symbolic than a practical stimulus. But when Rouquet, with Hogarth's counsel, put together *The State of the Arts in England* (1755), he emphasized Gravelot's role: "Mr. Gravelot, during the stay he made at London, greatly contributed to diffuse a taste of elegance among the English artists. His easy and fertile genius was a kind of oracle, to which even the most eminent occasionally applied. From him they learnt the importance of design; and till they can make themselves masters of this branch, they occasionally apply to some other artist who is capable of directing them" (p. 104).

9. See Girouard, I, pp. 59–60; III, p. 224.

10. *Monthly Magazine* XXVII (June and July 1809), 440; cited, H. A. Hammelmann, "First Engraver at the Royal Academy," *Country Life,* 14 September 1967, pp. 616–18.

11. *European Magazine,* LV (1809), 443. His birth date is usually given as 1708, but unless he was apprenticed at ten, he must have been born somewhat earlier. His apprenticing to Robert Browne, citizen and history painter, for £84, in 1718, is recorded in the *Index of Apprentices* (Guildhall Lib., Somerset House, Bk. 7, f. 13); he is listed as son of the widow Jane Hayman.

12. J. T. Smith, II, 271. See also Hayman's obituaries in *The Public Advertiser,* 3 February 1776; Morning Post, 5 February.

13. Vertue, III, 6. Lambert's connection with Rich may have led to Hogarth's. Records of accounts show a payment of £50 to Lambert on 28 December 1726 and one of £48 on 14 March 1727 (Account Books of Lincoln's Inn Fields Theatre, BM MSS. Egerton 2265,2266). See also the sworn affidavit by Lambert in Rich's *Mr. Rich's Answer to the Many Falsities and Calumnies advanced by Mr. John Hill . . .* (1739), pp. 13, 20; Mitchell's *Poetic Epistle* (1731); *Daily Journal,* 18 September

1732 (Lambert employed with Mr. Hervey in painting scenes for the new Covent Garden Theatre); *Daily Advertiser,* 17 February 1753. For his life records, possible marriage, etc., see Elizabeth Einberg, *George Lambert* (Kenwood, Greater London Council, 1970), pp. 5–10.

14. Einberg, cat. no. 55; Vertue, III, 24, 47 (I doubt if publishing one's portrait was such a "normal thing to do for a young artist wishing to make himself known to a wider clientele" as Miss Einberg thinks). For the reference to Lambert's library, see S. Ireland, I, 155; for the genealogy, see *HGW,* I, 111, and Einberg, p. 5.

15. *London Journal,* 26 August 1727.

16. *Painting in England, 1700–1850: Collection of Mr. & Mrs. Paul Mellon* (Richmond, Virginia, 1963), cat. no. 10; J. B. Nichols, p. 366; Sidney, Sixteenth Earl of Pembroke, *A Catalogue of the Paintings & Drawings in the Collection at Wilton House* (London, 1968), cat. nos. 34–37; Einberg, cat. no. 9. Two pictures in Lambert's sale catalogue are listed as with figures by Hogarth (Langford, 18 December 1765, nos. 78, 82). I do not think the figures in Lambert's views of Lord Burlington's Chiswick House are by Hogarth (Einberg, cat. nos. 14–15).

By the 1740s Lambert's figures change, either to a cruder version of the Hogarthian figures or to the style of Hayman (his pupil Samuel Wale is known to have furnished Lambert figures); presumably with the access of Hogarth's reputation in the late 1730s he no longer wished to be a collaborator. But in the 1730s the collaboration had been fruitful, and in those years he may have also supplied figures for some of Scott's landscapes—a continuation of the relationship they had enjoyed on their "peregrination" (Dobson, p. 25 n., citing a *View of Bloomsbury Square and Bedford House*). Scott and Lambert themselves collaborated on the six views of East India ports, for which they received £94 10s. on 1 November 1732; Scott painted the ships and seascape, and Lambert the landmass and buildings. For the Scott-Lambert collaboration, see the records of the East India Company; prints were published by Kirkall in 1735 and by Vandergucht in 1736. They also worked together on a set of views of Mount Edgcumbe and Plymouth Harbor of which only engravings have survived (Einberg, cat. nos. 43, 44).

17. "Mr. John Ellis born 1701—about fifteen years of age put to Sr James Thornhill to learn. staid not long with him" (Vertue, III, 47). For his assistance at Greenwich, see Whitley, I, 27.

18. Vertue considered the Rose and Crown Club inferior to the Virtuosi and (if it was not the same thing) St. Luke's. It survived until May 1745, the last meeting being held at the Half Moon Tavern (Vertue, VI, 31, 35; Whitley, I, 68). Hogarth is not included in Vertue's drawing of the club, and so was apparently not a faithful member, or perhaps not *yet* a member, but he appears in the list Vertue made of other members (VI, 351).

It has recently been suggested that Ellys collaborated with Hogarth on the cartoon "Rich's Glory or his Triumphant Entry into Covent Garden"; the theory is based on the inscription "WHIESULP," which might stand for "William Hogarth and John Ellys sculp" (No. 104 in "Theatre and Drama during the Restoration and Eighteenth Century," catalogue of an exhibit held at the Humanities Research Center, University of Texas, Autumn, 1964). Certainly the engraving is not etched by Hogarth, and this theory might explain why so unlikely a print has been associated with his name. It still, however, seems to me likely that "WHIESULP," added by a later hand, means "William Hogarth invenit et sculpsit" (a small superscript can be detected above the E, to suggest Et). See *HGW*, I, 300–01.

19 Victor, *History of the Theatres of London and Dublin* (London, 1761), I, 6 and 66.

20. Vertue, III, 38; Hammelmann, "John Vanderbank," *Book Collector* (1968), 288. Aside from the evidence of affluence, a correspondent to the *Grub-street Journal*, 11 October 1733, refers to Ellys' influential father and his close relatives, who "are generals in his majesty's army, wealthy merchants, senators, &c. either of which is able to buy the whole tribe of his seducers [i.e. opponents]." As to his portraits, by 1732 he had done likenesses of Sir Charles Wager, Lord Albemarle, Bishop Hoadly, Archbishop Wake, and James Figg in the pose of a gladiator. As to his character, he was noted for his truthfulness ("An Epistle to Mr. Ellys the Painter," presumably by his friend Thomas Cooke, in *The Comedian*, Aug. 1732, coll. ed., 1733, pp. 36–38). The por-

traits of Fenton and Walker were engraved in mezzotint by John Faber, published 20 March 1727/8 (*Craftsman*, 16 March). For an example of his Knellerlike portraiture, see his *Lord Whitworth and his Nephew* (Knole Park).

21. Vertue, III, 120, 71; BM. Add. MS. 30167, "A Folio Tract called the Virtuoso or St. Luke's Club"; the portrait by Hamilton is in the National Portrait Gallery, London.

22. From the Forman Collection; published in *Catalogue of the Works of Antiquity and Art Collected by the late William Henry Forman, Esq. . . . by Major A. H. Browne* (privately printed, 1892), p. 24; also published in the Dorking *Inventory* (1869), p. 157. The medal, now in the BM, was copied by James Stow in an engraving (published 1825 by Robert Wilkinson).

23. *Gen Works*, I, 47; Dobson, p. 24; *HGW*, I, 137; Thomas Faulkner, *The History and Antiquities of Brentford, Ealing, & Chiswick* (London, 1845), p. 442 n.

24. Lockman, p. 2. An advertisement for the *Sketch*'s publication, dated 7 May 1752, is reprinted in *The Vauxhall Papers*, XVI (23 August 1841). The same collection (XII [13 August 1841]) reprinted another description by Lockman in the style of the *Sketch* and identical in many parts. The basic work on the Vauxhall decorations is Lawrence Gowing, "Hogarth, Hayman, and the Vauxhall Decorations," *Burlington Magazine*, XCV (1953), 4–19.

25. *A Brief Historical and Descriptive Account of the Royal Gardens, Vauxhall* (London, 1822), pp. 7, 33; *A Description of Vauxhall Gardens. Being a Proper Companion and Guide for all who visit that place* (London, 1762), p. 28.

26. Walpole to John Nichols, 31 October 1781, *Letters*, ed. P. Toynbee (Oxford, 1904), XII, 80. Gowing has argued in favor of a large canvas, *Fairies Dancing on the Green by Moonlight*, which (according to the guides) hung in a supper box on the south side of the grove (Gowing, pp. 4–6). This painting, in the collection of Major A. S. C. Browne, Callaly Castle, may be Hogarth's work, but its condition does not make for easy authentication. It was cut in two after 1860, leaving the watchman in one section and the dancing fairies in the other.

27. *GM*, XXV (1755), 206: "At Vauxhall . . .

they have touched up all the pictures, which were damaged last season by the fingering of those curious Connoisseurs, who could not be satisfied without *feeling* whether the figures were alive."

28. J. T. Smith gives an account, II, 31, apparently from a manuscript of his (Smith's) father: "At the time Mr. Tyers had engaged in the Vauxhall-garden speculation, he requested the advice of Mr. Cheere as to the best mode of decoration. 'I conclude you will have Music,' observed Cheere, 'therefore you cannot do better than to have a carving of an Apollo. What do you say to a figure of Handel?'—'Good,' replied Jonathan, 'but that will be too expensive, friend Cheere.'—'No,' answered the Sculptor; 'I have an uncommonly clever fellow working for me now, . . ." etc. It sounds as if Smith's father simply noted that Cheere got Roubiliac the commission, and the rest is reconstruction.

29. Quoted, Girouard, III, p. 226; also I, p. 61. Ware had connections with both the Slaughter's group and the Palladians—Burlington, Kent, Flitcroft, Vardy, and Rysbrack. As a Burlingtonian Palladian, he dedicated his edition of Palladio's *Quatro Libri* to Burlington in 1738 (Hogarth and some of his friends were among the subscribers). But he also did the rococo interior of Woodcote and (probably) Belvedere, apparently frequented Slaughter's, and ran the St. Martin's Lane Academy jointly with Hogarth in 1738, and perhaps also in 1739 and '40 (Vertue, VI, 170); he was sculpted by Roubiliac around 1740 and again around 1755.

30. *Explanatory Notes and Remarks on Milton's Paradise Lost* (1734), p. cxli. For the story, attributed to Joseph Highmore, see S. Ireland, I, 117-20.

31. *HGW,* I, 314; see Walpole's *Book of Materials* for 1759 (I, 6), in the W. S. Lewis Collection.

32. S. Ireland, I, 118-20.

33. See below, II, 207-08, and Appendix I.

34. *Anecdotes of Painting,* ed. James Dallaway and Ralph Nicholson Wornum (London, 1849), II, 712.

35. See John B. Shipley, "Ralph, Ellys, Hogarth, and Fielding: the Cabal against Jacopo Amigoni," *Eighteenth-Century Studies,* I (June 1968), 313-31.

36. "Essay on Taste," *Weekly Register* No. 43, 6 February 1730/1; on Hogarth, No. 112, 3 June 1732; reprinted, No. 222, 8 June 1734, in the series on painting.

37. Vertue notes that Hogarth was able "to secure his interest and to prevent any other. (Amiconi was thought on.) but supplanted. especially by this Hogarth's noble artifice of presenting the workes" to the Hospital (III, 78, written in April 1736). Shipley's inference that Amigoni tried to supplant Hogarth (pp. 322–23) is based on a false chronology of events.

38. For the account of Lloyd's participation, see Arthur W. Crawley-Boevey, *The 'Perverse widow': Being Passages from the Life of Catharine, Wife of William Boevey, Esq. of Flaxley Abbey, in the County of Gloucester, with Genealogical Notes on that Family and others connected therewith* (London, 1898), p. 249 n. The portrait of John Lloyd is in the Mellon Collection.

39. *Weekly Register* No. 207, 23 February 1734, under date "Wednesday, *Feb.* 20." Cf. Robert Seymour (i.e. John Mottley), *A Survey of the Cities of London and Westminster* (1734), II, 883: "Among the Governors of St Bartholomew's Hospital was lately chosen Mr. William Hogarth, the celebrated Painter; who, we are told, designs to paint the staircase of the said Hospital, and thereby become a benefactor to it, by giving his labour *gratis.*" See also *Read's Weekly Journal,* 23 February.

40. No. 216, 27 April 1734.

41. No. 215, 20 April; No. 217, 4 May (see also conclusion of essay in No. 216, 27 April); the critiques of Amigoni's work are in No. 217 (as above); No. 219, 18 May; and No. 220, 25 May.

42. No. 217, 4 May. Cf. also the ridicule of history painters who show Joseph in a full-bottomed wig or Judith and Holofernes embracing in the entrance of a tent in full view of the whole army, including a row of brass cannon, etc. (No. 112, 3 June 1732). Cf. Richardson, *Essay,* p. 68, on the topic "Nothing Absurd, Indecent, or Mean": "A Dog with a Bone, at a Banquet, where People of the highest Characters are at Table; a Boy making Water in the best Company, or the like, are Faults which the Authority of *Paulo Veronese,* or a much greater Man, cannot justify."

43. *Grub-street Journal* Nos. 230 and 233, 23 May and 13 June. *The Weekly Register* replied, and the *Journal* summarized the quarrel and answered Ralph in No. 232 in its Pegasus Column. In No. 236 a parody "Critical Review of the Buildings, Statues, Vases, etc. in Grub Street" by "Vitruvius Grubeanus" was published. Vertue copied the exposure of Ralph's attributions in No. 233 and expressed amusement at the *Journal's* suggestion that the freethinking Ralph should read the Bible (III, 72). Vertue had already listed the paintings and their correct subjects (III, 67).

44. *Grub-street Journal* No. 235, 27 June. See also "Bavius," in No. 244, 29 August.

45. *Weekly Register* No. 228, 20 July 1734.

46. *Grub-street Journal* No. 245, 5 September 1734.

47. Charles R. Leslie and Tom Taylor, *Life and Times of Sir Joshua Reynolds* (London, 1865), I, 101.

48. Vertue, III, 61.

49. Vertue, III, 70. Thornhill was buried 10 May at Thornhill (burial register of St. Mary's, Stallbridge, vol. II).

50. *GM*, IV, (May 1734), 274–75; Mitchell, *Hogarth's Peregrination*, p. 14 n. For the text, see Appendix F.

51. Vertue, III, 74.

52. Journal of the Meetings of the Governors of St. Bartholomew's Hospital (archives of the Hospital, Hal/10). Reprinted by permission of the Governors of the Royal Hospital of St. Bartholomew.

53. Norman Moore, *The History of St. Bartholomew's Hospital* (London, 1918), II, 280.

54. Edwards, *Anecdotes of Painting, contd.*, pp. 19–20. Other accounts credit Rich (see J. T Smith, II, 157; Walter Arnold, *The Life and Death of the Sublime Society of Beef Steaks* [London, 1871], p. 2); and one story gives partial credit to the Earl of Peterborough (F. S. Russell, *The Earl of Peterborough* [1887], II, 261; also *The National Review*, IV, [1857], 313–14). The diagram of the Covent Garden Theatre (reproduced in Southern, *Georgian Playhouse* [London, 1948], p. 22) by G. P. M. Dumont for *Parallèle de plans des salles* (1763), shows all the rooms devoted to painting, carpentering, and storing of scenery; a cross section shows the room where the Beefsteaks probably met.

55. For the masonic-sounding rules, see Arnold, *Life and Death of the Sublime Society of Beef Steaks*, pp. xiii–xvi. See also the *Connoisseur* No. 19, letter about the Beefsteaks; and, to date some of the formalities, Eugene R. Page, *George Colman The Elder* (1935), p. 187.

56. See *HGW*, cat. no. 161; S. Ireland, I, 112.

57. *Gen. Works*, I, 129, 420–21.

58. The official Song of the Day, with the chorus "O joyful theme of Britons free, / Happy in Beef and Liberty," was written—presumably after 1763 when he became a member—by Theodosius Forrest, the son of Ebenezer. This song may be connected with Theodosius' Roast Beef Cantata which he derived from Hogarth's *Gate of Calais*, or *O' the Roast Beef of Old England* (1750), which itself may have been Hogarth's allusion to the club.

59. See *Marchmont Papers*, ed. Rose (1920), II; *Annals of Stair*, ed. Graham, II, 226; *HMC*, Egmost MSS., II, 14. When George was told of this club, he is supposed to have said, "Quoy? est qui se moque de moi?" (Egmont MSS., p. 53).

60. For Overton's 1733 catalogue, see *HMC*, *15th Report*, Appendix, Pt. VII (1898), p. 233.

61. Kunzle, p. 315 (he mistakes the year in which the Act was passed). Phillips (*Mid-Georgian London*, p. 171) points out an advertisement (apparently cited in Hilton Price, *Signboards of the Strand*) in some newspapers of 1725: "Rummer's Tavern, next the Water Gate, Somerset House. Persons concerned in the multiplying of pictures by impression are desired to meet here." He thinks this anonymous notice may have been inserted by Hogarth as a first attempt to do something about the printsellers following his experience with *Masquerades and Operas* in 1724. In fact, the advertisement was inserted by Le Blon for his latest scheme: "All Persons concern'd in Mr. Le Blon's Undertaking, for multiplying Pictures by Impression, are hereby required to bring the Tickets to which they claim a Property, to the Printing-House in Dutch-Lane near Somerset-Yard, on or before the 24th Day of June next in order to have their Numbers registered with Mr. Lesage. . . ." (*Daily Post*, 17 May 1725). For an account of Le Blon's "undertaking," see Vertue, VI, 189.

62. *Gen. Works,* I, 76 (as told by Hogarth to Sir John Hawkins).

63. *Times Literary Supplement,* 9 February 1967, p. 98.

64. See Marjorie Plant, *The English Book Trade,* p. 118; Harry Ransom, *The First Copyright Statute. An Essay on an Act for the Encouragement of Learning* (Austin, 1950), pp. 64, 77.

65. *The Case of the Designers, Engravers, Etchers, &c. stated. In a Letter to a Member of Parliament,* 7 pp., undated. The copy in the V & A, from the collection of Michael Lort, has a MS. inscription claiming that "Hogarth got this drawn."

66. *Journals of the House of Commons,* XXII, 364.

67. Ibid., pp. 380–81. On 3 March, no doubt encouraged by the artists' success, authors and compilers of books presented a petition seeking to strengthen their copyright act—already stronger than the one the artists eventually received. Soon after, a broadside appeared attacking the amendment and arguing that the new bill was in fact being put forward by the booksellers, to retain their twenty year copyrights, just now running out. This act runs as an obligatto alongside the Engraver's Act during the spring but was eventually rejected. (*Commons Journals,* XXII, 400 et sec.; see also Plant, p. 119.)

68. *Commons Journals,* XXII, 401, 414, 442, 457.

69. *Journals of the House of Lords,* XXIV, 516, 530; *Commons Journals,* XXII, 476. The committee minute is from a MS. in the House of Lords Library. The act is reprinted in Appendix E.

70. *Daily Advertiser,* 3 May 1735; repeated May 5, 7–19.

71. *Commons Journals,* XXII, 493.

72. There was no protection for English books in Ireland either; and the Dublin booksellers had elevated piracy to the level of a fine art. One is reminded of the *Rake* affair by the story of their pirating of Richardson's *Sir Charles Grandison* in 1753: Richardson took "special precautions, by splitting up the work between his three printing-houses and among different workmen, to make it impossible for anybody to copy the work as a whole; yet by some means the work was published in Dublin by three different firms before his own main edition was out" (Plant, p. 120; Nichols, *Literary Anecdotes,* IV, 588).

73. For an ambiguity Vertue detected in the Act, see Vertue, VI, 200.

74. 7 George III, Cap. 38, passed in 1767; see Appendix K. For the commemorative print, the subscription ticket for the *Election,* see below, pl. 252.

75. *Daily Journal,* 11 June 1735.

76. *Old Whig,* 12 June.

77. *General Evening Post,* 12–14 June; also in *Read's Weekly Journal, or British-Gazetteer,* and *Weekly Register,* 17 June, 14 June, same wording; in *Daily Advertiser,* 13 June, and *Grub-street Journal,* 19 June; GM, v (1735), 333.

78. *Daily Courant,* 11 June; *Daily Journal,* 13 June; *General Evening Post,* 12–14 June, and Burial Register of St. Anne's Parish, Soho (Westminster Public Library).

79. In the registers of policies taken out with the Sun Fire Office from 1710, vol. 44, policy no. 70649, 17 June 1736: "William Hogarth of the parish of Saint Martin in the fields Painter On his household Goods and Goods in Trade and Copper plates Pictures excepted in a Brick house being his now Dwelling house and situate at the Golden Head on the East Side of Leicester Fields in the parish aforesaid not Exceeding five hundred pounds £500."

His sisters' policy, though dated later (24 June), precedes Hogarth's in sequence in the book, which presumably means that they were sent in together by the agent and entered in the register in the wrong order. (The discovery of these entries, which I passed on to the archivist of the Sun Insurance Company, was recorded [mentioning only Hogarth's policy] without acknowledgement in the *Sun Alliance Group Gazette,* I, No. 13 [Autumn, 1965], 10–12.)

80. Vertue, III, 76. For the story that Moser's academy of drawing was combined at this time with the St. Martin's Lane Academy, see below, II, 140.

81. Vertue, VI, 170.

82. *Apology for Painters,* p.-95. My text replaces some strikethroughs in the manuscript and is slightly regularized.

83. Ibid., Kitson's introduction, p. 52 n. 76; Phillips, *Mid-Georgian London,* p. 278. Phillips thinks it was in the basement of one of

the largest houses in the Lane, probably in the upper half and on the west side, where the most heavily assessed houses appear.

84. Sidney C. Hutchison, *History of the Royal Academy* (London, 1968), pp. 47, 54, pl. 9.

85. Vertue, VI, 170. See also, e.g., *The Conduct of the Royal Academicians, &c.* (London, 1771), a pamphlet of the Incorporated Society of Artists. Ellys took over, at Vanderbank's death (1739), both his atelier and practice, and may have inherited the paraphernalia of the old Vanderbank Academy as well, and added it to the new academy.

86. *Apology for Painters,* introduction, p. 35.

87. See Appendix F for the whole letter.

88. Edgar Wind, *Art and Anarchy* (London, 1963), p. 32.

89. *Weekly Register* No. 112, 3 June 1732.

90. Although talking about a critic, Thomas (Hesiod) Cooke formulated the idea in one of his *Comedians* for 1732 when he wrote that "Most People" judge a painting "more by their Ears than their Eyes; for they seldom determine a Picture, or Painter, till they have taken the Opinion of a Person whom they take to be a Judge, and who perhaps gained

that Character only by cunningly finding Faults in Pictures, when he could not find the Beautys, were there never so many" (*Comedian,* 1732, p. 24).

91. *The Manners of the Age* (1733), p. 71. Cf. the *Weekly Oracle* (1737; quoted, Elizabeth Manwaring, *Italian Landscape in Eighteenth Century England* [New York, 1925], p. 32): "There was some Years since a Painter (now dead) who had a dexterous Hand at making a *Titian,* a *Guido,* or an *Angelo* by roasting them in a chimney over a proper fire; this Painter, for want of a Name, could scarce get three guineas for an original of his own; but has had almost as many hundred for a copy from a Man of Quality, who imagined himself one of the greater Connoisseurs of the Age."

92. Farington, *Biographical Note* (on Wilson), from a MS. ca. 1805, quoted W. G. Constable, *Richard Wilson* (London, 1953), p. 17; *Monthly Review* XV (1756), 285.

93. *Autobiographical Notes,* p. 216.

94. Quoted, Edward Hughes, *North Country Life in the Eighteenth Century, I. The North-East* (London, 1952), 387–88; *Grub-street Journal,* 22 January 1735/6.

CHAPTER 14

1. *Weekly Register* No. 216, 27 April 1734.

2. Ibid. No. 215, 20 April 1734.

3. *Daily Advertiser,* 18 November 1735.

4. Letter from "A Microloger," *GM,* LIII, Pt. 1 (1783), 316; repeated in L. M. Hawkins, *Anecdotes, Biographical Sketches, and Memoirs* (1824), p. 47 n. I have found no source for this as a general artist's anecdote, and for all I know Kierkegaard may have read his version in one of the accounts of Hogarth: "The result of my life is simply nothing, a mood, a single colour. My result is like the painting of the artist who was to paint a picture of the Israelites crossing the Red Sea. To this end, he painted the whole wall red, explaining that the Israelites had already crossed over, and that the Egyptians were drowned." ("A's" diary, in *Either/Or,* tr. David F. and Lillian M. Swenson [London, 1944], I, 22.)

5. Benjamin Boyce, *The Benevolent Man,*

A Life of Ralph Allen of Bath (Cambridge, Mass., 1967), pp. 104–09.

6. *Autobiographical Notes,* p. 216.

7. Ibid., pp. 202–03.

8. Vertue, III, 78.

9. For announcements of all the prints mentioned, see *HGW.* For the Bakewell advertisements, see *Craftsman,* 2 April 1737 and *Daily Gazetteer,* 5 March 1736/7. By 1743, when he advertised a print celebrating the victory of Dettingen (BM Sat. 2585), Bakewell's shop was further to the east on the north side of Cornhill opposite Birchin Lane. He was by then no longer mentioned in Hogarth's advertisements. Hogarth kept a sample book of his engravings, containing on the inside cover a list of the plates with prices and page numbers; this was in Gwennap's collection and sale, 17 April 1845 at Foster and Son's (catalogue in the V & A; see also *Gen. Works,* III,

294–95). For some idea of the sale and circulation of political prints by Hogarth's contemporaries, see the testimony of printsellers before Lord Stanhope in 1749 (P.R.O., S.P., Dom., Geo. II, General, Bundle 3, ff. 173–74, 167–68).

10. Journal of the Meetings of the Governors of St. Bartholomew's Hospital.

11. *Autobiographical Notes,* p. 202.

12. For a discussion of Rembrandt's influence on Hogarth's St. Bartholomew's paintings, see Antal, pp. 146–47, 244 notes 27, 28.

13. *Gen. Works,* II, 263; Lane to Nichols, *Gen. Works,* I, 189; see also Moore, *St. Bartholomew's Hospital,* p. 851.

14. *Anecdotes of Painting,* IV, 140; *Gen. Works,* II, 190. Murillo's *Pool of Bethesda* is now in the National Gallery, London, and Ricci's version is kept by the Ministry of Public Buildings. Laguerre's version, on the wall of the chapel at Chatsworth, includes a figure that is very similar to Hogarth's man sitting up in the foreground. Cf. also Richardson's description of Rembrandt's *Christ Healing the Sick* (the Hundred Guilder Print) in his *Essay on the Theory of Painting* (2d ed. [1725], pp. 66–67): he argues that variety is the important consideration, the delineation of the different types, such as the Ethiopian who shows how far Christ's fame had reached.

15. See Moore, p. 850.

16. As he rephrased it in another draft: he painted his specimen in the hospital, "from which I found no Effects and the reason upon consideration was so plaine that I dropt all the old Ideas"; he "pursued the former [his "modern moral Subjects."] Dealing with the public in general I found was the most likely [thing to] do provided I could strike the passions and by small sums from many by means of prints which could Engrav from my Picture myself I could secure my Property to my self." (*Autobiographical Notes,* pp. 202–03, 216.)

17. To Ann Granville, 22 April 1740; *Mrs. Delany's Correspondence,* II, 82–83.

18. *Explanatory Notes,* pp. 71–72; for Richardson's reading and Hogarth's response in *The Complicated R——n,* see above, I, 351. The dating of *Satan, Sin, and Death* is by no means certain: cf. Beckett, p. 72; Antal, pp. 155–56; and *Fuseli Studies* (London, 1956), p.

53; my own note in *Studies in Burke and his Time,* IX (1967), 815–20; and David Bindman, "Hogarth's 'Satan, Sin and Death' and its Influence," *Burlington Magazine,* XCII (1970), 153–59. The style of the unfinished picture is indeterminate, but the size corresponds to the *Rake* pictures, and Sin looks like a Hogarth female of the 1730s; the best argument for a date in the 1750s is S. Ireland's story that it was painted for Garrick (I, 178). For its relation to Burke's *Enquiry,* see below, II, 281.

19. Walpole, *Anecdotes,* IV, 140; Dr. James Parsons, *Human Physiognomy Explain'd: in the Crounian Lectures on Muscular Motion for the Year 1746* (1747), pp. 57–58; published as a supplement to the *Philosophical Transactions of the Royal Society,* XLIV (1746).

20. Bank f. Deutsche Beamte Sale, Lepke, Berlin, 22 November 1932 (No. 96); clipping and photograph in Witt Library, Courtauld Institute, London.

21. Bourne (1695–1747), *Poematia, latine partim reddita, partim scripta* (1734), p. 146; quoted, *Gen. Works,* I, 95–96. "Conspicillum" and "Usus Quadrigarum" are in *Miscellaneous Poems* (1772), pp. 229, 280; tr. in *GM,* XXV (1755), 85.

22. Charles Lamb, letter to William Wordsworth, 7 April 1815, *Letters of Charles Lamb,* ed. E. V. Lucas (London, 1935), II, 154.

23. See *HGW,* I, 174; *Grub-street Journal,* 25 November 1736. Hogarth's print was announced on 5 March 1736/7 (*Daily Gazetteer*).

24. *General Evening Post,* 4 September 1735; *London Daily Post and General Advertiser,* 11 October 1735; *London Evening Post,* 22–25 May, 12–14 August, 17–19 August 1736.

25. See J. T. Hillhouse, *The Grub-street Journal* (Durham, North Carolina, 1928), pp. 271–89.

26. *London Daily Post and General Advertiser,* 23 January 1737/8.

27. *Daily Post,* 25 April; *Gazetteer,* 29 April; *London Evening Post and General Advertiser,* 3 May.

28. Hogarth may have been familiar with drawings of the *Ganymede with the Eagle* in the French Academy at Rome: the eagle is the same size in relation to Ganymede and, seen from one angle, resembles Hogarth's eagle.

29. These appear in the Vauxhall catalogues under various designations: "3. New-river-

head, at Islington with a family going awalking, a cow milking, and the horn archly fixed over the husband's head," or "A bonfire at Charing-Cross, and other rejoicings; the Salisbury stage overturned, etc." (See *The Ambulator; or, the Stranger's Companion in a Tour Round London . . . comprehending Catalogues of the Pictures by Eminent Artists* [London, 1774].) Nichols records that Hayman made copies of the *Four Times of the Day* for Vauxhall, and that *Evening* and *Night* were still there in 1808 (*Gen. Works,* II, 150). A copy of *Evening* was at the Lowther Castle sale, 29 April 1747, lot 1855, 54 x 50 in. Lawrence Gowing remarks: "If, as is possible, it is a Vauxhall picture, the vertical measurement was approximately that of the decorations in the other boxes; the series would thus have retained some uniformity in spite of the upright shape of the *Times of Day*" (Gowing, "Vauxhall Decorations," p. 11).

30. See I, 226-28, 530 n. 57; for the identification of De Veil, see *Biogr. Anecd.* (1782), p. 211 (where Hawkins is cited as denying a resemblance); J. Ireland, I, 149-50.

31. *London Evening Post,* 16-18 August 1737.

32. Ibid., 21-24 January 1737/8.

33. Ibid., 9-11 March 1737/8.

34. Félibien, arguing for unity of coloring, thinks a picture should be highly finished and is best "quand un tableau est peint dans la dernière perfection." In fact, for this reason he finds old pictures better than new ones: the colors have had time to blend (the more the aqueous part of the oil has dried, the more blending takes place), and they can also be unified by covering them with varnish, which makes colors fuse. For the views of Richardson, who as an admirer of Rembrandt was relatively friendly toward the use of broken paint, see *Works,* pp. 70-71; and cf. Hogarth's *Autobiographical Notes,* p. 207.

35. A. Houbraken, *De Groote Schouburgh der nederlantsche konstschilders en schilderessen,* I (1718), 259. Cf. John Elsum, "An Old Man's Head, by Rembrant," in *Epigrams upon the Paintings of the Most Eminent Masters, Antient and Modern* (1700), p. 92, No. 119.

36. See Mercedes Gaffron, "Right and Left in Pictures," *Art Quarterly,* XIII (1950), 312-31; also Heinrich Wölfflin, "Ueber das Rechts

und Links im Bilde," in *Gedanken zur Kunstgeschichte* (Basle, 1941), pp. 82-96; Rudolph Arnheim, *Art and Visual Perception* (Berkeley and Los Angeles, 1966), pp. 22-24. The same holds true on a stage: when a curtain rises the audience looks to the left; actors consider the left the strong side of the stage, and the actor furthest to the left dominates a group (Alexander Dean, *Fundamentals of Play Directing,* [New York, 1946], p. 132).

37. Only the second plate is unreversed, and the painting was clearly painted without reversal in mind. Here as in *Southwark Fair,* however, Hogarth tends to make the picture come down at left and right, so the viewer can enter from either direction.

38. The almost totally unsympathetic Roger Fry first pointed up the dichotomy of Hogarth's moralism and "his authentic gift . . . as a pure painter." He initiated the idea taken up by Collins Baker and even Oppé and Waterhouse, that Hogarth was "a born painter in the strict and limited sense of the word; he had the art of a vigorous direct statement and a feeling for the density and richness of his material. He had a painter's sensual feeling for the material texture." Fry comments too on "the fat, buttery quality of his pigment" that subsequent writers also observed (*Reflections on British Painting* [London, 1934], pp. 35-37). While not in agreement with Fry's estimate of Hogarth's general capabilities, I would accept the dichotomy he indicates between moral illustration and pure painting, though believing the relationship to be far more complex than he finds.

39. *Nicolas Poussin, a New Approach* (New York, n.d.), p. 41.

40. Frank and Dorothy Getlein, *The Bite of the Print* (1963), p. 12.

41. It has also been noted that Hogarth uses the checker pattern of contrasting light and shade necessary for the black-white of an engraving in his early paintings; in his middle and later work the light becomes more evenly distributed (Beckett, p. 7).

42. Letter to John Nichols, *Gen. Works,* I, 318.

43. 8 December 1764.

44. *Art of Painting after the Italian Manner* (1703), pp. 63-64. See also Richardson, *Essay on Theory of Painting,* p. 24; that a sad scene requires sad colors, etc., pp. 144-45.

45. Shaftesbury's *Second Characters,* ed. Benjamin Rand (1914), p. 61; see Addison's *Spectator* papers on "The Pleasures of the Imagination."

46. *Works,* p. 143.

47. Marjorie Hope Nicolson, *Newton Demands the Muse* (Princeton, 1946), p. 150 (referring to Young's *Night Thoughts*).

48. M. F. Feuillet de Conches, "William Hogarth," *Gazette des Beaux Arts,* XXV (1868), 209.

49. See Athenaeus, *The Deipnosophists,* XII, 510; tr. C. B. Gulick, V, 295.

50. Getlein, op. cit., p. 142.

51. There is a curious, almost parodic, resemblance between the compositions of Thornhill's *House of Commons* and Hogarth's *Sleeping Congregation.* Hogarth's oil sketch, which carries the date 1728 on a plaque on the church wall, but which from the style would appear to be from the early 1730s, has raised the Onslow figure to a pulpit and reduced the Walpole figure to a sleeping girl, and the clerk to the reader; the detailed faces of the M.P.'s have been reduced to barely distinguishable tiers of the sleeping congregation. Perhaps Hogarth intended this sketch as a burlesque of *The House of Commons* (cf. his anti-Walpole satires of 1727-28). If one imagined the House of Commons transformed into a church, these would be the equivalents. Swift accomplished such a transformation on a cottage in "Baucis and Philemon" (1709).

52. See *HGW,* cat. no. 159, pl. 171.

CHAPTER 15

1. Vertue, III, 61-62.

2. "M^r Jervais his Majestys painter has had no success in painting their Majesties pictures & from thence he lost much the favour & interest at Court. nor that picture of the King on horseback the face which he was to do. was thought like. M^r Wooton did the Horse.

"But M^r Jervais had the good fortune to marry a Gentlewoman with 15 or 20 thousand pounds" (Vertue, III, 59).

3. The portrait resembles the sketch on a canvas of four heads, now in the Mellon Collection, which Oliver Millar thinks may have been his *ad vivum* study—though why it would contain three unrelated heads is a puzzle (*Early Georgian Pictures,* p. 183).

4. Duke of Cornwall MSS., IV, f. 216, in Millar, op. cit., p. 183 (reproduction, pl. 205). See also R. W. Symonds, "Hogarth a Ghost for Wootton," *Burlington Magazine,* LXXXI (1942), 176-79; Millar, "John Wootton, William Hogarth and Frederick, Prince of Wales," *Burlington Magazine,* CIII (1961), 383-84.

5. The presence of a head under this painting conforms to Hogarth's known practice on other canvases. The backgrounds, however, are much closer to sepia than his usual gray-green-olive shade; the tables and chairs lack his bravura touch—as in the decorative parts of the St. Bartholomew's pictures at about this time. The putti in the air resemble those in the Cholmondeley group, and those on the ground could also be by Hogarth, though they are more clumsily painted. See Millar, op. cit., pls. 177, 178 (cat. nos. 562-63).

6. "1736/7. M^r Merciere affairs have not been very right with the Prince. He being dismiss'd his Service. after 9 years continuance and seemed to retire into the Country as if he had Left of painting; made a sort of Purchase of an estate. however lately has taken Lodgings in Common Garden. and commence portrait painting. and has painted several peices of some figures of conversation as big as the life . . ." (Vertue, III, 82).

7. *London Evening Post,* 9-12 October 1736; see also John Chamberlayne, *Magnae Britanniae Notitia* (1736), p. 251. A payment was made 1 October 1744 to "M^r John Ellis, Limner" for work done for the Prince of Wales from 1733 to 1738, which included "a small whole length of his Royall Highness in Her Royall Highness Cabinet at Durdans" (D. of Cornwall MSS., XIII, f. 109; Millar, op. cit., p. 176).

8. See *HGW,* cat. no. 157, pl. 169.

9. Vertue, III, 82.

10. Rouquet, *State of the Arts in England* (1755), pp. 37-38.

11. *London Evening Post,* 2-4 March, 4-7 March; Vertue noted this visit, probably from the newspaper account (III, 82).

12. Vertue, III, 84.

13. *LM,* VII (1738), 552. As background, Ho-

garth would have remembered *The Spectator*'s assertion that England was the great country for portrait painters and that even foreigners (Van Dyck, Lely, Kneller) painted better portraits when they came to England. From this *Spectator* Hogarth got the point that the English *are* good portrait-painters and do not need foreigners. "So that instead of going to *Italy*, or elsewhere," *The Spectator* said, "one that designs for Portrait Painting ought to study in *England*"—as one should go to Italy to study history painting, or Holland to paint drolls (*Spectator* No. 555).

14. *The English Face* (London, 1957), p. 163.

15. Waterhouse, *Painting in Britain*, p. 138.

16. J. B. LeBlanc, *Letters on the English and French Nations* (Dublin, 1747), I, 160.

17. The Earl of March, *The Duke and his Friends* (Oxford, 1911), p. 308.

18. See Elizabeth Johnston, Introduction, *Paintings by Joseph Highmore 1692–1780, The Iveagh Bequest, Kenwood House* (London, 1963). The Duke of Richmond wrote his secretary Labbe, 25 January 1729, about a payment of "a debt which I contracted a long time ago of a hundred pieces to Highmore, the artist, in Lincoln's Inn Fields" (Earl of March, *The Duke and his Friends*, p. 80).

19. Beckett, pls. 37, 77–80. Verses "To Mr. Hogarth on Miss F—'s Picture" were published in *The Bee*, v (18–25 May 1734), 551–52, and reprinted in *GM*, IV (1734), 269. The verses make it sound like a single portrait, but it remains unidentified; unless it is one of those said to be of Lavinia Fenton.

20. "Essay on the Theory of Painting," in *Works*, p. 6.

21. Vertue, III, 45, 56–57; Whinney, *Sculpture in Britain*, pp. 72–73. By 1747, when Hogarth had given up his serious career as a portraitist, the *London Tradesmen* noted: "The taste for busts and figures in these materials [i.e. clay, wax, and plaster of Paris] prevails much of late years, and in some measure interferes with portrait painting. The Nobility now affect to have their apartments adorned with bronzes and figures in plaster and wax" (cited Whinney, p. 112).

22. Whinney, p. 103.

23. "Essay on the Theory of Painting," in *Works*, pp. 78–79.

24. *Shaftesbury's Second Characters*, ed. Benjamin Rand (1914), pp. 134–35.

25. *Autobiographical Notes*, p. 214 (ca. 1763).

26. *Autobiographical Notes*, pp. 216–17 (I have regularized this and the subsequent passages); Vertue, III, 97–98; Vanderbank's will, 13 December 1739 (P.C.C. 1740 Browne 188), shows that he was childless and left what property remained to his wife Anne. Vertue adds: "For his Friends I can't say he had made the best use of them, many he had had, very extraordinary, but did not acquit himself in the best manner.—many stories related of his carlessness or ingratitude on that account, are better forgot than to be rememberd.—as I was early of his acquaintance in his youth, so I sometimes shar'd his company and affections. but never to any degree, extraordinary—"

27. *Autobiographical Notes*, pp. 217–18. He tells the story again on p. 225.

28. *Philosophical Transactions of the Royal Society*, XLI, 484; Vertue, III, 96; National Library of Scotland, *MS*. 3134, f. 22; Lord Killanin, *Sir Godfrey Kneller and his Times, 1646 –1723* (London, 1948), p. 26.

29. Alastair Smart, *The Life and Art of Allan Ramsay* (London, 1952), p. 1.

30. *MS. Life of Allan Ramsay* [the Elder] (by his son), Laing MSS., Edinburgh University Library; quoted, Smart, p. 1.

31. Ibid.; see *GM*, CXCIX (1853), 370, which quotes a letter from his father addressed to "Mr. Allan Ramsay, at Mistress Ross's, In Orange Court, Near the Meuse, London."; Smart, p. 2. Asserting that his earliest portraits show awareness of Hogarth's portraits, Smart puts it this way: Ramsay began "to come to terms with the new informal portraiture of Hogarth" (p. 13). John Hayes says much the same, though not placing it specifically before Ramsay's trip to Italy (and so before Hogarth began to produce this sort of portrait): "Ramsay's inclination towards the unaffectedly natural in portraiture meant that his sympathies lay entirely with the new school of portraitists headed by Hogarth and Highmore. . . . The genial head of Sir John Hynde Cotton . . ., painted in 1740, is in sympathy with Hogarths of the later 1730's, though, stylistically, the conception of this portrait is perhaps closer to Van Loo. . . ." ("Allan Ramsay at the

Royal Academy," *Burlington Magazine,* CVI [1964], 190–93.)

32. Vertue, III, 96.

33. Ramsay to Cunyngham, 10 April 1740, in *Curiosities of a Scots Charta Chest,* ed. Hon. Mrs. Atholl Forbes (1897), p. 142.

34. See David Piper, *The English Face,* pp. 161–62.

35. Vertue, III, 96, 125; Smart, pp. 40–41; John Steegman, "A Drapery Painter of the Eighteenth Century," *Connoisseur,* XCVII (June 1936), 309 ff.

36. Vertue, III, 93–94, 96.

37. James Northcote, *The Life of Sir Joshua Reynolds* (London, 1819), I, 17–18; Hogarth, *Apology for Painters,* p. 101.

38. *Gen Works,* I, 237.

39. *Autobiographical Notes,* p. 218.

40. Vertue, III, 102.

41. The Journal of the Minutes of the General Court and General Committee are in the Captain Coram Foundation, Brunswick Square. See *HGW,* cat. no. 225, pl. 265.

42. Ibid., reprinted and regularized in John Brownlow, *Memoranda; or, Chronicles of the Foundling Hospital* (London, 1847), pp. 7–8.

43. R. H. Nichols, and F. A. Wray, *The History of the Foundling Hospital* (London, 1935), p. 14.

44. We should also note the remarkable resemblance to the portrait of Wren designed by Verrio and carried out by Kneller and Thornhill (Sheldonian Theatre), which may be a closer and more probable source for Hogarth's *Coram* (Whinney and Millar, p. 195 n.).

45. Waterhouse, *Three Decades,* p. 15; and pp. 14–17. Hudson's portrait of Theodore Jacobsen, the Hospital's architect, should also be compared with Hogarth's. Hudson shows him full-length in the pose of Scheemacker's well-known statue of Shakespeare, leaning on a plinth; Shakespeare's poem is transformed into the architectural plans for the Foundling. Jacobsen, a rich London steelyard owner who had retired to become an architect, presumably wished to see himself poeticized in this way. Hogarth's portrait of a few years earlier is a straightforward half-length in which Jacobsen simply holds up his plans (Beckett, pl. 135).

46. Piper, p. 184.

47. Letter of April 1751, quoted without reference by Smart, p. 55.

48. *Gen. Works,* I, 23.

49. Lady Elizabeth Cust, *Records of the Cust Family, Second Series* (London, 1909), pp. 250, 260, 261.

50. See below, pls. 272–73.

51. John Hoadly to Robert Dodsley, 1 November 1757, in Hyde Collection. The verses were reprinted in Dodsley's fifth *Miscellany* of 1758.

52. *London Journal,* 9 March 1734.

53. The £1700 he left in his will should be compared to the £40,000 left by Bishop Sherlock and the £50,000 by Bishop Hutton.

54. Pyle, *Memoirs of a Royal Chaplain* (London, 1905), p. 178.

55. *Joseph Andrews,* Bk. I, chap. 17; *Tom Jones,* Bk. XI, chap. 7.

56. The Hoadly brothers' play *The Contrast,* performed at Lincoln's Inn Fields 30 April 1731 and the three subsequent nights, though aimed primarily at Thomson (whom Fielding had also burlesqued), survives in only one sentence which alludes to Fielding. Whether Fielding would have taken it as an attack is questionable, but it was printed as such in the *Grub-street Journal,* 27 May 1731: "By G—," says one of the characters, "I hate all ghosts, from the bloody ghosts in Richard the Third to that in 'Tom Thumb.'" The play was never published because suppressed by the Bishop.

57. *BM. Add. MS.* 27995, f. 23. See "Memoirs of the Life of the late Rev. John Hoadly," *Annual Register,* XIX (1776), 38–43; Pyle, *Memoirs of a Royal Chaplain,* pp. 268–69.

58. See Robert R. Wark, "Two Portraits by Hogarth," *Burlington Magazine,* XCIX (1957), 344–47; C (1958), 26–27; *HGW,* I, 266. My reconstruction is based on the assumption that Baron would have adjusted for reversal and Hogarth would not.

59. G. R. Cragg, "The Churchman," *Man versus Society in 18th-Century Britain,* ed. J. L. Clifford (Cambridge, 1968), p. 59.

60. See Beckett, p. 53, pls. 130, 149.

61. William Stukeley, Bodleian MS. Eng. Misc. e. 260, f. 24; quoted, Joan Evans, *A History of the Society of Antiquaries* (Oxford, 1956), p. 92.

62. George Baker, *The History and Antiquities of the County of Northampton* (London, 1822-30), I, 248.

63. Cf. Lady Hesketh's curious opinion: "Hogarth who excell'd so much, and whose fame will never dye, made all his children Frightful! He had none of his own and my dear Father [Ashley Cowper] who knew him well, has often said that he believ'd his Friend Hogarth had an aversion to the whole Infantine Race, as he always contrived to make them hideous—and indeed though many children are introduced among his various Groupes I do not remember ever to have seen a pretty one—Strange enough, as it seems difficult to represent them otherwise" (22 July 1802, letter to William Hayley, BM. Add Ms. 30803B, f. 58).

64. The self-portrait's authenticity appears unimpeachable. Samuel Ireland obtained it from Mrs. Hogarth, and, noticing that Mrs. Hogarth, Paul Sandby, and Theodosius Forrest all testified to its likeness, he uses it as the frontispiece to *Graphic Illustrations of Hogarth* (see I, xi).

65. J. Ireland, I, cxx.

66. See J. V. G. Mallet, "Hogarth's Pug in Porcelain," *Victoria and Albert Museum Bulletin*, III (1967), 45-54.

67. *Analysis*, pp. 137, 141.

68. *Farington Diary*, typescript in BM, 17 June 1813. The anecdote is probably from about this time in the late 1730s.

69. Earl of Ilchester, *Henry Fox, First Lord Holland, His Family and Relations* (London, 1920), I, 51. The copy belonging to the Earl of Ilchester was painted in the 1740s, to judge by the order of the garter worn by the Duke of Marlborough.

69a. C. G. T. Dean, *The Royal Hospital Chelsea* (London, 1950), p. 221. See also *Farington Diary*, III, 77; *GM*, LXXXV (1816), Pt. 1, 633.

70. I have learned nothing definite about the source of *The MacKinnon Children*. According to Beckett's MS. in the Witt Library it shows William MacKinnon, the young chief of the clan Fingon, with his sister, at Binfield, Berkshire, which still belonged to his grandson Daniel Henry MacKinnon (1813-84). According to Mr. Harcourt Chambers, a descendant, the MacKinnon girl was named Charity or Edith; she married Dr. Thomas or William Fraser of Balmain, Scotland, a kinsman of Lord Lovat.

71. Vertue, III, 94. See John Woodward, "Amigoni as Portrait Painter in England," *Burlington Magazine*, XCIX (1957), 21-23.

72. Ibid.

73. Vertue, III, 96-97.

74. Regularized version of Vertue's transcription, III, 98. See also *HMC, 12th report*, Appendix IX (1891), p. 191.

75. Vertue, III, 107, 110.

76. Vertue, III, 111, 124.

77. For example, the *London Evening Post* for 11-14 November 1738 reported: "Last Week a fine *Venus* was finish'd at a Sculptor's in St. Martin's Lane for a Person of Quality; eight of the most celebrated Painters assisted at the Performance, and the Lady who sat nine Hours at different Times for the same, had three Half Crowns each Hour for her Complaisance and Trouble." The same paper for 14-16 November clarified the report. "Mr. Roubillack, the Statuary, is carving a curious Figure of a Lady for Sir Andrew Fountaine, Knt. which, we hear, will cost 300*l*."

78. Vertue, III, 117.

79. Vertue, III, 118; this puzzling reference follows: "also Crayon painters of portraits especially—Knapton—Hogarth Pond & hore—some Landskips also well done."

80. Vertue, III, 121.

81. *Autobiographical Notes*, p. 218.

82. Ibid., p. 212.

83. Ibid., p. 213.

CHAPTER 16

1. *Gen. Works*, II, 158; W. F. N. Noel, "Edwards of Welham," *The Rutland Magazine and County Historical Record*, IV (1909-10), 211.

2. Noel, p. 211.

3. Reproduced, *HGW*, I, opp. p. 25.

4. Preface; my text is Martin Battestin's (Oxford, 1967).

5. *Autobiographical Notes*, pp. 208, 212, 215, 216. See below, II, 408.

6. Bk. I, chaps. 8, 14.

7. According to W. B. Coley, "Fielding, Hogarth, and Three Italian Masters," *Modern Language Quarterly,* XXIV (1963), 386–91.

8. Op. cit., p. 388.

9. 10 May 1751, *The Letters of the Earl of Chesterfield to his Son,* ed. Charles Strachey (London, 1901), II, 150.

10. Hogarth, MS., Fitzwilliam Museum, written around the time he published *The Bench* (1758).

11. See E. Kris and E. H. Gombrich, "The Principles of Caricature," in E. Kris, *Psychoanalytic Explorations in Art* (New York, 1952), pp. 189–203. "Expressed in these terms," they write, "the portrait painter's task was to reveal the character, the essence of the man in an heroic sense; that of the caricaturist provided the natural counterpart—to reveal the true man behind the mask of pretense and to show up his 'essential' littleness and ugliness" (p. 190).

12. For the influence of Le Brun's stereotyped passions, see Brewster Rogerson, "The Art of Painting the Passions," *Journal of the History of Ideas,* XIV (1953), 68–94. For Hogarth's written account of physiognomy, strongly influenced by Parson's theory of musculature, see *Analysis,* pp. 137 ff. By arguing that after so long a time the muscles left their permanent marks on the face, Hogarth used the theory to support the satirist's view of a correspondence between inner being and outer appearance. For Parsons, see above, p. 390.

13. See my essay, "The Pilgrimage and the Family: Structures in the Novels of Fielding and Smollett," in *Tobias Smollett: Bicentennial Essays Presented to Lewis M. Knapp* (Oxford, 1971).

14. *Tom Jones,* Bk. XII, chap. 2.

15. Vertue, III, 116.

16. Vertue, III, 120. Referring to *Marriage à la Mode* elsewhere, he inserts the enigmatic note, "to the obscuration of my reputation" (VI, 201).

17. Vertue, III, 137; *Gen. Works,* I, 121; *HGW,* I, 64.

18. Vertue, VI, 134.

19. James Northcote, *The Life of Sir Joshua Reynolds* (1819), I, 138.

20. Hazlitt, "Lecture VII: On the Works of Hogarth," in *Lectures on the English Comic Writers* (London, 1910), p. 135.

21. *London Daily Post and General Advertiser,* 20 October 1735. It was revived in 1746 *after* the publication of his prints, in Colley Cibber's *The Comical Lovers, or Marriage a la Mode,* starring Kitty Clive, and advertised as "not acted these 30 Years" (see *LS,* pt. 3, II, 1223 ff.).

22. *Lethe* (produced at Drury Lane, April 1740), act I, pp. 23–24.

23. *Pamela* (1740), ed. W. M. Sale, Jr. (New York, 1958), p. 477.

24. *Specchio,* pl. VII (see Kurz, pl. 33); *The Prentice's Tragedy or the History of George Barnwell: Being a fair Warning to Young Men to avoid the company of Lewd Women* (ca. 1700), p. 6 (cited, Kurz, pp. 151–52; the last sentence, Kurz says, has been lifted from Garzoni's *Discorso,* which singles out *The Judgment of Paris* used in *Rake,* pl. 2 as especially wicked). Some of these pictures may have been in George Lillo's stage version, *The London Merchant* (1731), which Hogarth certainly saw. For the *Ganymede* picture, see Jonathan Richardson, *Essay on the Theory of Painting,* p. 65.

25. Dobson, p. 75.

26. Although I have not located a specific source, it does appear to be a Flemish, and not an Italian, paradigm. The School of Petrus Christus *Deposition* and the School of Coter *Trinity,* both in the Louvre, have the essential features; the former also has the Magdalen wringing her hands. One wonders whether he was in any way recalling Jonathan Richardson's passage on artists' errors in painting *The Descent from the Cross* in his *Treatise on Painting* (Works, pp. 30–31).

27. See Helen M. Garth, "Saint Mary Magdalene in Medieval Literature," Johns Hopkins University Studies in Historical and Political Science, LXVII (1950), Pt. 3, esp. pp. 31–36; "stood near" was Honorius of Autun's description (cited, p. 36).

28. Horace Walpole, *Aedes Walpolianae* (1742 ed.), p. xvi. Cf. Pope, "Epistle to a Lady" (*Moral Essays,* II), ll. 5–13, where he alludes to the fashionable ladies who have their pictures painted as "a naked Leda with a Swan," a St. Cecilia, and a Magdalen: "Let then the Fair one beautifully cry, / In Magdalen's loose hair and lifted eye. . . ."

29. See II, 149. One can get some idea

of Hogarth's holdings from the list of prints sold at Jane Hogarth's auction in 1790 (Appendix L).

30. See Earl R. Wasserman, "The Limits of Allusion in The Rape of the Lock," *Journal of English and Germanic Philology,* LXV (1966), 425-44.

31. A small oil sketch in the Ashmolean Museum, Oxford (Beckett, pl. 141), sometimes called "The Suicide of the Countess," may be a preliminary version of the fifth or sixth plate of *Marriage à la Mode,* an alternative ending for the series. It is only the slightest idea: a woman stripped to the waist, the suggestion of blood below the right breast, someone (female?) dabbing at it, a male holding the victim's hand and looking remorseful, and a child clamoring at his side. The cast looks as if it might be the Squanderfield family. No special signs of a masquerade costume are in evidence, but it appears that the countess has been stabbed herself instead of Silvertongue; or perhaps she has stabbed herself after his or the count's death (the man may be intended for her father). In a very general way the composition resembles Plate 6 as it finally emerged.

32. BM. Dodd MSS. IX/62 (Add. MSS. 33402).

33. Dated 11 February; in the W. S. Lewis Collection.

34. Vertue, III, 123-24.

35. Walpole to Mann, 25 July 1750, *Yale Edition of Walpole Correspondence,* XX, ed. W. S. Lewis, Warren Hunting Smith, and George Lam (1960), 164, remarking that King Theodore is in the King's Bench Prison for debt: "I have desired Hogarth, to go and steal his picture for me; though I suppose one might easily buy a sitting of him." The editors add that "this portrait does not seem to have been executed." For the room in Plate 2 of *Marriage à la Mode,* see Sir Wemyss Reid, *Life, Letters, and Friendships of Richard Monckton Milnes, first Lord Houghton* (1890), II, 364; Dobson, p. 74. For the story of Hogarth and Gray, see *Gen. Works,* I, 393.

36. Walpole to Ossory, 3 April 1773, *Walpole Correspondence,* XXXII, ed. W. S. Lewis and A. Dayle Wallace (1965), 114; Walpole, MS. *Commonplace Book,* p. 44 (W. S. Lewis Coll.). That *Strolling Actresses* was sold to Francis Beckford and then to Wood: J. Ireland, III, 232. In the 1780s it was in the possession of Wood's brother Thomas (1708-99), and it remained in the family till destroyed by fire at Littleton in 1874.

37. A receipt in Hogarth's hand, dated 2 March 1745, is in the Houghton Library, Harvard, Murdock MS. 21.

38. Roubiliac supplied the monument of the second Duke (d. 1742); the third Duke, who bought Hogarth's paintings, had his wife painted by Hudson, and in the 1750s filled his rococo rooms with chimneypieces by Cheere.

39. Mary Edward's sale, Cock's, 28, 29 May 1746; *Gen. Works,* II, iv. The Distressed Poet was also missing; it was presented by Hogarth to Mrs. Draper, Queen Caroline's midwife (J. Ireland, I, 117).

40. *London Evening Post,* 27-30 April 1745; *Daily Advertiser,* 29 April; *London Evening Post,* 6-8 June, 13-15 June, 20-22 June, and in many subsequent issues as late as mid-September, reminding that the subscribers' edition could be picked up and others bought.